BETWEEN WORLDS

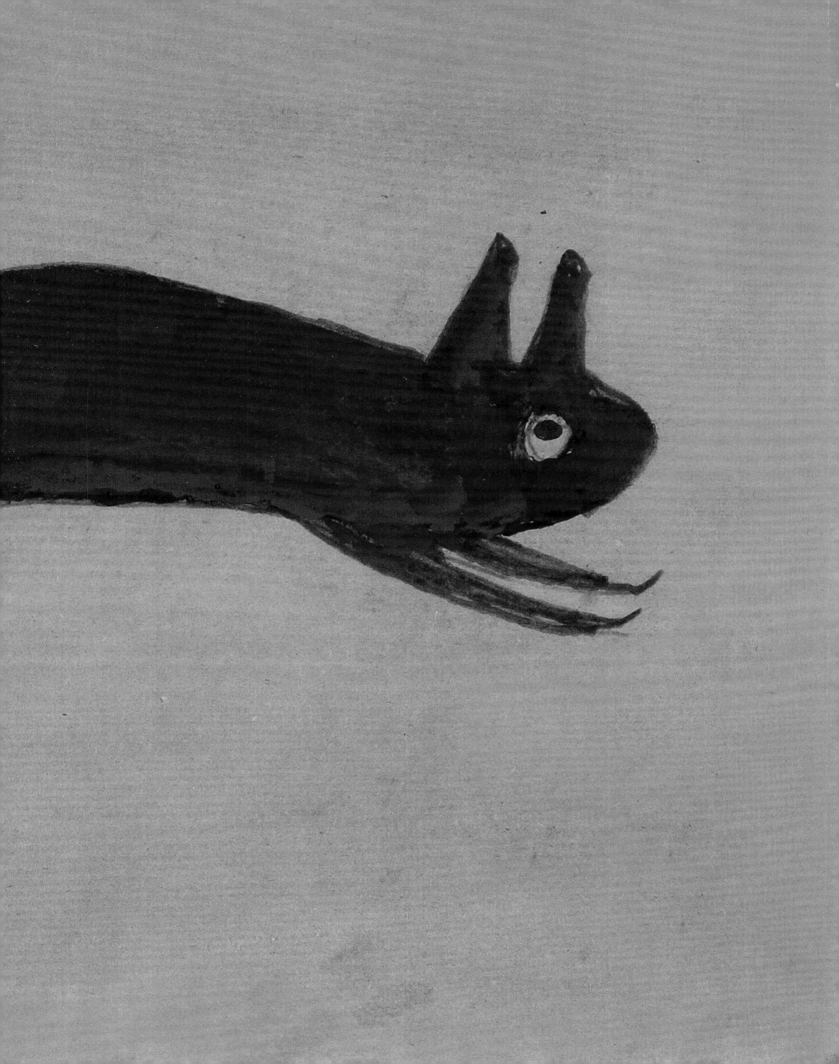

BETWEEN WORLDS

LESLIE UMBERGER

with an introduction by Kerry James Marshall

The Art *of* Bill Traylor

Smithsonian American Art Museum, Washington, DC, in association with Princeton University Press, Princeton and Oxford

BETWEEN WORLDS

The Art *of* Bill Traylor

By Leslie Umberger

Published in conjunction with the exhibition of the same name, on view at the Smithsonian American Art Museum, Washington, DC, September 28, 2018–March 17, 2019.

Produced by the Publications Office, Smithsonian American Art Museum, Washington, DC, americanart.si.edu

Theresa J. Slowik, *Chief of Publications*
Stacy Mince, *Curatorial Assistant*
Karen Siatras, *Designer*
Mary J. Cleary and Jane McAllister, *Editors*
Amy Doyel, *Permissions Coordinator*

Typeset in Landa and Proza and printed on Garda Silk 100# text

Printed in Canada by Friesens Corporation

Published by Smithsonian American Art Museum in association with Princeton University Press, Princeton and Oxford, press.princeton.edu

The Smithsonian American Art Museum is home to one of the largest collections of American art in the world. Its holdings—more than 43,000 works—tell the story of America through the visual arts and represent the most inclusive collection of American art of any museum today.

It is the nation's first federal art collection, predating the 1846 founding of the Smithsonian Institution. The Museum celebrates the exceptional creativity of the nation's artists, whose insights into history, society, and the individual reveal the essence of the American experience.

Jacket *(front)*: *House*, ca. 1941 (pl. 132)

Jacket *(back)*: from *Untitled (Snake)*, ca. 1939–42 (pl. 84)

pp. 1–2: *Rabbit*, ca. 1940–42 (pl. 81)

p. 6: Detail, *Untitled (Seated Woman)*, ca. 1940–42 (pl. 201)

p. 8: *Yellow Chicken*, ca. 1939–40 (pl. 25)

p. 10: Detail, *Brown Lamp with Figures*, ca. 1939–42 (pl. 59)

p. 14: *Red Man*, ca. 1939–42 (pl. 144)

p. 18: *Black Turkey*, ca. 1939–42 (pl. 200)

Library of Congress Cataloging-in-Publication Data

Names: Umberger, Leslie, author. | Marshall, Kerry James, 1955– writer of introduction. | Smithsonian American Art Museum, organizer, host institution.

Title: Between worlds : the art of Bill Traylor / Leslie Umberger ; with an introduction by Kerry James Marshall.

Description: Washington, DC : Smithsonian American Art Museum ; Princeton, NJ : in association with Princeton University Press, [2018] | "Published in conjunction with the exhibition of the same name, on view at the Smithsonian American Art Museum, Washington, DC, September 28, 2018–March 17, 2019." | Includes bibliographical references and index.

Identifiers: LCCN 2018026452 | ISBN 9780691182674 (hardback)

Subjects: LCSH: Traylor, Bill, 1854–1949—Exhibitions. | Outsider art—United States—Exhibitions. | BISAC: ART / Folk & Outsider Art. | ART / American / African American. | ART / American / General. | ART / History / Modern (late 19th Century to 1945). | BIOGRAPHY & AUTOBIOGRAPHY / Artists, Architects, Photographers.

Classification: LCC NC139.T69 A4 2018 | DDC 709.04/09--dc23 LC record available at https://lccn.loc.gov/2018026452

10 9 8 7 6 5 4 3 2

CONTENTS

Between Worlds: The Art of Bill Traylor is organized by the Smithsonian American Art Museum with generous support from:

ART MENTOR FOUNDATION LUCERNE

ELIZABETH BROUN

FAYE AND ROBERT DAVIDSON

SHEILA DUIGNAN AND MIKE WILKINS

JOSH FELDSTEIN

JOCELIN HAMBLETT

HERBERT WAIDE HEMPHILL JR. AMERICAN FOLK ART FUND

JUST FOLK/MARCY CARSEY AND SUSAN BAERWALD

LUCAS KAEMPFER FOUNDATION

MARIANNE AND SHELDON B. LUBAR

MARGERY AND EDGAR MASINTER EXHIBITIONS FUND

MORTON NEUMANN FAMILY FOUNDATION

DOUGLAS O. ROBSON IN HONOR OF MARGARET Z. ROBSON

JEANNE RUDDY AND VICTOR KEEN

JUDY A. SASLOW

KELLY WILLIAMS AND ANDREW FORSYTH

LENDERS TO THE EXHIBITION

American Folk Art Museum, New York
Scott Asen
Jill and Sheldon Bonovitz
Roger Brown Study Collection,
 School of the Art Institute of Chicago
Mr. and Mrs. Paul Caan
Mickey Cartin
Christian P. Daniel
Tom de Nolf
Louis-Dreyfus Family Collection
The William Louis-Dreyfus Foundation Inc.
Josh Feldstein
Peter Freeman
Robert M. Greenberg
Dr. Robert Grossett
Jocelin Hamblett
Audrey B. Heckler
High Museum of Art, Atlanta
David F. Hughes
Lucas Kaempfer Foundation
Penny and Allan Katz
Victor F. Keen
The Harmon and Harriet Kelley Foundation
 for the Arts

Karen Lennox Gallery
Kravis Collection
Jerry Lauren
Marianne and Sheldon B. Lubar
The Metropolitan Museum of Art, New York
Montgomery Museum of Fine Arts, Alabama
Morris Museum of Art, Augusta, Georgia
The Museum of Everything
The Museum of Modern Art, New York
Newark Museum, New Jersey
Jan Petry and Angie Mills
Philadelphia Museum of Art
Jay Schieffelin Potter
Private collections
Douglas O. Robson
Michael Rosenfeld Gallery, LLC
Luise Ross
Robert A. Roth
Dame Jillian Sackler
Judy A. Saslow
Smithsonian American Art Museum
Smithsonian Libraries
Siri von Reis
Whitney Museum of American Art, New York
Barbara and John Wilkerson

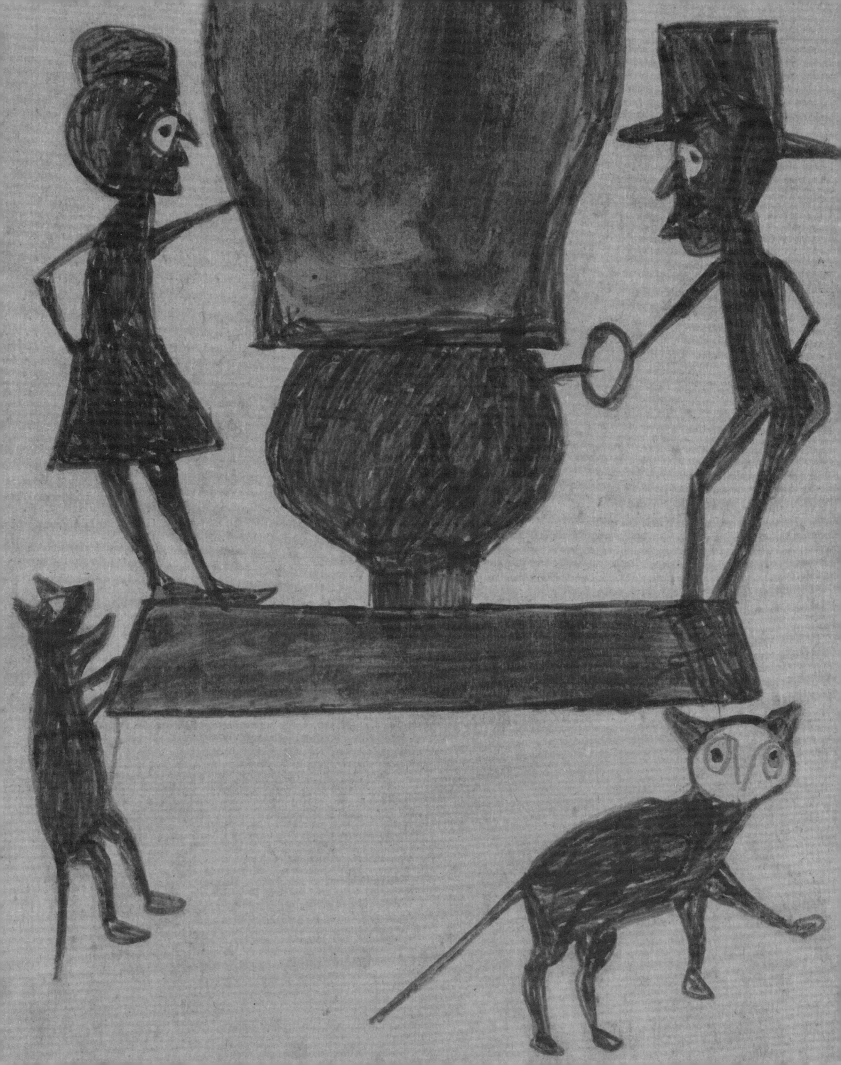

I, too, am America.

LANGSTON HUGHES, FROM "I, TOO, SING AMERICA," 1926

DIRECTOR'S FOREWORD

Bill Traylor (ca. 1853–1949) was born into American slavery, which tied him to the land and to Alabama for much of his life. A child during the Civil War and the nation's consequent declaration of Emancipation, Traylor navigated his formative years during Reconstruction and his adult life through an era of Jim Crow laws that blocked blacks from the full bounty of America.

But despite opportunities lost to him, Traylor was able, in his midseventies, to leave agrarian life and find his way to Montgomery, Alabama. In the late 1920s, he discovered an urban world of commerce and activity in the black section of town. Although the city was segregated, the African American community there was connected in ways that were radically different from anything he'd ever known. In that setting, Traylor found his destiny, producing astonishing works that mingle images from his personal narrative with abstracted motifs. His art was an unmistakable assertion of personal identity; his pictures reveal a private quest for meaning and clarity in a society that offered him neither.

The Smithsonian American Art Museum (SAAM) is honored to present the retrospective exhibition *Between Worlds: The Art of Bill Traylor* and the accompanying monograph. In them, Leslie Umberger, the Museum's curator of folk and self-taught art, reaches into history to give us a vivid picture, not only of the milieu of Traylor's life but also of his personal story and artistic trajectory, and in doing so has unearthed details of his life long thought lost to history.

Over some seven years, Umberger looked carefully and expansively at Traylor's art. The 155 paintings and drawings she selected comprise the most encompassing exhibition of his work to date. The publication explores and illustrates more than two hundred works on paper or cardboard, including seventeen from SAAM's own collection. This comprehensive presentation of Traylor's work, coupled with the unprecedented study of the artist's life, makes *Between Worlds* a landmark project.

This monograph also offers a deep view of social history, biography, and art history to reveal how late nineteenth- and early twentieth-century Alabama shaped Traylor and his art. Umberger, with the assistance of Stacy Mince, pored over vital records and historical texts, revisited existing scholarship, and connected with Traylor's family and followers to create a more holistic picture of the artist's life than has existed to date. Nineteenth-century records reveal the circumstances in which the formerly enslaved—stripped of the family names of their ancestors—took the surnames of the owners of the plantations on which they lived and worked. The story of Bill Traylor and his family is inextricably bound up with that of brothers John Getson Traylor (1809–1850) and George Hartwell Traylor (1801–1881) and their Alabama plantations. *Between Worlds* considers the lives of both the black and white Traylors. It presents a narrative of dramatic contrasts in which, through war and Reconstruction and beyond, each family renegotiated its history and relationship to the country.

Folk, self-taught, outsider, primitive: language reveals our insistent need to grapple with objects and images of deceptive simplicity, works, like Traylor's, that defy the traditional taxonomies that have long guided art lovers and historians. Such terms are verbal signals that help us locate visual powers in a universe of creative achievement; they are variously accurate and inaccurate, revealing and confusing. As expressed by artist Kerry James Marshall in his introduction to this volume, "Traylor and his work have come to embody many of the complexities and contradictions argued around aesthetic hierarchies and the issue of insiders versus outsiders in the construction of art history."

Since 1970, when SAAM acquired and undertook the preservation of James Hampton's awe-inspiring *Throne of the Third Heaven of the Nations' Millennium General Assembly* (ca. 1950–64), a mixed-media installation covered in tinfoil, paper, and paint, the Museum has blazed a trail that is actively widening and deepening the story of American art and artists. Today the collections at SAAM, which include thousands of works by untrained artists as well as the largest holdings of African American and Latino art of any nationally focused institution, ever more deeply reflect the collective identity of America. Understanding the many threads that together weave the tapestry of a heterogeneous nation means continually reassessing our point of view, interrogating our methodologies of study and interpretation, endlessly digging deeper to apprehend the intentionality of artists and elevate stifled voices, and connecting the varied histories that refute tidy categorization.

The frameworks of "folk" or "self-taught" offer starting points to apprehend Traylor but unnecessarily limit our grasp. *Between Worlds* charts the much-needed way forward for studying and presenting the work of autonomous artists—that is, understanding that broad categories are not a useful endgame; rather, it is through the in-depth individual stories that we reveal a meaningful whole. By advancing scholarship, using language to illuminate but not constrain, including multiple perspectives and voices to flesh out oblique histories, and honoring individual circumstances and views apart from established canons, *Between Worlds* profoundly advances our understanding of Bill Traylor, the man and the artist.

The moment for an important show on Bill Traylor is propitious. Just blocks from where Traylor made his art, the National Memorial for Peace and Justice and the Legacy Museum opened in Montgomery in April 2018. Both are projects of Bryan Stevenson and the Equal Justice Initiative, which describes the edifice as "the nation's first memorial dedicated to the legacy of enslaved black people, people terrorized by lynching, African Americans humiliated by racial segregation and Jim Crow, and people of color burdened with contemporary presumptions of guilt and police violence." Set on a hilltop overlooking the city, the memorial is a "sacred space for truth-telling and reflection about racial terrorism and its legacy."[1] Art critic Philip Kennicott hailed the "pergola of rusted steel" as inestimably important. "This ambitious project will force America to confront not only its wretched history of lynching and racial terror, but also an ongoing legacy of fear and trauma that stretches unbroken from the days of slavery to the Black Lives Matter movement of today."[2]

Appropriately, just one month before the National Memorial for Peace and Justice opened, a ceremony was held to place a headstone on Bill Traylor's gravesite, which had been unmarked since his burial in 1949. Family members, the *Between Worlds* curatorial team from SAAM, scholars and supporters of Traylor's work and legacy, and officials from the City of Montgomery and the State of Alabama gathered at Mount Mariah A.M.E. Zion Church in Montgomery to celebrate Traylor and unveil a marker sixty-nine years overdue. Like the newly inaugurated memorial so close to his refurbished gravesite, *Between Worlds: The Art of Bill Traylor* brings Traylor's legacy, and his accomplishments, lastingly to the fore in both Alabamian and American history.

STEPHANIE STEBICH
The Margaret and Terry Stent Director
Smithsonian American Art Museum

PREFACE

Bill Traylor made a large body of drawn and painted art in the last decade of his life. It did not all survive, but all or most of what did was made between 1939 and 1942. When Traylor took to image making, he had little to his name and was living predominantly on the streets of Montgomery, Alabama, in the segregated black business district. At the time, his art was of negligible value. But for Traylor, these images charted a life and stood as an indelible and validating testament of selfhood for a man whose worth as a person had been thwarted and undermined by his society since the day he was born into chattel slavery.

Between Worlds: The Art of Bill Traylor tells the story of Bill Traylor and situates the art he made against the backdrop of that life. It aims to reunite related themes, images, and characters in his works that had become fragmented and isolated once the paintings and drawings became available to a wider public. Traylor made more than a thousand artworks, yet a specific number cannot accurately be named because some were neglected and lost, many were never photographed, and Traylor did not title them. Purchasers or other holders of his works did not always keep sufficient ownership records, and the documents of provenance that are available are generally incomplete. During my research for *Between Worlds*, I evaluated most of the known works in Traylor's oeuvre; the exhibition ultimately conveys the heart of Traylor's complex journey through 155 key paintings and drawings, while the book considers an additional fifty pieces by the artist.

From the outset of this research project—which took roughly seven years from conception to execution, to manifest in an exhibition and publication—the intention was to bring together long-separated artworks that are related in content; give in-depth attention to Traylor's imagery, narratives, and symbolism; and carefully revisit the artist's biographical details to establish a comprehensive and illuminating framework for his body of work. Investigating history and vernacular culture and scrutinizing his works were all labor-intensive and time-consuming facets, but sorting the biographical

details presented the greatest obstacle. Trying to flesh out Traylor's personal path was like walking into quicksand—being sucked into an endless pursuit of more reliable facts and an ever-deepening pool of possibilities. Details of Traylor's biography have been variously proposed, passed along, and revised many times over the years. Each investigator built on earlier work, although most echoed the hearsay accounts that accompanied the tale of Traylor for decades. A few sought better and more exact data, bit by bit. Nonetheless, much of the information that has been published on Traylor to date is either inaccurate or presents a reductive narrative that cannot be verified by existing records; a number of analyses of the art depend on far too few examples to substantiate the proposed ideas, or they overreach in proclaiming connections that might not be valid. In many cases facts are not clearly delineated from opinions and lore, with the result, finally, that we have had no single comprehensive and reliable account of Traylor's life and art. The current project mandated a fresh start.

African Americans born in antebellum America are notably absent from government census records. The documents that do exist evidence a chilling account of people who were not valued as individuals but rather as property. Enslaved people were neither the authors nor stewards of documents that noted their names, gender, birth years, marriages, and deaths. After Emancipation, record keeping gradually improved but still exhibited a racial bias through pervasive error, inconsistency, and inadequacy. The story of Traylor's life has thus been exceedingly difficult to trace and validate.

Between Worlds calls upon the documentation of many voices, whether the folk stories—Southern or African American—that permeated Bill Traylor's world and elucidate some elements of his life and art; the historical accounts by the formerly enslaved that delineate aspects of his circumstances; or the recollections by Traylor's family members, those of the George Hartwell Traylor family, Charles Shannon, and many others who knew Bill Traylor that helped clarify his character and chronology. This volume's bibliography conveys the range and scope of the sources, including interviews, relied upon herein. A number of the oral accounts have been particularly invaluable; these were collected by Miriam Rogers Fowler, Marcia Weber, Mechal Sobel, Jeffrey Wolf, Derrel DePasse, Frank Maresca and Roger Ricco, and Ann Fowler, all of whom gleaned vital information from people in Traylor's realm. The results of their conversations with key participants, many of whom are no longer living, are frequently cited in this monograph. More information on these important sources and others can be found in the acknowledgments and notes at the back of this book.

This project afforded me the time and space to delve into Traylor's personal history and rectify, to the greatest possible extent, the record of his birth, life, relationships, locales, and death; position the known facts within historical and cultural contexts; and shed light on artworks that hold far more complexity than a first glance suggests. Advances in the digitalization of records facilitated the process and allowed new information to come to light. This project entails the most in-depth look at Traylor's life and art to date, yet it acknowledges that many facts of his life will never be established and the artist's personal agenda will ultimately remain hidden and enigmatic.

By viewing roughly eleven hundred works of art and further examining about half of that number, I was able to evaluate dates, artistic trajectory, development of themes and styles, color symbolism, the critical roles of community bonds and beliefs, and the potency of oral culture from the mid-nineteenth to mid-twentieth century. Traylor sometimes dabbled with a subject by making one or a few drawings, then moved on. More often, however, he revisited central ideas or worked at developing a theme over time, striving to make the actions clear, the emotions palpable, and the subtexts shout from beneath veiled simplicity. Some contend that Traylor's images lack depth or overarching meaning; that they are guileless depictions made by an accordingly unlettered man. This study convinced me beyond a doubt that Traylor well understood the risk of telling his story in the Jim Crow South and that he honed the tools of allegory and symbolism to record his personal account. Bill Traylor came to art making on his own and found his creative voice without guidance. Inasmuch as his art defies categorical affiliation, it must be understood as a complex and singular body of work. Traylor's art simultaneously manifests one man's visual record of African American life and gives pointed perspective on the story of his nation.

NOTES TO THE READER

Between Worlds is divided into two main sections: part one addresses Bill Traylor's life, and part two his art. Since one informs the other, they are not neat distinctions but rather, overlap and intertwine in many places. Traylor's life story, to the extent that it is known or can be traced, is given a great deal of attention here for two reasons: first, to distinguish the long-published theories and fictions from the facts of his life as determined herein; second, to elucidate Traylor's time, place, and cultural milieu, which is critical to understanding a body of artwork that is, at its essence, a visual embodiment of oral culture and the memories of a life.

The proliferation of electronic resources in recent years aided this project enormously. These efficient tools, which made time and resources go farther than can be imagined in manual searches, allowed us to flesh out information in ways that physical scrutiny of archives might not have revealed. Digital preservation efforts at national, state, and local levels not only make archival papers far more readily available, as described, but also reduce the handling and exposure of fragile documents. The increased digitalization of rare books has made costly or noncirculating materials accessible and enabled text searches as preparatory steps to interlibrary requests. The digitization of historical newspapers has been invaluable, as have online databases for scholarly and genealogical research.

Since handwriting-recognition software is not perfectly accurate, especially in the case of nineteenth-century documents, we cross-referenced various online records, which revealed heretofore undiscovered material, such as the 1895 birth record for Traylor's daughter Alline. Human error on the part of the nineteenth-century record keepers exacerbates the difficulties in securing facts today, so we cast a wide net in our attempts to check and cross-check information. We did not find every document we searched for; it remains unknown whether the documents exist or if variations in name and dates have obfuscated them.

Access to estate files and land records that had not been available to earlier researchers proved Traylor's place of birth, which in turn pointed to the proper slave schedules and census records for his family and provided a clearer view of Traylor's early life in Dallas County, Alabama. Marriage certificates and census records, some of which are newly found, helped us piece together Traylor's family life, while city directories mapped out his later years in Montgomery. To remind, the extant records for African Americans born before Emancipation are insufficient in many ways, and the absence of certain vital records leaves room for interpretation; the story of Traylor's life detailed here thus describes alternate possibilities for a variety of circumstances before proposing the most probable scenario. Each year, more records enter the public domain via digitalization and will increasingly aid genealogical research. Birth, death, and marriage records that nonfamily members are unable to obtain will be available to future researchers, which may help answer some of the lingering questions herein.

The language employed throughout this monograph bears some explanation. The word "folk" is used here in a variety of ways. The terms "folk" and "folk art," utilized in the 1980s and 1990s to shape a euphemistic framework for racial and class distinctions, were misused to the point of meaninglessness. Yet the historical meanings of folk and folkways are important and worth recovering, for these words refer to the communal practices and cultural structures that were central to life in Early American society and into the twentieth century. Many folkways and traditions continue in the present day but with distinct changes in our technological global society. In the context of *Between Worlds*, "folk" refers to the shared pulse of a communal culture, and "folkways" encompasses the beliefs, practices, and complex spoken, musical, visual, and mnemonic literature of a culture, particularly an oral one.

When researching nineteenth-century America, it is impossible to avoid sources saturated with racial bias (at best) and overt racism (at worst); this is a truth spanning the records that reduce humans to commodities and the literature that describes every encounter from the point of view of the empowered. Anthropologists and folklorists from the early decades of the twentieth century were not free of paternalistic viewpoints, and even today linguistic structures commonly speak of "slaves" but avoid pointing a finger at "enslavers." The issue of writing in and quoting dialect is thorny. The intention, on its surface, is to capture the authenticity of pronunciation, diction, grammar, accent, and idiom. While the information conveys evidence of region, culture, ethnicity, and class, it is a double-edged sword when the subjects were disempowered, uneducated, and impoverished.

When Zora Neale Hurston's novel *Their Eyes Were Watching God* was published in 1937, she drew admiration as well as derision from her African American colleagues for writing in dialect. Six years earlier, in 1931, publishers, including the then relatively new Viking Press in New York, had turned down Hurston's manuscript "Barracoon" for the same issues of language. "Barracoon" is Hurston's account of the last survivor from the last known US slave ship, the *Clotilda*.

In 1927, Hurston had traveled to Plateau, Alabama, near Mobile, where the *Clotilda* had harbored, to interview the man born Oluale Kossola in Africa but called Cudjo

Lewis after 1860, when he was ripped from his homeland and family and enslaved in Alabama at age nineteen. At the time of their meeting, Lewis was approximately eighty-six years old. Hurston adopted a participant-observer stance to collect his invaluable historic account, which she relayed in the words and manner of a native African caught tragically between one lifetime and another. Hurston was committed to using Kossola's diction (which she spelled as faithfully to the oral accounts as she could manage) and a storytelling style to convey and honor his persona over that of her own, the interlocutor. When the editors at Viking asked for the dialect to be eradicated, Hurston would not agree. Her work went unpublished until 2018, when Amistad presented it as *Barracoon: The Story of the Last "Black Cargo."*[1]

Philosopher Alain Locke criticized *Their Eyes Were Watching God*'s lack of social commentary but praised Hurston's authenticity: "Her gift for poetic phrase, for rare dialect, and folk humor keep her flashing on the surface of her community and her characters and from diving down deep either to the inner psychology of characterization or to sharp analysis of the social background. It is folklore fiction at its best, which we gratefully accept as an overdue replacement for so much faulty local color fiction about Negroes."[2]

Novelist Richard Wright, however, patently condemned Hurston for exploiting elements of black vernacular life as entertainment. "In the main," Wright opined, "her novel is not addressed to the Negro, but to a white audience whose chauvinistic tastes she knows how to satisfy. She exploits that phase of Negro life which is 'quaint,' the phase which evokes a piteous smile on the lips of the 'superior' race."[3] But in the 1970s the writer Alice Walker rescued Hurston from the male reviews that diminished her novel by missing its feminist subtexts, and she celebrated it for capturing the vibrant color of her culture. Walker inspired a full revival of interest in Hurston and a wealth of in-depth scholarship on her writing. Journalist Claudia Roth Pierpont contextualized Hurston's use of dialect as a measure of the poetic sophistication of people displaced from having power in most parts of their lives, writing: "This is dialect not as a broken attempt at higher correctness but as an extravagant game of image and sound. It is a record of the unique explosion that occurred when African people with an intensely musical and oral culture came up hard against the King James Bible and the sweet-talking American South, under conditions that denied them all outlet for their visions and gifts except the transformation of the English language into song."[4]

Accounts such as the Works Progress Administration's "Slave Narratives," stories, and memories recorded by anthropologists and folklorists are not as beautifully orchestrated as Hurston's careful prose.[5] They do aim, however, at being unvarnished, and they ultimately give voice to myriad beliefs, practices, and cultural fragments of the time; as such, they are invaluable, not meant to entertain but to inform. They often contain strongly contentious language, which this book usually leaves out, except when an omission undercuts the language as originally written.

It is important to note that Hurston critiqued the underlying problems caused by white collectors of black folklore. Charlotte Osgood Mason, a patron of Hurston and other Harlem Renaissance artists and writers, shared Hurston's view that a firsthand

account of an African American "by right belongs entirely to another race"; she believed that African American narratives should be guarded from whites who are driven by their own motives and too often impose bias.[6] Most folkloric accounts from black Americans were, however, collected by white scholars and are therefore the narratives frequently cited in this book, albeit with a watchful eye toward the pitfalls of those in which the givers and takers belong to different cultural groups.

Other conventions used in this book are as follows:

NAMES When discussing Traylor and his family as they were cited in federal censuses and vital records, the text uses the names as they appear in those sources; when not citing an original document, the text generally identifies people as they referred to themselves or by the names they went by the longest. Easter Traylor, for example, as noted in census records, referred to herself as Esther in legal documents in her adult life; her names are used interchangeably. Examples abound in the task of sorting out Bill Traylor's family and others. The Traylor siblings, whether related by both parents, one parent, via adoption, or as "fictive kin," are herein simply referred to as siblings.

PLACES Places in Alabama that were central to Bill Traylor's whereabouts are shown on a map of Dallas, Lowndes, and Montgomery Counties (fig. 4) and one showing the City of Montgomery and rural Montgomery County (fig. 16). A map of the City of Montgomery, made in 1929 (fig. 19), shows some of the known places where Traylor lived from 1910 to 1949 and other significant locations (see also fig. 16).

PLATES All works identified as plates ("pls.") are by Bill Traylor; they are illustrated in the order in which they are discussed in the essays. Plates in part two ("The Art of Bill Traylor") follow their respective chapters. Captions are abbreviated, but full information for each work is provided in the List of Plates (p. 383). An asterisk (*) in a caption indicates the work is not in the exhibition; all other plates represent works in the exhibition.

TITLES As mentioned throughout the text, artist and collector Charles Shannon sometimes inscribed the back of Traylor's artworks with comments the artist was said to have made about the works. He wrote them in Traylor's dialect as he understood it; to the degree that they can be relied upon as verbatim, they are the closest we have to Traylor's own voice. That Traylor revealed his full insight or intention to Shannon on said artworks is unlikely, but the artist's rare comments, as written by Shannon, are noted and discussed regarding most of the works considered here.

Because Traylor did not assign the titles used today for his paintings and drawings, the titles have come to take many forms. Between the time the artworks were first collected locally, and subsequently came into the public sphere, several manners of titling were employed. Neither Shannon nor any others who collected Traylor's art in the late 1930s and 1940s titled the works. Shannon, however, assigned titles to many

of the pieces in the late 1970s and 1980s when he began showing and selling the works in his collection. He drew some titles from Traylor's comments, which he had recorded; he based others on his recollections or opinions. Still other titles were imposed by individuals who variously handled or possessed the work. Some institutions and collectors have opted to retain the titles Shannon devised or that became attached to the works via a trail of exhibitions and publications. Other owners, including SAAM, have aimed for objective titles such as *Untitled (brief description)*. The variation in style and degree of subjectivity among the titles as presented in this book makes for an inconsistent checklist and discussion, but it is unlikely that the titles will ever be reconciled across the entire body of work. Any effort to create a catalogue raisonné would be irreconcilably undermined by a lack of reliable records across the entire oeuvre.

DATES The works of art that survive with known whereabouts were made between 1939 and 1942. The limited range of dates and materials in Traylor's work and the inability to date many of them precisely negate the need to include dates in the captions or organize the List of Plates chronologically. The artist may have made art before and certainly did after that period, but those works are not known to have survived. The pieces that Shannon dated at the time he collected them are noted with that date; works of art documented in photographs with known dates are given an according or estimated date. The standard institutional date given in many entries in the List of Plates (p. 383) is "ca. 1939–42," which may not always jibe with my more specific positioning of a work in Traylor's oeuvre as discussed in the text.

MEDIA The paints that Traylor used go by various names (tempera, poster paint, show card color, opaque water-based paint, opaque watercolor, or gouache) and vary compositionally; without scientific analysis, such distinctions cannot be identified, and lender preference was adhered to.

DIMENSIONS In artwork captions, dimensions are given in inches; height precedes width and depth.

Blessed is the former slave, for he shall one day be called a master.

Blessed are the unlettered, for they are not burdened with theories of history.

Blessed are the poor, for they make the most of what they are given.

Blessed are the aged, for they can be forever young.

Blessed are the dead, for they are gone. We are on our own now.

KERRY JAMES MARSHALL

THE BEATITUDES OF BILL TRAYLOR

By any measure the twelve hundred or so drawings that are the total known output of Bill Traylor's brilliant but meteoric artistic moment is unprecedented. Ever since his star turned in the exhibition *Black Folk Art in America* organized by the Corcoran Gallery of Art in Washington in 1982, Traylor and his work have come to embody many of the complexities and contradictions argued around aesthetic hierarchies and the issue of insiders versus outsiders in the construction of art history. It is now widely believed that no such distinctions should prevail, especially since the work of some formerly marginalized self-taught artists can seem more appealing in spirit if not technical sophistication than artworks made by academically trained artists. Thornton Dial Sr., William Edmondson, Lonnie Holley, Horace Pippin, and Bill Traylor have all been hailed as 'authentic negro geniuses' by their well-intentioned supporters. Their works are sometimes shown alongside modernist and abstract American art in important venues such as the Whitney Museum of American Art in New York.

But I wonder, given the differential experience of black and white people in America historically, as well as the absence of a truly independent Black philosophical system that codifies artistic values, if it is possible that even black Americans and white Americans observing from the same social strata really see the same thing when they look at the creations of these institutionally minted "modern" black artists. Is the relevance of these artists and their work universally understood across divergent cultural contexts? Presuming the answers are no, is it likely, then, that these two populations want the same experience from an artwork?

Nothing, I believe, changes the perception of a black person within his/her community, or their perception of themselves, more than the unsolicited attention of White folks who had previously been indifferent if not hostile to their very existence. A lingering suspicion over motives tends to mitigate uninhibited sharing, especially in people raised from birth to be deferential to a ruling White overclass. Some of this wariness had to be present in 1939 on Monroe Street in Montgomery, Alabama, when

Kerry James Marshall, *They Know That I Know*, 1992, acrylic and collage on canvas, 72 × 72 in. Private collection

a young white man started hanging around and white people with cameras started taking photographs of an old black man drawing pictures on scraps of cardboard. This is the social world in which Traylor existed and within which his artistic life was fulfilled. Our consideration of him as a phenomenon must necessarily be governed by an understanding of that dynamic, much of which curator Leslie Umberger has thoroughly researched for the exhibition and catalogue *Between Worlds: The Art of Bill Traylor.*

The way I see it, Bill Traylor has always been the property of a White collecting class. He, himself, was passed down as inheritance before Abraham Lincoln's Emancipation Proclamation. Now, long after Traylor's death, his creative labor is traded at high prices in markets beyond the reach of and rarely visited by black art patrons. Substantial holdings of his art are now in public museums, but not a single institution focused on African American culture is a significant repository of Traylor's art, or, moreover, has contributed a work to this exhibition. The latter fact is perhaps a troubling truth if it matters, ultimately, for a people to choose their own heroes and tell their own stories.

Do white people know something about art that black people don't, or at least have beliefs about it that are not generally valued within black communities? Among all other human activities, art making still manages to cling to some of its prescientific magical implications whereby having a "good eye" is one prerequisite to connoisseurship, especially when prospecting for unrefined gems. This is how it seems in the world of black art, where, for some, the best the 'negro race' has to offer seems to derive almost exclusively from the ranks of the self-taught. In 1940, in the introduction in the catalogue to his first show at the Carlen Gallery in Philadelphia, collector Albert Barnes proclaimed Horace Pippin the "first important Negro painter to appear on the American scene."[1] The *New York Times* went further in its obituary for Pippin (July 7, 1946), saying he was the "most important Negro painter to have emerged in America."[2] (Sorry, Aaron Douglas and William H. Johnson.)

Something must have been in the air, because the 1940s was also the period during which Bill Traylor was discovered. In the current decade, *New York Times* critic Roberta Smith dubbed Traylor "one of America's greatest artists."[3] I found out about Traylor around the same time many art-loving Americans did, through the *Black Folk Art in America* exhibition almost forty years ago. So, I guess it makes sense that the Smithsonian American Art Museum would ask an artist like me to write a piece for its survey catalogue.

Although separated by time and circumstance, Traylor and I do have a few things in common. Like Traylor did, I draw and paint pictures mostly of people. I, too, am from Alabama but was born in the big city of Birmingham. Traylor was a black man, as am I. He was born in or about 1853; I came just over one hundred years later, in 1955. I have a graying beard, whitening crop of hair, and a receding hairline, as he did.

From here, though, it is mostly differences that set us apart. Traylor was born into slavery; I have always been free. I knew from the age of five that I wanted to be an artist; Bill didn't get going till he was well past eighty. Like Traylor, I couldn't have named my ambition, but I knew I wanted to be that person who illustrated the Bible stories we read in Sunday school and made those wonderful stained-glass windows. I

wanted to be the one who painted sentimental and funny Christmas and Valentine's cards. I started early to focus my attention and energy toward fulfilling that dream.

I read everything I could find about art history, theory, and technique. By age fifteen, I was practicing anatomical drawing because Leonardo da Vinci wrote in his notebooks it was imperative to do so. I have nearly one thousand books on artists, art history and art theory in my personal library. This knowledge, this ability, this historical and theoretical structure, matters to me. It allows me to participate in what the late philosopher-critic Arthur Danto described in his collection of essays *Beyond the Brillo Box* (1992) as "an enfranchising theory…a conceptual atmosphere, a 'discourse of reasons,' which one share[s] with the artists and with others who made up the art world."[4] Traylor, who was isolated and could neither read nor write, was unaware of such empowering ideas.

I happen to agree with another late philosopher, art historian Ernest Gombrich, that "great art is rare…but that where we find it we confront a wealth and mastery of resources" that are transcendent. It would not be a stretch to say that Traylor had mastered his resources, and that the work he made transcended the limitations of his illiteracy. "The increase of artistic resources," Gombrich went on to say, "also increases the risk of failure."[5] This is as it should be, for me. This is what makes doing art so exciting. Failure is not a judgment we readily apply to artists of Traylor's cohort.

The necessity of claiming an equal voice in the debate over values in art and other matters cannot be overstated. For too long, black people have had no say in codifying their net worth or negotiating their terms of engagement. We have been spoken for and about by white intellectuals and profiteers with their own agendas, even in domains where you would think we should have some authority.

In interviews, painter and Traylor collector Charles Shannon revealed that he had also seen works made in the last years of Traylor's productivity. But, in Shannon's opinion, the later works were of poor quality, so he did not collect them. Umberger

notes that a few others, including family members, had also saved Traylor drawings, but none of the later work survives. Since that art was apparently lost, we have no way of making comparisons except through a few photographs that reveal a handful of the late works. Was nothing worth saving from after 1942? Really? What happened? Shannon, then, became the prevailing judge of what anybody else would see of Traylor's known output.

We know, from Shannon's own words, that he, like many other white modernist artists, fetishized black culture as the "expression of primitive souls" in ways that the curator of this survey has worked assiduously to remedy.[6] I worry that that romantic notion still clings tenaciously to old ideas about art in general, and self-taught black art in particular. This imagined state of grace is a source of the deepest division, I believe, between views

Kerry James Marshall, *Untitled (Skull)*, ca. 1970–71, graphite on paper, 17 × 19 in. Collection of the artist

about the artist as an intellectual versus the artist as a visionary, expressive medium. *Time* magazine critic Robert Hughes echoed this sentiment about dying culture in his review of *Black Folk Art in America*. "One should see it now. It will not be here tomorrow."[7]

Indeed, a foundational pillar of the modernist European avant-garde was a rejection of the alienating effects of too much civilization and industrialization. The nineteenth-century artist Alfred Maurer, however, exemplified the pitfalls of surrendering to the regressive tendency as fashion. Unable to escape the shadows of his fellow American painters John Singer Sargent and James McNeill Whistler, Maurer misread the appearance of primitivistic European modernism as its substance—and ended by producing kitsch.

The perceived digressions—famously acted out by Pablo Picasso during his 'negro' phase and by Henri Matisse during his fauve, or wild beast, period, are only twentieth-century manifestations of patterns of regression going back centuries, according to professor Gombrich in his posthumously published book *The Preference for the Primitive* (2002). In the case of Picasso and Matisse, though, the experiments were a prelude to more systematic and complex explorations.

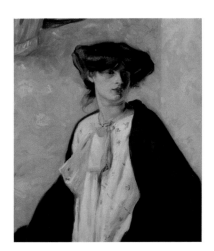

Cultural theorist Kobena Mercer makes the price of even genuine intellectual outsiderness quite clear in a critique of writer Richard Wright's claim to have had "intuitive foreknowledge" of the ideas of Martin Heidegger, Edmund Husserl, Søren Kierkegaard, and Friedrich Nietzsche before he had read their works. I want to quote Mercer at length here because I believe he gets to the heart of the contradictions I mentioned earlier, and because the stakes are so high.

> Wright's intellectual authority secures . . . the claim that the essential aesthetic values of [black] diaspora culture . . . are to be found, always already there as it were, in the "autonomous and self-validating non-European expressive traditions" . . . that have "spontaneously arrived at insights which appear in European traditions as the exclusive results of lengthy and lofty philosophical speculation." . . . By arguing from the authority invested in Wright's "intuitive foreknowledge," we may also be inadvertently pushed back into the essentialist trap which sees black subjects as "happy to feel rather than think."[8]

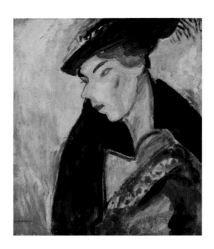

When I painted *A Portrait of the Artist as a Shadow of His Former Self* in 1980, my aim in using a reductive mode of representation was not to jettison everything I knew but rather, to reset my practice to a baseline, to zero degree, and drop detrimental habits I developed while privileging improvisation, so I could start again more analytically, more strategically, and with greater precision. The choice to do this is the gift of literacy.

Now, there is no doubt that Bill Traylor was deliberate in laying down the parade of people and animals that came to mind as he sat and drew in his favored spot on Monroe Street. You cannot make more than a thousand drawings stylistically consistent over a four-year span unless you clearly have something in mind you wish to accomplish. Since Traylor said so little about his motives, who really knows what his

Alfred Henry Maurer, *Woman with a Pink Bow*, 1907, oil on canvas, 32 × 25 ½ in. Private collection

Alfred Henry Maurer, *Woman with a Hat*, 1907, oil on board mounted on Masonite, 29 ¼ × 25 ½ in. Sheldon Museum of Art, University of Nebraska–Lincoln, Bequest of Bertha Schaefer

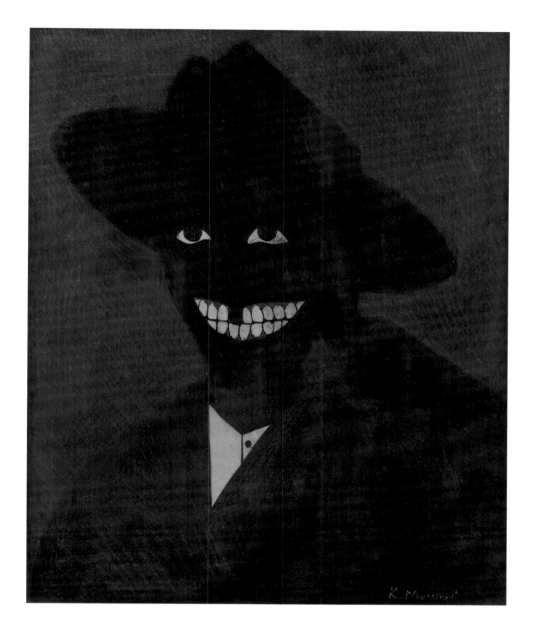

overall objectives were? In most cases the drawings and paintings, sure and direct, speak for themselves. The more idiosyncratic images, some surreal, others more abstract, well, these are an opportunity for viewers to match wits with the imagination of the maker and construct their own plausible scenarios. Leslie Umberger has provided many tantalizing leads, but the real adventure of finding meaning in Bill Traylor's art is ours alone.

KERRY JAMES MARSHALL

Kerry James Marshall, *A Portrait of the Artist as a Shadow of His Former Self*, 1980, egg tempera on paper, 8 × 6 ½ in. Private collection

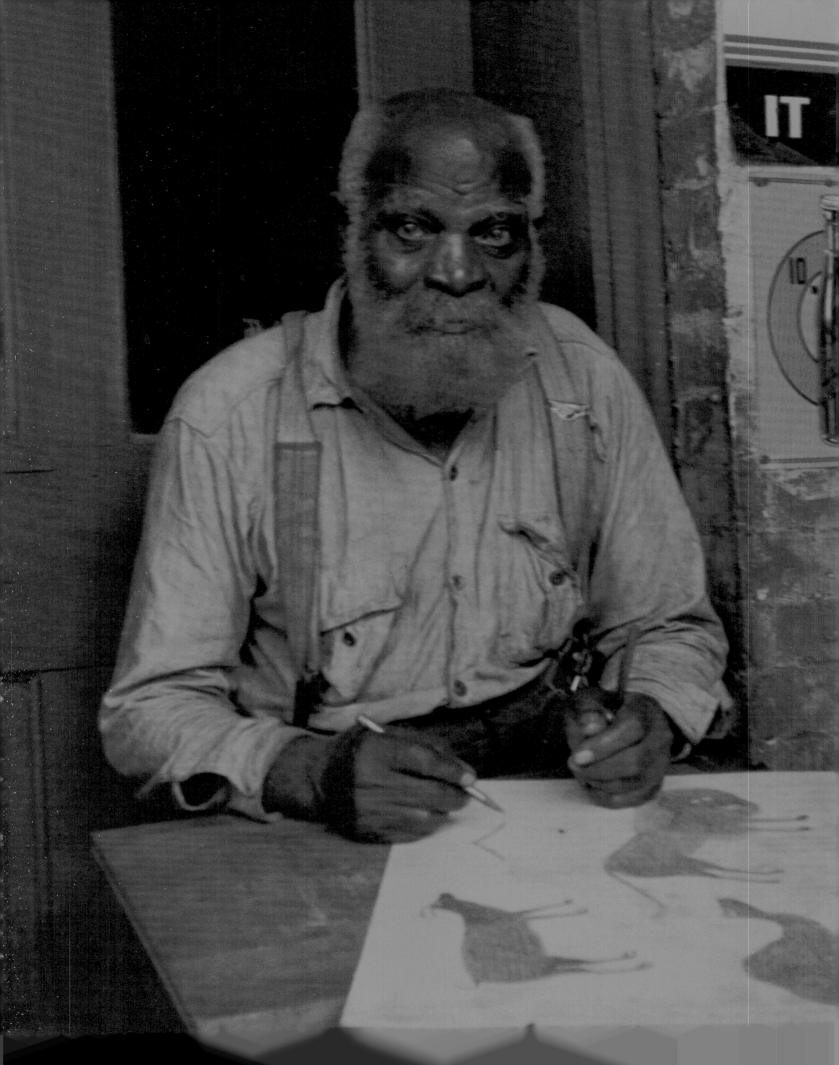

PROLOGUE

In the late 1920s, Bill Traylor (fig. 1), a black man from rural Alabama, found himself at a crossroads, when he would leave behind one lifetime and embark on another. Then in his midseventies, he realized that his tethers to plantation life had fallen away, so he traveled, alone, into the urban landscape of Montgomery. In the segregated part of town, he found work and lived successively in several different places; he would spend the next twenty-plus years there, with one foot rooted in his agrarian past and one in the evolving world of African American urban culture. After being in Montgomery for about a decade, his physical strength waning, Traylor made the radical steps of taking up pencil and paintbrush and attesting to his existence and point of view.

Sitting on a street corner minding his own business, Traylor was almost invisible, but his artwork, which was visually striking and politically assertive, eventually—posthumously—cast him as larger than life. He had no road map for his project, which he undertook in a time and place that entailed great risk. His scenes range from quotidian to edgy to bone-chilling: a woman and her child, a black person reading, a harrowing chase, a lynching.

Today Traylor is considered an American artist of renown, but that he became one at all was against the odds. His existence was almost equally divided between two centuries. He was a twentieth-century artist, known for his simple yet powerful distillations of tales and memories and brilliant use of color, but in important ways he remained a nineteenth-century man.

Bill Traylor was born into slavery around April 1, 1853, on the Alabama plantation of John Getson Traylor (then deceased) in Dallas County, near the towns of Pleasant Hill and Benton.[1] In 1863, when Bill was about ten, he and his family were relocated from the farm of John G. Traylor to that of John's brother, George Hartwell Traylor, whose plantation was just across the county line to the east, in Lowndes County, on what is now Double Church Road. When Emancipation became a reality in the South two years later, Bill and his family remained on George Traylor's land as laborers.

FIG. 1 Charles Shannon, *Bill Traylor (frontal)*, 1939, Montgomery, Alabama.
Charles E. and Eugenia C. Shannon Trust; see full image p. 376

Records indicate that Bill had three marriages, two legal and one common-law, occurring in 1880, 1891, and 1909. By 1910 he and his family (which would grow to include fifteen children from those compiled relationships) were living on the outskirts of Montgomery and working as tenant farmers.[2] His third wife, Laura, died in the mid-1920s, after which, in 1927 or 1928, Bill moved to Montgomery. Except for brief stints with his grown children in Detroit, Philadelphia, and Washington, DC, before and during World War II, he remained in Montgomery until his death on October 23, 1949.[3] These are the skeletal facts of his life.

The art world's discovery of Traylor has often overshadowed the details of his personal journey for two reasons. The first involves Charles Shannon, a prominent white artist from Montgomery who met Traylor in 1939 and began to collect and save his work; without that key encounter, Traylor and his art likely would not have gained any recognition. But the circumstances also placed the story entirely in the hands of the empowered teller rather than those of the man whose life it was. Dovetailing with this unequivocally skewed influence is the second fact that Traylor's own narrative is difficult to trace with any accuracy, and romantic myths easily filled the vacuum.

In his late years, Traylor put down a lifetime of memories, dreams, stories, and scenes. The body of his extant work, which he made in just four years, between 1939 and 1942, was internally driven and formed organically.[4] His images are steeped in a life of folkways: storytelling, singing, local healing, and survival. They look freedom in the eye but don't fail to note the treacherous road African Americans had to travel along the way. Traylor's pencil drawings evidence a learning process that spanned rudimentary mark making and a sophisticated reduction of form, color, and gesture. They show the artist's attentive observation and incisive ability to convey mood and action. Determined to shape a visual language for and by himself, Traylor became a master of freeze-frame animation and condensed complexity. His pictures comprise an oral history recorded in the only language available to an illiterate man—a pictorial one. Although people would purchase drawings from him for a dime or a quarter, he did not make them to please anyone else's taste or with anyone's guidance.

Unsurprisingly, Traylor's visual depictions echo the beliefs and stories that had carried his people's history from slavery through many subsequent decades. As these modes of expression are well known to do, Traylor's imagery often holds veiled meanings and lessons underneath the veneer of simplicity or hilarity. Traylor experimented with abstraction and became adept at using it. He would have understood acutely that faithful representation could be perilous for a black man to pursue; his art reveals the various ways in which he skirted clarity and mitigated risk.

Traylor's penciled and painted depictions confront us with not only the humanity of the artist but also the world beyond the personal; his is an eyewitness account of the American experience at a time when black people were supposedly free yet rarely had any control over their own lives. Traylor's work is unique in media, size, scope, place, and era. Aside from the historical and cultural ways in which his art is vitally important, it is also endlessly astonishing, bold, and enigmatic. When Traylor died in 1949, he left behind more than a thousand works.[5]

Regrettably, a dearth of accurate information about lineage and family history is an inherent reality for African Americans born before the twentieth century. Important papers are either scarce or missing entirely, and those that exist (often handwritten) are factually inconsistent and difficult to read. Literacy was viewed as incompatible with the institution of slavery. Even long after Emancipation, the ability to read and write was considered a sign of status, and whites, who too often regarded black people as inferior, made and kept the important civic documents for blacks without much concern for their accuracy. The result is that any investigation of extant records will frustrate attempts to chart a clear trail of facts.[6] Traylor's contemporaries provided important details about the artist and his art, but they also generated lasting misinformation and paternalistic views. Scholars and writers in more recent decades have variously contributed excellent and erroneous parts to a blended narrative that has become ingrained in the public mind.

The chronicle presented in *Between Worlds: The Art of Bill Traylor* has been gleaned from census records, slave schedules, Montgomery city directories, vital documents (birth, marriage, and death certificates), military registers, Social Security files, historical photographs, interviews, and family memories. But the material covered here also draws on a large body of scholarship encompassing folklore, cultural studies, history, and art history.

Part one of this book, "The Life of Bill Traylor," focuses on Traylor's personal biography from birth to death. His story emerges from the intertwined pasts of the white and black Traylors in rural Alabama, from the antebellum South through Jim Crow segregation. The many irregularities and alternate possibilities within this fractured narrative are outlined as clearly as the data allows, and facts are delineated from interpretations. The present assessment resists the temptation to connect various dots and craft a tale that seems clean, easy, and concrete; instead, it moves the history of Bill Traylor forward with the greatest accuracy possible. Although Traylor's life story will always be a lattice of facts and voids, his art sprang from the whole of his experience and must be examined in conjunction with the reality that informed it. Traylor offered few comments about his work, and the words he did utter were recorded by another and filtered through the lens of cultural distance. The lack of Traylor's voice sends us searching more deeply into his images, which run the gamut from simple to arcane. The research gathered here equips us with an encompassing grasp of the historical and cultural environment that shaped the artist and informed his art.

Part two, "The Art of Bill Traylor," sets the stage in the late 1930s, when Traylor first encountered members of the New South artists' collective and received attention for the pictures he made. It examines Traylor's creative progression, his experience as a late-life artist, and the posthumous attention his work garnered. Further, it explores his imagery in depth—its stylistic development, beliefs, themes, stories, and characters—and ultimately situates Traylor as the only known person enslaved at birth to make a significant body of drawn and painted work—one that offers a portal into African American culture in that time and place. "The Art of Bill Traylor" investigates Traylor's

rise to fame—and the ongoing battle with marginalization as an ironic partner to admiration—and positions him within the overarching context of American art.

Traylor was just a boy when the Union won the Civil War and the enslaved were declared to be free Americans. His parents were enslaved people, and Bill and his siblings were born into that heartless system and managed as property during their childhood years. Traylor's experience was rooted in knowing the difference between the white and black worlds and keeping personal thoughts and views hidden. He was part of the first generation of blacks to become American citizens, a group that has often been eclipsed by the bracketing histories of slavery and civil rights.

The historian and activist W. E. B. Du Bois noted that being an African American in the early twentieth century meant having a conflicting sense of self, with an ever-increasing desire to reveal a long-suppressed identity. "It is a peculiar sensation, this double-consciousness, this sense of always looking at one's self through the eyes of others, of measuring one's soul by the tape of a world that looks on in amused contempt and pity. One ever feels his two-ness—an American, a Negro; two souls, two thoughts, two unreconciled strivings; two warring ideals in one dark body, whose dogged strength alone keeps it from being torn asunder." Du Bois describes the ineluctable desire to merge the two selves into one, without losing either of the "older selves."[7]

Citizens or not, freedom was not going to come easily. The backlash against Emancipation was harsh. Lowndes County, where Traylor and his family spent much of their lives, had the reputation of being one of the South's most brutal places.[8] The social systems for keeping blacks impoverished and disenfranchised were forceful and pervasive. Traylor spent almost all his working years amid a culture that overtly preferred blacks to be illiterate and submissive, automatically accept accounting records that never seemed to come out in their favor, and toil endlessly on land that belonged to someone else, all while living in extreme poverty, without adequate nutrition or health care, and with the unremitting fear of wondering what comes next.

But it was also a time when things were percolating. Black schools were becoming prevalent, and programs for land ownership established. Musical forms that began as the folkways of the fields were urbanizing and growing popular. Many African Americans were gaining prominence as writers, scholars, artists, and agents of social change. Traylor would not live to see the civil rights movement, but he was among those who laid its foundation.

The Montgomery of Traylor's era, like all of Alabama, was segregated. He lived and worked in the neighborhood known then by the racially disparaging epithet "Dark Town," which was more lastingly designated the Monroe Street Black Business District. This section of town, situated between two busy thoroughfares—Monroe Street and Dexter Avenue—grew exponentially between 1900 and 1940.[9]

In the Jim Crow South, blacks were supposed to know their place and accept a role at the bottom of society. Despite the large atmosphere of oppression, the black business district was a seedbed for black culture. African American businesses encouraged blacks to "patronize…enterprises conducted by their own race, even at some slight disadvantage."[10] They doggedly made their own way and actively chose one another

over white establishments; those who were better off took care of the less fortunate as best they could, in what they called a "support-n-share" system. The district included banks and barbershops, grocery stores and diners, undertakers, a movie theater, pool halls, drugstores, shops for all manner of goods, and other black-owned and -operated shops, churches, fraternal lodges, and mutual-aid organizations. During the bus boycott of 1955, businesses there offered crucial assistance.

Montgomery in the thirties and forties was a clash of paradigms, entrenched in the past but being propelled into the future. It was a constricting place in which to live, but it offered Traylor just enough space to become an artist of powerful vision and ability. In the late 1930s, when Traylor was in his late eighties, homeless and in fragile health, he began to draw and paint memories of plantation life and images of an emerging African American culture in an urban setting. Yet his works are neither straightforward "memory paintings" nor realistic scenes from life. In fact, Traylor was a careful editor; he chose his subjects with specificity and omitted a great deal. His pictures are complex translations of oral culture that are best understood against the backdrop of the time, place, culture, and shifting societal views in which they were created. Traylor's compelling imagery narrates the crossroads of radically different worlds: rural and urban, black and white, old and new.

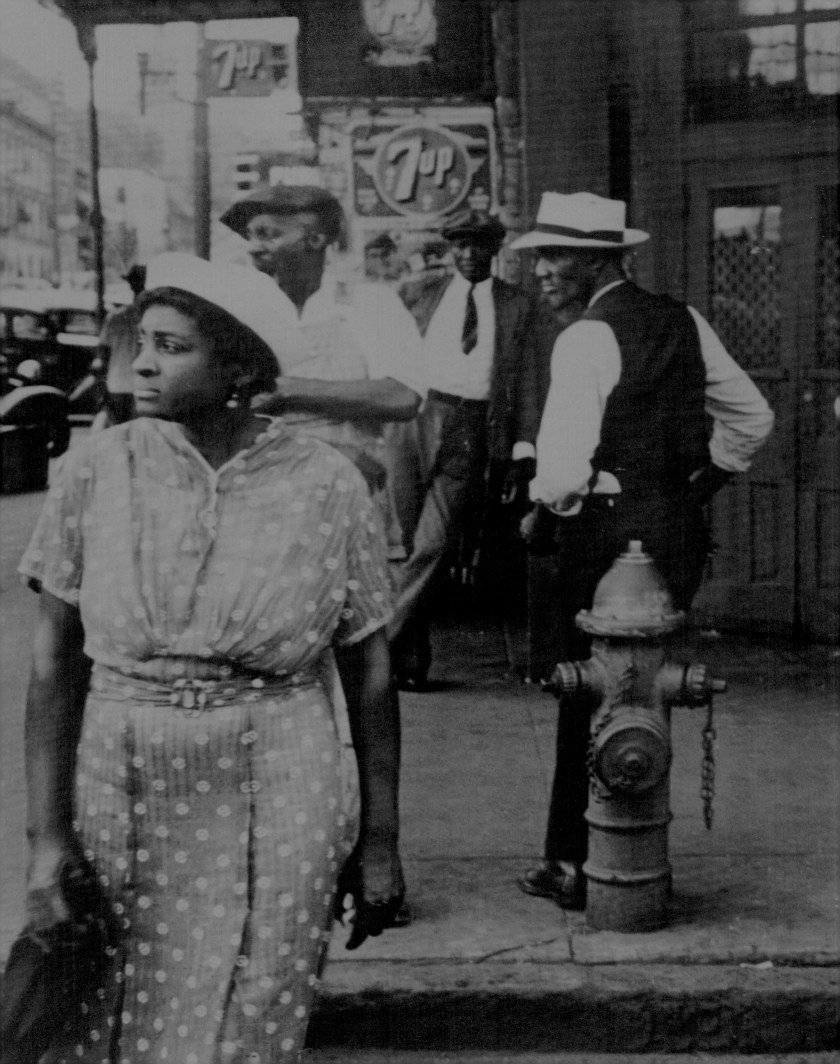

THE *life* OF BILL TRAYLOR

NINETEENTH-CENTURY ALABAMA
AND THE WORLD OF BILL TRAYLOR'S PARENTS

Bill Traylor's history is anything but straightforward. The account presented here attempts to identify the facts of his life as well as the elements that remain opaque. Our understanding of Traylor and the art he made is rooted in the world he came from; the family he grew up in and the one he created as an adult; his complex relationship with the people who enslaved his parents—and him as a child; the environment of Alabama during the late nineteenth and early twentieth centuries; and the African American culture that rose increasingly and inimitably after Emancipation.

Bill Traylor's story begins with his parents. Around 1805, Bill "Calloway-Traylor," Bill Traylor's father (also called "Old Bill"), was born into slavery in Georgia.[1] Owned by Benjamin Calloway, he resided at the Calloway plantation, south of Savannah. Sally "Calloway-Traylor," the artist's mother (also called "Old Sally"), was born into slavery around 1819 in Virginia; she, too, became the property of Benjamin Calloway.[2] In 1828, Calloway moved his household to Lowndes County, Alabama, near the border of Dallas County, and around 1840 he moved again, to Macon County, Alabama. Soon thereafter, in 1842, he sold Bill and Sally, together with a young girl and two seemingly unrelated adults, all cleaved from other family members without any say.[3]

The purchaser of these souls was John Getson Traylor, a man aiming for prosperity in the Alabama Black Belt.[4] A long, crescent-shaped region of the South encompassing the heart of plantation country, the Black Belt spans Virginia to Texas and is known for its dark, rich, fertile topsoil. The cotton gin, invented in 1793, kicked the cotton industry into high gear, and the demand for slave labor in the American South soared. In the 1820s and 1830s, the Black Belt had been identified as prime for cotton, and ambitious migrant planters rushed for it in a boom called Alabama Fever.

An insatiable hunger for cotton spurred a market for fertile land. The Mississippi Territory created in 1798 pushed the Creek Indians out of their native lands, and in 1803 the Louisiana Purchase again vastly expanded the American South. The settlers

Preceding pages: Rudy Burckhardt, *Pekin Pool Room street scene, Montgomery, Alabama,* ca. 1941; see full image p. 214.

brought slaves to the region and purchased still more. The term "Black Belt" took on a double meaning when enslaved African American labor became central to the area's cotton plantations. In his autobiography, *Up from Slavery* (1901), Booker T. Washington, founder and original president of the Tuskegee Institute in Alabama, wrote: "The term was first used to designate a part of the country which was distinguished by the colour of the soil. The part of the country possessing this thick, dark, and naturally rich soil was, of course, the part of the South where the slaves were most profitable, and consequently they were taken there in the largest numbers. Later, and especially since the war, the term seems to be used wholly in a political sense—that is, to designate the counties where the black people outnumber the white."[5]

The US Congress in 1808 had prohibited the importation of slaves from Africa, but the smuggling of enslaved people into the Americas and the interstate transport and selling of trade remained pervasive until the end of the Civil War. The number of enslaved Africans arriving between 1808 and 1864 has been estimated at more than fifty thousand—so the beliefs, tribal folkways, songs, and other cultural elements of Africa were continually being refreshed in America.[6] The *Clotilda*, the last known slave ship to enter the United States, sailed into the port of Mobile, Alabama, in the summer of 1860.[7]

Mississippi and Alabama became states in 1817 and 1819, respectively. White farmers moved to the area from the Eastern Seaboard and Europe, and cities grew up, primarily along the Mississippi, Alabama, Apalachicola, and Chattahoochee Rivers. Railways were in their infancy, and the advent of automobiles was decades away. The river steamboat was the primary mode of transportation. Montgomery was incorporated in 1819, and when the steamboat *Harriet* started running on the Alabama River, the city became a hub for cotton and slave trades.[8] Dallas and Lowndes Counties, which are the backdrop of Bill Traylor's story, were established respectively in 1818 and 1830, after Montgomery County in 1816.

Bill Traylor's parents are referred to herein as Bill Calloway-Traylor and Sally Calloway-Traylor, not because they ever used such a surname but rather, to distinguish them from children who would later bear the names Bill and Sally and the last name Traylor. Bill Calloway-Traylor, sometimes recorded as Old Bill would live until at least 1863; no death record has been found for Sally, or Old Sally, but she lived until at least 1880.

John Getson Traylor was born in 1809 in Edgefield, South Carolina. When he and his brother George Hartwell Traylor were boys, they moved with the rest of the European American Traylor family to Virginia; sometime before 1831, their family seemingly moved again, to rural Alabama, hoping to find their own success in a land that was still being settled.[9] In 1834, John began to keep a diary in which he recorded details about his work, the weather, social life, and other aspects of life.[10] He signed the pages "J. G." and noted that his Traylor family members were churchgoing Baptists; preaching and attending prayer meetings comprised a substantial portion of his activities. In 1834, J. G., as he called himself and as this book will primarily refer to him, was twenty-five years old and working as the overseer of the Green Rives plantation in Lowndes County, near Collirene, where he was a member of the Bethany Baptist Church.

In his diary, J. G. recorded general farm tasks, such as killing hogs, making fences, and planting corn and potatoes, and the dominant chores of plowing, planting, tending, ginning, baling, and marketing cotton.[11] J. G. referred to several "alections," as he wrote it, and how a number of times he went "to muster."[12] Curiously, he noted attending social engagements such as barbecues and weddings and visiting friends or relatives throughout the years, but he failed to remark on the birth of his children and cited only one birth of an enslaved child.

In 1836, J. G. described volunteering at the Creek Nation. Historian Miriam Rogers Fowler inferred that J. G. would have been helping with the census, since white settlers were still in the process of removing members of the Creek tribe to federally assigned territories in Oklahoma.[13] J. G. wrote about catching runaway slaves and stray cows with equal measure: "Cauht a runaway negro of Mr. Rushes an cared hur home … went to Mr. Milises an got a cow an she got away from me an went back the next day an drive her home … [and] lost a negro chile at perses."[14]

That same year, J. G. married Benjamin and Nancy Calloway's fifteen-year-old daughter, Mary (b. 1821). J. G. and Mary C. Traylor resided on the Green Rives plantation and had a son, Benjamin Traylor, in 1837, who died the following year. As overseer, J. G. would have been responsible for delivering corporeal punishments to the enslaved, but he made one rare notation about the planter doing it himself: "Mr Rives cam an took Lewis up an whipped him for having wiskey in his citching [kitchen]."[15] Another entry from J. G.'s journal reads: "Abrum com hom to his marster an he brote him to me an made him give him seven securities that he would not run away agane in seven year an his master give him up to me an I settled with him."[16]

Louisiana Elizabeth, called "Lou," was born in 1839 to J. G. and Mary, and the following year the family moved to Judge Reuben Saffold's plantation, where J. G. took a new job as overseer.[17] The Saffold plantation was in Pleasant Hill, Dallas County, Alabama, on the Lowndes County border, where it exists today, under the name Belvoir. Judge Saffold reportedly paid J. G. $600 to manage 314 acres and twenty-five slaves; he also received goods, including six hundred pounds of pork, a barrel of flour, one hundred pounds of sugar, fifty pounds of coffee, and feed for his horse. His guide for planting over the years was, he wrote, *"Davy Croclets almanack,"* a copy of which he purchased in Benton.[18]

In 1838, before J. G.'s move from Green Rives to Saffold's, English naturalist Philip Henry Gosse traveled to the United States in hopes of finding work as a teacher. On the steamboat between Mobile and Selma he met Judge Saffold, one of the area's elite, who offered him a position teaching a group of planters' children on his estate, just south of Selma near Pleasant Hill.[19] Gosse, who would reside there for almost a year, would publish his writings in the form of an epistolary book, *Letters from Alabama* (1859; fig. 2). His "letters," really field notes, record the flora and fauna, local architecture and culture, and brutality of slavery, the latter of which would ultimately drive him from his post. Harvey H. Jackson III, who studied the naturalist's work, wrote, "Philip Henry Gosse prepared a unique account of plantation society that was closer to the cabins of the frontiersmen than to the

drawing rooms of Tara, and whose men and women had far to go if they were ever to approach the likes of Scarlett, Melanie, Ashley, or Rhett—though reaching Rhett was the shorter distance."[20]

Gosse observed that plantation houses were "poor and mean."[21] Even homes for the wealthy planters were often built with rough, unhewn logs and "to an English taste are destitute of comfort to a surprising degree."[22] About one example he observed that they rarely varied in architectural style: "Houses differ in their degrees of comfort and elegance, according to the taste or finances of their proprietors, but in general they are built double; a set of rooms on each side of a wide passage, which is floored and ceiled in common with the rest of the house, but is entirely open at each end, being unfurnished with either a gate or door, and forming a thoroughfare for the family through the house."[23]

The dogtrot was meant to facilitate the flow of air through the rooms in the scorching climate. Gosse described some frame houses as well, calling them "much superior." These were "regularly clapboarded, and ceiled, and two, or even three stories high, including the ground-floor." He continued, "They are mostly of recent erection,

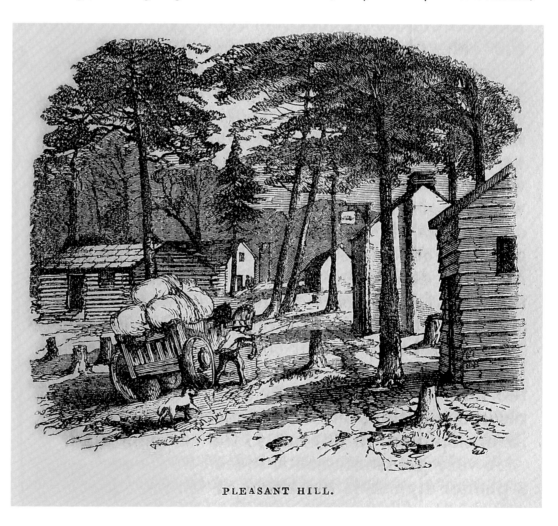

PLEASANT HILL.

FIG. 2 Plantation cabins in Pleasant Hill, Alabama, illustration from Philip Henry Gosse, *Letters from Alabama* (1859)

and are inhabited by planters of large property; these have comforts and elegancies in them which would do no dishonour to an English gentleman."[24] Of the Saffold house, he wrote:

> The house in which I am by residing stands in the middle of a large yard, formed partly by a fence of rails and posts, and partly the offices and outbuildings, such as the pantry, kitchen, spinning house, dairy, &c.; these are distinct buildings, formed of logs, and always more or less distant from the house. Two or three of the negro-houses are likewise usually placed in the yard, that hands may be called on at any moment if needed, the general range of huts being out of sight and hearing of the house. Little black children, stark naked, from a few weeks old to six or seven years, at which age they go out to the field, play, or grovel about the yard, or lie stretched in the glaring sunbeams, the elder ones professedly taking care of the younger or more helpless. Here of course they are early inured, by kicks and cuffs, to bear the severe inflictions of the lash, &c., which await them in after life.[25]

Folklorist Carl Carmer also described the structures designed by the "backwoods architects of Alabama"; some were painted clapboard houses, but most were the same rustic style Gosse delineated. "A long roof line slopes in a gentle undulating curve from the ridge-pole down, down until it is finally met by the upright pillars of the porch," Carmer wrote. "The stone chimney rises in uneven outline from the center at an end wall. The right wing, usually one room, is a complete unit. So is the left wing—which usually contains the kitchen and chimney. Between the two wings—with the roof above and the porch floor below—is nothing. A big square hole through the center of the house, sometimes called the 'dog-trot.'"[26]

Gosse made notes of the common meals—fried pork and chicken, squirrel pie, grits, corn bread, biscuits, and "roasting ears" of corn. He gave special attention to the growing and eating of watermelons, which had ripened on the vine by July and were cherished refreshments. Of them he declared, "I know not a more cooling or delicious fruit in the heat of the summer."[27]

Gosse scrutinized the brutality of slavery but admitted that he feared appearing too sympathetic—something slavers did not abide. He recorded that the market value for healthy adults spanned $200 to $1,000 each; children were sold by weight, for seven to ten dollars per pound. "What is to become of the slaves, if they be emancipated?" he wondered. The plantation system owed its success to inhumane free labor, which made it inconceivable for planters to remain solvent if they voluntarily freed the enslaved. Gosse voiced trepidation at the turmoil that might ensue if they were freed. "To throw two millions of persons, uneducated and uncivilized, smarting under a sense of accumulated wrongs, at once loose upon society, would be more than dangerous, it would be certain destruction. Yet the institution is doomed. Its end approaches surely, perhaps swiftly." Despite the rich fieldwork there for a naturalist, he concluded, "I feel slavery alone to be so enormous an evil that I could not live here: I am already hastening to be gone."[28]

As he traveled down the Alabama River, Gosse observed the call-and-response-style freedom song the boatmen were singing:

> I think I hear the black cock say,
> Fire the ringo, fire away!
> They shoot so hard, I could not stay;
> Fire the ringo! fire away!
> So I spread my wings, and flew away;
> Fire the ringo! fire away
> I took my flight and ran away;
> Fire the ringo! fire away!
> All the way to Canaday
> Fire the ringo! fire away!
> To Canday, to Canaday,
> Fire the ringo! fire away!
> All the way to Canaday.
> Ringo! ringo! blaze away!
> Fire the ringo! fire away![29]

Gosse departed Pleasant Hill at the close of 1838, and J. G. Traylor arrived at the Saffold plantation as overseer just over a year later. Gosse's writings, replete with biological and botanical knowledge, Latin names and scientific terms, and philosophical perspectives on Southern culture, greatly contrasts with J. G.'s succinct and practical farm diary.

Reading between the lines of J. G.'s text, however, offers valuable insights. He wrote on October 11, 1839, for example, about a visit to a neighbor: "I went to Mr. Crawfords to see William Traylor. Rained in the evening." Neither "William" nor "Traylor" was an uncommon name in the area; in this isolated citation, J. G. does not specify whether the individual mentioned is black or white, yet an enslaved person would not have been referred to with a surname. J. G.'s diary entry thus reveals the race if not the identity of this William Traylor.[30]

"I went to the forte and Boute a negro girl for 725 dollars," J. G. logged in March 1840. The banality of the occasion of his first purchase of another human being would undoubtedly have been one link in a chain of crises for the girl he speaks of. Although he did not record anything about her identity, she was possibly the child named on February 25, 1844, when J. G. entered a rare remark about a slave death: "I made a coffin and barid a negro childe Martha."[31] J. G. alluded to Fort Rascal, or "Forte Raskill," with some frequency, including his attendance at a "big diner" there in 1844.[32] According to the Pleasant Hill Presbyterian Church historical registry forms, "Fort Rascal, located at modern Pleasant Hill, was the center of a primitive town that catered to the needs of planters and speculators, and was also the site of a slave market."[33] The federal census of 1840 shows J. G. Traylor as the owner of one enslaved person, a "female under the age of ten."[34]

In 1841, J. G. purchased two unconnected parcels of land roughly a half mile apart to establish his own plantation north of Pleasant Hill. The first, comprising eighty-five acres, he got from W. J. McKinney (for $375), and the second, a little more than 170 acres, from J. M. Garrett (for $1,000). J. G.'s eldest brother, George Hartwell Traylor, owned a plantation not far from there, across the county line in Lowndes County. The county lines were shifting in those years, but the boundary separating Dallas and Lowndes Counties was a creek and thus likely a stable borderline. In July, J. G. made a rare note about his physical treatment of his enslaved: "Cloudy and hot all day. I whipped too negros for harlern. One run a way."[35] "Harlern," or hollering, refers to the family of unaccompanied field calls, or "arhoolies," such as whoops, hollers, calls, and cries. Planters and overseers generally believed that field songs promoted a good workflow, but worried that hollering might be illicit communication. J. G. would later record in his diary that his wife's father, Benjamin Calloway, died that August.[36]

J. G. purchased five enslaved people from Benjamin Calloway's widow before the rest of his father-in-law's estate went on public sale, on January 5, 1842.[37] Neither J. G. Traylor's nor Benjamin Calloway's records identify the individuals, but a compilation of documents suggests they were likely Bill and Sally (Bill Traylor's parents), Liza (presumably their eldest, possibly adopted, daughter), and, unrelated to them, a couple, George and Drusilla (sometimes spelled Drusella; this couple did not have children in 1842 but later would).[38] The same month, J. G. and Mary C. had another child, Thomas Gibson Traylor, whom the enslaved people on the Pleasant Hill plantation would eventually come to know as their overseer.

In the spring of 1842, after fifteen years of overseeing other planters' realms, J. G.'s health forced him to move his family to their own, newly established, plantation north of Pleasant Hill.[39] By the end of the year, Bill and George, J. G.'s main laborers, were hard at work building new houses there, for both J. G. and themselves, while also cultivating the new land. A December entry reads, "I halled a hous from grartts to my

FIG. 3 John Getson Traylor's home, built in 1845, Dallas County, Alabama; the house, photographed in 1979, is still standing.

hous." J. G. had moved a house from the land parcel he had bought from Garrett to the property he bought from McKinney, where he was residing. Several entries in January 1843 note work on a "neg hous" or "negro hous." In February he recorded selling six acres from the Garrett parcel. He named Bill (Calloway-Traylor) and another slave, George, for the first time in his diary when he wrote, "Bill plowd in the new groun. I sent George to a log rolling."[40]

In January 1844, J. G. chronicled the dismantling of the Garrett house that he had moved to the site and the process of rebuilding a house on the same site, with many mentions of Bill (Calloway-Traylor) as a primary laborer on the house and a smokehouse for putting up meat.[41] The new Traylor home was finished in July of the following year and would later pass down through the family, first to daughter Lou and her husband, Daniel Benjamin ("D. B.") Edwards, and then to subsequent generations of Edwardses; it still stands today (fig. 3).[42]

On February 13, 1845, J. G. mentioned Bill, George, Sally, and Drusilla in his diary: "I worked on my hous all day. Bill went to Mr. Todds to rol logs. George cut up old logs. Sally nocked down cotton stocks. Drusiter poud in oats. Clear and pleasant for som time."[43] Sally would have been pregnant at the time of this record, for the diary's only reference to an enslaved child's birth is in the entry for March 26, 1845: "Clear and pleasant all day. Sally had a chile at nite."[44] J. G.'s estate files, which note the slaves' ages, suggest that the child was most likely Frank, older brother to Bill Traylor (the artist).[45]

Frances "Fannie" Ann Traylor was born to John G. and Mary Calloway Traylor on October 12, 1844. Just before her second birthday, in an entry dated September 27, 1846, J. G. wrote, "I returned from the Springs and found my youngest child very sick like to dy."[46] But Fannie recovered, and the cotton harvest went on. The same year, Montgomery became the capital of Alabama, taking that status away from Tuscaloosa. Court Square at the middle of Montgomery (see part two, figs. 81, 82) had become one of the biggest slave markets in the South. The wending Alabama River was a well-used route for delivering captives to planters and cotton crops to market, which by then were at peak demand. In November, J. G. started writing about constructing a "jin hous" for cleaning, or "ginning," cotton, with Bill's help.

J. G.'s wife died in February 1847 ("Mary Traylor was taken sick and was sick two weaks and died on Monday Eavning 5 oclock the 15th instan," J. G. wrote).[47] She was buried the next day in Town Creek Cemetery. Work on the plantation resumed the day after the burial with the assistance of a hired hand, Silvy. But, J. G. would soon acknowledge, "Too weaks pas and nothing much don."[48] Later that month he wrote, "Cloudy and rainy in the morning George helped Mr. Hardy rol logs. Bill worked on the well at garetts. Silvy and the two little ons picked liter. I made leading lines." And the next day: "Cloudy and cold all day. Silvy and hur too picked up liter. George and Bill worked on the Jin hous. Sally plowed." A couple weeks later he noted, "George cut a dich Bill Halled out cotton seeds for manewer. Sally and Silvy bedid cotton growun."[49]

J. G. gave up keeping a diary that April. His ongoing health problems and despair over the loss of his wife were weighing heavily on him.[50] On the last page he records a poem or prayer that he apparently wrote in 1832:

Oh hoo can tell what time ma do
How all my sorrows yet ma and
Why I should ber regret so
Why I should be without a friend
Why I should live to fine an dy
Why I should live to morn an greav
The sorrows of this worl
Why should I on earth wish to live.
When this you see remember
When I am ded an gon Oh who can
tel what time ma do
Oh who can tel how all my sorrows
yet ma and will you my tru lov
reject a friend so tru
Why should I any longer earth liv
If you will not these Joys give.

In December 1848, J. G. made his last land acquisition, which expanded the plantation surrounding the house situated on the McKinney parcel to roughly four hundred acres. He purchased the large influx of 328 acres for $250 from Thomas M. Kindall, his neighbor to the west; this land was the acreage that J. G.'s enslaved people would continue to work until the middle of the Civil War (fig. 4).[51]

When J. G. penned his last will and testament on December 3, 1849, he wrote that he is "sick but of sound mind."[52] The 1850 federal census mortality schedule records his cause of death as "dyspepsia," but recurrent malaria was probably the actual cause. Rosa Lyon Traylor traced the history of her Alabama relatives (including J. G. Traylor) in her book, *Collirene, The Queen Hill* (1977). She explained that river travelers up from Mobile brought myriad illnesses: "There was cholera, sometimes in epidemic form. These early settlers wrote of Tyler grippe, backbone fever, malignant sore throat, other throat disorders, cholera, scarlet fever, malaria, mumps, tuberculosis, bowel affliction, and 'barks' (coughs). It was a hard life, and not one filled with many magnolias." Lyon Traylor believed it was exhaustion and chronic malaria that finally bested J. G. "When his young wife died in 1847, he gave up keeping his diary. For two more years he suffered his chills and fever, finally dying in January of 1850."[53] He had not yet reached the age of forty-one.

J. G.'s handwritten will names his brother, George Hartwell Traylor (of Lowndes County), as estate executor and guardian for his and Mary's three living children (Louisiana, Thomas, and Frances) until, it states, they respectively become twenty-one years of age (or marry) and take their inheritance.[54] The 1850 federal census indicates that Lou, Thomas, and "Fannie" immediately moved to live at George's plantation in Lowndes County.

The enslaved family members, who were now estate property, were to remain united, per J. G.'s wishes, to work together on the Dallas County plantation until

inheritances took effect, the first of which would turn out to be ten years later. J. G.'s land and all other property was to be divvied up between the three when Fannie, the youngest, came of age or married. The will also gave George the authority to sell anything he deemed necessary to accommodate for the children's needs. Twelve enslaved people were listed as part of the inheritance property. J. G.'s death would have brought intense fear and uncertainty into their lives. The will named them and indicated their deceased owner's intentions for their futures: "Bill and wife Sally with their children Liza, Henry, Frank, and Jim with their future increases, also Drusella and her children Harrison, George, Richmond, Joseph and their future increases, and also George, which said Negros it is my will and desire should be kept together till my said children shall arrive at age or marry."[55]

After J. G.'s death, Bill Traylor's family remained enslaved on the Dallas County plantation. The 1850 federal census record for Dallas County (enumerated in August) shows no white people living on that estate, but it lists twelve enslaved people there. The 1850 slave schedule for the same property counts only eleven enslaved people, although inconsistencies on such records are commonplace. The same schedule shows a

FIG. 4 Map showing the plantations of John Getson Traylor, George Hartwell Traylor, and John "J. A." Sellers, Dallas, Lowndes, and Montgomery Counties, Alabama

different twelve slaves on George H. Traylor's Lowndes County plantation, some six miles east of J. G.'s property, while the federal census that year shows thirteen. As J. G.'s will dictated, Bill and Sally and their children, and George and Drusilla and their children, stayed on at J. G.'s Dallas County plantation, with George H. overseeing its ongoing productivity.

LIFE AFTER JOHN GETSON TRAYLOR

During the years when George Hartwell Traylor served as executor for his brother John Getson Traylor's estate (1850–65), he kept records pertaining to all official transactions. These documents are succinct and lack detail, but they record the enslaved people held within the estate and confirm that the future artist Bill Traylor (son of Bill and Sally Calloway-Traylor) was born into slavery on J. G.'s cotton plantation in Dallas County, Alabama, near the town of Pleasant Hill in April 1853.[56]

Records that mention the year of Bill Traylor's birth are inconsistent, but when they are examined comprehensively, the evidence points persuasively to 1853. Four records agree that he was born in April: The 1900 federal census says that young Bill Traylor was born in April 1856 but does not specify a day. On his application for a Social Security number (filed years later, in June 1937) Bill gave his birth date as April 1, 1855; he provided the same date to Saint Jude Catholic Church in Montgomery, where he was baptized in 1944.[57] Although Traylor offered different years at different times, April 1 is a recurring marker of the month and day.

The fourth and final conferral of April 1 is less formal. It is a note found on a drawing that Bill Traylor made around 1939 (**PL. 1**) of a man in a green jacket, either a self-portrait or a depiction of George Hartwell Traylor. On the picture, someone wrote, "Bill Traylor. Born at Benton Ala. Lounds Ky, April 1, 1855 Raised under Mr. George Traylor." Accurate or not, Traylor had clearly selected April 1 as a personal way of marking the passing years of his life. Before Emancipation, slave owners customarily kept track of the ages of their charges, with varying degrees of exactitude. After the war, many freedmen, when asked about their ages, used a gauge of before and after "the Yankees came through" to estimate their years. One former slave, Liza Cloud, explained, "I was sixteen years old when the Yankees come through. I can't tell about the year I was born but I know the month. I was born the first of May. You know back there colored folks didn't know nothing about the years."[58]

Three documents concur on 1853 as the year of Traylor's birth. First, the estate records George H. Traylor kept regarding his brother's Dallas County plantation and property show that, in January 1863, "Little Bill" was nine years old; he would turn ten in April 1863. If Bill Traylor was born in 1854 as the 1880 federal census suggests, the birth date for his younger brother, Emit (sometimes spelled Emet), would also need to be adjusted, as records show Emit being born between 1854 and 1856 and was younger than Bill by at least a year or two.[59] A birth year of 1853 for the artist is indicated a second time on the 1870 federal census, in which Bill Traylor, recorded as "William Traylor," age seventeen, and some of his family are living in Lowndes County on George Traylor's land.[60]

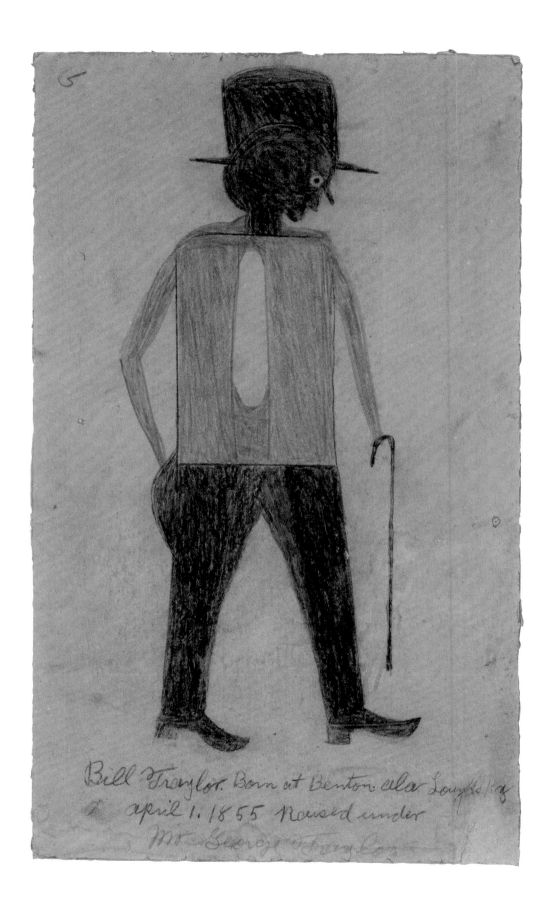

PLATE 1 *Man with Hat and Cane*

Lacking an heir old enough to manage J. G.'s plantation, George in 1856 hired Jonathan Flanigan to manage the Dallas County estate.[61] The changes of control would have provoked terrifying uncertainty for the black Traylors: a new overseer had no cause to be fond of the enslaved people and every cause to want a highly productive plantation. But the details of Flanigan's nature and the dynamics of that time are lost to history.

George Hartwell Traylor's first wife died in 1853.[62] He remarried in 1857, to Margaret Jane Averyt, and the same year sold J. G.'s land warrant 30155 (160 acres) to Greenwood & Co. for $124. This was the remaining Garrett land that was not connected to the acreage surrounding the main house and was sold to benefit J. G.'s children, who needed the cash more than the land. In 1857 another change of control came to the Dallas County plantation when J. G.'s son Thomas took over Flanigan's work as paid overseer for his deceased father's plantation.[63]

By 1860 fifteen enslaved people were enumerated on the slave schedule for Oldtown, Dallas County, under Thomas G. Traylor, who was living alone (with no other whites) as a farmer and owner of the property.[64] The enslaved were most likely eleven of the twelve mentioned in J. G.'s will, plus children born after the will was written: "Little Sally," Lucy, "Little Bill," and Emit. The youngest listed on the schedule are males ages seven and six, offering a third conferral that Bill was born in 1853, Emit in 1854.[65] Drusilla may have died, as she does not appear on any records after 1850 and is never subsequently bequeathed to any of J. G.'s heirs. On George's plantation in Lowndes, the same slave schedule indicates that he had eighteen enslaved people there; the youngest male at the time was eight years old.

At this time, J. G.'s daughters, Lou and Fannie, lived with their Aunt Sarah (Calloway) and Uncle Thomas (Webster) in Pleasant Hill, Dallas County.[66] But in July 1860, Lou married Daniel Benjamin Edwards, and the couple soon moved to land they rented from the Edwards family, a tract called Gardiner Place.[67] Their marriage brought about the first, and likely long-dreaded, division of the enslaved Traylors since 1842, when J. G. Traylor had bought the elder Bill and Sally, along with Liza, George, and Drusilla, from Benjamin Calloway's estate.

That November, Lou formally inherited Drusilla's widower, George (age 54), and children, Harrison (16), Joe (11), "Little George" (14), and Lucy (10) (fig. 5).[68] Old Bill, Old Sally, and their children thus remained an intact family. This same year, George H. Traylor and Margaret had their first child, George Alexander Traylor.[69] Two years later, at the height of the Civil War, George Alexander died.

By the time the enslaved Traylors were being doled out to J. G.'s heirs, the issue of slavery was causing a rift in the nation. In 1860, Abraham Lincoln of the antislavery Republican Party was elected president. Early the next year South Carolina, Mississippi, Florida, Alabama, Georgia, Louisiana, and Texas formed the Confederate Constitution, and soon after, Virginia, Arkansas, Tennessee, and North Carolina joined ranks. The Confederate States of America elected Jefferson Davis to be president of the Confederacy. Stephen F. Hale, Alabama's commissioner to Kentucky, wrote the Kentucky governor a lengthy letter justifying Alabama's secession from the Union: to perpetuate slavery

and prevent the "pollution and violation" of Alabama's wives and daughters. He saw Lincoln's election as "nothing less than an open declaration of war" on the South, her property, her institutions. If the South submitted, Hale feared, "slave-holder and non-slave-holder must ultimately share the same fate—all be degraded to a position of equality with free negroes."[70]

On January 11, 1861, Alabama seceded from the Union and joined the Confederacy in the Jefferson Davis Artillery; organized in Selma, the Artillery recruited men in Dallas, Lowndes, and Autauga Counties. In early February, Montgomery became the capital of the Confederacy (but it would be moved to Richmond, Virginia, that summer). J. G.'s son, Thomas Gibson Traylor, enlisted in the Artillery on July 27, and his Uncle George resumed overseeing the Dallas County plantation.

In May 1862, George and Margaret celebrated a second son, Marion Hartwell Traylor.[71] But matters darkened for the Confederacy that fall, beginning on September 17, after the Union claimed victory at the Battle of Sharpsburg, or Antietam—the bloodiest single-day battle in American history. President Lincoln subsequently issued a preliminary Emancipation Proclamation, which stated that by the first day of 1863, slaves in rebellion states would be freed. The *Montgomery Weekly Mail* began to publish articles about the president's intentions in early October. Lincoln signed the Emancipation Proclamation, a presidential executive order, on January 1, 1863.

Clearly, George was now pressed to make decisions about J. G.'s estate. George's records specify that as of January 10, 1863, he was renting the Dallas County plantation to a B. E. Carson; their agreement covered 1863–64 at seventy-five dollars per year.[72] On January 13, George noted that Old Bill (about 57), Eliza (about 18) and her child (about 1), Henry (19), Richmond (15), and Emit (8) would be formally inherited by

FIG. 5 Page from George Hartwell Traylor's record of the late John Getson Traylor's estate showing the inheritance of his daughter Louisiana (Lou), November 1860. Alabama Department of Archives and History

Thomas Gibson Traylor, even though he was still away at war. He also wrote that Old Sally (45), Frank (18), James (16), Little Sally (12), and Little Bill (9) were reserved for Frances (Fannie). The decision to finally separate Old Bill and Old Sally from their children, cleaving the family in two, would have come as devastating news to Bill's family.

George's records regarding slaves as property for inheritance at this date indicate that Alabama was then still ignoring the Emancipation Proclamation and did not yet intend to free anyone. On January 13, 1864, George recorded sales of general goods—plantation tools and housewares—from the J. G. Traylor estate. The proceeds were divided among the three children, with Thomas's and Fannie's portions set aside (fig. 6).[73]

Later that month Little Sally, Jim, Old Sally, and Emit were hired out to neighboring plantations for 1863 and 1864.[74] That moment marked a critical juncture. Having sold the household goods and farm tools and rented out the Dallas County house and farmland, George moved J. G. Traylor's remaining slaves off the Dallas County farm and housed them on his own Lowndes County plantation (see fig. 4).[75] Thus began the widespread but erroneous notion that Bill Traylor (the artist) was native to Lowndes County; he was actually nine or ten when he left J. G.'s Dallas County plantation near Pleasant Hill, where he had been born. Further confusion may have come from the fact that Bill was born into an enslaved family that at the time of his birth lived and worked (in the legal status of estate property) on the land of their deceased owner that was managed by their owner's brother. Bill, born three years after J. G. died, knew only George Hartwell Traylor (guardian and estate overseer) as his "master," which explains his view that he had been "raised under Mr. George Traylor."

FIG. 6 Page from George Hartwell Traylor's record of the late John Getson Traylor's estate showing the inheritances of Thomas and Frances (Fannie), January 1863. Alabama Department of Archives and History

On January 31, 1865, Congress passed the Thirteenth Amendment, which formally abolished slavery in the United States, and the era of Reconstruction was officially under way. The amendment was ratified the following December, but in the interim, Northern armies continued to occupy the South to enforce the congressional decrees in the eleven Confederate states. The Battle of Selma (in Dallas County) took place on April 2 and lasted just a day. On April 9, 1865, General Robert E. Lee's Confederate army surrendered to the Union army under Ulysses S. Grant. The signing of surrender documents signaled the end of the war, but smaller fronts were still playing out, and Confederate president Jefferson Davis was reluctant to accept defeat.[76]

In late March 1865, Brigadier General James H. Wilson led the Union Army Cavalry Corps through Alabama and Georgia to destroy Southern manufacturing facilities and capture fortified cities, an effort known as Wilson's Raid. Wilson's Raiders, comprising three cavalry divisions (some thirteen thousand soldiers), covered a wide pathway over a ten-day period before they converged on Montgomery on April 12.

A contingent of Wilson's troops crossed the Alabama River just south of Selma and headed east toward Montgomery along the south bank or possibly further inland. Ebenezer Nelson Gilpin, who was a private with the Third Iowa Cavalry, wrote in his diary that on the morning of April 10, 1865, Union and Confederate troops skirmished "where the roads crossed at a sharp angle" just before they approached a hill.[77] Later that day they came upon a creek, where twenty-foot clay bluffs impeded their crossing, but they managed to outwit the Rebels and cross below the "bend of the stream on their [the Rebels'] left"; afterward they headed on to Church Hill, where they camped at General Robinson's.[78] The next day, Gilpin wrote, the Union company crossed Big Swamp Creek on its way to Lowndesboro and eventually to Montgomery. Contrary to Gilpin's summary is a report by the Second Indiana Cavalry that describes a seemingly different route from Selma in which they came upon a skirmish with Rebel soldiers just outside Benton on Montgomery Road. During a charge toward the Rebels, the Union soldiers took a wrong turn and ended up in a swamp, in which one of their captains drowned.[79]

The Raiders' exact routes are hard to discern. George Hartwell Traylor's property had some elevation over the water table and was not likely to have had any swampland, yet a small swamp exists just west of Benton. The site of George's estate is about three miles from Benton (see fig. 4). The Indiana Cavalry may have stayed off the main road after the skirmish and gone south toward his property before heading east toward Montgomery. It is also possible that the Iowa Cavalry, in its effort to cover a different portion of the county, took a more southerly route from Selma. This way went east somewhere around the Dallas/Lowndes County border; the company would have passed through George's land, crossing Old Town Creek onto Double Church Road, then an unnamed but well-used stagecoach road before they camped in Church Hill.[80] Several creeks and county roads flow down from Selma and the Alabama River; the Iowa Cavalry could have followed them and perhaps pillaged nearby homes. An anecdotal story told by Alabama historian Bettye Benjamin says that the town of Lowndesboro managed to evade the attack. According to this

local legend, a doctor brought out a boy with a severe skin affliction and told the oncoming soldiers that smallpox was in the town.[81]

Margaret Elizabeth Traylor Staffney, one of Bill Traylor's granddaughters, recalled the stories she heard from her grandfather about the Raiders coming through George's farm.[82] In 1992, Staffney retold one of them, which maintained that he and one of George H. Traylor's children, who were childhood companions, heard the soldiers on horseback coming up the road. They ran to the woods and hid in a hollow tree trunk as the Raiders went through destroying plantations along the Alabama River. After it was over the kids encountered a burning farm, an emptied larder, and slaughtered animals.[83] John Bryant Traylor Jr., one of George's great-grandsons, has attested to those events, noting that gunfire from the Raiders left a hole in the ceiling of the plantation's main house.[84]

On April 11, 1865, the day before Union troops reached Montgomery, an order from military brass admonished them for pillaging and commanded that they comport themselves with dignity as they marched into the city. Three days later, Confederate sympathizer John Wilkes Booth fatally shot President Abraham Lincoln at a play at Ford's Theatre in Washington, DC, and Andrew Johnson, a minimally educated Southerner and former slaveholder, succeeded him as president, arguably leaving a dearth of leadership.

To date, no records show that the Traylor family applied for post-war assistance or compensation of destroyed property; receiving such funds may have required them to sign documents pledging loyalty to the United States, so they may have bypassed the opportunity. If Margaret Staffney's and John Traylor Jr.'s family lore about the source of the bullet hole in the ceiling are correct, the Raiders came through George Hartwell Traylor's plantation while Bill Traylor lived there—and left him with an indelible memory.[85]

In October 1865, Fannie Traylor took her share of the J. G. Traylor estate, which signaled that all J. G.'s children had come of age and received their inheritance and that Uncle George's guardianship and executorship had concluded. Sally, Frank, James, Little Sally, and Little Bill, however, were not part of her inheritance; they were now free.

Although census data was customarily taken on the year marking a new decade, a need to reassess the citizenry prompted one in 1866. The records for 1866 are even less consistent than their predecessors, as the information varies from county to county and the enumerators took down different information. Recently freed slaves were sometimes recorded solely by a first name, as the practice of their taking the last name of the plantation owner had not been firmly established. Some enumerators wrote the first names of the ex-slaves together with the names of the plantations they had belonged to. Unfortunately, this detail was not documented in Lowndes County, where the state census for the "colored population" recorded the first name of the head of the household, with no last name and no first names for the rest of the household; they show instead just a dash with a notation on the sex of a person and an approximate age range.

It is difficult to discern whether Bill and his family were enumerated on the 1866 census. Page seven of the Alabama state "colored population" census lists a male, "Billy,"

around thirteen years old. But the more likely record for Bill Traylor comes on page thirty-nine, with a "Henry" (no surname) listed as head of the household. Although there is no record of it, Old Bill (Calloway-Traylor) had likely died before 1866, and Henry was the name of Bill and Sally's eldest son (born around 1843), older brother to Little Bill and the de facto male head of household if Old Bill had indeed passed away. The others listed with Henry include a boy about Bill's age, a woman close to Old Sally's age, and siblings of ages that strongly suggest—to the loose degree that they are noted—that it is Bill's family recorded here. The names appear lower on the same page where additional black families have also claimed the last name Traylor, conferring that the Bill Traylor listing is in the right geographic proximity to other black (formerly enslaved) "Traylors." Furthermore, neighbors of George's (the Edwards and Hardy families) are listed on the same page, which is an all-but-certain confirmation that young Bill's family appears here.[86]

Voter registration records for 1867 have "T. G. Traylor" and "G. H. Traylor" as registered white voters in Lowndes County; three black Traylors—Henry, Frank, and James, all names of Bill's older brothers—are also registered. Their inclusion as free men and voting members of society reflects a radical change in the status quo. Slavery was outlawed, but prejudice and discrimination continued. Passed in 1868, the Fourteenth Amendment guaranteed citizenship and equal protection under the law to all American-born people, and the Fifteenth Amendment, passed in March 1870, gave African Americans the right to vote. African Americans joined forces with white allies to support the Southern Republican Party, which effected tremendous changes across the South. Despite the amendments, however, the Southern Republicans faded within the decade, and Southern state governments found ways to utterly erode the rights the amendments conferred.

In 1869, George and Margaret Traylor had a third child, Effie. By then, J. G.'s youngest daughter, Fannie, was living with her sister, Lou, and Lou's family in Oldtown, Dallas County, at the former home of their father, having moved there sometime after the war ended.[87] In J. G.'s family, it was not the oldest son who had inherited the family home and land (J. G.'s firstborn son, Benjamin, had died as a baby) but rather, the eldest child, Lou.[88] Lou's younger brother, Thomas, also lived in Oldtown with a Benjamin Edwards (on his land), with three black laborers and housekeepers.[89]

As noted above, the 1870 federal census also lists "William Traylor" (age 17), using the formal version of his name for the first time, as living with his mother and "three siblings," Emet (15), Mary (9), and Susan (7), in close proximity to George H. Traylor and his family in Lowndes County, more than likely in the same cabins they had previously occupied.[90] In 1992, Rosa Lyon Traylor, a white Traylor (by marriage) who lived on the original George H. Traylor plantation until her death in 2001, wrote a letter to Bill Traylor's great-granddaughter Antoinette Staffney Beeks stating that "Bill's cabin" stood on their property until sometime in the 1980s.[91] The Mary and Susan mentioned in the 1870 census are not noted in J. G.'s estate records and are most likely "fictive kin," people who may not have a blood relationship but were effectively part of the family. It is also possible that Mary (age 9) is the same child as the

unnamed one-year-old mentioned in the January 1863 entry of the estate files (discussed above) and reserved as part of Thomas G. Traylor's inheritance. Regardless, the importance of fictive kin for African Americans cannot be overstated. For African Americans who had suffered profound losses of native-family identity, brutal family ruptures, pregnancy through rape, and premature deaths of parents and children and who had no agency by which to make their own choices, the need to self-define family was paramount in honoring trauma, love, and necessity over convention.

A fourth and final child, Bettie, was born to George and Margaret around 1877. The next year, their nephew Thomas G. Traylor married Amanda Elizabeth Howard, and their niece Lou Traylor Edwards passed away in 1879, leaving her five children motherless. Her sister, Fannie, filled that role, first by moving to live with Lou's widower, D. B. Edwards, and her children and subsequently, in 1882, marrying him.

As Reconstruction subsided in the late 1870s, freed African Americans were discovering the tremendous limits to such "freedom." Racism and resentment persisted, and with little or no education, and meager employment opportunities and means to travel, blacks found themselves inextricably tied to the land of their former lives. Bill and his family were no exception. In *The Negro in Business* (1899), W. E. B. Du Bois wrote: "Physical emancipation came in 1863, but economic emancipation is still far off. The great majority of Negroes are still serfs bound to the soil or house servants. The nation which robbed them of the fruits of their labor for two and a half centuries, finally set them adrift, penniless."[92]

For African Americans, who had been denied education and wages since their arrival on American soil, newfound freedom did not grant them sudden personal agency. Whites in Alabama still banded together to restrict the movement and hiring of freedmen, so many of those who could, often remained where they had been enslaved, if the situation was stable. In *Shadow of the Plantation* (1934), Charles S. Johnson noted that many former slaves retained their association with former owners out of lingering fear of retaliation for leaving. Many of the other accounts he described suggest that true emancipation did not come right away for all. One former slave stated, "The Yankees come through and said slavery's done gone. Child, the [blacks] got to yelling and whooping all over the place. [Yet] some of 'em got kept in bondage as long as four years after freedom."[93]

After the war many white landowners in Lowndes County worked to reestablish exploitative labor arrangements, and despite requirements to sign government contracts stating that they would pay freed black workers, some refused to pay wages. Throughout the South, white landowners developed a system for paying tenant farmers at the end of a season, thereby tying the laborer to the farm until the harvest was completed. Landowners extracted fees for goods the workers may never have purchased or charged unfair prices for them, and they docked pay and claimed workers were absent when they weren't. Hasan Kwame Jeffries, author of *Bloody Lowndes: Civil Rights and Black Power in Alabama's Black Belt* (2009), wrote:

So many and so much were these deductions that quite a few planters paid their workers no year-end wages at all, but instead handed them a bill of debt that tied them to their land for another year. Large landowners also colluded with one another to reduce the bargaining power of their workers. One group of Lowndes County planters agreed not to hire African Americans within ten miles of their homes, hoping to secure a monopoly over the labor of their former slaves. Others organized vigilance committees that, together with the county militia and the sheriff's posse, terrorized African Americans traveling the roadways. These groups raided freedmen's cabins under the auspices of searching for signs of plotting; after beating the occupants, they seized firearms and stole what little cash and coin they found. "The Negro does not know whether to leave the plantation and be harassed or remain on the plantation and be brutalized," reported W. A. Poillon, a Freedman's [sic] Bureau agent stationed nearby in Mobile.[94]

General records such as agricultural schedules do not specify if Bill Traylor was paid to work George H. Traylor's farm, but they do show that George paid wages to black workers.[95] Whether it was a good situation or simply his best option, Bill stayed on as a laborer, working Traylor farmland into his fifties. He started a family there, near his kin, and undoubtedly benefited from a critical network of the familial and familiar. In *Bloody Lowndes*, Jeffries has underscored the importance of social networks as the core treasure African Americans had to rely on. "Bonds among real and fictive kin enabled black families and communities to survive the horrors of slavery, including forced separation," he explained. "In the aftermath of emancipation, social networks based on these personal relationships provided African Americans with an organizing infrastructure through which they mobilized their scarce resources."[96] Traylor specifically embodied that truth; family bonds shaped his life until one day, many decades after he had gained his freedom, they would fall away and leave him adrift.

One of the post-war bedrock social organizations was the formation of black churches, and the black exit from white communities of worship was dramatic. Pastors were often the center of the black community. Church services, Bible schools, and choir practices spilled over from morning into evening. "As the preaching, singing, and shouting bellowed from the packed sanctuary, non-churchgoers fellowshipped outside over cards and dice. Their numbers swelled throughout the day as churchgoing men slipped away from their families to join them. The sinners shared these Sundays with the saints."[97]

From the church groups arose benevolent associations that functioned as providers of civil insurance; families banded together to help the vulnerable in their communities, by defraying costs for health care or funerals. Masonic orders met at the churches as well.[98] These highly ritualized secret societies offered similar support, but because they relied heavily on ceremony, they played a significant role in institutionalizing social networks. "Once established," noted Jeffries, "these formal networks became a permanent presence in the black community."[99]

Community networks created a foundation for freedom rights as well. Black fraternal orders, especially those that shared a name with a white organization, had

to fight for their constitutional right to assemble. The white societies whose missions purported to cultivate brotherhood, friendship, and benevolence were against allowing blacks to join their ranks. In response, blacks sought permission from British chapters of the Masons or Odd Fellows, which granted those charters.[100] Orders that did not have British chapters, such as the Knights of Pythias and the Elks, started their own black lodges based on the official tenets of the white societies, which they obtained without consent.[101] African Americans also originated black societies. Their goals were the same as those of other orders, but they focused on aiding those who were left out of society, including women. The Mosaic Templars, for example, which had a large presence in Montgomery, was founded to combat "first, a white man's scorn; second, a Negro woman's poverty; third, a Negro's shame."[102] They held educational lectures, encouraged members to start and patronize black businesses, and had a loan association to assist members with homeownership.[103]

Nothing specifically ties Bill Traylor to a fraternal order, but his exposure to their culture is all but certain. Memberships in black lodges rose sharply after Reconstruction, mainly in the larger cities and towns. When he left farming life around 1927, Bill moved to downtown Montgomery; on the same block of Monroe Street where he would eventually spend time sitting and drawing were lodges for the Mosaic Templars, Knights of Pythias, and the Knights of Tabor.[104] The Great Depression came just a year later. Many societies in Montgomery did not survive the crash, as unemployed members became unable to pay dues. By 1940 the black lodges on Monroe Street had either moved or shuttered.

Beyond the records discussed herein, no other written information on Bill Traylor's personal or work life on either the John Getson Traylor or the George Hartwell Traylor plantation is known to exist. The documents that are available, however, help shape our understanding of the life he lived, his heritage, and his conception of family and provide an accurate environmental backdrop for the wellspring he would draw upon when his memories began to flow out onto paper.

Evidence on Bill Traylor
starts to emerge in documents dating around 1880, which offer an array of isolated facts that gives some shape to his adult life over the next few decades. The documentation remains scant and inconsistent, and given the significant overlap of family names in the region, it is not possible to draw many irrefutable conclusions.

Federal census records list the women and children who can be affiliated with Bill Traylor. Their variable names span minor differences such as spelling to radical distinctions, which might be nicknames or personal preferences; the marked disparities make it impossible to discern definitively where one individual stops and another begins—or how many people were actually in the picture. Recorded birth years for African Americans are unreliable as are the types of records on which they appear. Moreover, the handwriting of the census takers is difficult to read, and we have no way of knowing if the enumerator and the person providing the information were communicating well or even adequately. Traylor became involved with multiple women, sometimes simultaneously, and lived under cultural norms that in some ways seem unconventional today but suited his time and reality. To date no death records have been found for the women who played vital roles in Traylor's life. Traylor's children provided a number of different surnames for their mothers, further obfuscating those identities. Tragically, some crucial public records, including the 1890 federal census for Lowndes County, Alabama, were destroyed by fire in 1921.[1] Every sequence of events in Traylor's chronology is permeable; what follows are probable and possible scenarios that describe the likely circumstances of Traylor's family as it moved into the twentieth century.

THE FIRST MARRIAGE: BILL AND ELSEY

The 1880 federal census (enumerated in June) shows a William Traylor (age 26), living alone but in proximity to George H. Traylor in Lowndes County.[2] This was the first

year the census takers inquired about the birthplaces of parents. Traylor reported that his mother (Sally) was born in Virginia and his father (Bill) in Georgia. According to the same record, Bill's mother and several of his siblings lived nearby, likely also on George Traylor's land: brothers Emit (24), and James (34) and James's family; Sally (60), remarkably, was still living in 1880 but may have been even older than sixty and was described as "maimed, crippled, bedridden, or otherwise disabled." Sally, or Old Sally as she was sometimes called, was being cared for by Susan Walker (17), noted as a "servant" in the Traylor household. She is most likely the Susan Traylor the 1870 federal census lists as a presumed or fictive sibling living with Bill. The 1880 agricultural schedule shows that landowner George H. Traylor paid a thousand dollars to black wageworkers the previous year.[3] The workers are not named or numbered, yet they likely comprised people who were formerly enslaved on the Traylor farm.

At the same time, around 1880, John G. (often called J. G.) Traylor's children were grown and living independently from their uncle, George. Fannie Traylor lived with her brother-in-law, D. B. Edwards, whom she later married, and his children at her late father J. G. Traylor's house in Kings, Dallas County, Alabama.[4] Thomas G. Traylor, Lou and Fannie's brother, lived with his own family in Gordonsville, a couple of miles east of Uncle George's plantation.

During the era of slavery, the enslaved were not considered citizens and thus not allowed to enter into contracts, including marriages. If they did "marry," as in common-law or communally recognized ceremonies, such arrangements were not legally binding for slave owners. By 1866 freed blacks were clamoring to make their marriages lawful. The Freedmen's Bureau, established in March 1865, issued marriage licenses to some, while other couples were married by the courts. Bill Traylor's brother Henry and his wife, Minta Dunklin (known as Minty), were among the couples who married in 1866.[5] Fourteen years later, in 1880, "William" Traylor (rarely called by this formal version of "Bill") married for the first time, to Elsey Dunklin (fig. 7).[6]

The marriage between William and Elsey took place in Lowndes County at "Henry Lewis," which could have been either the plantation of Henry Lewis, near

FIG. 7 Marriage license of Bill Traylor and his first wife, Elsey Dunklin, 1880. From *Marriage Record: White & Black, Lowndes County, Alabama, Book A*, Lowndes County Courthouse, Hayneville, Alabama

George Hartwell Traylor's, or the tract of land D. B. Edwards had inherited from his family, known as the Lewis Tract. Few records pertain to Elsey Dunklin.[7] Those that do lead us to conclude that she and Bill had three children—Pauline, George, and Sally (hereafter referenced as Sarah, which is what she was called almost all of her life).[8] Elsey either died or was otherwise severed from the family shortly after she gave birth to Sarah in 1887. Around the time Sarah was born, a girl who would be known legally as Nellie Williams but was commonly called Nettie or Nutie was also born. Nellie was the daughter of Laura Williams, and her death certificate indicates that her father was a man named Burrell Williams.[9] By 1900, Bill Traylor was married to another woman, Laurine Dunklin, and Nellie was in their care.[10]

When George H. Traylor, the man Bill knew as his former master and then employer, died in 1881, his estate passed to his son Marion.[11] The following year J. G. Traylor's daughter Fannie married her late sister Lou's husband, D. B. Edwards. In 1884, Marion Hartwell Traylor married Annie "Ella" Boyd. They would have their first child in 1886, George Boyd Traylor. Their second child, Marion Hartwell Traylor Jr., was born in 1888 (fig. 8).

In the fall of that year, Marion Hartwell Traylor had his late father's land surveyed. The field notes include a plat of the original land grants of George H. Traylor's plantation, which comprised nearly 390 acres, and list Bill Traylor as a member of

the survey team: "Bill Traylor (col) Flagman" (fig. 9).[12] The fact that Bill was part of the team indicates that he was trusted; members were picked for their moral integrity and required to take an oath.[13] A flagman (sometimes called a marker or "point setter") worked with the chainmen (the surveyor's assistants) by setting a spiked flag at the end of a tally chain so that the surveyor could measure the distance. Bill's plantation experience likely made him well qualified for the work. The situation suggests a significant degree of loyalty or mutual dependency between the white and black Traylors, especially considering that not long before this effort, a race riot had shaken Lowndes County to the core.

The riot had impacted race relations far beyond Alabama. In March 1888 a mob of two hundred men had removed Theodore Calloway of Sandy Ridge in Lowndes County from the jail in Hayneville, Alabama. Calloway had been arrested for the murder of a white man, Mitchell Gresham, the week before.[14] Calloway claimed self-defense in the killing, but the *Atlanta Constitution* released an article that undercut his story among white readers.[15] The masked men who wrested Calloway from his jail cell dragged him to the front of the courthouse and performed a brutal lynching.

FIG. 8 George Boyd Traylor *(standing)* and Marion Hartwell Traylor Jr., 1901

Governor Thomas Seay of Alabama made an inquiry as to whether Sheriff R. E. Brinson of Lowndes County had properly handled the situation. The sheriff, who had seen no wrongdoing by the lynch mob, replied to the governor, "I beg to deny to your Excellency the authority to inquire of me as to the matter referred to in your letter of March 31, and on personal grounds, I object to any lecture in respect to the duties the law implied or the conscience imposes."[16] Brinson's overt racism added fuel to an already smoldering fury within the black population, which vowed vengeance against the white oppressors who had mistreated them for so many years. By May the Calloway lynching had fostered a riot that earned Lowndes County the moniker "Bloody Lowndes."

Newspapers at the time noted that blacks in Lowndes County outnumbered whites six to one.[17] Grasping the dominance of their numbers, African Americans began rallying at local lodges to plan an attack on the whites.[18] Rumors of such plans got back to the county sheriff, who set out with arrest warrants for the instigators. When the posse encountered an armed mob of black men on the road, a gunfight ensued, and two black men died. One of the men, Emerson Shepard, while dying, revealed the plot to "massacre the whites."[19] Outrage over the deaths grew among black citizens. When a large group of armed black men threatened Sandy Ridge, white citizens called for military assistance, and the governor sent troops to settle the unrest. Word of the lynching and succeeding riot spread across the nation. Sandy Ridge and the George Traylor plantation were only some thirty miles apart, so the news would surely have reached the Benton area.[20]

THE 1890S SOCIAL CLIMATE

The troubling reputation of Lowndes County was getting the attention of prominent black leaders. Booker T. Washington, the founding president, from 1881 to 1915, of the Tuskegee Normal and Industrial Institute (now Tuskegee University) in Alabama, expressed concern for Lowndes County, with its predominantly black population, and urged teachers from his alma mater, the Hampton Institute and Industrial School (now Hampton University) in Virginia, to form a new school in the county.[21] In response, Charlotte R. Thorn and Mabel W. Dillingham, in partnership with Booker T. Washington, founded the Calhoun Colored School and Settlement in Lowndes County in 1892, which aimed to bring education and opportunity to the poverty-stricken African Americans there. The program was inspired by the Hampton Institute, which taught African and Native Americans self-sufficiency through a curriculum in literacy and math, agriculture, and vocational or industrial trade skills

FIG. 9 Pages of an 1888 land survey showing field notes indicating Bill Traylor worked as a flagman, and plat of George H. Traylor's plantation in Lowndes County, Alabama

for male students and domestic skills for girls. Washington was a firm believer that the success of black Americans would come through their hard work and positive contributions to society, not revolt.

The founders and teachers of the Calhoun Colored School emphasized the values of commitment and labor; nothing was free. Tuition ranged from twenty-five to fifty cents per month depending on age, with discounts given to those who worked by day to pay for evening classes.[22] What set Calhoun apart from Hampton was that it focused on children and prioritized its land ownership program.[23] Its popularity soon led to the establishment of an adult program to cater to the community's needs.[24] With the help of friends in the North, the school endeavored to purchase land from white plantation owners and divide it into smaller, more affordable lots.[25] Locals could then procure their own parcels by entering into a rent-to-own contract with the intention of becoming deed holders after three years.[26] The era saw an unprecedented rise in the number of African Americans who were trying to break away from the past and gain financial independence. It also saw a surging bitterness among whites in the South who railed against any gains African Americans had made in the post-war Reconstruction, which lasted in the South from 1863 to 1877.

In 1906 the Department of Labor commissioned sociologist, historian, and author W. E. B. Du Bois to study black life after Emancipation in the heart of the Jim Crow South—Lowndes County. Lowndes was partly chosen as the subject of the research because the Calhoun Colored School was located there. Du Bois completed his report, "The Economics of Emancipation: A Social Study of the Alabama Black Belt," in 1908, but the Labor Department deemed it "too political" to publish.[27] The paper conveyed the conditions in Lowndes County some fifty years after Emancipation: few African Americans attended school for more than a few weeks a year, few voted, most lived in poverty, and racial violence was rampant. "The white element was lawless," Du Bois noted. "And up until recent times, the body of a dead Negro did not even call for an arrest."[28]

The same year the Calhoun Colored School was established, in 1892, the African American journalist Ida B. Wells had launched an anti-lynching campaign after three of her friends were lynched in Memphis, Tennessee.[29] Wells wrote a scathing editorial in the *Freeman*, a black newspaper in Memphis, addressing the lynchings and the fearmongering myth that black men were raping white women in epidemic numbers. Her outspoken views enraged the white press and citizens of Memphis, and Wells was driven out of town. She kept writing, though, and expanded her anti-lynching editorial to examine other atrocities; her works were published as a small book, *Southern Horrors: Lynch Law in All Its Phases* (1892). Wells gained notoriety by lecturing around the United States and in the United Kingdom through the first part of the 1890s.[30] She was respected among intellectual peers, who included Susan B. Anthony, Frederick Douglass, Du Bois, and Harriet Tubman. But she clashed with Washington, who called for industriousness while Wells advocated for racial justice.[31]

Washington was an ardent proponent of the idea that black Americans should not agitate for equal rights but rather, work hard to acquire vocational training, gain

respect, and participate in the economic development of the New South, a broad term meant to describe a postbellum era of racial equality. In 1895 he became the first black American to address a racially mixed audience with his "Atlanta Compromise" speech, which paved the way for other blacks to do likewise. Just a few years later, Wells also reached across racial lines by speaking to a diverse, although predominately white, audience about anti-segregationist issues.[32] Historian and biographer Linda O. McMurry has described Washington and Wells's relationship thusly: "His career was marked by a willingness to compromise; hers by an unwillingness to concede. She criticized almost everyone; he resented criticism from anyone. He tried to calm troubled waters; she sought to disturb still waters."[33] In many ways their opposing views on how to advance the cause of African Americans would carry through to the civil rights movement in the mid-twentieth century.

Four years after Wells began her anti-lynching campaign, the US Supreme Court upheld a Louisiana law (*Plessy v. Ferguson*) that legalized segregated accommodations for blacks and whites and inspired other states to institute Jim Crow segregation laws. The impact of national racial tensions on the Traylor plantation is unknown. It is certain, however, that for the black population of the era, life was a careful negotiation between the delicate balance of freedom and dependency, safety and peril—and understanding a landscape in which white society was, by and large, united against them as free citizens was crucial. Racially motivated violence and lynchings escalated, while debt slavery (peonage) and sharecropping systems kept the disenfranchised at the mercy of wealthy landowners. Over the seventy-three years between the end of Southern Reconstruction and 1950, lynchings in the South were rampant.[34] Many innocent blacks met their fate at the hands of "Judge Lynch," the unlawful citizens acting as vigilantes who deemed them guilty even when US law did not.[35] Their cruel acts intentionally subjugated black citizens, never allowing them to forget that the law of "separate but equal" was not the daily lived reality.

THE SECOND MARRIAGE: BILL AND LAURINE

Despite the interracial tension pervading Lowndes County, Bill Traylor continued to work and build a life at George Traylor's farm. A second marriage license, dated August 13, 1891, shows a union between "Will" Traylor and Laurine E. Dunklin in Lowndes County (fig. 10).[36] No clear relationship between Elsey Dunklin (Traylor's first wife) and Laurine Dunklin is known, although the two may have been stepsisters.[37] If Elsey and Laurine were not actual kin, their surname Dunklin may have come down to them through slavery. Related or not, they likely knew each other, and Elsey's death or departure may have somehow brought Bill and Laurine together.

Between 1890 and 1904, Marion Hartwell and Ella Boyd Traylor had six more children: Annie Belle, Felix Averyt, James Franklin, John Bryant, Thomas Getson, and Lucy Marion. During the 1890s, Bill Traylor's family also grew significantly (by five children, added to Laura's first daughter, Nellie) and continued to grow (by another six) until about 1914, when the last of Traylor's known fourteen biological children was born. An intricate maze of who lived with whom and was born to which mother as

traced in inconsistent documentation yielding variously spelled names, however, makes the records from 1890 to 1920 difficult to interpret. They indicate two possible truths. The first is that Traylor was involved with both Laurine (his second wife) and Laura Williams (his third wife) for some overlapping years and that the domiciles of the children fluctuated. The second is that the two were not distinct women but one and the same, and perhaps Laurine was also called Laura. A birth record for Alline, for example, shows her as a daughter residing in the home of Bill and Laurine in 1900, yet her birth record lists her birth mother as Laura Traylor.[38] Birth records are consistently more reliable for the mother's name than are death records—on which family members try to recall long-unused maiden names—yet all the records found for the children living in Laurine's home similarly list Laura as their mother.

The 1900 federal census provides one of the most informative documents for Bill Traylor and his family.[39] On this record Bill Traylor's wife Laurine is listed as Lorisa (or Larisa, in script that some have read as Louisa) Traylor[40]; it states that the couple has been married for nine years, which concurs with their marriage certificate dated August 1891, as noted (fig. 11).[41] All of Bill's documented children were born after 1880, so this record from 1900—given that the 1890 census is absent—is the first one they appear on. The three eldest children were seemingly Elsey's, recorded as: Pauline (age 15/b. 1884), George (14/b. 1885), and Sallie (12/b. 1887). Other children listed on the census are Nertie (12/b. 1887), who on later records appears alternately as Nellie, Nettie, and Nutie; Rubin (8/b. 1892), seen in later record(s) as Rueben and Ruben; Easter (6/b. 1893), at times spelled Esther; Alline (5/b. 1895), recorded as alternately as Aleen; Lillie (4/b. 1896), whose birth name was Lillie Lee, which she later changed to Lillian; and an unnamed boy child (1/b. 1898), whom later records would identify as Clement.[42] As noted earlier, Sallie, who would call herself Sarah, was the daughter Bill would live with (under her married name Sarah Howard) at the end of his life, before his death in 1949. Sarah's application for a Social Security number (fig. 12), filed in 1963, confirms Elsey Dunklin as Bill's first wife and the mother of several of his children; although Sarah listed her mother's maiden name with the inconsistent spelling Elsie Duncin, the connection is nevertheless irrefutable.[43]

FIG. 10 Marriage license of Bill Traylor and his second wife, Laurine E. Dunklin, 1891. From *Colored Marriage Book, Book C*, Lowndes County Courthouse, Hayneville, Alabama

TWELFTH CENSUS OF THE UNITED STATES.

SCHEDULE No. 1.—POPULATION.

State Alabama
County Lowndes
Township or other division of county Benton Precinct #1
Name of incorporated city, town, or village, within the above-named division, Benton Precinct #1
Enumerated by me on the 18th day of June, 1900, Chas. L. Miller, Enumerator.

Supervisor's District No. 2
Enumeration District No. 70
Sheet No. 9
Ward of city,

258 A

FORM 3227
(9-62)
U.S. Treasury Department
Internal Revenue Service

APPLICATION FOR ACCOUNT NUMBER
Information Furnished On This Form Is CONFIDENTIAL
Print In Dark Ink or Use Typewriter

Do not write in this space
421-62-6921

FIG. 11 Page from the federal census of 1900 listing Bill Traylor and his family (lines 20–30), including his second wife, Laurine E. Dunklin, shown here as Lorisa, and their nine children (three from his first marriage, to Elsey)

FIG. 12 Application for Social Security number for Sarah Traylor Howard, daughter of Bill and Elsey Traylor, filed in 1963

In a rare drawing that Traylor made many years after the fact, a young girl clings to the arm of a finely dressed woman (PL. 2). Children are not uncommon in Traylor's art, yet no work so clearly identifies the child as African American more than this one does; the detail given to the woman and child and the powerful bond conveyed between them compel the notion that they represent Traylor's own family. A note on the back records a remark Traylor made at the time he drew it: "Child begs mother not to leave."[44] The drawing may show Elsey with one of her daughters, although the ages seem off, as Pauline would have been only three if Elsey had died in childbirth with Sarah. The drawing more likely shows Laurine saying goodbye to one of the older girls (Pauline, Sarah, or possibly Easter)—for whom she was the only mother they had known or remembered. No information has been found to illuminate the nature of Bill and Pauline's father-daughter relationship, but a significant familial rupture sometime in the early 1900s—when Laura replaced Laurine (for unknown reasons) in the Traylor family—may have been the root of the known and lasting friction between Bill and his daughter Sarah.[45]

The case of Nellie is indicative of the overall complexity encompassing the Traylor family. One of the children, whose name is difficult to read on the 1900 federal census, where the name seems to read "Nertie," appears variously as Nellie, Nettie, and Nutie as well.[46] Decades later Nellie would be the version used on her death certificate.[47] Family members had heard the name Nutie, but Nettie would be handed down among later generations as a family name.[48] Records for Nellie's birth year are inconsistent, variously 1887, 1889, and 1890 or 1891.[49] Nellie was, according to the 1900 census, born the same year as Sallie/Sarah, in 1887.[50] Sallie/Sarah, Elsey and Bill's youngest child, was born in August, and Nellie in October. The list of Bill's children on the 1910 federal census (enumerated in May), however, includes a nineteen-year-old Nellie Williams, pointing to a birth year of 1891, who is noted to be a "step-daughter." Mechal Sobel theorized that the "Nertie" recorded living in the home of Laurine in 1900 and born sometime in October 1887 was an "outside child" (or fictive kin) for Bill, based on the fact that her birth came just three months after that of his daughter Sallie/Sarah.[51] If Bill was the father of two babies, born three months apart to two different mothers, it might be a reason for Elsey's departure in 1887.[52] If Elsey died, and Nellie was not Bill's biological child, the proximity of the births is mere coincidence.

GOODBYE TO LOWNDES

Poverty didn't impact only African Americans, but it did hit them disproportionately, and few were able to buy land, even when the law allowed it. Many began to leave the farms they had known for urban areas, seeking work and fraternity in cities in the South, North, and West. The planters who lost their workforce when the slaves were freed were desperate for cheap labor, and their need spurred sharecropping and peonage across the South.[53] Bill Traylor's livelihood after Emancipation has often been described as "sharecropper." Considering that George Traylor paid his workers, as evidenced on the 1880 agriculture schedule, Bill was more likely a paid laborer for most of the time he lived in Lowndes. The 1900 federal census lists him as a farmer

PLATE 2 *Mother with Child*

renting land, but it is not clear whether he was sharecropping or simply paying cash rent. As a laborer for the Traylor family, and a possible tenant farmer later in life, Traylor may have been able to save enough money to finally move his family toward opportunity and independence.[54]

Margaret Traylor, George Hartwell Traylor's second wife, passed away in 1908. Although her son, Marion Hartwell Traylor, had died four years earlier, Margaret's death likely became an impetus for Bill's leaving Lowndes County for Montgomery County, Alabama, around 1908. A magazine article written many years later (1946) gives an anecdotal and backward-looking account of Bill Traylor's departure from the Lowndes County farm on which he had lived most of his life, "after his wife and white folks were dead and his children scattered."[55] To the contrary, Bill's partner at that time and future wife, Laura, was very much alive in 1908 and still having children with Bill, the youngest of whom was born around 1914. Margaret Traylor may indeed have been the last of those whom Bill viewed as "his white folks," the masters of the house during his youth and early adult life. Moreover, when Margaret died, her eldest grandson, George Boyd Traylor, inherited the property.[56] It was said that the younger George was not kind to the workers, a factor that likely spurred Bill and Laura to cut ties with the life they had known in Lowndes County.[57]

By the time the 1910 federal census was recorded in May, Traylor and his household (eleven people, including him) were living just outside Montgomery city limits on Mobile Road between Mill Street and Hayneville Road, a place in Montgomery County identified by voting district as "Kendall Precinct 19." Laurine was no longer with the family, and Bill was residing with the woman now recorded as his third wife, Laura; the 1910 federal census lists her by the nickname Larcey.[58] Although they were residing on rented land, Bill is called the "employer," with his wife and children working for wages under him.[59] The Montgomery city directory for 1913 shows a Reuben Traylor (sometimes spelled Rubin or Ruben) living at 253 Mobile Road. This appears to be Bill's son, who, born in 1892, would have been about twenty-one years old; the address given is the same as that recorded for the rest of the Traylor family. The 1910 federal agriculture schedule may have shed additional light on the beginning of Traylor's new life in Montgomery County, but those records were unfortunately destroyed in 1920 or 1921.[60]

About three miles northwest of where Traylor and his family lived on Mobile Road, Orville and Wilbur Wright created a civilian flying school in 1910, the nation's first, on the plantation of Frank D. Kohn west of Montgomery.[61] Montgomery historian Mary Ann Neeley noted that people flocked to see the historic flights that took place there, although the school was short lived.[62] While the Wright brothers brought prestige and commerce to the region with their flight school, the area's cotton industry was beginning to deal with the boll weevil epidemic. If Traylor had been renting land on a cotton farm at the time, the boll weevil scare and the lack of reliable cash crops may have prompted him to stop renting (by choice or otherwise) and seek employment on another farm.

According to a timeline of Alabama available at Alabama Department of Archives and History, Montgomery, the dreaded boll weevil—a pest that feeds on

cotton buds, blooms, and seedpods—arrived in southern Alabama in 1909, having migrated from Mexico via Mississippi.[63] A US Department of Agriculture map charting the spread of the boll weevil in the States between 1892 and 1922 suggests that the beetle had reached only the southern corner of Alabama by 1909 or 1910 and that it had not spread to the Pleasant Hill/Benton area until around 1912. It seems unlikely, then, that the epidemic played a direct or significant role in Traylor's decision to leave the Lowndes County plantation around 1908. An article in the *Colored Alabamian* in the spring of 1913 announced that the bug was expected to arrive in Montgomery sometime that year, so it may not have been in Benton by then either.[64] Regardless of the date it came to the area, the plantations of George Hartwell and John Getson Traylor—which had been heavily into cotton as well as other crops and livestock— were likely hard hit by the plague of beetles when it did arrive. By 1916 it had infested the entire state, resulting in devastating losses of cotton crops, and by 1920 had infected all US cotton crops.

"King Cotton" was a way of life in the Southern states, and Black Belt farms were generally overly dependent on it. In *One Kind of Freedom* (1977), Roger Ransom and Richard Sutch note that the upheaval caused by the epidemic was a revolution of sorts in the South: "[It took] a shock nearly equal to emancipation to jolt the agrarian South out of the routine it followed for the four post-emancipation decades. That shock was the coming of the boll weevil."[65] The degree to which the bug was memorialized in folklore and songs indicates how large a space it occupied in the collective mind of the era. Historians, however, debate the degree to which the boll weevil played a role in the Great Migration, the mass relocation of more than a million African Americans from rural Southern states to the Northeast, Midwest, and West, particularly to big cities.[66] The migration was gradual but marked, beginning around 1910 and continuing through 1930 or later. The agricultural crisis was only one factor among many, but statistically many tenant farmers or day laborers were displaced from their income source by the crisis; for those in need of a new opportunity, the time was right to migrate.

Isabel Wilkerson historicized the exodus in *The Warmth of Other Suns: The Epic Story of America's Great Migration* (2010). She notes:

> The Underground Railroad spirited hundreds of slaves out of the South and as far north as Canada before the Civil War. Later, in 1879, Benjamin "Pap" Singleton, a former slave who made coffins for colored lynching victims and was disheartened by the steadiness of his work, led a pilgrimage of six thousand ex-slaves, known as Exodusters, from the banks of the Mississippi River onto the free soil of Kansas.
>
> In the ensuing decades, a continuous trickle of brave souls chanced an unguaranteed existence in the unknown cities of the North. The trickle became a stream after Jim Crow laws closed in on blacks in the South in the 1890s. During the first decade of the twentieth century, some 194,000 blacks left the coastal and border states of the South and settled in relative anonymity in the colored quarters of primarily northeastern cities, such as Harlem in New York and in North Philadelphia.[67]

FIG. 13 Boll Weevil Monument, Enterprise, Alabama, dedicated December 11, 1919. In 1998 the original monument (shown here) was removed and a replica was installed in its place.

By 1914 the war in Europe was already having an impact on Alabama's cotton industry as manufacturing interests shifted from cloth to weaponry. The United States entered World War I in 1917 and increasingly began to make and supply the Allies with war matériel. Rural laborers found a plethora of opportunities for work. The *Encyclopedia of Alabama* noted that farmers suffered a shortage of laborers, estimating that "more than 150,000 whites and approximately 85,000 blacks left rural Alabama for jobs in the North and in manufacturing centers elsewhere in the South."[68] Wilkerson believed that the war provided many African Americans the chance to earn a better living and do so in a less hostile environment. "The North began courting them, hard and in secret, in the face of southern hostility, during the labor crisis of World War I," she explains.

> The war had cut the supply of European workers the North had relied on to kill its hogs and stoke its foundries. Immigration plunged by more than ninety percent, from 1,218,480 in 1914 to 110,618 in 1918, when the country needed all the labor it could get for war production. So the North turned its gaze to the poorest-paid labor in the emerging market of the American South. Steel mills, railroads, and packinghouses sent labor scouts disguised as insurance men and salesmen to recruit blacks north, if only temporarily. The recruiters would stride through groupings of colored people and whisper without stopping, *"Anybody want to go to Chicago, see me."* It was an invitation that tapped into pent-up yearnings and was just what the masses had been waiting for. The trickle that became a stream had now become a river, uncontrolled and uncontrollable, and about to climb out of its banks.[69]

While having jobs to go to certainly made relocation a viable option, Bryan Stevenson, executive director of the Equal Justice Initiative in Montgomery, asserts that racial terror was the true driving force. "There are very few people who have an awareness of how widespread this terrorism and violence was, and the way it now shapes the geography of the United States.... The African Americans [who came to populate cities in the North] did not come as immigrants looking for economic opportunities, they came as refugees, exiles from lands in the South where they were being terrorized."[70] Stevenson notes that blacks who stayed behind in the South might be best understood as "internally displaced peoples." The transition was arduous, and for some who had only known life in the South, starting over in an unknown place and culture seemed worse than trying to endure.

Alabama outwardly put a noble face on a challenging time, celebrating farmers who faced the struggle head on—even before it had ended. In 1919 the town of Enterprise, Alabama (about a hundred miles from Montgomery), erected a monument to the people's ability to overcome adversity and diversify, with crops such as peanuts (fig. 13).[71] Despite the efforts of cotton farmers who learned, year by year, how to cope with and combat the weevil, Alabama suffered its peak losses in 1950; when Traylor died in 1949, the issue had been part of the landscape of his life for four decades.

Bill Traylor's third known union is better documented than those that preceded it, but only to a small degree. The records pertaining to African Americans are still remarkably shoddy. Numerous theories on Traylor's wives and children have been proposed, but no definitive truth can be substantiated by the extant records. Various accounts have suggested that Bill had twenty-some children, but federal census records show fourteen natural children and one stepchild. The US Census Bureau was established in 1902, but the first census was taken in 1790. The original categories were broad: free whites, all other free people, and the enslaved.[72] Census records with Bill and Elsey cohabitating do not exist, since the 1880 federal census was enumerated in June and they were married that August; only the two later wives/mothers appear on census records.[73] Additional birth mothers and children not indicated as part of his core family may have existed, but such research was beyond the scope of this project.

The 1910 federal census further obfuscates the reality of Bill's family life. As mentioned, Laura's name is given as Larcey, a nickname, and their surname is misspelled as Taylor. Although no marriage certificate exists for the couple, the 1910 census shows they had been married for one year (fig. 14). The notation "M2" indicates that it was not a first marriage but was not meant to specify which number it was; enumerators simply used "M2" for any union subsequent to a first marriage.[74] The census may have overlooked Bill's first marriage to Elsey entirely, or she may be included in this unspecific notation. Genealogists at the Alabama Department of Archives and History suggest that Traylor's "marriage" to Laura was likely a common-law arrangement, and the lack of a license or certificate would not have been unusual. Charles Johnson's research similarly notes such nonlegal unions as commonplace, writing, "The arrangement is one of mutual convenience and desire, and has survived shocks sufficient to provoke permanent separation and divorce."[75] Bill and Laura may have "jumped the broom," a vernacular ritual in which the couple recites vows and jumps over a broom handle, thus uniting them. The practice was sufficiently widespread for the expression to become synecdoche for a wedding ceremony to the present day.

FIG. 14 Page from the federal census of 1910, listing Bill Traylor, his third wife, Laura, shown here as Larcey, who wed in 1909, along with their children (lines 56–66)

Donald J. Waters, who compiled an anthology of late nineteenth- and early twentieth-century folklore from the Hampton Institute's *Southern Workman*, notes that the custom was not entirely about fixing the partnership with family and friends but also about formalizing the event with the heavens and the netherworld. "Black folk dealt with the spirit world through superstition and conjure. The persuasive gesture of jumping the broom took the form of superstition.... Although the wedding gesture was tinged with lightheartedness amid the human audience, it was made before the spirit world with the same seriousness that often impelled Afro-Americans to call upon ritual specialists to persuade, or 'conjure,' spirits in matters of both health and morals."[76]

Regardless of legal certification, Laura was effectively Bill Traylor's third wife, and theirs was the longest of his three known unions. For reasons that might be owed to a similarity of names or fluid households, some Traylor family members believed Laurine and Laura to be the same person.[77] In the research for this project, this possibility has been explored in depth. Ultimately, the 1910 federal census provides a compelling case for their being separate individuals, but without vital records for one or both women, there is no certainty about this point.[78]

For the 1910 federal census, it was Laura who provided the enumerator the list of her and Bill's children and the familial ties identifying them. She was supposed to have described the children's connections to the head of the household, namely, Bill, not to herself. Yet Laura and the enumerator may not have communicated well with each other, as most of the delineated relationships documented here contradict logic.

The enumerator recorded that Laura had six children, five of whom were still living. If that statement is true, then her living children at the time of the census in 1910 would be, logically, Nellie plus the youngest four: Clement, William (also called Will, Willie, and Billy), Mack, and John.[79] The older girls still living in the household, Easter, Alline, and Lillie, then, were not indicated to be Laura's children by birth on this record, despite the name Laura as mother given on some of their records, notably Alline's. The youngest children in the family at that time seem certainly to be Laura's, and it remains unknown if Laurine ever went by "Laura" which could be one possibility for the perplexing records after Laura Williams entered the scene.[80] The identification Laura gave of Nellie Williams as a "step-daughter" (to Bill as head of the household) might be the only relationship noted accurately. Nellie's siblings—or half-siblings—are recorded on the 1910 census as: Reuben (age 17/b. 1892; son), Easter (16/b. 1893; daughter), Aleen (15/b. 1895; daughter), Lillie (14/b. 1896; daughter), and Clement (15/b. 1895; stepson). Three additional children since the prior, 1900 census are noted: William (9/b. 1901; stepson), Mack (7/b. 1903; stepson), and John (2/b. 1908; stepson). Clement, William, Mack, and John have the added last name spelled "Trailor"; their identification as Bill's stepsons seems to be an outright error, although the combination of the added last name and the relationship inconsistencies might indicate some distinction in Laura's mind between these boys and the earlier children.

The variations of Laura's last name, predominantly given by family members, complicate identification of her on census documents. Laura is not an uncommon

name, and the several last names attached to her exponentially expand the possibilities of her identity, which remains opaque. Versions of Laura's surname include Williams, Winston (one alternate spelling of Whinston), Wilson, and Thomas, as well as her "married" name of Traylor. In one instance, on Esther's application for a Social Security number, Laura is listed as Louisa Weston.[81] No Traylor child ever cited their mother as Laurine (or Lorisa) Dunklin. The maiden name most often given for Laura is Williams. Williams may be the name of her first husband (legal or common law). Her maiden name is given as Winston on the death certificates of two of her children and on the Social Security number application of one of them, making Winston the most compelling of the possibilities for her name preceding marriage.[82]

Ultimately, during a time when names overlapped and illiteracy and racism played a role in the inadequate records for African Americans, an absolute narrative for Traylor's wives and children is probably not achievable. Charles Johnson's research on former slaves and their descendants charted various family models of Alabama's Black Belt and described the most common structures in detail. Unsurprisingly, he attests that because women usually had the most control over the children, households frequently comprised a mixture of half- and full siblings as well as extended and added-on (fictive kin) members.

There were other scenarios, however. In many families an elder such as a grandparent was the head of the household, enabling the parents to work. Johnson describes a third established structure as "male heads of transient families with shifting family members." He noted that in such cases: "The male head remains constant while various other types of relationship, including a succession of wives and their children by him, shift around him. The children and wives who fail to accommodate themselves to the pattern drift out and away, or are thrown off while others remain, constituting essentially a family organization."[83] This structure may well describe Bill's family. It offers an explanation other than death for Elsey's and Laurine's departures; it also illuminates the changing makeup of the children residing with Bill regardless of maternal parentage. It is not difficult to imagine why Laurine would have cared for Elsey's children, particularly if the first wife and mother had died. A number of complexities may similarly explain why Bill and Laurine might have taken in a child that wasn't blood kin to either of them, and may have done so on multiple occasions.[84]

Information about Bill Traylor in the mid-1910s is limited. There is some possibility that the family lived in other locations than Mobile Road during that decade. A "Wm Traylor" appears in the 1915–16 Montgomery city directory as a married laborer in a house at 201 James Street (present-day Patrick Street), which is between Hill Street and the Atlantic Coast Line RR and also close to his 1910 residence on Mobile Road. Considering there was another William Traylor living in Montgomery at the same time, it's unclear which one occupied the James Street address.

The facts about Bill Traylor's life in the early and mid-1920s are also scant. By 1920 the Bill Traylor family had moved to rural Montgomery County, where, according to the census that year, they lived and worked on the "Will Sellers Plantation on Selma Road," near where Old Selma Road Park is today. The 1910 and 1920 federal censuses include

information about individual school attendance and/or literacy. Bill and Laura consistently answered no to both. Nellie Williams is also noted as illiterate, as are Will and Mack. The information about education is not always filled out, but the other children seem to have some degree of literacy. Traylor's family lived too far away from the Calhoun Colored School to take advantage of the programming there, but other schools were available for African American children in Montgomery County.

The households as listed on the 1920 federal census convey that the cabins on the Sellers planation were too small to accommodate the whole Traylor family under one roof. It notes that Bill and Laura lived together but were no longer working; the older children are all listed as farm laborers. Bill and Laura were either too aged for physical work, or the Sellerses were able to afford to pay only younger, stronger workers. The same census shows Bill (age 80—an error that adds some thirteen years to his life) and Laura Traylor (50) living with sons Mack (18), John Henry (13), and Plunk (10), whose name might also be read as Roland.[85] Listed as living next door to Bill and Laura are Arthur Traylor (10) and his older brother, Clement Traylor (26). Living next door to them is Kiser Traylor (5) and his older brother, Will Traylor (22).

A few years earlier, Will and Clement had been living in Birmingham. When Will registered for the draft in 1918 he was residing with his sister Nellie in Birmingham, as evidenced by the address listed, although it says his mother, Laura Traylor, is his nearest relative.[86] Clement also registered for the draft in 1918 and noted that he too lived with sister Nellie in Birmingham, listing her as Nellie Thomas, possibly her married name. Clement was listed as unemployed in 1918 when living with Nellie, so by the time of the 1920 census, both older brothers must have returned to Montgomery County with their parents, likely for available work on the Sellers plantation.[87]

Three children accounted for in the Traylor family history do not appear clearly on the 1920 census—Roland, Walter, and James/Jimmie—although the discrepancies seem based on nicknames versus given names. The child "Plunk" on the 1920 census may have had the birth name of Roland (fig. 15).[88] On Walter Traylor's application for a Social Security number and later, his death claim, his birth year of 1914 corresponds with the child called Kiser; family history acknowledges that Walter went by Bubba.[89]

FIG. 15 Page from the federal census of 1920 detailing Bill Traylor's family (lines 56–64)

Arthur is listed as such only on the 1920 census; military records indicate that James Traylor was born in Montgomery on December 20, 1910. Nineteen ten is Arthur's birth year, an indication that "Arthur" may have been Jimmie's birth name.[90] Jimmie's 1940 census information and military records indicate that he lived for a time near his siblings Nellie Mae Traylor Pitts and Clement Traylor in Pennsylvania during the 1940s into the early 1950s, before and after serving in World War II.[91] It's unclear when he moved out of Pennsylvania, possibly after Nellie's death in 1952, but a later family document states that he died while living with his sister, Easter Graham, in Detroit, Michigan.[92]

The "Will Sellers Plantation," as the 1920 federal census erroneously listed it, where the Traylors lived in 1920, was owned by John "J. A." Sellers. The plantation was in rural Montgomery County, and the owner's nephew William Sellers managed it (fig. 16).[93] In urban Montgomery the city directory also listed William as the secretary and treasurer of Sellers & Orum, a cotton warehouse owned and headed by John Sellers and located at 201 Monroe Street, at the corner of North Lawrence. John and William Sellers lived in Montgomery: John on Perry Street, and William in the upscale neighborhood of Cloverdale. Bill Traylor and his family worked and lived on John Sellers's land.

The 1923 Montgomery city directory shows that William Sellers opened another business, the Alabama Feed and Seed Company at 114 Monroe Street. With the plantation supplying products to the city businesses, Bill likely made regular trips into Montgomery to deliver farm goods to the shops. Traylor may have become familiar with the landscape of Montgomery beginning around 1910 while he was living on what was then the outskirts of town and increasingly so later when helping his sons with deliveries for the Sellerses. The black population of Montgomery surged immediately after Emancipation, and Traylor would certainly have known about the black business district many years before he eventually decided to live there. When his children moved on and farm life ran its course, he knew he could make his way there, where people like him were similarly redefining their lives.

William Sellers's Alabama Feed and Seed Company moved in 1925 to 108–110 Monroe Street. By 1929 the business had moved again, this time near Washington Park, close to where Bill and his family had lived on Mobile Road in 1910. In 1930, John Sellers joined William's operation as president, and they renamed the company the Alabama Feed, Fertilizer, and Ginning Company.

Laura Traylor vanished from public record sometime in the mid to late 1920s; she presumably died, although her death record has not been located. Bill's exodus from the Sellers farm around 1927 indicates that Laura's death, perhaps that year, likely precipitated his departure. Laura did not serve as a witness to their son Will's marriage in 1929, and by 1930, records confirm Bill Traylor as a widower.[94] The Great Depression was dawning, and farm produce prices that were already suffering would plummet throughout the coming decade. If employment and Laura had served as the glue that held the household together, the family life that kept Bill rooted on a farm as a laborer had come to an end. No longer a reliable provider, and perhaps deciding

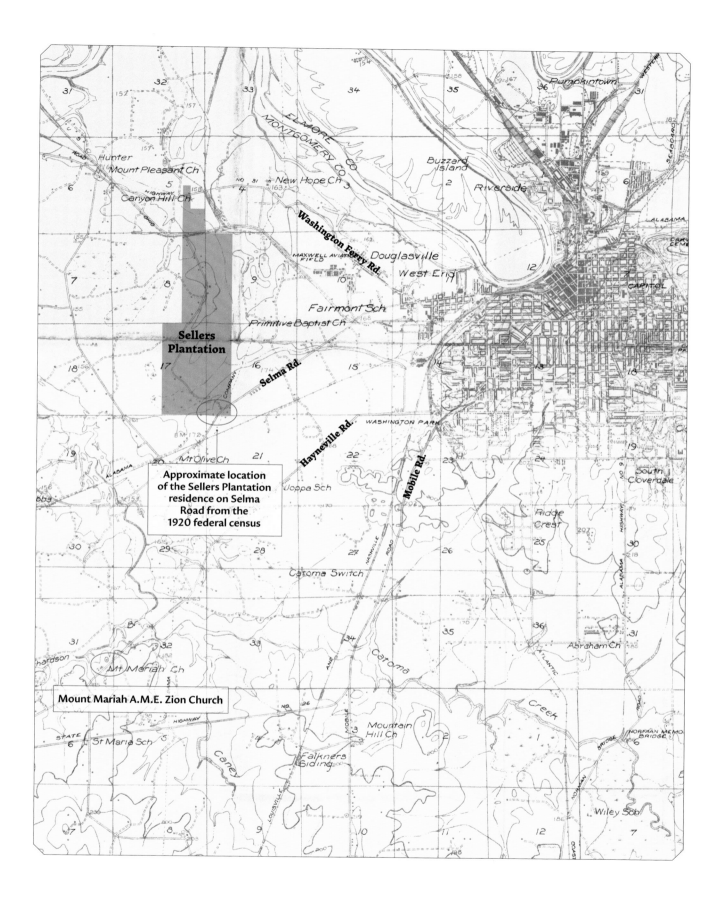

Sellers
Plantation

Approximate location
of the Sellers Plantation
residence on Selma
Road from the
1920 federal census

Mount Mariah A.M.E. Zion Church

FIG. 16 Map showing, in rural Montgomery County, Alabama, the plantation of John "J. A." Sellers
and the church cemetery where Bill Traylor would be buried in 1949 (see figs. 34, 35)

that he could take care of only himself, Bill separated from his children. The youngest, Walter, who would have been only twelve or thirteen, likely attached himself to an older sibling in a northern city.[95]

BILL TRAYLOR IN MONTGOMERY, 1927–1939

Sometime around 1927, Bill Traylor split off from his family and moved alone into downtown Montgomery, Alabama. Even if he was familiar with the city, his move there would have been his first full immersion in a thriving African American community and a radically new and ever-changing urban world. Montgomery was segregated, but leaders within the black community advocated for social and civic allegiance, allowing a relatively insular section of town to become a seedbed for black businesses, music, fashion, foods, and cultural identity. Montgomery would offer Traylor just enough space to develop a remarkable artistic vision—even though it was still a time when personal expression might put his life at risk.

When Traylor first moved into town, he found work and living quarters. By the time the 1928 Montgomery city directory was published, "Wm Traylor" was an unmarried laborer renting 9 Coosa Street from Asa W. Wilson, which makes it likely that Traylor had moved into the city sometime the preceding year.[96] Montgomery had been the center of the cotton kingdom and a major artery in the slave trade and the American wholesale industry during the nineteenth century; by the middle of the twentieth century it would become the center of the civil rights movement. Between those eras it was a city in flux. The history of that interlude is often overlooked. Samuel C. Adams Jr., who studied the acculturation of Southern blacks who migrated from farms to cities such as Montgomery rather than move north, noted, "As the group becomes articulate in its protest against caste or other limitations, the members begin to create its own history and group loyalty."[97]

Jim Crow segregation laws were deeply ingrained in Southern society by the time Bill transplanted himself to Montgomery. The city had not been destroyed in the Civil War as many Southern cities had; in the post-war Reconstruction era in Montgomery, black neighborhoods, businesses, and churches—which often doubled as schools—grew and thrived. It was a prosperous town, welcoming technological advances including the telephone, electric lights, and a groundbreaking electric trolley line.

Montgomery's first courthouse, built in 1822, was near an artesian well at the end of Market Street. Businesses built up around Court Square, and the area continued to be called by that name even after the courthouse was moved in 1852. In 1853 a basin was dug around the well to create a water supply for fighting fires. For some time it remained a fenced basin of water around which vendors would sell their goods. But by the late 1870s the basin had become a trash-filled eyesore, and in 1885 the city purchased and installed a factory-made fountain on the site (see fig. 81, below). The statue featured Hebe, daughter of Zeus and Hera, cupbearer to the gods and goddesses at Mount Olympus.[98]

The 1920s saw a dramatic societal shift as people left the farms and headed to the cities. Years later, in 1992, the Alabama Historical Association honored an African American who made his mark on Montgomery, Victor Hugo Tulane. "Almost penniless,

Tulane came from Elmore County in 1880s, opening a grocery store on [the] SE corner of High and Ripley in 1905 (National Register of Historic Places)." The historical marker at Jackson and High Streets further reads: "While living at 430 South Union, he was cashier at the African-American–owned Penny Savings Bank, as well as a druggist. Served as Chairman of the Board of Old Ship A.M.E. [African Methodist Episcopal] Zion Church, member of Board of Trustees of Tuskegee Institute and of Swayne School, and first African-American honorary member of the Montgomery Area Chamber of Commerce. Died 1931; city honored business leader by naming Victor Tulane Court in his memory, 1951."

A more encompassing history of Tulane would reveal that he had worked his way up from stock boy until he saved enough to buy the grocery store, then another, and then moved into the real estate business. He became a key figure in the expanding black business district around Monroe Street.

Montgomery businesses were predominantly confined to the downtown area. Pockets of businesses were in neighborhoods such as Old Cloverdale, Capitol Heights, and West End, but most of the commercial interests were centered around Court Square, up Montgomery to Five Points, down Commerce Street to Union Station, up South Court Street a few blocks, and up Dexter Avenue for another few blocks. One description notes: "Court Square was the hub of the downtown business area and was rightly considered to be the focal point of activity with everything radiating out from it like spokes in a wheel, with the surrounding residential area some six blocks or so away more or less, representing the rim of a wheel."[99] The Monroe Street Black Business District, Traylor's neighborhood, was sandwiched between Dexter Avenue and Monroe Street, connected by North Court, Perry, Lawrence, and McDonough Streets.[100]

An account of Monroe Street from 1958 describes the area. Although written years after Traylor lived there, it evokes a similar scene:

> It still caters to the earthy side of life and any man, black or white, with two bits in his pocket is not scorned by those there engaged in trade. The fruit wagon, the shoe shine stand, the gunsmith, the fish market, the seed merchant, the tavern, the second-hand clothing man, the vendor of patent medicines and the pawn shop keeper were doing business on these blocks in 1895 and are doing business there today. Gone are the barkers and gone are the mules and wagons, and gone are the days when the gamblers kept their women in the upper stories and cotton was king and Monroe Street on a Saturday was a sight worth seeing. . . .
>
> Although the sophisticated of the colored gentry have always done business there . . . it was the country negro and his hard-earned money that for many years sustained the raucous life of Monroe Street. There they gathered each Saturday shouting excited greetings, with the big-eyed children tagging behind their mamas and papas. There the smell of fried fish, pig tails and pig ears permeated the air with an odor ten times as agreeable as it sounds. . . . It has been and is a place of contrast.[101]

A short film Rudy Burckhardt made in 1941, nearly twenty years before the above account, shows the neighborhood in Traylor's day.[102] Even then, the mules and carts

that once dominated the streets had given way to an urban shopping district. The film captures black and white Americans walking through the area in smart attire, carrying packages and toting children while cars and busses fill the streets. Brief glimpses of the Pekin Pool Room and the neighboring business are caught on the film, as is the Coca-Cola cooler Bill sat by (see below, figs. 38, 41, 45, 47).

While the neighborhood was originally a place where African Americans could get an economic foothold, segregation laws unintentionally lent a hand. Black people were increasingly standing together. Civic leaders encouraged black Montgomerians to boycott white businesses and either patronize within the black business district or start businesses of their own. Segregation laws were meant to keep the black population on the lower rungs of society, yet since the Civil War ended, black citizens in Montgomery and across the country had been rising into the ranks of the middle class. Photographs of the Dexter-Monroe corridor in Montgomery from the years Traylor lived there are scarce, yet the black-owned and -operated newspapers advocating for self-reliance evoke a powerful picture of a rising culture.

From 1907 to 1916 the *Colored Alabamian*, which was published out of the home of the Reverend Robert C. Judkins at 105 Tatum Street, was the only "negro" paper in Montgomery. With "Equal rights to all, special privileges to none" (inspired by Thomas Jefferson's "Equal rights for all, special privileges for none") as its tag line, this weekly Saturday periodical promoted the education and advancement of the black population in Jim Crow Alabama. Prominent black scholars and members of the National Negro Business League contributed regularly with the express goal of raising awareness, fostering community, and encouraging young African Americans to play an active role in shaping their world. The paper lambasted the propaganda of disenfranchisement, mob violence, lynchings, and police brutality; it supported unity, literacy, and the rise of black businesses and promoted events at local churches and lodges.

When Reverend Judkins left Montgomery in 1916 to preach in New Jersey, his paper shuttered. But the following year *The Emancipator* (with J. Edward McCall as chief editor and W. J. Robinson as general manager) reopened in an office at 116 North Court Street. From 1918 through its demise in 1920, the newspaper was located at 411 Dexter Avenue. Its mission statement appeared under the title, nestled between images of Abraham Lincoln and Booker T. Washington: "This publication is dedicated to the colored people of America, and to all other peoples fettered by visible or invisible chains. The emancipation of the Negro has only just begun. We have been freed from the bondage of iron chains, but this is only one step in our emancipation. We are still bound and enslaved by the invisible shackles of poverty, illiteracy, sin, sickness and human injustice; and the aim of *The Emancipator* is to help us as a race and as individuals to free ourselves from these chains."[103]

Much like its predecessor, *The Emancipator* pushed African Americans to educate themselves, boosted black-owned businesses, and reported on national concerns such as legislation and lynchings. Articles, advertisements, and pictures of prominent business owners graced its pages. Images of R. A. Ross and W. M. Clayton, who would

soon open the Ross-Clayton Funeral Home, first appeared in June 1919.[104] The paper relayed stories from the North, where cities such as Pittsburgh and Detroit had passed equal rights laws and discussed how the migration of Southern blacks to those cities had impacted Alabama. Perhaps not coincidentally, some of Traylor's children moved to those cities around the same time. The paper is a snapshot of the day, with advertisements by local business owners, movie listings from the Pekin Theatre, weekly menus at the Walker Café, and a calendar of music shows, from W. C. Handy's band to the Negro Folk Song Festival.[105]

Before the advent of broadcast radio, people's exposure to music came from live concerts and phonograph recordings. Ragtime, Dixieland jazz, and the blues were all relatively new forms of music, and record labels such as Okeh and Paramount were producing so-called race records with great success. In November 1920 the first commercial radio station powered on in Pittsburgh with a listenership of almost a thousand people.[106] Two years later roughly five hundred stations, including two in Montgomery, WGH and WKAN, had been licensed in America.[107]

Radio was the rage, but networks were not yet completely in place. Many rural areas still didn't have electricity, so exposure to radio happened only on trips to town. It wasn't until the Rural Electrification Act was passed in 1936 as one of President Franklin D. Roosevelt's New Deal programs that the farther reaches of the country were able to enjoy radio entertainment in their homes. Shows of local origin were popular, and Sunday afternoons were reserved for dance orchestras to flaunt their skills. WSFA radio station, which had been started in 1930 by Howard Pill and Gordon Persons (who later became governor of Alabama), was located on the mezzanine floor of the Jefferson Davis Hotel in downtown Montgomery, which offered the station its facilities.[108] It was at this radio station that singer-songwriter Hank Williams launched his career. Although the hotel remained segregated well into the 1960s, African American preachers, including Rev. Ralph David Abernathy and Rev. Dr. Martin Luther King Jr., were allowed into the studio to broadcast Sunday-morning sermons.

Within a few years of Bill's new life in the heart of a thriving black community, his son Will was killed.[109] Will had seemed to be struggling in work and marriage; he was not staying employed, and his family life likely suffered. In Birmingham, Will had lived with his sister Nellie before rejoining Bill and Laura, according to the 1920 federal census, at the Sellers farm. He and the mother of his three children, Mimmie Calloway, may have lived alternately in Birmingham and Montgomery before they formally married on April 3, 1929, in Birmingham.[110] The marriage was brief, however, as Will was felled by the Birmingham police just over four months later.

On August 26, 1929, the *Birmingham Post* headline read: "Negro Burglar Is Slain at Home in West End." Bill Traylor identified the deceased as his (and Laura's) son Will, who had been residing at 1109 3rd Alley North in Birmingham. The newspaper article asserts that the police fatally shot a negro intruder who was attempting to break into a West End home at one o'clock in the morning by picking a door lock with an ice pick. "According to officers, the negro thrust his hand into his pocket as soon as he found that he was discovered. Believing that he was reaching for a gun, [officers] Justin and

Walker fired. When he was searched by the officers, a pistol and a flashlight were found. The negro was discovered before he made an entrance to the home....A verdict of justifiable homicide was returned after an investigation by Coroner Russum."[111] Will's death certificate noted that he was twenty-eight years old, "colored, unemployed, and married." Cause of death: "Gunshot wound of left chest (Homicide)."[112] The officers asserted that they were on a patrol when they found and killed Will, and that their actions had closed a spate of burglaries in the neighborhood. The "investigation" and the "verdict" came on the same day that Will died.

Law enforcement in Alabama was unquestionably on the side of white society. Decades later, Eugenia Carter Shannon would write, "Although the Ku Klux Klan was not as politically powerful in the United States as it had been in the 1920s, [in the 1930s] it was still entrenched in positions of influence in the South. Montgomery was no exception. Some Montgomery law enforcement officers were known to be, if not Klansmen, supportive of the Klan's racist activities and very hard on black citizens."[113] After the resurgence of the Klan in 1915, membership surged in Alabama during the 1920s.[114] Seemingly upstanding members of the community—lawyers, newspaper editors, doctors, and others—believed that white supremacy was a valid societal standard.In September 1929 field secretary for the National Association for the Advancement of Colored People (NAACP), Robert W. Bagnall, wrote an article called "The Present South." In it he stated, "But it is 'the magic city' of Birmingham that holds the prize for terrorism. There police and courts are run by that order of thugs—the Ku Klux Klan. Without provocation police shoot Negroes so frequently there, that it is no longer news....An aura of fear that presses on one like a black cloud surrounds Negroes in this city."[115]

The Great Depression had taken hold of the nation by the time the 1930 federal census was recorded. It shows Bill as a seventy-five-year-old widower residing at a boardinghouse at 59 Bell Street, between Catoma and Goldthwaite, paying six dollars a month in rent and working as a shoemaker in the employ of a private business owner.[116] The residence seems to have been unsegregated, as a white engineer, Irving Tinsley, is listed there as well.

It's difficult to assess when Bill Traylor stopped earning a regular paycheck and could no longer afford rent, but between 1931 and 1944 he was not listed in the city directory. The 1935 directory notes that Sol Varon, a known associate of Traylor's, owned a confectionary shop on North Lawrence Street and a grocery store on Monroe Street. It also shows another person Traylor knew, Jesse Jackson, living at 111 ½ Monroe Street and working as a watchman for the Ross-Clayton Funeral Home, the location of which is given as 111 Monroe. In 1987 independent historian Betty Kuyk interviewed David Calloway Ross Sr., who remembered Bill Traylor from this era. Although no year is specified, Ross recalled, "I saw him with papers and things. He always carried a bag with him. He was a good sitter. He could sit quiet and say nothing. So I didn't quiz him. I figured he didn't want to hear that noise." Ross told Kuyk, "It was [a] hard time in those days—the Depression."[117]

Ross explained that the family-run funeral parlor was open all night, and because they kept a fire burning the police asked them to let people like Traylor come

in to sleep where it was warm. He remembered Traylor as poor but independent. He also recalled that Traylor had children from far away, daughters from Detroit and Pittsburgh, who would visit.[118] They would find Bill and take walks with him when they came to town. Ross knew Traylor had another daughter in town who he didn't want to live with.

The name Jesse Jackson came to light through this conversation between Ross and Kuyk, when Ross informed her that another man from Lowndes County had hung around with Bill and he, too, slept at Ross-Clayton. According to Ross, Traylor used to yell in his sleep, plagued with bad dreams. "I heard him hollering in his sleep, so I asked Uncle Jesse Jackson if he knew what was happening. And he said that Traylor murdered a guy long ago, and it came down heavier on him every year."[119] If Traylor did indeed commit murder, or had a hand in someone's death, it may well have become a burden on his soul; equally likely though, is that it was the execution of his son, by the Birmingham police, that caused him such lasting anguish. While the idea that Bill Traylor may have killed someone is striking and, if true, may have played an important role in his subsequent imagery, it remains hearsay, first relayed almost fifty years after Bill's alleged sleepless nights at the Ross-Clayton Funeral Home, and cannot be presumed as fact. Given the violence that Traylor undoubtedly witnessed over a lifetime in the Deep South, any number of events could have plagued him and account for the prevalence in his images of raised hatchets and cudgels and attacking dogs.

Economically, Montgomery was better off than some places in the United States in the 1930s. "Most citizens of both races had relatives or friends on farms nearby with whom they could barter for food," Eugenia Carter Shannon recalled. "People of every class fished the Alabama River and the many creeks that flowed into it. Plentiful wooded areas provided wild game to supplement meager budgets. Even young city boys became proficient at shooting edible birds with sling shots made with strips of rubber from old bicycle inner tubes."[120] She added that food was easier to come by than money, though. The payrolls of the state and the local airbase, the present-day Maxwell Air Force Base and Gunter Annex, were relatively stable, but small businesses and employees in the city had a harder time.

The site of the Wright brothers' short-lived flight school, built on Frank Kohn's cotton field in 1910, had become a repair facility for small airplanes during World War I and a supply depot (named Maxwell Field in 1922) through most of the 1920s. The site was slated for closure after the war, but Congressman J. Lister Hill, who joined the US House of Representatives in 1923, recognized its historical significance and economic potential for the Montgomery area, and he partnered with Montgomery leaders to secure federal funds to salvage the venue.[121] Maxwell Field entered its "Pre-War Golden Age" when the Air Corps Tactical School of Langley, Virginia, was relocated there in 1931.[122] The program brought a massive expansion of the airfield; administrative buildings, hangars, and living quarters were built to serve the school.[123]

Race relations remained tense, and they worsened in late March 1931 when nine black youths were falsely accused of raping two white women on a train near

Scottsboro, Alabama. The boys had been riding the train illegally, looking for work or food. They were apprehended, quickly tried, and convicted; eight were initially sentenced to death, and the youngest, a twelve-year-old, to life imprisonment. The American Communist Party, which was active in an anti-lynching campaign and combatting racism and economic exploitation, took on their case, bringing it national and international prominence.

George H. Traylor's grandson John Bryant Traylor married Rosa Lyon in 1935, the same year President Franklin D. Roosevelt established the Works Progress Administration (WPA), a New Deal agency that created public projects to provide work for people during the Great Depression.[124] Unlike preceding presidents, Roosevelt didn't believe that economic depressions simply needed to run their course but rather, the federal government should act to save struggling business, industry, and agriculture. Between 1935 and 1943 the WPA employed millions of Americans, including a great number of artists, musicians, and writers. Another New Deal agency, the Social Security Administration, was established in 1935 as social welfare program to help support senior citizens.

Relief agencies were becoming part of the American landscape. The Resettlement Administration (RA) was created in 1935 to offer emergency relief for migratory workers, sharecroppers, tenant farmers, and impoverished landowning farmers. America suffered from crop surpluses, and farmers often couldn't sell what they had. The RA, part of the US Department of Agriculture, in 1937 was folded into the Farm Security Administration (FSA); it would become best known for fostering a program

FIG. 17 Application for Social Security number for Bill Traylor, filed in 1937

FIG. 18 John Engelhardt Scott, *Montgomery Shoe Factory at 105 South Court Street in downtown Montgomery Alabama*, 1960. Alabama Department of Archives and History

to document America during the Depression through photography and writing. In her insightful essay "Going Urban: American Folk Art and the Great Migration," Lynda Roscoe Hartigan observed, "Coincidentally, just down the street from the FSA's Montgomery County headquarters, Traylor created an intriguing parallel to the photographs that were federally commissioned to document the state's rural and urban culture."[125]

Derrel B. DePasse and Miriam Rogers Fowler both found that Traylor "went on welfare under the Old Age Assistance in Montgomery County on February 6, 1936."[126] The address he gave for the welfare application was 111 Monroe Street, listed in the 1936 city directory as a funeral home. Traylor was awarded a subsistence sum of fifteen dollars per month, which would have kept him fed at a time when diner meals could be had for about fifteen cents. In 1937, Traylor applied for and received a Social Security number (fig. 17). Jesse Jackson was still residing at 111 ½ Monroe Street above the funeral home where he worked, according to the 1937 city directory.[127]

Around the same time, a high school boy named Jay C. Leavell began working at J. J. Newberry's five-and-dime on Dexter Avenue near Court Street, making display signage and working the lunch counter for his brother Billy, who was the manager. When Jay was about thirteen, he had started painting signs in response to a community need. Store owners wanted hand-painted signs done directly on the window glass in water-soluble poster paint, to put up the day's specials or prices.[128] Jay wrote about staking out the territory of downtown Montgomery; he would do the signs for certain businesses, while another young sign painter did them for others. By the mid-1930s, Montgomery businesses accommodated a third man into the market.[129]

Leavell would later write a series of essays about the Montgomery of his youth. "Another tendency of the times was for business people to have breakfast downtown, and here again the lunch counters, especially in the Five & Dimes, were usually filled," Leavell recalled of the 1930s.

> While the store itself did not open until 9 o'clock, the lunch counter opened for breakfast at 7 o'clock, and the side door nearest Klein's was opened at that hour.... Quite often I would leave the house about 6 o'clock in the morning and walk to town, and would either complete some display work or window trimming which needed to be done before the store opened, or often I would help behind the lunch counter.... I recall at Newberry's you could get one egg (any style), a slice of bacon, grits, toast or biscuits, and a cup of coffee for 15 cents.[130]

By 1939, Jesse Jackson had disappeared from the Montgomery city directory, and the Ross-Clayton business relocated to 518 South Union Street.[131] Although Bill was seemingly unemployed after 1931, he may have been bartering for room and board at the shoe shop where he had once worked. No records verify which shoe repair shop employed Traylor, but researcher and longtime Montgomerian Marcia Weber has identified two likely possibilities. The Brenner family owned the Montgomery Shoe Factory located on South Court Street near Washington Street (figs. 18, 19). They lived

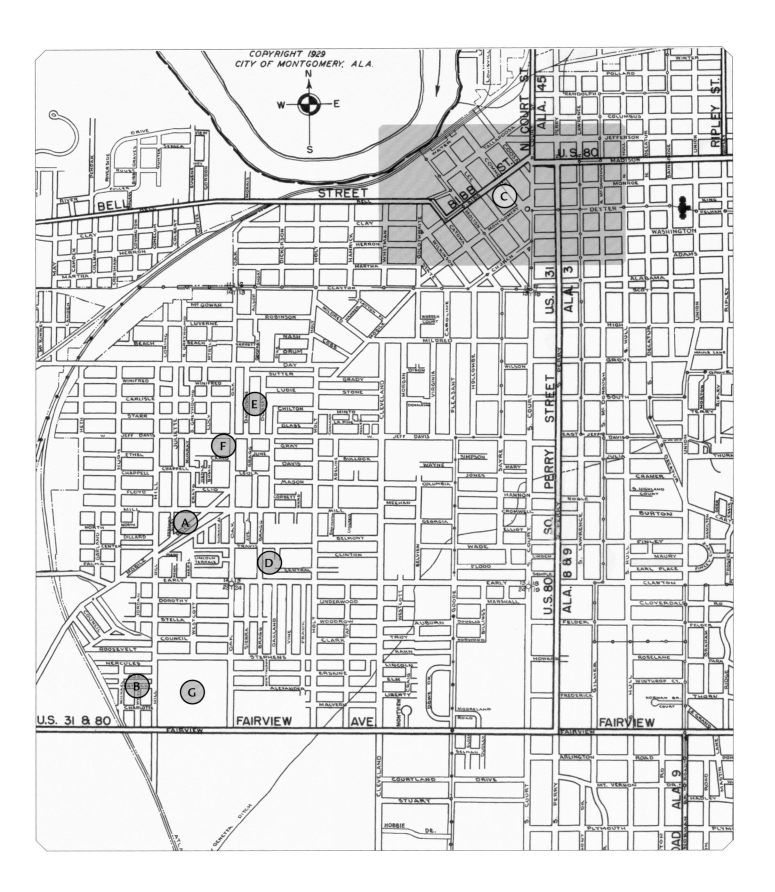

FIG. 19 Map of Montgomery, Alabama, in 1929, a year or two after Bill Traylor moved there, showing places where Traylor resided and other pertinent businesses and locales

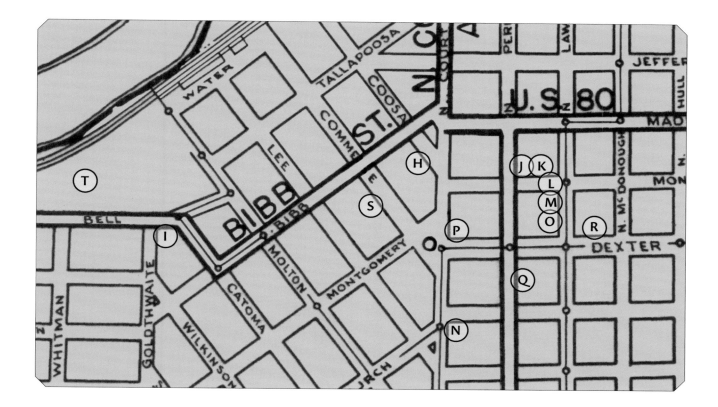

KEY TO MAPS

Facing page:

A · (1910) Mobile Road*

B · (1915–16) James Street (now Patrick Street)*

C · (ca. 1927–45) Downtown Montgomery (see detail, above)

D · (1945–49) 154 (later 314) Bragg Street

E · (1947) Fraternal Hospital on Dorsey Street

F · (1949) Oak Street Hospital

G · (1944, 1949) City of Saint Jude / Saint Jude Catholic Church

*The addresses Traylor occupied before 1927 or 1928 were not yet within the city limits of Montgomery, which expanded sometime around 1926.

Detail, above:

H · (1927–28) 9 Coosa Street

I · (1930) Boarding House, 59 Bell Street

J · (ca. 1936–39) Ross-Clayton Funeral Home, 111 Monroe Street (Ross-Clayton Undertaking Co., ca. 1923–30)

K · Jake Smith Blacksmith and Welding Shop, 115 Monroe Street

L · Pekin Pool Room, 124 Monroe Street

M · Sol Varon Fruit Stand, 27 North Lawrence Street

N · Montgomery Shoe Factory

O · Liberty Shoe Repair, 25 North Lawrence Street

P · J. J. Newberry's, 5–9 Dexter Avenue

Q · Perry Winkle Café, 19 South Perry Street

R · (1939) New South Gallery, 207 ½ Dexter Avenue

S · (1940) New South Gallery, 24 ½ Commerce Street

T · (ca. 1942–44) Unnumbered shanty between Bell Street and the Alabama River (site of former used-car lot and hobo encampments)

at 118 North Goldthwaite Street, near Bill's Bell Street boardinghouse, where they may have met him.[132] The other business that may have employed Traylor was the Liberty Shoe Repair Shop at 25 North Lawrence, owned by Joseph Linahan and next door to Sol Varon's confectionary.[133] Margaret Traylor Staffney once recalled that her grandfather also sold pencils for a time in the late 1930s, which may have been when he first had the opportunity to draw.[134] Around the same time, Leavell graduated from high school and opened a sign and display shop at the rear of his brother Billy's new cafeteria, the Perry Winkle Café on South Perry Street, a couple of blocks from where Bill Traylor was spending most of his time, outside the Pekin Pool Room.[135]

1939

The year 1939 is often where the history of Bill Traylor starts, even though he was by then around eighty-six years old. That spring or summer, some white Montgomery artists who had started a small coalition called the New South, with a school, and gallery, noticed Traylor. Two New South members, painters John Lapsley and Charles Shannon, gave different accounts of how they came to meet Bill Traylor. Lapsley explained that a student of theirs knew him first: "It was that boy, [Jay] Leavell, who told us about Bill [Traylor]."[136] Newberry's five-and-dime, where Leavell worked, had a door that opened onto Monroe Street, and Leavell likely encountered Traylor there on numerous occasions. Other accounts concur that Leavell had first met Traylor around 1938 when he brought food and goods to some of the homeless men in the neighborhood.[137]

The New South members took great interest in Traylor: an African American man making art dovetailed with their concern with issues of social justice, and over the coming years they all played a role in supporting Traylor. Lapsley recalled that when he first encountered Traylor drawing, the works Traylor was making were crude renderings of single objects or animals, such as a cat or rat. He described New South's attention to Traylor as genuine, but he conceded that it was also a "product of the times," wherein white liberals were eager to idealize the image of a humble "negro" artist.[138]

In 1988, looking back at that period, Shannon would assert that the marks he saw Bill Traylor make on a piece of cardboard one day in the spring or summer of 1939 were perhaps the first the artist had ever made. "Using a little stick for a straightedge and holding a stub of a pencil in his big hand, he was completely engrossed in making clean, straight lines."[139] Although it was Leavell who noticed and met Traylor first, it was ultimately Shannon who took the lead in visiting Traylor and collecting his art thereafter. Some four decades would pass from Shannon's first encounter with Bill to his initial recounting and recording of those early memories around 1979. Yet the information Shannon provided about Traylor comprises the most significant eyewitness account on record; other stories came from David Ross Sr., fellow New South artists and their spouses, and several members of Bill Traylor's family.

Importantly, however, Traylor's art would never have made the impact it ultimately did were it not for its own power and originality. Discovery stories such as Shannon's have been enduringly popular for their über-narrative of the hero and

the poor soul, the empowered and the oppressed. Yet, as Lapsley noted, such accounts are woven around a core that best serves the savior and those who consume the story. The capacity and vision so vividly evidenced in Traylor's art drew on the eighty-six years that had informed it, and its immediacy conveys the stark contrast between the many decades of his life lived before he reached Montgomery and the years he was experiencing in the Montgomery of the 1930s. His drawings would address the quotidian and the nightmarish with equal aplomb; they embody a life poised on a tightrope bridging disparate worlds.

THE NEW SOUTH ARTISTS' COLLECTIVE, MARCH 1939–FEBRUARY 1940

Charles Shannon had initiated the artists' collective known as New South in March 1939, not long before Jay Leavell introduced him and John Lapsley to Traylor.[140] In addition to Shannon, the other charter members were Jean and George Lewis, Blanche Balzer (who would become Shannon's first wife), Mattie Mae Knight and Paul Sanderson (who would later marry), and Emily Chilton (figs. 20–23).[141] Jean Lewis

FIG. 20 New South members Mattie Mae Knight (Sanderson) and Paul Sanderson *(at left)* with George Lewis and Jean Lewis *(at right)*, ca. 1939–40

FIG. 21 Blanche Balzer and Charles Shannon *(back row center)* with other, unidentified New South members, ca. 1940

would recall: "We became attuned to the fact that there were local organizations in Montgomery for music and theatre but none for painting. There was no place for an artist to exhibit in the city except for the back room of Pauline Arrington's bookstore on Perry Street. We decided something should be done about it."[142]

On March 15, 1939, the original group drafted a formal constitution with a preamble and twelve articles.[143] They determined to add members to form a board of ten with an additional advisory group. A call for membership went out, and Leavell was among the incoming recruits.[144] The group had extraordinary aims that included running an art gallery, a theater, a store for books and art supplies, a reading room

FIG. 22 New South members John Lapsley and Blanche Balzer *(back row)* and Mattie Mae Knight (Sanderson) and Paul Sanderson *(foreground)*, ca. 1941; photograph by Jean and George Lewis

FIG. 23 Charles Shannon *(far right)* with Blanche Balzer *(center right)* with unidentified acquaintances

and reference library, and a music-listening area, and offering art, writing, and music-appreciation classes, lectures, and discussion groups.

In June 1939 the New South members rented a space at 207 ½ Dexter Avenue in downtown Montgomery.[145] The *Montgomery Advertiser* praised an exhibition of contemporaneous ceramics called *Shearwater Pottery from Mississippi* and Lapsley's paintings. "New South is carrying out its ideal of encouraging production by Southern artists and craftsmen, and acquainting Montgomery and the South with its living arts and crafts."[146] At the end of June they mounted a second exhibition, *The Growth of Corn*, described by Miriam Fowler as addressing the environment and respecting the food chain.[147]

By fall the New South group had moved to its second and final location on the third floor of a commercial building at 24 ½ Commerce Street and started to expand the organization.[148] "It was like a revolution," Lapsley noted. They had volunteers to keep the gallery open for sixty hours a week, and the art supply/book store was making some money. Shannon and Lapsley taught life drawing; Crawford Gillis, painting composition; George Lewis, music appreciation; and Paul Sanderson, English literature. They began a newsletter (sold for a dime) that featured both black and white authors, and saved on costs by printing many of their pieces on brown wrapping paper.[149]

Charles Shannon painted a larger-than-life mural depicting Bill Traylor drawing (fig. 24), and Lapsley painted an adjacent mural of a kneeling black man breaking the chains that bind him.[150] Mattie Mae Sanderson later recalled that the impact of the murals was powerful, but the paintings were not entirely popular: "They took up one side of the building on Commerce Street. People in Montgomery didn't like the murals. You see, it was a new idea to people in the South—we were kind to the Negroes. A lot of people thought it was Communistic."[151]

New South continued to raise the hackles of some Montgomery locals with its cutting-edge sociopolitical work. Looking back upon that era years later, Eugenia Carter Shannon would note that whites thought to be sympathetic to the plight of blacks were regarded as "traitors to the white social order" and often despised more than black people themselves.[152] The life drawing classes that Shannon and Gillis held also threatened the Southern status quo. Gillis, who was heavily influenced by the political murals of Mexican artists such as José Clemente Orozco, mounted an exhibit in November showcasing twenty-six of his works, which was not well received. Jean Lewis explained, "Nobody confronted us. That would not be Montgomery's way of handling things.... The expression 'don't go near' would be used.

FIG. 24 Charles Shannon working on his mural of Bill Traylor at New South Gallery, 24 ½ Commerce Street, Montgomery, 1939; photograph by Jean and George Lewis. Courtesy Caroline Cargo Folk Art Collection (Cazenovia, NY)

And it happened. In some areas we were being dropped socially. We were being dropped from what my mother would call her 'visiting list.'"[153]

Shannon, Gillis, and Lapsley all had New York training and exposure and believed progressive ideas could carry forth in the "new South." Shannon had an overt interest in black rural life in the South that had grown after art patron Leonard Hanna Jr. invited him to visit New York and introduced him to such cultural luminaries as composer Cole Porter and photographer Carl Van Vechten (fig. 25).

In his essay "High Singing Blue," Phil Patton describes Van Vechten as the "central figure in encouraging white intellectuals to look to black music," an interest the photographer and Shannon shared as they visited Harlem jazz clubs in the late 1930s. And "Shannon was far from alone in this appreciation," Patton wrote. "As Ann Douglas shows in her recent study of modernism in New York, *Terrible Honesty: Mongrel Manhattan in the 1920s*, African American culture was as fascinating and exotic to the American modernist as things 'Oriental' had been to the European romantic. Black culture seemed powerful, primal, and above all undiminished by the paralysis of self consciousness."[154] The writer and folklorist Zora Neale Hurston had her own term for white people—be they sincere humanitarians or tourists—interested in the social uplift of blacks: "Negrotarians."[155]

By all accounts, Shannon was earnest in his appreciation of black art and culture and in his desire to help Traylor, even if an inherent paternalism marked his engagement. Jean Lewis noted that in Montgomery at that time, there was no such thing as a natural social relationship between blacks and whites. "The casual interaction common among whites just didn't come up inter-racially. It took an effort and a purpose."[156]

Lapsley believed black culture was a common interest of the New South members, recalling that they all enjoyed listening to black jazz and Billie Holiday. But he also recalled never seeing a black person at New South; Jim Crow laws were inflexible. Ann Fowler, who interviewed several New South members while researching the organization, noted that New South interest in black issues was taken to be genuine, and the inclusion of two of Shannon's paintings in Alain Locke's book *The Negro in Art* (1940) indicated that support from white artists was important.[157] The biography of Shannon in that book described him as "one of the liberal

FIG. 25 Carl Van Vechten, *Charles Shannon*, June 2, 1938. Beineke Rare Book and Manuscript Library, Yale University

Southern regionalists, with a sense for both the comedy and tragedy of the Southern scene."[158] Locke noted that white artists' paintings of black subjects "run counter to the barriers and limitations of social and racial prejudice."[159]

In spite of the initial zeal, the New South was short lived. In February 1940 the group mounted its last exhibition, *Bill Traylor: People's Artist*.[160] The title took inspiration from a 1938 exhibition at New York's Museum of Modern Art, *Masters of Popular Painting*, and the accompanying catalogue essay by Holger Cahill, "Artists of the People." Shannon was aware of art-world interest in so-called modern primitives and hoped Traylor might be similarly received. He recalled that the gallery walls at Commerce Street were painted a light blue, but many other colors could be seen through the peeling layers. The exhibition drew from the works that Shannon had purchased from Traylor in the time he had known him—the better part of a year. All the New South members pitched in to hang the show and make a small booklet (fig. 26). Shannon estimated there were about one hundred works in the gallery; Jean and George Lewis photographed the installation.

The unsigned booklet essay has been attributed to Shannon. Jo Leavell, Jay's wife following the New South era, noted that her husband did the publicity and the catalogue's art reproductions, using his sign-painting and silkscreen knowledge.[161] The essay drew on what Shannon knew about Traylor at the time; many erroneous biographical facts about Traylor that have come down to us, including his place of birth and the amount of time he had lived in Montgomery, are rooted in the exhibition booklet. The essay simultaneously exalted and romanticized Traylor's art, noting "Bill Traylor's works are completely uninfluenced by our Western culture. Strictly in the folk idiom— they are as unselfconscious and spontaneous as Negro spirituals."[162]

By the early 1940s, Traylor had difficulty getting around and walked with two canes. Shannon described taking Traylor to visit the exhibition, noting that it took

FIG. 26 Exhibition booklet for solo show *Bill Traylor: People's Artist*, New South Gallery, Montgomery, Alabama, February 1–19, 1940. Smithsonian Libraries, Washington, DC; donated by the family of Joseph H. Wilkinson

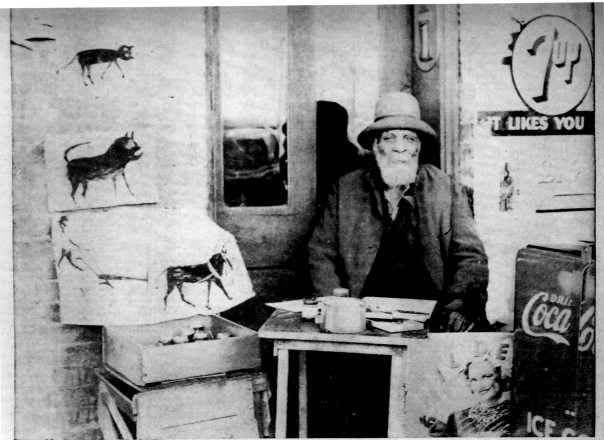

Here sits Uncle Bill Traylor and here he paints his Impressionistic Images

The Enigma Of Uncle Bill Traylor

* * * * * * * * *

Born A Slave, Untutored In Art, His Paintings Are Reminiscent Of Cave Pictures---And Picasso

SCHOLARS and art critics will never come beating a path to Bill Traylor's door. That for the most obvious reason. He has no door.

The 86-year-old negro, a former slave, coal black, and gray bearded, says he left a cabin on the George Traylor plantation in Lowndes County when he was "about sixty-five." That, he claims was his last stable home.

Today, he sleeps in the 10-foot floor space allowed him at Ross-Clayton Undertaking establishment. The end-on-end coffins are shuffled aside to make room for his dingey pallet. This article and his twice patched pipe are his most necessary possessions.

Art, that often overestimated thing which has brought lesser figures than Bill Traylor into temporary limelight, comes third with the old negro, or not at all when he doesn't feel up to it. Art is too new with him to give his ancient pipe dreams even sporadic competition.

Matter of fact, give Traylor an old box top, the kind he finds in the gutter, with a couple of blue and green crayons and an orange thrown in and he's as happy as a child with a new drawing outfit.

Because He Liked It

That, he will tell you himself, is why he happened to start drawing at the age of 85. He liked it. It was something to do. To keep from "sitting around" a Lawrence Street negro pool room all day, he tried "sitting around" the same with a piece of cardboard in his lap. Pretty soon that cardboard had crayon scratchings on it and the scratchings turned out to be pictures.

That's where Traylor came in. Some Montgomery critics started calling him an artist, and not without cause.

Unconscious of his doubtful achievement, Traylor had arrived at an uncouthness in personal appearance that might have done justice only to the most ambitious strivings of the darkest Bohemian in Greenwich Village. It was one day last Summer. The tattered negro sat "passing de time" on his stool in front of the poolroom. He had his pictures in his lap. A young artist passed.

"What have you there?" said the artist—or words to that effect.

"Pictures," grumbled old Bill.

The artist went away, but already he was determined to come back and take another look. The pictures he had seen were fantastic things. At first glance, they resembled the crayon scratchings of a three-year-old child. On second thought, they became

something else.

There was a definite art to this stuff, the young man had decided. There was something almost fiendishly grotesque about these sprawling flat figures of cats, and chickens, and men.

In a Cave in Africa

Oh, yes, of course! He had seen similar things before! They were almost identical to the figures found drawn in certain caves in South Africa about thirty years ago. The figures had been left on the cave sides by a group called for lack of a better name, "The Cave Artists!"

But how and why, the artist was asking himself, did the drawings of this ex-slave named Traylor, resemble the cave drawings, now considered works of art? He went back and asked Traylor. Traylor shook his head, puzzled. Not only did he not know how came the resemblance, but he had never heard of the cave artists . . . naturally, nor of any other artists.

The young man told Traylor he had composition and technique. Where had he studied? . . . Who had taught him the rudimentary principles of art?

Again the negro shook his head, not understanding. These were just pictures. He was drawing them because he was bored. And why did he start all his figures with a square block, and then shade in the curves and muscles as he saw fit? . . . Well, that just seemed like the way to do it.

How Should He Know?

After all, queried the old man, how should he know how? He hadn't been doing that sort of thing more than six months.

That it was ultimately put across to Traylor, was precisely not the point. The point was that without study of any kind, without even looking at other pictures, he had done spontaneously what artists in the modern school were learning to do only after years of hard work and more laborious instruction.

The artist who discovered Traylor was a member of that group self-styled "The New South." Moreover, he soon discovered that fifty cents would

buy half a dozen or so of Traylor's fantastic figures.

Today, the walls of the "New South," in a room three flights up on Lower Commerce Street, are literally staring with four-eyed sprawling cats; whirling with grotesque, spread - winged fowl of an almost surrealistic barnyard; and leaping at every corner with Traylor's versions of chicken stealing, 'possum hunting, and downright hand to hand fighting on his highly imaginative plantation.

There are even those who claim that the negro's work resembles that of Pablo Picasso, Spanish modernist and cubist, in that its figures are carefully planned and arranged with artistic economy in the allotted space.

Like Picasso, the dumbfounded exslave is also accused of making unreal images, resemble in their clearness of structure, an abstract idea of life and reality. Traylor, moreover, blinked at the claims that he, like Picasso, does not try to imitate form, but creates form, "carrying all convictions to their logical extreme."

Traylor's two-eyed profiles and his brilliantly colored animals have been c o m p a r e d to those of the famous Spaniard.

Keeps It To Himself

Whatever, if a n y t h i n g, all this means to Traylor, he hasn't disclosed in audible comment. He g o e s on mumbling and painting.

However, when this reporter asked him point-blank about his resemblance to Picasso, he showed his usual astonishment at the s o u n d of a foreign name, and goaded further conceded this comment:

1. If his cats were sometimes not black or white or calico, but slate blue with dashes of orange in unexpected places, it was not because he was imitating the great masters, but because, lacking the conventional colors for the animals, he still had blue paint, but soon gave out of that. That's where the orange came in!

2. If he got a lot of figures on paper it was not because of what they called good economy, but because the drygoods boxtop he happened to get hold of that particular day, was bigger than usual. There was just room for

those figures on that top, and that was all there was to it.

3. Whether people would ever pay "big money" for his pictures or not, he didn't know. But as long as they paid something like 50 cents a half dozen, "or maybe a dozen, or maybe fer fifteen," he "warn't complainin'."

Why, Bill was asked, did certain of his pigeons look like no birds ever seen on earth? And why did t h a t gracefully poised yellow bird, looking more like a flaming yellow flamingo, turn out to be just his idea of a barnyard rooster?

"I paints what I sees," said Traylor gruffly, and that is possibly his secret. If Traylor paints what he sees, then it is a strange world he moves in. His great-bodied, pin-headed men —men as Traylor sees them—appear to the casual observer to be at first sight the attempts of a small child to

draw his kind. On closer observation they glare from the paper as savage caricatures.

What there is in the work of the negro artist, this reviewer is not fitted to say. To say the cautious least, there is marked composition and grace in many of his drawings. There is a grotesqueness which h o l d s the eye, and in many of his flat figures on a flatter background, there is, at least, a sense of harmony in motion, and a plan of design almost Oriental in its confusing grace.

As far as Traylor will a d m i t, he knows only one thing about art, that one should observe carefully regardless of what one sees. "I jes' set on the street and don't do nothing," he said. "I jes' keep on lookin' at things and thinkin' 'Let's see if I can make dat look like dat'".

He k o n w s something else. He's "w o b b l y kneed" with his "H e a d a-swimmin' ". He doesn't know whether there's a heben or not, only that everybody leaves here quick. "Here" for Bill means more or less the floor space where he s p r e a d s his pallet "amongst the coffins". But he is not afraid.

He has long since learned that: The spirits "neber tell old Bill goodnight . . . or good morning nei.her."

Buck Doe Says

Buck Doe

"Harvey, this here Springtime bizness shore karries me back to the farm," said Buck Doe as he entered the Tavern in search of a decoction that would probably have caused Judge B. Meek Miller to blush if he l ad observed Buck downing it. But when he had finished with the offering and had wigwagged Harvey his satisfaction after being sure that Labe Turk did not see the double spike Harvey placed in the glass, Buck set foot on the rail and talked of his old farm days. Buck was raised on the farm, or at least he did not leave the farm until he was more than 14 years old, and as he says, until he had planted so many peas that if they had been put in one

row they would have reached from Maine to California and a return by way of Mobile and Atlanta to the starting point.

"Harvey, my paw wuz the most optimistic farmer I ever heered uv along about the fust uv January in them days when I wuz a comin up a farmer didn't work more'n five months in the year an sum not that much. Paw never made enuff money to git me no shoes until I wuz ten an then they wuz brass toed brogans. But he allus had plenty to eat sech as gravy an biskits and cawn bread and chickens and onct a week sum cheese a`out he bought in town. Paw Doe didn't buy no flour in town and allus made his own sugar an it wuz brown but it wuz sweetenin right on an we growed on it.

Worryin' Time

"Harvey, about this time uv the year paw Doe begun to git a leetle pessimistic. Jest as soon as he planted the fust seed, whether it wuz a turnup seed er a grain uv cawn er a cottonseed, he'd begin to wurry. I hear our farmers do that now. About this time uv the year paw would plant cawn. Jest as soon as he got it kivered up an there wuz no more cawn to plant, paw some night at supper would say, 'maw we got all

(Turn To Page 5)

them about a half hour to get up the three flights of stairs, and that once there, Traylor took it in but did not wish to linger, and there was no evidence that he felt any pride in seeing his work on view. "He went around and looked at every picture," Shannon recalled. "After one time around, when he got to the end, he was ready to go.... There had been no acknowledgement that this was his work, and he never mentioned his show again."[163]

The exhibition sparked a notice in the *Montgomery Advertiser*, "African Art of Bill Traylor Now on Walls of New South," and another in the *Birmingham News*, "Ex-Slave's Art Put on Display by New South: Bill Traylor, 85 Draws Things as He Sees Them."[164] A longer article, "The Enigma of Uncle Bill Traylor," came a month later in the *Montgomery Advertiser* (fig. 27).[165] As "African Art of Bill Traylor ..." announced: "Beginning this week New South will have on the walls of its gallery at 24 ½ Commerce Street, an exhibit of the work of Bill Traylor. Using waster cardboard for his panels, and done in pencil, crayon, and show card color, Bill Traylor's work is remarkably similar to the renowned rock paintings and cave drawings of Africa."[166]

The unnamed columnists picked up the theme of cave drawings from what is presumably Shannon's text in the New South exhibition booklet, which stated, "Because his roots lie deeply within the great African tradition, and not within that of the white man; and because beautiful and living works have resulted—Bill Traylor is perhaps one of the most significant graphic artists the Negro race has yet produced in this country."[167] The apparently well-meant element of truth in this—that Traylor's work reached back into the culture of his ancestors—also had the effect of undermining the very real presence of a Southern American life and present-day influences as well, and would be twisted and misused by writers like newspaperman Allen Rankin and many others to position Traylor's art as inadvertent and accidental instead of intentional and intelligent. In "The Enigma ...," Rankin celebrates Traylor through a haze of patronizing stereotypes and (at best) paraphrased answers to questions that Traylor had likely not been inclined to answer to begin with, such as: "Why, Bill was asked, did certain of his pigeons look like no other birds on earth? And why did that gracefully poised yellow bird, looking more like a flaming yellow flamingo, turn out to be just his idea of a barnyard rooster?"[168]

The New South organization closed in the spring of 1940. The youthful energy that drove it initially was difficult to sustain with a volunteer staff and everyone's busy lives. Abstract expressionism was consuming the attention of the art world, and socially conscious prewar painting styles were becoming passé. Shannon received an artist's residency that took him to Georgia that year, but he continued to visit Montgomery, and Traylor, on the weekends. Miriam Rogers Fowler noted that all the New South members encouraged Bill Traylor's creativity and looked after his well-being. Jean Lewis recounted once looking for Traylor when he was not at his usual spot on Monroe Street. She located him, ill and resting in a nearby basement, where she brought him soup. He recovered and returned to his spot soon after.

It is unknown precisely how many New South members acquired original art from Bill Traylor. Charles Shannon and Blanche Balzer Shannon collected most of

FIG. 27 Photograph of Bill Traylor and his art in *Montgomery* (AL) *Advertiser*, March 31, 1940, after his first exhibition, at New South Gallery, Montgomery

the material.[169] Jay Leavell owned approximately ten works, and Jean and George Lewis a group of about the same number.[170] Ben Baldwin had at least five works,[171] and Paul and Mattie Mae Sanderson at least ten.[172] Rankin is said to have had some works, which he bought in 1946, when he met Traylor; those works reportedly did not survive.[173] Miriam Rogers Fowler noted that John Lapsley, and possibly Crawford Gillis had also owned some of Traylor's work, and people who met him on the street would have been free to purchase work directly from him. One such account exists, that of Shirley Osborne Hensley, who, with her sister, Virginia Asherton Mendenhall, visited her Montgomery friend Mirah Walkins. Hensley recalled, "Mirah wanted Virgie and I to see the produce and flower markets and as we were walking we passed this man who was drawing on the street. I remember we bought a dozen or so....They were so humorous and full of life....I don't think we paid more than a quarter for each. I wanted to send them in place of postcards."[174]

The New South members who remained in Montgomery kept in touch with Traylor in various ways and degrees, but the images and documents that illuminate Traylor's early years of art making fell away after the New South was shuttered. It would be after World War II before Traylor was documented in any concrete way. In the meantime, however, Traylor continued to live predominantly on the streets of Montgomery, making art by day and eating and sheltering in neighborhood businesses.

THE LAST YEARS, 1942–1949

The World War II years left a dearth of information on Bill Traylor's life and his artistic practice. Charles Shannon worked as an artist correspondent for the US Army's War Art Unit in the South Pacific and was stationed for some time at Virginia's Fort Belvoir, where he painted a mural at the hospital.[175] Blanche Balzer continued to visit Traylor and purchase whatever art he had made since she had last seen him. Blanche and Charles married in January 1944. That fall the army transferred Shannon to New York, where Blanche joined him in December, after which their visits to Traylor ceased.

Traylor had visited his daughter Easter Traylor Graham in 1940 and on another occasion during the war; he also made visits to various children in the North and East, perhaps seeking some long-term stability and care in his old age. In a letter she wrote to Shannon in 1946, Easter explained that they could not adequately care for him: "He's lived with each one of his children in Chicago, New York, Philadelphia, Washington, and other different places but won't stay with either. We all love him and want to keep him, but he just won't stay."[176]

Traylor was certainly aware of the dramatic exodus of African Americans in the 1920s, when a million people of African descent left the South. The numbers dropped to under a half million during the Depression years, but they surged again when World War II broke out and roughly a million and a half black Southerners headed north in search of a better life.[177] Despite his need for a new home, Traylor likely found that his children's lives in the North were dramatically different from anything he knew; his old-world ways were out of place and possibly unwelcome, and like many lifelong

PLATE 3 *Bottle Figure*

Southerners who attempted migration, he was compelled to go back to what was familiar to him. He told Easter he would rather be homeless in Montgomery than stay on with her in Detroit.[178] When Traylor returned to Montgomery, he did not go to Monroe Street but instead moved into an unnumbered, single-room shanty on Bell Street, at a spot overlooking the Alabama River and the train tracks, where hobos encamped.[179]

According to Megan Stout Sibbel, the Roman Catholic Church had positioned itself as the spiritual savior of African Americans; gathering spots for the homeless would surely have been a focal point. "In the years following the end of the Civil War, officials in Rome and the United States increasingly sought to marshal the Church's considerable resources with the aim of reaping the 'colored harvest.'"[180] Sibbel explains, "The term 'colored harvest' was used as a shorthand reference to the millions of non-Catholic African Americans who, the hierarchy assumed, would snatch at their chance for salvation in the Mother Church. The term appeared frequently within Catholic documents and publications that addressed mission schools and churches in the South."[181] By the mid-1920s the Church was discussing how to cope with the loss of so many Southern black families to northern cities; conversion became a pressing objective.[182] When Pope Pius XI died in 1939, his successor, Pope Pius XII, "used the sesquicentennial of the establishment of an American ecclesiastical hierarchy to again broach Catholic outreach to individuals of African descent."[183]

In the early years of the war and possibly during his travels to visit his children, Traylor's health took a downturn. In 1944, perhaps fearing for his life as well as his soul, Traylor converted to Catholicism at Montgomery's Saint Jude Catholic Church, where his daughter Sarah and her husband, Albert, were parishioners; Reverend Jacob conducted the baptism on January 5.[184] Sarah may have encouraged the conversion, but Catholic nuns were also a powerful force in converting many in the African American communities. Certain paintings Traylor made before moving to Sarah's house appear to depict nuns in abstracted, form-reducing habits (PL. 3).

According to family, Traylor had developed diabetes. Shannon's memory and records (both public and family) diverge after this point. Easter had noted that the challenge in keeping Traylor at her home in Detroit during his wartime visit was owed in part to the difficulty of getting him to and from her second-floor residence: "[I] have no help or way to get him back and forth up and down the stairs."[185] Granddaughter Margaret Traylor Staffney has explained that Traylor had needed not just one amputation but two—the first, in 1943, taking only some toes, the second, in 1946, his entire left leg.[186] Traylor may have traveled north after the first surgery and been left considerably more disabled after the subsequent one, closer in time to Shannon's return to Montgomery.

Traylor's increased need for health care may have precipitated Montgomery's welfare agency discovery that he had family in the city, thus ending his monthly stipend. By 1945 the city directory lists Traylor as "renting" living quarters at 154 Bragg Street, the home of Sarah and Albert Howard (fig. 28).[187] Traylor may have lived there as early as 1944. Granddaughter Myrtha Lee Delks recalls meeting Traylor for the first

time as a teenager, at the Howards' home in 1943 or 1944.[188] By all accounts, Traylor's residency there was an unhappy arrangement on both ends, but Traylor continued to spend his time painting.

Between the fall of 1944 and January 1946, when Shannon was discharged from the army, he and Blanche lived in New York. Rankin (still working in Alabama, as a freelance journalist) had heard that the Museum of Modern Art in New York may have had some interest in Traylor; Rankin phoned the Shannons, looking for information on Traylor so he could revive recognition of the artist in Montgomery.[189] "I mainly supposed this would be good for Bill Traylor," Blanche recalled. "Charles was in a U.S. Army Hospital on Staten Island with the flu—I got off work and made the trip by subway down to the tip of the island, crossed on the Staten Island ferry then journeyed by trolley and bus to the hospital, ready to write down whatever Charles told me and call Allen back. He refused to tell me anything and became angry. I realized he felt he discovered Bill Traylor and that Allen R. was trying to take something from him."[190]

Upon hearing that Traylor wouldn't talk with Rankin directly, Shannon got involved. He spoke with Rankin about an article Rankin was writing for *Collier's*, and apparently agreed to loan additional artworks for the photo shoot. The resulting article was lengthy and fraught with racial prejudice. Rankin expressed astonishment that a man like Traylor could be capable of painting at all—but explained it away with patronizing statements such as, "Through some capricious blunder of the centuries, this old plantation Negro is painting like the prehistoric cave artists." Rankin proffered quotes and anecdotes as Traylor's own that Shannon would later call out as fabricated or inaccurate versions of information that he himself had provided.[191]

Shannon recalled that not long after they had moved back to Montgomery, he went to visit Traylor on his Monroe Street perch—but Traylor had left the neighborhood by then.[192] His life at Sarah's was not comfortable, as he was relegated to spending his days in the yard out of Sarah's way. He had a note sent to Shannon, asking if he would

FIG. 28 House at 154 Bragg Street, Montgomery, Alabama, where Bill Traylor lived with his daughter Sarah and her husband, Albert Howard, in the 1940s. The house has been razed since this photograph was taken around 1992; photograph by Marcia Weber

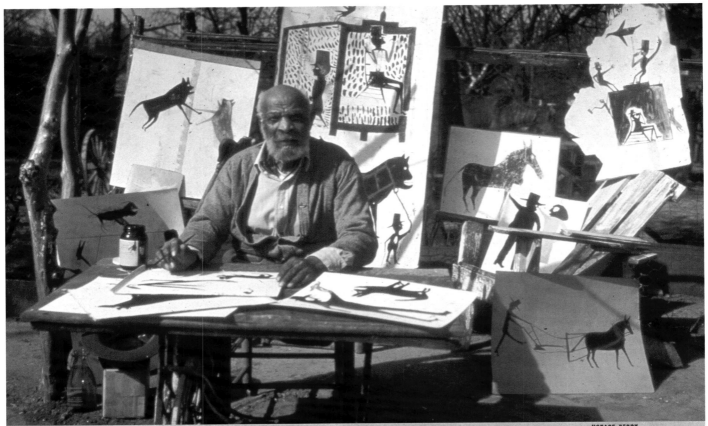

Bill Traylor, 92 now, didn't start to paint till he was 87. His works resemble the primitive art found in early caves

HORACE PERRY

HE LOST 10,000 YEARS

BY ALLEN RANKIN

visit, which Shannon then did. "I found him sitting under a fig tree in the backyard," Shannon recalled. "He had his drawing materials beside him, but nothing much was happening. He was miserable and asked me to write a letter to his daughter in Detroit to ask her to take him in. I wrote the letter for him and the daughter replied that she loved him very much but it would be better if he stayed where he was."[193]

Delks recalled the sadness she felt realizing Traylor's daughter didn't wish to be caring for him. "We talked after Aunt Sarah introduced us. Then he started crying and he told me Aunt Sarah was not nice to him. He had to eat his meals outside under the tree where he sat all the time. As I looked at this beautiful old man, my heart filled up with love for him and I started shedding tears along with him."[194]

When Rankin visited Traylor at the Howards' home on March 4, 1946, for the *Collier's* article that would be published several months later (figs. 29–31), photographer

FIG. 29 *Collier's* magazine article by Allen Rankin, June 22, 1946, featuring a photograph by Horace Perry of Bill Traylor and his art. Alabama State Council on the Arts

Horace Perry accompanied him. The photographs that Perry took that day in March show paintings by Traylor that were made over a span of time; some are large, bright, and of a looser style than other, earlier works. At least five, however—which Traylor made before 1942 and Shannon owned—are anachronistic in Perry's images.[195] Happenstance led to an article in the *Montgomery Advertiser* about the photo session:

> The former newspaper man [Rankin] had gone to Traylor's home, in company of Horace Perry, formerly staff photographer of the *Advertiser* to view the Negro artist's paintings and to gather material for an article he intended to write about the painter. A series of the Negro's paintings had been arranged, for photographic purposes, in the Traylor yard, Rankin told police who investigated the accident, and in stepping back to obtain a better view of the pictures he stepped into the well. Police said the well had been covered over with planks, which had rotted and gave way under Rankin's weight.[196]

Looking back, Shannon would erroneously assert that Traylor had not drawn during the war years, and opine: "The little work he did after his return was not good and I didn't save it."[197] Shannon may have commented to Rankin and Perry that he believed Traylor's recent work was subpar; Shannon loaned at least five paintings for the *Collier's* photo shoot, to "salt" the original array.[198] Shannon was no longer interested in keeping Traylor's art, yet Rankin reportedly saved a group of paintings that Traylor made around that time.[199]

After loaning works for the photo shoot, Shannon did not keep up with Traylor. With his health worsening, the decline of support from Shannon and other New South members, and an unsympathetic home environment, Traylor's art making may have dropped off. In 1947, Traylor was admitted to the segregated Fraternal Hospital on Dorsey Street. Traylor had Sarah write to Shannon—asking him to come. "It was an awful place," Shannon said of the hospital. "Bill could hardly talk, there wasn't any real conversation. I remember kneeling down beside him and he could barely speak.

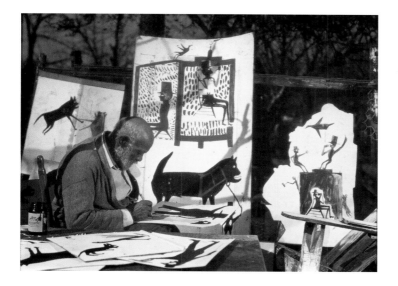

FIG. 30 Bill Traylor at Sarah and Albert Howard's home in Montgomery, during photo shoot for *Collier's*, March 4, 1946; photograph by Horace Perry

FIG. 31 Bill Traylor's art at photo shoot for *Collier's*, March 4, 1946; photograph by Horace Perry

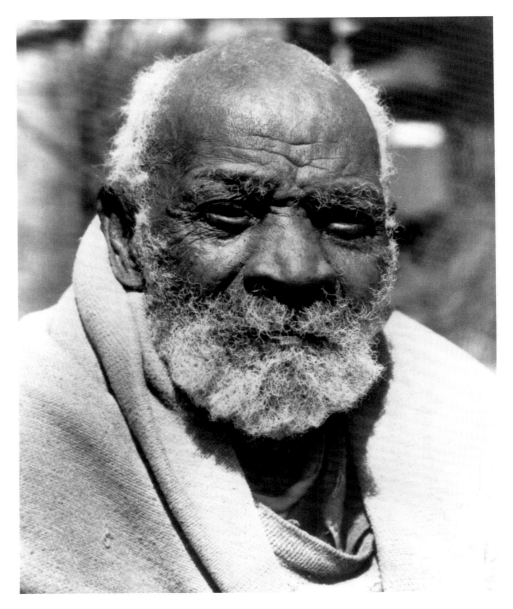

I can't even remember now what was said."[200] Not long after his visit, Sarah wrote to Shannon and told him her father had died; she asked for the money Shannon had held for Traylor.[201]

In fact, Bill Traylor had moved back to Sarah and Albert's home, perhaps to Sarah's chagrin. On March 30, 1948, Rankin, this time with photographer Albert Kraus, again visited Traylor, for another article Rankin was working on, now for the *Alabama Journal*.[202] Kraus took an image of Traylor making large paintings under the same fig tree where he had been working two years earlier (fig. 32).

Sometime after Rankin and Kraus's visit, Traylor was moved to the Oak Street Hospital. Horace Perry took what may be the last photograph of Traylor, looking

FIG. 32 Bill Traylor at Sarah and Albert Howard's home in Montgomery, March 30, 1948; photograph by Albert Kraus

FIG. 33 Bill Traylor, location unknown, in what may be the last photograph of the artist, ca. 1948–49; photograph by Horace Perry

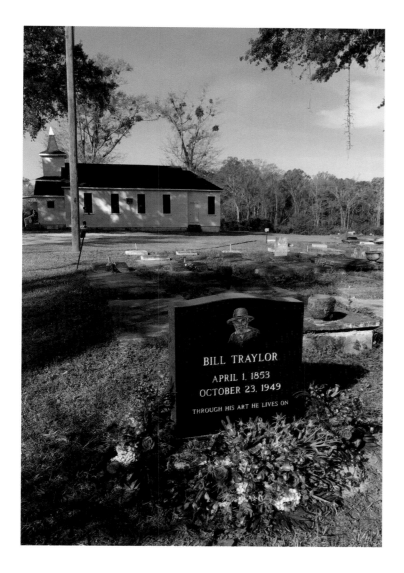

extremely aged, at an unknown location (fig. 33). Traylor died at Oak Street Hospital on October 23, 1949. He was buried at Mount Mariah A.M.E. Zion Church on Old Hayneville Road (figs. 34, 35).[203] Leila Greene and her brother, Frank L. Harrison Jr., great-grandchildren who attended the funeral with their grandmother (Traylor's daughter) Lillian, said that the service was conducted at Saint Jude's and that Traylor's coffin was carried by a mule-drawn wagon to the cemetery; Frank recalled the subsequent burial at Mount Mariah A.M.E. Zion Church.[204]

FIGS. 34, 35 Bill Traylor's resting place at Mount Mariah African Methodist Episcopal Zion Church, Montgomery, with new headstone installed in March 2018

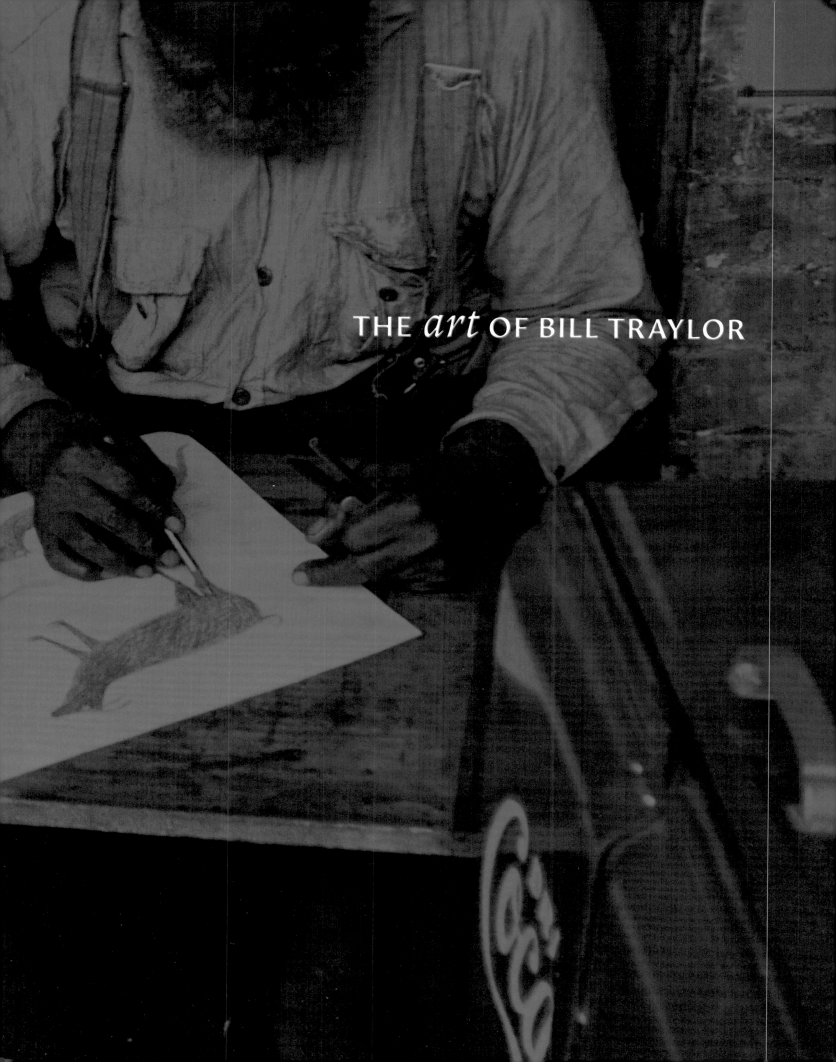

THE *art* OF BILL TRAYLOR

Got one mind for white folks to see,
'Nother for what I know is me;
He don't know, he don't know my mind.

AFRICAN AMERICAN TRADITIONAL SONG

EARLY WORK, ca. 1939–1940

By 1939, Bill Traylor had lived in Montgomery for about twelve years and was an ensconced member of the city's black business district. No one knows for sure when Traylor first began making drawings. Painter Charles Shannon believed that the drawings he and fellow painter John Lapsley saw Traylor making in the spring of 1939 were among Traylor's first. Yet Montgomery local and aspiring young artist Jay Leavell had met Traylor sometime in 1938 and noticed that Traylor was drawing then, before Jay introduced Traylor to Lapsley and Shannon in 1939. Moreover, one of Traylor's granddaughters, Margaret Traylor Staffney, recounted childhood memories of visiting her grandfather around 1937 or 1938, when he was spending days on the street and nights at the Ross-Clayton Funeral Home. Staffney's recollection was that her grandfather was selling pencils and had already begun drawing. The hand-printed exhibition booklet prepared in February 1940 for the New South exhibition of Traylor's art (part 1, fig. 26) notes that he had been making art for "less than two years"—allowing for Traylor's early work to date to 1938, even if late in the year.[1] Artworks Traylor may have made before 1939, heretofore unidentified, either did not survive or were conflated with the rudimentary drawings Shannon first saw and described from early 1939; it is impossible, therefore, to reliably date any drawings before then. Ultimately, Traylor's comprehensive body of art—showing a rapidly evolving stylistic progression after he began to devote a substantial amount of time to it—strongly suggests that the experimental works Shannon observed in 1939 were either the first ones or very close to being so.

THE EARLIEST WORKS OF ART AND SOURCES OF INSPIRATION

As the accounts from Jay Leavell and Margaret Traylor Staffney are scant, the information from Shannon comprises the most complete evocation of Traylor's early art making. In an interview in 1989, Shannon described the day he met Bill Traylor. He recalled having been out on one of his regular Saturday visits to sketch in what he

Preceding pages: Charles Shannon, *Bill Traylor's Hands/Drawing Board and Cane*, 1939.
Charles E. and Eugenia C. Shannon Trust; see full image p. 115.

called "black territory," when the country people would come into town, park mule-drawn wagons, and socialize while doing errands. "One such morning in the spring of 1939 an old black man was sitting on a box on the Monroe Street sidewalk. He had a white beard and was bent over. It looked like he might be drawing. When I got close to him I could see he had a little straight-edge stick and was ruling lines with the stub of a pencil on a small piece of cardboard."[2]

Shannon returned the next day. Traylor was in the same spot, in front of a timber-plank fence that enclosed a blacksmith's shop; again, Traylor was drawing on cardboard. Shannon described the small picture Traylor was making (PL. 4): "Drawn in pencil silhouette, images of rats, cups, and shoes were arranged neatly in rows across the space."[3]

If the story that Traylor was selling pencils around the time he began lodging at the Ross-Clayton Funeral Home (1937) is correct, he may have been experimenting with them before his drawing practice truly took flight.[4] After Emancipation, African Americans made learning to read and write a priority; they well understood these skills to be a tool of empowerment that had insidiously been kept from them. From the moment Traylor moved off the Traylor plantation near Benton around 1908 and took his life into his own hands, the need for literacy would have only increased. By all accounts, however, Traylor never became literate. Census records and the few who knew him have claimed that he never learned to read or write.[5] Ruby Pickens Tartt, who in the 1930s collected Negro folklore in Alabama for the Works Progress Administration, later renamed Work Projects Administration (WPA), noted some workarounds for nineteenth-century blacks who had not been raised with literacy. One man, Josh Horn, told her that his children learned to read and write and taught him how to recognize certain words or passages—as visual symbols rather than words. "Now the chillum done showed us how to find mos' any little verse us knows in the Bible, by what it look like on de page," Josh told Ruby. "Tain't 'zactly like readin,' but me an' Alice pleasures us-selves mighty wid it."[6]

Traylor may not have been literate, but evidence suggests that he was able to approximate his name with a drawn version of it.[7] He also demonstrated his cognizance of what significant letters meant, particularly when he made drawings of the "Alphabet Agencies," that is, those known by acronyms. Traylor replicated the capital letters he saw in posters for the WPA, the National Recovery Administration (NRA), and Resettlement Administration (RA) in his drawings of working men (PLS. 5, 6), which clearly indicated his awareness that the programs were helping people by providing work. By extension, Traylor's art became a literary vehicle of sorts—his personal means for putting down what he had seen, felt, recalled, or witnessed.

Whether or not Traylor used a pencil before 1939, Jim Crow laws and attitudes shaped an environment in which African Americans worried about retribution for taking up the tools of literacy and doing so required a degree of caution. When Traylor came to Montgomery in 1927 or early 1928, he was starkly alone after being surrounded by a large family for seven decades; his wife had died, and his children had gone their individual ways. Traylor had also reached an age considered advanced for a man born

in the nineteenth century who had labored hard and probably lacked proper nutrition, rest, and health care for most or all of that life.

Traylor was nevertheless driven by his survival instinct and need to earn a living. He found employment repairing shoes, which perhaps appealed to him because it allowed him to sit while working. No records describe his hours or tasks, but his granddaughter Margaret Traylor Staffney recalled that he knew how to do shoe repair and would occasionally fix the grandkids' shoes.[8]

As noted, Shannon believed that in 1939 he witnessed Traylor's artistic start. Right or wrong, in important ways, the scenario he recounted seems to chart the beginning of Traylor's artistic journey. After the two men met, Shannon noted, "[Traylor] worked steadily in the days that followed and it became evident that something remarkable was happening: his subjects became more complex, his shapes stronger, and the inner rhythm of the work began to assert itself."[9]

Several factors attest to the general veracity of Shannon's account. Traylor's early pencil drawings became quite sophisticated, but what are (arguably) the first ones are crude, suggesting a learning stage of mark making and representation. On small scraps of paperboard, as in *Untitled (Lamp, Bottle, and Cat)* (PL. 7), Traylor hesitantly described forms that would come to recur time and again in his visual lexicon. The first images are translations of objects to drawings. Related items such as a wine goblet, a wood stove, a plate, a pot, a water pitcher, a mug, a bucket and ladle—and then a bold bit of action: a person being bucked off a mule (*Untitled*, PL. 8). The mule and its victim are not conjoined on the paper—but neither are they solitary objects. The tiny scene conveys a dynamic event, with clearly drawn forms and an unmistakable action, that is, a story.

Another early drawing, a two-part scene (*Owls in Tree/Shoeing Mule*, PL. 9), foreshadows imagery that Traylor would often repeat in the coming years. The top half shows a tree, dead and leafless. It is a home or roost, in which sit two owls, a vulturelike bird, and several small songbirds; at its base, a cat begins its ascent toward the hoped-for bounty. In the bottom half of the cardboard another situation is pictured. One man steadies a mule while a blacksmith attempts to shoe it. Two larger horseshoes clarify the goings-on in the cramped scene. A tiny third man seems to harass the blacksmith with a stick, insinuating a fraught relationship between the smith and the paying customer. The tableau is small and surrounded by faint, erased lines that may or may not be intended as part of the narrative. Yet many elements in the drawing became standards for Traylor, and three of his habitual themes are presented herein: the predator/prey relationship, the provocateur with power or a weapon, and the tree that reaches toward heaven but is also the site of precipitous events.

These drawings seem to predate more elaborate depictions of the blacksmith's work site. In *Blacksmith Shop* (PL. 10), Traylor created a large and well-developed image that charts the blacksmith's labor and tools in concurrent vignettes. The tools and fittings are inventoried: tongs, hatchets, hammers, turnscrews, chisels, files, drawknives, and horseshoes. Nearby two men pound out horseshoes on a large anvil; elsewhere, two men shoe an uncooperative mule. The overall picture is not strictly

business though. At the top left a man is assaulted as he sits and takes a swig from a bottle of whiskey, presumably just drawn from the adjacent barrel. His raised arm and splayed fingers indicate shock and dismay as his attacker, a man in a tall hat, aims to club him on the head.

The style in which Traylor describes the altercation near the whiskey barrel, which hovers ambiguously between horror and humor, became a trademark tension in his work. The injection of violence into an otherwise commonplace moment indicates a milieu in which these seeming extremes may never have been far apart. The way Traylor depicted violence is highly animated (figures' arms flailing, hands energized, and eyes wide); it is easy to read the scene as raucous and funny and dismiss the underlying but ever-present brutality. *Blacksmith Shop* is, in part, a day-in-the-life snapshot of an Alabama blacksmith shop and the men at work there. Yet Traylor heightens the importance of the image as a specific record in time and place by adding a character who can be identified as one of his friends from the Monroe Street neighborhood. Known only as Jimmie, the man had lost his legs. Traylor shows Jimmie wearing a hat and using two hand-tools to operate a customized piece of gear with rockers akin to sleigh blades that he uses to ambulate, possibly an apparatus that the smiths fashioned for him.[10]

Another reference to friendship in this picture is subtle and more difficult to interpret; it is the faint scratch of a written name. A similar attempt at a signature appears in the smaller, bottom scene in *Owls in Tree/Shoeing Mule* and in the upper left corner of *Blacksmith Shop*, where two men shoe a mule (see figs. 36, 37). Both are hesitant, illegible scrawls approximating signed names. Shannon described a friend who may have taught Bill how to draw his name: "Black men who were out of work drifted around the Monroe Street area and at times some of them would be seen sitting on the box next to Bill. One of these men became a frequent companion and taught Bill how to write his name; you can see Bill's signatures develop on his drawings from illegible ones to quite readable ones."[11]

FIG. 36 Detail, *Owls in Tree/Shoeing Mule*, pl. 9

FIG. 37 Detail, *Blacksmith Shop*, pl. 10

Traylor's signatures have caused considerable conjecture, predominantly because they seem to contradict not only his illiteracy but also his inner reason for making pictures, which was not for artistic recognition. Yet Traylor often hung up his drawings for passersby to see. He made holes in the tops of the small pieces of cardboard, through which he pulled loops of tied string and attached his pictures to the fence that he sat against, creating a sidewalk display of his art. Through a lens of consumerism, it might be supposed that Traylor wanted to sell them and that the signatures and array spoke to that effort. But it is more likely that Traylor had a need to make his voice, however quiet, be heard and assert himself within the world, even if the places where he sat did not belong to him. He put his name down on the first things that were ever truly his own. By mounting his work, Traylor declared himself, answered a natural inclination to create a storyteller-audience atmosphere, and fulfilled a personal need to demarcate a physical space as his own, a right that had been denied to him first by oppression, then by homelessness.[12]

The early, hard-to-read markings of the artist's name do not suggest that Traylor looked at the printed characters of the alphabet and attempted to copy them properly or individually. In fact, the letters in the signatures are arched and disconnected as though he had observed an example written in script. Traylor's versions indicate no awareness of where specific letters stop or start or what features would make them legible as letters. Rather, they show only a line striving to become something that it has not yet become.

Some have wondered whether Traylor began providing signatures early on or retroactively added them after he learned to mark his name. Other anecdotes relay that Traylor acquired the skill to write his signature in later years, so the early drawings lack it. In fact, though, the early drawings are as likely to have a signature as the later ones, and not all the drawings Traylor made include one.[13] It has also been proposed that Traylor himself never wrote or drew his name—that someone else added them later to validate them. A comprehensive study on the signature element alone would be worthwhile and revealing; in the meantime, it can be said that the material and visual style of the signatures are generally consistent with the materials and styles of the drawings themselves, making it unlikely that they were added retroactively. The experimental lettering on the *Shoeing Mule* scene (fig. 36), for example, matches the tone, grade, and grain of the graphite as well as the pressure applied by the artist's hand throughout the imagery. The signature on *Blacksmith Shop* (fig. 37) is so faint that it might go unnoticed—and thus runs counter to any goal of branding the work with authorship. If Shannon was correct that a man from the neighborhood taught Traylor how to sign his name, it may have been an element that Traylor alternately used and left out, and perhaps had help with on more than one occasion.

Traylor undeniably had an affinity for aged pieces of cardboard. Shannon acknowledged this after bringing Traylor clean board, which Traylor used only after it had sat around for a while, taking on the patina of street life. Shannon observed that Traylor enjoyed the smudges, stains, and odd elements of the found paperboards and often incorporated the extant bits of information into his work. "For example, he found

a counter display card with staples in it where men's handkerchiefs had been attached — Bill drew a pigeon picking at a staple [*Pigeon (on men's handkerchiefs card)*, **PL. 11**]."[14]

In *Blacksmith Shop* (**PL. 10**), Traylor integrated a patch on the card where the surface paper was torn away. The man drinking at the keg sits in a chair, but the chair seat aligns with the top surface of this torn patch and fuses it seamlessly as an element of the scene. Traylor didn't address his preference in words, but his persistent use of aged surfaces, ability to create dynamism in his pictures through odd shapes of cardboard, and clever employment bits of printed matter into his images speak volumes. Many African American artists and others who lived and worked through the Depression were rooted in a scrap-salvage reality and made second-life objects into a cultural and metaphorical aesthetic in which happenstance and wear were utterly compatible with delight and beauty. Ultimately, the shirt-box cardboard, candy-box tops, and window advertisements, or show cards, upon which Traylor made his art were plentiful and rendered any other materials unnecessary.

In some cases, when Traylor remarked about a specific work of art, Shannon noted the comment on the back of the drawing. Accounts vary about how talkative Traylor was. Kitty Baldwin, Shannon's girlfriend in 1939 who went along on some visits to Bill, recalled that Bill hardly spoke a word; she believed he was a quiet person.[15] Blanche Balzer (who later became Shannon's first wife) thought Traylor was simply uneasy with women, which in the context of Jim Crow segregation and the perils it presented, probably meant he was uncomfortable engaging with white women. "He didn't care much for women," she stated. "When Charles had to go into the service, [I] went down a good bit.... [Traylor] was usually ill at ease when I came. He knew why I came — that Charles was in the service and couldn't come and he kept his head down just like he looked in that picture. That's the way he sat most of the time because he was usually drawing and talked while he drew."[16]

Shannon agreed that Traylor could be taciturn, and he indicated that he didn't ask Traylor many questions but instead let Traylor offer information:

> There was a lot of silence, but sometimes he would just start talking, he would tell me a story or we'd have a little discussion about something. I remember one story he told. He said: "The old bullfrog got up one evening and said, 'I've got to leave this pond for a few days. Who's going to sleep with my wife while I'm gone?' And all the little frogs said, 'Meee...meee....' Then the old frog said, 'Who's going to work and take care of my wife while I'm gone?'...And I ain't heard a sound till yet."[17]

Since Shannon's anecdote was first printed in an interview and a magazine story, many contemporary authors have quoted it as an amusing folktale, yet its significance lies in the fact that Traylor so clearly conveyed a moral tale in the form of traditional animal allegory.[18]

In another early pencil drawing (**PL. 12**), which Shannon noted on the back as dating to "Early — Summer of 1939," a person walks with a small dog and carries an enormous basket atop her head. The work, *Man with Basket on Head (Early)*, is remarkable for being

one of the rare images in which Traylor overtly depicted an African American folkway. Supporting heavy loads on one's head was a need-driven practice that nineteenth-century African American women learned from elders who brought the custom from Africa. The weighty burden was also symbolic of the pressure put on slaves and field hands to produce an expected quantity and the spiritual toll of being valued only as a source of labor. The custom decreased as automobiles became increasingly available to haul cargo in the place of laborers, but it would have been very familiar to Traylor.[19] Traylor added significance to the drawing by making a humorous comment about it, which Shannon wrote on its back: "Bird on top of the basket and he don't know it." The captivating notion of telling stories with pictures was instinctive for Traylor. Among the early works, small in scale and done solely in pencil, are pictures of a snake chasing a hen off her nest of eggs, cryptic scenes with snakes, bottles, and falling people, and another favorite, a man working a single-mule plow.

Traylor's natural ability as a storyteller is twofold. Part of it is manifested in his consistent drive to convey an anecdotal narrative in which interplaying forms crystalize in a cohesive moment in which expression, gesture, and ambiguity all play important roles. Even when Traylor's figures are solitary, their expressions, poses, clothing, and accoutrements present vivid snapshots. The other part of Traylor's skill is seen in his facility for pictorially describing an animal or person with such sensitivity to its shape and stance that the viewer easily grasps mood, age, attitude, and, importantly, recognizable and recurring characters—be they human or animal.

Informative, though still incomplete, documentation of this early work—dating from the spring of 1939, the time Shannon stated that he first laid eyes on Traylor, through February 1940, when the New South artists' collective mounted *Bill Traylor: People's Artist*—substantiate Traylor's advancing technique, topics of interest, and stylistic development. Shannon's handwritten descriptions or notes about the drawings; the photographs he took of Traylor and Traylor's works of art; the dates he recorded on some original artworks; and the photographs Jean and George Lewis took in 1939 and 1940 that document Traylor working on his street perch and Traylor's art on the walls of the New South exhibition all offer a window onto the nine- or ten-month period leading up to the exhibition.[20] Assigning dates to the paintings and drawings made after that point is less precise, as Shannon's written comments and dates became rare, Traylor's style and confidence more even, and documentary photographs few and far between.

Early on, Traylor's single animals moved from small, scratched-out shapes to larger, more commanding central figures with rounded bellies, perked ears, and expressive tails. Many of his figures (human and animal) are defined by torsos drawn as geometric boxes and legs made with a straightedge (as Shannon noted seeing him use), overlaid with softer, freehand shading. Adding rounded bodies over a linear skeleton became one of Traylor's hallmarks, yet many of his early drawings of animals, in pencil, lack this rectangular structure and instead are composed of a sketched oval or have no visible underlying framework.

At the time Shannon met Traylor by the fence behind the blacksmith's shop, Traylor was sleeping in the back room of the Ross-Clayton Funeral Home.[21] Shannon

said he had seen how Traylor "rolled out some rags on the floor among the caskets to sleep."[22] A few months later the funeral parlor relocated, and Traylor began sleeping in a shoe-repair shop and spending his days a couple doors down, sitting against an unused back door of the Pekin Pool Room.[23] As he had hung his drawings on the fence near the blacksmith's shop, here by the pool room he propped them up on the walls that he sat against, as photographs document. Traylor's time at the funeral parlor seemed to have made a greater impression on his psyche than did his experience in the shoe shop or near the pool hall. About Ross, the undertaker, Traylor observed that he was wary of the coffins: "When he comes in, he always looks around seein' if dem boxes is empty."[24]

Soon after Shannon met Traylor he determined to paint a portrait of him. Shannon took photographs as study shots for what would become his mural of Traylor for the New South exhibition (see part 1, fig. 24).[25] Shannon noted that within two weeks of meeting Traylor, he began to bring him art materials—"pencils, better cardboard, the full range of poster paints and brushes"—and that others, too, supplied crayons, charcoal, and pastels. In the study shots taken around this time, Traylor is drawing on one of the large clean and straight-edged pieces of board that Shannon gave him; the small, rough-cut boards he had found and sized himself lay at his feet in a pile.

In some of the photographs taken on the same day in 1939, a few of which are illustrated herein (see figs. 38–41), Traylor sits with his back to the unused back door of the pool room.[26] To his left, not far from the wall, is a Coca-Cola cooler with an open space at the bottom for holding crates of empty bottles. Behind the cooler lay some of Traylor's drawings and extra pieces of cardboard. Traylor is wearing a buttoned-up cotton shirt, pants with suspenders, and lace-up shoes. His cane rests in the doorway (fig. 41). In all but one of the photographs he is hatless. He is bald, with a graying beard and mustache. Boys hang about, watching Traylor at work and the white man paying attention to him and them.

In the photos showing Traylor working, he is sitting on a crate or stool and with a drawing board on his lap.[27] He holds a pencil in his right hand and a second pencil and small knife in his left. A slight, rough piece of wood, probably the "straight-edge" he used at times, sits at his feet. Also on the ground, to his right, sits a shallow box with supplies in it—string, small jars or spools, and additional pencils. The drawing Traylor is making shows three animals with little to suggest a dynamic relationship between them (fig. 41). Here Traylor may be experimenting with a clean white drawing space for the first time or close to it. The animals are a camel, a lion, and a goat. It's an odd selection, perhaps suggesting Traylor's eagerness to explore and expand his visual vocabulary.

Sitting near a hotel and movie theater in a bustling commercial neighborhood, Traylor had any number of visual sources at hand. The back sides of the drawings he made on found paper or cardboard indicate the array of advertisements in which he clearly came into contact. Politicians talking about the future of American capitalist society and the continuing struggles of the Depression passed through town. Preachers,

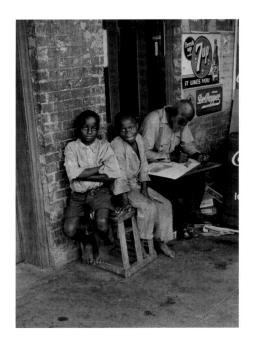

who flocked to the city, as Eugenia Carter Shannon put it, "regularly preached doom to shoppers on Monroe Avenue and Dexter Avenue during the 1930s and 1940s."[28]

Minstrel performances, tent shows, the circus, and carnivals all came through town, and what Traylor may have missed in person he saw on posters and flyers. R. J. Reynolds launched a major advertising campaign when it introduced Camel cigarettes in 1913; its play on the exotic nature of the rarely glimpsed creature on which the brand's name and design was based soon made Camel a top-selling cigarette. Traylor noted having seen the advertising image of the camel and, on posters for the circus, some of the more exotic animals he drew. On one of Traylor's drawings of a large, long-tailed cat, Shannon recorded Traylor's explanation: "See'd one in a show once."[29]

In one photograph (fig. 41), a drawing of a dog is partially visible on the ground behind Traylor. It appears to be confidently drawn, substantial in shape, and densely toned in pencil. In just a few weeks, Traylor's ability to define musculature and stance had advanced markedly from his initial hesitant and scratchy forms. The drawing of the dog is much like others Shannon saved from this period, each of which focuses on a creature's physicality and disposition. In other drawings (not illustrated), a lion and camel feature as sole subjects, wherein Traylor explored the unfamiliar lion's mane and the camel's humps, respectively. Far more often though, Traylor's approach seems somewhat methodical, as he worked through repetition to improve his depictions of animals he knew well rather than attempt those he had seen only once or in a picture.

Shannon noted that Traylor didn't draw from life, a statement meant primarily to contradict Allen Rankin's article in *Collier's* that fabricated an anecdote about Traylor's telling a mule to stand still so he could draw it.[30] While Traylor may not have based his images on creatures standing immediately before him, he did rely on his familiarity with some beasts over others. His personal memories comprised a rich archive of living

FIGS. 38–40 Charles Shannon, *Seated Boys/Seven Up Sign/Traylor Drawing, Young Men Watching Bill Traylor Draw,* and *Three Boys/Door with "Colored Pool Room,"* all 1939. Charles E. and Eugenia C. Shannon Trust

and working with animals, from the omnipresent native wildlife of rural Alabama to the farm animals he managed daily. In Montgomery, Traylor may have been made newly aware of unfamiliar exotic animals, but the city was home to dogs, horses and mules, cats, rats, and birds. Dogs would have been a potent symbol bridging the present to plantation days. Traylor's many drawings of canines—from tiny toy pets being led by fashionable ladies to fearsome beasts ready to rip one limb from limb—are among the central characters in Traylor's visual story.

In his early works, Traylor explored expression and stance in repeated forms of dogs, cats, horses, and birds. A drawing may show a dog in complete profile, with just one eye visible to the viewer, while in another, the dog's face is turned slightly into view to reveal two eyes on the same plane (**PLS. 13–15**). Snouts are alternately pointy or blunt, expressions docile or fierce. Traylor's representations rapidly became deft, to the extent that viewers can recognize a specific animal where it reappears in other images. The artist drew not simply one kind of dog but rather, as many characters and physiques as human subjects would reveal. The allegorist in the artist is evident in the work he would make from this point forward.

With cats, Traylor clearly puzzled over their languid forms and the way they shift shapes. Variously walking, sitting, and reclining with their heads, oddly, still raised, the lithe creatures, move with liquid agility. In *Untitled (Lamp, Bottle, and Cat)* (**PL. 7**), the cat has a different orientation than the other two objects, which are similarly positioned and sized. The cat looks like it is walking but, given the many felines that Traylor would subsequently draw in the awkward reclining position mentioned above (see **PLS. 16, 17**), and those walking upright, from left to right on the page (see **PL. 18**), it seems that his images of cats attempt to capture one in the sitting or side-lying position.

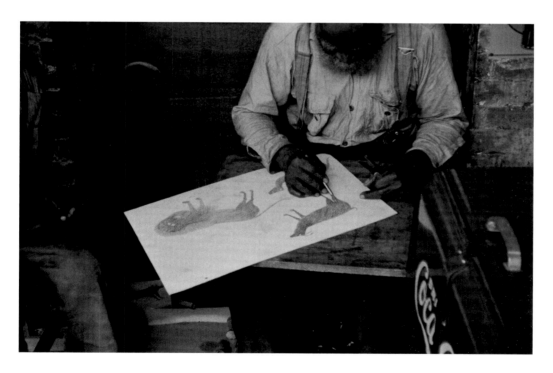

FIG. 41 Charles Shannon, *Bill Traylor's Hands/Drawing Board and Cane*, 1939.
Charles E. and Eugenia C. Shannon Trust

Shannon was not the only person to interact with Traylor, but he was the only one to chart Traylor's evolving art. He observed that Traylor investigated various topics in clusters or focused periods of time. Soon after Traylor gained access to paint, he explored simplified forms as well as abstraction. His "basket" period came in the summer of 1939, when all sorts of his painted shapes, usually with thatch patterns and sometimes with plant or animal forms, resembled baskets or woven vessels. Traylor's regalia of animals appeared early and recurred periodically throughout Traylor's years of artistic productivity, as did his drawings of people and his more elaborate narrative scenes. Unlike these more abiding themes though, some of Traylor's explorations, such as the baskets and plant forms, seem both close-knit and short-lived. In one such group of related works, Traylor delved into images that seem dreamlike and surreal; plants and animals fuse and morph into strange combinations and highly abstract forms, and the narrative is confounding.

Traylor's baskets seem to bridge a period of straightforward depiction and one in which this kind of representation appears less relevant. Traylor's frequent, early rendering of woven containers has prompted musings on whether Traylor learned basket making on the plantation. Basketry would have been a common craft on self-sufficient farms where containers were needed for hauling cotton, corn, eggs, and other farm goods; indeed, J. G. Traylor specifically mentioned that one of the enslaved people on his farm engaged in weaving such containers.[31] White oak trees were plentiful in Alabama, and baskets made from split oak were sturdy and lasting. In the early drawing *Man with Basket on Head (Early)* (**PL. 12**), the basket is clearly a large woven form. Although Traylor may not yet have been fully adept at scale at the time he created his basket paintings, the grand basket (in comparison to the size of the person carrying it) in *Man with Basket on Head (Early)* closely resembles the large woven vessels used in the fields; individuals carried sacks for their pickings, which they periodically emptied into large collection baskets along the way. The drawing is rare and remark-able for its precise depiction of a field routine that Traylor was familiar with and one that is documented in photographs (fig. 42).

Traylor executed his "early" drawings — meaning the works that can be dated either empirically (via notes on the backs or through documentary photographs) or by stylistic association to roughly 1939–40 — solely in graphite pencil. Soon after, Traylor moved to colored pencil and "show card colors," or opaque water-based paints.[32] Like Shannon, who gave Traylor art materials, high school student Jay Leavell, who worked at the lunch counter at Newberry's five-and-dime and painted signage there, shared his poster paints with Traylor and brought him cardboard from discarded candy boxes at the store.[33] Other materials Traylor used, such as charcoal and crayon, may also date to this period, but

FIG. 42 O. Pierre Havens, *Women picking cotton*, ca. 1868–1900, stereograph.
The New York Public Library

few examples of works in these media exist. Traylor took easily to colored pencil, the physical properties of which were like the graphite pencils he was accustomed to by then. A green pencil seemed to be a passing favorite, as he did several drawings in green alone or combined with silver-gray graphite.

One early work in poster paint (not illustrated) depicts a lone blue basket with an arched handle, a clearly delineated vessel painted with crossed lines.[34] If Traylor made mistakes while learning to use the fluid paint, works that reveal such errors were not saved. The extant early paintings are cautious but steady and precise. Describing a realistic basket, for example, did not seem to be Traylor's primary aim; most of the paintings from his basket period show intriguing combinations of plantlike and woven forms, many of which are highly animated. Birds find purchase on the rim or handle of a basket. The baskets themselves seem to grow like plants, with multiple tiers or cavities, as if their organic materials (oak strips or palm leaves) had begun to divide and morph, partly domesticated but still wild, or half living and half dead. In *Untitled (Pineapple)* (PL. 19), the natural patterns of plants converge with renditions of baskets, making the living plant almost indistinguishable from the broken, harnessed, once-living material.[35] In *Basket with Plant Form* (PL. 20; below, in fig. 52), a palmlike plant clearly issues forth from its thatched container, a living being confined within a vessel shaped from the bones of its deceased ancestors.

In a remarkable drawing, *Untitled (Basket, Man, and Owl)* (PL. 21; below, in fig. 52), Traylor's basket, in bold blue pencil with accents of red, becomes a stage or platform of sorts. Atop the bulging woven shape, a man stands at the left; an owl is perched at the right. A botanical shape growing out of the structure is anthropomorphic, with features that seem to be arms, five-fingered hands, and legs. The man is as detailed as any of Traylor's figures to this point, with arms, legs, and facial characteristics penciled in black, the torso in blue, the head and neck in livid red.

Among the drawings made between 1939 and 1940, one stylistically distinguished group is among the most enigmatic of Traylor's oeuvre. His symbolism and arcane subject matter spark questions about the degree to which folk magic and vernacular religion played a role in his imagery. Some drawings include an altar-like array of plants and birds, provoking wonder about what Traylor may have seen or experienced while sleeping at the undertaker's. "Old time" religious practices grew out of slavery every bit as much as work songs, allegorical tales, and folk remedies did, but too often these customs have been less understood and overlooked.

The reason in part is that the superstitious nature of the folk practices known variously was conjure, hoodoo, rootwork, or root medicine took on problematic associations in the twentieth century, when such beliefs were commercialized and overtly attached to racial stereotypes of uneducated, superstitious African Americans. In truth, the syncretized rituals that fused personal convictions and traditions, as well as elements of the sacred and secular, responded to harsh and shifting realities were critical and complex.

Theologian Theophus Smith proposed the most concise and precise definition of conjure is a "magical means of transforming reality."[36] Conjure, rootwork, and hoodoo

all refer to the secular practices in which African Americans used recipes and rituals to influence their fates, calling on specialists or "trick doctors" to persuade, or "'conjure,' spirits in matters of both health and morals."[37] Smith argues that conjure had such significant impact on African American religious beliefs that it affected virtually all worldviews of black Americans in the early twentieth century. Conjure relied on magic as a supplement to religion in an unpredictable and unjust society, and in a far more overarching sense served as a commonly understood vehicle for envisioning the power to change the world.

Smith has also explained that black Christians often distinguished between imitating Jesus and emulating him, deeming that the latter would provide insight as to how Christ had effectively used his victimization to transform his oppressors.[38] Traylor's personal beliefs and practices are undocumented. His drawings provide no irrefutable answers, but in small ways, when seen as related groups of imagery rather than isolated works, they offer important clues about the artist's views and how they may have evolved over time, especially as the end of his life drew nearer.

In terms of factual leads about Traylor's imagery, Shannon, as mentioned above, conveyed remarks that Traylor made as Shannon best recalled them.[39] A few of those comments have thus far guided viewers' perceptions on Traylor's depictions of race. Shannon stated that one way in which Traylor drew white people was to leave their faces, paraphrasing Traylor, "just in outline, without tone." A second practice was to place his straightedge down the profile of the face. Shannon relayed Traylor's explanation: "When the stick touches the nose and the chin but it doesn't touch the lips, it's a white man. If it touches all three, it's a black man."[40]

This latter way of discerning race is a useful consideration but has too often been implemented as a rule rather than just one interpretive method—as Traylor described it. Traylor's "tool" for determining race was further defrayed as his drawings evolved over time, beyond that moment of commentary, and it is noteworthy that the artist's codes for race were neither formulaic nor entirely consistent. At times Traylor may have wanted to keep the reading of race ambiguous. The important distinction he made—namely, that he filled in black faces with tone rather than define the head solely with an outline—has generally been overlooked in discussions of Traylor's art, despite Traylor's frequent employment of that technique. In every artwork Traylor made, interplaying influences formed a matrix.

In *Untitled (Basket, Man, and Owl)* (PL. 21), the head of Traylor's figure is filled in—not with the black of the arms, legs, nose, and chin but with red. The blue torso may denote clothing, being a common color for garments, yet blue, with spiritual associations in African American culture, may also identify the man as a preacher or proselytizer, with hands raised and one finger pointing to the sky in a gesture of high emotion. Although the figure has an outlined head, the black limbs and facial features argue for his being African American; the red may signal anger, passion, or even a death foretold.

Owls, as in *Untitled (Owl)* (PL. 22), would become one of the creatures Traylor often illustrated. Beyond the comments he made about mules and cows, what we know

about Traylor's knowledge or ideas concerning specific animals is speculation. The widespread connotations of owls as harbingers of death, soul-eaters, or symbolic omens, however, are pervasive in folk cultures around the world, and Traylor likely drew them in this totemic context.[41] In the 1920s, sociologist and folklorist Newbell Niles Puckett collected folk beliefs of Southern blacks. Puckett explained that bird lore is a topic unto itself within black culture, second only to the larger genre of animal lore, and that owl lore dominates within bird lore. He cites the prevailing belief that the owl, master of the nighttime realm, is a known prognosticator of death. "In Europe and in Africa, the hooting of an owl near a house is indicative of the death of one of the inmates. This almost universal superstition is doubtless due to the nocturnal habits of the bird and his strange half-human cry, and possibly represents a remnant of the belief of the late Middle Ages that such birds were evil spirits coming to devour the souls of the dying. Thus, coming from a double source, it is no wonder that the hooting of an owl is regarded by the Negro as a death omen."[42] One folk story puts the mysterious properties of the owl into verse:

A ROOST ON THE RIM OF THE MOON

I seen a owl settin'
On de rim er de moon
He draw in he neck
An' rumple he feather,
An' look below at de world.

He shook de horn on he head,
Wall he big eye
An' laugh at de things
Above an' below
From he roost
On de rim er de moon.

He woke de fowls
In de barnyard
An' he dead stirred
In dey grave,
When he laugh
From he roost
On der rim er de moon.

An' de ole folks say
He were a dead man;
Dat evil did float
Wid de sound er he voice,
When he laugh
From he roost
On de rim er de moon.

An' de dead
In de graveyard
Raise up dey voice an' moan;
Dey laugh and de cry
At de sound er de owl,
When he laugh
From he roost
On de rim er de moon.

He stir up de fever an' chill
Wed he shadow,
When de sound er he voice
Pass over the swamp,
When he laugh
From he roost
On de rim er de moon.[43]

It is hard to overestimate the role of songs and stories during the folk-culture era of slavery and the decades that followed. These modes were not only unifying and entertaining but also effective for disseminating subversive stories under the guise of innocent animal tales. Various scholars have traced the evolution of African folk heroes to their American cousins: the African Jackal became Fox or Coyote, Rabbit replaced Hare, and Terrapin was Tortoise. In America the villainous Hyena was recast as Wolf, Fox, or Bear.[44] Alan Brown, who chronicled the lore that Ruby Pickens Tartt collected in the 1930s on Southern black culture for the WPA, noted, "The survival of folk tales into the twentieth century is due in part to the ignorance of Whites regarding their true meaning. While the masters of slaves discouraged the tribal languages and customs, they tolerated animal stories, thinking that they were merely a harmless way to entertain children. Actually, though, the folktales were projections of the personal experiences and dreams of the Negro slaves."[45]

For African Americans the shift in their way of life—from one predominantly centered on work, church, and fireside tales of the farm to a more urban lifestyle—was slow. Sociologist Charles S. Johnson explained that for such cultures, collective history "exists for the most part in the form of unrecorded ballads and legends which, with its folk lore, constitutes a tradition that is handed down from generation to generation by word of mouth rather than through the medium of the printed page."[46] People on the smaller, rather isolated, and less worldly plantations often adhered more tightly to local lore and superstitions than did those in places where folks came and went frequently. After Emancipation many freedmen didn't move far from where they had been enslaved. Some were enticed to stay on the plantations of former owners by being given their cabin to own; for many, a known dynamic was preferable to an unknown one. One formerly enslaved man told Johnson that his decision to stay near the only land he had ever known was driven by familiarity as well as fear, by the codes that restricted the liberties of blacks in the South. "I've never been out of the state. Reason is, I wouldn't know what way to go.... You got to be loyal, 'cause you know this is a white man's country."[47] Many African Americans did move to urban areas and black enclaves after Emancipation, but many remained close to their network of family and adopted kin.

Folkways are never static and evolve with those who participate in them. Yet the old ways were likely more engrained upon the formerly enslaved born in the nineteenth century than on the younger generations who, as they became increasingly educated, in varying degrees eschewed the traditions and beliefs of their parents and grandparents. In 1947 the late American ambassador to Niger, Samuel C. Adams Jr., observed, "This former world of experience no longer exists, and this means that the condition which once fostered the development and maintenance of the folk literature is less effective. This has come about as a result of the breakdown of isolation, increase in literacy, in the growing importance of the press and other printed matter; the awakening interest of people toward the movies, the radio, and general city ways."[48]

The complex folk religion and amalgamated beliefs rooted in a disempowered plantation life played potent if intangible role in Traylor's art. J. G. Traylor was a

Baptist preacher, and his brother, George Hartwell Traylor, would have been of the same faith. Enslaved people usually had their own spiritual gathering place, a brush arbor or some such dedicated space, and they may also have attended the churches of their owners. Overtly, at least, they adhered to the same faiths as the members of the white household. Regardless of outward-facing Christian structures, enslaved African Americans regularly comingled American religious practices with those handed down through family—vestiges of the old world, an African homeland that united African Americans of diverse heritage.

Scholar of African American religion Albert J. Raboteau wrote: "The powerful emotionalism, ecstatic behavior, and congregational response of the revival were amenable to the African religious heritage of the slaves, and forms of African dance and song remained in the shout and spirituals of Afro-American converts to evangelical Protestantism. In addition, the slaves' rich heritage of folk belief and folk expression was not destroyed but was augmented by conversion."[49] Conjure, hoodoo, and root medicine each describe an intricate matrix of magic, medicine, morality, the supernatural, and spirituality, a cultural fabric that encompassed the Alabama of Traylor's time just as it had in earlier days (fig. 43). While the practices were widespread, their popularity ebbed and flowed, as did the common cultural awareness of them.[50]

Conjurers, or trick doctors—those who practiced with root medicines, herbal poultices, and charm packets (sometimes called mojo bags or hands, conjure bags or balls, bottle spells, or some such combination) meant to control or redirect a fate, were arguably more popular after the Civil War than in antebellum days when planters had financial incentives for having doctors attend to the care of their enslaved laborers. According to folklorist F. Roy Johnson, "black magic conjure" was popular among slaves who sought revenge on enemies. "White magic conjure" was more popular after the war. "When freedom came, the Negro, inexperienced at planting his own economy, as a rule was poor. He turned to the all-powerful conjure doctor with his roots, herbs, and spectacle to avoid medical services."[51] Conjurers were sometimes described as two-faced, or two-handed; performing a charm was "left-handed work," and counteracting one was "right-handed."[52]

Historian of African American religion Jeffrey E. Anderson states that in the early to mid-twentieth century, scholars debated the degree to which African conventions lived on in America, but over time "those arguing in favor of substantial African survivals prevailed." He wrote: "Nineteenth-century hoodoo was a result of creolization and syncretism, that is, the mixing of multiple African,

FIG. 43 Map of Alabama showing "Conjure Country," from Carl Carmer, *Stars Fell on Alabama* (1934), illustration by Cyrus LeRoy Baldridge

European, and Native American cultures, which together resulted in a form of magic unique to the American South. Ultimately, the origins of hoodoo or conjure lie in the traditional religious beliefs of the land from which the slaves' ancestors hailed."[53]

The varying degrees of influence coming from African societies, European cultures, and American Indian tribes in different regions in the United States ultimately must be traced from plantation to plantation; they all played important roles. But Anderson notes that chief features of conjure in states settled by the French and Spanish on the Gulf Coast and lower Mississippi region derived from the Fon, Ewe, and Yoruba, whereas areas settled by the English on the Atlantic coast were more significantly shaped by what was then the Kongo—the largest single contingent of western central Africans captured and brought as slaves. The Mande were more evenly distributed. Other African tribes including the Ibo (or Igbo), the Akan, and the Ga-Dangme were also influential in the fusion practices of African American conjure or hoodoo.[54] Voodoo (often confused with hoodoo), derived from Haitian vodou and African vodun, remained a distinct religion in Louisiana.

Although some Christian blacks maintained that magical practices were at odds with doctrine, boundaries between Christianity and hoodoo were more often fluid. The words of one slavery-era song say, "Keep away from me hoodoo and witch; Lead my path from de poorhouse gate; I pines for golden harps and sich; Lawd, I'll jes' sit down and wait. Ole Satan, am a liah an'a conjure too; Ef you don't mind out he'll conjure you."[55] Scholars agree that the preacher and the "white magic" conjurer might be the same person—advocating for love, health, peace, and prosperity. On the other hand, someone doing Satan's work might be known for "crossin' up folks," performing a dark magic that brought about illness or harm.[56]

Puckett wrote: "The Negro's intense beliefs in devils and angels and in secondary spirits of all kinds gave him sort of a polytheistic Christianity. Jesus was anthropomorphic; represented in a Negro spiritual as coming along riding 'wid er rainbo' cross his shoulder.' The conjure doctor who sided exclusively with good spirits in the fight against evil often was a church leader."[57] F. R. Johnson asserted that the root doctor and church leader might be the same person: "A good herb doctor might be called a root doctor and might 'cut cards' in conjure [tell fortunes and assess a person's problems]; many extended leadership into the church."[58] In 1889, Philip Bruce argued that hoodooists ultimately held more sway over local communities than preachers, because their work was based on fear.[59]

Hoodoo was one way to assert power in a world in which slavery and Jim Crow had undermined blacks at every turn. Its influence permeated all levels of society and even became an integral part of folk legends; men told their children stories of outlaw conjurers, and women spoke of magical animals. Railroad Bill, a folk hero based on the escaped murderer Morris Slater who eluded the law for years, was said to be a conjurer and shape-shifter—transforming into animals to break free time and again. Old John was another ex-slave of folk legend said to be a conjurer.

Many argue that the most famous conjurer in folklore was the character Rabbit. Emanating from the stories of an African trickster rabbit called Leuk, tales of Rabbit

in America came to span the Gullah of coastal Georgia, South Carolina, and part of Florida to Missouri and throughout the South. Rabbit became popularly known as Brer Rabbit (also Br'er, Brother, and other variations) when Joel Chandler Harris collected and adapted the stories in the 1870s, then published them the following decade. Rabbit was iconic for being powerless but smart and fleet of foot. For the enslaved, he was heroic for outwitting his oppressors and surviving against the odds. Poet, writer, and historian Arna Bontemps contrasted Brer Rabbit to his African predecessor, writing, "No hero-animals in Africa or elsewhere were so completely lacking in strength. But the slaves took pains to give Brer Rabbit other significant qualities. He became in their stories by turn a practical joker, a braggart a wit, a glutton, a ladies' man, and a trickster. But his essential characteristic was his ability to get the better of bigger and stronger animals."[60] Rabbit had a dark side, too. Bernard Wolf has observed, "The Negro slave, through his anthropomorphic Rabbit stories, seems to be hinting that even the frailest and most humble of 'animals' can let fly with the most blood-thirsty aggressions."[61]

Anderson argues that folk heroes and conjurers served a vital function. "Even if one assumes that their powers were wholly spurious, their reputed supernatural aptitude had powerful benefits for those who believed. They gave nineteenth-century blacks hope in lives over which they had little control.... It is not surprising that conjurers rose to such prominence in their communities."[62] F. R. Johnson concurs that hoodooists charged for their services and well understood the potent mix fear, hope, and effective marketing. Reputation was key. Numerous accounts tell of "quack herb doctors" who were punished by their clients; in other cases, conjurers were so feared and revered they could rest on name alone. Silvia Witherspoon, once enslaved, spoke about an Alabama man she knew who could "conjure de grass an' de birds, an' anything he wanted to." She went on to say that people from the area "useta give him chickens an' things so's he wouldn't conjure 'em."[63]

In urban areas hoodoo became popular enough to shape a commercial trade in the early 1900s, including mail-order establishments that sold roots, medicines, and ready-made charm packets (fig. 44). In the 1930s and 1940s, hoodoo storefront shops existed in many towns, almost always located in the heart of the African American neighborhoods. Some marketed themselves as homeopaths, pharmacies, or candle shops. By World War II the mail-order ventures were booming, but at the local level the trade had become depersonalized, and the commodity culture put traditional hoodoo practitioners out of business. Many of the new merchants, local or mail order, were not conjurers themselves, nor were they predominantly African American.[64] They replaced natural ingredients, including roots, plants, and animal parts, with oils, soaps, and incense, and some vendors were known to sell entirely spurious goods, such as dyed water, or motor oil thickened with dirt. How-to books and catalogues further commercialized what were once tradition-based practices and undercut local culture.[65]

Returning to *Untitled (Basket, Man, and Owl)* (PL. 21): Traylor's use of color and the details of the forms he depicted offer a compelling case of the drawing's allusion to a preacher warning about death. The red face of the gesticulating man could have any

number of meanings, yet the redness of his head and not his facial features is deliberate. As stated above, the angry red face may portray an impassioned preacher, but Traylor may also be alluding to correlations with red that stem from his African forebears, namely, that it is the color of birth and death, sunrise and the sunset.[66] Michael A. Gomez notes another important connotation for red, which is that the intense color carried strong associations of trickery or deceit for successive generations. The author explains what he terms "red cloth tales"—the so-called capture accounts (or stories) dating back generations among the enslaved, which evolved into overarching metaphors of betrayal. Such stories describe red cloth (flannel or bandannas) as a desirable trade good used to trick Africans to come aboard slave ships and, even more treacherously, a lure utilized by African agents who bartered with the lives of their fellow Africans.[67]

Two separate oral traditions emanated from the red cloth tales—one for the white people who enslaved Africans, and the other for the African trader, for whom African Americans "reserved unique and specific condemnation."[68] Gomez and the historian Sterling Stuckey view the "red cloth tales" as critical elements in the journey of enslaved Africans from tribal ethnicities toward a vital African American aggregate identity. They argue that "capture stories" remained powerful and were handed down through the generations, with the effect of creating unity. "The white man was found guilty of guile, guilty of violence, guilty of horrors unimaginable. This is the fundamental truth that the African-born wanted their offspring to understand about the initial capture. This, the red cloth tales teach, is the underlying significance of the slave trade."[69]

In practice, red cloth signaled trickery or deceit, but it became a favored color for charm packets worn as bags or wristbands for protection from enemies or as a

FIG. 44 King Novelty Co. Catalog No. 93, 1948

spiritual prophylactic.[70] Gomez and Stuckey both assess the lore pertaining to the African agents who betrayed their fellow countrymen. The tales describe an African king or chief who sent thousands into bondage and was condemned to eternal wandering as "King Buzzard": "An' when he dead, dere were no place in heaven for him an' he were not desired in hell. An' de Great Master decide dat he were lower dan all other mens or beasts; he punishment were to wander for eternal time over de face er de earth.... Dat his sperrit should always travel in de form of a great buzzard, an' dat carrion must be his food."[71]

Blue is widely documented as a spiritually shielding color, an African association that survived in America. Throughout western and west-central Africa, blue beads were considered protective charms and in some cases were as highly valued as gold.[72] The use of blue on Southern houses as a deterrent is so pervasive the paint company Sherwin Williams discusses "haint blue" on its website, noting that porch roofs, window trims, and doorways employ the color as a symbolic means of extending the daylight and keeping evil spirits (haints, haunts, or ha'nts) from entering the premises.[73] Traylor would use red and blue media with frequency and specificity in the years to come. His works in blue are greater in number and have garnered more attention, but those in red indicate a clear awareness that the intense hue carried meaning.

The basket shape in *Untitled (Basket, Man, and Owl)* seems more like a platform than a vessel, given the extended piece on top done in red and angular, like an anvil or altar. The plantlike form at the top of the structure—a fusion of a tree and a wildly gesturing person—is the hardest to decipher of all the elements. Absent Traylor's own explanation, we can only wonder about his intentions. But the anthropomorphic plant forms recur in other images, many of which Shannon chose for the exhibition mounted at the New South, and together they indicate something dogging Traylor's thoughts.

THE FIRST EXHIBITION AND RELATED WORKS

In February 1940 the group of artists who organized as the New South mounted a show of Traylor's art. The works they selected for *Bill Traylor: People's Artist* speak volumes about Traylor's evolving skill, style, and subject matter. Photographs taken by Jean and George Lewis document around seventy-two installed artworks, plus three that appear as representations within Shannon's mural painting. The New South newsletter for February 1940 states that Traylor's total artistic output at the time was about one hundred works, a fact that is contradicted in the hand-printed booklet that accompanied *Bill Traylor: People's Artist* (part 1, fig. 26), in which Shannon wrote, "Since our wall space is limited, only part of his several hundred pieces can be shown; but an attempt has been made to select works representative of his various techniques and subjects."[74]

The Lewises' photographs serve as the most comprehensive record of Traylor's artistic evolution in his early days as a full-time artist. They offer vital information on Traylor's escalating skill in the year leading up to the exhibition as well as his range of subjects. Perhaps most interestingly, they reveal that Traylor's trajectory was less predictable than might be supposed. He was not plodding along learning realism or

figure drawing but rather, ambitiously working out an abundance of ideas at once, both representational and abstract. Traylor's earliest pencil drawings are discernable by cautious, rudimentary marks. Pictures done in pencil and colored pencil appear to come next, increasing significantly in confidence and compositional complexity. Water-based poster paints (opaque watercolors) opened a new frontier for Traylor when they became available to him. Some of the early painted pieces show a hesitancy of mark making or a dryness in the paint, qualities that distinguish them from later, more free-flowing works. From the time Traylor took up paint, he set off on an unrelenting pursuit, tackling several fronts either in tandem or rapid succession.

Shannon has provided the most specific information about Traylor's works of art from this time; his notes about his observations are illuminating, and his remarks—some of which reveal identities of people portrayed or record Traylor's comments on a given work—are invaluable as the sole communication from the artist. It should be understood, however, that not all that Shannon said or wrote was entirely accurate. The location he gave for Traylor's birth and the year he gave for Traylor's death were incorrect. The dates Shannon noted on some artworks, and the annotations he made approximating Traylor's remarks about those pieces and others, seem generally accurate but may or may not be precise. Moreover, Shannon's categorical frameworks and added "titles" were subjective to his point of view and came some four decades after he

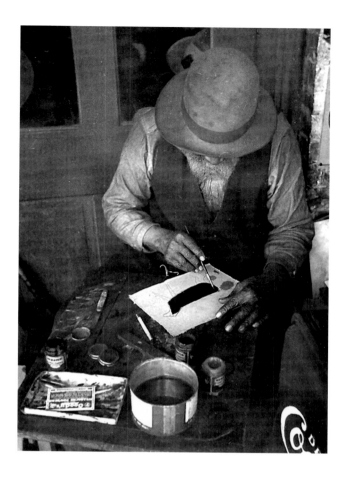

knew Traylor. By several accounts Shannon was highly particular about how the story of Traylor was told; he wanted it to reflect well not only on Traylor but also himself, which may have affected how or what he presented.[75] Shannon's acumen in appreciating the art and saving it, however, was exceptional, and some of his perceptions or observations, as a fellow artist—such as the fact that Traylor sometimes dwelled on a cluster of works before moving on to another subject, as the works indeed suggest—are especially valuable.

The Lewises photographed Shannon as he was painting his New South mural in the fall of 1939, and their images of Traylor at work (figs. 45–47) were likely taken around the same time. In them, Traylor sits in the same place as he does in Shannon's photographs (above, figs. 38–41), by the pool room. He wears the same clothes he wears in Shannon's photographs, but with a vest and a hat, suggesting that warm weather has begun to chill; his cane rests in the same doorway. Pieces of cardboard are on the ground; visible among them is an advertisement or box top for the candy bar Baby Ruth. He uses his drawing board but has now acquired a small table—on which sit several jars of paint, a can of water, and the lid of a small box that contains his knife—and extra brushes and pencils. A scrap of cardboard in the box reads "Goody's Headache Powder." Traylor is painting a miniature black cow; in views that look down on the painting from above, Traylor's pencil outlines that underlay the black paint are visible.[76]

Alone or in conjunction with the photographs of the artist, the Lewises' installation shots of *Bill Traylor: People's Artist* help contextualize Traylor's "early" work, that is, the works predating February 1940. Moreover, the exhibition photographs reveal arrangements of art that are guided by Traylor's imagery and subject matter, which is a useful way to discuss them here. The following thematic sections describe the art in the exhibition as the works appear on the gallery walls in the Lewises' photographs. Other, related works dating around 1939 or 1940 are also explored as organized by theme below.

ANIMAL ICONOGRAPHY The room constituting the New South gallery was not large, but the installation was dense. One wall featured animal paintings, including one of a man on horseback (fig. 48, showing **PLS. 23–25**, among others). Notable for being an exotic creature was a black elephant, which Traylor likely saw in a parade or reproduced on a poster. A painting of a cow and another of a bull revealed what would become Traylor's iconic style of monochromatic silhouettes, while a second cow, painted with spots (**PL. 23**; in fig. 48), demonstrated a more realistic approximation of a hide, although it was not a

FIGS. 45–47 Bill Traylor painting on Monroe Street, Montgomery, Alabama, ca. 1939; photographs by Jean and George Lewis. Courtesy Caroline Cargo Folk Art Collection (Cazenovia, NY)

feature he revisited much thereafter. In *Turtle Swimming Down* (**PL. 24**; in fig. 48 in a prior orientation) a terrapin plunges downward, its legs and neck outstretched; in a nearby painting, another terrapin is similarly pictured from above, as if it, too, is suspended in water.[77] Of note on this wall was a small scene much like those identified as dating to the early summer of 1939. The crude drawing shows a snake chasing away a slight, ill-defined, turtle-like creature from her precious egg. The predator/prey narrative would foreshadow another of Traylor's abiding themes as a parallel of white and black relations in the South.

A painting of a bold yellow bird, *Yellow Chicken* (**PL. 25**; in fig. 48), stood out for its singularity, especially regarding its electrifying yellow paint, a color that never became

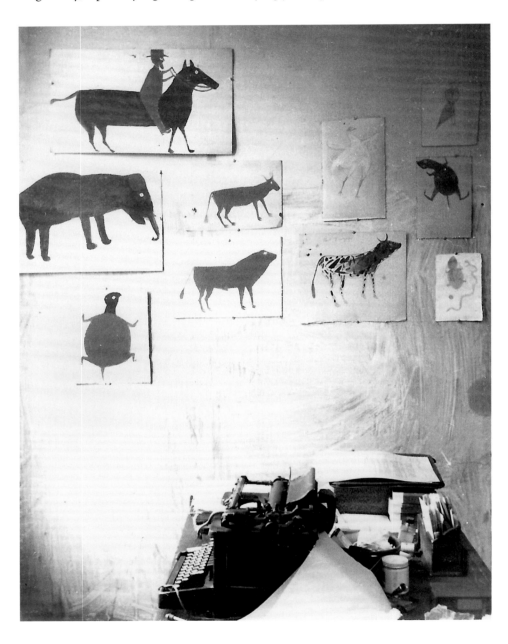

FIG. 48 Installation view of *Bill Traylor: People's Artist*, exhibition at New South Gallery, Montgomery, Alabama, February 1940, showing works including pls. 23–25; photograph by Jean and George Lewis. Courtesy Caroline Cargo Folk Art Collection (Cazenovia, NY)

common in Traylor's body of work. The yellow paint was likely scarce, and his use of it in this potent image conveys a clear understanding of its visual power. The bird is a hen, with a plump body, large thighs, and undersize wings. Its pencil-drawn figure is visible beneath the sparingly applied paint, exposing wide-open eyes and bony feet and conveying the sense that the paint was added, somewhat dryly, over a drawn form. The beak and legs are tinged with streaks of red, highlighting the chicken's wattle and red-toned skin. Although the chicken is highly animated, the closed mouth contradicts a sense of panic. Its wings are raised and spread wide; the lilt in its hips conveys a stance that is more humanlike than avian.

Traylor's intense bird seems to be dancing with flourish, glorious in bright finery. Her upright position and broad strut suggest that Traylor was employing his skills as an allegorist, that the chicken represents something or someone beyond its visage. Both "bird" and "chick" were English-derived slang referring to women, but "bird" as a metaphor for women also has African roots.[78]

A case for Traylor's use of birds as allegorical stand-ins for women becomes increasingly compelling in drawings such as *Two Figures with Pitchfork and Birds* and *Untitled (Figure Construction with Kneeling Man)* (PLS. 26, 27). In these energetic, dance-like scenes, men fight or tussle while birds rest on their heads—women on their minds. The bird might alternately, even simultaneously, embody the idea of freedom, a theme Traylor conveyed time and again with abundant allusions to birds taking flight or appearing unbound by gravity, as in *Bird* and *Blue Bird* (PLS. 28, 29).[79]

Blues songs often describe skin tones as colors, such as "high yellow" or "Macon brown."[80] Yellow embodied important connotations in terms of skin color and class. People referred to as "high yalla" had some degree of European ancestry but were considered categorically black because of the "one drop rule."[81] Black women with this distinction sometimes straddled racial communities; whites barred them from full acceptance, and blacks often resented them. The word "high" connoted (for both blacks and whites) a supposedly superior social class that afforded privileges to African Americans with lighter skins. The term "high yalla" was and still is commonly known and has appeared in myriad songs and stories throughout the twentieth century. Even Harlem's famous Cotton Club had a "high yellow hiring policy for chorus girls," which deemed black dancers with light skin more appealing to its all-white audience. Traylor was likely familiar with the term and surely knew women who were referred to by it. Given the power and charged presence of *Yellow Chicken*, it reads as a symbolic portrait of sorts, either of a person or the idea of being free as a bird.[82]

Chickens were a valuable commodity, and Traylor would depict them many times, including in complex scenes in which the chicken was a prize worth fighting for. Poultry could feed the family with eggs and meat and be used as currency when needed. The stereotype of African Americans as chicken thieves took root during slavery but became pervasive during Jim Crow as minstrel "colorists" mainstreamed these racist tropes through postcards and cartoons of black men sneaking up on chickens in hopes of obtaining a feast. Effectively dehumanizing the men, the insidious images used the pretense of humor and the desperation of poverty to demean and

demonize. Booker T. Washington, born about three years after Bill Traylor, relayed the sad truth behind such stories:

> One of my earliest recollections is that of my mother cooking a chicken late at night, and awakening her children for the purpose of feeding them. How or where she got it I do not know. I presume, however, it was procured from our owner's farm. Some people may call it a theft. If such a thing were to happen now, I should condemn it as theft myself. But taking place at the time it did and for the reason that it did, no one could make me believe that my mother was guilty of thieving. She was simply a victim of slavery.[83]

ACTION SCENES A photograph of one of the longer gallery walls in *Bill Traylor: People's Artist* (fig. 49) shows over fifteen works, three or four of which are overexposed and rendered illegible by sunlight. The works are all complex scenes, of the type foreshadowed in the tiny predator/prey drawing of the turtle losing her egg to a snake. They are generally large and ambitious, many with multiple vignettes on a page. Significant in this photograph is the large *Blacksmith Shop* (PL. 10) with its inventory of tools and array of activities going on. Next to it is another striking work, *Untitled (Event with Man in Blue and Snake)* (PL. 30). Shannon gave such layered scenes of disarray the moniker "Exciting Event." Like *Blacksmith Shop,* this drawing in colored pencil and pencil points at liquor as a reliable ingredient for trouble. In this case a man with a liquor bottle flees a pursuer yielding a hatchet or mallet, a hound at his side.

Scenes of men drinking, behaving drunk, or being chased, presumably for stealing liquor, became another of Traylor's recurring story lines. Alabama native Margo Russell's parents were born in the first decade of the twentieth century; her grandparents would have been about Traylor's age, her parents and aunts and uncles closer to the ages of his children. She reflected on own her upbringing in the mid-twentieth century, which took place just under forty miles from Traylor's home ground and in many ways recalled an earlier time. "There were squirrel hunts, coon or possum hunts, all mixed with laughter, dancing, quarrels, terrible fights, and times when people got real drunk on corn liquor. These people were God-fearing, hard-working, hard-living folk."[84]

Russell's memories seem to overlap with Traylor's, which he has pictured as complex altercations hovering between humorous and deadly. In the drawing of the man fleeing with his bottle, two women raise the alarm. One, old and stooped, shakes her cane in his direction, while the younger one runs after him, swinging a stick. This drawing may be the first in which Traylor's enigmatic man in blue appears.

Here, the man dressed in solid blue sidles quietly off scene while others are occupied with the liquor thief or drunk man. He is carefully drawn, stooped with age, and entirely clad in light blue except for his black hat, shoes, and cane. His face, except for his blue eye, is also black, carefully filled atop of a blue underlayer as if done as a second thought to clarify the man's race. His clothes are the only pop of color in an image drawn otherwise in graphite and black pencil. Traylor's choices were deliberate and exude a sense that the blue garments lend protection or invisibility to the man

who calmly slips out of an altercation. A large serpent underlies the goings on, per-
haps connoting the latent danger of a story line that might otherwise be taken as
lighthearted or funny.

A nearby drawing is largely devoted to the topic of drinking and the chaos it
brings. In *Untitled (Scene with Keg)* (**PL. 31**; in fig. 49) is a large liquor barrel with a tap at
the bottom. A bird perched atop the keg seems to be swooning with the effects of the
powerful drink, and the ensuing scene is chaotic. Several men, presumably the makers
of the moonshine, carry clubs and go after people who are drinking it, suggesting
theft or impropriety. The entire scene describes a breakdown of civility brought about
by liquor. Traylor himself once commented on the impact liquor had upon his own life
saying, "What little sense I did have, liquor took away."[85]

THE HOUSE Together with chase scenes and drinking troubles, another of Traylor's
recurring themes featured on this wall were scenes taking place at a house. For Traylor
the house was a setting for high drama. Traylor once explained to Shannon that he
had been trying to figure out how to depict figures inside a house, and many subse-
quent pictures attest to those efforts.[86] Over time Traylor's works employing the house
at center stage captured his evolution as an artist better than any other thematic vein.

FIG. 49 Installation view of *Bill Traylor: People's Artist,* exhibition at New South Gallery, Montgomery,
February 1940, showing works including pls. 10 and 30–32; photograph by Jean and George Lewis.
Courtesy Caroline Cargo Folk Art Collection (Cazenovia, NY)

Traylor consistently drew houses raised up on brick legs or "piers," a type of construction that allowed airflow under the house to combat termite damage and moisture rot and reduce access for vermin. All the known buildings on the George Traylor plantation during the years Traylor lived there were built in this traditional fashion.[87] Traylor's houses are not all identical in shape, but many are similar.

The plantation house belonging to the George Traylor family was not two stories, as many of Traylor's images of houses appear to be, according to Kendall Buster, the great-great-granddaughter of Margaret Averyt and George Hartwell Traylor, who remembers the house from her childhood. Buster explained, "The house was one story but had a pitched roof that allowed for an attic. As I recall there were steps to the attic, not a pull-down step, but a proper stairway somewhere at the end of the hall." Photographs (such as fig. 50) show that it was raised up with brick posts covered in wooden cross lathe; steps led up to the front and back doors. "It had a very open feeling," Buster recalled. "Once you exited the long hallway you were outside on a back porch that had little rooms leading off of it. This was very typical of the houses of that era.... I think that they began as open center spaces with rooms off both sides that were later roofed off and closed up. But the back had, as I recall, a way to exit the kitchen straight onto the back porch."[88]

Traylor's houses are often drawn with a ladder leading up to the roof or attic. His inclusion of ladders might overtly refer to historic rural conventions of keeping ladders propped up in case of fire (fig. 51). But the storyteller in Traylor made great use of them as a device with which to carry scenes from the foreground into the house interior and to the rooftop—where high intrigue often seems to play out. Considerable folklore casts ladders as symbolic connections between heaven and earth, or life and the afterlife. Whether Traylor employed them as a structural tool or a connotation

FIG. 50 George Hartwell Traylor's home, built ca. 1835, Lowndes County, Alabama; the house, no longer extant, photographed ca. 1947

of something deeper is uncertain, but he likely understood the meaning of the ladder and climber, who symbolically ascended toward heaven. Such ideas span African tribal and Abrahamic religions.

"Jacob's Ladder" refers to a story in the Book of Genesis in which Jacob dreams of a ladder descending toward him on earth and ascending to heaven. For this reason, the atmospheric phenomenon of sunbeams streaming through gaps in the clouds toward earth are often called Jacob's ladders. African and African American art historian Robert Farris Thompson has recorded the ladder as a symbol for Tempo, a Kongo-derived spirit whose name means violent wind or hurricane.[89] Historian and author Betty M. Kuyk identified another African connection, the Yoruba practice of placing small ladders on altars to Olokun, the god of the oceans. The ladders allow the believer to metaphorically step across oceans—from one world into the other, from life into the afterlife.[90] The ubiquitous ladder picks up again in a Masonic allegory, wherein a person figuratively works to ascend the rungs of faith, hope, and charity.[91] African art historian Herbert M. Cole relayed a proverb from the Akan people that most succinctly conveys the encompassing symbolism of ladders: "Everyone climbs the ladder of death."[92]

One painting on the same long wall (fig. 49) shows three people on a houseboat; unique in Traylor's oeuvre, it is not a conventional "house" scene but nevertheless conveys an abode or shelter. The figures are not fishing, as one might expect, but instead are pointing and looking about, as if in uncertain surroundings. The singularity of the setting—the covered boat—likely signifies that the story was fleeting in Traylor's mind, in contrast to those he revisited time and again.[93]

Conversely, house scenes such as *Red House with Figures* (**PL. 32**; in fig. 49) are iconic. Traylor used the ample space on this plain rectangular board to create at least

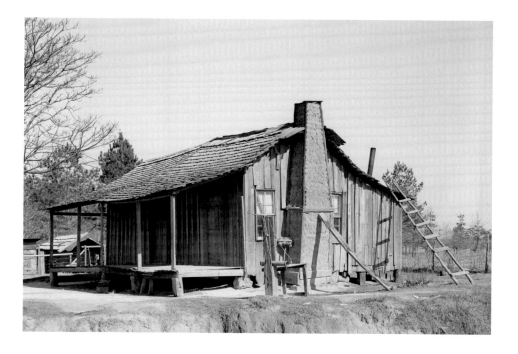

FIG. 51 Russell Lee, *Slave cabin in Taylorsville, Mississippi*, 1939. Library of Congress, Prints and Photographs Division, Washington, DC

six concurrent commotions taking place on or around the house. At this stage in his artistic development, Traylor drew the house as an opaque square form; no people are inside, but the structure anchors a hive of activity. On the back of the artwork, Shannon inscribed Traylor's explanation: "Old lady fussed at him so much he came out in the yard to read and she come after him. The little girl listened to what she tell him."[94]

Traylor's intriguing remark pertains to the central scene. The issue of racial depictions in *Red House with Figures* arguably departs from the methods Traylor once described, as mentioned above. The most curious figure is the man in the chair, who fled the confines of the house to read outdoors. He alone has a head unfilled by tone or color, a feature that might identify him as a white man. But it more likely refers to his activity, as it is not his entire head and face left uncolored but only the top part, just behind the eyes, that is, his mind. The woman and girl who pursue him have brown faces, but the girl's long straight hair makes the family's race ambiguous.

Having told Shannon that the man "came out in the yard to read," Traylor shows the reading man holding a book with the letters *A* and *B* on it, at odd orientations to each another. On multiple occasions Traylor employed the book as significant possession of literacy, drawing either *AB* or *ABC* on a book's cover, the latter seen in *Untitled (Woman in Blue Holding an ABC Sign)* (PL. 33). Traylor's books symbolize an awareness of the power literacy afforded black people. As a man who never became literate but watched that force carry his children and an entire generation forward into the twentieth century, he certainly would have ruminated on the tool that had been denied to him.

The man trying to read sits amid noisy discord. In the upper portion of the picture, what appear at first to be three men in identical brimmed hats are trying to physically control others—at the ladder, on the roof, and at the right side of the house. On closer inspection it seems the three men may be just one—shown in sequenced moments of action, or synchronic time. A fourth man is shown in the lower half, down the left side of the page, near the women; he is distinctly dressed and older, walking with a cane. The older gentleman's hat is unlike those the younger men wear; it looks more like a Civil War billed slouch hat or kepi, and his long jacket further alludes to a military style; his clothes and stance set him apart from the younger folks. Other, smaller men constitute a scene at bottom right.

Given the urban backdrop of Traylor's life in Montgomery, his house images likely draw from his experiences on the plantation and the events that played out there over decades. The scenes contrast significantly with his representations of the well-dressed folks and distinctive individuals he would have seen in Montgomery. In *Red House with Figures* one highly active authoritative man is seems to be everywhere at once. He investigates a scramble with varmints on the ladder and accosts a fleeing youth (portrayed with a slim body and proportionally larger head than the adults have) on the rooftop and simultaneously at the base of the house. The scene at the bottom may feature the same person; shown in synchronous animation, he pursues and causes the downfall of a man stealing liquor. Overhead, birds fly away.

Today, whatever specific stories Traylor might have been telling are lost. Yet the elements he chose to repeat time and again, and the details he included with regard

to accoutrements, physique, gesture, emotional dynamic, and time and place, add up significantly as the works are examined comprehensively. The house, or more generally an inhabitable structure, provides an apt metaphorical parallel to the human mind, an idea that has been explored by a number of scholars. Traylor's dogged attention to the house as the anchor of memorable events indicates that it was a potent container for him.

The French philosopher Gaston Bachelard called the house "our first universe, a real cosmos in every sense of the word." He argues that the house is a place we experience not solely in day-to-day reality as one's corner of the world, but also hosts and shelters our memories as we return to them indefinitely. "Through dreams, the various dwelling-places in our lives co-penetrate and retain the treasures of former days."[95] And whether the memories are good, bad, or a complex fusion of the two, they dwell forever in the rooms and spaces we have known and are vestiges that shape identity. For Traylor another location hosts even more-haunting memories. In equal measure to houses, Traylor employed trees as the host site for memories: a less inhabitable space for humans but not a less dramatic one.

BLACK ICONS, SELF-PORTRAITS, AND FAMILIAR PEOPLE Another photograph from the *Bill Traylor: People's Artist* exhibition (fig. 52) shows twenty-three works tightly fit onto a short wall; some are attached directly to a window in the wall, and two rest on the sill. The paintings are organized into three sections; those with conventional subjects are in the center. A pair of boxers is a focal point. Traylor depicted boxers on several occasions, revealing his awareness of popular culture—particularly as they pertained to African Americans. Joe Louis, known as the "Brown Bomber," competed between 1934 and 1951

FIG. 52 Installation view of *Bill Traylor: People's Artist*, exhibition at New South Gallery, Montgomery, February 1940, showing works on a short wall with a window, including pls. 1, 20, 21, 36, 37, 42, 44, and 47; photograph by Jean and George Lewis. Courtesy Caroline Cargo Folk Art Collection (Cazenovia, NY)

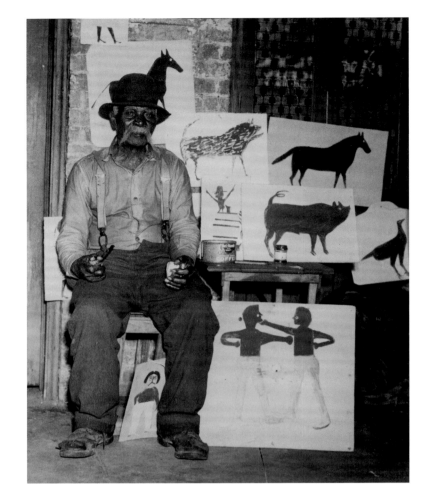

but was the world heavyweight champion from 1939 to 1949 and widely regarded as the first African American to reach the status of hero across the nation. Louis, moreover, was an Alabama native, born into poverty in rural Chambers County, although he lived most of his life in Detroit. He defended his champion title thirteen times, and many saw him as an icon of liberation. The renowned poet Langston Hughes recalled his impact: "Each time Joe Louis won a fight in those depression years, even before he became champion, thousands of black Americans on relief or WPA, and poor, would throng out into the streets all across the land to march and cheer and yell and cry because of Joe's one-man triumphs. No one else in the United States has ever had such an effect on Negro emotions—or on mine. I marched and cheered and yelled and cried, too."[96]

Traylor didn't often depict icons, and he never said his boxer paintings such as *Boxers in Blue* (**PL. 34**), a similar work to the one in the New South show, were of Louis. Yet it was Louis whose image appeared in newspapers across the country (fig. 53). The poet Maya Angelou recalled listening to a rematch for the world championships in 1938 on the radio. When it looked like he might lose, she wrote in one of her autobiographies (1969), "My race groaned. It was our people falling. It was another lynching, yet another black man hanging on a tree.... This might be the end of the world. If Joe

FIG. 53 Joe Louis and Max Schmeling boxing at Yankee Stadium, The Bronx, New York, 1936

FIG. 54 ACME News photo for unknown publication of Bill Traylor on the street, alongside *Boxers in Blue* (pl. 34) and other works, June 6, 1940; photographer unknown. Collection of Judy A. Saslow

lost we were back in slavery and beyond help." But when things turned around, she wrote of the bursting pride: "Champion of the world. A Black boy. Some Black mother's son. He was the strongest man in the world. People drank Coca-Cola like ambrosia and ate candy bars like Christmas."[97]

Boxers in Blue appeared alongside Traylor in a newspaper photograph taken about four months after the New South exhibition, in June 1940 (fig. 54).[98] Other African American sports heroes were noteworthy, but none of them encapsulated the racial battle—with physical confrontation—in precisely that same way that Louis had. A unique drawing (PL. 35) resembles another black sports hero, runner Jesse Owens (fig. 55). Owens set world records for speed in 1935 and went to the Olympics in 1936 in Berlin, aggravating Nazi leader Adolph Hitler when he won four gold medals. A more compelling model for the runner's shape that Traylor mirrored, however, was one that was pictured on a Curtiss Candy box for Jolly Jacks Candy (fig. 56). Traylor regularly drew on the backs of discarded candy boxes or advertisements; this graphic for Curtiss Candy appears on the back of one of his paintings from 1939, *Untitled (Construction with Lamps (AKA Lamps on Mantelpiece)* (PL. 54).

Two drawings in the New South exhibition, on the short wall with the window (fig. 52), depict couples arguing.[99] In one, *Woman with Umbrella and Man with Crutch* (PL. 36), the man has half of one leg amputated and uses a crutch. Traylor may have known the couple depicted here from his neighborhood. The amputated leg is not as much of an identifier as it might seem; access to adequate health care for black Americans was sorely lacking, and many African Americans were amputees. When speaking about Jimmie, the double amputee in the image of the blacksmith shop (PL. 10), Shannon explained, "There were the men that had one leg, there were two or three of them around the area where Bill sat. One has a peg-leg, by the way, and the others have crutches."[100] As noted earlier, Bill needed the aid of two canes by the time of the New South exhibition. A drawing, *Self-Portrait* (PL. 37; in fig. 52), which hung just below *Woman with Umbrella and Man with Crutch*, shows a man using two canes. He wears a hat and clothing not unlike Traylor's own and sports a long beard, as Traylor often did. Shannon identified the work as a "self-portrait," although it is unclear whether Traylor gave any indication that it was.

By the time the New South exhibition was mounted, Traylor had already come up with visual techniques for simplifying and abstracting forms that are simultaneously reduced, fused, and still uncannily descriptive — devices that would endear him to lovers of modern art. Traylor painted his man with two canes as a singular brown form on top, broken only by the unpainted area and pencil dot describing the figure's eye. Meeting the upper body midway, the man's cobalt blue pants rest below the brown form of the coat and torso as if the two shapes were cut from paper, one set atop the other. Traylor would use this brilliantly simple technique in many subsequent depictions of men wearing coats that dropped below their waistlines.

Another painting, *Fighter* (PL. 38), which Shannon dated to January 1940, was not documented as part of the *Bill Traylor: People's Artist* exhibition but is visually kindred to the man with two canes. Its subject, too, is bearded and wears the same tall,

brimmed hat. In *Fighter*, however, the man walks without support and is animated—running, arms raised, one hand balled into a fist, the other pointing. Shannon noted Traylor's remark about the piece on the back: "Jan. '40; He runnin' aroun waiting to fight."[101] Both men resemble Traylor. Although Traylor's third-person remark belies that he was portraying himself, the work may be a self-portrait, expressing a memory of an earlier time or a longing for his stronger physical self.

Man with Hat and Cane (part 1, **PL. 1**; in fig. 52), adhered to the window, could also be a self-portrait or possibly a portrait of George Hartwell Traylor. The figure does not resemble Traylor, at least based on what we know of his physique and clothing from the few photographs that exist. The New South members must have considered the possibility that it was a self-portrait, however, for they hung it next to the one Shannon had titled *Self-Portrait* (**PL. 37**; in fig. 52), perhaps because the inscription references Bill. On the front of *Man with Hat and Cane* is written: "Bill Traylor. Born at Benton Ala. Lounds Ky, April 1, 1855 Raised under Mr. George Traylor." The handwriting is neither Shannon's nor Traylor's; a note on the back says, "written by a friend." The friend might have been the person who, according to Shannon, helped Traylor learn to write his name, or was someone else from the neighborhood who knew how to write. The cursive hand, unfaltering if imperfect, and use of abbreviations and punctuation (similarly flawed) signal a scribe of reasonable education.[102] The sentence itself suggests a collaboration with Traylor, who must have provided the information about his birth date (the year is an inaccurate estimate, to the extent of our knowledge) and the name of George Traylor.

FIG. 55 Jesse Owens at the Summer Olympic Games in Berlin, 1936

FIG. 56 Candy box, showing Curtiss Candy's "NRG Kid," on the back of which Traylor painted *Untitled (Construction with Lamps)* (AKA *Lamps on Mantelpiece*), pl. 54

Another work with writing on the front, *Untitled (Dog Fight with Writing)* (PL. 39), offers interesting points of comparison. Although it is not documented as having been shown in *Bill Traylor: People's Artist*, its visual style and the inscription stating "85 years old" indicate it was made close in time to the drawing of George Hartwell Traylor (PL. 37), which was in the exhibition. The writing appears to have been done by someone other than Traylor or Shannon but, considering the variations in letters such as *T* and *r*, not necessarily the same person who wrote on *Man with Hat and Cane*.

A close assessment of *Untitled (Dog Fight with Writing)* hints that two different hands appear on the work. The top line of script, which bears the name Bill Traylor, closely resembles Traylor's signature on many other drawings. Arguably written by Traylor himself, the letters are indistinct; the words appear to be mimicked, symbolic copies rather than script that evidences linguistic knowledge. If Traylor had indeed learned to draw his name, as is widely believed, this artwork, having model text for Traylor to mime, may be the work on which he first attempted it.[103] The rest of the writing differs from that top line and appears to be a second writer's hand.[104] The second writer's script is more fluid and clear than the first writer's; it contains spelling errors but reflects the writer's knowledge of the cursive alphabet. The second writer adds the additional sentence: "This Dryling Was Done By Bill Tralor old man. 85 years old."

PLANTS, BASKETS, ABSTRACT FORMS, HYBRID BEINGS, AND WILD CREATURES On the same wall as the several of the works just discussed (in "Black Icons, Self-Portraits, and Familiar People") is an array of drawings with plant and basket imagery. The complex *Untitled (Basket, Man, and Owl)* (PL. 21; in fig. 52) sits at the center of a group of nine drawings; a tenth, *Basket with Plant Form* (PL. 20; in fig. 52), rests on the windowsill. Not all the drawings are legible in the photograph, but at least two have basketlike forms with plants sprouting from the top. Related in style but hanging elsewhere in the room, *Untitled (Footed Form)* (PL. 40; below, in fig. 63) shows similarly squat, flat feet as well as raised arms, each with an unidentifiable half-domed form; humanlike feet at the base of the basket shapes turn familiarity into something foreign, an amalgam of object and being. On the wall with the window (fig. 52), other drawings of footed forms indicate a subtheme of sorts, including another footed form, one with a snake ascending, adding a distinctly unsettling presence. Overall these images are arcane, forms coming to life as if in the act of transforming.

For Traylor botanical forms frequently vivify in a quasi-magical atmosphere. When considered as a related group of images, these plant-human pieces provoke specific questions about the role of conjure for Traylor, for in lore, the conjurer or root doctor is often said to have the power to transform him- or herself from one being into another. The botanical images also spark questions about the funeral parlor where Traylor lodged, what ceremonies or rituals he may have seen there, and the nightmares, according to David Ross Sr., that plagued Traylor.[105] These transformation drawings give visual manifestation to imagery drawn from communal stories and the artist's dream life. Collectively, they relay the ways in which mystical ideas and oral culture take shape when put to paper.

The graphite and charcoal *Plant/Animal Forms* (**PL. 41**) is spare and elegant.[106] Two birds, long legged and slim, flank an abstracted object on a tabletop. The birds are not petite songbirds but rather, large creatures taking roost. The object on the table resembles a candelabra in shape, yet when seen among other plant drawings is more compellingly a branched tree or shrub. The legs of the table are arched with curvilinear feet, decorative and fancy. Absent any concrete narrative, the drawing conveys a strong sense of formality and ritual, such as might have been present in the funeral parlor or at the graveside. It gives a clear sense that the birds are symbolic, markers of freedom as the soul prepares to fly away toward heaven.

Many of Traylor's plant forms seem to be hybrid beings, sprouting forth from human legs that dance wildly about. In *Leg Forms with Bird* (**PL. 42**; in fig. 52), the table legs have come to life. The legs bear boots, and the table itself is no longer stable—it kicks up a row. Traylor's capacity for graphic power and elegance is on full display here, and the New South members were so taken with this spare, enigmatic painting they reproduced it (and two other works) in the small exhibition booklet (part 1, fig. 26).[107] A single, slender, long-legged bird—close in appearance to the ones paired in *Plant/Animal Forms*—rests on a perch. The kicking table legs flail in opposite directions, the hips and feet sprout plants, and the formality of the image is taken over by something otherworldly, a place where logic yields to the nonsensical, and the irrational is perfectly rational.

David Ross Sr. was not the only person to mention Traylor's intense dreams. Traylor's granddaughter Margaret Traylor Staffney said that when she visited her grandfather, his morning routine was to tell her about his dreams.[108] Traylor's world had been more fluctuating than stable in the decades since the Civil War and was one in which root medicine, ritual, and superstition played powerful roles, as did the information gleaned from dreams.

Among the accounts Puckett and others collected are methods for interpreting the meaning of dreams and widespread expressions of belief in a "dream-soul." A dream-soul is connected to African conceptions of the existence of an indwelling spirit within each person. The dream-self is a subliminal traveler, a separate being that can suffer real injury in the dreamland and must be cared for and protected. Puckett quotes a person from Alabama as saying, "A dream is regarded as a real experience in which the soul of the sleeper goes to another world." So arduous is the dream-self's journey, many believed that water or spirits must be left in the bedroom so the thirsty traveling soul would not suffer.[109] One woman, in 1934, described the traveling spirit as she thought it was commonly understood in slavery times. For her, the connection between the two spirits was about not simply the dream traveler but also the duality of peace and trouble within each person's nature.

Yo see, everybody got two kinds ob speerits. One is der hebben-goin' speerit. Dat is de speerit what goes right on to hebben or hell. Den der is de trabblin' spirit.... [These] trabbel about all ober the world 'tween de hours of sunset and de second cok crow in de mornin.'. . . De hebben-goin speerit don't gib you no trouble, but de trabblin' speerit,

‘e be de one dat gib you worriment. ‘E come back to de t’ing ‘e like. ‘E try fur come right back in de same house.[110]

The boot-like feet in *Leg Forms with Bird* bear a strong resemblance to a cobbler's anvil, which would have been among the tools Bill used or saw frequently—in the late 1920s when he worked at the shoe-repair shop and after the summer of 1939 when he was sleeping in a shoe shop. One type of the cast-iron anvil looked like an upended foot on a stick (fig. 57), but others had two- or three-footed structures of different sizes off a central axis (fig. 58). The forms are spare and have elegant silhouettes, but they also transform the shape of a human foot into something threatening, hammer-like, and potentially cruel—and it is not hard to imagine that they could propel dark dreams from anyone sleeping among their shadowy shapes.

Leg Forms with Bird may also relate to one or more oral tales. Folklorists have noted that ghosts often symbolize a call for bravery. One Alabama ghost story tells of a vacant house, a haunted place. A sign in the window announced that anyone who could last the night there could have the house; a poor boy gave it a shot. While cooking dinner in the fireplace, the boy heard a voice from within the chimney, but when he looked for it, all he saw was a leg. It said: "I am going to drop." The boy told the leg to come on down—but please stay out of my soup. The leg came down and jumped on a chair. Another leg descended the chimney and said the same: "I am going to drop." The boy said fine—but please don't fall into my dinner. He offered the disembodied legs some of the meal he had made and then a place to sleep. "Soon after he went to bed, the legs pulled him under the house and showed him a chest of money. The little boy grew rich and married."[111] Persevere and prosper.

Leg Forms with Bird is one of several artworks in which Traylor depicts disembodied legs kicking about. Another, *Legs Construction with Five Figures* (PL. 43), also powerfully evokes the iron forms of the cobbler's anvil.[112] This drawing is a more violent and chaotic image than *Leg Forms with Bird*. The hard and straight booted legs again point in opposing directions; birds roost on twin perches, which look much like a second, upturned set of legs with birds in place of feet. Five figures and a dog are embroiled in a fracas. The agitated dog bares its teeth as a man with a large hatchet aims to chop the structure down and the others poke at the birds and one another. By the time he made this drawing, Traylor was employing a thematic device that he would come to use frequently: a man with a prod or stick jabbing at the hind end of another person. Here the prodder is about the same size as the other figures. More often, Traylor reduced the size of the prodder in relationship to the prodded, conveying the strong sense that the small figures are symbolic stand-ins for the troublemaking element within each person; the little devil, who dwells alongside, battles eternally with the good or angelic within each soul.

The man at the top of *Legs Construction with Five Figures* is the sole figure wearing a hat. This accessory and his position at the uppermost level of the construction convey his rank. The hatted man jabs at a bird in a pointing or poking motion rather than with a grabbing hand, which Traylor denotes with flayed fingers. Sobel interpreted

FIG. 57 Cast-iron cobbler's anvil, Eclipse Co., ca. 1900

FIG. 58 Shoemaker's anvil, date unknown

the overall scene as a complex portrayal of jealously and rage, a tangle of aggressive men, and "birds" being prodded. But the story could be any reminiscence within Traylor's deep memory or dream bank; the pervasive birds keep the metaphor of flight and ascent ever present.

Kuyk and Sobel gave exceptional weight to Ross-Clayton Funeral Home worker Jesse Jackson's claim (relayed by David Ross Sr., as discussed in part 1 of this volume), that Traylor had killed someone back in Lowndes County and the death (whether intentional or accidental) had bedeviled him more and more over time.[113] Although Jackson's account will never be either substantiated or disproven, the possibility that Traylor experienced some regrettable violence or took part in a conjuration that had a perceivably bad outcome is entirely possible—plausible even—in an era when violence was pervasive. The accounts collected from ex-slaves around the country for the WPA's Federal Writers' Project from 1936 to 1938, known as the "Slave Narratives," are just one source for firsthand descriptions of the physical violence that blacks endured from the era of slavery through the time the narratives were commissioned and recorded in the 1930s. They include tales of commonplace brutalities, runaway slaves being hunted down by hounds or shot, and merciless Ku Klux Klan attacks.[114]

In *Shadow of the Plantation* (1934), Charles S. Johnson probed the culture of violence and African American deaths in Alabama. Looking at records from 1929, he noted that assaults and homicides were commonplace and included pervasive "violence attending jealousy in sex relations." One report came from a woman afraid to leave windows open at night because "people do's so much killin' round here, I'se scared to leave 'em open"; another said they were afraid to go to local dances because "dere's so much cutting and killing going on." Johnson's notes describe accidental deaths, stabbings, shootings, and beatings to death, and a situation of "rough-handed closeness of a frontier community before adequate control of personal relations have been developed." Another note says, "Social control in this community is related only vaguely to law."[115] Traylor's images contain a high degree of violence, yet when they are viewed comprehensively, it is clear they narrate no one single event but more likely, a lifetime of peril and challenge and shaping a personal identity within a terrifying space.

Near the drawings of the kicking legs and birds, other works in *Bill Traylor: People's Artist* suggest that the plant itself has come to life, taken on a human physique. In one such drawing, an enormous pair of legs hosts the entire tableau on its hips. *Half of Green Man with Dog, Plant, and Figures* (PL. 44; in fig. 52) is done entirely in green pencil except for the shoes, which are in graphite. Traylor used the green pencil for several drawings from this period, many of which explored the same theme of hybrid plant-human forms. Green may have been particularly significant to Traylor; at least one traditional story was told of an African American conjurer who could turn as "green as grass moss."[116] But green widely references the natural world, and botanicals of all types were integral to magical recipes and practices. Traylor's propensity for green in this phase may indicate nothing deeper than that he possessed a certain pencil, but the color likely appealed to him for its ability to magnify a sense of the vegetal world.

The green legs in *Half of Green Man* are fat and jaunty and markedly different from the spare black forms that resemble the boot-shaped anvils. Atop the hips sits a rectangular block, attended by a man and woman on either side. They seem distressed; she has one hand on her head as if confused or upset. He points, possibly at the large palmlike plant sprouting from the box. A dog sidles up to the scene, drawn at an odd angle, meant to depict either an approach or a jump. The scene may recall an event at the funeral parlor; the box is coffin-like, and the plant could be a potted palm, pine, or a lily resting on top. Traylor may have been reflecting on an intense dream or an imagined scene in which the soul of the departed comes to life, causing distress to the mourners on hand.

Two additional drawings in the same green pencil—*Sprouting Green Figure* and *Two Cats Jumping on a Man* (**PLS. 45, 46**)—relate to *Half of Green Man*, although they are not known to have been in *Bill Traylor: People's Artist. Sprouting Green Figure* is even more compelling than *Half of Green Man* as a transformation scene. The figure has the same ample legs, but the box has grown torso-like and sprouted an arm. Traylor effectively conveys the energy of the strange figure's jump by having it brush the top of the picture plane; the lower third is empty, evacuated air space.

The morphing man is more evolved still in *Two Cats Jumping on a Man*. His left "hand" (upper right corner) is a fronded plant; his right comprises three sticks with spheres at the end of each, as if his very hands are magical entities. The latter is an object that resembles an upside-down pawnbroker's sign or divining rod, but it could be a different kind of plant—such as rattlesnake master, which has erect stems topped with spherical heads and was used in folk and Native American medicine to treat snake bite—or more generally a magical device or instrument. Two cats leap upward, one at the upraised hands. Cats, whose bones are often prescribed in recipes for mojo hands or charm packets, seem to pursue his plants or charms. The man wears the tall hat often ascribed to the root doctor or conjurer. The cats may symbolize a demonic force; the Devil was said to be a conjurer in his own right and one who favored coming in the guise of a cat.[117] Whatever mystical story is in play here, these three pictures in sequence denote a rapidly evolving form—and a powerful, apparently transformational event playing out.

In *Human Plant Form on Construction with Dog and Man* (**PL. 47**; above, in fig. 52), another drawing in the New South show, an intense drama once again unfolds. The coffin-like form seems even more manifest than the central shapes in the previously discussed works, setting on a footed riser. The dog leaps up in alarm at the being that has sprung forth—a human-legged creature whose head and upper torso have been replaced by the fronds of a plant. Dogs loyally defend their owners from danger; Mississippi folklorist Ruth Bass noted that dogs in African American lore would do so against death and the Devil himself.[118] Whether the hybrid plant-man is the spirit of the deceased rising from the coffin, or death coming to take him, the plant-figure, waving and threatening to leap from its perch, raises great alarm in man and dog.

The disembodied legs and transforming plant-people occupied a great deal of Traylor's imagination during this period. Several works not known to have been in

the New South show are stylistically similar and further explore these themes. In *Untitled (Figure on Construction with Legs)* (**PL. 48**), a tall, skinny pair of legs carries off a person, perhaps even a child; and in *Anthropomorphic Figure and Cat* (**PL. 49**) the same skinny legs have looped over on themselves, forming two noose-like shapes at the knees. The plant shape sits atop a rigid triangular mound, and a black cat, perhaps the Devil again, stands by. Traylor continues his exploration of mysterious forms and expands upon those from earlier paintings—the coffin-like box, the plant hybrids, the man holding spheres on sticks.

In a photograph of the exhibition showing ten works above a small table (fig. 59), one painting, *Dancing Cauldron* (**PL. 50**), is of a single cauldron; it is plain but almost appears to have feet that could carry it off. Just below the cauldron painting, another work (not a plate herein) shows a simplified oil lamp. Both items depicted are common and purportedly used in conjure practice. Whether Traylor was consumed by a recurring dream or translating elements from a ceremony he had witnessed or taken part in—funerary, fraternal, or conjure related—is unknown. Yet the preponderance of the enigmatic forms Traylor made in the 1939–40 period collectively suggest that the community of African Americans in Montgomery—set apart by its own businesses, rituals, religious practices, societies, and outflow of ideas—was activating and agitating his mind, perhaps prompting Traylor to reconcile events from his past with the reality of old age, increasing disability, the loss of loved ones, and his own mortality.

The silhouetted cauldron and oil lamp mentioned above, together with a third, abstracted plantlike form, can be just partially seen at the center left of the photo (fig. 59). The wall is a mix of themes, but four paintings evoke built structures. One shows people walking in line upward onto a towerlike frame. Traylor spoke of this construction, which he described as something they made for jumping into the cooling river waters; it was a structure he drew more than once. "They would run out on it and dive in the river, come out and take a drink, and return to dive again."[119] This pastime in Traylor's memory—the repeated act of taking a drink, climbing toward the heavens, and jumping into the river would have been practical for cooling off in hot weather and cleansing, physically and spiritually. But the most indelible memory that stemmed from it was likely that of simply having fun, being free from the pain and burden of work, if only for a spell.

Prominent in this array (fig. 59) is a large abstract work, *Cedar Trees* (**PL. 51**), in which rounded cone forms sit atop geometric shapes. It is an especially interesting piece for the remark Traylor made about it: "Cedar trees, like they have side of doors."[120] The explanation of potted, shaped cedars brings a simple meaning to an otherwise highly abstracted work. Yet Traylor's interest in cedars may have had more depth than the image itself suggests, however, for in Southern African American tradition cedar trees are often planted at the heads of graves; the practice, with roots in western and west-central Africa, marks the pathway from the buried loved one in earth upward into the ethereal heavens. His ruminations may have encompassed the profoundly varied uses or understandings of these botanical forms in white and black America—respectively decorative and spiritual.[121]

Such a spare but elegant explanation is lacking for the drawing hanging next to *Cedar Trees—Abstraction, Red, Blue, Brown (AKA Abstraction)* (PL. 52; in fig. 59)—which, if reproduced as a black-and-white image, might be read, like *Cedar Trees*, as topiary in a pot. If shrubbery was the inspiration for this work, Traylor made a radical departure from visual reality when he painted the top sphere in brown (sitting atop a black parallel bar), the center sphere in bright blue, and the trapezoid, planter-like shape at the bottom in red. Traylor's ability to reduce forms to their most simple and leave colors pure and unmodulated would, in later years, endear him to lovers of modern art. Here the abstraction is likely an interpretation of something he saw in the neighborhood and an exploration of the paint colors he had been given.

In the same installation photo, shown hanging next to the straightforward depiction of an oil lamp, is a dramatically different lamp in *Figure/Construction, Man Stealing Liquor* (PL. 53; in fig. 59). This one has a blue base, abstracted as a sphere atop a trapezoid. The glass chimney is transparent, and within it, Traylor has positioned a man in red pants and blue polka-dotted shirt sitting on a chair, pointing at a bottle on a high shelf. A man in a red shirt stands astride the chimney opening and points at the same bottle, while a man wearing a blue shirt plummets downward, falling from the ladder that leads up to the high shelf. A woman and girl scream and run toward the scene.

Oil lamps were the common light source for much of Traylor's life. On one hand, they represent the most quotidian of tableaux, the home fire at the kitchen table, a place to gather when the day has ended and the family eats. On the other hand, lamps like this also are mentioned in accounts of conjure rituals, most of which entail taking a fingernail clipping or bit of hair from the person being conjured, perhaps along with other specified materials, and burning it in the lamp. Glenn Sisk, who studied and wrote about African American churches in Alabama, described funeral customs in the Black Belt region during the late nineteenth and early twentieth centuries, noting that many antebellum customs were still common after World War I. Every death occasioned ritual and ceremony.

A long-standing custom was "sitting up" with the dead, particularly in the days just after the death, when the spirit was thought to still hover near its body. Sisk described incantations and superstitions that accompanied various deaths, as well as events that were part mourning and part celebration. "When the remains were embalmed, they were 'kept out' for three days to a week," Sisk explained. "There were large crowds every night at the 'setting up,' where they made merry with coffee drinking, if not with stronger drink. A light was placed at the head of the casket to 'light the way to the other side,' and at intervals, hymns were sung."[122] *Figure/Construction, Man Stealing Liquor* is difficult to interpret but clearly speaks of an accident or death and concomitant emotional anguish. The figure sitting inside the glass chimney may be recounting the event, even as the deceased's spirit lingers close by.

It would be easier to accept Traylor's oil lamps as generic elements of quotidian life if he had drawn them less frequently or given them less weight in his images. In works of 1939 and 1940, he employed them repeatedly, often as center stage. Among the first known depictions of one is *Untitled (Lamp, Bottle, and Cat)* (PL. 7), an early work

in which Traylor was just learning how to represent a physical form on paper. The simple drawings Traylor made early in 1939 and perhaps even before that are more than just an exploration of representation, however; they show the select beings and objects that held meaning for Traylor—cats, bottles, and oil lamps—all of which would become recurrent images in his work. *Untitled (Lamp, Bottle, and Cat)* is particularly striking for the conjure associations with all three of the elements it combines. "Witch cats" are widespread in conjure lore; white, black, yellow, and spotted cats, and more, were often regarded as the shifted shapes of witches, and as noted above, their bones were used in charm or trick recipes and divining practices.[123]

Traylor's lamps might convey the mood and setting of a fireside tale, a conjure ritual, or something unknown. The atmosphere of *Untitled (Construction with Lamps) (AKA Lamps on Mantelpiece)* (PL. 54) is laden with a sense of ceremony or appeasement.[124] The painting, all in black, shows a pair of lamps poised at right and left edges of an altar-like table; a chalice or goblet is at the center. Apart from these three distinctive objects, the table structure is abstract. The base could be an adaptation of shapes in the coffin room at Ross-Clayton's, a place that Traylor spoke about beyond the time he was still lodging there.

For Traylor the funeral parlor would have been both a welcome shelter and an uneasy place, where, as he was sleeping among the caskets, he might be thinking about his own numbered days or worrying about the unhappy spirits of someone he had wronged. Tables, stands with boxes and plants, and similar recurring shapes such as in *Basket, Black and Green* (PL. 55) denote the enduring presence of that place in Traylor's mind. Many accounts note that African Americans of Traylor's day shared the widespread belief that a hard life or wrongful death would beget an unhappy, restless spirit.

One formerly enslaved informant told Harry Middleton Hyatt that whiskey was often "fed to a protective hand or to a troublesome spirit." The same person said: "Well, dey say if a person dies, if he die cruel to yo' or something lak dat, say his spirit will come back. Well, it comes den though a dream.... Yo' take a piece of lumber an' take yo' lamp. First, yo' take that lumber, a new piece dat never been used an' set dat lamp about three feet from it, an' he'll never walk in no more." Hyatt asked what kind of lamp, and the informant replied, "Just a ordinary burning lamp, a oil lamp."[125] Traylor was not the only one who thought about the spirits that might hang about at Ross-Clayton. In *Untitled (Ross the Undertaker)* (PL. 56), one of the few works in which Traylor made a portrait of a known person, he painted undertaker David Ross Sr., saying to Shannon, as noted above: "When he comes in, he always looks around seein' if dem boxes is empty."[126]

Traylor's symbolic drawings of birds, plants, lamps, disembodied legs and shape-shifting figures might not overtly depict Ross-Clayton's funeral parlor, but collectively they convey a strong undercurrent of unease, a heavy space given over to contemplation and ritualized behavior. The comingling of representation and abstraction makes these works seem like images fusing memory and the unreal, perhaps the nightmares that David Ross Sr. reported Traylor was having while he lodged in funeral home.

In a particularly feverish scene, *Untitled (Black Basket Form, Snake, Bird, and Man)* (PL. 57), a table seems to come alive, its legs writhing with a serpentine motion as a large snake slithers up its side; a perched bird is in mortal peril, and the mood is heavy with horror and chaos. Snakes are a ubiquitous presence on farms, so on one level they are a plentiful and quotidian part of rural life. On another, however, they play a prominent role in the folklore of conjure ritual. The human body itself was often conceived as a container, as was the body of the snake, especially the venomous ilk. Dreams of rattlesnakes were read as bad omens or portents of tricks. "A rattlesnake means the strongest kind of conjure doctor," one person explained. Small snakes in dreams might portend only a small illness, but more serious predictions were common. "If you see a snake curled up to spring, it means the conjure doctor is very angry with you. If the snake is lying down quietly, it means the conjure doctor is just beginning to think about you."[127]

Traylor's dreams or memories may well have been linked to the space where the dead lay before burial. It's also possible that either the proprietors of the funeral home or members of bereaved families set out former possessions or offerings for the dead to ease their transitions. A more extreme scenario would be that hoodoo or conjure practices took place there, or that a secret society held initiation rituals there. Jeffrey Anderson observed that the "secret" aspect of such societies, often African derived, held powerful sway within the community, and as a result, evidence of them is scant.

The writer and folklorist Zora Neale Hurston claimed to have undergone initiations in an African-derived society while studying hoodoo in Louisiana. Although Alabama traditions varied from those that took shape in Louisiana, they had affinities rooted in the ancestral beliefs of enslaved people brought to the relatively close ports of Mobile and New Orleans. Hurston described one ritual that involved snakeskins and a water jar, left on an altar in an invitation into the spiritual realm. While that encounter has no direct relationship to Traylor's imagery, Hurston's recollections and *Untitled (Black Basket Form, Snake, Bird, and Man)* similarly evoke snakes, altars, spiritual realms, and peril.[128]

Traylor's oil lamps grew dramatically in scale as he maneuvered their relative importance in his images. In *Lamp, Abstract Table, Figures, and Dog* (PL. 58), the table takes an hourglass shape with a central vertical pillar, a structural form that Traylor drew more than once.[129] The single oil lamp is the dominant object in this drawing, as large as the combined bodies of the small man and woman attending to it. The man seems concerned, pointing to the oil tank. The woman, hand to head, also has an air of worry. Their small dog indicates the domestic nature of the scene, but with all three beings ungrounded, floating in midair, the atmosphere is of urgency or trickery; something is amiss. The lamp in *Brown Lamp with Figures* (PL. 59) has ballooned to almost twice the size of the couple tending it, and in *Simple Forms—Lamp* (PL. 60) the figures seem like sprites next to the colossal object.

In another part of the gallery, drawings of wild and feral beings were on view (fig. 60). Three of the creatures are recognizable as animals. The striking feline with colored spots in *Spotted Cat (AKA Two-eyed Black Cat with Colored Spots)* (PL. 61; in fig. 60) is no house pet; lacking the rounded physique that Traylor had developed for

domesticated cats, it is tall and substantial, more feline by default than by accurate rendering. *Wild Animal* (**PL. 62**), featuring a similar creature, a lanky black cat with fangs so bared as to almost split its head apart, was not in *Bill Traylor: People's Artist* but exudes a similar sense of un-tamed fury as *Spotted Cat*. Another work seen in the installation photograph (fig. 60) shows two animals, stacked on one page, that are equally ambiguous in species but look more canine than feline. What Traylor seems to explore in all the animals depicted on this gallery wall is not physical realism but temperament. These beasts are agitated—with mouths open, they snarl or howl, and the cats' eyes are wide with fervor. In one drawing in the top row, a creature appears hybridized, a human head on an animal body, walking on all fours.

In yet another drawing on this gallery wall (in bottom center, fig. 60), the depicted being is childlike, with a disproportionally large head indicating a child's physique; the flat, seated position suggests immobility and the aggravation that goes with it. The raised left hand and right hand on the hip could be adultlike gestures, but the overall effect is of a toddler, perhaps even one of Bill's own children, whose raw frustration is on full display. High emotion remains the theme in another work seen in the photograph, *Untitled (Man, Woman, and Dog)* (**PL. 63**), which depicts people (and a dog) in excited states, with arms raised and knees bent, jumping or moving. Hair, long and loose, form large halos around the heads of these figures as well as the wailing child—in striking contrast to the head wrappings, hats, or shorn hair often associated with plantation conventions. Traylor's men often wear hats, a custom that persisted beyond slavery given the hot Alabama sun. The women he draws, however, are almost without exception shown with uncovered heads. It is a subtlety that is easy to take for granted when viewed through the lens of contemporary culture, but for the formerly enslaved and their progeny the suppression and marginalization of hair were integral to a far larger oppression.

FIGS. 59, 60 Installation views of *Bill Traylor: People's Artist*, exhibition at New South Gallery, Montgomery, February 1940. Fig. 59 (*left*) shows works including pls. 50–53; fig. 60 (*right*) includes pls. 61, 63, and 64. Photographs by Jean and George Lewis. Courtesy Caroline Cargo Folk Art Collection (Cazenovia, NY)

In *Untitled (Man, Woman, and Dog)* as in the drawing of the toddler and another of a person jumping (upper left, fig. 60), Traylor chose to show hair as unshorn and unrestrained. Head wraps served some practical purposes, such as mitigating lice and covering the effects of ringworm—a widespread disease on plantations, where not everyone was afforded shoes, and sanitation was lacking. More significant though, hair was an important element in a European-dominated culture that cast African traits as inferior. In African traditions hair is a "spiritual crown," a physical manifestation of identity and spirit.[130] Enslaved women were often denied the ability to wear their hair as they would have liked; they were made to understand that the degree of straightness in a woman's hair might afford an enslaved woman a higher position in the household hierarchy, which, like skin color, was an insidious mechanism for fostering racist tropes that cast nonwhite attributes as inferior. Sociologist Orlando Patterson has argued that hair, although it could be altered or hidden, was ultimately a more potent marker of servitude than skin color in North American and Caribbean slavery.[131]

Willie Morrow, who produced the first plastic Afro pick, developed curl-relaxing styling products, and wrote several books about African and African American hair, has expounded on the same points, explaining that hairstyles and ornaments that denoted tribal affiliation and culture were stripped away from the enslaved. "Whereas curly and kinky hair was glorified in West African societies, it became an emblem of inferiority once enslaved Africans reached American shores. Thus the pride and elegance that once symbolized curly and kinky hair immediately became a badge of racial inferiority."[132] Sociologist Ingrid Banks notes that soldiers and prisoners had to wear short hair, and that long, natural hair has conversely come to represent the larger personal freedom that it is.[133] Hair, free or bound, in fact would remain such a potent subject that contemporary American artists Sonya Clark, Ellen Gallagher, Alison Saar, Lorna Simpson, Kara Walker, and others would make it part of ongoing bodies of work.

In this cluster of early drawings (fig. 60), Traylor depicted the peoples' hair as wild and free as can be. As he developed his visual style, such details became nuanced; he showed hair, but minimally, not with attention or extravagance. He may have realized that hair was a hot-button issue in identity politics and could bring trouble, or he may have been simply depicting people as he saw them, in a culture that allowed, if not always benevolently, the freedom of personal style within conservative bounds.

Untitled (Man, Woman, and Dog) (PL. 63) is striking for its intensity. The drawing in crayon and pencil shows a couple and a dog. They move with abandon, their mood hard to gauge. The woman is shown with her left arm pointing to the sky, index finger raised, right hand on hip, and long, ferocious, barred teeth that seem more animal than human. Her partner jumps about, his lips shown in an exaggerated silhouette that might indicate yelling or singing, with teeth that are similarly drawn as long spikes. The dog jumps and nips at the woman's feet, not attacking but caught up in the melee.

On both figures hair flails wildly; Traylor gives the coiffure multiple layers of diverging hatch marks to create a clear sense of movement. Ghost shapes of erased limbs indicate that Traylor moved the woman's leg and the dog's tail from where he had originally drawn them, making them more animated than in the first rendition.

Traylor didn't erase often, but in the early works done in pencil and colored pencil, trace evidence of removed marks does occasionally exist, reflecting the artist's desire to fine-tune the image when it was not reading the way he wanted. Traylor would come to draw scenes of men and women arguing time and again. In almost every case their bodies are upright and rigid, except for raised or akimbo arms and pointing fingers. This exceptionally dynamic work convincingly shows figures dancing; the various kinds of after-hours houses or "jook" (juke) joints would certainly have been an integral part of life in the Monroe Street neighborhood.

Jook joints go by various names and are a well-documented part of African American culture; they were the secular gathering spots that arose in tandem with black populations in urban areas after Emancipation (fig. 61). Hurston (who also called them "bawdy houses") asserted, "Musically speaking, the jook is the most important place in America. For in its smelly shoddy confines has been born secular music known as the blues, and on blues has been founded jazz. The singing and playing in the true Negro style is called 'jooking.'"[134]

On the plantation, recreation for the enslaved took place mostly covertly, as unsanctioned gatherings were likely to be regarded as forums for dissent. The feminist historian Stephanie M. H. Camp has noted that pleasure was a major form of resistance for the enslaved, who regularly slipped away to secret spaces for dancing, playing music, drinking, and courting.[135]

One ex-slave, Wash Wilson, from Louisiana reported that the enslaved often called dancing "shouting," making this distinction because "dancing" was associated with sinful activity. "Us 'longed to the church, all right, but dancin' ain't sinful iffen de foots ain't crossed. Us danced at de arbor meetin's but us sho didn't have us foots crossed."[136] Sociologist and scholar on African American dance, religion, and traditional culture Katrina Hazzard-Gordon notes that enslaved people performed a variety of dances, some of them learned from white masters, but that the preponderance of the dances were African in character, survivals that morphed and adapted over time. "Among the dances they performed were wringin' and twistin',…the buzzard lope, breakdown, pigeon wing, cakewalk, Charleston, 'set de flo,' snake hips…and the shout, which unlike the others retained both a sacred and secular character."[137]

Hazzard-Gordon looked back at her own Fundamentalist upbringing in Ohio in the 1950s and 1960s. "Frequently amid the sounds of tambourines, bongos, saxophone, and piano, both the dance and the music became virtually indistinguishable from those in the local after-hours joints," she explained. "We could hear the same chord progressions, call-and-response patterns, implied polyrhythms, and use of falsetto and melisma. Dances that secular performers called the mashed potatoes, the shout, and the jerk were being performed in praise of God. Add food and fellowship, substitute gambling and drinking for the prayers and reverence, and you have all the ingredients necessary for jookin'."[138] Jook joints or honky-tonks were primarily for the working class; not advertised, they were usually known only by word of mouth. They were associated with drinking and gambling and not as formalized as bars or taverns. Johnny Shines, a Mississippi Delta blues musician who played in a lot of jooks, noted

that they were more make-do than bars. "Beer was served in cups; whiskey you had to drink out of a bottle."[139]

Hazzard-Gordon describes sharp hip-popping movements, angularity, and asymmetry among the many characteristics of jook dancing, which seem clearly represented in Traylor's drawing *Untitled (Man, Woman, and Dog)* **(PL. 63)**. Writer and gallerist Randall Morris observed that this work may allude specifically to the jitterbug, a swing-style dance that arose in the late 1920s from related dances such as the lindy hop and the jive but became popularized with that name after 1934, thanks to Cab Calloway's recording of "Call of the Jitterbug," which remained popular through the 1940s.[140]

> If you'd like to be a jitter bug,
> First thing you must do is get a jug,
> Put whiskey, wine and gin within,
> And shake it all up and then begin.
> Grab a cup and start to toss,
> You are drinking jitter sauce!
> Don't you worry, you just mug,
> And then you'll be a jitter bug![141]

The lyrics of Calloway's song overtly referenced the good-time drinking culture that spanned jook joints and the Harlem nightclubs and drew on a slang term given to alcoholics who were sometimes said to have the "jitters." Yet Calloway's suggestion that

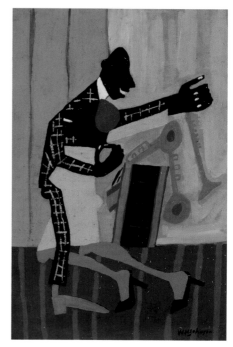

FIG. 61 Dancing in the Juke Joint. Farmworkers dance in the recreation tent of a Farm Security Administration agricultural workers' camp, Bridgeton, New Jersey, June 1942.

FIG. 62 William H. Johnson, *Jitterbugs (II)*, ca. 1941, oil on paperboard, 24 × 15 ⅜ in. Smithsonian American Art Museum, Gift of the Harmon Foundation, 1967.59.611

alcohol was the source of "jittery" dancing put a racially fraught spin on a dance style that was original, innovative, and modern and featured the athletic grace, strength, and creativity of the dancers.

Between 1940 and 1942 the painter William H. Johnson, who was teaching in Harlem during the height of the craze and took a keen interest in depicting African American daily life as he knew it, made a series of paintings of "jitterbugs" showing nimble, synchronized dancers as intertwined blocks of color (see fig. 62). The bold and emotive dance styles that became popular with younger generations of African Americans were held in mixed regard by community elders. Blues encouraged cultural solidarity and a bawdy, rebellious, culture that utilized pleasure as an act of resistance, particularly for those born after Emancipation.[142]

Blues historian William Barlow has explained that older, more conservative or pious members of the black community felt that the new styles of music were blasphemous and the dancers were the victims of the Devil. He compared rural blues musicians to black preachers, crediting both with shaping oral tradition and drawing from traditional African performing styles to communicate, and observed that preachers and musicians, despite their often-polarized views, were in direct competition for the loyalty of their audiences. "Although [preachers and musicians] both recognized the perilous situation confronting African Americans in the South after the collapse of Reconstruction and the resurgence of white racism, they differed in their responses to the crisis. Black preachers had strong ties to the 'old time' religion of their slave forbears," he wrote. "Because they embraced the religious traditions and beliefs used as survival mechanisms during slavery, their cultural outlook had a conservative orientation. They looked to the past for their inspiration, urging self-reliance, social restraint, and religious resistance to prejudice and discrimination. In contrast, the rural blues artists identified with an emerging secular consciousness critical of the oppressive social order. They advocated personal rebellion, urban migration, and resistance as a means of combatting their oppressors."[143] This tension between tradition and change, intensified by the perils of racism, the benefits of paternalism, and a lack of any clear direction forward, may describe Traylor's personal situation as well as the images it inspired.

Perhaps the most enigmatic drawing on this wall of *Bill Traylor: People's Artist* is *Scary Creature* (PL. 64; in fig. 60). In terms of physical position and energy, it affiliates visually with *Untitled (Man, Woman, and Dog)* (PL. 63) on the same wall. Its "creature," however, is markedly different from the dancers; neither human nor animal, the being has a person-like body but large, pointed ears, fierce teeth, and serious claws on hands and feet.

Traylor's use of space on the plain expanse of cardboard make the creature look air-bound, mid-leap in a position of surprise attack. Unlike the dancers who are drawn with scattering marks that suggest energized movement, *Scary Creature* is dense and solid, worked with slow and careful monochromatic black marks. Traylor may have been rendering a creature from dreams, but it is equally likely that he was picturing a ghost or the Devil—an ever-present figure in folklore and music. If made around the time Traylor

was seeing younger folks dancing in jook joints, with elders not unlike himself saying the Devil had taken them over, he might have made such a thought manifest in his art.

HAINTS, HAGS, TRICKSTERS, AND BEASTS Traylor's paintings often tug at tales of good and evil—or perhaps, specifically, of virtue and debauchery. Many of his tall, dark characters with suits and hats are ambiguously cast—the preacher, the conjurer, the Devil himself—and the murkiness in their actual roles for Traylor should not be underestimated; they are not concrete in identity but fluid. Other characters are more animal than human, or more spirit than mortal. The liminal quality of the subjects— the beings that can transition from state to state or exist at the threshold between life and death—is key in such works. Mysterious people and frightening spirits populate the collected lore of the South and the Atlantic coast. The characters are not static in their natures. Regardless of which of them Traylor knew about, a high degree of flexibility or unfixed identity seems to have carried into his depictions of them.

The subtle distinctions in visage between the preacher, the undertaker, the conjure doctor, and the Lord of the Underworld apparently captivated Traylor, who, it can be argued, drew them all. As tempting as it can be to attach an identity to Traylor's fancily clad men, more is to be gleaned from their relationships than from their distinctions. Among the odd characters that Traylor depicted, he never gave the Devil himself any clear-cut form. The subject of *Scary Creature* (PL. 64) has pointed ears yet lacks horns or a forked tail. But the Devil may have been just the last link in a chain of fearsome beasts. One song identifies a mythical creature called the Stiff-leg, who chases the wolf but runs from the Devil.[144]

In another work, *Untitled (Chase Scene)* (PL. 65), which Shannon called "Preacher and Devil," the creature being chased is unconvincing as the Devil but may indeed be a ghost or spirit, even the so-called Stiff-leg. Traylor himself never gave his works proper titles. At best, he made an explanatory comment, which Shannon then wrote on the back of the work.[145] Four decades later, Shannon (with his second wife, Eugenia) broke the works into categories and gave them descriptive, but subjective, titles. Aside from the drawings that have quotes by Traylor on their versos, it is unknown whether Shannon's applied titles came entirely from his mind or, rather, from a distant memory of what Traylor might have said. *Scary Creature* and *Untitled (Chase Scene)* are examples of this historical ambiguity.[146] Since the time when Shannon "titled" the works, subsequent exhibitors or owners have either left them as is or altered them. They frequently added "Untitled" to add a note of caution and neutralize the subjective viewpoints.

Whether Traylor conveyed the subject of "Preacher and Devil" to Shannon or the title indicates only Shannon's presumptions matters a great deal, but such pieces of the puzzle were not clearly recorded. The pursuing figure in hat and boots brandishes an ax while chasing a figure with hair that is unique in Traylor's oeuvre — long, straight, and cut high over the ears. The figure painted in brown has a strong character, but without clothing (which Traylor routinely used to indicate sex and identity), the figure seems dreamed or unreal; the ambiguity carries forth from his mind into

the painting. The rural Southern woods during the nineteenth and early twentieth centuries had no shortage of stories about ghosts and witches. One bit of lore summed up the falling of nighttime: "Dusk came, and with it the ha'nts."[147]

Nightmares were often said to be caused by hags, that is, witches or malevolent spirits who visited in the night, "riding" the sleeping victim. Accounts of haints (ha'nts), or ghosts, are common in the lore of this era, which speaks to the widespread belief that those who died unjust or unhappy deaths lingered on to roam the earth. A likely scenario in Traylor's *Untitled (Chase Scene)* shows a preacher or conjurer running off a haint or hag—maybe even a dreaded woodland ghost called "De Hairy Man."[148] Another woodland haint was the Moonack, whose countenance would cause insanity.[149] Jack-o'-my-Lantern was said to wander the woods by night, using his fiery light to lead people to their demise, perhaps connecting to a Lowndes County ghost story that describes a ghost in the form of a ball of fire.[150]

As previously noted, the South in the first half of the twentieth century was exceedingly violent, which only bolstered the idea that countless departed souls who had gone by grievous manners might remain to voice their anguish to those on earth. William Barlow described much of the rural South in the twenties and thirties as "still a backward, almost feudal, agricultural stronghold dominated by a small group of wealthy white plantation owners and merchants."[151] Blacks were denied their civil rights and rigidly segregated, so they had limited access to education, health care, sanitary shelter, and good nutrition. The rate of disease and premature death for African Americans before World War II was much higher than it was for whites. Violence was not limited to white on black. Pervasive drinking and gambling at after-hours clubs and elsewhere led to merciless fights within the black population, too. No shortage of people would have had reason to come back to haunt the people or places of their former lives.

One Alabama mountain song says, "Sacred Harp Singin', Dinner-on-the-grounds, Whiskey in the woods, An' the devil all around."[152] Legends of the Devil are given in the collected lore of authors Carl Carmer, Langston Hughes, Harry Middleton Hyatt, Newbell Niles Puckett, Ruby Pickens Tartt, and many others; the Devil is a conjurer who might take any form, human or animal. Writing in the 1920s, Puckett noted, "To the Negroes the devil is a very real individual, generally anthropomorphic, but capable of taking almost any form at will. He walks constantly upon the earth, always interfering with human affairs. Sometimes he is invisible.... Most of the time, however, when going about on the earth, the devil has the appearance of a gentleman, wearing a high silk hat, a frock coat, and having an 'ambrosial curl' in the middle of his forehead to hide the single horn that is located there."[153] The tales linking the Devil and blues music are legion—the "box," or guitar, being regarded in folk culture as the instrument of the Devil himself. One informant gave this account:

> If you want to know how to play a banjo or guitar or do magic tricks, you have to sell yourself to the devil. You have to go to the cemetery nine mornings and get some of the dirt and bring it back with you and put it in a little bottle, then go to some fork of the

road and each morning sit there and try to play that guitar. Don't care what you see come there, don't get 'fraid and run away. Just stay there for nine mornings and on the ninth morning there will come some rider riding at lightning speed in the form of the devil. You stay there then still playing your guitar and when he has passed you can play any tune you want to play or do any magic trick you want to do because you have sold yourself to the devil.[154]

Barlow recorded stories of blues musicians selling their souls to the Devil in exchange for fearsome talent. He gives the account of Tommy Johnson: "It happened—so the legend goes—at a deserted Delta crossroads at midnight during a full moon where Johnson was sitting, playing blues on his guitar....A large black man appeared from nowhere, took his guitar, tuned it, played a blues number, and then gave it back."[155]

Barlow explains another well-documented feature in African American vernacular beliefs, the crossroads, a place where the spiritual and physical worlds intersect. Legba, the Dohomean avatar of the Yoruban deity (orisha) Èshù-Elégba, hangs about there. Dahomey (or Fon) was a kingdom in the area of present-day Benin, and the figure of Legba, the Dohomean version of the Yoruban deity, was closely associated with Satan during slavery—the "trickster god of communication and contingency."[156] Robert Johnson, a Mississippi Delta musician of legendary ability, fostered rumors that he, too, had sold his soul at the crossroads, when he sang, "Me and the Devil was walking side by side."[157] Author and literature professor Thomas S. Marvin has explained that, according to a Dahomean myth, Legba became the chief of the gods owing to his skill as a musician. "Jazz and blues musicians may be considered 'children,' or followers, of Legba because they are liminal figures who stand at the crossroads where realms meet, connecting their listeners with the spirits of the ancestors and the lessons of history."[158]

A NUANCED CHRISTIANITY: RING SHOUTS AND CRUCIFIXIONS That Traylor was concerned with ideas of heaven and hell, and the fate of his body and soul as death drew nearer to him, is most strongly indicated by his conversion to Catholicism in 1944. In the preceding years Traylor revealed in his images the tension he clearly felt between morality and self-indulgence. Perhaps Traylor dabbled with the Devil as a large and looming creature, but most of his portrayals of "the devil" are less about Satan and more about the little devil within each of us—a little man, a small spirit hassling or prodding his larger counterpart into trouble. In *Man with Top Hat and Green Trousers* (PL. 66)—not known to have been in *Bill Traylor: People's Artist* but is likely from about the same period—the central figure is plagued by smaller figures. Weighing him down on every limb appear to be beleaguering memories: being treed by a dog or chased by a plantation overseer, fighting for his life in any number of ways. Although the imagery here is characteristically ambiguous, the tension and battle fatigue are palpable, and Traylor's use of varied scale reads clearly as either embodied memories or relentless spirits.

Traylor didn't often make drawings that were overtly about religion or faith. Shannon observed, "He never talked about religion. He did draw two crucifixions, one in tempera and one in compressed charcoal. And he did three 'congregations,' using a circle with figures around the outside representing the congregation, and in the circle a central figure with arms outstretched was the preacher."[159] An installation photo of *Bill Traylor: People's Artist* (fig. 63) shows, on the last wall of the gallery, a drawing of a preacher and congregation (PL. 67) and another of a crucifixion (PL. 69).

Preaching in Circle with Figures (PL. 67; in fig. 63) is the simplest of Traylor's three preacher and circle images. Done in red and blue pencil, Traylor seems to be working out how to draw figures around a circle, with a convergence of perspectives at the top. The circle is drawn as a heavy red band, a barrier. Scholars of West African tradition and of the American black church have noted that the most distinct connection between the two is the ring shout, an African sacred circle dance that entailed sacred music, stepping, hopping, clapping, and shouting in a counterclockwise ritual motion. Historian of African American culture Sterling Stuckey has noted that the Kongo ritual circle was "so powerful in its elaboration of a religious vision that it contributed disproportionately to the centrality of . . . the counterclockwise dance ceremony called the ring shout in North America"; Stucky explains that countless American cultural elements arose from it, including field hollers, work songs, spirituals, and,

later, blues and jazz music.[160] Hazzard-Donald (formerly Hazzard-Gordon) wrote, "Because certain practices found in early Hoodoo successfully found their way into the African American church, post-emancipation Hoodoo tradition is not completely separate from Black Christian church tradition, but rather it is entwined with it, either as a complement or a challenge to church power. This is especially true for the Spiritualist, Sanctified, and Baptist churches where old tradition black belt Hoodoo ritual is often a complement to sacred church activity."[161]

Robert Farris Thompson maintains that the unit of circling dancers created an unbroken social unity, a danced cosmogram that mirrored the east-to-west path of the sun around the earth as well as the cyclical path of life itself.[162] The dancers, clapping and stomping, would build a rhythm, literally a stirring up of the spirit. Musical elements such as shouts, call-and-response patterns, and "worried" or "blue" notes (a harmonic tone) emanated from this practice. Samuel A. Floyd Jr., the founder of the Center for Black Music Research at Chicago's Columbia College, has agreed, arguing that the foundations of all modern and contemporary African American musical styles can be traced to the ring shout.[163] Traylor's figures in this image do not hold hands, but they form a tight circle around the preacher,

FIG. 63 Installation view of *Bill Traylor: People's Artist*, exhibition at New South Gallery, Montgomery, February 1940, showing works including pls. 40, 67, and 69; photograph by Jean and George Lewis. Courtesy Caroline Cargo Folk Art Collection (Cazenovia, NY)

whose arms are raised in a gesture that unifies and calls upon God.[164] The figures are all blue, signifying spiritual unity or oneness.

In *Preacher and Congregation* (PL. 68)—which was not in the New South exhibition but is related to *Preaching in Circle with Figures*—Traylor minimizes the boundary line (this time in blue) between the preacher and his followers. He calls out one of them, at left, as more prominent than the others by rendering him the same size and weight as the preacher and drawing him with the same heavy black media. The other, smaller figures are drawn faintly; two are in blue pencil and three in black, perhaps the forgiven and the sinners awaiting their turn. The preacher has his hand raised and fingers splayed wide as he looks skyward, beckoning the heavens—for guidance or forgiveness. Betty Kuyk surmised that Traylor is showing himself as the dark figure hovering near the preacher, seeking forgiveness, looking to "die good."[165] The circle is less unbroken here. Whether Traylor conceived these drawings as depictions of ring shouts or another kind of prayer circle or meeting is uncertain, but his understanding of the unity and enlivening of spirit brought about by a conjoined (physically or otherwise) group is clear.

Of the two crucifixion images Traylor is known to have made (discussed below, PLS. 69, 70), both of which Shannon titled, the one in Conté crayon on cardboard (PL. 69) appeared in the New South exhibition (see fig. 63); the second, *Black Jesus* (PL. 70), not in the New South show, is gouache and pencil on cardboard. In each the crucified figure is barely more than a silhouetted form but seems unmistakable as a representation of an African American.

In the 1920s writers and illustrators associated with the Harlem Renaissance increasingly employed religion as a point of resistance identity. In *On De No'thern Road* made in 1926 (fig. 64), Aaron Douglas depicted a black man journeying from the rural South to the urban North, his heavy burden alluding to Christ bearing the cross on the road to Calvary. To underscore the connection, *Opportunity* magazine, which published his print, placed Douglas's illustration alongside a poem by Langston Hughes, "Bound No'th Blues," which evokes Simon of Cyrene, who helped Christ carry his load. Artist's renditions that correlated Christ's crucifixion and Southern lynchings became increasingly more overt.[166] Countee Cullen's "The Black Christ" was published in 1929 in a collection of poems, with illustrations by Charles Cullen, that equated Christ's suffering with that of African Americans.[167]

Hughes was a champion for social action and racial consciousness, and in 1931 he responded to the case of the Scottsboro Boys, when nine black youths in Alabama were unjustly accused of raping two white women on a train; the case came to embody the concept of disenfranchisement, and the miscarriage of justice caused international outcry. Hughes went to North Carolina to do readings and contribute to a journal called *Contempo*, which devoted its December 1931 issue to the Scottsboro Boys. Hughes submitted a poem called "Christ in Alabama"; illustrator Zell Ingram made the accompanying drawing, *Black Christ* (fig. 65).[168]

The Scottsboro Boys effectively became the "vernacular Christs of the South," in the words of art historian Caroline Goeser. Goeser argues that Ingram's image was particularly transgressive. Instead of showing a lynched black man in conjunction

with a crucified Christ, drawing a parallel, it showed Christ as a black man: "Eyes closed, head bowed down, and hands held up to reveal stigmata in the center of his palms. Ingram's bust inverted the conventional color paradigm of the white Christ with dark wounds where his hands had been nailed to the cross. His Christ was a black youth who bore white wounds, just as the Scottsboro boys would carry the wounds of their abuse by a corrupt white legal system in the American South."[169] Hughes conducted a controversial poetry-reading tour spanning seventeen states, including a stop in Alabama, where he visited what was then the Kilby Prison just

FIG. 64 Page from *Opportunity* magazine, 1926, showing poem by Langston Hughes accompanied by art by Aaron Douglas, *On De No'thern Road*, 1926, relief print. Spencer Museum of Art, University of Kansas, Museum purchase: Helen Foresman Spencer Art Acquisition Fund, Lucy Shaw Schultz, 2003.0012.03

FIG. 65 *Black Christ*, 1931, by Zell Ingram, on cover of *Contempo*, December 1931, with "Christ in Alabama," a poem by Langston Hughes. North Carolina Collection, The Louis Round Wilson Library, University of North Carolina at Chapel Hill

north of Montgomery and read the poem to the Scottsboro Boys. While touring, Hughes gave away numerous copies of his poetry volume *The Negro Mother and Other Dramatic Recitations* (1931) to those who could not afford to buy them. After it appeared in *Contempo*, the poem "Christ in Alabama" was paired with other works, and illustrations by Prentiss Taylor, in a booklet called *Scottsboro Limited: Four Poems and a Play in Verse* (1932; fig. 66).[170]

Periodicals such as *The Crisis* and *Opportunity* were publishing poems and images that reactivated Christ as an African American man; by 1935 the subject of lynching, and to a lesser degree the linking of crucifixion and lynching, was a growing theme in American art. Walter White of the National Advancement for the Advancement of Colored People (NAACP) organized the exhibition *An Art Commentary on Lynching*, which contained disquieting works by artists George Bellows, Paul Cadmus, Isamu Noguchi, and Reginald Marsh in addition to works by ten African American artists, Malvin Gray Johnson and Hale Woodruff among them. Thomas Hart Benton's painting *A Lynching* depicted white laborers raising a black man onto a telephone pole in a scene with distinctly cross-like iconography, an image that art historian Margaret Rose Vendryes observed, "[brought] home the irony of civilization still accommodating savagery."[171]

Shannon, as a teacher and artist in his own right and fascinated with Traylor, claimed that he never gave Traylor instructions on how or what to draw, and no evidence contradicts his assertion. Whether Traylor chanced to see any of the illustrations of black crucifixions made by black activists or fine artists of the day is unknown. Images in books, magazines, or other media that planted the idea of a black Christ were passed around within the African American community. Even if Traylor missed seeing

FIG. 66 Pages from Langston Hughes, *Scottsboro Limited* (1932), showing Hughes's poem "Scottsboro" accompanied by an untitled drawing by Prentiss Taylor. Beinecke Rare Book and Manuscript Library, Yale University

such images, the ideas that inspired them percolated throughout the community, especially as topics of lynching and racial injustice made their way, even if metaphorically, into the lyrics of blues musicians. Particularly timely may have been Billie Holiday's musical interpretation of one of the anti-lynching campaign's most well-known poems, "Bitter Fruit" by Abel Meeropel, a Jewish schoolteacher from New York. Holiday's recording of "Strange Fruit," based on the poem, made number sixteen on the charts in July 1939.[172] The song is haunting and powerful, evoking the unnatural horror of seeing mutilated bodies hanging from trees.

> Southern trees bear a strange fruit,
> Blood on the leaves and blood at the root,
> Black body swinging in the Southern breeze,
> Strange fruit hanging from the poplar trees.

Lynching was understood to take a variety of forms; it encompassed any kind of extrajudicial punishment, including public murders in which the police either looked the other way or participated under the cover of Ku Klux Klan membership. Another type of lynching was murder by on-duty police, who operated with impunity, such as when they killed Traylor's son Will in 1929, ten years before "Strange Fruit" hit airwaves.

The connection between police killings, black persecution, and the concept of a black Jesus is arguably manifested in Traylor's images in which the son—his son and/or God's son—is crucified.[173] In these pictures Traylor asserted his awareness of and membership in the large community of African Americans that understood outrage and the power of unity. Traylor was creating art that could be read as sacrilegious and possibly jeopardize his safety. The inclusion in the New South exhibition of *Crucifixion* (PL. 69; in fig. 63), done in a dark, soft black media on cardboard, attests to Traylor's general trust of Shannon and the other New South members, although it is equally likely that its presence made Traylor uneasy. In this picture the crucified man looks meek and afraid, repentant. In the related work in gouache and pencil on cardboard, *Black Jesus* (PL. 70), which was not in the show but presumably done around the same time, the figure is considerably stronger.

In most of Traylor's images that imply direction—such as a man plowing or a horse walking—"forward" is the right side of the frame. Accordingly, the figure in *Crucifixion* looks backward—perhaps into the past or as a last glance at life. In *Black Jesus* the figure faces forward. His expression is awake and aware. Traylor took care to paint his skin tone, hair, and the structure that holds the body with different tones and colors. The figure is, as in the first image, unmistakably a black man, but the feeling here is defiant rather than meek. With eyes wide open he faces the future.

Almost fifty years after the New South members brought Traylor to see the exhibition of his art at the gallery, Shannon recalled Traylor as a man who had little awareness that he was the artist behind the work he was seeing. After explaining that getting Traylor to the show, especially up the stairs, was a time-consuming task, Shannon described the rest of the visit:

He went in and, steadying himself with his two canes, he looked around with no change of expression, he just looked. He leaned over and, pointing with his cane, said, "Lookit dat man 'bout to hit dat chicken." He went around and looked at every picture. After one time around, when he got to the end, he was ready to go. So we took him back down the stairs, back to where we got him on the sidewalk, and he sat down on his box, picked up his pencil, and started drawing. There had been no acknowledgement that this was his work, and he never mentioned his show again. Nobody was less impressed with Bill Traylor than he was himself.[174]

Shannon's perspective, however, is through the lens of an artist who, himself, craved attention and understood the glory attached to having a solo exhibition of one's art. Traylor, whose art recorded a series of moments, on the other hand, was likely revisiting the memories themselves rather than the drawings he made of them. If that indeed was the case, he was probably also experiencing some level of discomfort as a group of white people—even if supportive—watched him. They would have been drinking in his responses and looking for insights into imagery that varied from narrative to arcane to the semiovert, such as the violence in *Untitled (Event with Man in Blue and Snake)* (PL. 30; in fig. 49) or the black figure in *Crucifixion*, a piece they may have situated within the context of art-world trends and social concerns but that may have made Traylor feel vulnerable. The New South members were generally ill-informed about the facts of the artist's life and did not know about the killing of Traylor's son Will; Traylor's taciturn or oblique responses may not have suggested a dislike or distrust of them but rather, the degree to which he was comfortable revealing himself to members of a culture he was indoctrinated to hold at a certain distance.

Interestingly, the New South members never pressed Traylor for information about his work or asked him to explain the opaque images. Perhaps they underestimated his ability to account for or articulate them, or perhaps they were aware that openly acknowledging subversive content in some of the edgier works was unwise. *Crucifixion* and *Black Jesus* may not have been the first and were not the last instances in which Traylor would explore themes of black persecution, the hostilities he experienced in his lifetime, or the ongoing cultural terrorism of lynching. Between the demise of the New South in February 1940 soon after Traylor's exhibition, and the American involvement in World War II in 1942, Traylor made a body of work that explores all the themes touched on in his first year of art making and became an artist of inestimable power and originality.

PLATE 4 *Shoes, Figures, Etc.*

PLATE 5 *Untitled (NRA WPA)*

PLATE 6 *WPA Poster*

PLATE 7 *Untitled (Lamp, Bottle, and Cat)*

PLATE 8 *Untitled*

PLATE 9 *Owls in Tree / Shoeing Mule*

PLATE 10 *Blacksmith Shop*

PLATE 11 *Pigeon (on men's handkerchiefs card)*

PLATE 12 *Man with Basket on Head (Early)*

PLATE 13 *Greyhound*

PLATE 14 *Sickle-Tail Dog*

PLATE 15 *Fierce Dog*

PLATE 16 *Spotted Cat (AKA Cat)*

PLATE 17 *Cat*

PLATE 18 *Cat, Pale Face*

PLATE 19 *Untitled (Pineapple)*

PLATE 20 *Basket with Plant Form*

PLATE 21 *Untitled (Basket, Man, and Owl)*

PLATE 22 *Untitled (Owl)*

PLATE 23 *Untitled (Spotted Cow)*

PLATE 24 *Turtle Swimming Down*

PLATE 25 *Yellow Chicken*

PLATE 26 *Two Figures with Pitchfork and Birds*

PLATE 27 *Untitled (Figure Construction with Kneeling Man)*

PLATE 28 *Bird*

PLATE 29 *Blue Bird*

PLATE 30 *Untitled (Event with Man in Blue and Snake)*

PLATE 31 *Untitled (Scene with Keg)*

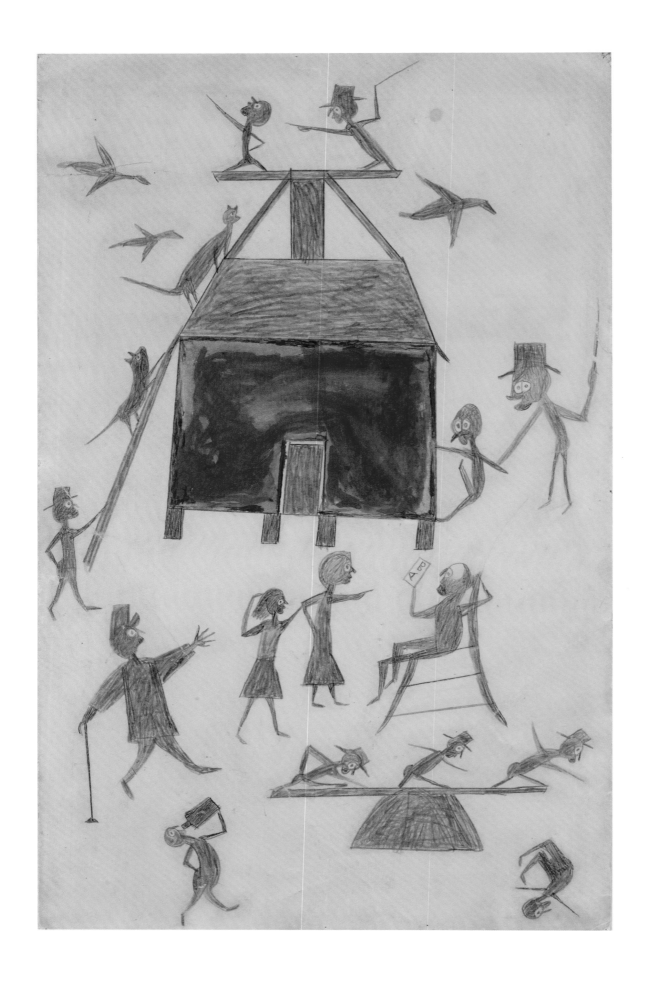

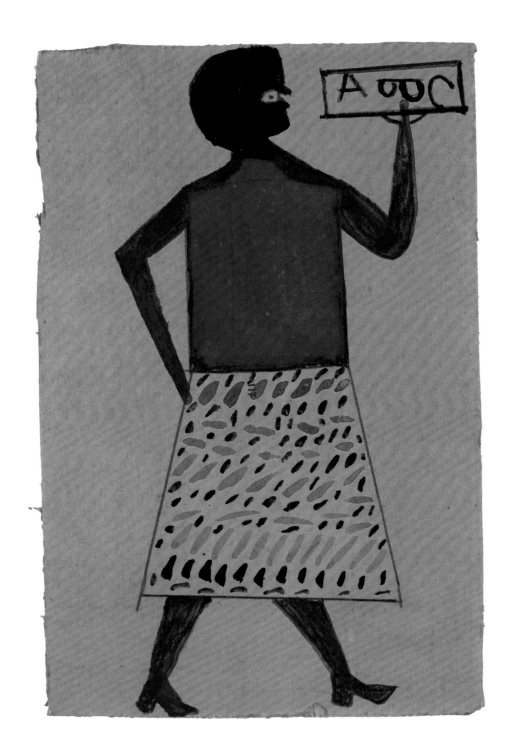

PLATE 32 *Red House with Figures*

PLATE 33 *Untitled (Woman in Blue Holding an ABC Sign)*

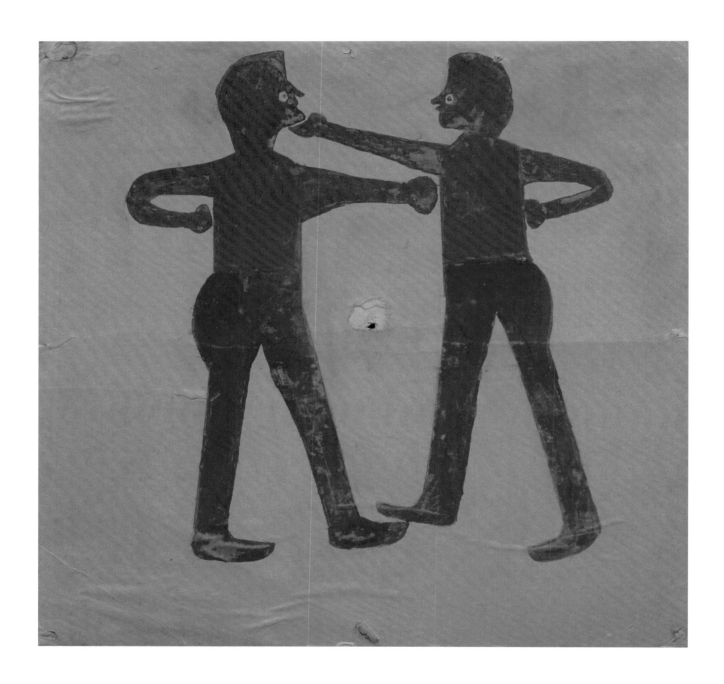

PLATE 34 *Boxers in Blue*

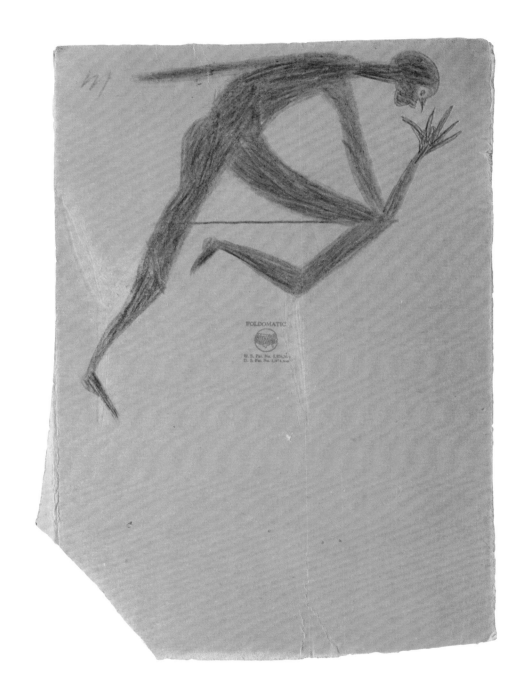

PLATE 35 *Untitled (Running Man)*

PLATE 36 *Untitled (Woman with Umbrella and Man on Crutch)*

PLATE 37 *Self-Portrait*

PLATE 38 *Fighter*

PLATE 39 *Untitled (Dog Fight with Writing)*

PLATE 40 *Untitled (Footed Form)*

PLATE 41 *Plant / Animal Forms*

PLATE 42 *Leg Forms with Bird*

PLATE 43 *Legs Construction with Five Figures*

PLATE 44 *Half of Green Man with Dog, Plant, and Figures*

PLATE 45 *Sprouting Green Figure*

PLATE 46 *Two Cats Jumping on a Man*

PLATE 47 *Human Plant Form on Construction with Dog and Man*

PLATE 48 *Untitled (Figure on Construction with Legs)*

PLATE 49 *Anthropomorphic Figure and Cat*

PLATE 50 *Dancing Cauldron*

PLATE 51 *Cedar Trees*

PLATE 52 *Abstraction, Red, Blue, Brown* (AKA *Abstraction*)

PLATE 53 *Figure/Construction, Man Stealing Liquor*

PLATE 54 *Untitled (Construction with Lamps)* (AKA *Lamps on Mantelpiece*)

PLATE 55 *Basket, Black and Green*

PLATE 56 *Untitled (Ross the Undertaker)*

TREET SAFETY RAZOR CORP.
NEWARK, NEW JERSEY
DISTRIBUTOR

PLATE 57 *Untitled (Black Basket Form, Snake, Bird, and Man)*

PLATE 58 *Lamp, Abstract Table, Figures, and Dog*

PLATE 59 *Brown Lamp with Figures*

PLATE 60 *Simple Forms—Lamp*

PLATE 61 *Spotted Cat (AKA Two-eyed Black Cat with Colored Spots)*

PLATE 62 *Wild Animal*

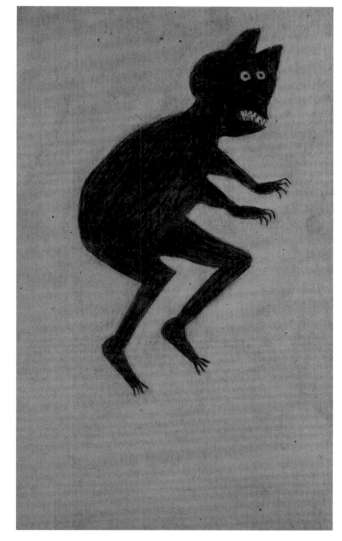

PLATE 63 **Untitled (Man, Woman, and Dog)**

PLATE 64 **Scary Creature**

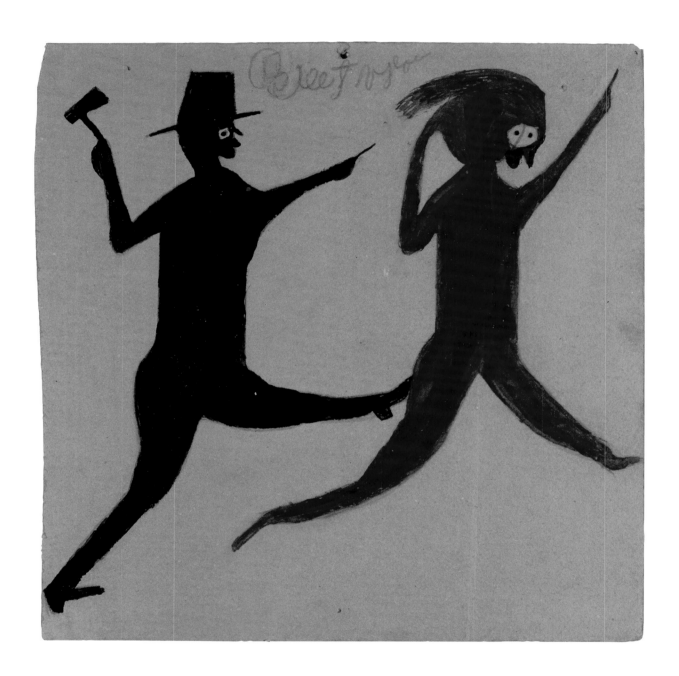

PLATE 65 *Untitled (Chase Scene)*

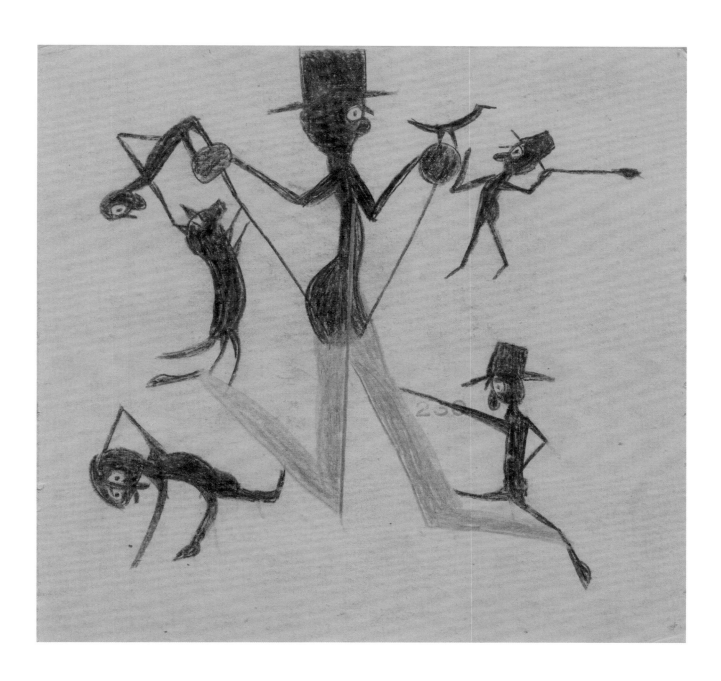

PLATE 66 *Man with Top Hat and Green Trousers*

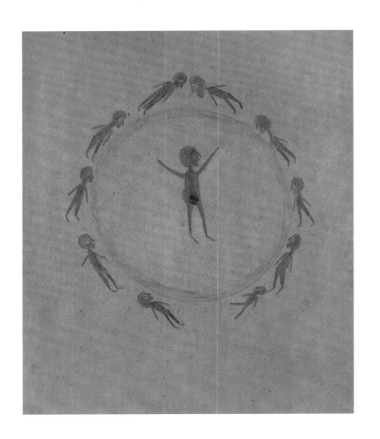

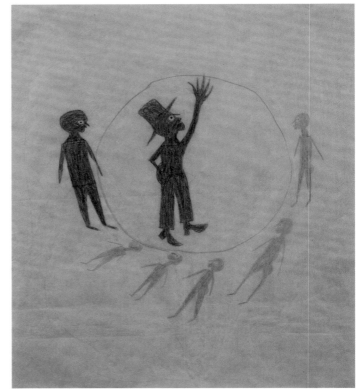

PLATE 67 *Preaching in Circle with Figures*

PLATE 68 *Preacher and Congregation*

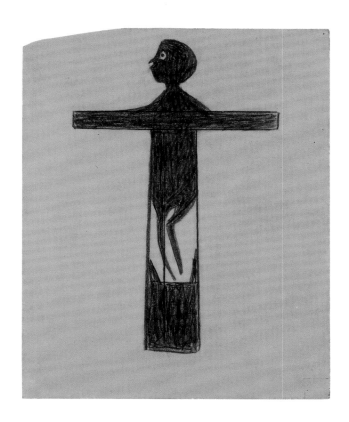

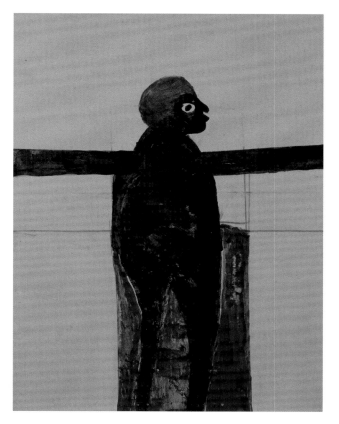

PLATE 69 *Crucifixion*

PLATE 70 *Black Jesus*

FLORESCENCE, ca. 1940–1942

In the early 1940s, Bill Traylor's artistic production was at its zenith. In the grand scheme of artistic careers, Traylor's was exceptionally short. The span of Traylor's art has generally been dated by the period during which Charles Shannon and other members of the New South artists' group collected and documented it, that is, 1939 to 1942. In truth, Traylor may have started drawing as early as 1937 or 1938, and it is evident that he made art until at least 1948. In the end however, it is the art Traylor made between 1939 and 1942 that survived and has supporting documentation.

Although it is compelling to believe that Traylor started drawing before Shannon first began saving his art, the unpolished, exploratory drawings that Shannon dated to 1939, and the rapid stylistic progression witnessed shortly thereafter, argues for 1939— or very close to it—as, indeed, the initial year of Traylor's art making. Importantly, the stylistic changes in Traylor's work, from the first known drawings to those documented in the final years of his life, chart a clear trajectory and establish parameters against which heretofore unknown works could be meaningfully evaluated. Comprehensively, 1939 to 1942 (when Shannon left Montgomery and stopped collecting Traylor's art) remain the most plausible dates of execution for more than a thousand extant works.[1]

Discussing a "career" as short as Bill Traylor's—one for which records are scant and entire periods seem entirely missing—proves almost as difficult as pinning down the facts of his life. Nevertheless, the art itself reveals a great deal and, paired with various notes and photographs, a tenuous timeline of Traylor's artistic journey emerges. Regarding his early years, one of Traylor's granddaughters believed he was drawing in 1937 or 1938, and Montgomery local Jay Leavell's memories also point to Traylor's artistic beginning as sometime in 1938. This may indeed be the case—but no extant works can be dependably dated to those years. For the purposes of this study, "early work" refers to drawings and paintings that date from roughly the beginning of 1939 through February 1940, following the New South exhibition *Bill Traylor: People's Artist*. The

period directly after, March 1940 through the summer of 1942, is referred to herein as Traylor's "middle period"—a time of florescence during which Traylor created the lion's share of the extant oeuvre. The "late works" came between the summer of 1942 and Traylor's death and may be documented only in photographs.

Photographs of Traylor and his artworks taken in 1939 and 1940 reliably (if imprecisely) date specific works to those years; their media, style, and relationships among imagery offer insights for other works likely made contemporaneously up to 1942. Other photos that document Traylor with art he made in the later 1940s (between 1942 and his death) also exist, although the art seen in them may not; the possible fates of those works are discussed herein.[2] A small portion of the art considered to date to 1939–42 may indeed have been made slightly later, but documentation to support that possibility is thus far lacking.[3]

In the early 1940s, Charles Shannon had known Traylor for about a year.[4] Having watched Traylor's art develop significantly in that relatively short time, Shannon recognized the font of creativity for what it was, recalling that Traylor "went inside himself and it just began to pour out; it was like striking a spring."[5] Traylor's small, scratched-out forms in faint pencil had become larger, more fluid, and increasingly sure. All that Traylor had seen and experienced distilled in his mind as he sat—thinking, watching, and drawing. He was exploring realism, narration, symbolism, and abstraction as they intersected with the oral culture that inspired all his work. His manner of learning was organic, his compass was internal, and the world was moving fast as he sat still.

By then, most of Bill's children had followed the Great Migration north, and more than a decade had passed since Traylor's third wife, Laura, had died. The New South collective had disbanded in late February 1940, and Shannon, having been selected to participate in the Rosenwald Fund's West Georgia College Project, moved to Georgia.[6] The group members remained socially engaged progressives and continued to see Traylor, but little record of those encounters was kept after the structure of the group dissolved. While Charles was away, Blanche Balzer Shannon still purchased Traylor's paintings and drawings, and Charles visited Traylor when he was in Montgomery.

The war had begun in Europe in 1939, but life on Monroe Street went on largely as it had before. At the time, Shannon wasn't aware of Traylor's local family. He knew that Traylor wanted to visit his daughter Easter in Detroit, which he did in 1940. "We helped scrape up some money to buy him a [bus] ticket and thought we'd never see him again. In a couple weeks, though, he was back. He was very upset that the bus lines did not provide restrooms for black people."[7] Traylor's great-granddaughter Nettie Traylor-Alford described Easter as the "glue" of the family; she ran a boardinghouse, and three of her brothers (Clement, called "Son," Walter, called "Bubba," and James, called Jimmie) and her sister Lillian lived or stayed there at times.[8] Granddaughter Myrtha Lee Delks, who visited Easter in the mid-1950s, was among the descendants who recalled her aunt having, on view at her residence, some of the drawings that Traylor had made while visiting her.[9] Ultimately, the North didn't feel like home, and Traylor told Easter that he'd rather be homeless in Montgomery than remain in Detroit, so the visit was brief.[10]

Back in Montgomery, Traylor resumed his spot on the street (figs. 67–69) and immersed himself in his work, probing some subjects in depth, touching briefly on others, and leaving vast amounts of the world around him out of his imagery altogether. Horse- and mule-drawn (even goat-drawn) carts (fig. 70) were giving way to automobiles and buses, but Traylor did not picture them, with one exception, of a cart driver apparently losing control of his animal (not illustrated herein).[11] He did not depict the storefronts or businesses around him, although fragments from his surroundings—for example, a silhouetted dinosaur that he may have seen on posters at the nearby movie theater— occasionally came into his drawings. Traylor did not paint barns or work structures from around the farm, with one notable anomaly: *Untitled (Blue and Brown Buildings)* (PL. 71), which shows a squat building that may be the smokehouse from the planta- tion, where farm laborers preserved meat (fig. 71). The only inhabitable structure that Traylor would explore repeatedly was the domestic house. Most often, Traylor's scenes

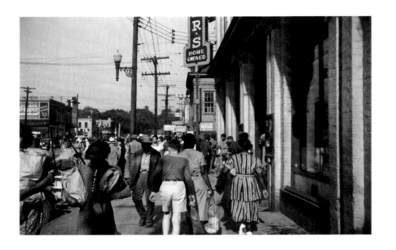

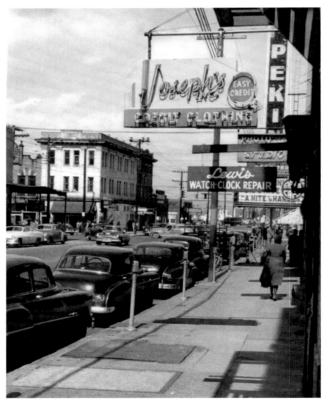

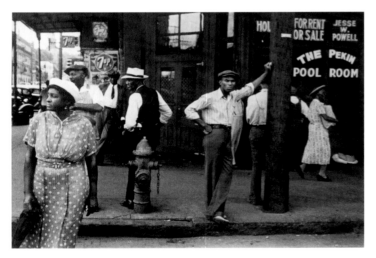

FIG. 67 Charles Shannon, *Sidewalk Crowd/Woman in a Striped Dress*, 1939. Charles E. and Eugenia C. Shannon Trust

FIG. 68 Rudy Burckhardt, *Pekin Pool Room street scene, Montgomery, Alabama*, ca. 1941

FIG. 69 Ken Hughes, *Pekin Theatre on North Lawrence Street, looking toward Monroe Street, Montgomery, Alabama*, ca. 1950

were "set" in the wide-open space of the surface of his paper; the absence of a back-drop effectively evokes an immense field or the interior of a room.

Alone in the expanse of the page, animals such as in *Untitled (Brown Pig)* and *Untitled (Pig with Corkscrew Tail)* (PLS. 72, 73; the latter in fig. 54, above) are among Traylor's most easily recognizable works. The artist portrayed them as individuals, unique in shape and character in ways that went far beyond their species. Many were clearly creatures he knew well and illustrated time and again. Traylor also developed certain devices for locating his stories. He anchored his narratives with structures, such as a table, the diving platform from his youth, the fountain in Montgomery's central square, and mechanisms from plantation days, including the cotton screw and a whiskey still. Sometimes Traylor's platforms feel weighted, vaguely evoking an auction block or hangman's gallows. The most haunting of Traylor's recurring locations was a centralized tree. It is in these works that Traylor's skill at creating double story lines and ambiguity to obscure or reveal different meanings—one for black viewers and another for whites—are the most evident; what seems a possum hunt to some is a sinister pursuit to others.

Traylor's interest in describing complex scenes is evident in his earliest works, and he continued the practice. The artist's tableaux undoubtedly originated in his memo-

ries and family stories, which he drew rather than wrote down. Some of his imagery is arcane. In part Traylor was learning how to show his subject visually in an effective way, yet it often seems that he was intention-ally secretive in what he portrayed, perhaps depending on who he thought was watching. Living two lives, he switched his system of communication between his encounters with whites and those with blacks—the behavioral norm for African Americans, who were still expected to adhere to strict social codes of racial eti-quette.[12] But Traylor did not entirely hide his works showing fraught scenes, such as *Man with Hatchet Chasing Pointing Man* (PL. 74). Those, too, made their way into Shannon's collection, together with the affable cows and fat catfish, such as in *Untitled (Cow)* and *Black Fish* (PLS. 75, 76). When Traylor took up drawing, he essen-tially began conducting a perilous daily experiment on what segregated Montgomery would tolerate from an old, homeless black man who had seen a lot. To the degree Traylor remained invisible to most white passersby, it was largely to his advantage. His age, worn clothes, and illiteracy dovetailed with a racial prejudice that pre-sumed he could never be sophisticated, intelligent, creative, or—least of all—subversive.

FIG. 70 Young man in goat-drawn cart, downtown Montgomery, Alabama, ca. 1900; photographer unknown

FIG. 71 Outbuildings, George H. Traylor plantation, Lowndes County, Alabama, 1991; photograph by Marcia Weber

CHASE SCENES AND COMPOUND NARRATIVES Whatever first motivated Traylor to record his memories on paper, many of his early works seem dedicated to conveying complex narratives that, in his characteristic manner, hover uncomfortably between the humorous and the treacherous. Done in pencil, on plain pieces of cardboard and arranged vertically, examples including *Untitled (Event with Man in Blue and Snake)* and *Untitled (Scene with Keg)* (PLS. 30, 31; in fig. 49) are among those that inspired Shannon's category "Exciting Events." When Traylor began working predominantly in poster paint or similar media around 1940–42, he continued to draw ambitiously narrated altercations that entail hatchets, rifles, animals, people, and a high degree of chaos. The classification of these drawings and paintings as "Exciting Events" may have aimed at objectivity but nevertheless foregrounded a semblance of humor and down-played violent undertones.

Exciting Event with Snake, Plow, Figures Chasing Rabbit (PL. 77) evidences multiple scenes that Traylor would subsequently select as singular subjects in later drawings. Near the top a man is operating a single-bottom plow, an act of labor that Traylor painted with elegance in several later pictures, including *Man with a Plow* (PL. 78). In the former, the pencil drawing, two human heads lay near the feet of farmer. Whether Traylor meant for them be severed from their bodies or simply never finished the figures is one of the work's more ambiguous elements, but erasures elsewhere on the page suggest that Traylor left the bodiless heads as he intended to portray them. Overall, the circumstances appear intense; an old woman and a small child stand by while men hunt a fleeing rabbit; an immense snake bisects the page. Overtly, it's a hunting scene—men after food prey. Yet the sense of allegory that would have been part and parcel of Traylor's upbringing radiates. This work's large sprinting rabbit and the many subsequent works in which rabbits are the central quarry increase the likelihood that Traylor uses "Rabbit" as a stand-in for a man, specifically an African American.

Br'er (or Brer) Rabbit (fig. 72) became known in America through the Uncle Remus folktales Joel Chandler Harris recorded, but the character existed long before Harris made him popular. In African American lore the rabbit or hare is a hero with many characteristics; he is a joker, braggart, and ladies' man, among other things. The animal might be physically weak, but he is cunning. The theme that meekness and cleverness could overpower might was an abiding favorite in slave culture and long after. Rabbit as a trickster archetype exists the world over and likely evolved in North America from multiple origins—among them, African folktales of Kalulu the Hare, and Native American stories about the Anishinaabe's trickster Nanabozho. In the United States, Rabbit as a stand-in for the persecuted black man became pervasive.[13] Some accounts by runaway slaves describe their use of rabbit grease to hide their scent from pursuing hounds, offering another angle on the rabbit as a symbol for a person on the run.[14]

Traylor's rabbits are ultimately a topic unto themselves. In a group of images of rabbits (PLS. 79—83), Traylor's ideations of the long-legged, long-eared critters progress visually. *Untitled (Rabbit)* (PL. 79), arguably the earliest of the four, explores the form of a running rabbit, yet the creature is round and mouse-like, and only outstretched legs

and tall ears identify its species. In *Running Rabbit* (PL. 80), Traylor gave Rabbit the ability to fly; the animal sails through the air despite a plump and squat physique. In *Rabbit* (PL. 81) the animal's legs are long, strong, and uncannily human-like. In *Blue Rabbit Running* (PL. 82) the puffball tail and ears indicate alert, but the animal has become both substantial and sublime, painted in rich blue to connote his spiritual armor and fleet-footed escape.

In *Exciting Event with Snake, Plow, Figures Chasing Rabbit* (PL. 77), the bunny's legs resemble a man's as they do in *Rabbit* (PL. 81); the creature's long front limbs are more like human arms than the relatively short front legs of cottontails. The most overt parallel Traylor makes between a rabbit and a fleeing person is in *Untitled (Chase Scene)* (PL. 83). Here the sole figure in the work depicted with black paint runs from a pursuer with a hat.

Above the man initiating the pursuit is a dog, the pair surely intended to be a white planter and his dog chasing down a fleeing black man, the enslaved or accused. Above the fleeing black man is a large rabbit, also running for his life. The predators hunt the prey. Two birds fly above the rabbit and black man, toward freedom. A curious detail in the image appears near the fleeing man's left hand, where Traylor drew three arched, parallel marks. The significance of the lines—how many and on which hand—has myriad possibilities, but they seem manifestly symbolic. They may indicate the fear or tension in the man's body, a physical trembling. (That the lines are meant to convey movement is made forcefully by another work, not illustrated herein, in which Traylor painted a man smoking; there, around the hand of an otherwise still figure, arched lines clearly evoke localized motion.[15]) Considering the various possibilities of their symbolism, however, the number three could be a prayer to the holy trinity for escape, or a link to the folk belief "third time lucky" or "third time's the charm." Whatever the lines meant to Traylor, they are drawn plainly and deliberately and add a sense of specificity to a troubled memory. The unambiguous layout of pursuers, the pursued, and the birds flying toward freedom make this painting Traylor's most blatantly signaled.

The oversize snake in *Exciting Event with Snake, Plow, Figures Chasing Rabbit* may, as it seems to in *Untitled (Event with Man in Blue and Snake)* (PL. 30; in fig. 49), symbolize the underlying menace in the scene. In both cases the large snake moves in tandem with the fervor but does not raise its head to strike. Traylor would employ snakes time and again as symbols of peril; he surely knew them well. Robert Farris Thompson has pointed out that in the Kongo culture, serpents represent danger, and conjure accounts regularly associate snakes with the trick doctor and coming threat.[16]

In rural Alabama plantation country, where warm weather is synonymous with "snake season," snakes may be feared or respected for many practical reasons. Among the hazards that African Americans lived with

FIG. 72 A. B. Frost, *Brer Rabbit Conversing with Brer Fox, Brer Wolf, Brer Coon, and Brer Bear*, illustration for the story "Brother Rabbit Takes Some Exercise," 1883, from Joel Chandler Harris, *Nights with Uncle Remus: Myths and Legends of the Old Plantation* (1911)

were the snakes that shared their space at the edge of the plowed land and in the wooded sections of the farm. For enslaved people or freedmen laborers, having the boots and heavy pants that might protect them from the venomous bites of the cotton-mouths, copperheads, and rattlesnakes who lived in proximity was more likely the exception than the norm. On an isolated farm, a snakebite could easily be fatal, despite herbal remedies such as snake-root tea.[17]

Snakes are occasionally the full subject of Traylor's artworks. In *Untitled (Snake)* (PL. 84) the creature's colored spots and a black tail resemble the timber, or canebrake, rattlesnake (*Crotalus horridus)* that Traylor would have known to steer clear of; he drew its mouth agape, ready to strike. *Blue Snake* (PL. 85) demonstrates Traylor's understanding of a viper's striking power—the muscular coil just behind its head divulges the gathering force.

Traylor often cast snakes as instigators of chaotic scenes. Sometimes they seem latent, a danger that is ever present but not an immediate threat. Other times, as in *Snake and Two Men* (PL. 86), the menace is indisputable. The snake is angered, with mouth open and fangs bared. *Snake and Two Men* echoes Traylor's tense drawings from around 1939–40 that show nightmares or hoodoo-related encounters. A man points up at the snake's victim, who is bisected by eleven horizontal lines. Mechal Sobel theorized that the lines (and the numbers of them) related to superstition evidence a potential relationship in Traylor's work to playing the numbers, as laid out in *Aunt Sally's Policy Players' Dream Book* (1889; fig. 73). This was a small printed booklet popular during the late nineteenth and early twentieth centuries in which "Aunt Sally" correlated dream images with numbers to bet in the underground wheel-of-fortune lottery known as "policy." If a person dreamed of a cat, for example, Aunt Sally would tell the dreamer to play the number fourteen.[18] Blues singers such as Blind (Arthur) Blake mentioned the game in songs like "Policy Blues": "I begged my baby to let me in her door; Wanted to put my 25, 50, 75 in her 7, 17, 24."[19]

Sobel notes that "Aunt Sally" associated the number eleven with sickness, imprisonment, or a dreadful hex of some sort. In this reading, the pointing man might be instigating a conjure trick on the man under attack. The victim has a shape evoking a bow saw or hunter's longbow drawn across his waist. Sobel interprets the half-circle shape as the bottom half of sphere, alluding to the underworld, its position across his groin suggesting, in her view, a sexual crime.[20] The man's eyes are wide with terror and his legs and feet splayed; he kneels in paralysis before the viper's deadly pose. Only Traylor knew the true content of the work, but the intense sense of fear and mystery in the image recalls the similarly dark mood of *Untitled (Black Basket Form, Snake, Bird, and Man)* (above, PL. 57) and effectively translates some harrowing memory. Both snake scenes depict a mortal confrontation and bring to mind the fearsome relationship (perceived or real) between snakes and the hoodoo man: "If you see a snake curled up to spring, it means the conjure doctor is very angry with you."[21]

FIG. 73 *Aunt Sally's Policy Players' Dream Book* (1926 ed.). First published in the late nineteenth century, the booklet offered interpretations of dreams and lucky numbers for playing "policy," an underground lottery once popular with the black community.

The many drawings in which Traylor includes a set of parallel lines indicates that he knew numbers, probably from his many years of heading a household and keeping his own accounts. The quantity of lines in these sets varies, and they appear only in select works; yet when they do, they are carefully made and positioned—another piece in Traylor's puzzle. One early drawing (not illustrated), which Shannon labeled on one side as "Whippoorwill, July 1939," has such marks, more of them than usual—fifty-three on the front side with an image of a bird, and another twenty-nine (or thirty if counting one that is scratched out) on the reverse, which has a drawing of a dog.[22] On a powerful painting of a coiled black snake about to strike, *Snake* (PL. 87), Traylor painted ten parallel lines, each slightly longer than the previous one; the care with which he made the marks signifies their importance if not their meaning. The relationship between the coiled snake, potent symbol of the riled conjure doctor, and the lines is compelling.

In a painting that shows one of the most overt uses of numbers in any of Traylor's works, a man in a hat strides by, holding up five fingers on one hand and one on the other (PL. 88).[23] The man is stepping off a paver or plank, shaded in a way that describes its dimensionality. An agitated little dog looks up the man but can't reach him. Traylor's symbolism here is characteristically impenetrable, yet the image is striking for its clarity and singularity; the figure's arms are not raised in high emotion at the shoulder but rather, from the elbow up, calmly and clearly signaling six digits. Six might have had a range of meanings to Traylor, but his enigmatic specificity in this instance invites speculation. Ronald L. Smith, who wrote a fictional tale for young readers about hoodoo, cast his villain as a malevolent soul who employed the number of the beast from Revelations to sow fear: "You know my number boy?" the demon asked, "It's six six six, full of tricks." The dark character was not the Devil himself but knew well how to employ superstition-based terror as a powerful tool.[24] Traylor's man showing six fingers gives a similar impression; the omen is unknowable, but the effect can take hold of a receptive mind.

In the early "event" scenes, another recurring theme is that of the "chicken thief." As mentioned previously, this trope was not only a racist stereotype but also, for impoverished people trying to feed their families, the reality entailed within being a "victim of slavery," as Booker T. Washington put it. Traylor drew someone making off with a chicken or other bird in hand in many drawings. *Chicken Toter Being Chased* (PL. 89) shows a farmer or merchant carrying a crate of chickens, presumably to market. Two attackers try to relieve him of his bounty; one points as the other takes aim with a mallet. Who's who in terms of racial roles is not clear here, and its narrative of an organized and open assault varies from those in most of Traylor's other thievery pictures, in which the scene usually shows a farmer chasing a thief. In this case the chickens are pictured plainly as goods; there is little to suggest the birds are otherwise meaningful.[25]

More characteristic of Traylor's chicken-stealing scenes are *Untitled (Mule, Dog, and Scene with Chicken)*, *Chicken Stealing*, and *Hog, Dog, and Chicken Stealing* (PLS. 90–92). Chaos reigns in all three. In the former (PL. 90), Shannon inscribed Traylor's comments to say: "Old one-legged fellow getting after boy for scaring the chicken." The

written comment is curious, as the boy appears to be whacking the chicken with a stick—not merely "scaring" it.

In the other two works the narratives swirl around the pages. Events in *Chicken Stealing* (**PL. 91**) seem to lack sequence but are not illogical. A planter or farmer (wearing hat and boots) carries his rifle in pursuit of the thief; below him an overseer or farmhand with a hatchet joins the chase, as do two dogs; a flying bird above them signals the fleeing man's hope. Two farmwomen point the way or sound the alarm; the two smallest figures prod the women with sticks, signifying their troublemaking spirits. In this singular representation, Traylor, uncommonly for him, shows the escaping man as distinctly barefooted, indicating the man's poverty and, in effect, his need. With a bird in each hand he runs for his life.

In *Hog, Dog, and Chicken Stealing* (**PL. 92**), the hog and dog seem detached from the fracas, as do an old woman and little girl, whose orientation is at odds with that of the animals. The large men are drawn with elegance and care. Towering in boots and a tall hat, the man in power is either the chicken owner or farm overseer; he points, readies his mallet, and kicks the fleeing thief in the rear—causing the absconder to unhand the pullet. The thief's shoes are not as heavy and strong as the boots of the pursuer, but the two men are otherwise similar in appearance, with long hooked noses, brimmed hats, and large, lean frames. Another, small man, pointing and yelling, may be the planter himself, angered but not doing the dirty work. The resemblances of the men overall pose the question of whether Traylor purposely injected ambiguity into their identities to create a nimble story. All three drawings demonstrate the artist's ability to render figures and animals with increasing specificity and nuance.

UNCOMMON SCENES Within Traylor's myriad story lines are some that appear only a few times. An encounter with a bear inspired a series of works in which a lumbering creature causes panic.[26] *Untitled (Men Shooting Bear)* (**PL. 93**) seems to be an early attempt to draw the large animal. Traylor portrays bears with barrel-like torsos and sizable claws but faces that are too delicate; his bears are distinct in physique from his dogs and cats but not entirely ursine either. In *Blue Animal with Five Figures* (**PL. 94**) the creature is easier to identify but still indefinite. Traylor's pursuit of rendering the bear progressed in *Untitled* (**PL. 95**), in which a far more bear-like animal attacks, and his victim jumps sky high. At first the animal appears to be biting at the man's rear end, yet preexisting marks on the surface of the paperboard seem to emanate from the bear's mouth like a roar, much like those suggesting the bark of the blue dog in *Dog* (**PL. 96**).

Certain of Traylor's drawings chart a notable incident or singular memory but never develop into a recurring story line. Two known drawings of an airplane sighting, one of which is *One-Legged Man with Airplane* (**PL. 97**), show a person jumping and pointing to convey the high drama of that first remarkable event. When the Wright brothers based their civilian flying school west of Montgomery in 1910, locals thrilled to see the practice flights over the fields. Later, given the war buildup and the airbase outside Montgomery, the sight of planes likely became more commonplace. Moreover, the US Army had been strictly segregated during World War I, but on April 3, 1939,

Congress designated funds to train African American pilots. The program that created the first African American military pilots, the Tuskegee Airmen, formed in 1941 at Tuskegee University, less than forty miles from Montgomery; it also trained pilots at various fields around the country, including Maxwell Field.[27] A major advance for the black community would have undoubtedly created a stir—an excitement that Traylor may well have represented in these works.

Miriam Rogers Fowler observed that some of Traylor's images of physical structures relate to farm implements or constructions like the cotton screw (fig. 74), used to press cotton into bales, or the diving platform Traylor had described to Shannon— whereupon scenes of people climbing, jumping, or falling off, sometimes drinking, at other times fighting, alternately appear to recall rowdy fun or hostile scenarios (PL. 98).[28]

Susan M. Crawley, an independent curator and scholar who for ten years served as curator of folk art at the High Museum of Art, Atlanta, Georgia, has astutely described these pictured recollections as self-reflective, theorizing that Traylor was not making a record of his life for others but rather, "revivifying long-ago experiences." She continued, "Through this conjuring he was able to reify his memories and live them again when his external circumstances seemed bleakest and his future emptiest. At the end of his life, through his extraordinary visual evocations, he could hold his memories in his hands, organize them, and attempt to form them into a coherent whole."[29] Arguably, Traylor did not intend for his structures to realistically mimic those he had known or used, but he instead applied them as stage sets for the memories themselves. The painting *Two Men with Dog on Construction* (PL. 99) shows a structure with counterpoised barrels at either end of an armature that appears to turn, or screw down as a press would. Cotton screws, while they varied in design, did not employ barrels, but tobacco casks, or hogsheads (fig. 75), did.[30]

Tobacco farming in Alabama was not nearly as common as cotton farming, but it did exist, particularly in Butler County, which was just south of Lowndes. Tobacco demanded a lot of land and many hands on deck when the crop was ready for harvest.

FIG. 74 Cotton press, near Routes 917 & 38, moved from Berry's Crossroads, Latta, Dillon County, South Carolina. From the Historic American Engineering Record, 1968. Library of Congress, Prints and Photographs Division, Washington, DC

FIG. 75 James Wells Champney, *Getting a Tobacco Hogshead Ready for Market*, from Edward King, *The Great South: A Record of Journeys . . .* (1875)

While the Traylor plantation did not grow it, Bill may have been hired during harvest-time to work on a plantation that did. Most of the barrels that Traylor drew are clearly whiskey kegs, with tap spouts at their bases. In in this painting, however, Traylor depicted a structure that does not accurately convey the design of a tobacco press with barrels but is close enough to suppose a relationship.

Another uncommon scene appears in *Figures on Blue Construction* (PL. 100), a fluid and delicate work that demonstrates Traylor's developed style and flourish. Frontier farmers who grew more grain than they could use often distilled the remains into moonshine or whiskey, either at their own stills or on neighboring farms. Alcohol was a common drink on plantations; drunkenness was a not an admirable trait, but the drink was generally thought of as salubrious. Traylor's impression of a homemade still could have recalled any number of sites or occasions; again, his accuracy in showing the physical structure seems far less important than setting the stage for the improvisational dance that plays out in Traylor's bright blue scene. On this construction men balance, tinker, and whack at the mechanism while another, underneath, collects the precious fluid in a bottle. *Figures on Blue Construction* is iconic of Traylor's knack for creating physiques that bend to the task, their rubbery limbs uncannily describing the motion of work. In scenes that convey the hive-like mood surrounding a pressing task, Traylor has all but presented the audible buzz of voices and clanking hammers.

HORSES AND MULES Traylor is often regarded as an artist who made simple pictures of animals, from the undomesticated but omnipresent creatures such as turtles and lizards (*Brown Lizard with Blue Eyes*, PL. 101) to the pigs, cows, horses, and mules that became icons of his artistic practice. Traylor's horses and mules are sensitive and animated renderings that transmit a sense of intimacy—close partners in farmwork on one level and complex metaphors on another.

Yellow Horse, Black Mule (PL. 102) is undated but is kindred with earlier drawings and likely dates around 1939 or 1940. Even in this relatively early work, in which Traylor's tentative lines, erasures, and remade marks are all visible, he was already well able to depict with clarity the difference between the two creatures. Having lived on farms for some seven decades, he would have been highly familiar with the looks, characters, and skills of the two animals. A mule is the offspring of a female horse and male donkey; they are larger than donkeys but smaller and stouter than horses, with shorter, thicker faces and longer ears as well. Mules have a reputation for being stubborn, but farm accounts consistently note that they are preferable to horses and donkeys for farmwork, relied on for their strength, endurance, surefootedness, and unflappable nature—a fusion of traits that makes them in many ways superior to both their parent species.

Some of Traylor's earliest scenes contain vignettes of men plowing. He once told Shannon that he missed tilling a field and described how he and his fellow laborers would mix the soil with wagonloads of leaf mold brought up from the woods in winter.[31] If the brief stories that Traylor told Shannon reveal anything, it is that he always had a memory in mind, of an event, a certain animal, or perhaps a relationship between animals.

Traylor drew a paired horse and mule several times. He was possibly thinking about the varied natures of the animals or even the family relationships and generational differences, undoubtedly knowing the horse was the mule's mother. He most often showed them as silhouetted beasts in solid black, such as in *Untitled (Mule and Horse)* (PL. 103), which reveals his innate ability to reduce a being to its most essential form and create a shadow figure that effectively distills species and character. Such works became signatures of Traylor's—highly reductive forms that demonstrate his attention to expression, stance, situation, and mood, as in the "listening" mule in *Untitled (Mule)* (PL. 104), upon which Shannon inscribed Traylor's comment: "He hear sompin'. Come up on one at night and he'll sho see you for you sees him."

Traylor's horses range from neutral to cool in emotional tone. They are ever present but generally more subtle characters than his mules, as seen in *Mule with Red Border* and *Untitled (Horse)* (PL. 105, in fig. 29; PL. 106). In Traylor's experience the horses that carried plantation overseers were large and aloof, bridled and intimidating. Mounted figures are not among Traylor's foremost subjects, but he pictured them often enough to make the overriding mood clear: with a consistently ominous feel, the unwelcome dominance of the boss is manifest, as in *Red Man on Blue Horse with Dog* (PL. 107).

Traylor made succinct but loaded comments about two paintings (PLS. 108, 109), one of a mule, the other a horse. In the former a brown mule looks defeated—head down, eyes wide, pupils centered—not with fear but gloom or despair. The description reads "He's Sullin'." Whether Traylor was having a laugh at a difficult animal or empathizing with a hard-used, unhappy creature remains conjecture. Yet mules played a powerful role in African American folklore, and ample literature describes a widely used metaphorical parallel between mules and the enslaved—both assessed as possessions—in terms of physical health, durability, and overall usefulness as a beast of burden. The racially disparaging term *mulatto* is derived from the Spanish word for young mule, and when applied to African Americans it referred to one black parent and one white, a distinction that marginalized mixed-race children from both groups.[32] In her novel *Their Eyes Were Watching God* (1937), Zora Neale Hurston conveyed her own perspective:

> Honey, de white man is de ruler of everything as fur as Ah been able tuh find out. Maybe it's some place way off in de ocean where de black man is in power, but we don't know nothin' but what we see. So de white man throw down de load and tell de nigger man tuh pick it up. He pick it up because he have to, but he don't tote it. He hand it to his women-folks. De nigger woman is de mule uh de world so fur as Ah can see.[33]

If Traylor made the mule painting vague enough to be read as humorous, the other painting he described to Shannon (PL. 109) was more precise: "Turned him out to die," Traylor apparently said of the skinny brown horse, whose ribs, drawn in pencil, are left clearly visible through the artist's thin wash of brown. The horse is grazing, left to whatever meager bits of vegetation he can scrounge from the hillside pasture, until death takes him. As is the case with all Traylor's paintings, we are left to wonder

about his mindset and the details of his memory. Decisions made on hardscrabble farms were undoubtedly not always easy or straightforward, but Traylor's ruminations on an aged animal, turned out to forage on his own devices, surely felt, to Traylor, much like own situation on the streets of Montgomery.

TENSION AND FIGHT SCENES Traylor became adept at injecting tension into any scene that described a relationship. Anxiety is an abiding feeling in his work, whether the subject is juxtaposed animals, encounters between men and women, chase scenarios, or more complicated stories that occur around structures, houses, or trees.

Traylor's work often suggests one creature's dominance and the other's submission, in an inherent predator/prey narrative. But the images are sometimes subtle, such as in an early pencil drawing showing a dog and cow in which the two animals stand near each another (PL. 110). Traylor has drawn the face of the dog with two eyes to the front, watching the cow. The dog is still, but her tail is raised high and her ears are perked—alert, watching, not there to kill the larger beast but rather to control her, dominate her every move. The cow's legs are slightly spaced to suggest stillness or a slow lope. With eyes wide, she looks straight ahead, not at the dog, not with overt terror, but with an awareness that she must submit; if she were to run, it would be her end.

Traylor created a variation on the penciled *Dog and Cow* in the painting *Red Cat, Black Bull* (PL. 111). The dominant animals in the two works are remarkably similar. Slight variations in stance and physique resulted in one being named as a dog, the other as a cat, yet the animals are quite similar and ultimately indistinct. Whatever the subjects, Traylor has consistently conveyed the impression that the stronger animal is watching, stalking; be it a farm dog prepared to herd or a big cat about to take down livestock, the feeling the work imparts is the same. The bull's eyes are as wide as the cows, but his back legs have energy contained in their bent forms, as if he is poised to run. The predator is vibrant red, a color Traylor retained in his later works to suggest aggression, ferocity, or extreme danger.

Traylor's large cats and dogs are usually, but not always, distinct in species. His domesticated housecats—in various positions but inevitably with round heads and short noses—are diminutive, as in *Spotted Cat (AKA Cat)* (above, PL. 16). In contrast is a spotted cat of a large variety shown in *Spotted Cat with Two Eyes* (PL. 112). Traylor could easily have seen mountain lions in Alabama, but they have no spots. Bobcats are native to the area, but they have short powerful legs and bobbed tails—details Traylor might not have caught if he had seen one only briefly. South American jaguars and their smaller cousins, jaguarondis, are not known to have come as far north as Alabama but, with ranges in Louisiana and Florida, it is not unthinkable that one might have made an appearance in Traylor's realm.[34]

The spots depicted in *Spotted Dog* (PL. 113) are dazzlingly arranged—like a jaguar's— and alternate in blue and red with a precision rarely seen in Traylor's patterning. The animal is structured like many of Traylor's dogs, with a strong jaw, defined snout, and sharp teeth. A work that Shannon dated to March 1940 and about which he recorded

Traylor's remark as "circus animal" (*Spotted Dog and Black Bird*, **PL. 114**) points to this similar beast as being a leopard or some other large spotted cat; Traylor could have seen such an animal either live at the circus or reproduced in advertising images.[35] Traylor made *Spotted Dog and Black Bird* on the back side of a poster for "freak show" by Robert L. Ripley of "Ripley's Believe It or Not" fame. Announcing "Hollywood Oddities, Freaks, Strange People," it illustrates a racially exoticized African man and the address "121 Dexter Street," a nearby venue, where Traylor may have seen the posters if not the shows themselves.[36] Although Traylor may not have been able to read the words on the advertisement, the image speaks for itself: an African man with a pointed head headlining a ticketed display of human beings could only have been discomfiting.

In *Cat and Dog* (**PL. 115**), arguably made around the same time, Traylor placed the species in proximity, which emphasizes their distinctions. Compared to some of his other scenes of dogs and cats, the action here has become increasingly dynamic; the dog turns downward on the page, taking an aggressive stance toward the cat. The cat hisses. Their encounter is under way.

The dogfight became one of Traylor's most iconic images of conflict. The inter-species battle he explored in *Cat and Dog* shifts dramatically in *Untitled (Dog Fight with Writing)* (above, **PL. 39**), in which a brown a dog duels a black one. Here Traylor escalated the aggression; we are not left to wonder what the outcome of the clash will be—they are posed to fight to the death. Traylor has released the animals from the rigid orientation of the horizon line and parallel positioning he once relied on; they are face to face in heated assault.

In this large work Traylor also broke ground in his exploration of space and motion. The theme is palpably potent, and he painted many variations of it.[37] More often than not, the fight involves a brown or red dog versus a black one, but some exceptions exist. Traylor's intent on capturing the ferocity of the battle is clear in *Two Fighting Dogs* (**PL. 116**), which presents the dogs as manifestly male, with their limbs in direct contact and jowls only inches apart. The animals are so unbounded by gravity that Traylor's intended orientation is not absolute; whether the left dog or the right is dominant, one is winning at the other's demise. *Untitled (Two Dogs Fighting)* (**PL. 117**) shows a still more deft description of action; the dogs are limber and natural, their fight overflowing with an energetic force and level of emotion not previously conveyed.

Traylor's use of dogs as character types—as expansive as those in human personalities—is multifaceted. Rarely did he portray a dog attacking a person, yet at least one such work, *Dog Attacking Man Smoking* (**PL. 118**), is known. The drawing seems to depict one man encouraging a dog to tear into another man; the specifics of race are indefinite but implied. The hat-wearing provocateur is shown as the smaller of the two; he uses an animal to stand in for his own physical strength. The victim may be the larger man (in keeping with many of Traylor's works), but he is still at a disadvantage, powerless to stop the assault. Much of white Montgomery society around 1940, when Traylor made *Dog Attacking Man Smoking*, would have endorsed or tolerated the action described here, which metaphorically presents an all-encompassing situation. Of note here is the victim holding a pipe; Traylor smoked a pipe (at least on occasion),

which may suggest the assault is a personal memory (see above, fig. 54).[38] By and large, Traylor was seldom so overt as to show a man being attacked by an animal; he preferred to shield his story lines with ambiguity—human violence that could be read as chaos, animal fights that might well be allegorical—but on the surface could be viewed or explained as simple anecdote.

Some of Traylor's dogs, animals he knew and portrayed according to their varied roles, recur as characters in his imagery. Some are loyal pets, ubiquitous creatures of rural and urban life; some might be hunting companions, and still others are loathed foes. The Alabama slave narratives collected by writers representing the Works Progress Administration in the 1930s are just one source for accounts of how terrifying the scent hounds were for the enslaved, and African Americans in general, well into the twentieth century.[39] Bloodhounds or mixed-breed curs were trained, either by planters or professional "dog men," to hunt and kill. Charlton Yingling and Tyler Parry explain that "Breeders honed dogs' superhuman biological systems, maximizing their ability to smell, hear, outrun, outlast, signal, attack, and sometimes execute black victims."[40] Solomon Northup, the ex-slave whose story became widely known, first thorough his memoir *Twelve Years a Slave* (1853) and subsequently through a republication (1968) and movie (2013), was among those who described how a runaway's fear of wild animals might pale in comparison to the thought of the plantation dogs. Of his surreptitious journey through the Louisiana swamp Northup wrote: "For thirty or forty miles it is without habitants, save wild beasts—the bear, the wild-cat, the tiger, and great slimy reptiles that are crawling through it everywhere. I staggered on, fearing every instant I should feel the dreadful sting of the moccasin, or be crushed within the jaws of some disturbed alligator. The dread of them now almost equalled the fear of the pursuing hounds."[41]

As the Confederacy began to unravel, higher numbers of slaves ran away, and the profession of slave tracking grew. The practice didn't die out but rather transformed from era to era. An article about slavery published in Alabama in 1903 observed that life wasn't much different after Emancipation, when peonage or debt slavery was common. "If any of the negroes sought liberty by deserting the plantation they were hunted down in the old slavery days' fashion with bloodhounds."[42]

In the early twentieth century, police departments boasted that they were training dogs specifically for heightened aggression toward African Americans, and the practice remains contentious today. "The infusion of black Americans' lived experience with the presence of police dogs persisted during the Civil Rights era. By the early 1960s, images of black protesters viciously attacked by police dogs confronted Americans nationwide," note Yingling and Parry, who traced altercations with police canines and black Americans to the present decade. They argue that modern law enforcement can use dogs "for their effect, rather than their utility, [which] fits neatly into dogs' historical role of instilling fear and submission in African Americans."[43] Bryan Stevenson, founder and executive director of Alabama's Equal Justice Initiative, has devoted decades to revealing the magnitude of state-sanctioned terrorism in American history and tracing the links between

slavery, segregation, and mass incarceration. (Stevenson was also the visionary force behind the opening, in April 2018, of the National Memorial for Peace and Justice and the Legacy Museum in Montgomery, a monument to every county in the United States in which a lynching took place, plus a museum detailing this painful history on the site where the enslaved were once warehoused; see Foreword, p. 11.) Stevenson agrees that canines are a direct part of this lineage, from hounds bred to hunt runaway slaves, to police dogs trained to instill terror. He recalled the debilitating physical impact that the very sight of a police dog had on a member of his defendant's family: "I didn't know exactly what had happened to Mrs. Williams, but I knew that here in Alabama, police dogs and black folks looking for justice had never mixed well."[44]

Enslaved people and tenant farmers had their own dogs for hunting and relied on them for help to bring extra food to the table.[45] Whatever their nature, dogs appear routinely in Traylor's narrative scenes. With his view to the Monroe Street Black Business District, he depicted black women who were not only dressed head to toe in pattern and color but also sported tiny dogs representing ownership or companion animals, a luxury. One example is *Woman in Green Blouse with Puppy and Umbrella* (PL. 119). Here, the dog is unthreatening, a beloved pet. In various early pencil drawings, such as *Sickle-Tail Dog* (above, PL. 14), Traylor drew single dogs in a portrait-like manner, as if they were animals he knew. He outlined and filled them in with sensitivity; their demeanor appears placid.

As his confidence grew, in terms of what he could successfully render and what he might draw or paint without retribution, Traylor's dogs become increasingly large and menacing. More than once he painted a black bulldog-like canine that seems crotchety but not necessarily ferocious (above, PL. 15; PL. 120). In *Untitled (Dog)* (PL. 121) the black animal is larger but similar in appearance, with a distinctive bladelike tail. Traylor's pencil marks can be seen clearly underneath the poster paint. Shannon asserted that Traylor had devised a method of sketching out a rectangle to define the torso (of human or animal) as a starting point, then adding components—not unlike the ways in which figure drawing is sometimes taught to students.[46] The black paint washes fluidly around within the dog's shape, not as a reach for realism but in a manner that creates a sense of pulsing life. The dog's teeth are bared, his eyes are wide, but his affect is relatively stiff and measured.

Traylor only rarely mixed his paint colors, most often using them "straight out of the jar."[47] But sometimes he blended hues. A striking example of his use of mixed paint is in an image that seems to show the same dog seen in *Untitled (Dog)*. In *Dog* (PL. 96), however, color alters the creature's presence. Red and blue comingled into a patchy violet make him appear rough and riled up; red tinges his extremities with the hot color of blood. Traylor has again brilliantly taken advantage of a blemish on the paperboard, in this case positioning a patch of parallel tears in the paper to suggest a sharp bark emanating from the dog's mouth, heightening his ferocity. The tear emulates the fourth dimension of sound in a way that an attempt to show the dog's voice with paint would have done less effectively.

For supports, Traylor reportedly favored the discarded pieces of board he found in the neighborhood, fragments of candy or shirt boxes, and the backs of advertising cards or show posters. He responded to their odd or damaged shapes, to small bits of printing on them, and to holes, hardware, stains, or flaws—as he did in his red and blue *Dog*. He didn't decline the clean drawing boards that Shannon offered early on, but he did seemingly allow them to age for a while. Traylor's decisions were deeply internal; he might have identified with items that manifested their long journeys, or perhaps he was calling upon on a well-known practice of making do or making something from nothing, shaping something beautiful (or that mapped selfhood) from something ugly, unappreciated, and disposable.

Although Traylor's options on paint colors were limited by what he was provided with, he considered choices within his available array. His use of red was judicious; it does not appear often, but when he used it, he used it well. His deft grasp of the emotional qualities of colors may have been based on their visual potential or the cultural roots in which colors had established symbolism and meaning, or a bit of both. The dog with the blade-shaped tail reappears as *Red Dog* (PL. 122). Traylor discovered the power of adding a flailed-out tongue, which became a standard feature of his vicious canines. *Red Dog* is just under twelve inches square, yet the color gives the dog an unmistakable blazing intensity; he is lethal. The haunting red mongrel with the saw-blade tail returned, larger, in *Red Dog* (PL. 123); here he is a rabid giant with a crazed eye. Traylor's scribbled pencil marks are visible through the paint, heightening the sense of fury or boiling blood; the hulk and fire of the dog communicate in no uncertain terms the fear it had inspired.

In *Man and Large Dog* (PL. 124) the immense beast is black, his body as solid and unyielding as an anvil. Collared and led, the beast dwarfs the small man leading him. The figure is meant to be European American, painted in white; his face, as pale as the paper of the page, is outlined in black. He wears a tall black hat, a polka-dotted shirt, and brown pants. On the verso of *Man and Large Dog* is another full-scale painting, *Man and Woman* (PL. 125); here a similar man, but black, argues heatedly with a woman, who is white.

They point at an unseen object of contention. The black man's clothes are almost identical to those of the white man in *Man and Large Dog*, except his hat is brown instead of black. The arguing man and woman also wear white shirts with brown polka dots; her skirt is dotted in black. Both people carry an umbrella or parasol, an accoutrement of the leisure set, not the workingman. Although the individual paintings on either side of the board can be read independently, the related clothing argues for connectivity.

It would be difficult to overstate the reach and impact of state-sanctioned domestic terrorism in the years of Traylor's life. Reports by the Equal Justice Initiative have documented more than four thousand lynchings in America between 1877 and 1950.[48] In the Jim Crow South, a white woman's accusation of an impropriety, real or imagined, by a black man could equate to a death sentence for him—so a face-to-face confrontation such as this would be extraordinary. The scene in *Man and Woman*

(**PL. 125**) is therefore equivocal, possibly imagined or metaphorical rather than a real encounter. The white woman puts her finger right in this man's face, but he points in the same direction she does rather than back at her. Perhaps they both gesture toward the past—a day when the clothes of the black man would have been mere rags, with no printed fabric, no umbrella. She can't let that bygone era pass, but he has become his own man. He stands up for himself in this image, flouting the racial etiquette that would have been demanded of him on the real streets of the day.

As William Arnett, collector and founder of the Souls Grown Deep Foundation in Atlanta, Georgia, suggested in one reading of this two-sided work, the lady's husband might be the white man on the other side of the cardboard, perhaps lingering in the past as well. Traylor painted this white man in the dotted shirt (**PL. 124**) and hat multiple times; he appears also in *Top Hat* and *Men on Red* (**PLS. 126, 127**).[49] About the giant dog he leads in *Man and Large Dog*, Arnett said: "The point seems obvious. The white man regards the black dog as his pet on a leash, but, clearly, if the pet gets angry, the master is in trouble. That pet could take over any minute, especially if the white lady keeps scolding too long."[50]

Arnett refers to a metaphor for the paradox of slavery: the strong black man is held in bondage by a seemingly weak white man, but the latter nevertheless has sufficient wealth and the extant power structure on his side. Showing an African American man who is not simply free, but well-to-do, *Man and Woman* may jump decades forward to Traylor's present but suggests the significant limits of freedom. Decent clothes and independence did not translate to respect or real equality in Alabama.

Traylor would no doubt have heard many a tale of rebel uprisings, real-life manifestations of the darker faces of Rabbit. Nat Turner, who died three decades before the Civil War began, was a historic-figure-turned-folk-hero for plotting and leading a rebellion of enslaved and freed men, which resulted in the deaths of some sixty white men, women, and children. Turner's uprising had taken place more than a hundred years before Traylor made *Man and Woman*, yet the story of the revolt was still celebrated in Traylor's day. Turner's glory and freedom were short-lived, and the physical and legal backlash was brutal to African Americans—including Turner, who was hanged—but the terror that this folk hero inspired throughout the white South remained legendary.

Other stories, too, were about slaves who overcame and outdid. Morris Slater, for example, known foremost as Railroad Bill, was a turpentine worker turned infamous Alabama badman. A "notorious Negro desperado," Slater ended up dead (in 1896)—but not before a three-year stint eluding the law.[51] Traversing with such deftness that most thought he must be a shape-shifting conjure man, he inspired tales and songs alike. The hunt for Railroad Bill encompassed the Montgomery region, where accounts of his escapades became especially ingrained. Under the headline "The Wonderful Negro Popularly Supposed to Be Superhuman," Montgomery's *Daily Advertiser* stated that Bill (sometimes just called Railroad) was a powerful conjurer who could be killed only by a silver bullet; to escape he could fool the bloodhounds and change, at will, into a sheep, hawk, or hound. It read: "Some of the most preposterous stories are

told by the negroes in that neighborhood—and though it seems incredible, some white people who should know better, not only repeat these remarkable bogey tales, but actually believe them. This class of people are firmly convinced that Railroad Bill has the superhuman power of easily transforming himself into any object, animate or inanimate, that he wants to."[52]

Writer Burgin Matthews notes that the outlaw was certainly a legend during his lifetime, but stories of his escapades endured in white and African American folklore well into the twentieth century. In the 1920s and 1930s, Railroad Bill was still widely spoken of; folklorists Howard Odum and Alan Lomax separately collected and printed songs and folktales about Railroad Bill's deeds, his astonishing defiance, the racist sheriff he killed, and the many wrongly accused black men who died at the hands of white lawmen in pursuit of Bill. Numerous songs were recorded and popularized, often by white singers.[53]

Whether Traylor had oppression and rebellion in mind when he painted *Man and Large Dog* remains unknown, yet Arnett's reading of it as a metaphor for enslaved people with white masters, or the ongoing repression of African Americans in white-dominated society, is hard to contest. The enormous black dog is fierce and raging but also tethered and—at least momentarily—controlled. The verso image of *Man and Woman* and the analogous clothing in the two paintings offers a compelling argument for their relatedness. The past and present intermingle as ruminations on social progress that has not come far enough.

Traylor's paintings of a single dog reached a pinnacle with *Mean Dog* (PL. 128), in which a ferocious black canine is backdropped in pulsating red, showing off Traylor's skill with commanding colors. A merciless intensity emanates from the animal's mouth as an open roar that connects to the rabid red tone of the page. Traylor painted the background of his works only in a few instances, and the effect here is powerful. The formidable animal may be a hellhound but is far more likely the dreaded tracking hound—meant for humans. Perhaps more than any other of Traylor's works, *Mean Dog* conveys that he was not a simple man at peace with how things were but rather, he carried himself with an exterior calm that belied the underlying memories of rage, grief, and torment.

HOUSE SCENES For Traylor the house was among the most complex and revisited sites for his stories. As discussed above, in "Early Work, ca. 1939–1940" (pp. 106–61), he utilized the house to situate domestic drama and shelter a preponderance of memories. So abiding is the house, it spans Traylor's earliest known works and serves as one of the strongest markers of his formal trajectory. Traylor noted that the challenge of depicting people inside a house was one that he revisited time and again, and his affinity for a multiplicity of concurrent settings—rooftop, interior, and yard—also recurs in each stylistic phase.[54]

Among the earliest house scenes is one known as *Drinking Bout* (PL. 129). As a painting surface, Traylor employed the underside of a Planters Peanuts box top and framed his drawing with the wrapped edge of the printed box.[55] With a pencil and

straightedge he defined the essential form of the house structure. Inside, a man sits, bottle in hand, as another man points at him in accusation. The seated man is painted in solid black; the pointing man is all black except for the area on his head where hair would be, not unlike the seated man reading in *Red House with Figures* (above, **PL. 32**; in figs. 31, 49). Mechal Sobel proposed that the whiteness inside the head might symbolize Death or the dead, a spirit returning to confront someone living who is behaving immorally or had wronged him. The theory is far more convincing in *Drinking Bout*—wherein the white-headed figure points accusingly at the seated drinker—than it is in *Red House*, in which the white space of the mind more compellingly refers to book-inspired thoughts, general mental activity, or introspection.

In *Drinking Bout* the figures are at odds: one is angry, the other shocked or afraid. On the roof a familiar scenario occurs: two men struggle over a falling bird. Although Traylor's birds often denote freedom, or at times possibly a contested woman, this black bird may be a roosting raven or crow, the Devil's bird, or a death omen for the house.[56]

Red House with Figures, which appeared in the New South show and is dated to fall 1939, has a closely related narrative to another work from 1939, which Shannon noted was made several months earlier, in July of that year. As he had done with *Red House with Figures*, Shannon recorded Bill's remarks about *Untitled (Yellow and Blue House with Figures and Dog)* (**PL. 130**) on the back of the drawing. He wrote: "7/39, Fellow inside reading. Man in yard. Smokes pipe, fondles gun while dog looks at him. Man goes up ladder after chicken. His home at [indecipherable; paper torn]."

Traylor took time with *Untitled (Yellow and Blue House)* to compose and shade it with care. If Shannon's note reflects a close approximation of what Traylor said, the image can be read according to that straight description. A man chases chickens from the rooftop and seemingly has one in each hand. Arguably, the creatures' slim dark forms might be more crow-like than fowl, and as previously noted inky black corvids of any type were widely regarded as a portent of death or the bird of the devil, offering an alternate reading of the image. The rooftop man's clothes raise questions as well; he wears no hat, and his boots, black suit, and white three-button "bosom shirt" resemble formal wear or servant's livery—yet Traylor never resided anywhere large or fancy enough to see clothes like that regularly. The man inside is reading, an activity that Traylor has consistently depicted through "books" shown as small rectangular shapes with *AB* or *ABC*, such as in *Untitled (Woman in Blue Holding an ABC Sign)* (above, **PL. 33**). In at least one case he used *ABCD*, written inside the rectangle (see **PL. 149**), and in multiple remarks to Shannon, Traylor described the people holding these rectangular shapes as "reading." The lower scene, too, is as Traylor stated: a man smokes a pipe and idly holds his rifle, while his dog, tame and obedient, stands by.

The complexity of *Untitled (Yellow and Blue House)* ultimately lies in the identity of three men. They are carefully colored in with pencil, which, as Traylor once explained to Shannon, connotes an African American. Yet their profiles are eccentric; all have long noses and diminished lips, contours that could (per his other comment to Shannon about checking profiles with a straightedge, discussed above in "The Earliest Works of Art and Sources of Inspiration" (pp. 106–25), refer to white men. The question arises

here: was Traylor already experimenting with pliable narratives, or is the information he gave Shannon entangled with the protocols of "racial etiquette" and simply insufficient for decoding the scene?

Sobel assessed the figure on the rooftop holding the neck of a dead bird as a "death spirit." She proposed that Traylor's proclivity for drawing a man in black suit and buttoned-up shirt referred to the Haitian vodou loa, or deity, Baron Samedi, lord of the dead or the cemetery. Samedi (whose character extends into New Orleans voodoo and American hoodoo as well) is traditionally portrayed as slick and stylish, often wearing dark glasses, smoking a cigar, and carrying a bag; he dresses like an undertaker, with whom he is visually interchangeable. Death himself wears a "white bosom shirt," and the conjure doctor or hoodoo man might also wear a "frock coat and a stovepipe hat." The latter might be distinguished from other sharp-dressed men by an overall greasiness, red or bloodshot eyes, a necklace of dried lizards, and a staff that can morph into a serpent.[57]

In 1982 curator Lowery Stokes Sims noted that Traylor's often-repeated man in the high top hat and tails "evokes the personification of Baron Samedi in Haitian lore, the Americanization of Esho/Elegba [Èshù-Elégba; also called Eshu]," Baron Samedi's Yoruban forefather.[58] Art historian Maude Southwell Wahlman, also writing in 1982, similarly explored the potential relationship between African- or Caribbean-derived top-hatted old men and Traylor's men, whom Traylor portrayed as increasingly fancy after 1939, and with added accoutrements, such as a cigar, bag, and top hat.[59] In *Untitled (Yellow and Blue House)* the bird-catching man on the roof wringing one bird's neck may indeed be the Lord of Death, but he may also be a more informal interpretation of death as a character (Death), paying a visit at an unfortunate house.[60]

The careful style of this drawing contrasts with works in which Traylor's figures have been more quickly drawn, wherein the scratchy lines embody and convey a frenetic energy and harried narrative. Time moves slowly in *Untitled (Yellow and Blue House)*; the scenes are plotted out and have, at least without Traylor's further guidance, flexible meanings. That Traylor understood how to use ambiguity as a tool, a shield under which he might explore themes of freedom and struggle, becomes increasingly harder to dismiss when presented with careful and complex images such as this one.

Still another reading of *Untitled (Yellow and Blue House)* allows that the man on the roof could be a servant catching fugitive hens, as Traylor described the scene. Men in the theater and service professions wore the stiff-bosom shirt or dickey that is suggested here, but the item is also an element of formal dress. The fact that the man is both hard at work and missing his hat suggests servitude over power. While a man in servant's dress may be more out of place in this image than Death is, some of Traylor's images of chicken thieves, escaping poultry, and birds singing from rooftops comment on potent racial stereotypes: the thief faced with starvation, the desperate balance between servitude and survival for black families, and the elusive dream of true freedom.

Inside the house sits a man holding an *ABC* primer, Traylor's recurring reference to literacy—the powerful tool he never possessed. As noted above, Traylor's filled-in faces often if not always represent African Americans, yet the profiles of these men

might also fit Traylor's one-time comment on how he depicted white men. The clothes and belongings—the house, birds, book, boot, rifle, pipe, and obedient dog—are, without question, noteworthy worldly goods that collectively send a message about personal domain and self-governance. Arguably, Traylor intended for the clothing and accessories to offer individual viewers inclinations toward their own perspectives on who's who and allow the artist to present alternate explanations if he felt so inclined.

Brown House with Multiple Figures and Birds (**PL. 131**) is a painting in which Traylor's intent to capture a complicated memory or event outpaced his motivation to craft a slower, more symbolic work; it appears less calculated and less allegorical and more like a recollection rapidly put down. In *House* (**PL. 132**), painted around 1941 (based on a dated advertisement on the back, which is not illustrated herein), Traylor has refined the scene to its essentials. The architecture of the home is the same as in the afore-mentioned work, but here a luminous washed blue gives the house an ethereality. A bearded old man wearing an expression of concern is visible in the doorway. The worrisome event takes place on the rooftop, where a younger man, painted in solid blue, is drinking from a large bottle. Three smaller brown men seem more like personified thoughts than additional actors in the scene; sticklike tendrils link each of them to part of the blue man's situation. One points to the drinker's head (he appeals to reason: stop drinking, come down!). The next points to the bottle, the vice that will cause ruin. The last of them, perhaps representing desire, slips from the rooftop—the liquor, one way or another, will cause downfall.

In *House, Blue Figures, Blue Lamp* (**PL. 133**), Traylor focused entirely on the interior scene, a domestic, kitchen setting. A woman lights the oil lamp on the table, upon which a large pitcher also rests; a man sits near the table drinking from a large cup, and a cat walks under the table. The pitcher is black; the other items are all blue. The color choices—the black paint of the pitcher, so close in hue to the surrounding brown—seems more like evidence of artistic redirection than of symbolism. The brown of the house perimeter comes directly into contact with the pitcher's right edge, yet unpainted borders distinctly set the other forms apart. Farther inside the home, the warm brown suggests a comfort zone.

Traylor tried a different approach when fashioning the interior space in *Man in Brown and Blue House with Figures* and *Man Talking to a Bird* (**PLS. 134, 135**); in each, a speckled surface suggests the solidity of the exterior wall while simultaneously allowing the viewer to see through into (or imagine) the interior space. The story line is again the rooftop bird hunt. Traylor seemed to tip back and forth between a true-story narrative and an interest in poetic abstraction. *Untitled (Exciting Event: House with Figures)* (**PL. 136**) is an icon of the former—a dramatic opera playing on multiple fronts, sending the viewer's eye hurtling around the page in a never-ending cycle of cause-and-effect happenings, while *Man Talking to a Bird*, in form, color, and simplicity, represents the latter. Small moments such as the frequently repeated image of the blue bird on the roof reveal Traylor's progression of forms, from the stiff and staid creatures drawn early on, to the later breezy and jazzlike (**PL. 136**) and, eventually, to identifiable yet abstracted representations that carry the narrative alone (above, **PL. 29**).

Without the benefit of secure, documented dates on all of Traylor's works up to 1940, his trajectory after 1940 is even less clear. Certain works, however, evidence a traveled road of artistry and increased ease of expression. *Untitled (Radio)* (PL. 137; detail, fig. 76) is among Traylor's largest extant works. Traylor chose to work on the front of the shaped piece of cardboard, which is brighter than the back side and slightly stippled. The painting's unconventional title refers not to the imagery but to the printed word on the cardboard surface: "Radio." Traylor positioned the board to incorporate the graphic lettering sideways in his painting. The paperboard itself once had additional letters; the words "Mystery Control" were stripped away, by Traylor or someone else, before Traylor painted on it (fig. 77).

The eccentrically shaped pieces of paperboard on which Traylor painted, of which there are many, were predominantly window advertisements of one type or another; the commercially printed surface of these ads only sometimes survived. The large "Radio" window card could have come from any of the downtown department stores or possibly the Fred Byrne Radio Service, a repair shop at 312 Dexter Avenue in Montgomery. In the late 1930s, radio manufacturers were trying to entice buyers back after the Depression. The Philco Mystery Control device was a hotly promoted wireless remote control invented in 1939 and produced in the same years that Traylor was drawing on the streets, from 1939 to 1942. Advertisers billed it as the most "thrill-ing" invention since radio itself.

Traylor seems to approximate the graphic treatment of the word "Radio" in the straight painted lines that he used to define the house in *Untitled (Radio)*. This work appears at the other end of a continuum with *Untitled (Yellow and Blue House with Figures and Dog)* (PL. 130), as similar imagery and story lines coalesce into a single tightly organized scene. The characters are comparable, but in place of carefully controlled

FIG. 76 Detail, *Untitled (Radio)*, pl. 137

FIG. 77 Philco Mystery Control advertisement published in the November 12, 1938, issue of the *Saturday Evening Post*

delineations are loose, stylized figures that deliver an explosive energy. The tiered story of earlier works, containing items like the book, have given way to a broader, punchier message that uses abstraction over detail. The men point and take aim as the bird, yet again, flies away.

DRINKERS Men drinking figure as prominently in Traylor's oeuvre as any other characters. They appear most often in his compound scenes but in many cases are featured as the solo act. Traylor once remarked on the tilting drunk preacher in one image, identifying him as the "figure kicking up his heels and twirling his hat on his finger."[61] Liquor may also have been Traylor's own snare. He once confessed, "What little sense I did have, whiskey took away."[62]

Traylor's paintings of drinkers trace a similar arc as the house drawings, moving from careful and studied to wild and free, as Traylor's expanding artistry loosened their limbs as the alcohol itself might have done. No record confirms whether either of the Traylor plantations (John Getson's or George Hartwell's) had a liquor still. Where grain crops existed, however, so did stills, and if one plantation didn't have one, it likely used the neighbor's to convert extra grain to drink. Prohibition, which was in effect from 1920 to 1933, had ended before Traylor was known to be making art, but his memories of the Prohibition era and the far-reaching impact it had on consumer culture may have featured in many of his works.

Nationwide prohibition of the manufacturing and sales of alcohol didn't officially come until the Eighteenth Amendment, which passed in 1919, was implemented the following year. But in the South, Prohibition had a longer history. The Women's Christian Temperance Union had pressured politicians to create a more moral and healthy society, and Alabama had a "Bone Dry" law in place from 1915 to 1933. While it did not slow actual production, it increased police raids in search of illegal stills.[63] Moonshiners and bootleggers had to pay off police or take to violence to protect what they had. Many argued that Prohibition led people to binge drink rather than parcel liquor as a limited-use luxury good. Drinking unregulated moonshine in and of itself was a risky business, as it often contained denatured alcohol, methanol (wood alcohol), creosote, lead toxins, and even embalming fluid; the consequences of drinking the wrong stuff might be lasting physical damage or even death. The dry years resulted in a decline in alcohol and related diseases, but the "cure" was eventually deemed worse than the original problem.[64] National prohibition ended in 1933.[65]

Traylor's drinkers, usually but not always men, reach for bottles on high shelves, pucker their lips, throw back, jump around, bend, and sway (PLS. 138–47). Liquor is shelved slightly out of reach—metaphorically forbidden or hard to obtain—but a welcome pleasure. The bottles may hold other things as well, as illustrated in *Black Man with Bottle* (PL. 141), in which the top-hatted man peers at his little bottle like it might contain the ingredients of a conjure trick rather than a drink. For the most part, however, the paintings suggest a feeling of freedom brought on by alcohol. Traylor once commented on the puckered lips—the numbness or tingling brought about by first sips. Although he didn't speak specifically about attending local jook joints—the underground

and pop-up clubs where people gathered—they surely existed all around him. A note (fig. 78) on the back of one work (*Big Man, Small Man*, **PL. 161**), written by an unknown scrawling hand in blue pencil, shows an informal post telling people where to come for a night of music and dance: "DANCE at the Yax Club. Friday Nighs Sept 29th. Sponsored by the Seven Sisters Club. Music by Claud Shannon and his Orchestra, the Public is invited. Admission 25 c."[66] Traylor's drinkers, particularly when seen collectively, reveal his soaring imagination and exceptional ability to let form describe feeling. He was never bound by realism.

WOMEN The womenfolk Traylor painted are sometimes associated with a house and sometimes alone, walking. The house scenes, whether abstracted or dense with action, pull almost entirely from plantation memories—when Traylor lived in or around houses and, meaningfully, was surrounded by family members. Traylor's women range from girlhood to old age and effectively capture the flavor of a multigenerational household. His pictures of individual women take us to Montgomery, where an old man accustomed to seeing rural working women dressed in drab brown or plain white dirty and hard-worn clothes was now recording the astonishing range of colors, patterns, and ornament in the attire of African American women.

The socially rising urban ladies may have aroused various emotions for Traylor, who was now alone after a lifetime among women and children. His wives likely never enjoyed any such finery. His daughters and granddaughters may have fit more easily into a picture of what he was seeing before him, but it was a world that Traylor must have related to in a complex way. The urban women he paints are proud and glorious. The lady in *Woman in "O" and "X" Pattern Dress* (**PL. 148**) wears pattern from head to toe. Walking confidently with one hand on her hip and the other raised in a pointing or hailing gesture, she is a long way from the plantation. More than once, as in *Untitled (ABCD Woman)* (**PL. 149**), Traylor has shown a woman holding a book, that all-powerful tool. In *Woman with Bird* (**PL. 150**) a woman, bird perched on her finger, wears intense red and holds her head up and walks hand on hip. Her small bird might represent the simple luxury of an avian pet, but it might symbolically refer to her good looks or, in keeping with a larger theme, freedom, which she holds in her hand.

The women Traylor paints reveal the array of ethnicities of people he saw and knew. In *Woman* (**PL. 151**) he colored the figure's skin in a transparent orange wash, which sets her apart from those whose race is more clear-cut. Her features are long and sharp; her raised hand and uptilted chin lend her an air of importance—a countenance Traylor would have noticed in fancy women about town doing errands, looking past him as he sat. Transient workers, immigrants, and other minorities also lived and worked in the Monroe Street Black Business District.

FIG. 78 Back of *Big Man, Small Man*, pl. 161

Traylor made more than two dozen works of men and women with fair skin and dark hair, brows, and eyes; Shannon once explained to researcher and gallerist Marcia Weber that eyebrows painted as a single line arching over both eyes was Traylor's manner of depicting Mexicans who lived in the neighborhood or were in town looking for work around the train or bus stations.[67] Mexicans in the American South had long suffered from racist antipathy and—whether transient or in town longer term—shared the segregated quarters of town with other nonwhites. The figures Shannon described as Mexicans, are shown wearing fine or decent clothing with bright colors and patterns—not fancy perhaps, but also not that of farm laborers, and the presence of women further suggests that those he painted resided in the community.

One such woman, in *Mexican Lady with Green and Red Spotted Dress* (**PL. 152**), has such a distinctive brow line that it has caused some to wonder if Traylor saw images of Frida Kahlo, the Mexican painter married to muralist Diego Rivera. All the New South artists were fans of the Mexican muralists, and Kahlo and Rivera had significant impact on the American art scene when they lived in the United States in the 1930s. While Traylor might have seen a photograph of the photogenic Kahlo in the press, it is equally likely that he was inspired by the people right around him, including those from other local minority populations.[68] The pattern of the woman's dress fabric is a blend of dots and T shapes, a fanciful design that speaks to the specificity of the garment or wearer and is not seen elsewhere in Traylor's work. Traylor took care to stretch the amount of green paint he had to complete the decoration.[69]

If Traylor extended the stylistic trait of the darkened brow to other ethnicities, the woman could have been someone Traylor knew fairly well, Suzanna Varon. The Varons were Turkish immigrants and part of Montgomery's Sephardic Jewish community, which shared the predominantly black downtown district.[70] Biographer of the Varon family, Barry Parker, explained: "The city's Sephardic population was, itself, a minority within a minority. German Jews had been first among their co-religionists to settle in the city, followed by East European Jews. These Ashkenazim, who had their own pecking order, looked down on the late-arriving Sephardic Jews, whom they considered oriental in their customs and worship.... The Sephardim were met with further suspicion for speaking Ladino rather than Yiddish, the common tongue of European Jewry."[71]

Sol Varon and his brother Isaac owned and operated a fruit stand adjacent to where Traylor sat and drew outside the Pekin Pool Room. Sol and his wife, Suzanna, and all the Varons were friendly with Traylor (fig. 79). Isaac was known to be fond of alcohol, and their corner was said to be a gathering spot for neighborhood drinkers.[72] Sol later opened the Red Bell Café, an eatery known for catering to an African American clientele.[73] Suzanna was known as a talented cook, and the middle child, Nace Varon, recalled that his parents—the closet thing Traylor had to full-time neighbors—regularly gave Traylor food and drink; Nace often delivered it.[74] Suzanna had dark hair and wore round glasses and bore a resemblance to the woman in *Mexican Lady with Green and Red Spotted Dress*. Nace noted that Traylor had been fond

of him, and when he had enlisted into the Navy in 1944 (at only 16), that Traylor painted him in his uniform and gave the work to Nace as a parting gift.[75]

Traylor's paintings of women and men together (such as **PLS. 153–55**) often show heated moods and arguments. The couples usually stand bolt upright and point off-scene toward an abstract issue of discord. About one such drawing (not illustrated) Traylor commented, "Man getting woman told. She's pointing to where he's been."[76] These altercations, dramatic but also quotidian, convey a sense of universality and the slight humor with which others make a wide berth for an arguing couple. Their suits and dresses invoke the backdrop of the Saturday social scene downtown. These are not about desperately impoverished homes or violent altercations but rather, the more commonplace dynamics of relationships.

Traylor's portrayals of women on the street are more radical than they might first seem. Elsewhere in the American art world, African Americans appearing in artworks or commercial representations were often stereotyped, not always in overtly racist ways but as tragic, destitute rural figures scraping their way out of an unthinkable past or, conversely, romanticized figures singing or dancing in Harlem jazz clubs. Traylor's perspective was dramatically different. He was a black artist representing his own people as they appeared before him, which was nothing like the days he recalled from long ago. *Woman, Blue Gloves, Brown Skirt* (**PL. 156**) proudly presents a black woman walking down Monroe Street with her head held high, sporting fine blue gloves, the embodiment of cultural pride.

MEN Traylor depicts men in a wide array of moods and roles (as in **PLS. 157–60**). Through color and clothing Traylor distinguished individuals that he portrayed multiple times, a facet of his work that has been largely overlooked because the related paintings were separated before the relationships among them were identified or documented. Traylor's sophisticated representations of age, personality, and societal function crystalize when his cast of characters is considered in light of his sense of self within his community.

Stylistically, drawings that appear to show the details of an individual are distinctive from those that may, more broadly, illustrate a folktale or legend. In *Big Man, Small Man* (**PL. 161**), for example, the story line outstrips any sense of individual characters. The men are basically black silhouettes; stooped, the larger of the two jumps and points with great animation, as if frightened or shocked by something before him. A small man, not simply shorter but presented on an entirely different scale as the other, seems to prod him on.

In folklore accounts, death, trouble, or discontent often comes in the form of a "little man." Folklorist Ruth Bass recorded tales about a visitor, small in physique but

FIG. 79 Sol Varon and his wife, Suzanna, acquaintances of Bill Traylor's who were part of Montgomery's Sephardic Jewish community, date unknown

mighty in the woe he brings. "Oh Death, he is a little man, / He goes from do' to do', / He kill some soul, and he wounded some, / Ah' he lef' some soul for to pray."[77] Langston Hughes and Arna Bontemps chronicled "De Knee-High Man," a malcontent who always wanted something better than what he had.[78] A story in the *Southern Workman and Hampton School Record* recounts a tale of a troublemaking spirit imp, a "small, black, formless being the size of a common hare," who could take from you whatever he wanted.[79] These ideas are not a far stretch from the concept of a dual soul, one that is good and righteous and the other, the wandering soul, restless and out for trouble or on the dark side.[80] Traylor seems to have had a specific conception of the little man, the troublemaker, for such a character shows up in a number of works, always poking, prodding, and pushing people into situations in which they ought not to be.

In *Man with Yoke* (PL. 162) a tall man in a red shirt carries a yoke akin to what a pair of plow-pulling oxen or a person toting buckets might harness. His load, however, appears to be a moral one, heavy as it is. Here as for all Traylor's works, interpretations could be myriad, but the importance of balance as a key concept in his oeuvre cannot be overstated. The two small beings he shoulders reveal his battle. One of the little men holds a bottle: vice. The other preaches sobriety or righteousness. Traylor's iconic bird soars overhead.

Men in fancy suits, tailcoats, and tall hats and accessorized with bags, canes, umbrellas, and cigars are a central enigma in Traylor's body of work. His figures fitting this description have been explored as the personifications of Death, the Undertaker, and the Conjure Doctor—powerful roles that Traylor's characters may step in and out of. Accounts in folklore imagine Death as a tall man in black, wearing a "white bosom shirt." Josh Horn of Alabama, who was describing his wife, Alice, as she lay on her deathbed, gave one such account to folklorist Ruby Pickens Tartt in the 1930s:

> Then I axed who she seed, an' say hit was er big tall man dressed all in black. He rid up to the door on er big white horse, an' he stood right by her, and seem like sompin' in white swished by her, said 'course dat could been his white bosom shirt. Ef it had been er dream 'bout er white horse I'd er knowed hit was Death, but dis here was like a vision, a' I 'lowed Alice gwine be all right, but she wasn't....I know it wan't no conjur, 'cause Alice never had no fallin' out wid nobody in her life, an' you got ter have enemies ter get conjured.[81]

Horn's account notes that the man in all black could have been either Death or a conjure man, both of which relate to the Undertaker. Traylor's paintings of single men dressed in tailcoats and bosom shirts are icons of sophistication and respect, and the painting in which he identified "Ross the Undertaker" (above, PL. 56) provides a clear link in Traylor's conception as well. He shows Mr. David Ross with his small tool bag, an accoutrement that might contain work tools but is also associated with conjurers. Certainly, the undertakers dressed in a manner that commanded attention; around 1920, David Ross Sr.'s father, Robert Ambers Ross, posed for a photograph in which he proudly wears a three-piece suit not unlike the one in which Traylor portrayed his

son.[82] The figure in *Untitled (Man with Stogie)* (PL. 163) bears a striking resemblance to the one in *Untitled (Ross the Undertaker)* and may be a second portrayal of the subject. The cigar, possibly a luxury good affordable to one of the most affluent business owners in the African American community, appears in another painting of a finely dressed man, *Man in Black and Blue with Cigar and Suitcase* (PL. 164). As previously noted, the cigar is sometimes a symbol of Baron Samedi, Haitian vodou's Lord of Death. Some say that the Yoruban Eshu, his forefather, smoked a pipe (see PLS. 165, 166), although the flexibility of such symbols in vernacular culture should not be underestimated. The extent to which the African Eshu, the Caribbean Baron Samedi, and the American South's more general idea of Death were distinct conceptions for Traylor's is less significant than the probability that such a character existed or comingled in his imagination.

In an incisive essay published in 2007, Jennifer P. Borum explored the theories of Lowery Stokes Sims, Maude Southwell Wahlman, and Betty Kuyk, each of whom had written about the relationship between West African and Caribbean death figures and Traylor's top-hatted men. Borum concluded that the most compelling connection was that of Èshù-Elégba, or the Haitian Papa Legba, who is said to smoke a pipe, use a cane, and wear a straw hat.[83] Traylor may have been depicting Legba in works including *Untitled (Man in Blue Pants)*, *Man with Cane Grabbing Foot*, and *Walking Man* (PLS. 166, 167, and 171), among others. As mentioned above, in the religion of vodou Baron Samedi is the loa of the dead and keeper of the cemetery. The sprightly Legba is the guardian of the crossroads—the gatekeeper between human and spiritual realms. In a literary essay, writer M. B. Sellers describes him as the "size of a child," with spidery hands and a hunched back that "still carried a surplus of dignity." He walked with a mahogany cane and wore with a wide-brimmed straw hat. Sellers continues: "He began to hobble towards me. His right leg stuck out at a duck foot's angle, reminding me of a hockey stick. But he was agile, still, directing his cane straight into the softest spots of dappled Mississippi mud. He aimed without looking, his salient eye fixed on me, and I stood there waiting. And his hat—oh, that damnable, beautiful hat. It changed again with each reflection of the Southern sun."[84]

Borum elucidates connections that cultural critic and writer Lewis Hyde made between Legba and famed abolitionist Frederick Douglass. She extends the connection from Douglass to Traylor, arguing that Traylor would have appreciated Legba in terms of being a trickster whose flexible symbolisms and meanings could not be pinned down or underestimated and that both he and Douglass would have been more likely to self-identify with Legba over Baron Samedi.[85] With regard to Traylor, Borum notes: "For this witty, elderly artist, possessed of a sharp sense of humor, keen powers of observation, crystal clear memory, and the skill to render it all in a reductive poetics, it is Legba who makes more sense as the operative archetype, not the grim reaper. Legba, after all, is always called upon as the opener of the gate. To my mind, Legba's appearance in Traylor's oeuvre is nothing less than a spirit conjured by the artist to signal the nature of his elusive work."[86]

Whether Traylor's singular men echoed Samedi, Legba, the Undertaker, the Conjure Man, a fusion of these archetypes—or merely the real-life dressed-up

businessmen of Monroe Street—Traylor reimagined their visages at length **(PLS. 168, 169)**. And whether Traylor's agile man with the cane and the one in a topcoat carrying a bag are distinct entities or characters that comingle, Traylor increasingly traded out their black clothes for blue, thereby successfully alluding to the spirituality of the figures and letting the blue's liminality interplay with black and white shapes and forms and, ultimately, embody the characters' inherent nature.

MEN IN BLUE Traylor had a predilection for blue. This is a well-known and oft-recited observation, based on the degree to which he employed it in his art. The blue pencils and paints available to him varied, but the prevailing one was an intense cobalt poster paint, so vibrant it radiates in any light. One of Traylor's fancy women might feature a blue skirt or gloves on occasion, but they are awarded the color sparingly, unlike his men. Traylor's animals—a dog, cat, rabbit, or snake—were more likely than his women to be shown in all blue, a color that seems meant to set them apart. Among his animals, birds are more commonly blue than are other species, perhaps for their special capacity to participate on earthly and heavenly realms.

Traylor's men in blue seem to be a category unto themselves. The characters are exceptional in various ways, whether through their ability to skirt danger, such as intimated in the early colored-pencil figure in *Untitled (Event with Man in Blue and Snake)* (above, **PL. 30**), or in their sheer intensity, such as in *Truncated Blue Man with Pipe* (**PL. 170**), the subject of which, even in this solid-color silhouette, bears a striking resemblance to Franklin Delano Roosevelt. His men in blue are often physically aged—stooped, and walking with a cane (again, as Legba might)—but nevertheless seem spry. In *Untitled (Event with Man in Blue and Snake)* as well as *Walking Man* (**PL. 171**) he sidles off-scene, as if sidestepping a sticky situation. In *Untitled (Man in Blue and Brown)* (**PL. 172**) the man's head and upper extremities are in blue, while below the waist is brown; his feet are in one world, his heart and mind in another. The stippled blue torso in *Untitled (Man with Blue Torso)* (**PL. 173**) radiates energy; the man raises his hand in a "praise be" gesture and adopts the affect of a preacher or holy man.

The lifting of holy hands is intensified in *Untitled (Blue Man on Red Object)* (**PL. 174**), in which the blue man in the long frock coat has both hands upstretched high to the heavens. The mood is forceful; unwritten biblical words about fire and brimstone manifest in the viewer's mind, skipping deftly past the need of verbal language. Painted black, little men, a frequently used device of Traylor's, hover at the preacher's legs; the faithful holds tight and the sinner falls. The pulpit or housetop from which he preaches rises from a form resembling an open book; most everything below the preacher's half-hidden feet are painted in a fiery blood red tinged with black undertones—the hell fires below. The black dog looks on from the lower realm at a man already turned cinder red.

As if in response to the preacher's ardent ways and one's possible fiery fate, the blue-suited man in *Untitled (Smoking Man with Figure Construction)* (**PL. 175**) seems all about the good times. This cool-blue character also raises his hand with fingers spread, but the second hand on his hip, together with cigarette and hip flask, suggests good times over piety. The smoking man floats high above a structure that, in general

form, recalls the diving platform of Traylor's memory but in this situation reads like a narrative contrivance in which enclosed and open spaces allude to freedom and entrapment. Among the figures beset in Traylor's signature melee, a man with a tall hat reaches to grab a long-legged angular black bird—in flight, real or metaphorical—a recurring reference point for Traylor.

Increasingly, Traylor learned that the structures of his life offered useful props for the complex scenes he favored. In *Untitled (Legs Construction with Blue Man)* (PL. 176), Traylor seems to reach back in time and reuse the legs or shoe-anvil form he had developed in 1939 and early 1940. The painting is undated, yet it is more fluid and elastic than earlier works, in which tension arises from the tug between stiff forms and implied movement. Here the kicking black feet create a parallelogram that is at once a container and platform. The blue man, balding and bony, more clearly bears the features of an old man; nevertheless, smoking his pipe all the while, he seems to defy gravity in a jig-like jump. Contained within the stagelike structure, a smaller man with an ax takes aim; his hat and gesture connote peril and power. The owl portends death, and the hellhound nips at the blue man's heels—yet somehow the blue man rises above it all. He escapes unscathed. He is the ultimate trickster, just beyond reach.

BALANCING ACTS AND PRECIPITOUS EVENTS A sizable portion of Traylor's paintings engage the notion of balance. By employing tall central structures, Traylor created physical apparatuses on which his subjects climb, teeter, and fall. Upon his metaphoric stage is manifest the precarious cultural equilibrium between a violent past and a precarious but hopeful future. The notion of balance wove its way through American farm life in many ways: rain and shine, feast and famine, sowing and reaping, birth and death. The need to equalize disparate aspects of life also permeated conjure culture, church life, and other parts of African American society. Life in Montgomery in the 1940s was a balancing act unto itself for blacks, particularly for an aged man like Traylor, who was aware of the stark contrast between the old world and the one he walked in daily—but also that any small infraction of protocol could be terrifyingly fateful.

Decades after Bill Traylor had died, Shannon aimed to place the Traylor works of art he had personally acquired into museums, university collections, and other places where they might be seen and appreciated. He and his second wife, Eugenia Carter Shannon, devised a system for categorizing the works by type: "Earliest Works," "Extra-Large Works," "Simple Forms," "Dogs" "Fighters," "Odd Animals," and so forth. They called one such category "Special," to designate it as atypical within the overall corpus.[87] For the compound scenes, they made two categories: "Exciting Events" and "Figures, Constructions." Shannon explained that his goal was to form larger "collections" of artworks that comprised samples from each specialized category; the overarching groups were meant to create equivalent cross sections of Traylor's oeuvre to offer museums and other interested parties. Shannon assigned letter designations—the A Collection or B Collection, for example—to distinguish the various groups.

The works the Shannons classified as "Exciting Events" and "Figures, Construction" entail complex scenes. Those typed as "Exciting Events" sometimes utilize structures

but more often are those in which action plays out in a linear way or around an open plane or natural form such as a tree. The "Figures, Constructions" works are more likely to take place on an abstracted "built" structure that accommodates multiple tiers of action. Although the works of this kind appear to range as significantly in date as other categories, Shannon's memory is that they came "late"; but he was perhaps simply recalling a period when Traylor focused on them more than he had before. "These came late, probably during the last year of his working," Shannon said, referring to what he viewed as Traylor's last year of art making—1942. "They brought together many of the visual themes he had developed by that time: strong abstract forms, combination plant-animal and abstract forms, people in various 'states' ranging from serenity to hysteria, thieves and drunks and devilish kids. They were done with a sure touch and demonstrate his great mastery of his craft. With these came his most complex compositions and they were full of wonderful humor, both illustratively and in a purely visual way."[88]

By arranging multifaceted scenes on vertical structures, Traylor had devised a visual mechanism for presenting concurrent events and dimensions of time in one picture plane. Miriam Rogers Fowler and Marcia Weber were the first to propose that Traylor had utilized constructions from the plantation—such as the cotton screw and the diving platform—into usable stages for his scenes.[89] Fred Barron and Jeffrey Wolf extended that idea to Traylor's Montgomery milieu. As they noted in their essay "In Plain Sight" in the exhibition catalogue *Bill Traylor: Drawings from the Collections of the High Museum of Art and the Montgomery Museum of Fine Arts* (2012), efforts of some Montgomerians in the 1980s to establish a historic district where the African American business community once thrived were thwarted; Traylor's old neighborhood has since been reduced to a series of parking garages, parks, and remodeled storefronts.[90] Nevertheless, Barron and Wolf were able to document important surviving landmarks that sit just around the corner from Traylor's former perch outside the pool hall. Those that Traylor seems to have employed most frequently are the Court Square Fountain; the Klein and Son clock that sits just across from the fountain; and, at least once, the Alabama State Capitol building, which was a few blocks away but visible from all the way up the main artery of Dexter Avenue from Court Square (figs. 80–82). The authors made compelling connections between those structures and the ones Traylor drew— upon which he arranged his theatrical sets of people fighting, frolicking, drinking, or parading. That Court Square itself had once hosted one of the largest slave markets in the South, or that the buildings that flanked it had been holding pens for enslaved people yet to be sold or shipped, was not likely lost on Traylor when he saw African Americans living their lives around these historic places.

Traylor made these landmarks his own, and intentionally or not, they transformed under his touch into emblems of the generational tug-of-war that defines so much of his story. The Court Square of the 1940s was utterly altered from its antebellum past. Yet even today, from the fountain one can still look down Commerce Street, once lined with the offices and holding pens of slave traders, and see the ample Alabama River port, where so many enslaved people were herded mercilessly to market.

Traylor in 1938 might have watched the fifteen-foot-tall, four-faced Klein and Son street clock being installed at No. 1 Dexter Avenue, just outside the Central Bank Building in which the immigrant businessman Leo Klein had a jewelry store.[91] Perhaps the metonyms of clock hands and human hands appealed to Traylor, for what appear to be relatively early (ca. 1940–41) paintings with figures on constructions are three works that employ the clock form that uses humans to mark the time with their arms (PLS. 177–79). The simplest of these shows a man and woman standing atop a clock, clinging to its finial; below them a human figure stands with limbs spread, marking the time. The hats on the man and woman may recall a formal occasion, such as the dedication of the Klein and Son clock or other joyful celebration.

Other clock scenes, particularly those in *Figure Construction (Woman and Man with Axe)* (PL. 178), in which a brutal incident plays out, are darker. A hatted man standing by the clock may be a slaver or auctioneer. A dark figure marks the time with his body. The sinister man, or another like him, raises a hatchet over a cowering woman, who is unclothed and openly desperate as her hands implore him, or the fates, to alter the course. This painting more than others appears to locate the heartache and bloodshed in the place where the clock marks time.

Shannon once described Traylor's art as "raucous" in mood, a plausible description but perhaps one that emphasized waggishness and wildness over the clearly complex, often heavy, memories. Traylor did indicate a sense of humor and play in some scenes in which he comingled frolic with mayhem. In *Figures and Construction* (PL. 179) a figure with outstretched hands, once again, poses like a timepiece at the center; the clock face seems to merge forms with the spraying, broad-based fountain. A man wields his weapon at a fleeing person who is trying to grab onto fleeting freedom.

The figure atop the Montgomery's Court Square Fountain is Hebe, the Greek goddess of eternal youth, daughter of Zeus and Hera. Below her are towel bearers, Narcissus

FIG. 80 Klein & Son clock, Montgomery, Alabama, 2017

FIG. 81 Court Square Fountain, Montgomery, 2017

figures, and bitterns spouting streams of water from their beaks. The sculpted figures may not have held any mythological associations for Traylor, but their positioning around the pools of elevated water seemed to ignite his imagination, and he painted multiple scenes with people cavorting and fighting around a similar but variously abstracted structure.

Traylor's fountain scenes are alternately humorous and foreboding. In *Untitled (Construction with Yawping Woman)* (PL. 180), dark-skinned people, a family probably, point, yell, and panic to find a dog in the elevated bowl. A later work, *Blue and Black Figures on Construction with Orange Bird* (PL. 181), is similarly benign, yet the people in the playing group are lighter skinned. Traylor's blue and orange long-legged birds closely resemble the bronze bitterns on the fountain. A curious white-faced black cat—more often present than not in Traylor's fountain scenes—watches the action, peeking around as if surprised and curious.

In *Figures, Construction, Black, Brown, Red* and *Untitled (Figures and Construction with Blue Border)* (PLS. 182, 183), children play against a backdrop of darker events. In the former (PL. 182), the small child sporting with a hoop near the base of the structure shows a white girl in red, at play in an otherwise tense environment. Here, ten figures on the structure—man, beast, bird, and devil—create a highly dynamic scene, in which Traylor's propensity for balance and contrast is on full view. A figure poised high atop the structure holds his liquor bottle aloft. At ground level, where he might fall to, a man lurks with a menacing dog on tether. On the upper beam, a drunken youth tumbles off one end while an old man, counterbalanced on the other, peers down

FIG. 82　Alabama State Capitol building and Court Square Fountain, Montgomery, ca. 1950; photograph by Albert Kraus

cautiously; a bird taking flight seems to counterpoise a man clinging by a finger. The action, for Traylor, may have been self-evident. But he may also have understood that disorder functioned as a cloak, blunting memories, like dreams, which were laden with emotion and lacking a linear narrative.

In *Untitled (Figures and Construction with Blue Border)* (PL. 183), Traylor used a "Foldomatic" box top with a colored border. Four light-skinned children are at play, and the spherical logo at the center of the page doubles as one of the balls they toss around. The omnipresent white-faced black cat watches. Traylor's children are recognizable figures, portrayed with small bodies, large heads, and eyes that take up much of their face. They frolic with the oblivion of childhood, as the old man in their midst faces his fate. Posed at the top of the structure, he is stooped and older; his dark skin and age set him apart from the others. A large menacing dog paces below as a tremendous black bird swoops down on the old man, with outstretched, grabbing talons.

Traylor's birds take many forms; songbirds, owls, shorebirds, fowl, and buzzards are distinct and carry with them their age-old allegorical roles. Unlike the delicate long-legged birds that evoke ladies, or the frequently shown free-soaring one overhead, this bird is massive, dark, and threatening, with the curved beak and hooded eye of the buzzard. Death has come. The old man clings to his pet and the fountain, but his wide eye reveals his helpless fear.

Figures on Construction, Dog Treeing (PL. 184) is a darker scene set on a more exaggerated form with high-pitched sides. A white-headed person points accusingly at a bird—which stands with wings flailed back in discord. With a hound nipping at his heels, another person just below the bird reaches for it. The bird has been exposed by the pointing person, and a man with a hatchet comes for it. The bird, not unlike the one in Traylor's *Yellow Chicken* (above, PL. 25; in fig. 58), adopts the stance of a human with hands up; nothing hints that anything good will follow. The intensity is similarly high in *Figures and Construction with Cat* (PL. 185). The man with an ax attacks, and the large black bird thrashes backward as if already assaulted—again in an upright pose that seems more human than avian. Outside the melee the looming face of the familiar white-faced black cat peeks out.

The insect clinging to the underside of the platform base brings an intriguing detail in this work. In one or two early pencil drawings, Traylor drew bugs, mostly as a bird's quarry. The large, black, open-mouth, six-legged creature in *Figures and Construction with Cat* is one of Traylor's rarest characters. The gape-mouthed bug, a beetle of sorts, is arguably a boll weevil, even though the depiction is more interpretive than accurate. Still, it's hard to imagine a bug that played a greater role in Depression-era Alabama; a similar insect, although with only two legs, appears in the drawing *Animated Events* (discussed below, PL. 191). The bug took on a folkloric role in Southern African American culture, beyond simply an identity as a rapacious field pest. Folksongs about the insect liken it to a man, just looking for a place to call home and food for his family. The verses characterize the bug as nimble, cunning, small but mighty, embattled but enduring.

In this way the boll weevil became a folk hero not unlike Brer Rabbit. William Barlow explained, "A major characteristic of the commonplace animal trickster of the

postbellum era was its indestructability. The boll weevil was the most omnipotent folk symbol cast in this mold.… Furthermore, they viewed the misfortunes that the boll weevil brought the white plantation owners as retribution for the exploitation of black farm workers. The black folk ballads that sprang up to immortalize the boll weevil reflected those attitudes."[92] In the late 1930s and 1940s, some of the folksongs became popular radio recordings, perhaps refreshing the memory, for Traylor, the inside joke about the bug that crippled the cotton industry.[93]

Wherever it appears, Traylor's bug is latent; he lurks, eyes and mouth wide open, but stays hidden. Two figures painted in red suggest those who have already fallen, and people are upset by the violence. Traylor does not offer any resolution, just a never-ending plague of hostile memories.

A similar cast of characters appears in *Construction with Exciting Event* (**PL. 186**), one of the only paintings to be located on a domed structure resembling the Alabama State Capitol building, which can be easily seen from the fountain square, the one-time slave market (figs. 81, 82). The bird flying overhead and the white-faced cat mark an ongoing story line, although the conclusion of the tale never comes. A preacher seems to raise hands to heaven over Montgomery as a murderous event takes place on the streets below. The victim is not presented in the guise of a bird this time; here he is raw, exposed, and openly terrified.

Shannon's intention, when he made the lettered collections for museums and other holdings of Traylor's work, was for each grouping to not only be comparable in range and quality but also represent the wide span of Traylor's categories of image types through examples. Yet by separating Traylor's themes and types, Shannon inadvertently severed the artworks' connectivity and narrative threads in a lasting way. Between the late 1970s and the present, readings of Traylor's art as meaningfully affiliated works have been undercut, and Traylor became persistently understood as an artist who had worked in motifs without observable interplay throughout the body of work. Assuredly, Traylor's messages were subtle, and Shannon was not alone in missing the bigger picture. Traylor became adept at abstracting forms such as the one in *Construction with Exciting Event*—in which the pertinence of the capitol building, other than the fact that it was there, "in plain sight," might be lost, as Wolf and Barron observed. Traylor's manner of using structures to stage his dramas vary in consequence but should be carefully considered and never presumed neutral. Assessing the narrative in *Construction with Exciting Event* in the context Alabama's seat of governance— the Cradle of the Confederacy no less—with its clear view of a corridor that hosted unimaginable pain and anguish, significantly shifts the lens through which the feverish scene unfolding in its shadow might be interpreted.[94]

For Traylor realistic representation was likely never a goal, as such aspirations are academic and have only relative importance. He also probably felt comfortable with his stories being displaced from reality, for it made them less apt to be interrogated. Traylor's ability to reduce things and experiences to their extreme minimum ultimately served him well. In *Figures, Construction* and *Untitled (Red Bird on Construction)* (**PLS. 187, 188**) and other works, his stages are skeletal references, echoes of an altar

table, auction block, or tiered structure of the Montgomery fountain. Traylor braided and unbraided his recurring themes of violence and freedom, moving back and forth between frenetic, all-encompassing narratives and quiet spaces of abstraction that effectively distill feeling. His tricky scenes evidence the balancing act that defined life for African Americans in the Jim Crow South. Despite dramatic societal shifts over Traylor's lifetime, Alabama was foundationally entrenched in historical paradigms; that Traylor refined and reduced his locales didn't change what they were at the core, in his memory. Zelda Sayre Fitzgerald, a prominent white daughter of Montgomery who is said to have played around Court Square Fountain as a child, became a progressive thinker and emblem of the Jazz Age. In 1920 she married in New York and lived there over the next decade with her writer husband F. Scott Fitzgerald. When the couple resided in Montgomery in 1931 and 1932, the stagnancy of time, in cultural terms, struck her as profound; she wrote, "In Alabama, the streets were sleepy and remote and a calliope on parade gasped out the tunes of our youth.... Nothing had happened there since the Civil War."[95]

In Traylor's realm a great deal had changed, yet the underlying truth of Zelda Fitzgerald's words resonates. For African Americans the world was radically different yet deeply rooted in past attitudes and ways. Above all it was a dangerous place to live; racially motivated violence, loss, and ongoing lack of expediency colored every part of life. Traylor's generation was particularly grasping to find stability somewhere between the old behaviors and the new. His children lived on the other side of a generation gap that is hard to imagine fully. Traditional practices, rural living, oral culture, and old-time religion and magic were set against modernity, urbanity, education, and the imperative to thrive in a complex culture. Blues music embodied and reflected the strain between tradition and innovation as well as the desire to synthesize a harsh and unpredictable landscape with one that contained love, survival, beautitude.[96] Traylor's "balancing act" images tie him most closely with the quintessentially vernacular worldview expressed as laughing to keep from crying.

THE LYNCHING TREE Blues scholars once argued that the blues singers of the late nineteenth and early twentieth century "remained self-protectively mute on the issue of white mob violence," yet Adam Gussow points out that scholars have more recently fleshed out the ways in which the theme of lynching has been a key subtext throughout the blues tradition. He calls the role of blues "recuperative," a cultural vehicle that has "enabled black people to salve their wounded spirits and assert their embattled individuality."[97]

Gussow traces the world of violence for post-Reconstruction African Americans, noting that it was all encompassing and nuanced. He explores "disciplinary violence," in which white vigilantes sought to punish a "property" that had escaped from their control; "retributive violence," in which police used institutional power to terrorize and restrict the freedoms of black Americans; and the black-on-white retaliations that evidenced a desire to strike back and resist. He also discusses calls "intimate violence," or the "gun-and-blade-borne violence black folk inflict on each other," which he

describes as a "desperate, rage-filled striking out at a black victim when what one really wanted to strike back at was a white world that had defined one as nameless and worthless."[98] Of importance he notes the mixed blessing of the autonomy that places such as black jook offered—to choose partners, drink, dance expressively, sing, cry, scream, and fight, wound, or kill in a world that considered the lives of African American expendable. The fear of being lynched was pervasive and relentless for southern blacks. After staying in Mississippi in 1937, psychologist and social scientist John Dollard wrote, "Every Negro in the South knows that he is under a kind of sentence of death; he does not know when his turn will come, it may never come, but it may also come any time."[99]

Traylor certainly had personal experience with the retributive violence of police, and the loss of his son Will, or Willie, remained an open wound. Traylor understood firsthand that racial terror by lynching took many forms; the pervasive violence was, in Bryan Stevenson's words, a "tactic for maintaining racial control by victimizing the entire African American community, not merely punishment of an alleged perpetrator of a crime."[100] Bill must have been acutely aware that drawing and painting, while celebrated by progressive whites, could have been viewed as threatening by most of Montgomery's mainstream white population, and that by not depicting straightforward narratives he might be sidestepping a perilous altercation.

A small body of work within Traylor's oeuvre illuminates the fact that lynching, in whatever extralegal form it took, weighed heavily on his mind. What is perhaps more remarkable than the fact that Traylor made such drawings is that he kept—and let Shannon keep—them. Violence—in the form of people wielding hatchets and clubs or falling from dizzying heights or implied through the latent pressure that imbues Traylor's scenes populated by dogs or mounted overseers—is ubiquitous in Traylor's work but possible to underestimate or even read as humor or general mayhem.

Traylor presented other nightmarish scenes that are abstract enough to obscure clarity from our reach. Such is the case in *Untitled (Figure Construction in Black and Brown)* (PL. 189), in which a terrified-looking man is trapped inside a tomb-like cavity while empowered figures on the exterior seem to argue over his fate. The sense of the victim's helplessness and the disproportionate supremacy of the large-handed man in the hat are forcefully clear. Also elusive is *Two Men, Dog, and Owl* (PL. 190), in which a dog and two men with sticks assault an owl—symbol of death. The face of the owl is black. Its wide eyes stare, but it otherwise sits motionless; it wraps its protective blue wings tight around itself, but the fight is already lost. The meaning in an image like this one was more than likely stark in Traylor's mind, and others in his community would have read it on similar terms. Yet he also could have explained it away as commonplace—farmers killing an owl that took a hen.

Another of Traylor's favored settings is a tree. Throughout the 1980s and 1990s, a scene centered around a tree was referred to (by sellers and admirers of the works alike) as a "possum hunt" or simply an "exciting event," as Shannon categorized it. In many of Traylor's works featuring trees, Traylor overtly adhered to a hunting narrative. Possum hunts and nighttime searches for other animals were indeed part of

plantation culture. Accounts given by naturalist Philip Henry Gosse, ex-slaves, and younger generation of Southern blacks all speak of such expeditions, as real events as well as plausible covers for other kinds of chases.[101]

In *Animated Events* (PL. 191) a hunter takes aim into a tree filled with birds; his hound is ready to retrieve the prey. The mood of the supposed hunting scene is shifted significantly by a woman screaming, her arms raised and fingers wide in utter anguish; a white child runs away. A curious insect, upside down in the position of a clinging pest, maybe a boll weevil, lurking to note endurance or survival. Traylor's selection of paint colors and manner of indicating identities in the image seem tangled, as though he sought to determine the degree to which the truth can plainly appear.

In one of Traylor's most iconic tree scenes (*Untitled*, PL. 192), the story gains clarity but remains nimble. Big dogs, at first blush, seem to be treeing a weasel or possum. Slaves, and subsequently black laborers, were sometimes sent into a tree to try to flush a wily beast clinging to the upper branches; this work was among those Shannon called "possum chase."[102] By the time Traylor drew the image, he had mastered the multilevel narrative. Seen another way, the image is disturbing. Three men in hats (two are top hats) chase two without; in the upper right corner, on a separate plane from the men in top hats, one man, with mallet raised, chases a person who is fleeing. The pursuer at bottom right points out the location of a man clinging to branches as the other aims his rifle directly at him. The treed man's hands and face express terror and helplessness.

Existing red paint stains on a piece of cardboard may have driven the scene Traylor created in *Untitled (Dog, Figures, and Tree)* (PL. 193). In this discomfiting image, a person plummets from a tree (recognizable only by the scratchy roots at it base) toward the waiting maw of a huge, menacing dog. A wide-eyed man runs for his life. While Traylor may have shied from painting a blatantly bloody scene, the splotches of red paint on the board effectively evoke fear and bloodshed in an image that is among the artist's most unsettling.

The tangle of events in *Exciting Event (Man on Chair, Man with Rifle, Dog Chasing Girl, Yellow Bird, and Other Figures)* (PL. 194) suggests powerful memories, shown as dreamlike or through the haze of time. The compound narrative may be related to Traylor's tactic for decentralizing focus and heightening an evasive story line. Every creature in the image—even a young white girl who flees from an attacking hound—is either on the giving or receiving end of an assault. The large bright bird, squawking in distress, draws attention to the tree—the home that holds her nest. No one is safe.

Traylor must have been hesitant to record on paper this horrific topic that was likely his worst fear and memory, but three known works speak directly to lynching. In one, the rarely seen drawing *Untitled (Lynching)* (PL. 195), he clearly sketched out a lynching at a gallows. The lines are tentative, erased and redrawn, ultimately remaining underdeveloped. Twenty-five of Traylor's signature short lines in the lower left corner raise the question of counting or keeping a record. The gallows structure reflects Traylor's occasional use of a straightedge, but the figures are scant and uncharacteristic, as if he was hesitant to even finish the work. One figure holds the device that

pulls the world out from under the doomed person. The extreme sway of the hanging body announces the force of the moment as it happens.

In the second such artwork, *Untitled* (**PL. 196**), the tree, or gallows, has faded into abstraction, but the event is still clear. Two men hang; their faces are black, but their brains are white as life drains away. Death, in the form of the owl, sits above—its head also white.

In the most abstract of the three, *Figures and Trees* (**PL. 197**), Traylor used an odd-shaped board, on which he oriented the image in a way that disrupts any sense of stability. He employed a minimum of detail and abstraction to his advantage, and at a glance the scene might not seem bleak. One of the men looks like he is holding onto the tree branch; the other one, however, has no arms with which to do so and more convincingly hangs by his neck. The figures still have purchase on roots or branches beneath their feet, as if they might be about to jump into a river and swim away, for enjoyment—or escape. The abiding feeling of the drawing, however, is not playful but solemn and haunting. It imparts a heavy sense of ongoing fear and the inability to erase indelible memories.

THE END OF AN ERA

Between 1939 and 1942, Traylor survived on a combination of grit, welfare, and the kindness and camaraderie of folks in the Monroe Street neighborhood. He had attempted to move on from the South in 1940, visiting daughter Easter in Detroit and other kin in the North and East, but the pull of the only home knew brought him back to Montgomery time and again.

Starting before World War I, modern artists had taken inspiration from early American folk art, celebrating the simple styles for revealing a uniquely American vision. The American art historian and first director of the Museum of Modern Art (MoMA), New York, Alfred H. Barr Jr., advocated for luring these ideas about the untainted perspective of "the folk" into the twentieth century. In the 1930s and 1940s, Barr was showing the work of living artists who were untrained or otherwise effectively marginalized from elite artistic culture.

The most sizable of those experimental exhibitions was *Masters of Popular Painting: Modern Primitives of Europe and America* in 1938. "Popular or folk art has always existed and during the past century it has been given increasing attention. But it is only since the apotheosis of Henri Rousseau that individual popular artists have been taken seriously," Barr wrote. "The purpose of this exhibition is to show, without apology or condescension, the paintings of some of these individuals, not as folk art, but as the work of painters of marked talent and consistently distinct personality." Exhibition collaborator Holger Cahill, who was also director of the Federal Art Project of the Works Progress Administration, positioned American folk art as a fresh and untapped wellspring of originality: "Folk and popular art is significant for us because, in our fear that contemporary civilization has almost abandoned its form-creating function in favor of the sterile mathematics of machine-form, we are startled and reassured to find this rich creativeness still alive in the unpretentious activities and avocations of the common man."[103]

In 1937, Barr organized a solo show for the African American stone carver William Edmondson. Edmondson was the first African American to receive that honor at MoMA, to the chagrin of many trained artists who felt that such recognition should have been granted to someone among their own ranks. Shannon was hopeful about garnering attention for Traylor, and in late 1940 or early 1941 he took a selection of Traylor's paintings to New York City.[104] A friend introduced him to Victor D'Amico, who was head of the Department of Fine Arts at the Ethical Culture Fieldston School in Riverdale, New York, and director of MoMA's education department from 1937 to 1969. D'Amico took interest in the work, and in January 1942 he mounted a show of it at the Fieldston School called *Bill Traylor: American Primitive (Work of an Old Negro)*.[105]

The exhibition in Riverdale took place in the aftermath of the Japanese attack on Pearl Harbor and received scant acknowledgment as the United States became consumed with its provoked entry into World War II. D'Amico shared his enthusiasm for Traylor's work with Barr and other MoMA colleagues, and they, too, reacted favorably. Barr's staff initiated a purchase by sending Shannon an amount of money they deemed fair and asking Shannon to advise if he felt otherwise.

But Shannon was displeased with the communication, and, unfortunately, cost Traylor entry into one of the world's premier collections some five decades earlier than it ultimately eventuated. Shannon later recalled, "Without ever consulting me as to whether or not I wanted to sell the work or, if so, at what prices, I simply received a check with a letter telling me that Mr. Barr and staff had 'agreed to pay $2 a piece for the larger drawings and $1 for the smaller ones.'" Shannon, who may have misunderstood the communication, asserted that MoMA staff sent a check for the works they wished to own personally, and that another check from the museum—for pieces Barr selected for the collection—would be sent separately. Shannon rejected the museum's proposal and demanded the return of the paintings.[106]

Shannon was drafted into World War II on June 6, 1942.[107] If Traylor continued to live in or visit the Monroe Street district after 1942 it was intermittent. He visited his children in the North and East; granddaughter Margaret Traylor Staffney reported that when he returned, he lived again on Bell Street, in a makeshift residence, on a strip of land overlooking the Alabama River.

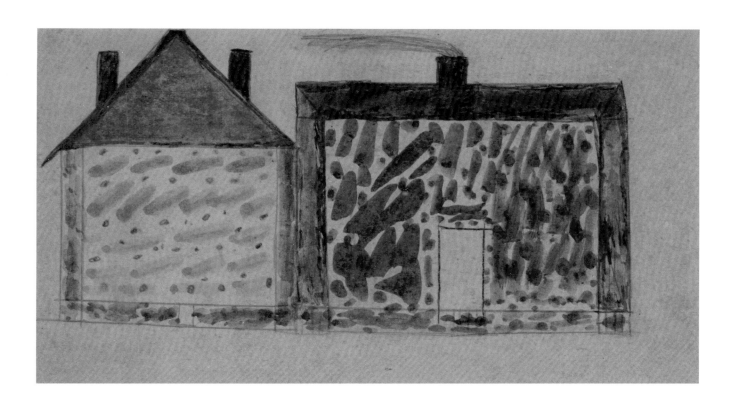

PLATE 71 *Untitled (Blue and Brown Buildings)*

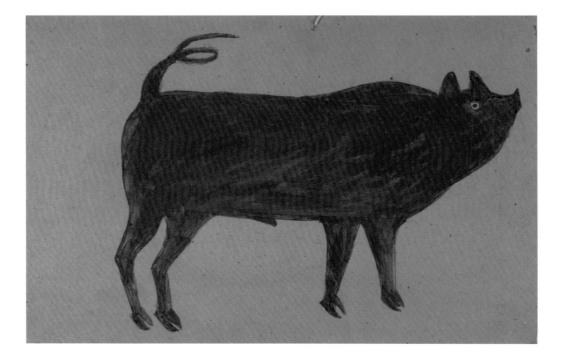

PLATE 72 *Untitled (Brown Pig)*

PLATE 73 *Untitled (Pig with Corkscrew Tail)*

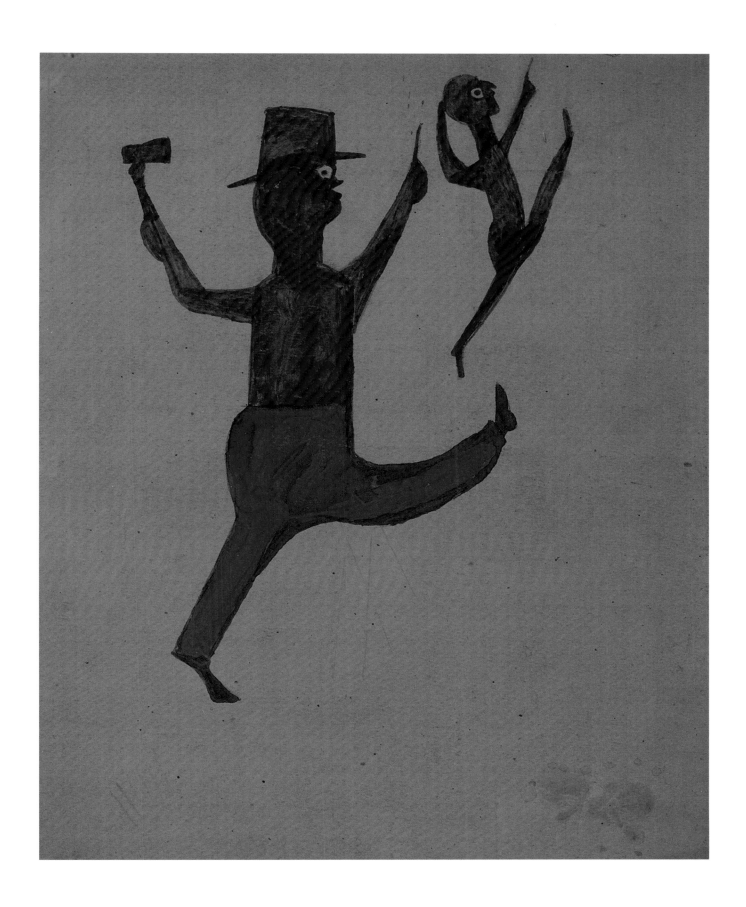

PLATE 74 *Man with Hatchet Chasing Pointing Man*

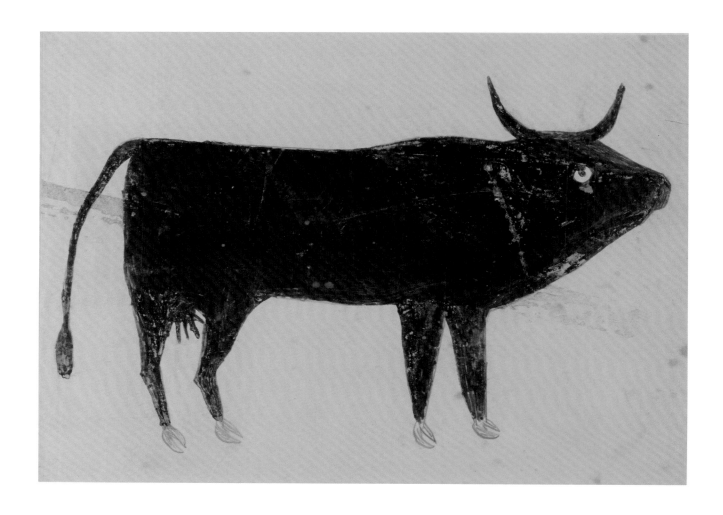

PLATE 75 *Untitled (Cow)*

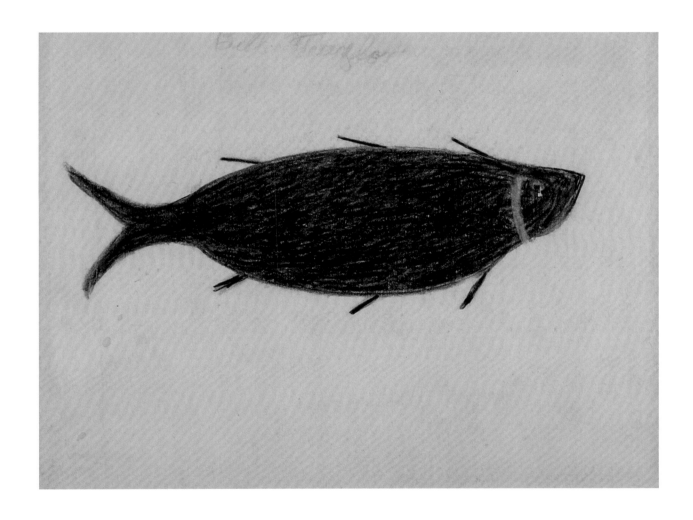

PLATE 76 *Black Fish*

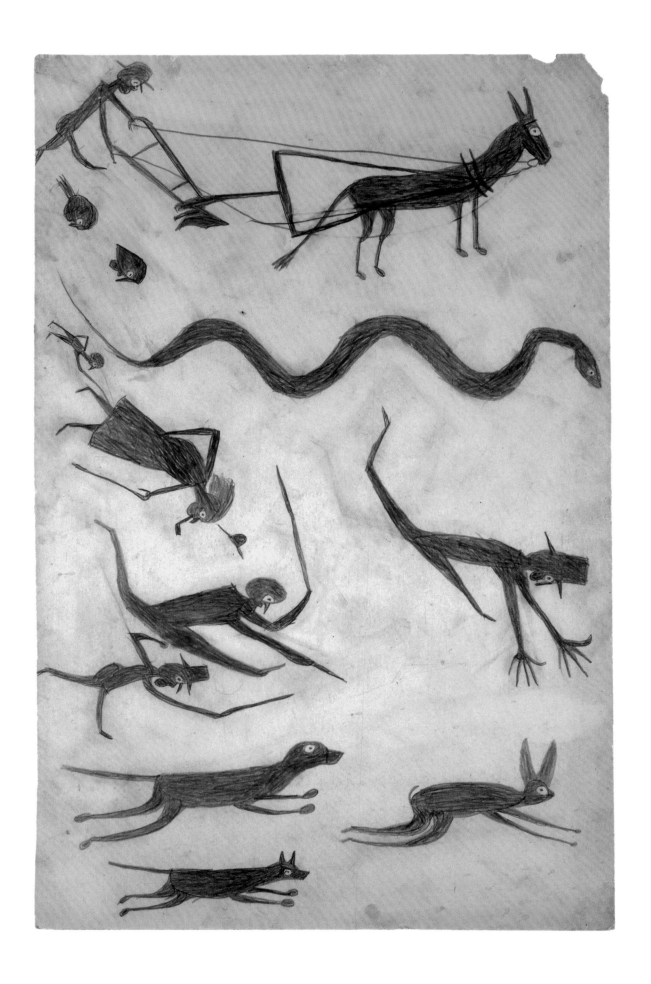

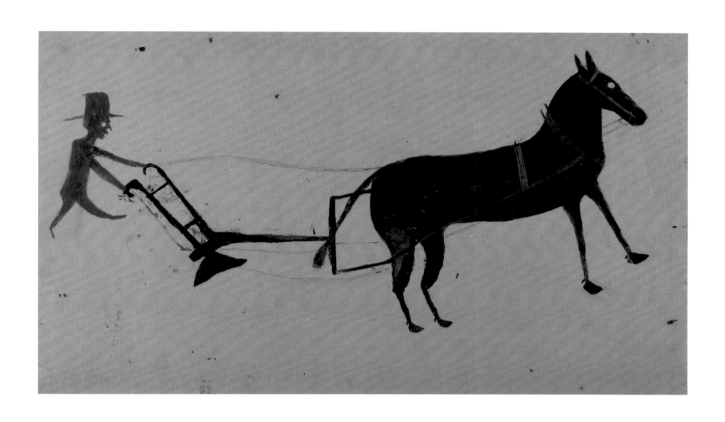

PLATE 77 *Exciting Event with Snake, Plow, Figures Chasing Rabbit*

PLATE 78 *Man with a Plow*

PLATE 79 *Untitled (Rabbit)*

PLATE 80 *Running Rabbit*

PLATE 81 *Rabbit*

PLATE 82 *Blue Rabbit Running*

PLATE 83 *Untitled (Chase Scene)*

PLATE 84 *Untitled (Snake)*

PLATE 85　*Blue Snake*

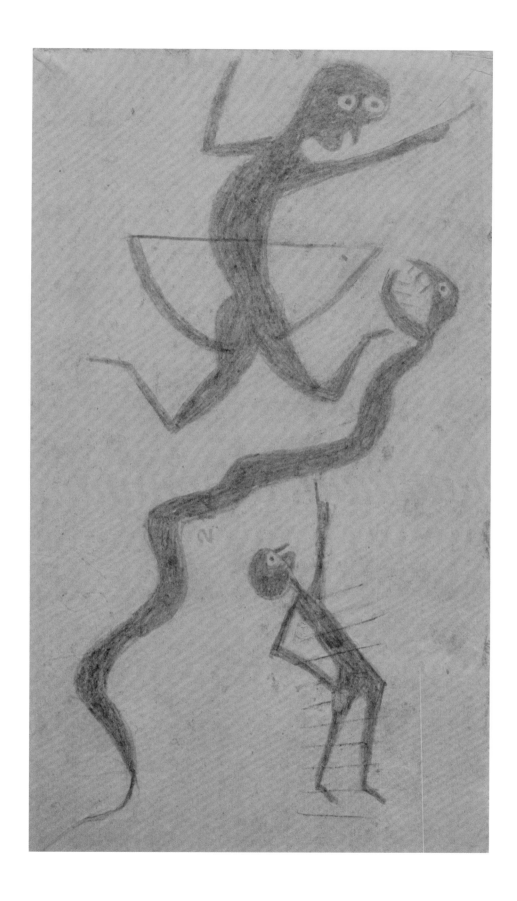

PLATE 86 *Snake and Two Men*

PLATE 87 *Snake*

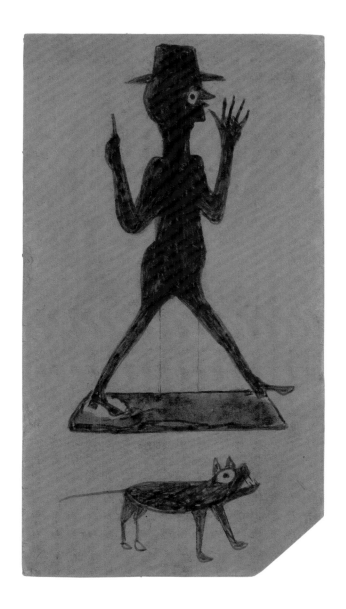

PLATE 88 *Figures, Construction*

PLATE 89 *Chicken Toter Being Chased*

PLATE 90 *Untitled (Mule, Dog, and Scene with Chicken)*

PLATE 91 *Chicken Stealing*

PLATE 92 *Hog, Dog, and Chicken Stealing*

PLATE 93 *Untitled (Men Shooting Bear)*

PLATE 94 *Blue Animal with Five Figures*

PLATE 95 *Untitled*

PLATE 96 *Dog*

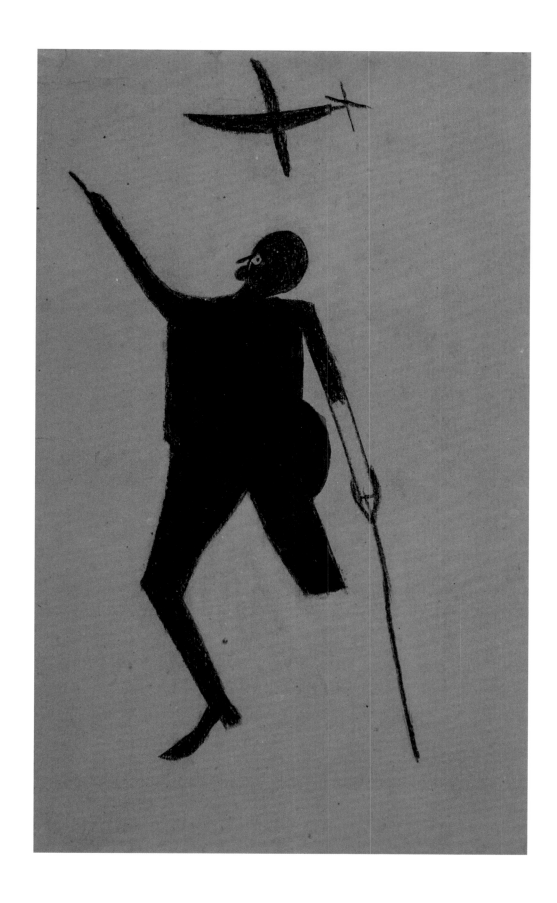

PLATE 97 *One-Legged Man with Airplane*

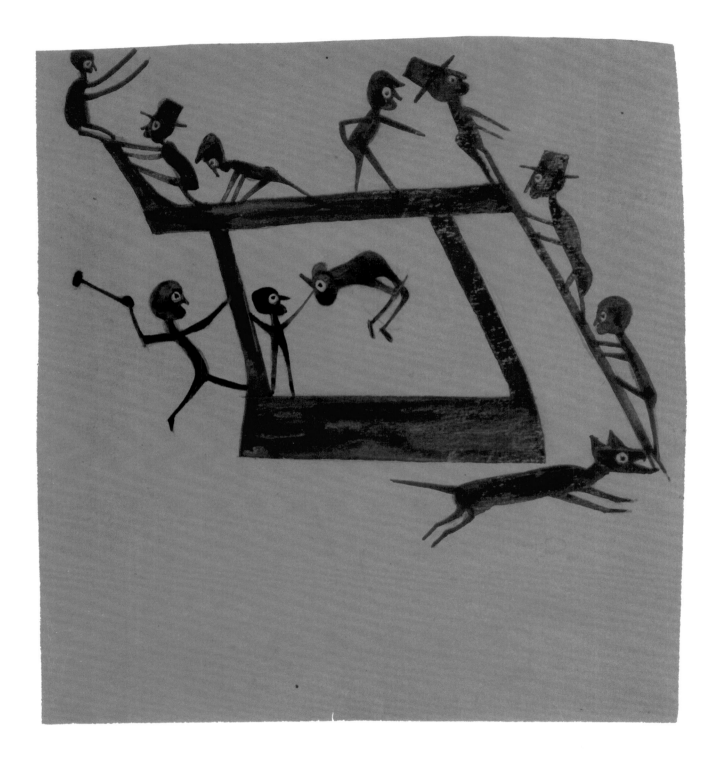

PLATE 98 *Figures, Construction*

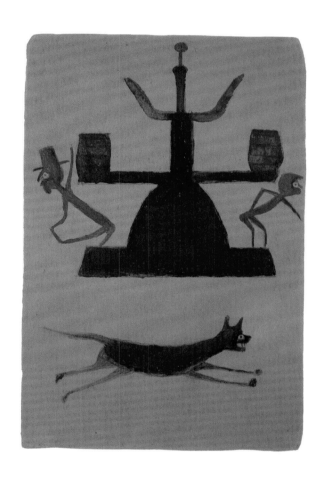

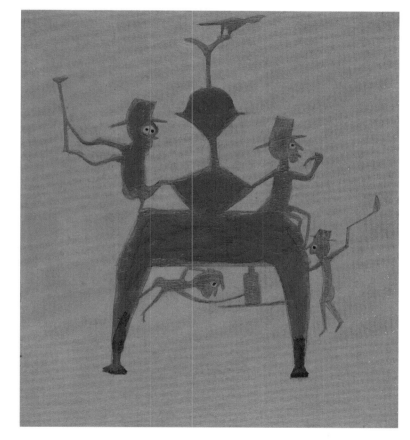

PLATE 99 *Two Men with Dog on Construction*

PLATE 100 *Figures on Blue Construction*

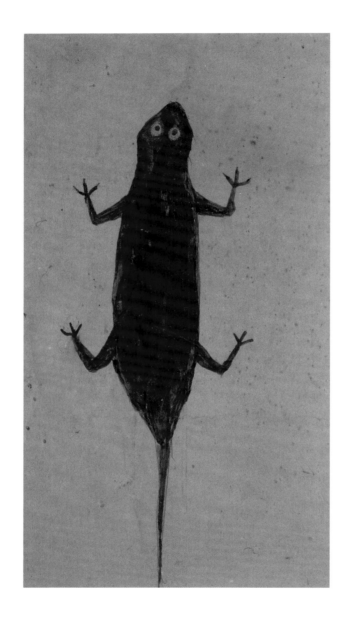

PLATE 101 *Brown Lizard with Blue Eyes*

PLATE 102 *Yellow Horse, Black Mule*

PLATE 103 *Untitled (Mule and Horse)*

PLATE 104 *Untitled (Mule)*

PLATE 105 *Mule with Red Border*

PLATE 106 *Untitled (Black Horse)*

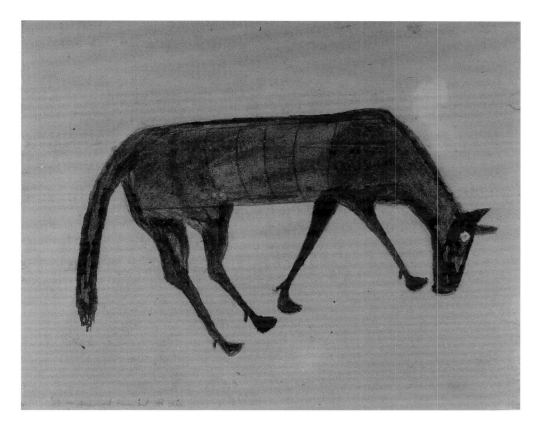

PLATE 107 *Red Man on Blue Horse with Dog*

PLATE 108 *"He's Sullin'"*

PLATE 109 *Horse ("Turned him out to die")*

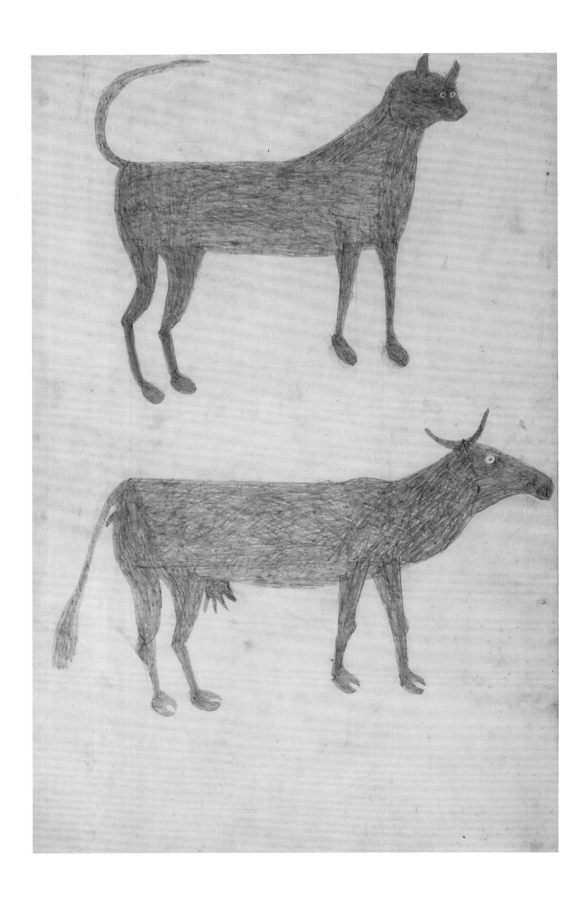

PLATE 110 *Dog and Cow*

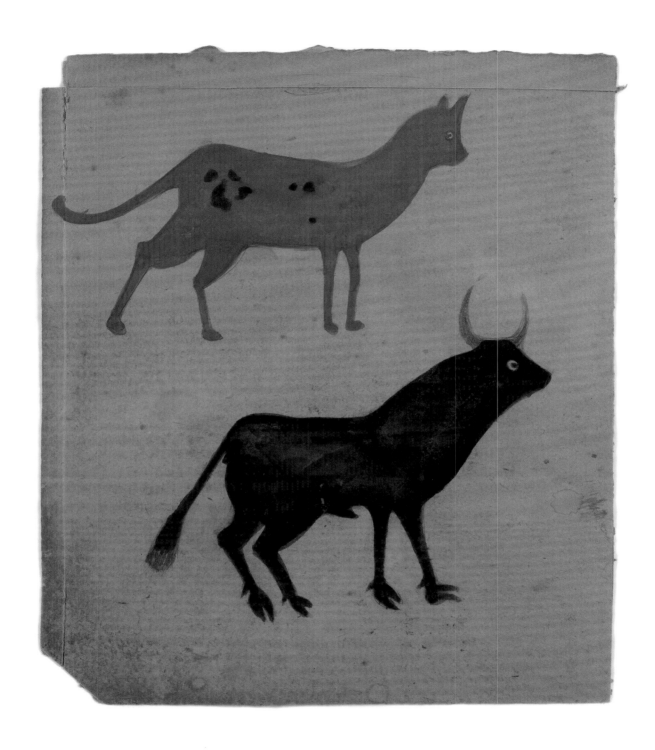

PLATE 111 *Red Cat, Black Bull*

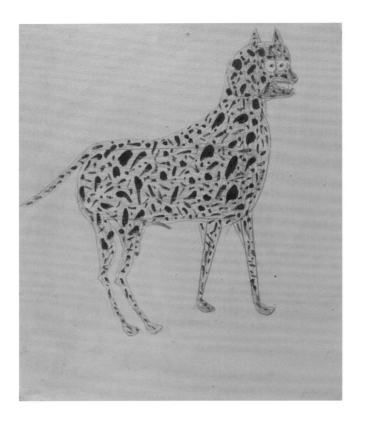

PLATE 112 *Spotted Cat with Two Eyes*

PLATE 113 *Spotted Dog*

PLATE 114 *Spotted Dog and Black Bird*

PLATE 115 *Cat and Dog*

PLATE 116 *Two Fighting Dogs*

PLATE 117 *Untitled (Two Dogs Fighting)*

PLATE 118 *Dog Attacking Man Smoking*

PLATE 119 *Woman in Green Blouse with Puppy and Umbrella*

PLATE 120 *Black Dog*

PLATE 121 *Untitled (Dog)*

PLATE 122 *Red Dog*

PLATE 123 *Red Dog*

PLATE 124 *Man and Large Dog*

PLATE 125 *Man and Woman*

PLATE 126 *Top Hat*

PLATE 127 *Men on Red*

PLATE 128 *Mean Dog*

PLATE 129 *Drinking Bout*

PLATE 130 *Untitled (Yellow and Blue House with Figures and Dog)*

PLATE 131 *Brown House with Multiple Figures and Birds*

PLATE 132 *House*

PLATE 133 *House, Blue Figures, Blue Lamp*

PLATE 134 **Man in Brown and Blue House with Figures**

PLATE 135 **Man Talking to a Bird**

PLATE 136 *Untitled (Exciting Event: House with Figures)*

PLATE 137 *Untitled (Radio)*

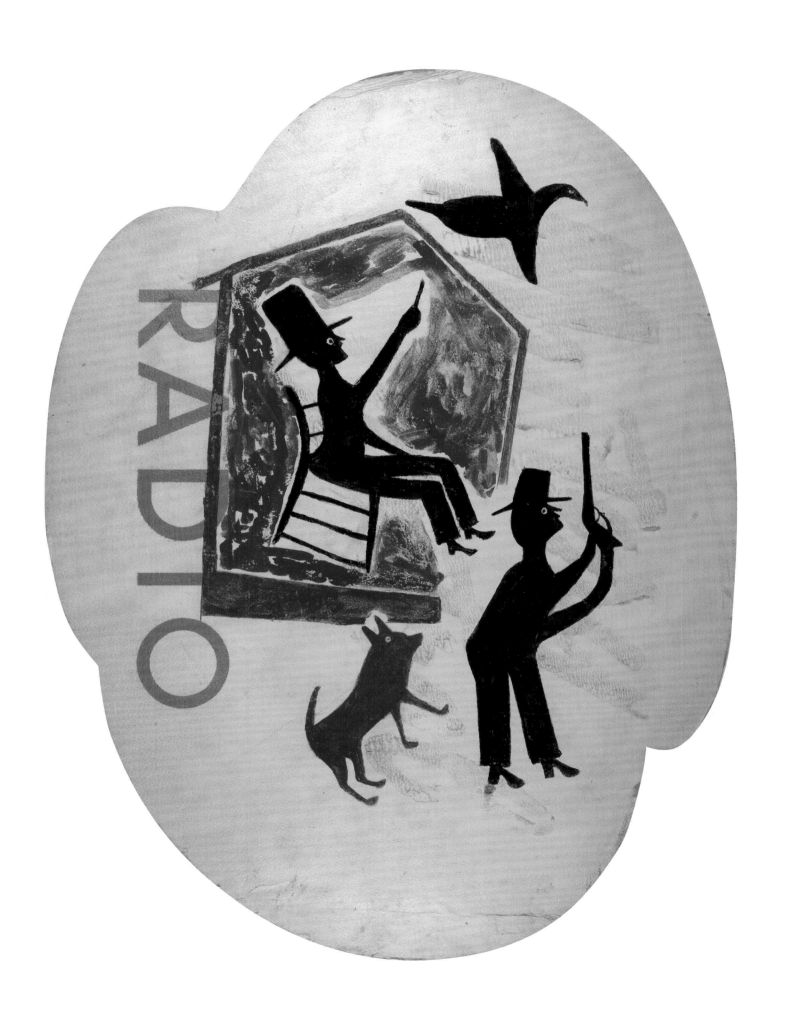

PLATE 138 *Man Reaching for Bottles*

PLATE 139 *Untitled (Drinker)*

PLATE 140 *Arched Drinker*

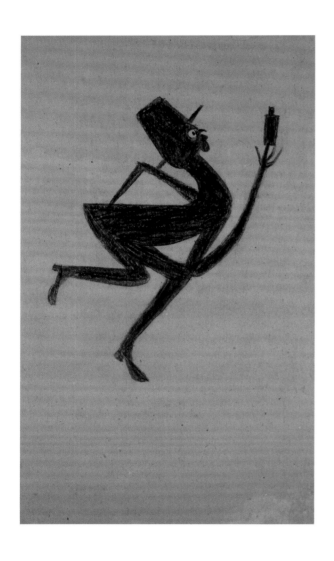

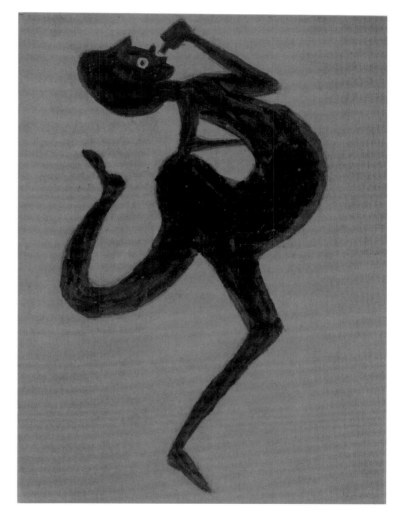

PLATE 141 *Black Man with Bottle*

PLATE 142 *Female Drinker*

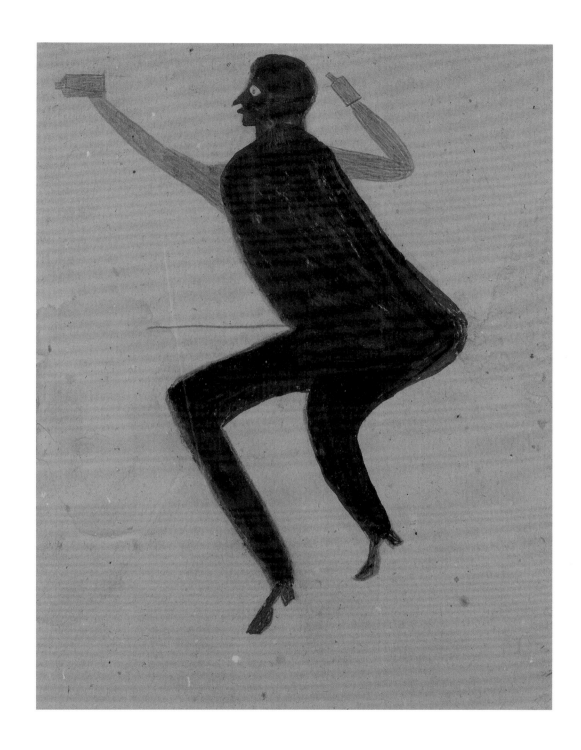

PLATE 143 *Green Man with Two Bottles*

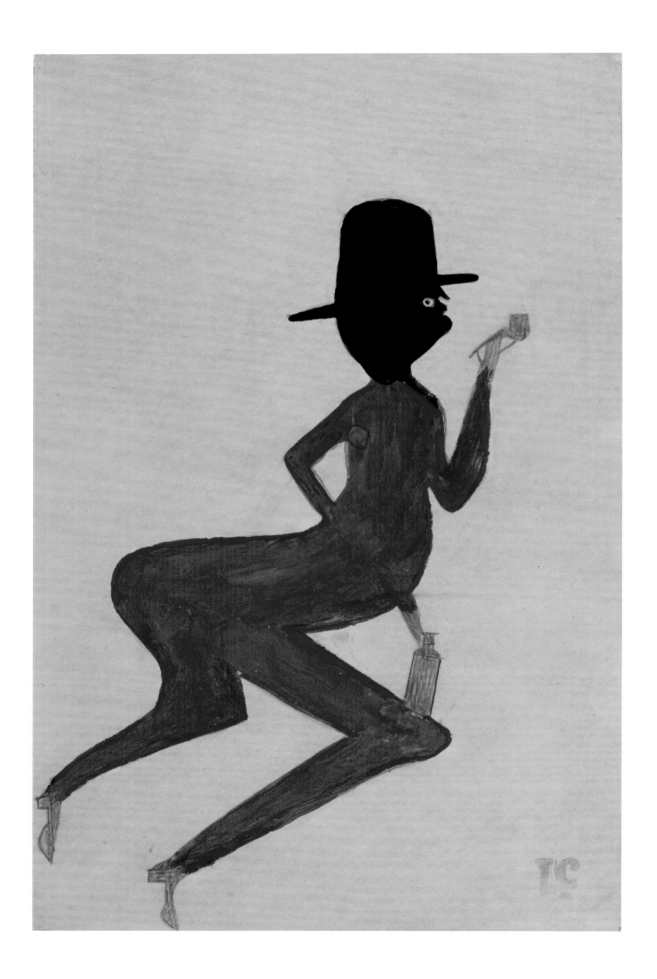

PLATE 144 *Red Man*

PLATE 145 *Drinker in Chair*

PLATE 146 *Spread-Legged Drinker*

PLATE 147 *Man Bent at Waist with a Bottle*

PLATE 148 *Woman in "O" and "X" Pattern Dress*

PLATE 149 *Untitled (ABCD Woman)*

PLATE 150 **_Woman with Bird_**

PLATE 151 **_Woman_**

PLATE 152 *Mexican Lady with Green and Red Spotted Dress*

PLATE 153 *Man and Woman Pointing with Dog*

PLATE 154 *Man, Woman*

PLATE 155 *Woman Pointing at Man with Cane*

PLATE 156 *Woman, Blue Gloves, Brown Skirt*

PLATE 157 *Red-Eyed Man Smoking*

PLATE 158 *Man Wearing Maroon and Blue with Bottle*

PLATE 159 *Pointing Man in Hat and Blue Pants with Cane*

PLATE 160 *Man with Two Canes*

PLATE 161 *Big Man, Small Man*

PLATE 162 *Man with Yoke*

PLATE 163 *Untitled (Man with Stogie)*

PLATE 164 *Man in Black and Blue with Cigar and Suitcase*

PLATE 165 *Self-Portrait with Pipe*

PLATE 166 *Untitled (Man in Blue Pants)*

PLATE 167 *Man with Cane Grabbing Foot*

PLATE 168 *Man with Top Hat and Cane*

PLATE 169 *Man in Blue Suit Pointing*

PLATE 170 *Truncated Blue Man with Pipe*

PLATE 171 *Walking Man*

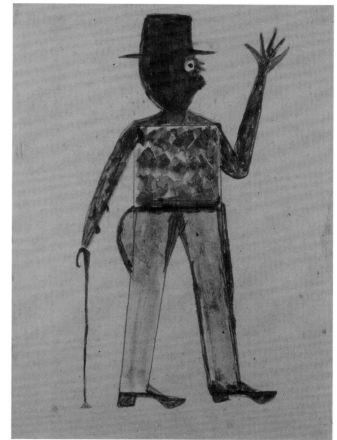

PLATE 172 *Untitled (Man in Blue and Brown)*

PLATE 173 *Untitled (Man with Blue Torso)*

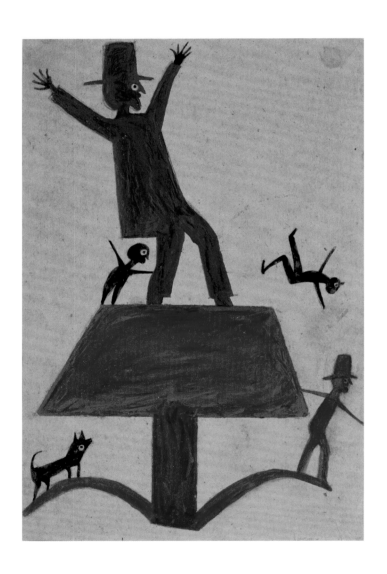

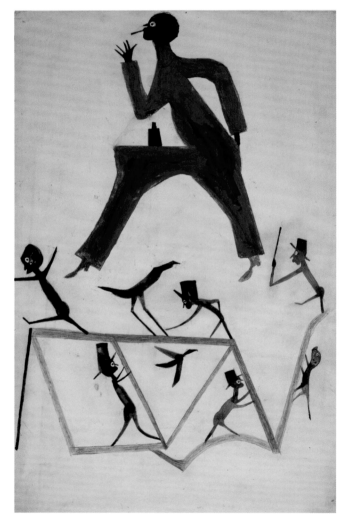

PLATE 174 *Untitled (Blue Man on Red Object)*

PLATE 175 *Untitled (Smoking Man with Figure Construction)*

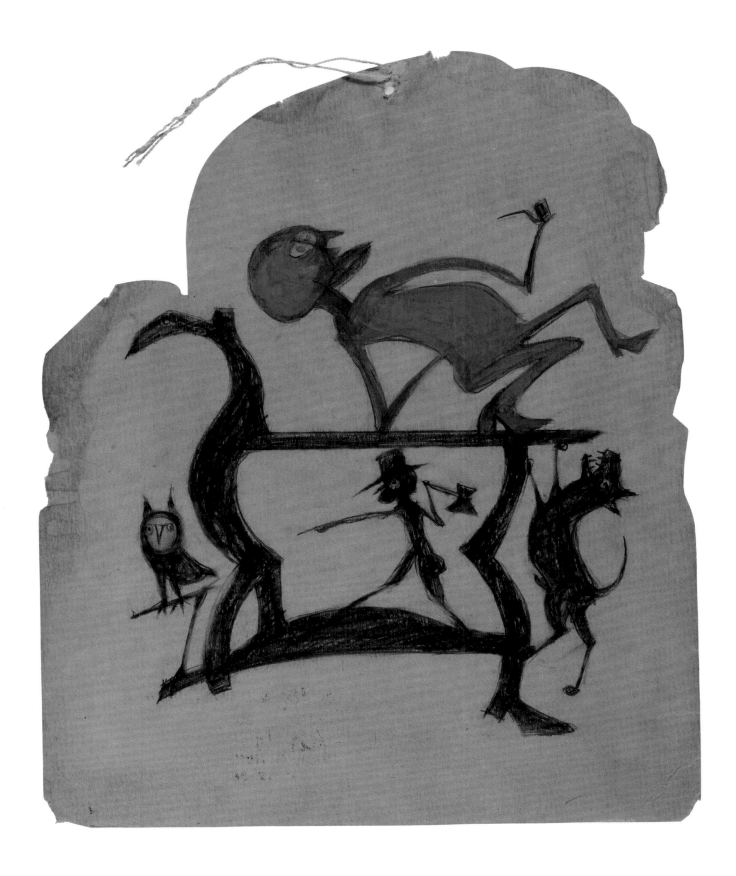

PLATE 176 *Untitled (Legs Construction with Blue Man)*

PLATE 177 *Figures, Construction*

PLATE 178 *Figure Construction (Woman and Man with Axe)*

PLATE 179 *Figures and Construction*

PLATE 180 *Untitled (Construction with Yawping Woman)*

PLATE 181 *Blue and Black Figures on Construction with Orange Bird*

PLATE 182 *Figures, Construction, Black, Brown, Red*

PLATE 183 *Untitled (Figures and Construction with Blue Border)*

PLATE 184 *Figures on Construction, Dog Treeing*

PLATE 185 *Figures and Construction with Cat*

PLATE 186 *Construction with Exciting Event*

PLATE 187 *Figures, Construction*

PLATE 188 *Untitled (Red Bird on Construction)*

PLATE 189 *Untitled (Figure Construction in Black and Brown)*

PLATE 190 **Two Men, Dog, and Owl**

PLATE 191 **Animated Events**

PLATE 192 *Untitled*

PLATE 193 *Untitled (Dog, Figures, and Tree)*

PLATE 194 *Exciting Event (Man on Chair, Man with Rifle, Dog Chasing Girl, Yellow Bird, and Other Figures)*

PLATE 195 *Untitled (Lynching)*

PLATE 196 *Untitled*

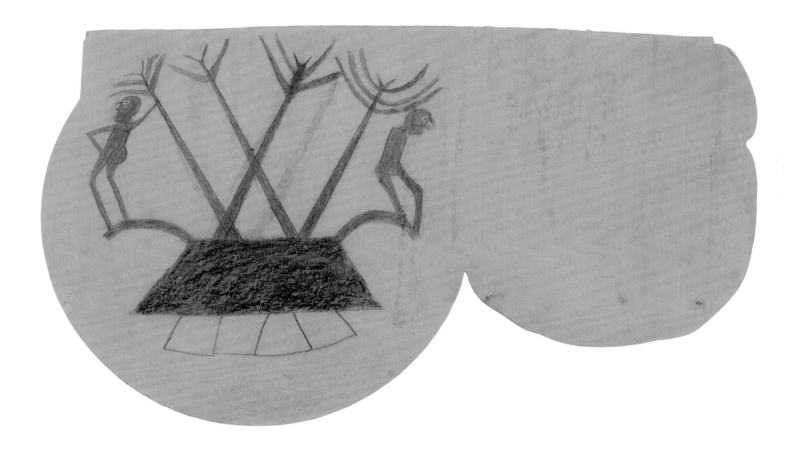

PLATE 197 *Figures and Trees*

ART IN THE FINAL YEARS, 1942–1949

Although Traylor's health had continued to decline in the

1940s, by many accounts he kept making art through 1947 or 1948, possibly longer. With
Shannon gone from Montgomery, the specifics of Traylor's whereabouts during World
War II are vague. Blanche Balzer remained in Montgomery until she and Shannon
married in January 1944, but if she had significant dealings with Traylor after Charles
left for the war in June 1942, they went undocumented. The story of Traylor's art after
1942 is even less substantiated than his life in his final years. What is known is told in
part one—in "The Last Years, 1942–1949" (pp. 96–103)—and recapped here.

Sometime after Shannon left Montgomery, Traylor visited several of his children
in the North and East, as he had done two years before. The dates of those sojourns can
be roughly charted through the memories of Traylor's descendants, which are unspecific
but pertain to the time frame of 1942–44, possibly extending into 1945. Shannon once
asserted that Traylor's travels had thwarted his artistic practice, remarking: "[Traylor]
told me he did not make art during the war, and the little work he did after his return
was not good and I didn't save it."[1]

Yet members of the Traylor family uniformly disagree that Bill Traylor had stopped
making art after the war began. Accounts from grandchildren and great-grandchildren
concur that Traylor continued to draw and paint during his long-distance travels to
see family. As life continued to change in Montgomery, Traylor may have explored and
reconsidered his options for where and with whom he might live out his days, but for
as long as he was able to, relatives say, Traylor kept on with the art making that had
become his way of life.[2]

In spite of Traylor's two or three visits to his daughter Easter's home in Detroit,
he had told her that he would ultimately rather live on the streets in Montgomery
than stay on in Michigan; it seemed the North was just not a place he could fully adjust
to.[3] Upon his return to Montgomery, he apparently faced a shift in dynamics on

Monroe Street, and he took up lodging in an unnumbered shack on Bell Street, a structure that his granddaughter Margaret Traylor Staffney described as an abandoned used-car-lot office. The site was on a bluff that commanded a view of the rail yards and the Alabama River, an overlook with a similar geography to that of George Hartwell Traylor's rural farm. Staffney recalled that the area (now the Wright Brothers Park), as well as a patch below on the riverbanks, served as a makeshift home for hobos who used the river as a natural food source. Her memory of Traylor's "home" was that it was rough, but she recalls that her grandfather relished his independence and seemed happy there.[4]

Traylor's diabetes had become increasingly acute, and in 1943 he underwent surgery to remove several toes.[5] That same year he met another granddaughter for the first time. One of Will and Mimmie's three children (Margaret, Laura [or Myrtha], and Clement) had been adopted by another family as a child; she found out about her birth family at age seventeen. Myrtha Lee Canty—who was named Laura Traylor after her maternal grandmother and later became Myrtha Lee Delks in marriage—traveled to Montgomery from her home in Birmingham to meet her biological family. Among the relatives she met were a half-sister, Ada (from her mother's relationship before Will); her siblings Margaret and Clement; her birth mother and aunts; and her grandfather, Bill. Looking back on this moment, Myrtha was hazy on the details of the get-togethers, which happened in 1943 and 1944, but she recalled Traylor as an elderly bald man with a long white beard who—at least some of the time—was making art.[6]

In January 1944, Traylor was baptized at Saint Jude Catholic Church. Whether he made that decision of his own accord or was propelled by his daughter Sarah remains unknown (fig. 83). By then Traylor may have been living, at least part time, with Sarah and her husband, Albert Howard—but he was not documented as formally residing with them until 1945. The city welfare agency had come to realize that Traylor had local relatives he could live with, and it consequently ended his support allotment; the 1945 Montgomery city directory was the first to show Traylor as a "renter" in the Howards' Bragg Street home.

For Traylor the loss of his son Will (Margaret, Myrtha, and Clement's father) in 1929 continued to be painful to bear. "He talked to me, hugged and kissed me," Margaret wrote about those visits with him. "He would sit in the backyard and draw, but every time he looked at us he would cry and say, 'Willie's little children.'"[7]

By 1946, Traylor had had his gangrenous left leg removed, and getting around was increasingly challenging. The loss of his leg, along with his mobility, was traumatic. He told Shannon: "I begged them not to cut it off. I told them I wanted to go out like I come in."[8] While at Sarah's, Traylor would have lived closer to some grandchildren and seen more of them, but by all accounts, it was an extremely difficult period for him. Many factors were likely in play: a fraught relationship with Sarah; his loss of physical strength, health, and personal freedom; and the cumulative strain of an arduous life—made evident in his emotional response to Will's children. Margaret and Myrtha were aware of Traylor's sadness, as was Shannon, who once visited him on Bragg Street and penned a letter to Easter on Bill's behalf, asking her if Bill might give Detroit another try.[9]

As noted in the discussion in part one about this period in Traylor's life (pp. 96–103), Shannon was uninterested in the art Traylor was making then. Of his visit to Bragg Street he said, "I found [Traylor] sitting under a fig tree in the backyard. He had his drawing materials beside him, but nothing much was happening."[10] Photographs taken by Horace Perry and Albert Kraus in 1946 and 1948, respectively (above, figs. 29–32), capture Traylor surrounded by his art in the Howards' backyard and artworks on display for the photo shoot. Not all the artworks shown in the 1946 photographs, which accompanied Allen Rankin's article for *Collier's*, were from this final period—some had been made and documented years earlier and were seemingly added by Shannon to improve, from his perspective, the overview.[11]

In photographs for the *Collier's* article, then, art from Traylor's earlier working period (1939–42), such as *Yellow Chicken* (above, PL. 25; in fig. 29) and *Red House with Figures* (above, PL. 32; in fig. 31), comingle with a larger number of later artworks, likely made closer to 1946, when the photographs were taken. What we can see, in the photographs available to us, is that the later paintings are visually distinct from those Traylor made in the pre-war days. In these last years, when Traylor was older and removed from the vibrant street life that had once inspired such vibrant creativity, the artist seems to have been grasping to maintain some of his abiding themes—dogs that dwarf their masters, men sitting in houses holding books or drinking, couples arguing, birds taking flight—yet these later paintings appear looser, brighter, larger, and more simplified. In the end, however, these few glances at his work do not offer a full enough view for us to assess the later paintings in detail, and whichever works Rankin may have acquired from Traylor at the time did not survive.[12]

Family recollections are that sisters Sarah and Lillian traveled to Detroit after Easter's death in 1966 to collect works of art their father had left there, but after Sarah's death in 1974, those artworks, as well as any Traylor made while living with Easter, were lost when nonfamily members readied her home for sale. It is unclear whether the artworks held at any of his adult children's homes were made during his early visits, around 1940, or in the later ones, between 1942 and 1945; accounts suggest that Traylor was active in both periods. The whereabouts of any works that Traylor made at his daughter Lillian's home are also unknown, and no other accounts of works made after 1942 have been verified.[13]

Traylor died at Oak Street Hospital on October 23, 1949. He was buried at Mount Mariah African Methodist Episcopal Zion Church on Old Hayneville Road.[14]

FIG. 83 Sarah Traylor Howard, daughter of Bill and Elsey Traylor; date unknown

AFTERLIFE: THE POSTHUMOUS SUCCESS OF BILL TRAYLOR'S ART

After Bill Traylor passed away in 1949, interest in him and his art also died. It was some thirty years later, in the late 1970s, when Traylor and his work came back into public focus. During the intervening three decades, the United States, and the art world along with it, had undergone radical changes.

By the 1950s and 1960s, America was leading the international art scene for the first time. Post-war movements such as abstract expressionism, pop art, minimalism, and conceptualism had eclipsed popular vernacular and folk-art forms, which were cast as passé next to cutting-edge art trends. As the tidewaters of civil rights swelled, artists wielded their influence by creating symbols and records of injustice, rebellion, strength, equality, and empowerment. Had he lived to 1955, Traylor might have been astonished to see Montgomery, Alabama, become ground zero for civil rights. Just six years after his death, the Montgomery Bus Boycott gripped the city—and the country—after Rosa Parks was arrested for refusing to relinquish her bus seat for a white passenger. In his later years Traylor had probably sensed the social forces that were increasingly in play, but he could not have known that public attention would return to him—giving him, through his art, an afterlife on earth.

Americans who believed in peaceful protests were disillusioned by the violence perpetrated on protestors such as the Freedom Riders, who in 1961 activated to challenge the constitutionality of segregated buses, and the executions of leaders such as Medgar Evers and John F. Kennedy in 1963 and Martin Luther King Jr. and Robert Kennedy in 1968. Minorities of all stripes increased their levels of protest. The Black Power movement not only challenged the ideology and strategy of nonviolence but also encouraged questions about history and ethnic identity, thereby fostering notions of cultural pride and beauty that countered long-standing stereotypes designed to demean and demoralize.

The Vietnam War escalated the environment of protest, and American art in the 1970s embraced environmentalism, feminism, beatnik culture, and free thinking as

well as previously excluded "low brow" forms, such comics, assemblages made from secondhand goods, and low-rider cars. High-profile African American artists, including Romare Bearden, Jacob Lawrence, Norman Lewis, and Sam Gilliam, had been represented by New York galleries since the 1950s, but twenty years down the road, smaller galleries and community centers had popped up, showing art that had previously had no venue.

By then Shannon had divorced and remarried. His second wife, Eugenia Carter Shannon, took an interest in her husband's collection of long-stored paintings and drawings by Bill Traylor. In 1975 the couple agreed that the time was right to test Traylor's art with evolving audiences, and they began to organize the artworks.[1]

In 1977, Charles and Eugenia approached New York dealer Terry Dintenfass, who had a large gallery on West 57th Street and had shown the paintings of Horace Pippin, then the only prominent African American self-taught painter. Dintenfass declined, but two of her employees, Richard Oosterom and Luise Ross, were taken with Traylor's work. Ross later recalled that Traylor's art did not represent Dintenfass's aesthetic, but she, on the other hand, had an epiphany when she experienced Bill Traylor's work. Ross recollected, "Richard and I appreciated the narrative and graphic elements of Traylor's self-taught expression."[2] In 1979, Oosterom opened his own gallery and asked Shannon for the opportunity to sell Traylor's work.

> I was quite honest about being very young and not having the money to purchase the lot or a grouping, but I could offer consignment and a one-man show in the following six months. Charles and Eugenia responded with an offer for me to come see them. I think I stayed with them overnight. We spent the majority of the time in Charles's studio and looked at just about every piece he had.... If I remember correctly, Charles and Eugenia had the work in piles by sizes and descriptions, such as "exciting events," and we worked our way through them all. I don't remember if it was my idea or Charles's that we break up the collection into five groups, but with their consent to show Bill's work at my gallery, we were coming up with a way [in] which works could be sold individually and that represented Traylor's array of work. The remainder [which Shannon retained] could be sold in lots, preferably as collections that either individuals or institutions would keep together, which would also equally represent the array. The "E Collection" started that day.[3]

Oosterom took the so-called E Collection on consignment and organized what would be Traylor's first exhibitions in Manhattan, at R. H. Oosterom Gallery—in a group show in 1979 and a solo show in 1979–80.[4] A private entity bought a large painting of a mounted rider and donated it to the New York Public Library's Schomburg Center for Research in Black Culture in Harlem, New York. This purchase constituted the first, and significant, institutional acquisition of Traylor's art.[5] Shannon recalled: "[Oosterom] had seen the Traylor work when we had taken it up to Dintenfass Gallery. He asked if he could show it and we said fine. We were looking for somebody. He gave [Traylor] a show and it got some reviews. We were pleased with that. He sold a few things; it was no big event. The ball had started to move a bit."[6]

Shannon met Joseph Wilkinson that same year. Margo Russell, Joe's wife at the time, was a painter from Andalusia, Alabama, and knew Shannon through his agent, Sue Wiggins. The Shannons and Wilkinsons became friends. Margo and Joe were living in Winston-Salem, North Carolina, and attending a church that was actively endeavoring to become integrated; Joe was among the volunteers making connections in African American communities toward that purpose.[7] Wilkinson recalled that Shannon was thinking about placing a second group of Traylor's works. "His goal was to sell…to a black-owned institution, because he wanted the work to be kept together and made available to people from all walks of life, and especially blacks who might otherwise never have an opportunity to be exposed to Traylor."[8] By then Wilkinson knew people affiliated with institutions that fit that description and agreed to help Shannon seek an appropriate owner.

Wilkinson showed Traylor's art to various appropriate institutions, but none were compelled to spend money on works by an unknown, untrained artist who had painted on dirty, irregular scraps of cardboard. "By 1981," Wilkinson wrote, "I was discouraged and had run out of contacts." Yet he and Margo were increasingly drawn to the work and decided to purchase the D Collection. Wilkinson's involvement was fortuitous. "Later that year while living in Atlanta, I had a visit from a friend who owned a gallery," Joe recalled. "I showed him some of the slides and some of the drawings. By happy coincidence he knew Jane Livingston, the then curator of the Corcoran Gallery."[9] The gallerist was Angus Whyte.[10] Whyte relayed the tip about Traylor's art to Livingston, who was in the process of organizing the exhibition *Black Folk Art in America, 1930–1980* to open at the Corcoran in Washington, DC. Wilkinson, Shannon, and Luise Ross (who purchased works via Oosterom) loaned a total of thirty-six works by Traylor to the Corcoran's traveling exhibition, which opened there in January 1982 (see pp. 372–73).

Traylor's work made a big splash that year, when Shannon donated his first major gift to an institution, namely, thirty Traylor artworks to the Montgomery Museum of Fine Arts. Curator Margaret Lynne Ausfeld subsequently organized a solo exhibition for the hometown artist.[11] Ross organized another one-person exhibition, for the Arkansas Arts Center, Little Rock, which traveled to the Mississippi Museum of Art, Jackson.[12] Vanderwoude Tananbaum Gallery in New York, Hammer and Hammer Gallery (now Carl Hammer Gallery) in Chicago, Karen Lennox Gallery in Chicago, and Janet Fleisher Gallery (now Fleisher/Ollman Gallery) in Philadelphia also mounted shows.[13]

"I think the Corcoran show was a changing point for Charles," Oosterom noted. "He was very secretive about Traylor's being selected for the show, never telling me until it was practically public knowledge, or the curators there that work was in NYC. I think he was thrilled that Traylor was becoming the star he always thought he was, but it may have come too quickly for him in some regard. Perhaps after selling to the Wilkinsons he was rethinking what to do with the remaining pieces..now that 40 percent of the works were out there in some fashion."[14]

Indeed, the Corcoran exhibition was a turning point—not just for Shannon or Traylor but also for an entire segment of the population whose art had never been recognized. Jane Livingston and John Beardsley co-curated the exhibition that gave rise to a new generation of collector-enthusiasts, and the project is still discussed today—lauded for shining a light on art created by self-taught African American artists but critiqued for doing so in a distinctly marginalizing manner.

"In coming to terms with the character of apparently inexplicable sophistication found in the work of these untutored and often enisled figures (William Traylor in this respect personifies the mystery beyond mysteries)," Livingston wrote in the Corcoran's exhibition catalogue, "It is tempting simply to invoke an idea of a kind of prolonged childhood which these artists enigmatically sustain." She entertained the validity of this notion before ultimately rejecting what would nevertheless remain a widespread subtext for self-taught artists for decades to come, namely, "that folk artists somehow experience a life-long childhood."[15]

Livingston and Beardsley may have stumbled to define the art in *Black Folk Art in America* with appropriate historical knowledge or cultural sensitivity, but they had astutely identified an area of artistic production that was powerful, valid, and obscure. By bringing together twenty untrained African American artists born between 1853 and 1926, they had given a platform to a group of artists whose lives had been shaped by an intense cultural shift in the United States and who had immersed themselves in personal creativity in the first decades in which African Americans had the space and personal agency to do so.

Traylor's gripping painting of a coiled and hissing black snake graced the cover of the Corcoran's exhibition catalogue, making Traylor a posthumous star of the show. Audiences were more receptive to the art of previously unrecognized populations than ever before, yet the career trajectories for art-school trained minorities and so called "folk artists" remained markedly different.

Traylor and other self-taught artists included in the Corcoran show, among them David Butler, Ulysses Davis, Sam Doyle, and William Edmondson, met with some market success, even if at prices that were a fraction of other sectors of the market. Of the twenty artists represented in *Black Folk Art in America*, just three were women. Sister Gertrude Morgan, Inez Nathaniel-Walker, and Nellie Mae Rowe would become well known by enthusiasts in the field but far less recognized beyond specialty audiences.

Throughout the twentieth century, trained African American artists fought for legitimacy on par with their white peers. Yet when participants in the white main-stream art world lauded untrained artists such as Traylor and Edmondson, they too frequently undercut the artists' creative sophistication as "mysterious" or "accidental" rather than acknowledge it as intelligent and intentional.[16] Alternately, the work of two artists represented in the Corcoran exhibition, James "Son" Thomas and Mose Tolliver (another native of Montgomery, Alabama), was cheered for being crude—yet poignant and honest. Trained African American artists would increasingly view the inclusion of their untrained brethren not so much as an advance for their race but rather as a fraught issue—wherein the white establishment had found a clever and

effective vehicle for diversification that was overtly celebratory, yet subtly it positioned black artists as primitive and guileless.[17]

Market tactics played up these angles, using filters of "otherness" as frameworks for the art as both palatable and exotic. "Folk art," a term that once accurately described tradition-based art forms, became a confusing code for artists who were poor, uneducated, and marginalized on a number of fronts and whose raw and humble art was great (in whole or part) for blossoming from the scrap heaps of the artists' tremendous personal challenges.[18]

Throughout the 1980s and 1990s, interpretive models for "folk art" remained predominantly grounded in biography, which capitalized on the cultural divide between many of the artists and their white upper-middle-class following. Paradoxically, marketers often tethered art that was highly innovative and independent to traditional notions of "folk art," spinning the art and the artists as simple, nostalgic, and quaint but adding labels like "contemporary" to stitch together any apparent inconsistencies. Some curators, scholars, and dealers attempted to situate the art within the complex milieu from which it emerged, but consumer excitement was generated more effectively through contexts that borrowed from the Corcoran model, which cast the artists as naïve, mysterious, and miraculous.

Newspaper reviews of the Oosterom exhibition and *Black Folk Art in America* were not as evolved from pieces written in 1940 after Traylor's New South exhibition as might be supposed—many critics still conflated African cultural roots and cave art. Kay Larson of the *Village Voice* enunciated the glee she imagined writers of Traylor's day must have enjoyed: "The prospect of a quaint old exslave nodding over his pictures of mules, fighting dogs, chicken thieves, and henpecking wives was pure gravy for journalists, who quickly made him into a local celebrity."[19] The compliments were consistently either backhanded or wrongheaded. Gylbert Coker's review was supportive but, typically, overlooked the nuanced sophistication, abstraction, and coded imagery in Traylor's work and instead quantified it as simple: "He took life as it came and painted life as he saw it."[20] In the *New York Times*, Vivien Raynor wrote, "It is impossible to look at this show [*Black Folk Art in America*] without a touch of self-congratulation at being able to appreciate, for instance, the Paleolithic élan of Bill Traylor and his superbly placed serpent, his portrait of himself on two sticks and his lone, perfect, abstraction."[21]

The Montgomery Museum of Fine Arts, the Arkansas Arts Center, and Vanderwoude Tananbaum Gallery published essays on Traylor in conjunction with their respective solo exhibitions of Traylor's works in 1982 as well. After Oosterom closed his gallery, Ross acquired the collection of Traylor's art that Oosterom had taken on consignment from Shannon, and she loaned artworks to the Arkansas Arts Center and Vanderwoude Tananbaum exhibitions. Gallerists Frank Maresca and Roger Ricco purchased all forty of the Traylor works in the Vanderwoude Tananbaum exhibition and thereafter became abiding dealers of Traylor's art.[22]

For the Montgomery Museum, the curator, Ausfeld, positioned Traylor within a folk tradition, contextualizing him as someone who didn't learn from art teachers or

in school but rather, from firsthand observation and the people around him. She rightly noted that Traylor used pencils and paint, rather than words, to tell his own story and recognized that he generally portrayed his animals with more dignity than his human characters. Ausfeld acknowledged the emotional tension in scenes that used an overlay of comedy to chart something far darker, but her most penetrating comment was insightful and succinct: "If there is one quality which truly distinguishes Traylor's work it is its evocation of spiritual presence."[23]

Lowery Stokes Sims wrote an essay for Vanderwoude Tananbaum's catalogue *Bill Traylor (1854–1947): People, Animals, Events, 1939–42* for the exhibition of the same name that opened there in September 1982. Sims, then associate curator of twentieth-century art at the Metropolitan Museum of Art, delved into a rational assessment of Traylor's aesthetic choices and how they might relate to African or Afro-Caribbean art and cultural traditions. Like Ausfeld, she noted the tension between apparent humor and undeniable danger: "The process of deciphering Traylor's whimsical yet sinister compositions seems elusive. One can at best provide clues." By assessing the work on its own terms, Sims avoided Livingston's pitfalls of attempting to distinguish "folk" from "fine" art: "The overwhelming merit of this artist's work is the unerring sense of design, and its near perfect balance of the compositional elements. Traylor's hyperbolic sense of observation mirrors the manipulated sense of realty experienced by the revelers in his people compositions."[24]

For the Arkansas Arts Center, Maude Southwell Wahlman—who at that time was teaching art history and Southern studies at the University of Mississippi—contributed an essay that explored the African roots of Traylor's work. Wahlman began with a call for readers and viewers to "understand the creolizing process whereby several cultural traditions are blended to produce unique examples of a new art tradition." She speculated that Traylor had ancestral roots in Haiti or Cuba and among Kongo-speaking peoples in Africa, and she emphasized the tenacity of those roots in American culture. She also acknowledged that American streams flowed into Traylor's works, which are ultimately complex amalgamations from a man who created with intention. "The sophistication of his drawings conveys an artistic sensitivity on one level and a symbolic depth on another.... Bill Traylor's drawings are evidence that American folk art is not naive, primitive, or simplistic."[25]

In the summer of 1982 the High Museum of Art in Atlanta purchased (from Shannon) a group of thirty works, six of which were included the following year in its exhibition *A Selection of Works from the 20th-Century Permanent Collection.*[26] In 1933, Carl Hammer and Janet Fleisher both mounted repeat gallery exhibitions of Traylor's work, as did Gasperi Gallery in New Orleans, Hill Gallery in Birmingham, Michigan, and Ricco-Johnson Gallery (which formally became Ricco/Maresca Gallery in 1985) in New York. Two galleries in San Francisco—Acme Gallery and Alexander Gallery—featured Traylor in 1984. In 1985 two galleries in New York—Luise Ross Gallery and Hirschl & Adler Modern—mounted concurrent Traylor exhibitions.[27]

Black Folk Art in America went on tour and garnered significant press coverage, which led to notice by some of Traylor's family members.[28] One of Bill Traylor's great-granddaughters, Leila Harrison Fields Greene, recalled that in 1983 she and her

brother had watched a television segment on Bill Traylor with their grandmother, Lillian Traylor Hart; Greene recalled seeing the coverage on CBS News Sunday Morning with Charles Kuralt.[29] At the time Traylor had one other living child in Detroit who may have seen the exhibition when it went on view at the Detroit Institute of Arts in Michigan, namely, Lillian's brother Walter.[30]

By the mid-1980s, Shannon understood that Traylor was going to become popular, and he determined to marshal the works still in his care. "We went to Hirschl & Adler [because] we didn't want him to stay being thought of as a folk artist and shown with all this cute folk art. I shouldn't put it that way, because there are awfully good ones.... We want him out in the real world with the rest of them or we don't want to play. That was the thinking."[31] For the Hirschl & Adler catalogue, Shannon wrote a short essay, which established what would become a durable, if flawed, narrative for his "discovery" and promotion of Bill Traylor.[32]

All of Traylor's children who could be traced had died by the mid-1980s, which caused the younger generations to lose touch. About a decade after Will's son Clement had passed away, Clement's daughter Nettie Trayler-Alford dreamed that her father was urging her to get the family back together.[33] In addition, a colleague at work had brought Nettie a newspaper clipping on the artist Bill Traylor, asking if she was related to him—despite the varied spelling of the last name.[34] Nettie asked Walter, who went by "Uncle Bubba," about Bill Traylor, and he told her that Bill Traylor was indeed his father. Nettie decided to organize a Traylor-Calloway-Durant family gathering in Detroit in 1991. In preparation she assembled family photographs, stories, and memories and printed a brochure for the attendees: "Traylor-Calloway-Durant 1991 Family Reunion Weekend, August 9–11, 1991."[35] Nettie shared the clipping about the exhibition with her family at the reunion, where they discussed Bill Traylor and his art, reviewed what they knew about him and other deceased family members, and assessed the lore being presented in museums and galleries as Traylor's biographical history. A couple months later, in November, they saw the newly published book by gallery co-owners Frank Maresca and Roger Ricco, *Bill Traylor: His Art, His Life* (1991), in which Shannon recounted the story of his artist-to-artist relationship with Bill Traylor.

His Art, His Life was generously illustrated, and the information provided, in the format of an interview with Shannon, became the most in-depth public record on Traylor's character and views as Shannon understood them. Shannon had noted some of the remarks Traylor had made about his drawings; he also tried to set the record straight about fabricated quotes, such as "It jes' came to me," which Allen Rankin (and many writers thereafter) had falsely attributed to Traylor in his articles for *Collier's* (1946) and *Alabama Journal* (1948). *His Art, His Life* was informative yet also tightly controlled; it illuminated Traylor's life in general but was factually incorrect on a number of points. Maresca recalled that Shannon had put the publication on hold until they agreed to Shannon's text edits and image choices and the removal of an introduction that he and Ricco coauthored. Shannon objected to any mention of other New South members and strongly asserted a faulty narrative. Maresca summarized the situation: "The book is, as Charles Shannon said, 'the book that he wanted it to be.'"[36]

When Bill Traylor's family read the interview as published in *His Art, His Life*, they were intrigued but also perplexed by what was said. Foremost, they did not understand the nature of Shannon and Traylor's relationship, and they questioned whether Shannon bought the art or took it from Traylor with the intention to care for and market it. They decided to have another reunion the following year for further discourse.

In August 1992 the family met again in Atlanta. Great-granddaughter Antoinette Staffney Beeks had worked on the family genealogy, and those who had direct memories of Bill Traylor contributed typed essays for the second reunion booklet, which also contained a letter from Rosa Lyon Traylor, a member of the white Traylors still living on George Hartwell Traylor's farm near Benton. By then the Traylor descendants had looked more deeply into their patriarch's fame and Shannon's role in it. The family invited Marcia Weber and Miriam Rogers Fowler to attend the gathering, and Luise Ross traveled from New York to come as well, bringing along a selection of original works of art to share and discuss at the reunion.[37]

Bill Traylor's family was delighted to discover that his paintings and drawings were admired and collected, but they were less pleased to realize that they had been excluded from their forefather's history and financial windfall. Shannon had been in touch with Bill's daughter Sarah in Montgomery during Bill's life and corresponded with another daughter Easter; both women were deceased by the time of the reunions, having died in 1974 and 1966, respectively. Shannon had never contacted any younger family members, and he presumed full rights and ownership for the artworks he acquired from Traylor.

The family filed suit that fall.[38] Many aspects were considered, including the fact that works of art the family had owned and been aware of did not get properly cared for or saved, and that Shannon was an artistic advocate for racial equality and dignity long before the modern civil rights movement existed. The media seized on the optics of the situation and antagonized the battle with headlines such as "Lawsuit Claims Man Stole Ex-Slaves Art" and "Art Dealer Sued over Prints and the Pauper." The latter article reported that Shannon (working with Hirschl & Adler Modern) had stolen art, exploited Traylor, and profiteered illegally from the relationship.[39]

In October 1993 the parties reached a settlement.[40] Lawyers for the Traylor family released a lengthy statement about their claim, which had arguably damaged Shannon's reputation, and the desire to set the situation right: "Failures in communication caused the litigation. Understanding the truth has brought it to a halt." It summarized:

> We went into this case believing that Charles Shannon did not pay for the art he obtained from Bill Traylor and had never accounted to his descendants for those drawings and paintings. After utilizing civil discovery procedure to obtain documents, interview witnesses, and take the deposition of Charles Shannon, we felt we had investigated the relationship between Charles Shannon and Bill Traylor in the early 1940s as thoroughly as possible. We became convinced that, in fact, Shannon had supported Bill Traylor and had paid him fair consideration for his art work.[41]

The press fracas aroused by the Traylor-Shannon lawsuit mirrored a larger phenomenon in which the relationships between poor, uneducated, disenfranchised artists and their savvy collectors and art dealers was being increasingly scrutinized. Interest in untrained and un- or under-educated, artists was also exploding, fueled by the reality that motivated collectors could find the artists themselves, oftentimes at their rural Southern or Appalachian homes, and get between the artist and professional representation.

By the late 1980s and into the 1990s, the American field of "contemporary folk art," or art by untrained or self-taught artists, attempted to distinguish itself from traditional, heritage-based folk arts. It also began, problematically, to comingle with a European framework for untrained artists, although the history and trajectory in Europe was quite different than it had been in the United States. The galleries that were invested in Traylor independently developed tools for situating Traylor with multiple (sometimes conflicting) realms and descriptions—he was a master artist: modern yet primitive, simple but complex, culturally rooted but an "accidental" genius.[42]

Traylor was not the only artist caught in a whirlwind of shifting and evolving categories for artists who were not art-world insiders—and would come to be known by the inappropriate and oversimplified alternative term "outsiders." In Europe in the early twentieth century, Pablo Picasso and Wassily Kandinsky had taken an interest in a "naïf" painter who worked by day as a tollbooth collector, Henri Rousseau. They made Rousseau's vibrant, dreamlike paintings famous but took care to distinguish his unwitting brilliance from their own, which was intentional, learned, and sophisticated.

Gallerist and scholar Jane Kallir explained that Kandinsky "promulgated the notion that artists without formal training are better able to capture the 'inner resonance' of their subjects than those whose spontaneity has been dulled by rote schooling." His idea took off. In the 1920s psychiatrists Hans Prinzhorn of the Psychiatric Clinic of the University of Heidelberg in Germany and Walter Morganthaler at the Waldau Clinic in Bern, Switzerland, studied the creative production of mental patients, which in turn inspired the Surrealists to study and follow "unconscious impulses."[43] French artist Jean Dubuffet became a prominent advocate for what he termed *art brut*, or raw art. Kallir elaborates:

> Despairing of civilization, Dubuffet looked to its margins for hope and inspiration, which he found in the work of mental patients, spiritual mediums, and extreme outcasts. In effect, he melded the two prewar conceptions of self-taught art, ascribing primordial innocence and purity to the work of social deviants. Art Brut in turn spawned "outsider" art, the title chosen by the British art historian Roger Cardinal for the first English-language book on Art Brut, published in 1972. However, something was literally lost in translation and in the transplantation of the genre from Europe to the United States.[44]

Traylor became one of many artists to get swept up in a growing American enthusiasm for "outsider" art, a rubric that suffered immeasurably by being conflated with both art brut and "folk art." To all but a few, the terms became effectively

meaningless, as they arbitrarily grouped Americans who had been severely marginalized and victimized by a racially conflicted history with eccentrics, religious zealots, the disabled, the mentally ill, and anyone else who was not academically trained or a working professional in mainstream society.

At the core of the issue, "outsider" described the artist—not the art. The term became and remains a euphemistic dog whistle for racial, class, and social distinctions. "Outsider" effectively shifted the issue of quality away from the art and onto the artist—to the exotic biographical qualifiers than undergirded the art itself. Once a work's meaning was attached to identity and experience more than to skill, creativity, and intentionality, the artist became eternally subordinated—a child to the trained adult "fine artist" to which Livingston had contrasted them and to the pure or innocent spirit that Kandinsky set against the "rote" academic. "By denying the self-taught artist's intentionality, the art-world mainstream denied these artists the right to be taken seriously," Kallir observed. "Insofar as the discipline of art history has traditionally treated artworks as texts, the purpose of which is to communicate an artist's conscious or unconscious intent, the doctrine of 'purity' made it impossible to properly study self-taught artists and therefore impossible to admit them to the canon."[45]

Debates on what to call and how to show, discuss, exhibit, and historicize art by untrained artists continue still, and volumes have been dedicated to the subject—a testament to the enduring fortress of an art canon built by and for the elite. While true and lasting social change can seem glacial in its progression, artists such as Traylor set a bar art that demanded to be examined and examined again.

ROOTS

James Hampton was the only artist in the Corcoran exhibition whose collective body of work had been acquired by a museum before *Black Folk Art in America*. The Smithsonian American Art Museum (then called the National Museum of American Art, after a recent change from National Collection of Fine Arts) had acquired all but a few small pieces of Hampton's work more than a decade earlier, in 1970. Hampton's project was an extraordinary multi-element installation that originally filled a rented carriage house not far from the museum itself in Washington, DC. *The Throne of the Third Heaven of the Nations' Millennium General Assembly* was an overtly Christian altar-style array, made from found objects and pieces of discarded furniture covered in silver and gold foil and colored paper. When Hampton died prematurely in 1968, his landlord sought a steward that could care for the complex and fragile work.

Hampton's family declined to take his art, so the landlord sold it, after which the entire assemblage was donated to the Smithsonian. *The Throne* is now understood as a displaced "art environment," an ever-changing work that was built over time in a specific place, with multiple elements, the meaning of which inheres in the collectivity of the pieces of the whole. *The Throne*, with its matched materials, paired components, and overall symmetrical organization, demanded cohesion more overtly than some other multi-element installations by African American vernacular artists. One such example was David Butler, whose work was shown in

the Corcoran exhibition. His embellished house and yard filed with painted metal sculptures in Patterson, Louisiana, was not recognized as a unified art environment or yard show before collectors purchased the artworks one by one and effectively dismantled the site.[46] Fortuitously, the almost two hundred parts of Hampton's *Throne* were acquired as a single work of art, and its public display has allowed for it to be seen and studied as such.

When *Black Folk Art in America* took place, the phenomenon of art environments and their deeper cultural roots were not widely understood by art historians or museums. When they had been considered, it was generally in terms of isolated, eccentric artists or architects, such as Sabato (Sam) Rodia and his *Watts Towers* outside Los Angeles, rather than as a larger phenomenon within which artists were staking a claim for selfhood and personal domain.[47] Gregg Blasdel first described the more overarching existence of art environments in his article "The Grass Roots Artist" (1968), a theme that continued in the pioneering exhibition *Naïves and Visionaries*, organized at the Walker Art Center, Minneapolis, in 1974, which offered some unity to the work of the artists, including Samuel Perry Dinsmoor of Kansas, Tressa (Grandma) Prisbrey of California, Fred Smith from Wisconsin, and Washington's James Hampton, all of whom had spent years transforming personal spaces into multidimensional art projects.[48]

What *Naïves and Visionaries* and *Black Folk Art in America* overlooked was the fact that African American art environments formed its own entity—a continuation of or stylistic reshaping of age-old "yard shows," also called dressed yards or spirit yards, describing manners of embellishing homes, graves, and other personal places that trace from Africa throughout Caribbean, into the American South, and beyond. Regenia Perry contributed an essay to *Black Folk Art* in which she discussed the origins of "black American folk art." Perry touched briefly upon the links between African grave decoration and "Afro-Georgian funerary art," drawing in part on Robert Farris Thompson's paper "African Influences on the Art of the United States" (1969).[49] It was a critical connection, but Perry did not go deeply into the implications of Thompson's work for all of the art in the exhibition.[50]

Enthusiasts and scholars were already dividing into camps: those who understood the genre as culturally rooted, serious, and important, and those who saw it as stylistically captivating yet largely disconnected from culture, history, meaning, and intentionality. Bruce Kurtz of *Art Forum* summarily dismissed the notion that African American art had distinct and persevering roots, writing in his review, "That one can discern black American folk art as a discrete entity separate from other folk art is a preposterous assumption."[51]

Kay Larson, another reviewer of *Black Folk Art*, asserted, "Rural people tend not to be much concerned with history, perhaps because they have had so little access to it."[52] Larson may have meant to imply that the artists she refers to were unversed in European cultural or art history, but in her myopia she inherently dismissed their lived personal history in the Jim Crow American South and utterly devalued the framework of their practices. Many gatekeepers within the predominantly white mainstream art world would be similarly skeptical or presumptuous, and for decades to come the

evidence of African and Afro-Caribbean roots in the work of artists such as Bill Traylor, Sam Doyle, Nellie Mae Rowe, and countless others would be routinely denied or downplayed in favor of a rubric that amplified simplicity and naïveté.

Institutional, academic, and commercial presentations of art by marginalized African American artists would vary over the years. The polarized methodologies signaled an ongoing tug-of-war between scholars advocating for the critical importance of social and cultural backdrop in art that never meant to play to a commercial art scene, and those who preferred to view the work as simple, fresh, and great but inherently less sophisticated and historical than "fine art." Others would argue that the two poles were not mutually exclusive, that art by self-taught African Americans might have roots in African culture and antebellum folkways, but that those sources were unfixed, unprovable elements and not worthy of deep consideration.

In truth, those roots ran both deep and wide but were often invisible to foreign eyes. Such subtleties were an inherent part of artistic production that survived—to the degree that it did—by appearing insignificant or valueless to slave owners who aimed to quash African connections and unity. Later, the surviving traditions for marking graves, preserving oral histories and practices, and employing abstract symbols and musical folkways to maintain family memory and group identity expanded and morphed but remained unassuming and unnoticed.

As African Americans increasingly had homes of their own, the personally "dressed" spaces and places became more visibly connected. They were still unique to the maker, so the connections remained unobvious. It wasn't until 1983, when Thompson published his influential book *Flash of the Spirit: African & Afro-American Art & Philosophy*, that the shape and distinguishing characteristics of African American yard shows first reached an audience much beyond the academic.[53]

Thompson captured the attention of many artists and scholars when he persuasively argued that yard, home, and grave decoration practices were covert and made from humble, available, often discarded items or materials with symbolic meaning—routinely overlooked or dismissed by white Americans who thought they were unimportant and ugly, which effectively made them invisible and durable. Wyatt MacGaffey, a scholar of Kongo expressive culture, concurred, noting that throughout central Africa, "The rubbish heap is a metaphor for the grave, a point of contact with the world of the dead."[54]

Grey Gundaker, who followed in Thompson's footsteps for her research on African American diasporic art and culture, also traced "dressed" yard back to "slave landscapes," where anything from a lock on the cabin door to a clearing in the woods might demarcate the all-important self-governed space. She similarly underscored the subtle yet powerful connectivity of such spaces. "African-American dressed yards resonate with each other over great distances like elaborations of a code only partly visible."[55]

These scholars charted unmistakable links between African traditions and African American folkways for altering a home or yard to provide spiritual protection and create pathways to ancestral memory. Such practices were critical mechanisms

for Africans who were forcibly assimilated and had their language groups and family bonds broken at every turn, and for holding and carrying the oral culture shaped during slavery. In their most clear examples, the devices employed movement, color, sound, and the element of surprise to trick, confuse, and deter harmful spirits. Yard shows were full of metaphor and metonymy, symbolic cosmograms, and amalgamated, personalized meanings. By the time *Flash of the Spirit* was published, Hampton's *Throne* had become a permanent fixture at the Smithsonian American Art Museum, and Thompson's assessment was the first to peel back the overt layers of Christianity and reveal a complex work of art rooted in African folk religion and distinctly black formations of Christianity, enriching and expanding the study of African American vernacular art immeasurably.

The Corcoran show featured several artists who had made easily observable yard shows or art environments, but it focused on individual objects, not larger patterns. David Butler, Sam Doyle, James Hampton, and Nellie Mae Rowe made the most apparent examples, although Ulysses Davis, William Edmondson, Leslie Payne, and several others worked in related veins to reshape personal worlds with works of art. The key element that every one of the artists in *Black Folk Art* had in common was that they had each staked a claim for selfhood and personal agency by making encompassing bodies of work that radically asserted individual vision as well as a rightful place in the world. The yard, the home, the rented space, the street corner—these were all versions of the yard show: intimate, self-governed, ever in flux.

The research of gallery owner and independent scholar Randall Morris points to the same conclusion. Morris recently highlighted a central idea that has been too-long overlooked: "The spirit yard is the root for most African American vernacular art." Morris notes that the yard show is both a carry-over from the Kongo cemetery complex and the cultural matrix of spiritualties that informed and morphed into a post–Middle Passage religion. He explains, "[This was] not a slave religion, but a religion rebuilt and reinvented by the slaves. It was the parent concept of Conjure and Hoodoo, but those are secular practices informed by spirituality and this was the matrix religion itself. It may never have been given a name."[56]

Noting Wyatt MacGaffey, Robert Farris Thompson, Grey Gundaker, and Judith McWillie as scholars who have spent decades building a compendium of knowledge about the visual languages of yard shows, Morris calls out the work of art historian Dana Rush as equally significant, particularly her observations on the importance of accumulation and renewal and the critical aesthetic of the unfinished.[57] "It is not about the finished piece; instead it is about the process of its life, added to and changed over time, constantly in flux as it moves through space and time, never finished, always in process."[58]

Traylor may not have built an art environment or yard show, yet his determination to make pictures and hang them on a fence rail or arrange them around his street-corner bench for passersby to see is rooted in the same methods and motives. With each painting he made, adhered to a loop of string, and hung up, Traylor asserted his determination to exist, be visible, and employ personal agency to impact

and shape his surroundings. Even with nothing and no place to call his own, he was existentially freer in the black neighborhood of Montgomery than he had been when working the land of others, and he literally made his mark. Traylor's visual language was experimental and ever fluctuating. His paintings embody the person he was, a man who bridged centuries and paradigms, was fluent in folkways and allegory, and had a native perspective on the "blues aesthetic."[59] Ultimately, he used color and form the way some artists bend tin, shape concrete, or carve wood, he exerted the tools he had to shape a personal world that established his voice, his identity, and his own space on the earth.

MASKS AND DISTILLATIONS

Traylor's art is deceptive in its apparent simplicity, but the underlying content ultimately lends the work depth beyond the surface. From the moment Traylor first made a splash in 1982, he remained a staple for commercial and nonprofit exhibition venues that specialized in art by the untrained. His art was increasingly included in mainstream museum shows around the world, which were actively working to broaden narratives that had excluded ethnically and culturally marginalized artists. Progress was slow going; the preponderance of museum exhibitions still carefully segregated the work of self-taught or "outsider" artists from the institution's main fodder. Nevertheless, Traylor's art was evermore collected by major museums, and among self-taught artists he remained one of the most prominent.[60] The work achieved "blue-chip" status on the market and captured the attention not just of collectors and curators but fellow artists as well—prominent contemporary artists such as Kerry James Marshall and Glenn Ligon.[61]

Marshall, an Alabama native himself, was born in Birmingham six years after Traylor died and just before the bus boycott began in Montgomery. He became internationally known for paintings that "monumentalize and ennoble African-American daily life," as art critic Holland Cotter described them.[62] Marshall first saw Traylor's work in the *Black Folk Art in America* exhibition and recalled looking past the so-called "visionary thing" at something deeper that resonated with the art he himself was making at the time. "I was searching for something that seemed to me like an authentic black aesthetic, one that had an equivalency with postwar blues," Marshall said. "And there was a drawing by Traylor of a coiled snake that just knocked me out. I sensed something in it."[63]

Traylor's intoxicating economy of form, his ability to reduce physicality and mood into stark, saturated images, would define his artistic style and make his work abidingly popular. The painting of the hissing black snake that intrigued Marshall would, for many, become lastingly associated with Traylor himself. Alone in the painting, the inflamed animal could be either predator or prey, reviled or respected; either way the work is both reductively abstracted and startling alive, saturated in what Ausfeld called a "spiritual presence."[64] Throughout his body of work, Traylor's minimalistic use of color and balance of negative and positive space create a sense of calm, even as the use of precarious physical structures and hectic narratives heighten tensions.

Traylor knew the value of plain materials and apparent simplicity. Life would have taught him that straightforwardness could deceive and that objects and images speak to different people in different ways. He lived knowing how to code-switch in his racial interactions, and he learned how to make art that was subjective to the viewer's gaze, as the information a white or black observer brought to the painting either lit it up or shut it down. Ironically, Traylor's images have drawn significant resistance to the notion that they call upon conjure culture, folk rituals, the spirit world, and racial oppression—as if a denial that such things existed and were endemic to Traylor's era and culture would keep him and his art located in a simpler place, where a mule is just a mule, and a man sprouting plants from his hands has no explanation beyond personal eccentricity. His art answered to a personal agenda and, to a degree we'll never know, Traylor became comfortable with white people purchasing it. He would have understood though, that the ways in which black and white viewers understood his images were dramatically unalike—for they saw everything in the universe through an entirely different lens. That simple fact was to Traylor's benefit; he made his art and it survived.

In the relatively brief arc of Traylor's artistic endeavor, a certain few ideas were more abiding than others. Thoughts and memories sketched out in early works were reshaped and reenvisioned over time, revealing not only his stylistic progression but the potency those evocations had for him. The artistic distance between *Man with Basket on Head (Early)* (above, **PL. 12**) and *Untitled (Man Carrying Dog on Object)* (**PL. 198**), for example, is infinite. Recollection and earnest description have naturally and poetically condensed; the works are evermore stylized and succinct versions of their worldly forms.

Traylor's dogged progression speaks volumes about his advancing ability to distill potent allegories and memories into snapshot moments. He moved from hesitant drawings of animals, stiff and unengaged, to those that adroitly capture tension and encounter though pose, gaze, color, and a brilliant use of negative space that describes motion and direction. The goat in *Untitled (Red Goat with Snake)* (**PL. 199**) is sure and solid, his red coat signaling the blood rush of adrenaline. The work stays minimal, yet the symbolism is crystalline. This stout billy goat is rigid with fear; legs stiff and eyes wide in terror as the smaller but deadly serpent sidles up, holding all the power despite the goat's size and strength. Quiet on the surface but boiling beneath it, these paintings were the stand that Bill Traylor could make.

Even as Traylor's reputation as an important artist grew, most of the exhibitions that included his art were simple, largely drawing from extant collections and accessible lenders; they did not present shaped, wide-reaching, measured selections that could expand apprehension of his art. The paintings themselves were routinely shown in groups, but critical mass outpaced relationships or meaning. In crowded isolation the paintings were elegant, funny, or quirky. Yet their relational meanings and ongoing stories were ruptured, supporting a notion that Traylor's works were conceptually facile, formally compelling but without depth. For decades the artist's intentionality and narrative structure was undercut. It went largely unnoticed that Traylor's scenes set at a house, for example, featured recurring characters and chronicles of interpersonal

politics. It was not appreciated that, cumulatively, his character portraits of horses, mules, birds, dogs, and other animals reveal their tremendous allegorical roles, and his chase scenes became increasingly bold and lethal but also evermore lyrical and reflective.

Even Traylor's unique, stand-alone works transform when situated with others of a kind. With simple, somber silhouettes, Traylor could render a universe of volume and feeling into the flattest of shapes. A black turkey is lithe and poised—head raised and ready to move, directed rather than fearful (PL. 200). A woman sits (PL. 201). Her physical demeanor is grounded and confident, yet her feet don't touch the ground; she is free and unbound. Her arms rest akimbo on hips—a display of inner power. The woman's chin and nose tilt upward with a gaze that is forward looking; she sees above and beyond the trials of the past. The simplicity of a water jug is deceptive (PL. 202). It is a quotidian household object, yet the flat black span of its surface reads as malleable, voluminous, and feminine; the jug's curved handle evokes an arm poised on the hip. Seen in unison, these austere black paintings expand and flex, exuding a synergy that runs throughout Traylor's body of work to create an oral, mnemonic, and visual archive. A turkey, a woman sitting, a jug. A bird, a love, a vessel. Something wild, something empowered, something essential.

In Montgomery, Traylor traveled his own road. His perspectives were grounded in nearly five decades of labor on plantations for which fortunes were predicated on oppression. The generational divide between African Americans born into slavery and those born after Emancipation is perhaps greater than other age gaps. Traylor's children, particularly the younger ones, grew up with notions of a changing society and aspirations for leaving the South, which most of them experienced. Traylor, on the other hand, moved into the urban landscape with his old-world ways as his primary possessions, worldviews that entwined Baptist Christianity with the African American Church, the folk practices of hoodoo, and a vivid world of spirits. The younger generations, embarrassed by the old superstitions and the stereotypes heaped upon rural blacks that adhered to them, eschewed those traditions. Traylor himself may have tried to put the old ways behind him. His conversion to Catholicism was possibly spurred by social or family pressure, his own evolving beliefs, or fears that old magical ways were the wrong path to salvation.

In Traylor's strongest works, it is the unknowable burden, the masked content, the distilled complexity and emotion that delivers the punch (PL. 203). Many suppose that the magnetic quality of Traylor's paintings is attached to his superficial story— the mystery of an oppressed man rising like a phoenix. Yet the true potency of Traylor's paintings lies in the details of that oppression and in the artist's learned ability to describe memories while veiling profound issues of race and class behind a veneer of the quotidian. His self-empowerment required fortitude and intention.

In their very existence, Traylor's works of art are subversive. The writer, musician, and producer Greg Tate notes that Traylor's characters embody agitated spirits, and by their presence, disturb the equilibrium of the scene. "[Traylor's] doing something within the work that's meant to represent black people being very confrontational, emotionally confrontational, politically confrontational, intellectually confrontational at a time when

that was an invitation to annihilation." The mystery is indeed magnetic; it issues forth from a profound synthesis of the crucibles that shaped the America of today. It reflects the extreme privacy required to survive slavery, Reconstruction, and Jim Crow segregation in Alabama. Tate goes on to say: "Anybody who creates a body of work that is just so profoundly mysterious didn't mean to ever be completely understood. Transparency was not one of [Traylor's] prime directives."[65]

Traylor's art conveys a lifetime in which all cultural and traditional knowledge was held within the minds of the living and transmitted to the younger generations—a knowledge base increasingly spurned by those coming of age with literacy, northern migration, and increased personal agency, which effectively quashed the need and the desire to carry forth a legacy drenched in slavery and superstition. As an elder, Traylor sat alone, pouring his testimony onto paper rather than into the hearts and minds of his children and grandchildren. But in the making of images, Traylor reclaimed his identity in a crucial act of defiance that pushed back at too many years of oppression.

As is true with many self-taught artists, Traylor's art survived by chance, at the intersection of a moment in time and people roused to his art when most would not have noticed or valued it. The works on torn and stained candy and clothing box tops and storefront advertisements were inherently more fragile than objects carved from stone or wood, even more ephemeral than stories and songs. Traylor's body of work is a unique repository, the only substantial surviving body of drawings and paintings by a man born into the ruthless but dying system of American slavery, a record of a man living between complexities, between paradigms, between worlds.

Traylor saw more change than stasis in his life, but unoppressed freedom and security remained beyond reach. His images record the gamut of emotions and experiences and picture a life in which a man like him might rise above the old challenges and be truly free. The writer and social critic James Baldwin asserted, "All art is a kind of confession, more or less oblique. All artists, if they do survive, are forced, at last, to tell the whole story, to vomit the anguish up. All of it, the literal and the fanciful."[66]

The gaps in Traylor's artistic story will ultimately remain more expansive than his recorded history; the lens for decoding his personal symbols, ultimately, is not among our possessions. Bill Traylor gave himself permission to record memories— beautiful, ordinary, intricate, and ugly—and the incongruous African American society that was radically evolving before his eyes in the heart of the South. No other artist captured the complex, drawn-out moment between slavery and civil rights or offered an insider's perspective on ushering out the centuries of wrong inflicted upon his people. Bill Traylor validated his own life and the experience of his people by putting it down on paper, and his project stands today as one of the most important bodies of drawings and paintings in American history.

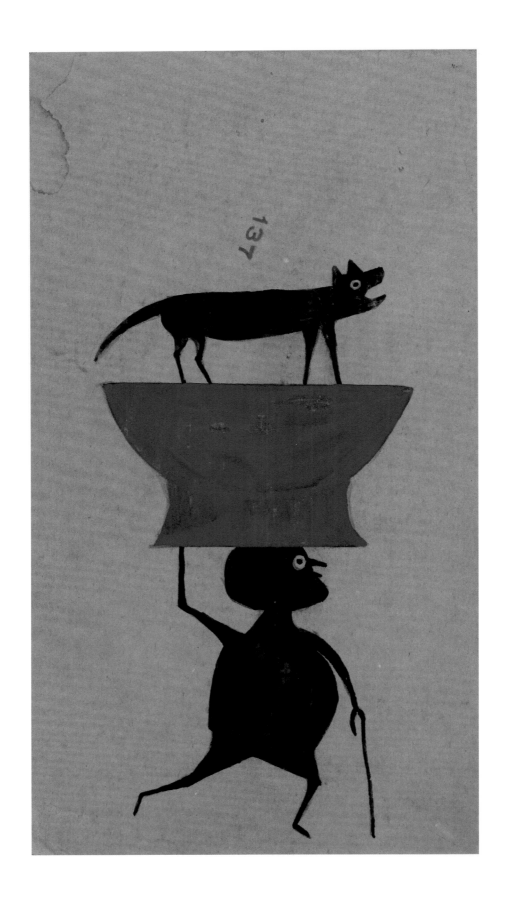

PLATE 198 *Untitled (Man Carrying Dog on Object)*

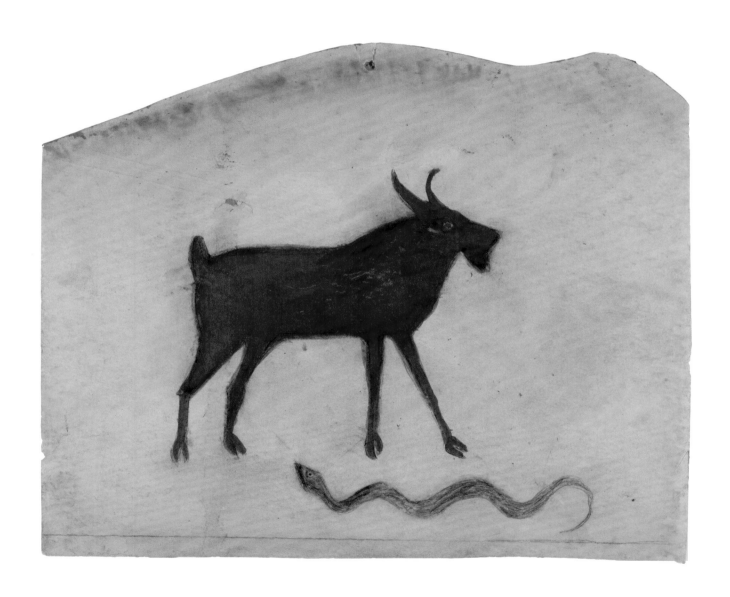

PLATE 199 *Untitled (Red Goat with Snake)*

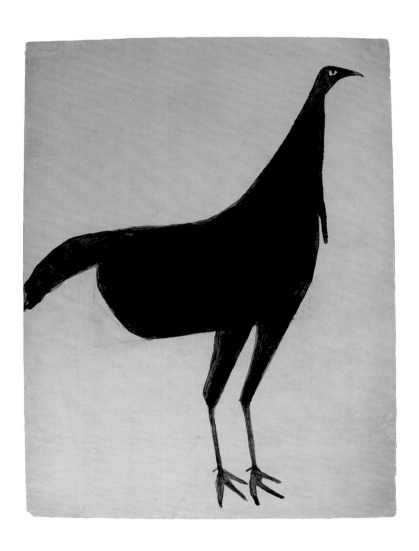

PLATE 200 *Black Turkey*

PLATE 201 *Untitled (Seated Woman)*

PLATE 202 *Black Jug*

PLATE 203 *Figure with Construction on Back*

PLATE 204 *Man with Cane on Construction, with Dog*

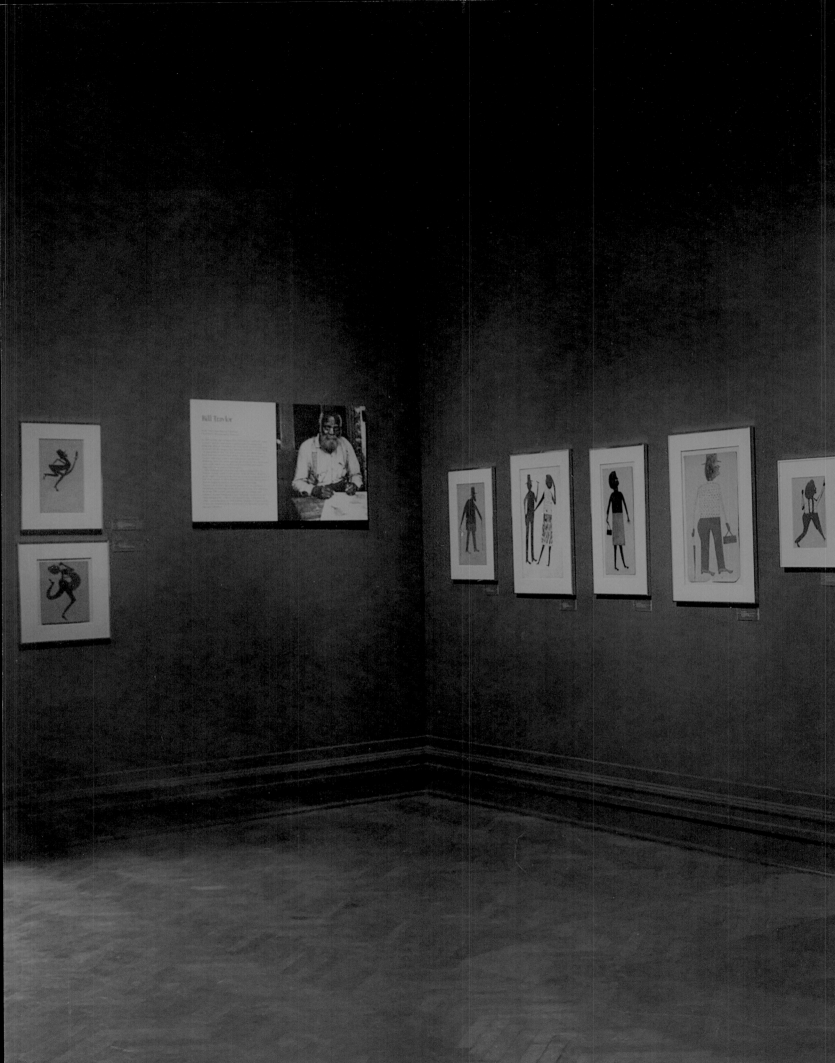

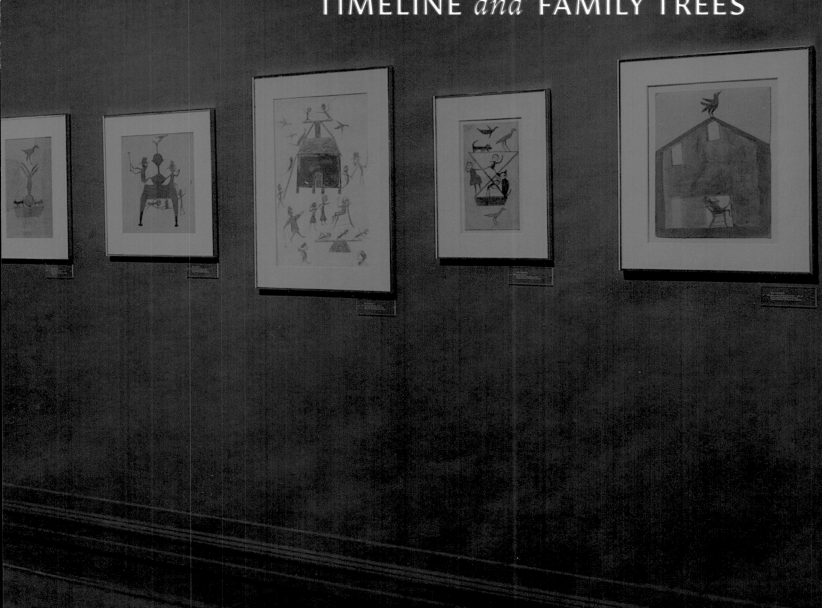

TIMELINE *and* FAMILY TREES

THE LIFE OF BILL TRAYLOR (ca. 1853–1949)

This chronology outlines key moments from the artist's life as well as select posthumous events. It is drawn from multiple sources, including historical documents and public records, and based on the most thorough research to date. For most of the circumstances of his life, however, records are inconclusive; dates and events must therefore be considered approximate. All locations are in Alabama unless otherwise noted. The posthumous exhibitions included here are not comprehensive.

1853, APRIL Bill Traylor, son of "Old Sally" (ca. 1819–1880+) and "Old Bill" (ca. 1805–ca. 1865), is born into slavery on the John Getson "J. G." Traylor plantation in Dallas County. J. G. Traylor had died in January 1850, leaving his brother, George Hartwell Traylor, as executor of his estate and guardian of his children. John's children move to George's plantation in nearby Lowndes County, but the enslaved people (considered property of the estate) remain on John's property and keep the farm in operation.

1863, JANUARY President Abraham Lincoln issues the Emancipation Proclamation, granting freedom to slaves in Confederate states—if the Union wins the war. George H. Traylor is prompted to move the enslaved people from his brother J. G.'s Dallas County plantation to his own plantation in Lowndes County. Bill Traylor and his family are part of the relocated group.

1865, JANUARY The US Congress passes the Thirteenth Amendment to the Constitution, which abolishes slavery throughout the United States; in May the Civil War ends. Bill Traylor and his family remain on George's land as farm laborers.

1870 Traylor remains on George H. Traylor's land with his mother and sibling Emit and adopted or fictive kin Mary and Susan. His father is presumed to be deceased by this time.

1880 Traylor is still living and working on George H. Traylor's land. In August he marries Elsey Dunklin. Although no death record was found for Bill's mother, she likely died sometime in the 1880s.

1891 Traylor marries his second wife, Laurine E. Dunklin (relationship to Elsey Dunklin is unclear).

Preceding pages: Installation view of Bill Traylor's works in *Black Folk Art in America, 1930–1980,* Corcoran Gallery of Art, Washington, DC, 1982

1900 Bill and Laurine (often called Larisa) Traylor, together with some nine children, continue to work for the George H. Traylor family as farmers.

1908 After living for fifty-five years in rural Dallas and Lowndes Counties, most of them working, Traylor moves with his family to rural Montgomery County.

1909 Traylor marries his third wife, Laura Williams (also called Larcey, Laura Thomas, and Laura Winston).

1910 Bill and Laura Traylor live with nine children just outside the Montgomery city limits on Mobile Road between Mill Street and Hayneville Road.

1915–16 Traylor and his family possibly reside on James Street (now Patrick Street) south of Washington Park, just outside the Montgomery city limits.

1920 Bill and Laura Traylor and seven children are living on the plantation owned by John "J. A." Sellers on Selma Road, a couple miles outside the Montgomery city limits. The older children work as farm laborers and support their parents, who are no longer working.

1927–28 Traylor is widowed. He moves, alone, into Montgomery and rents a room from Asa W. Wilson at 9 Coosa Street.

1929 Traylor's son Will (also called Willie) is killed by the Birmingham police.

1930 Traylor lives in a boardinghouse at 59 Bell Street for six dollars a month, working as a shoemaker for a private family.

1933 Traylor's son Mack dies in Montgomery from ill-health.

1936–37 On a welfare record from February 1936, Traylor lists his address as 111 Monroe Street, the address of the Ross-Clayton Funeral Home; he gives

the same address the following year on his application for a Social Security number.

1938 Traylor meets Jay Leavell, a boy from the neighborhood who becomes an art student at the New South artists' collective. Around this time Traylor starts drawing; family accounts state he is also selling pencils.

1939 Traylor takes to drawing on a regular basis, sitting outside near a blacksmith shop next door to the Ross-Clayton Funeral Home near the corner of Monroe and North Perry Streets. Leavell, who first notices that Traylor was an artist, introduces him to John Lapsley and Charles Shannon, members of the New South. Various members purchase drawings from Traylor; Shannon becomes the most dedicated collector of Traylor's art. Traylor's son Ruben dies in Buffalo, New York, from ill-health.

1940 Traylor is reportedly lodging at a shoe repair shop. He starts drawing and painting outside the Pekin Pool Room, a block away from the Ross-Clayton Funeral Home, near the corner of Monroe and North Lawrence Streets.

FEBRUARY 1–19 New South exhibits between eighty and one hundred of Traylor's drawings at its gallery; group members Jean and George Lewis document the show in photographs. The exhibition is featured in the *Montgomery Advertiser* and *Birmingham News*.

MARCH The *Montgomery Advertiser* publishes an additional full-length article, "The Enigma of Uncle Bill Traylor," complete with an image of him drawing outside the Pekin Pool Room. Later in 1940, New South members combine resources to buy Traylor a bus ticket to Detroit to visit his daughter Easter.

1941, DECEMBER The United States enters World War II.

1942, JANUARY The exhibition *Bill Traylor: American Primitive (Work of an Old Negro)* opens at the Ethical

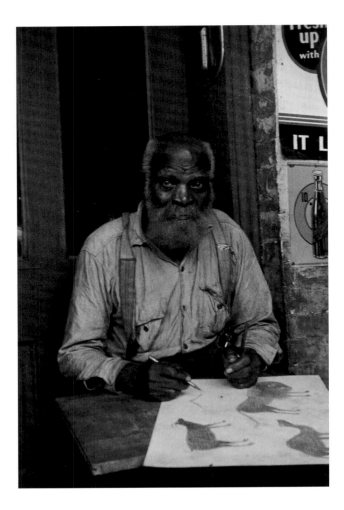

Culture Fieldston School in Riverdale, New York. The show is curated by Victor D'Amico, head of Fieldston's art department and founding director of the department of education at New York's Museum of Modern Art (MoMA). Alfred Barr, then director of MoMA, and his staff express interest in Traylor's work, but Shannon declines to negotiate either a sale or a gift to the museum.

JUNE Charles Shannon is drafted into the US Army and does not see Traylor again until after the war. Beginning around this time, Traylor travels to Detroit, Pennsylvania, Washington, DC, and perhaps other places to visit several of his children. Family accounts say that Traylor returned to Bell Street in Montgomery and lived in an unnumbered shanty overlooking the Alabama River. No formal records substantiate this information.

1943 Suffering from diabetes, Traylor undergoes surgery to amputate toes on his left foot.

1944 Traylor is baptized on January 5 at Saint Jude Catholic Church in Montgomery.

1945 At the behest of the city's welfare agency, Traylor goes to live with daughter Sarah (b. Sallie) (see fig. 83, p. 348) and her husband, Albert Howard, on Bragg Street in Montgomery.

1946 Traylor undergoes a second surgery, to amputate his left leg. After four years, Traylor sees Shannon only twice (in March at Sarah's Bragg Street home and the next year during a hospitalization); they do not keep in touch. At the same March visit, reporter Allen Rankin and photographer Horace Perry meet Traylor for a *Collier's* magazine article, "He Lost 10,000 Years."

1947 Traylor is admitted to a segregated nursing home, noted by Charles Shannon as the Fraternal Hospital (no longer extant) on Dorsey Street in Montgomery. Shannon erroneously believes Traylor dies during his stay.

1948 Traylor returns to Sarah and Albert's Bragg Street home and is visited again by Allen Rankin, this time with photographer Albert Kraus for the *Alabama Journal* article "He'll Paint for You—Big 'Uns 20 Cents, Lil' 'Uns, a Nickel."

1949 Traylor dies October 23 at Oak Street Hospital. He is buried at Mount Mariah African Methodist Episcopal (A.M.E.) Zion Church on Old Hayneville Road in southwest Montgomery.

1975–77 With his second wife, Eugenia Carter Shannon, Charles Shannon begins to organize his holdings of Traylor's art and seek professional representation for the work.

Bill Traylor, 1939 (see fig. 1)

1979 Traylor's first solo exhibition in New York City takes place at R. H. Oosterom Gallery from December 13, 1979, to January 12, 1980.

1982, JANUARY Thirty-six of Traylor's artworks are included in *Black Folk Art in America, 1930–1980*, an exhibition at the Corcoran Gallery of Art, Washington, DC. The exhibition travels to seven additional venues, concluding in July 1984. Thereafter his art becomes increasingly celebrated, exhibited, represented, written about, and collected by public and private institutions in the United States and internationally.

NOVEMBER *Bill Traylor*, exhibition at Montgomery Museum of Fine Arts, Alabama, November 6–December 30, 1982.

1983 *A Selection of Works from the 20th-Century Permanent Collection*, exhibition at High Museum of Art, Atlanta, Georgia, October 25–December 29, 1983.

1988 *Bill Traylor Drawings, From the Collection of Joseph H. Wilkinson and an Anonymous Chicago Collector*, exhibition at Randolph Gallery of the Chicago Public Library Cultural Center.

1991–92 *Bill Traylor: Judy Saslow's Collection*, exhibition at Ginza Art Space, Tokyo, and the Collection de l'Art Brut, Lausanne.

1992 Members of the Traylor family sue Charles and Eugenia Shannon and Hirschl & Adler Galleries, New York, to recover legal ownership of Traylor's artworks; they reach a settlement in fall 1993.

1994 The Bill Traylor Family Trust registers copyright for Traylor's artworks.

1994–95 *Lively Times and Exciting Events: The Drawings of Bill Traylor*, exhibition at Montgomery Museum of Fine Arts.

1998–99 *Bill Traylor (1854-1949): Deep Blues*, exhibition at Kuntsmuseum, Bern, and Museum Ludwig, Cologne.

2004–5 *Bill Traylor, William Edmondson, and the Modernist Impulse*, exhibition at Krannert Art Museum, University of Illinois at Urbana-Champaign.

2012 *Bill Traylor: Drawings from the Collections of the High Museum of Art and the Montgomery Museum of Fine Arts*, exhibition at High Museum of Art, Atlanta, Georgia.

2013 *Traylor in Motion: Wonders from New York Collection*s, exhibition at American Folk Art Museum, New York.

2018 A headstone is placed on Traylor's previously unmarked grave at Mount Mariah A.M.E. Zion Church, and he is posthumously celebrated by city and state officials in Alabama. A documentary film, *Bill Traylor: Chasing Ghosts*, debuts at the Smithsonian American Art Museum, Washington, DC, in conjunction with a monographic book and the exhibition *Between Worlds: The Art of Bill Traylor* (September 28, 2018-March 17, 2019).

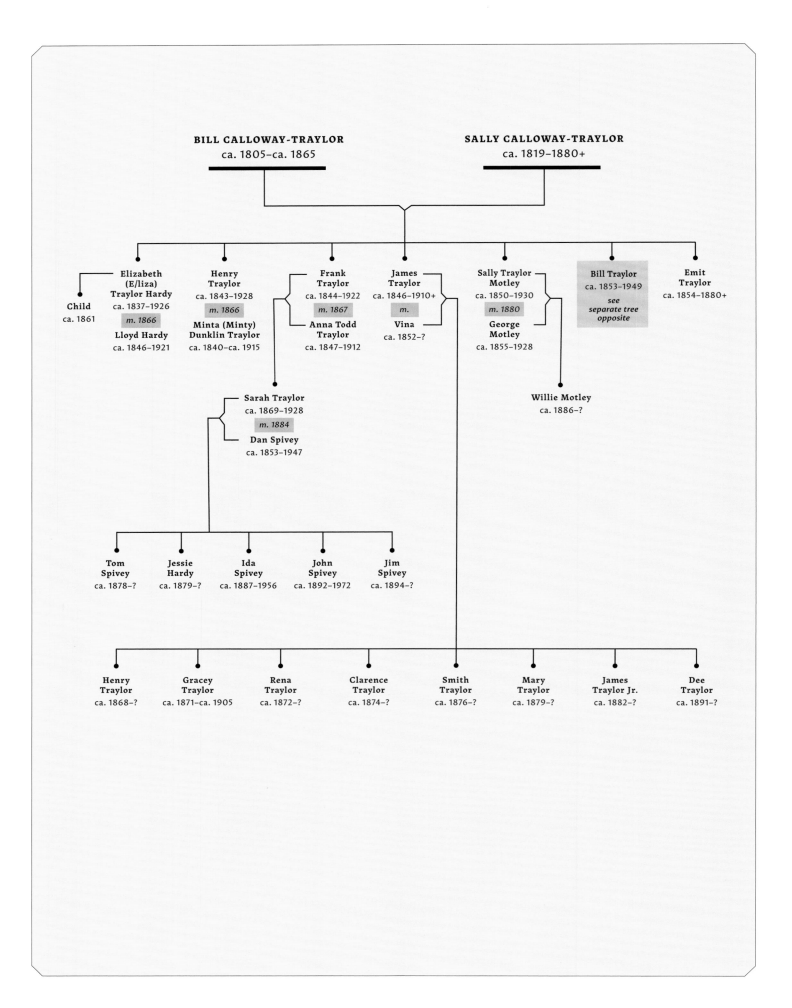

BILL CALLOWAY-TRAYLOR
ca. 1805–ca. 1865

SALLY CALLOWAY-TRAYLOR
ca. 1819–1880+

**Elizabeth
(E/liza)
Traylor Hardy**
ca. 1837–1926
m. 1866

Child
ca. 1861

Lloyd Hardy
ca. 1846–1921

**Henry
Traylor**
ca. 1843–1928
m. 1866

**Minta (Minty)
Dunklin Traylor**
ca. 1840–ca. 1915

**Frank
Traylor**
ca. 1844–1922
m. 1867

**Anna Todd
Traylor**
ca. 1847–1912

**James
Traylor**
ca. 1846–1910+
m.

Vina
ca. 1852–?

**Sally Traylor
Motley**
ca. 1850–1930
m. 1880

**George
Motley**
ca. 1855–1928

Bill Traylor
ca. 1853–1949
*see
separate tree
opposite*

**Emit
Traylor**
ca. 1854–1880+

Sarah Traylor
ca. 1869–1928
m. 1884

Dan Spivey
ca. 1853–1947

Willie Motley
ca. 1886–?

**Tom
Spivey**
ca. 1878–?

**Jessie
Hardy**
ca. 1879–?

**Ida
Spivey**
ca. 1887–1956

**John
Spivey**
ca. 1892–1972

**Jim
Spivey**
ca. 1894–?

**Henry
Traylor**
ca. 1868–?

**Gracey
Traylor**
ca. 1871–ca. 1905

**Rena
Traylor**
ca. 1872–?

**Clarence
Traylor**
ca. 1874–?

**Smith
Traylor**
ca. 1876–?

**Mary
Traylor**
ca. 1879–?

**James
Traylor Jr.**
ca. 1882–?

**Dee
Traylor**
ca. 1891–?

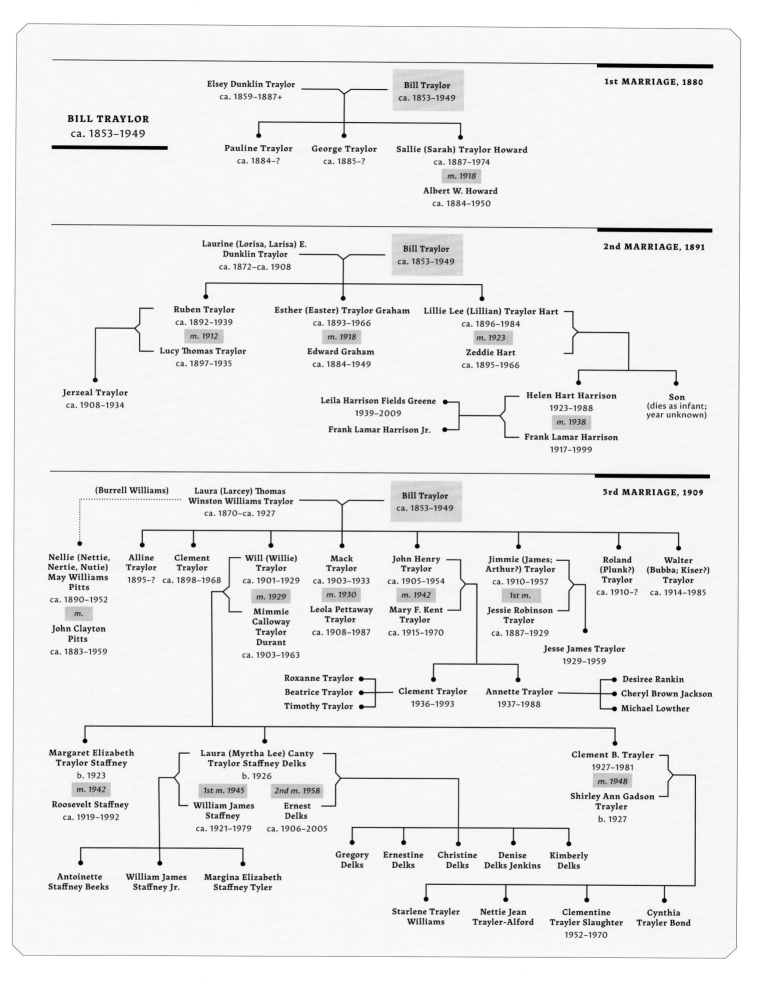

BILL TRAYLOR
ca. 1853–1949

Elsey Dunklin Traylor
ca. 1859–1887+

Bill Traylor
ca. 1853–1949

Pauline Traylor
ca. 1884–?

George Traylor
ca. 1885–?

Sallie (Sarah) Traylor Howard
ca. 1887–1974
m. 1918
Albert W. Howard
ca. 1884–1950

Laurine (Lorisa, Larisa) E.
Dunklin Traylor
ca. 1872–ca. 1908

Bill Traylor
ca. 1853–1949

Ruben Traylor
ca. 1892–1939
m. 1912
Lucy Thomas Traylor
ca. 1897–1935

Esther (Easter) Traylor Graham
ca. 1893–1966
m. 1918
Edward Graham
ca. 1884–1949

Lillie Lee (Lillian) Traylor Hart
ca. 1896–1984
m. 1923
Zeddie Hart
ca. 1895–1966

Jerzeal Traylor
ca. 1908–1934

Leila Harrison Fields Greene
1939–2009

Frank Lamar Harrison Jr.

Helen Hart Harrison
1923–1988
m. 1938
Frank Lamar Harrison
1917–1999

Son
(dies as infant;
year unknown)

(Burrell Williams)

Laura (Larcey) Thomas
Winston Williams Traylor
ca. 1870–ca. 1927

Bill Traylor
ca. 1853–1949

Nellie (Nettie,
Nertie, Nutie)
May Williams
Pitts
ca. 1890–1952
m.
John Clayton
Pitts
ca. 1883–1959

Alline
Traylor
1895–?

Clement
Traylor
ca. 1898–1968

Will (Willie)
Traylor
ca. 1901–1929
m. 1929
Mimmie
Calloway
Traylor
Durant
ca. 1903–1963

Mack
Traylor
ca. 1903–1933
m. 1930
Leola Pettaway
Traylor
ca. 1908–1987

John Henry
Traylor
ca. 1905–1954
m. 1942
Mary F. Kent
Traylor
ca. 1915–1970

Jimmie (James;
Arthur?) Traylor
ca. 1910–1957
1st m.
Jessie Robinson
Traylor
ca. 1887–1929

Roland
(Plunk?)
Traylor
ca. 1910–?

Walter
(Bubba; Kiser?)
Traylor
ca. 1914–1985

Jesse James Traylor
1929–1959

Roxanne Traylor

Beatrice Traylor

Timothy Traylor

Clement Traylor
1936–1993

Annette Traylor
1937–1988

Desiree Rankin

Cheryl Brown Jackson

Michael Lowther

Margaret Elizabeth
Traylor Staffney
b. 1923
m. 1942
Roosevelt Staffney
ca. 1919–1992

Laura (Myrtha Lee) Canty
Traylor Staffney Delks
b. 1926
1st m. 1945
William James
Staffney
ca. 1921–1979

2nd m. 1958
Ernest
Delks
ca. 1906–2005

Clement B. Trayler
1927–1981
m. 1948
Shirley Ann Gadson
Trayler
b. 1927

Antoinette
Staffney Beeks

William James
Staffney Jr.

Margina Elizabeth
Staffney Tyler

Gregory
Delks

Ernestine
Delks

Christine
Delks

Denise
Delks Jenkins

Kimberly
Delks

Starlene Trayler
Williams

Nettie Jean
Trayler-Alford

Clementine
Trayler Slaughter
1952–1970

Cynthia
Trayler Bond

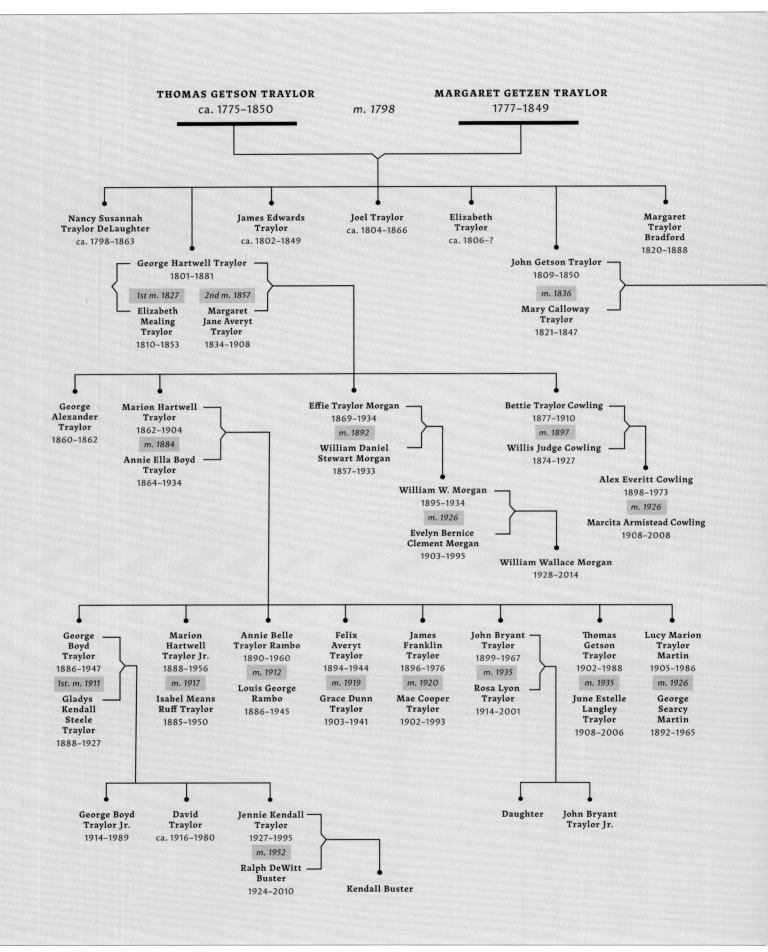

THOMAS GETSON TRAYLOR
ca. 1775–1850

m. 1798

MARGARET GETZEN TRAYLOR
1777–1849

Nancy Susannah
Traylor DeLaughter
ca. 1798–1863

James Edwards
Traylor
ca. 1802–1849

Joel Traylor
ca. 1804–1866

Elizabeth
Traylor
ca. 1806–?

Margaret
Traylor
Bradford
1820–1888

George Hartwell Traylor
1801–1881

1st m. 1827

Elizabeth
Mealing
Traylor
1810–1853

2nd m. 1857

Margaret
Jane Averyt
Traylor
1834–1908

John Getson Traylor
1809–1850

m. 1836

Mary Calloway
Traylor
1821–1847

George
Alexander
Traylor
1860–1862

Marion Hartwell
Traylor
1862–1904

m. 1884

Annie Ella Boyd
Traylor
1864–1934

Effie Traylor Morgan
1869–1934

m. 1892

William Daniel
Stewart Morgan
1857–1933

Bettie Traylor Cowling
1877–1910

m. 1897

Willis Judge Cowling
1874–1927

William W. Morgan
1895–1934

m. 1926

Evelyn Bernice
Clement Morgan
1903–1995

William Wallace Morgan
1928–2014

Alex Everitt Cowling
1898–1973

m. 1926

Marcita Armistead Cowling
1908–2008

George
Boyd
Traylor Jr.
1886–1947

1st. m. 1911

Gladys
Kendall
Steele
Traylor
1888–1927

Marion
Hartwell
Traylor Jr.
1888–1956

m. 1917

Isabel Means
Ruff Traylor
1885–1950

Annie Belle
Traylor Rambo
1890–1960

m. 1912

Louis George
Rambo
1886–1945

Felix
Averyt
Traylor
1894–1944

m. 1919

Grace Dunn
Traylor
1903–1941

James
Franklin
Traylor
1896–1976

m. 1920

Mae Cooper
Traylor
1902–1993

John Bryant
Traylor
1899–1967

m. 1935

Rosa Lyon
Traylor
1914–2001

Thomas
Getson
Traylor
1902–1988

m. 1935

June Estelle
Langley
Traylor
1908–2006

Lucy Marion
Traylor
Martin
1905–1986

m. 1926

George
Searcy
Martin
1892–1965

George Boyd
Traylor Jr.
1914–1989

David
Traylor
ca. 1916–1980

Jennie Kendall
Traylor
1927–1995

m. 1952

Ralph DeWitt
Buster
1924–2010

Kendall Buster

Daughter

John Bryant
Traylor Jr.

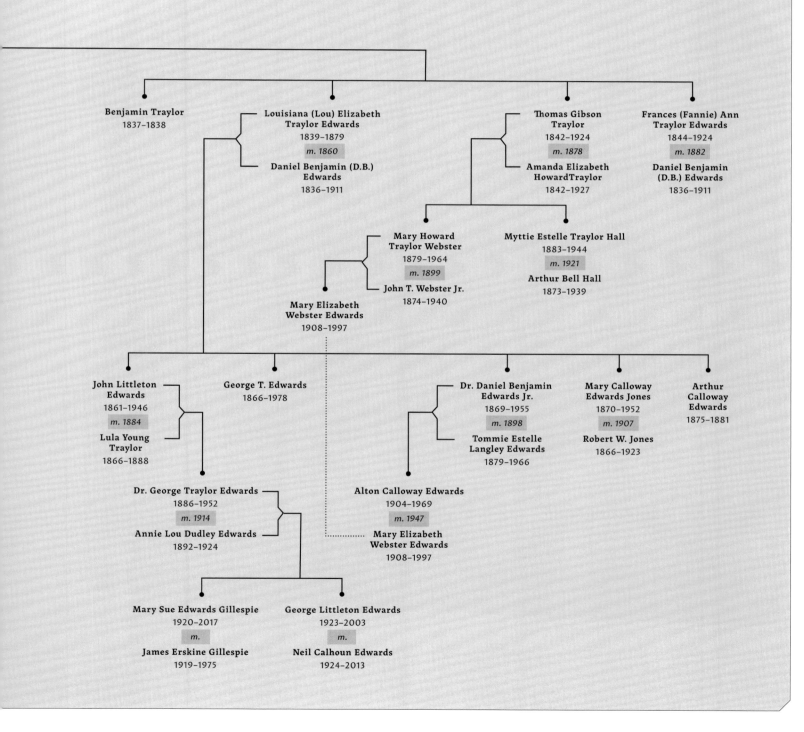

Benjamin Traylor
1837–1838

Louisiana (Lou) Elizabeth
Traylor Edwards
1839–1879
m. 1860

Daniel Benjamin (D.B.)
Edwards
1836–1911

Thomas Gibson
Traylor
1842–1924
m. 1878

Amanda Elizabeth
HowardTraylor
1842–1927

Frances (Fannie) Ann
Traylor Edwards
1844–1924
m. 1882

Daniel Benjamin
(D.B.) Edwards
1836–1911

Mary Howard
Traylor Webster
1879–1964
m. 1899

John T. Webster Jr.
1874–1940

Myttie Estelle Traylor Hall
1883–1944
m. 1921

Arthur Bell Hall
1873–1939

Mary Elizabeth
Webster Edwards
1908–1997

John Littleton
Edwards
1861–1946
m. 1884

Lula Young
Traylor
1866–1888

George T. Edwards
1866–1978

Dr. Daniel Benjamin
Edwards Jr.
1869–1955
m. 1898

Tommie Estelle
Langley Edwards
1879–1966

Mary Calloway
Edwards Jones
1870–1952
m. 1907

Robert W. Jones
1866–1923

Arthur
Calloway
Edwards
1875–1881

Dr. George Traylor Edwards
1886–1952
m. 1914

Annie Lou Dudley Edwards
1892–1924

Alton Calloway Edwards
1904–1969
m. 1947

Mary Elizabeth
Webster Edwards
1908–1997

Mary Sue Edwards Gillespie
1920–2017
m.

James Erskine Gillespie
1919–1975

George Littleton Edwards
1923–2003
m.

Neil Calhoun Edwards
1924–2013

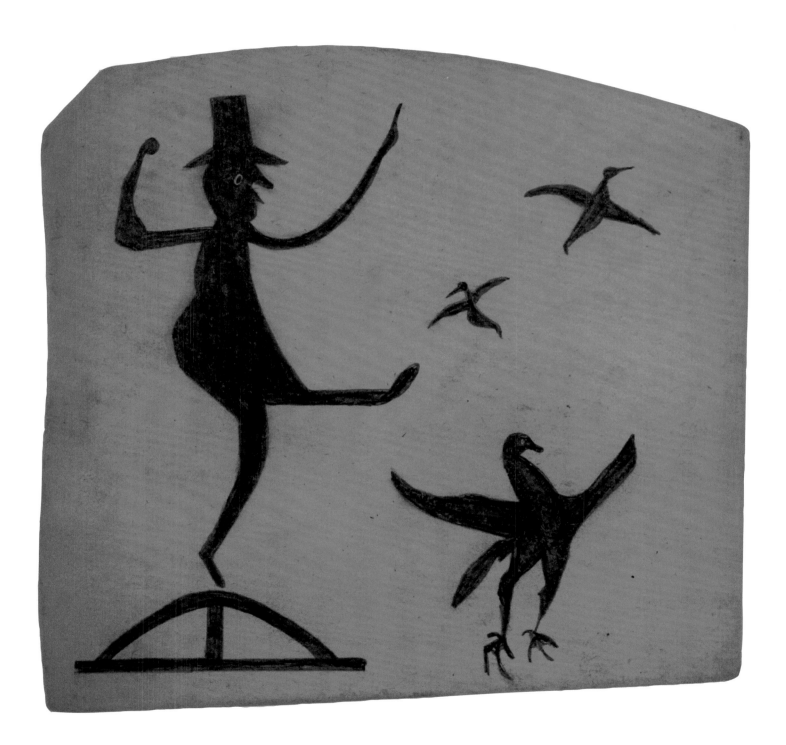

PLATE 205 *Man Pointing with Three Birds*

LIST OF PLATES

All works illustrated as plates are by Bill Traylor. Works marked with an asterisk (*) are not in the exhibition; all others are. The plates are listed in the order in which they are discussed in the essays. Dimensions refer to the sizes of the supports, many of which are irregular; height precedes width. For information on titles, dates, and media as applied to Traylor's works, see Notes to the Reader, p. 19.

1*

Man with Hat and Cane, ca. 1939–40
pencil, colored pencil, and charcoal on
cardboard
17 ¼ × 9 ⅞ in.
The William Louis-Dreyfus Foundation Inc.
Illus. p. 49; in fig. 52

2

Mother with Child, July 1939
colored pencil and pencil on cardboard
15 ½ × 11 ¾ in.
Collection of Judy A. Saslow
Illus. p. 68

3*

Bottle Figure, ca. 1939–42
poster paint and pencil on cardboard
15 ½ × 8 in.
The William Louis-Dreyfus Foundation Inc.
Illus. p. 97

4*

Shoes, Figures, Etc., ca. 1939–42
pencil on cardboard
10 × 8 ¼ in.
The Metropolitan Museum of Art, New York,
Gift of Charles E. and Eugenia C. Shannon,
2001.686.1
Illus. p. 162

5

Untitled (NRA WPA), ca. 1939–42
pencil and poster paint on cardboard
12 ½ × 8 ⅛ in.
Private collection
Illus. p. 163

6

WPA Poster, ca. 1939–42
pencil and crayon on cardboard
14 × 11 in.
The Harmon and Harriet Kelley Foundation
for the Arts
Illus. p. 163

7

Untitled (Lamp, Bottle, and Cat), 1939
pencil on paperboard
12 × 3 ½ in.
Smithsonian American Art Museum,
Museum purchase through the Luisita L. and
Franz H. Denghausen Endowment, 2015.19.2
Illus. p. 164

8

Untitled, 1939–40
graphite on paper
12 ¼ × 5 ¹¹⁄₁₆ in.
Philadelphia Museum of Art,
125th Anniversary Acquisition,
Gift of Josephine Albarelli, 2002
Illus. p. 164

9

Owls in Tree/Shoeing Mule, ca. 1939
pencil on cardboard
12 ¼ × 6 ¼ in.
The Museum of Modern Art, New York,
Gift of Charles and Eugenia Shannon
Illus. p. 164; detail, fig. 36

10

Blacksmith Shop, ca. 1939–40
pencil on cardboard
13 ⅜ × 26 ¼ in.
The Metropolitan Museum of Art, New York,
Gift of Eugenia and Charles Shannon,
1995.399
Illus. p. 165; detail, fig. 37; in fig. 49

11*

Pigeon (on men's handkerchiefs card),
ca. 1939–42
poster paint and pencil on cardboard
16 × 8 ⅛ in.
Collection of Jeffrey and Susan Sussman
Illus. p. 166

12

Man with Basket on Head (Early), ca. 1939
pencil on cardboard
12 × 5 ¾ in.
Collection of Judy A. Saslow
Illus. p. 167

13*

Greyhound, ca. March 1940
pencil on cardboard
15 ½ × 9 ¾ in.
Collection of The Charles E. and Eugenia C.
Shannon Trust, Courtesy of Betty
Cuningham Gallery
Illus. p. 168

14*

Sickle-Tail Dog, ca. 1939–42
pencil on cardboard
9 × 7 ¾ in.
Collection of The Charles E. and Eugenia C.
Shannon Trust, Courtesy of Betty
Cuningham Gallery
Illus. p. 169

15*

Fierce Dog, ca. 1939–42
pencil and poster paint on cardboard
9 ½ × 13 ¾ in.
Collection of The Charles E. and
Eugenia C. Shannon Trust, Courtesy of
Betty Cuningham Gallery
Illus. p. 169

16*

Spotted Cat (AKA Cat), ca. 1939–42
pencil and watercolor on cardboard
12 ¹³/₁₆ × 11 in.
W. Harris Smith Family Collection
Illus. p. 170

17*

Cat, ca. 1939–42
gouache and pencil on found cardboard
11 × 8 in.
Collection of Victor F. Keen
Illus. p. 171

18*

Cat, Pale Face, ca. 1939–42
pencil and poster paint on cardboard
13 × 7 ¼ in.
Collection of The Charles E. and
Eugenia C. Shannon Trust, Courtesy of
Betty Cuningham Gallery
Illus. p. 171

19

Untitled (Pineapple), ca. 1939–42
colored pencil and graphite on cardboard
13 ¼ × 7 ¼ in.
High Museum of Art, Atlanta, Georgia,
Purchase with funds from Mrs. Lindsey
Hopkins Jr., Edith G. and Philip A. Rhodes,
and the Members Guild
Illus. p. 172

20

Basket with Plant Form, ca. 1939–40
pencil and colored pencil on cardboard
16 × 11 in.
The William Louis-Dreyfus Foundation Inc.
Illus. p. 172; in fig. 52

21

Untitled (Basket, Man, and Owl), ca. 1939
colored pencil on cardboard
14 × 9 in.
Collection of Victor F. Keen
Illus. p. 173; in fig. 52

22*

Untitled (Owl), ca. 1939–42
pencil and opaque watercolor on paperboard
13 × 7 in.
Courtesy The Museum of Everything
Illus. p. 174

23*

Untitled (Spotted Cow), ca. 1939
poster paint and pencil on cardboard
13 × 15 in.
Collection of Sheila Starke and Bolling P.
Starke Jr.
Illus. p. 175; in fig. 48

24*

Turtle Swimming Down, ca. 1939–40
poster paint and pencil on cardboard
11 ¾ × 7 ¼ in.
The William Louis-Dreyfus Foundation Inc.
Illus. p. 175; in fig. 48

25

Yellow Chicken, ca. 1939–40
gouache and pencil on cardboard
11 ½ × 10 in.
The Museum of Modern Art, New York,
Gift of Charles and Eugenia Shannon
Illus. p. 176; in figs. 29, 48

26

Two Figures with Pitchfork and Birds,
ca. 1939–42
charcoal and pencil on cardboard
12 ½ × 15 ¾ in.
The William Louis-Dreyfus Foundation Inc.
Illus. p. 177

27

*Untitled (Figure Construction with
Kneeling Man),* ca. 1939–42
poster paint and graphite on cardboard
13 ³/₁₆ × 7 ³/₁₆ in.
High Museum of Art, Atlanta, Georgia,
Purchase with funds from Mrs. Lindsey
Hopkins Jr., Edith G. and Philip A. Rhodes,
and the Members Guild
Illus. p. 177

28

Bird, ca. 1940–42
watercolor and graphite on cardboard
15 ¹/₁₆ × 13 ⅜ in.
Montgomery Museum of Fine Arts,
Montgomery, Alabama, Gift of Charles
and Eugenia Shannon, 1982.4.22
Illus. p. 178

29

Blue Bird, ca. 1939–42
poster paint and pencil on cardboard
9 ½ × 9 in.
Collection of Judy A. Saslow
Illus. p. 179

30

Untitled (Event with Man in Blue and Snake),
1939
colored pencil and pencil on cardboard
22 × 13 ⅝ in.
Collection of Penny and Allan Katz
Illus. p. 180; in fig. 49

31

Untitled (Scene with Keg), ca. 1939–40
pencil and opaque watercolor on paperboard
21 ¾ × 13 ¼ in.
Courtesy The Museum of Everything
Illus. p. 181; in fig. 49

32

Red House with Figures, 1939
poster paint, colored pencil, and pencil on cardboard
22 × 13 ½ in.
Collection of Judy A. Saslow
Illus. p. 182; in figs. 31, 49

33

Untitled (Woman in Blue Holding an ABC Sign), ca. 1939–42
tempera and pencil on cardboard
12 × 7 ¾ in.
Collection of Jerry and Susan Lauren
Illus. p. 183

34

Boxers in Blue, ca. 1939–40
poster paint on cardboard
20 ⅞ × 22 in.
Collection of Judy A. Saslow
Illus. p. 184; in fig. 54

35*

Untitled (Running Man), ca. 1939–42
crayon and graphite on found cardboard
9 ⅝ × 7 in.
Private collection
Illus. p. 185

36

Untitled (Woman with Umbrella and Man on Crutch), 1939
opaque watercolor and pencil on paperboard
17 ¼ × 11 ¼ in.
Smithsonian American Art Museum,
Gift of Herbert Waide Hemphill Jr., 1991.96.7
Illus. p. 186; in fig. 52

37

Self-Portrait, ca. 1939–40
gouache and pencil on cardboard
17 ¼ × 11 ⅜ in.
The Metropolitan Museum of Art,
New York, Promised Gift of Charles E. and Eugenia C. Shannon
Illus. p. 187; in fig. 52

38

Fighter, ca. 1940
watercolor and graphite on cardboard
17 ¼ × 11 ½ in.
Montgomery Museum of Fine Arts,
Montgomery, Alabama, Gift of Charles and Eugenia Shannon, 1982.4.26
Illus. p. 187

39

Untitled (Dog Fight with Writing),
ca. 1939–40
opaque watercolor and pencil on paperboard
21 × 22 in.
Smithsonian American Art Museum,
Museum purchase through the Luisita L. and Franz H. Denghausen Endowment, 2016.14.2
Illus. p. 188

40*

Untitled (Footed Form), ca. 1939–40
poster paint and graphite on cardboard
15 × 12 ¹⁵⁄₁₆ in.
High Museum of Art, Atlanta, Georgia,
Purchase with funds from Mrs. Lindsey Hopkins Jr., Edith G. and Philip A. Rhodes, and the Members Guild
Illus. p. 189; in fig. 63

41

Plant/Animal Forms, ca. 1939
graphite and charcoal on cardboard
9 ⅝ × 7 ⅜ in.
Montgomery Museum of Fine Arts,
Montgomery, Alabama, Gift of Charles and Eugenia Shannon, 1982.4.1
Illus. p. 190

42

Leg Forms with Bird, ca. 1939–40
charcoal on cardboard
13 × 7 ½ in.
Private collection
Illus. p. 191; in fig. 52

43

Legs Construction with Five Figures,
ca. 1939–40
colored pencil on cardboard
13 ¼ × 7 ¼ in.
Collection of Judy A. Saslow
Illus. p. 191

44

Half of Green Man with Dog, Plant, and Figures, ca. 1939–40
colored pencil and pencil on cardboard
13 ⅞ × 11 in.
The William Louis-Dreyfus Foundation Inc.
Illus. p. 192; in fig. 52

45

Sprouting Green Figure, ca. 1939–42
pencil and colored pencil on cardboard
14 ⅛ × 8 in.
Peter Freeman, New York
Illus. p. 193

46

Two Cats Jumping on a Man, ca. 1939–42
crayon and green pencil on cardboard
15 × 9 in.
Collection of Tom de Nolf
Illus. p. 193

47

Human Plant Form on Construction with Dog and Man, ca. 1939–40
colored pencil on cardboard
8 ¾ × 8 ¼ in.
The William Louis-Dreyfus Foundation Inc.
Illus. p. 194; in fig. 52

48

Untitled (Figure on Construction with Legs),
ca. 1939–42
charcoal on cardboard
9 ⅛ × 9 ⅛ in.
High Museum of Art, Atlanta, Georgia,
Purchase with funds from Mrs. Lindsey Hopkins Jr., Edith G. and Philip A. Rhodes, and the Members Guild
Illus. p. 194

49

Anthropomorphic Figure and Cat,
ca. 1939–42
charcoal on cardboard
9 × 8 ¼ in.
The William Louis-Dreyfus Foundation Inc.
Illus. p. 195

50*

Dancing Cauldron, ca. 1939–40
poster paint and pencil on cardboard
9 ¾ × 8 ¼ in.
The William Louis-Dreyfus Foundation Inc.
Illus. p. 196; in fig. 59

51

Cedar Trees, ca. 1939–40
compressed charcoal on cardboard
21 ⅞ × 13 ⅞ in.
Collection of Dame Jillian Sackler
Illus. p. 197; in fig. 59

52

Abstraction, Red, Blue, Brown (AKA Abstraction), ca. 1939
poster paint and pencil on cardboard
14 ⅞ × 12 ½ in.
Collection of Victor F. Keen
Illus. p. 198; in fig. 59

74
Man with Hatchet Chasing Pointing Man,
ca. 1939–42
poster paint and pencil on cardboard
21 × 16 ⅞ in.
Louis-Dreyfus Family Collection
Illus. p. 255

75*
Untitled (Cow), ca. 1939–42
pencil and opaque watercolor on paperboard
12 × 16 ¾ in.
Courtesy The Museum of Everything
Illus. p. 256

76*
Black Fish, ca. 1939–42
colored pencil on cardboard
10 × 8 in.
Collection of Siri von Reis
Illus. p. 257

77
*Exciting Event with Snake, Plow, Figures
Chasing Rabbit,* ca. 1939–42
pencil on cardboard
22 × 14 in.
The William Louis-Dreyfus Foundation Inc.
Illus. p. 258

78*
Man with a Plow, ca. 1939–42
poster paint and pencil on paperboard
15 × 23 ¾ in.
Collection of Jerry and Susan Lauren
Illus. p. 259

79
Untitled (Rabbit), April 1940
opaque watercolor and pencil on paperboard
9 ¼ × 9 ¼ in.
Smithsonian American Art Museum,
Museum purchase through the Luisita L. and
Franz H. Denghausen Endowment, 2015.19.1
Illus. p. 260

80
Running Rabbit, ca. 1939–42
pencil and poster paint on cardboard
9 ¾ × 8 in.
Private collection
Illus. p. 260

81
Rabbit, ca. 1940–42
watercolor and graphite on cardboard
8 ⅜ × 11 ⅛ in.
Montgomery Museum of Fine Arts,
Montgomery, Alabama, Gift of Charles
and Eugenia Shannon, 1982.4.10
Illus. p. 261

82
Blue Rabbit Running, ca. 1939–42
poster paint and pencil on cardboard
9 × 11 ⅞ in.
The William Louis-Dreyfus Foundation Inc.
Illus. p. 261

83
Untitled (Chase Scene), ca. 1940
opaque watercolor and pencil on paperboard
7 × 13 ¼ in.
Smithsonian American Art Museum,
Gift of Micki Beth Stiller, 2015.25
Illus. p. 262

84
Untitled (Snake), ca. 1939–42
poster paint and pencil on cardboard
13 ¼ × 26 in.
Collection of Jocelin Hamblett
Illus. p. 263, back cover

85
Blue Snake, ca. 1939–42
colored crayon on decorative paper surfaced
cardboard
3 × 19 ¼ in.
The Museum of Modern Art, New York,
Gift of Charles and Eugenia Shannon
Illus. p. 264

86
Snake and Two Men, ca. 1939–40
pencil and colored pencil on cardboard
13 ¼ × 7 ¼ in.
Collection of Judy A. Saslow
Illus. p. 265

87*
Snake, ca. 1939–42
gouache and pencil on cardboard
11 ⅝ × 10 ⅛ in.
The Metropolitan Museum of Art,
New York, Promised Gift of Charles E.
and Eugenia C. Shannon
Illus. p. 266

88
Figures, Construction, ca. 1940–42
watercolor and graphite on cardboard
13 × 7 in.
Montgomery Museum of Fine Arts,
Montgomery, Alabama, Gift of Charles
and Eugenia Shannon, 1982.4.5
Illus. p. 267

89*
Chicken Toter Being Chased, ca. 1939–42
pencil on cardboard
16 ¾ × 9 ½ in.
The William Louis-Dreyfus Foundation Inc.
Illus. p. 267

90
Untitled (Mule, Dog, and Scene with Chicken),
July 1939
pencil on paperboard
23 × 14 in.
Smithsonian American Art Museum,
The Margaret Z. Robson Collection, Gift of
John E. and Douglas O. Robson, 2016.38.93
Illus. p. 268

91*
Chicken Stealing, July 1939
pencil on cardboard
21 ¾ × 14 in.
Collection of Siri von Reis
Illus. p. 269

92
Hog, Dog, and Chicken Stealing, ca. 1939–42
pencil on cardboard
22 × 14 in.
Private collection
Illus. p. 269

93*
Untitled (Men Shooting Bear), ca. 1939–42
pencil and colored pencil on cardboard
22 ¹/₁₆ × 14 in.
High Museum of Art, Atlanta, Georgia,
Purchase with funds from Mrs. Lindsey
Hopkins Jr., Edith G. and Philip A. Rhodes,
and the Members Guild
Illus. p. 270

94*
Blue Animal with Five Figures, ca. 1939–42
poster paint, pencil, and colored pencil on
cardboard
22 × 14 in.
The William Louis-Dreyfus Foundation Inc.
Illus. p. 270

95
Untitled, ca. 1939–42
colored pencil on paperboard
14 × 21 ¾ in.
Collection of Mr. and Mrs. Paul Caan
Illus. p. 271

96

Dog, ca. 1940–42
watercolor and graphite on cardboard
13 ¾ × 12 ¹¹⁄₁₆ in.
Montgomery Museum of Fine Arts,
Montgomery, Alabama, Gift of Charles
and Eugenia Shannon, 1982.4.18
Illus. p. 272

97*

One-Legged Man with Airplane, ca. 1939–42
colored pencil and poster paint on cardboard
15 ½ × 9 ⅜ in.
Collection of Siri von Reis
Illus. p. 273

98

Figures, Construction, ca. 1940–42
watercolor and graphite on cardboard
12 ¹¹⁄₁₆ × 11 ⅝ in.
Montgomery Museum of Fine Arts,
Montgomery, Alabama, Gift of Charles
and Eugenia Shannon, 1982.4.16
Illus. p. 274

99*

Two Men with Dog on Construction,
ca. 1939–42
poster paint on cardboard
12 ⅛ × 8 in.
Collection of Mark and Sara Hayden
Illus. p. 275

100

Figures on Blue Construction, ca. 1939–42
gouache and pencil on cardboard
14 ⅞ × 13 ¼ in.
The Museum of Modern Art, New York,
Gift of Charles and Eugenia Shannon
Illus. p. 275

101*

Brown Lizard with Blue Eyes, ca. 1939–42
poster paint and pencil on cardboard
13 ¼ × 7 ¼ in.
The William Louis-Dreyfus Foundation Inc.
Illus. p. 276

102

Yellow Horse, Black Mule, ca. 1939–42
pencil and colored pencil on cardboard
11 × 21 in.
Private collection
Illus. p. 277

103

Untitled (Mule and Horse), ca. 1939–42
graphite and poster paint on cardboard
22 ¼ × 14 in.
Roger Brown Study Collection,
School of the Art Institute of Chicago
Illus. p. 278

104

Untitled (Mule), December 1939
opaque watercolor and pencil on paperboard
15 × 14 in.
Smithsonian American Art Museum,
The Margaret Z. Robson Collection, Gift of
John E. and Douglas O. Robson, 2016.38.90
Illus. p. 278

105*

Mule with Red Border, ca. 1939–42
poster paint and pencil on cardboard
18 ½ × 20 ½ in.
The William Louis-Dreyfus Foundation Inc.
Illus. p. 279; in fig. 29

106*

Untitled (Black Horse), ca. 1939–42
poster paint on cardboard
16 ¾ × 15 ¾ in.
Private collection
Illus. p. 279

107

Red Man on Blue Horse with Dog, ca. 1939–42
poster paint and pencil on cardboard
22 × 14 ¼ in.
Louis-Dreyfus Family Collection
Illus. p. 280

108

"He's Sullin'," ca. 1939–42
poster paint and graphite on cardboard
11 ⅜ × 17 ¼ in.
Collection of Scott Asen
Illus. p. 281

109

Horse ("Turned him out to die"), 1939
pencil and poster paint on cardboard
13 × 16 in.
Collection of Barbara and John Wilkerson
Illus. p. 281

110

Dog and Cow, ca. 1939–42
pencil on cardboard
23 ¾ × 15 ¾ in.
Collection of Siri von Reis
Illus. p. 282

111*

Red Cat, Black Bull, ca. 1939–42
poster paint and graphite on cardboard
15 × 12 ½ in.
Collection of Ellen DeGeneres and
Portia de Rossi
Illus. p. 283

112*

Spotted Cat with Two Eyes, ca. 1939–42
opaque watercolor and graphite on beige card
15 × 12 ½ in.
Collection of Douglas O. Robson, promised
gift to the Smithsonian American Art Museum
Illus. p. 284

113

Spotted Dog, ca. 1939–42
pencil and poster paint on cardboard
6 ¾ × 11 ¼ in.
Collection of Christian P. Daniel
Illus. p. 284

114

Spotted Dog and Black Bird, ca. 1939–40
on reverse: "Hollywood Oddities" poster,
not illustrated
opaque watercolor and graphite on cream card
22 × 14 in.
Jill and Sheldon Bonovitz, Promised gift
to Philadelphia Museum of Art
Illus. p. 285

115

Cat and Dog, ca. 1939–42
tempera and pencil on cardboard
22 ¼ × 14 in.
Courtesy of Michael Rosenfeld Gallery, LLC,
New York
Illus. p. 285

116

Two Fighting Dogs, ca. 1939–42
poster paint and pencil on cardboard
18 ¼ × 19 ⅞ in.
The William Louis-Dreyfus Foundation Inc.
Illus. p. 286

117

Untitled (Two Dogs Fighting), ca. 1939–42
poster paint and graphite on cardboard
16 ½ × 21 ⅛ in.
High Museum of Art, Atlanta, Georgia,
T. Marshall Hahn Collection
Illus. p. 287

118*

Dog Attacking Man Smoking, ca. 1939–42
colored pencil on cardboard
9 ½ × 7 in.
Collection of Siri von Reis
Illus. p. 288

119

Woman in Green Blouse with Puppy and Umbrella, ca. 1939–42
colored pencil and charcoal on cardboard
13 ¼ × 9 ¾ in.
The William Louis-Dreyfus Foundation Inc.
Illus. p. 289

120*

Black Dog, ca. 1939–42
poster paint and pencil on advertisement board
8 × 10 in.
Collection of Audrey B. Heckler
Illus. p. 290

121*

Untitled (Dog), ca. 1939–42
poster paint and graphite on cardboard
18 ⅜ × 15 ¼ in.
High Museum of Art, Atlanta, Georgia,
Purchase with funds from Mrs. Lindsey
Hopkins Jr., Edith G. and Philip A. Rhodes,
and the Members Guild
Illus. p. 290

122*

Red Dog, ca. 1939–42
poster paint and pencil on cardboard
11 ½ × 11 ¾ in.
Louis-Dreyfus Family Collection
Illus. p. 291

123

Red Dog, ca. 1939–42
poster paint and pencil on cardboard
17 ½ × 31 ½ in.
Collection of Audrey B. Heckler
Illus. p. 291

124

Man and Large Dog, ca. 1939–42
on reverse: **Man and Woman,** pl. 125
poster paint and pencil on cardboard
28 × 22 in.
Collection of Jerry and Susan Lauren
Illus. p. 292

125

Man and Woman, ca. 1939–42
on reverse: **Man and Large Dog,** pl. 124
poster paint and pencil on cardboard
28 × 22 in.
Collection of Jerry and Susan Lauren
Illus. p. 293

126

Top Hat, ca. 1939–42
pencil and poster paint on cardboard
23 × 17 ¼ in.
Collection of Jerry and Susan Lauren
Illus. p. 293

127

Men on Red, ca. 1940–42
on reverse: **Double Goat,** not illustrated
watercolor and graphite on paper
28 ½ × 22 ⁷⁄₁₆ in.
Montgomery Museum of Fine Arts,
Montgomery, Alabama, Gift of Charles
and Eugenia Shannon, 1982.4.30
Illus. p. 294

128

Mean Dog, ca. 1939–42
on reverse: **Man Leading Mule,** not illustrated
poster paint and pencil on cardboard
22 × 28 in.
Collection of Jerry and Susan Lauren
Illus. p. 295

129

Drinking Bout, ca. 1939–42
pencil and opaque watercolor on
cardboard with commercially printed paper
10 × 7 in.
Private collection
Illus. p. 296

130

**Untitled (Yellow and Blue House with
Figures and Dog),** July 1939
colored pencil on paperboard
22 ¼ × 14 ¼ in.
Smithsonian American Art Museum,
Museum purchase through the Luisita L. and
Franz H. Denghausen Endowment, 2016.14.5
Illus. p. 297

131*

**Brown House with Multiple Figures and
Birds,** ca. 1939–42
poster paint and pencil on cardboard
22 ½ × 17 ¾ in.
The William Louis-Dreyfus Foundation Inc.
Illus. p. 298

132

House, ca. 1941
watercolor and graphite on cardboard
22 ¼ × 14 ⅛ in.
Montgomery Museum of Fine Arts,
Montgomery, Alabama, Gift of Charles
and Eugenia Shannon, 1982.4.29
Illus. p. 299, front cover

133

House, Blue Figures, Blue Lamp, ca. 1939–42
poster paint and pencil on cardboard
15 × 13 in.
Collection of Marianne and Sheldon B. Lubar
Illus. p. 300

134

Man in Brown and Blue House with Figures,
ca. 1939–42
pencil and poster paint on cardboard
21 ⅞ × 13 ⅞ in.
Collection of Barbara and John Wilkerson
Illus. p. 301

135*

Man Talking to a Bird, ca. 1939–42
poster paint and pencil on cardboard
16 ½ × 13 ½ in.
Gitter-Yelen Collection, New Orleans,
Louisiana
Illus. p. 301

136

**Untitled (Exciting Event: House with
Figures),** ca. 1939–42
poster paint and pencil on cardboard
13 ½ × 13 ⅞ in.
High Museum of Art, Atlanta, Georgia,
T. Marshall Hahn Collection
Illus. p. 302

137

Untitled (Radio), ca. 1940–42
opaque watercolor and pencil on printed
advertising paperboard
32 ½ × 24 ½ in.
Smithsonian American Art Museum,
Museum purchase through the Luisita L. and
Franz H. Denghausen Endowment, 2016.14.4
Illus. p. 303; detail, fig. 76

138

Man Reaching for Bottles, ca. 1939–42
pencil on cardboard
17 × 14 in.
Newark Museum, Newark, New Jersey,
Gift of Richard L. Huffman in honor of
Valrae Reynolds, 2006.34.1
Illus. p. 304

139

Untitled (Drinker), ca. 1939–42
poster paint and graphite on cardboard
13 × 11 ¼ in.
High Museum of Art, Atlanta, Georgia,
Purchase with funds from Mrs. Lindsey
Hopkins Jr., Edith G. and Philip A. Rhodes,
and the Members Guild
Illus. p. 305

140

Arched Drinker, ca. 1939–42
watercolor and pencil on cardboard
14 × 13 ¾ in.
The Museum of Modern Art, New York,
Gift of Marie-Josée and Henry R. Kravis
Illus. p. 305

141

Black Man with Bottle, ca. 1939–42
charcoal on cardboard
14 × 8 in.
Collection of Audrey B. Heckler
Illus. p. 306

142

Female Drinker, ca. 1939–42
gouache and pencil on cardboard
11 ½ × 8 ½ in.
The Metropolitan Museum of Art,
New York, Promised Gift of Charles E.
and Eugenia C. Shannon
Illus. p. 306

143

Green Man with Two Bottles, ca. 1939–42
poster paint and pencil on cardboard
13 ¾ × 10 ¾ in.
The William Louis-Dreyfus Foundation Inc.
Illus. p. 307

144

Red Man, ca. 1939–42
pencil and poster paint on cardboard
12 × 7 ¾ in.
Collection of Jerry and Susan Lauren
Illus. p. 308

145

Drinker in Chair, ca. 1939–42
pencil and poster paint on cardboard
11 × 8 ¼ in.
Collection of Douglas O. Robson, promised
gift to the Smithsonian American Art Museum
Illus. p. 309

146

Spread-Legged Drinker, ca. 1939–42
poster paint and pencil on cardboard
9 ⅛ × 13 ⅝ in.
Collection of Jerry and Susan Lauren
Illus. p. 310

147

Man Bent at Waist with a Bottle, ca. 1939–42
poster paint and pencil on cardboard
11 ¾ × 7 ½ in.
Louis-Dreyfus Family Collection
Illus. p. 311

148

Woman in "O" and "X" Pattern Dress,
ca. 1939–42
poster paint and pencil on cardboard
15 ⅛ × 7 ⅝ in.
Collection of Siri von Reis
Illus. p. 312

149

Untitled (ABCD Woman), ca. 1939–42
pencil and poster paint on cardboard
13 × 7 ½ in.
Collection of Robert M. Greenberg
Illus. p. 312

150

Woman with Bird, ca. 1940–42
watercolor and graphite on cardboard
13 ⅜ × 7 ⁵⁄₁₆ in.
Montgomery Museum of Fine Arts,
Montgomery, Alabama, Gift of Charles
and Eugenia Shannon, 1982.4.7
Illus. p. 313

151

Woman, ca. 1940–42
watercolor and graphite on cardboard
17 ⁹⁄₁₆ × 10 ¹¹⁄₁₆ in.
Montgomery Museum of Fine Arts,
Montgomery, Alabama, Gift of Charles
and Eugenia Shannon, 1982.4.25
Illus. p. 313

152

*Mexican Lady with Green and Red
Spotted Dress,* ca. 1939–42
paint and pencil on cardboard
12 ⅞ × 9 ⅛ in.
Collection of David F. Hughes
Illus. p. 314

153

Man and Woman Pointing with Dog,
ca. 1939–42
colored pencil and pencil on cardboard
22 × 14 in.
The William Louis-Dreyfus Foundation Inc.
Illus. p. 315

154

Man, Woman, ca. 1940–42
watercolor and graphite on cardboard
14 ⅛ × 21 ⅝ in.
Montgomery Museum of Fine Arts,
Montgomery, Alabama, Gift of Charles
and Eugenia Shannon, 1982.4.28
Illus. p. 316

155*

Woman Pointing at Man with Cane,
ca. 1939–42
poster paint and pencil on cardboard
17 ⅛ × 11 ⅛ in.
The William Louis-Dreyfus Foundation Inc.
Illus. p. 316

156

Woman, Blue Gloves, Brown Skirt,
ca. 1939–42
pencil and poster paint on cardboard
19 ⅝ × 9 in.
Collection of Jerry and Susan Lauren
Illus. p. 317

157*

Red-Eyed Man Smoking, ca. 1939–42
poster paint and pencil on cardboard
13 ¼ × 8 ¾ in.
The William Louis-Dreyfus Foundation Inc.
Illus. p. 318

158

Man Wearing Maroon and Blue with Bottle,
ca. 1939–42
poster paint and pencil on cardboard
15 ⅜ × 8 in.
The William Louis-Dreyfus Foundation Inc.
Illus. p. 318

159

*Pointing Man in Hat and Blue Pants
with Cane,* ca. 1939–42
poster paint and pencil on cardboard
19 ½ × 9 in.
The William Louis-Dreyfus Foundation Inc.
Illus. p. 319

160

Man with Two Canes, ca. 1940
poster paint and pencil on cardboard
20 ½ × 11 ¾ in.
Collection of Josh Feldstein
Illus. p. 319

161

Big Man, Small Man, ca. 1939–42
pencil and charcoal on cardboard
13 × 9 ¼ in.
Collection of Judy A. Saslow
Illus. p. 320; reverse, fig. 78

162

Man with Yoke, ca. 1939–42
pencil and gouache on cardboard
22 × 14 in.
Private collection
Illus. p. 321

163

Untitled (Man with Stogie), ca. 1939–42
pencil and opaque watercolor on paperboard
14 × 11 in.
Courtesy The Museum of Everything
Illus. p. 322

164

*Man in Black and Blue with Cigar and
Suitcase,* ca. 1939–42
pencil and poster paint on cardboard
21 ½ × 16 in.
Collection of Jerry and Susan Lauren
Illus. p. 323

165

Self-Portrait with Pipe, ca. 1939–42
pencil and colored pencil on cardboard
11 ½ × 7 ⅞ in.
Collection of Siri von Reis
Illus. p. 324

166

Untitled (Man in Blue Pants), ca. 1939–42
poster paint, pencil, colored pencil, and
charcoal on cardboard
10 ⅝ × 7 ¼ in.
High Museum of Art, Atlanta, Georgia,
T. Marshall Hahn Collection
Illus. p. 325

167

Man with Cane Grabbing Foot, ca. 1939–42
pencil and charcoal on cardboard
11 ½ × 7 in.
The William Louis-Dreyfus Foundation Inc.
Illus. p. 325

168

Man with Top Hat and Cane, ca. 1939–42
pencil and poster paint on cardboard
15 ¼ × 7 ¼ in.
Collection of Jerry and Susan Lauren
Illus. p. 326

169

Man in Blue Suit Pointing, ca. 1939–42
poster paint and pencil on cardboard
23 × 12 in.
Collection of Jerry and Susan Lauren
Illus. p. 327

170

Truncated Blue Man with Pipe, ca. 1939–42
poster paint and pencil on cardboard
9 × 9 ¼ in.
Louis-Dreyfus Family Collection
Illus. p. 328

171

Walking Man, ca. 1939–42
opaque watercolor and graphite pencil on
board
13 ¹⁄₁₆ × 7 ¼ in.
Whitney Museum of American Art, New York,
Gift of Eugenia and Charles Shannon, 95.215
Illus. p. 328

172

Untitled (Man in Blue and Brown),
ca. 1940–42
opaque watercolor and pencil on paperboard
15 × 11 ½ in.
Smithsonian American Art Museum,
The Margaret Z. Robson Collection, Gift of
John E. and Douglas O. Robson, 2016.38.91
Illus. p. 329

173

Untitled (Man with Blue Torso), ca. 1939–42
pencil and poster paint on cardboard
19 × 13 in.
Collection of Robert A. Roth
Illus. p. 329

174

Untitled (Blue Man on Red Object),
ca. 1939–42
poster paint and pencil on cardboard
11 ¾ × 7 ¾ in.
High Museum of Art, Atlanta, Georgia,
Purchase with funds from Mrs. Lindsey
Hopkins Jr., Edith G. and Philip A. Rhodes,
and the Members Guild
Illus. p. 330

175

*Untitled (Smoking Man with Figure
Construction),* ca. 1939–42
poster paint, crayon, and graphite on
cardboard
22 ³⁄₁₆ × 14 in.
High Museum of Art, Atlanta, Georgia,
Purchase with funds from Mrs. Lindsey
Hopkins Jr., Edith G. and Philip A. Rhodes,
and the Members Guild
Illus. p. 330

176

Untitled (Legs Construction with Blue Man),
ca. 1940–42
opaque watercolor, pencil, and charcoal
on paperboard
12 ¾ × 10 ½ in.
Smithsonian American Art Museum,
Museum purchase through the Luisita L. and
Franz H. Denghausen Endowment, 2016.14.3
Illus. p. 331

177

Figures, Construction, ca. 1940–42
watercolor and graphite on cardboard
13 ¹⁄₁₆ × 7 ¹⁵⁄₁₆ in.
Montgomery Museum of Fine Arts,
Montgomery, Alabama, Gift of Charles
and Eugenia Shannon, 1982.4.9
Illus. p. 332

178

*Figure Construction (Woman and Man
with Axe),* ca. 1939–42
gouache and pencil on cardboard
9 ⅝ × 7 ⅜ in.
The Museum of Modern Art, New York,
Gift of Charles and Eugenia Shannon
Illus. p. 333

179

Figures and Construction, 1941–42
pencil and watercolor on cardboard
10 ¼ × 7 ¼ in.
Morris Museum of Art, Augusta, Georgia
Illus. p. 333

180

*Untitled (Construction with Yawping
Woman),* ca. 1939–42
opaque watercolor and pencil on paperboard
13 ¼ × 11 in.
Smithsonian American Art Museum,
Museum purchase through the Luisita L. and
Franz H. Denghausen Endowment, 2016.14.1
Illus. p. 334

181

*Blue and Black Figures on Construction
with Orange Bird,* ca. 1939–42
poster paint and pencil on cardboard
12 ½ × 6 ¾ in.
Louis-Dreyfus Family Collection
Illus. p. 334

182

Figures, Construction, Black, Brown, Red,
ca. 1939–42
poster paint and pencil on cardboard
15 ¼ × 7 ¼ in.
Collection of Audrey B. Heckler
Illus. p. 335

183

*Untitled (Figures and Construction with
Blue Border),* ca. 1941
poster paint and pencil on cardboard
15 ½ × 8 in.
American Folk Art Museum, New York,
Gift of Charles and Eugenia Shannon,
1991.34.1
Illus. p. 335

184

Figures on Construction, Dog Treeing,
ca. 1939–42
poster paint and pencil on cardboard
15 ½ × 7 ⅛ in.
The William Louis-Dreyfus Foundation Inc.
Illus. p. 336

185

Figures and Construction with Cat,
ca. 1939–42
gouache and pencil on cardboard
13 ⅞ × 9 ⅛ in.
The Metropolitan Museum of Art,
New York, Promised Gift of Charles E.
and Eugenia C. Shannon
Illus. p. 336

186*

Construction with Exciting Event,
ca. 1939–42
poster paint and pencil on die-cut cardboard
12 × 12 in.
Louis-Dreyfus Family Collection
Illus. p. 337

187*

Figures, Construction, ca. 1940–42
watercolor and graphite on cardboard
14 ¼ × 8 ¾ in.
Montgomery Museum of Fine Arts,
Montgomery, Alabama, Gift of Charles
and Eugenia Shannon, 1982.4.14
Illus. p. 338

188*

Untitled (Red Bird on Construction),
ca. 1939–42
poster paint and pencil on cardboard
13 ¾ × 10 ¼ in.
Collection of Jerry and Susan Lauren
Illus. p. 338

189

*Untitled (Figure Construction in
Black and Brown),* ca. 1939–42
poster paint on cardboard
13 × 8 in.
Collection of Jocelin Hamblett
Illus. p. 339

190

Two Men, Dog, and Owl, ca. 1939–42
colored pencil and charcoal on cardboard
13 ¾ × 10 ⅞ in.
The William Louis-Dreyfus Foundation Inc.
Illus. p. 340

191*

Animated Events, ca. 1939
graphite and tempera on cardboard
12 ¾ × 6 ⅞ in.
San Antonio Museum of Art, Gift of
Dr. and Mrs. William Block in honor of
Dr. and Mrs. Harmon Kelley, 94.6
Illus. p. 340

192

Untitled, ca. 1939–42
colored pencil on cardboard
19 ¾ × 15 in.
Collection of Jan Petry and Angie Mills
Illus. p. 341

193

Untitled (Dog, Figures, and Tree), ca. 1939–42
pencil and opaque watercolor on paperboard
12 × 15 in.
Courtesy The Museum of Everything
Illus. p. 342

194

*Exciting Event (Man on Chair, Man with
Rifle, Dog Chasing Girl, Yellow Bird, and
Other Figures),* ca. 1939–42
poster paint, pencil, colored pencil, and
charcoal on cardboard
15 ½ × 11 ½ in.
The William Louis-Dreyfus Foundation Inc.
Illus. p. 343

195

Untitled (Lynching), ca. 1939–42
pencil and colored pencil on cardboard
10 ½ × 7 ¼ in.
Karen Lennox Gallery
Illus. p. 344

196*

Untitled, ca. 1939–42
poster paint and pencil on cardboard
11 ½ × 8 ½ in.
Private collection
Illus. p. 344

197

Figures and Trees, ca. 1939–42
pencil on cardboard
10 ¾ × 18 ½ in.
Kravis Collection
Illus. p. 345

198

Untitled (Man Carrying Dog on Object),
ca. 1939–42
poster paint and graphite on cardboard
13 ¼ × 7 ¼ in.
High Museum of Art, Atlanta, Georgia,

Purchase with funds from Mrs. Lindsey
Hopkins Jr., Edith G. and Philip A. Rhodes,
and the Members Guild
Illus. p. 366

199

Untitled (Red Goat with Snake), ca. 1940–42
opaque watercolor and pencil on paperboard
11 ¾ × 14 ¼ in.
Smithsonian American Art Museum,
Gift of Judy A. Saslow, 2016.15
Illus. p. 367

200

Black Turkey, ca. 1939–42
poster paint and pencil on cardboard
14 ½ × 11 in.
Lucas Kaempfer Foundation
Illus. p. 368

201

Untitled (Seated Woman), ca. 1940–42
opaque watercolor and pencil on paperboard
14 ½ × 8 in.
Smithsonian American Art Museum,
The Margaret Z. Robson Collection, Gift of
John E. and Douglas O. Robson, 2016.38.92
Illus. p. 368

202

Black Jug, ca. 1939–42
pencil and poster paint on cardboard
14 ³⁄₁₆ × 13 ³⁄₁₆ in.
Collection of Jay Schieffelin Potter
Illus. p. 369

203

Figure with Construction on Back,
ca. 1939–42
poster paint and colored pencil on cardboard
12 ⅜ × 8 ¼ in.
Collection of Judy A. Saslow
Illus. p. 370

204

Man with Cane on Construction, with Dog,
ca. 1939–42
poster paint, pencil, and colored pencil on
cardboard
14 × 7 in.
Louis-Dreyfus Family Collection
Illus. p. 371

205

Man Pointing with Three Birds, ca. 1939–42
crayon on cardboard
10 ¾ × 10 ¼ in.
Collection of Robert A. Roth
Illus. p. 382

ACKNOWLEDGMENTS

As *Between Worlds* fully evidences, Bill Traylor was a singular and notable figure. To properly historicize and assess the art of a person whose life was so scantily recorded—apart from the images he made—has been a challenging undertaking, one that readily brings to mind the adage "it takes a village." I am profoundly gratefully to the many individuals and institutions who generously contributed their time and knowledge, shared art and archives, and untiringly supported an endeavor that, in answer to the enormity of the task, grew considerably from its original conception. Without so many capable and caring hands joining leagues to nurture and shape this project with me, it would simply not have been possible.

For an African American man like Traylor, whose memories reached into a dark historical wellspring, making an artistic record of one's recollections, dreams, and visions in midcentury Montgomery was bold and brave. Artists and writers in the city took notice, and to them we owe a collective debt of gratitude for caring about, and for, the body of work that is the focus of this project. Some of the individuals belonged to the progressive artists' coalition called the New South. Critical to the recognition of Traylor's art were Jay Leavell, Charles Shannon, John Lapsley, Blanche Balzer (Shannon) Angell, and Jean and George Lewis. Leavell and Shannon each provided Traylor with a significant amount of cardboard supports and art supplies. Several New South members purchased art from Traylor and saved it. Shannon compiled, with the help of his then-wife, Blanche Balzer (Shannon) Angell, a collection that comprises what is today the majority of Traylor's existing works. Shannon and the Lewises took photographs that, together with a handful of those by photojournalists, constitute the sole photographic record of Traylor and his art.

In his most active art-making years, when Traylor was living predominantly on the streets of Montgomery, his family had a limited awareness of his artistic activity; a broader understanding of its scope and significance came many years later. I am grateful to the members of Bill Traylor's family, whose support has been critical.

I dedicate this project to them. I extend special thanks to the artist's granddaughters Margaret Traylor Staffney and Myrtha Lee Traylor Delks, and his great-granddaughters Leila Greene, Antoinette Staffney Beeks, Nettie Trayler-Alford, and other descendants, who gave interviews in years past and recorded personal memories that were vital to the effort of piecing together details of a life that, in formal terms, went largely undocumented. Other family members who have been involved with the research for *Between Worlds* are Shirley Ann Trayler, Frank Harrison Jr., Margina Elizabeth Staffney Tyler, Cynthia Trayler Bond, Christine Delks, Ernestine Delks, Kimberly Delks, Denise Delks Jenkins, and Nettie Williams.

For helping me with the monumental task of unearthing and interpreting the available records for Bill Traylor's life and that of his family, I am profoundly grateful to curatorial assistant Stacy Mince at the Smithsonian American Art Museum (SAAM), who served as primary research assistant for *Between Worlds* but made herself particularly invaluable through her dogged pursuit of innumerable historical documents and her untiring scrutiny of faint, barely legible handwriting in nineteenth- and early twentieth-century records. Her construction of the family trees for both black and white Traylor families, her dedication, and her extraordinary research skills added to this effort immeasurably.

I am indebted to several scholars who conducted research on Bill Traylor in earlier years. Historian Mechal Sobel has been a consultant since the early days of this project and deserves recognition for being the first to correctly identify Dallas County, Alabama, as the place of Bill Traylor's birth. Sobel's relocation of Traylor's birth family shifted the appropriate records from Lowndes County (where Traylor went to live in 1863) to Dallas County, which revealed the proper slave schedules and estate records pertaining to his birth family and homed in on the most likely birth date for Traylor, namely, April 1, 1853. Traylor's birthplace has been erroneously publicized as Lowndes County, where he lived a large part of his life; that misinformation was taken as gospel for so long that Sobel's revelation was dismissed by many as merely an outlying possibility. After carefully following all available records, however, I concur with Sobel that the details of Traylor's birth trace to Dallas County and the plantation of John Getson Traylor; when Bill was about ten years old, he and his remaining family members relocated to the Lowndes County plantation of John's brother, George Hartwell Traylor. Several records unearthed during the research for *Between Worlds* led to conclusions that diverge from Sobel's on matters other than Traylor's birthplace, but Traylor's point of origin is a key to the larger puzzle.

Director, producer, and editor Jeffrey Wolf and writer Fred Barron have devoted years to tracking down details about Bill Traylor. Their creation of the film *Bill Traylor: Chasing Ghosts* (2018, Breakaway Films) dovetailed with my research for *Between Worlds* for SAAM. I have worked closely with Wolf, who graciously shared information that he, Barron, and other collaborators on *Chasing Ghosts* gathered over the years. Although our projects were ultimately independent of each other, we have partnered in many ways and together navigated many tangled roads of research and rumination. Wolf and Barron have been dedicated to retracing the path of Traylor's life and situating

his art within the context of its built and natural environments. I am grateful to them. Alabama natives Marcia Weber and Miriam Rogers Fowler were the first to connect Traylor's art to some of the physical structures of his world, especially in the earlier, rural part of his life. Luise Ross and Susan M. Crawley further explored those ideas. Subsequent projects, including mine, stand on the shoulders of their collective efforts.

In 1988, Fowler was appointed director of the Alabama State Artists Gallery in Montgomery, where she conducted interviews with many who knew Traylor, and her work verified details (regarding family and New South members) and captured ephemeral perspectives that informed this project immeasurably. Fowler passed away in 2012, but her friend and cohort Marcia Weber has been among the most ardent supporters of *Between Worlds*. Weber began to research Traylor and the New South in 1984 and continues to pursue that work. She generously shared her files, tapes, and photographs, made introductions, helped me navigate the rural Alabama of Traylor's youth and the Montgomery of his senior years, and spent hours by my side in the Alabama Department of Archives and History chasing missing links and stray details; I sincerely appreciate her devotion. Margaret Lynne Ausfeld, among the earliest advocates for Traylor's work, graciously shared the resources compiled over the years at the Montgomery Museum of Fine Arts and supported this project on numerous fronts.

Special thanks go to Jack R. Harris Sr., who made available to me for consultation an unpublished manuscript by his late wife, Derrel B. DePasse, "Memories Within: The Life and Art of Bill Traylor" (1996). While my own manuscript for *Between Worlds* was largely complete when I first read "Memories Within," I was intrigued by the number of common threads that DePasse and I had independently teased out of Traylor's work and followed into the literature, folklore, and narratives of formerly enslaved people. Most often these leads took us to varied ends, but in art such as Traylor's a myriad of perspectives is invaluable. DePasse had conducted and drew upon her interviews with Traylor family members (black and white) from the 1990s, which provided significant information that is no longer obtainable.

Had DePasse completed her project on Traylor, she might have been the first to publish a well-considered investigation of folk magic specific to Traylor's imagery. As early as 1969, pioneering scholar Robert Farris Thompson explored the connectedness between African American art and its African roots, which laid the groundwork for scholars thereafter. In 2003, in her book *African Voices in the African American Heritage*, Betty M. Kuyk probed potential African roots (visual and conceptual) in Traylor's work and broached the topic of conjure and "rootwork" in a broad discussion of African American self-taught artists, and Sobel proposed connections between Traylor's art and conjure culture in her *Painting a Hidden Life* (2009). I am indebted to Randall Morris, an independent researcher and gallerist, who has also closely examined and lectured on Traylor's art in relation to conjure or hoodoo; our ongoing conversation about the arcane subtexts in the imagery, the artist's consciousness, and the unimaginable weight of racial oppression as a fact of daily life for Traylor and his family served as a reliable compass anytime I felt myself wavering.

Ann Fowler shared her unpublished master's thesis on the New South, which provided additional valuable firsthand accounts from the group's members. I sincerely thank Montgomery historian Mary Ann Neeley, who supplied expert knowledge about historic Montgomery, and Alison Lebovitz for contributing information about and images of her family, the Varons, who were Traylor's neighbors there, near the Pekin Pool Room. Kendall Buster, the sculptor, professor, and descendant of George Hartwell Traylor, shared photographs and childhood memories about the plantation in Benton County where Bill spent many decades; I am truly grateful for her input and belief in this project's merit.

Assistance from the archivists and librarians who granted access to and helped locate research materials was invaluable. I particularly want to thank the respective staff at the Alabama Department of Archives and History, Montgomery, and the Estelle and Melvin Gelman Library of George Washington University, Washington, DC, as well as Samantha McNeilly in the Archives and Special Collections offices of the Auburn Montgomery Library at Auburn University, Alabama, and Anne C. Evenhaugen, head librarian for the American Art and Portrait Gallery Library of the Smithsonian Libraries, Washington, DC.

Projects that entail exhaustive research and a high number of far-flung loans require tremendous resources, and I am inestimably grateful to the individuals, corporations, and grantors who helped make *Between Worlds* possible. Terry Stent and Robert Davidson early on added their voices to mine in advocating for the importance of strengthening SAAM's holdings of Bill Traylor's art; their clarity and belief were bedrock to this effort. Judy A. Saslow put tremendous wind in our sails by offering major support, and her donation of *Untitled (Red Goat with Snake)* (pl. 199) evidenced exceptional generosity and faith in SAAM's stewardship. Judy's heartfelt commitment to Traylor's legacy extended to helping the Museum build an exemplary holding of his art and lending key works to the exhibition; my gratitude to her is infinite. I am also extremely thankful to Micki Beth Stiller, who shared her time, thoughts, and Montgomery connections and donated the Traylor painting *Untitled (Chase Scene)* (pl. 83) to SAAM. The Art Mentor Foundation Lucerne and Sheila Duignan and Mike Wilkins also provided crucial and much-appreciated backing. Douglas O. Robson donated five artworks by Bill Traylor and supported the exhibition's related symposium in honor of his mother, Margaret Z. Robson, and many other donors helped bring this exhibition and publication into being.

Other supporters of *Between Worlds* include Betsy Broun, Faye and Robert Davidson, Josh Feldstein, Jocelin Hamblett, Marianne and Sheldon B. Lubar, the Herbert Waide Hemphill Jr. American Folk Art Fund, Just Folk/Marcy Carsey and Susan Baerwald, the Lucas Kaempfer Foundation, The Margery and Edgar Masinter Exhibitions Fund, Morton Neumann Family Foundation, Kelly Williams and Andrew Forsyth, Jeanne Ruddy and Victor Keen, Jan Petry, Helen Burnham and George Jacobs, Karol Howard and George Morton, Penny and Allan Katz, Margaret Parsons, Carl and Marian Mullis, and Kenneth Walker. Angela Usrey and Willie Young generously donated in memory of one of Bill Traylor's greatest enthusiasts, William Louis-Dreyfus.

Since Traylor's art first went on the market in the late 1970s, a number of professionals at galleries and auction houses have worked with Traylor's art, and I called on many of them to help locate works that had changed hands over the years. I could not have done this without the involvement of Tom Parker and the staff at Hirschl & Adler Modern, Carl Hammer, Frank Del Deo, Luise Ross, Frank Maresca and Roger Ricco, John Ollman, Susan Baerwald, Betty Cuningham, Stephen Romano, and Karen Lennox. I extend thanks also to Tim Hill, Maggie Hill, Cara Zimmerman, and Nancy Rosen.

The public and private lenders are the foundation to *Between Worlds*, as are the museum colleagues who advised or consulted in important ways. My friend and longtime Traylor advocate and collector William Louis-Dreyfus passed away before *Between Worlds* came to fruition. Over the course of many years, William shaped the single largest collection of Traylor's art. He was passionate about honoring the artist, who had the temerity to make art in a society that might begrudge him the mere act of holding a pencil. William made his holdings available to me many times over the years and enthusiastically shared his thoughts and insights on the art he stewarded; he was unfailingly generous in lending works and ever supportive of the long path I had to travel for this project, even as it became increasingly clear that he would not be present at its end.

Individual, foundation, and gallery lenders include Scott Asen, Jill and Sheldon Bonovitz, Mr. and Mrs. Paul Caan, Mickey Cartin, Christian P. Daniel, Tom de Nolf, Josh Feldstein, Peter Freeman, Robert M. Greenberg, Robert Grossett, Jocelin Hamblett, the Harmon and Harriet Kelley Foundation for the Arts, Audrey B. Heckler, David F. Hughes, Penny and Allan Katz, the Lucas Kaempfer Foundation, Karen Lennox Gallery, Victor F. Keen, the Kravis Collection, Jerry Lauren, the Louis-Dreyfus Family Collection and the William Louis-Dreyfus Foundation Inc., Marianne and Sheldon B. Lubar, Patty and Mark McGrath, Michael Rosenfeld Gallery, Jan Petry and Angie Mills, Jay Schieffelin Potter, Douglas O. Robson, Luise Ross, Toni Ross, Robert A. Roth, Jillian Sackler, Judy A. Saslow, the James D. & Sylvia I. Vail family, Siri von Reis, Barbara and John Wilkerson, and several lenders who choose to remain anonymous.

Many museum colleagues assisted in various ways and facilitated loans of art. They include Valérie Rousseau and Ann-Marie Reilly, American Folk Art Museum, New York; Katherine Jentleson and Frances Francis, High Museum of Art, Atlanta, Georgia; Sylvia Yount and Betsy Kornhauser, The Metropolitan Museum of Art, New York; Margaret Lynne Ausfeld and Pamela Bransford, Montgomery Museum of Fine Arts, Alabama; James Brett, Maria del Rosario Gallo, and Robin Mann, The Museum of Everything; Christophe Cherix and Emily Edson, The Museum of Modern Art, New York; Kevin Grogan and Stacey Thompson, Morris Museum of Art, Augusta, Georgia; Lynne Cooke, National Gallery of Art, Washington, DC; Tricia Laughlin Bloom and Heidi Warbasse, Newark Museum, New Jersey; Ann Percy, Shelley Langdale, and Nancy Leeman, Philadelphia Museum of Art, Pennsylvania; Adam D. Weinberg, Donna De Salvo, Barbara Haskell, Jessica Pepe, Whitney Museum of American Art, New York; Lisa Stone, Roger Brown Study Collection, School of the Art Institute of

Chicago, Illinois; and Anne Evenhaugen and Kirsten van der Veen, Smithsonian Libraries, Washington, DC.

A number of individuals shared their thoughts and memories with me for this project; their recollections helped stitch together a tapestry that, at the outset, comprised more holes than cloth. In addition to those already mentioned are Susan M. Crawley, Jack Lindsey, Frank Maresca, Richard Oosterom, Margo Russell, Luise Ross, and Joseph H. Wilkinson, the latter of whom donated a rare copy of the handmade exhibition booklet *Bill Traylor: People's Artist* (1940) to the Special Collections of the Smithsonian American Art Museum and National Portrait Gallery Library of the Smithsonian Libraries. Beth Spivey showed me the lay of the land in Lowndes County on multiple occasions and shared her expertise as lifelong local resident, historian, and curator at Selma's Old Depot Museum. A special thank-you goes to Brian Shannon of BMS Art, Chicago, who supported this project on too many fronts to articulate and was persistently sharp, organized, proactive, and generous in propelling myriad goals forward and sharing knowledge. I also thank David L. Hughes, Angela Usrey, and Bill Luckett, each of whom went above and beyond in helping generate support for this multifaceted effort.

Others, too, offered critical help in seeking works of art, securing loans, and providing information. They include Peter Lunder, Mary Anne Costello, Gabrielle Lavin Suzenski, Alexandra Batsford, Thea Smolinski, Lisa Stone, William Keyse Rudolph, Steven Holmes, Gary Owen, Laura Wiley-Donohue, and Karolynne McAteer. I would like to thank Caroline Cargo, Tommy Giles, Eugenia Carter Shannon, Eugenia Shannon Pyrlik, and collectors of Bill Traylor's work who made historical photographs and images of their art available for this publication.

I owe a special thanks to artist Kerry James Marshall, who has pondered Bill Traylor and his art at length and given considerable time to this project. In his introduction to this volume, Marshall poses important questions about the indelible imprints of race and class disparity that saturate and surround Traylor's art. From the Jim Crow era to the America of today, ethnocentrism has become deeply ingrained. Marshall asks us to interrogate its relative viewpoints and long shadows as well as the question of whether one group can ever fully see or understand the art of another. I am also extremely grateful to musicians Jason Moran and Marvin Sewell for their original *Untitled: (Blue)*, an improvisational duet response to the art of Bill Traylor, performed at SAAM.

The unparalleled team at SAAM ultimately brought this project into being. Betsy Broun, director emerita, was at the helm when I proposed *Between Worlds;* without her heartfelt enthusiasm it would never have taken wing. Betsy well understood the necessity of expanding the story of American art to include self-taught and vernacular artists and minority cultures. Preceding her tenure, when SAAM was still called the National Collection of Fine Arts (NCFA), the Museum was among the first major institutions to take an interest in art by untrained artists. In 1970, NCFA/SAAM initiated one of the first specialized collections of this material within an American art museum, both to foster groundbreaking scholarship and actively integrate it into

a large framework of historical art. Broun's advocacy for strengthening the Museum's collection toward a still-greater historical balance and advancing scholarship and recognition of artists such as Bill Traylor through solo exhibitions and publications were of critical importance. Stephanie Stebich took the helm as the Margaret and Terry Stent Director in the project's challenging final stages and has been equally stalwart in her support; I extend my sincere thanks to her for helping bring *Between Worlds* to fruition.

I am grateful to all my curatorial colleagues for their endorsement of this project. I have already noted Stacy Mince, curatorial assistant, who was invaluable. I give heartfelt thanks to SAAM's Chief Curator Virginia Mecklenburg, who reviewed, counseled, and offered unflagging interest at every juncture, and to Senior Curator Eleanor Jones Harvey for sharing her knowledge on antebellum plantation culture and advising on aspects of researching nineteenth-century history. Betsy Anderson, Laura Augustin, Anne Hyland, and Jean Lavery provided crucial administrative support. Debra Purden assisted with preliminary records and locating artworks. Deputy Director Rachel Allen oversaw the budget, Advancement Specialist Kate Earnest was dedicated and enthusiastic throughout the project, and Chief Development Officer Donna Rim provided the road map for making it happen. In the Registrar's office, Heather Delemarre deftly managed shipping and insurance for the large number of borrowed works of art, domestic and international.

I am exceptionally grateful for the heavy lifting done by those involved in the publication of this book, first among them the outside peer reviewers whose keen and valuable insights strengthened this volume. Director of Publications Theresa Slowik secured and expertly managed arrangements with Princeton University Press. SAAM senior editor Mary Cleary and independent editor Jane McAllister worked together to verify facts and harness and hone a daunting manuscript; with dedication and aplomb, they improved my efforts tenfold. Publications designer Karen Siatras envisioned and carried out an inspired publication design entirely worthy of Bill Traylor. Eleni Giannakopoulos of GPO Creative and Digital Media Services wrangled complex family trees into a cogent layout, Emily Guth Schlemmer researched the copyright for Bill Traylor's art, and permissions coordinator Amy Doyel handled copious rights and reproduction agreements. Exhibitions designer Sara Gray expertly wove skill, passion, and respect into her design with help from Chief of Exhibitions David Gleeson, AV-media arts specialist Harvey Sandler, and graphic designer Grace Lopez. Offering protection to these fragile works of art were lighting designer Scott Rosenfeld, who created an environment that was safe but illuminating; paper conservator Catherine Maynor, who provided advice and care for delicate works made on compromised supports; and graphic arts collection manager Denise D. Wamaling, who graciously made the art available to me time and again. Media conservator Daniel Finn digitalized archival audio and video files to preservation-level specifications so that the interviews they contained could be maintained long-term; exhibits specialist Thomas Irion and frame conservator Martin Kotler gave thoughtful attention to the matting and framing of the seventeen Traylor works in SAAM's collection, and to other details

for the exhibition. Senior Curator of Contemporary Interpretation Joanna Marsh and Kress Interpretive Fellow Melissa M. Hendrickson provided strategies for visitors to better access and apprehend the exhibition, and Elizabeth Dale Deines created resources for educators. Laura Baptiste oversaw press inquiries, the media campaign, and public programs with the aid of Angelica Aboulhosn, Gloria Kenyon, and Chavon Jones; I sincerely thank them all.

The work of many additional hands and minds is less visible but invaluable and includes the support of my friends and family who saw less of me and shouldered countless extra burdens during the project's course. I hold them in my heart and am forever grateful. I further dedicate *Between Worlds* to the memory of my mother, whose absence these past seven years has been felt acutely, and to my son, who generates joy and meaning in each new day.

LESLIE UMBERGER
Curator of Folk and Self-Taught Art
Smithsonian American Art Museum

NOTES

The following abbreviations in **bold** are used in the notes for frequently cited interviews. The abbreviations (interviewer's name followed by interviewee's) are listed/indented under their respective sources, whether books, articles, or collections of papers or files. The DePasse, Maresca and Ricco, and Sobel books, in the list below, appear in the notes in short form only, as references to them are usually to the interviews contained in them.

Traylor family papers follow the interviews; the frequently cited family reunion booklets are likewise abbreviated. The interviews and family papers are not repeated in the bibliography, where they would otherwise constitute a distinct Archives section.

Interviews

DePasse, Derrel B. "Memories Within: The Life and Art of Bill Traylor." Unpublished manuscript, 2000 (irregularly paginated). Access granted by Jack R. Harris Sr., Nov. 14, 2017. Copy in the author's curatorial files. DePasse's original interview transcripts were not located during research for *Between Worlds*.

> **DePasse/R. Buster interview, 1996:** Ralph Dewitt Buster, July 11, 1996, Sardis, AL. Ralph Buster (1924–2010) was the husband of Jennie Kendall Traylor (1927–1995), who was daughter of George Boyd Traylor and one of two great-granddaughters of George Hartwell Traylor.

> **DePasse/Greene interview, 1999:** Leila Harrison Fields Greene, Nov. 11, 1999, location unknown. Greene is a great-granddaughter of Bill Traylor.

> **DePasse/Lapsley interview, 1996:** John Lapsley, July 12, 1996, location unknown.

> **DePasse/Leavell Fleming interview, 1996:** July 13, 1996, [Montgomery, AL]. Jay Leavell's widow, when remarried, became Jo Leavell Fleming.

> **DePasse/Staffney interview, 1996:** Margaret Traylor Staffney, July 9, 1996, Montgomery, AL. Staffney is a daughter of Will Traylor and granddaughter of Bill Traylor.

Fowler, Ann. "The New South." Unpublished graduate research paper, Emory University, Atlanta, GA, 1990. Copy in the author's curatorial files with permission from A. Fowler.

> **A. Fowler interviews, 1988, 1989:** Crawford Gillis, John Lapsley, Jean Lewis (Mar. 3, 1989), Mattie Mae Knight Sanderson (Mar. 5, 1989), and Charles Shannon, Montgomery, AL.

Fowler, Miriam Rogers. Files on Bill Traylor. In Collection of Jeffrey Wolf, New York.

> **M. R. Fowler/Angell interview, 1990:** Blanche Balzer (Shannon) Angell, July 29, 1990, at Balzer's home, Fort Collins, CO. Copy of transcript in the author's curatorial files.

———. Papers, in Bill Traylor curatorial files. Montgomery Museum of Fine Arts, AL. Copies of select (unpaginated) transcripts of taped interviews are in the Collection of Jeffrey Wolf, New York, and the author's curatorial files.

> **M. R. Fowler and Weber/R. Buster interview, ca. 1993:** Weber made notes of conversations between Fowler and Ralph DeWitt Buster, around 1993, in Sardis, AL. Weber, personal files shared with the author, 2015–17; copy in the author's curatorial files.

Maresca, Frank, and Roger Ricco, *Bill Traylor: His Art, His Life* (New York: Alfred A. Knopf, 1991).

Maresca and Ricco/C. Shannon interview, 1989: Charles Shannon described his artist-to-artist relationship with Bill Traylor to gallery co-owners Maresca and Ricco; Montgomery, AL, Nov. 1989. Shannon's remarks about Traylor, including his "quotes" by Traylor, are heavily referenced in *Between Worlds*; the precision of Traylor's exact words and meaning will remain unknown. Wherever Shannon is noted as "quoting" Traylor, his phrasing should be considered paraphrasing; "paraphrasing" is sometimes used herein for emphasis.

Lyle Rexer/C. Shannon interview, 1990: A follow up, on Mar. 4, 1990, by telephone, to the interview by Maresca and Ricco, 1989. An audio recording and written transcript provided by Ricco/Maresca Gallery, New York, are in the author's curatorial files.

Sobel, Mechal. *Painting a Hidden Life: The Art of Bill Traylor.* Baton Rouge: Louisiana State University Press, 2009.

Sobel/Staffney interviews, 1993, 1995: Margaret Traylor Staffney, June 15, 1993, and Feb. 29, 1995, Montgomery, AL.

Stiller, Micki Beth. Montgomery, AL. John Lapsley's notes provided to Stiller by James Hedges; copy in the author's curatorial files.

Lapsley/Hedges interview, ca. late 1980s–early 1990s: Lapsley made notes (undated) of his conversation with James R. (Jimmy) Hedges III (1942–2014) but did not record it. Location unknown, the late 1980s or early 1990s. (The James R. Hedges III and the Rising Fawn Gallery Papers are in the Archives of American Art, Smithsonian Institution, Washington, DC.)

Weber, Marcia. Personal files on Bill Traylor. Originals given to Alabama Folk Artists Collection, 95/3. Archives and Special Collections, Auburn University at Montgomery Library, AL. Copies of files shared, in part, with the author.

M. R. Fowler and Weber/Delks, Greene, and Staffney audio interview, 1992: At the Traylor family reunion held Aug. 7–9, 1992, in Atlanta, GA, Miriam Rogers Fowler and Marcia Weber recorded (on audio) an interview with Myrtha Lee Delks, Leila Greene, and Margaret Traylor Staffney. Weber provided the author a copy of the resulting cassette tape, which SAAM transferred to CD; the recording and a transcript are in the author's curatorial files. M. R. Fowler and Weber also videotaped parts of the reunion, including the presentation of Bill Traylor's art by Luise Ross.

Kogan and Weber/Staffney video interview, 1992: Several days after the Traylor family reunion held Aug. 7–9, 1992, Marcia Weber videotaped Lee Kogan interviewing Margaret Traylor Staffney. Weber provided to the author the resulting Hi-8 video, which SAAM transferred to DVD; a DVD is in the author's curatorial files.

Weber/Leavell Fleming conversations, 1984: Weber and Jo Leavell Fleming had many conversations in 1984 in Montgomery, AL, regarding Jo's late husband Jay Leavell's interactions with Bill Traylor. In Apr. 2016, Weber shared her memories of these conversations with the author via telephone.

Umberger, Leslie. Interview of Frank Maresca, codirector Ricco-Maresca Gallery, New York, by telephone, May 31, 2017. Transcript in the author's curatorial files.

Umberger/Maresca interview, 2017

Wolf, Jeffrey. Files on Bill Traylor. Collection of Jeffrey Wolf, New York. All interviews conducted by Wolf cited herein were for his film *Bill Traylor: Chasing Ghosts*, Breakaway Films, 2017–18. Copies of transcripts in the author's curatorial files.

Wolf/Delks interview, 2017: Myrtha Lee Delks, Oct. 4, 2017, Detroit, MI, accompanied by Antoinette Staffney Beeks.

Wolf/Williams interview, 2018: Starlene Trayler Williams, a great-granddaughter of Bill Traylor, Mar. 27, 2018, Montgomery, AL.

Mince and Wolf/Harrison interview, 2018: Stacy Mince and Jeffrey Wolf interview of Frank L. Harrison Jr., a great-grandson of Bill Traylor, Feb. 26, 2018, Fort Washington, MD.

Traylor Family Papers

Beeks, Antoinette Staffney, comp. "Descendants of Bill Traylor." 1993. Given to Jeffrey Wolf, New York, 2017; copy in the author's curatorial files.

Beeks, Antoinette Staffney, ed. "Traylor-Calloway-Durant Family: The Bond that Ties, August 7–9, 1992, Atlanta, Georgia." Unpublished booklet for a family reunion. Marcia Weber, personal files shared with the author, 2015–17; copy in the author's curatorial files.

1992 reunion booklet

Trayler-Alford, Nettie, ed. "Traylor-Calloway-Durant Family Reunion Weekend, August 9–11, 1991." Unpublished booklet for reunion held in Detroit, MI. Marcia Weber, personal files shared with the author, 2015–17; copy in the author's curatorial files.

1991 reunion booklet

Census records, birth, death, and marriage certificates, and other vital documents are usually referenced only generally in the notes; their sources and repositories are given in full in the bibliography. All censuses mentioned are federal censuses unless otherwise stated. For the treatment of names, see *Names* in Notes to the Reader, p. 22. To cross-reference among notes from various parts of *Between Worlds*, note sections are referenced in shorthand as LifeA, LifeB, ArtA, ArtB, ArtC, and Afterlife (whereas the simple "above" or "below" refers to a note in the same section). The acronym SAAM is sometimes used for Smithsonian American Art Museum; ADAH is Alabama Department of Archives and History, Montgomery. For brevity, with few exceptions, web addresses for online sources are given in the bibliography but not in the notes; where "(website)" is indicated, readers are directed to Blogs and Websites in the bibliography.

Director's Foreword *(pp. 11–13)*

Epigraph: Langston Hughes, "I, Too, Sing America," from *The Poetry of the Negro, 1746–1970*, ed. Langston Hughes and Arna Bontemps (New York: Doubleday, 1970), 182.

1 Equal Justice Initiative (website). The National Memorial for Peace and Justice and the Legacy Museum opened in Montgomery, Alabama, on April 26, 2018. The Equal Justice Initiative partnered with artists including Kwame Akoto-Bamfo, Dana King, and Hank Willis Thomas and designers from Mass Design Group, Boston, in creating the monument and museum. See also LifeB.n70, ArtB.n48.

2 Philip Kennicott, "A Memorial That Refuses to Let Dixieland Look Away," *Washington Post*, April 25, 2018.

Notes to the Reader *(pp. 19–23)*

1 In *Barracoon: The Story of the Last "Black Cargo"* (New York: Amistad, an Imprint of HarperCollins Publishers, 2018), Zora Neale Hurston (156n5) and Deborah G. Plant (introduction) discuss Kossola's name and its variations. Sylviane A. Diouf, *Dreams of Africa in Alabama: The Slave Ship Clotilda and the Story of the Last Africans Brought to America* (New York: Oxford, 2007), cites Hurston's "Barracoon" manuscript, archived in Box 164–86, file 1, Alain Locke Collection, Manuscript Department, Moorland-Spingarn Research Center, Howard University, Washington, DC. For slaves arriving from Africa and the *Clotilda*, see herein part one, "The Life of Bill Traylor" (p. 37), and LifeA.n7.

2 Alain Locke, review of Zora Neale Hurston's *Their Eyes Were Watching God: A Novel* (1937), in *Opportunity*, June 1, 1938.

3 Richard Wright, "Between Laughter and Tears," review of Hurston's *Their Eyes Were Watching God* (1937), *New Masses*, Oct. 5, 1937.

4 Claudia Roth Pierpont, "A Society of One: Zora Neale Hurston, American Contrarian," *New Yorker*, Feb. 17, 1997.

5 For information on the slave narratives collected as a Federal Writers' Project in the 1930s, see ArtA. n6.

6 Plant, introduction to Diouf, *Dreams of Africa in Alabama*, citing Charlotte Osgood Mason in Hurston's "Barracoon" manuscript, p. xxv.

Beatitudes of Bill Traylor *(pp. 25–29)*

Epigraph: Kerry James Marshall, an adaptation of the Bible's Beatitudes, Matthew 5:3–12, written for his introduction to *Between Worlds*.

1 Albert C. Barnes, quoted in Steve Conn, "The Politics of Painting: Horace Pippin the Historian," *American Studies* 38, no. 1 (Spring 1997): 5.

2 "Horace Pippin, 57, Negro Artist, Dies," *New York Times*, July 7, 1946, cited in ibid.

3 Roberta Smith, "Rays of Light and Menacing Shadows: Roberta Smith's 2013 Art Highlights, and Some Concerns," *New York Times*, Dec. 12, 2013.

4 Arthur C. Danto, *Beyond the Brillo Box: The Visual Arts in Post-Historical Perspective* (New York: Farrar, Straus and Giroux, 1992), 5.

5 E. H. Gombrich, *The Preference for the Primitive: Episodes in the History of Western Taste and Art* (New York: Phaidon, 2002), 297.

6 Charles Shannon, quoted in Josef Helfenstein, "Bill Traylor and Charles Shannon: A Historic Encounter in Montgomery," in *Bill Traylor, 1854–1949: Deep Blues*, ed. Josef Helfenstein and Roman Kurzmeyer, exh. cat. (New Haven, CT: Yale University Press, 1999), 97. The full passage reads: "It was with the experiences of that summer sharpened by the perspective gained in the North that I began to feel what this country down here really meant to me. I worked with the negroes in building my cabin for two months. . . . I went to their churches with them, to their dances and drank with them—I saw expressions of primitive souls. I came to love this land—the plants and the people that grew from it."

7 Robert Hughes, "Finale for the Fantastical: Washington's Corcoran Mounts a Fiery, Marvelous Folk Show," *Time*, Mar. 1, 1982, 71.

8 Kobena Mercer, *Welcome to the Jungle: New Positions in Black Cultural Studies* (New York: Routledge, 1994), 246–47.

Prologue *(pp. 31–35)*

1 Bill Traylor would cite his birth date as April 1; based on evidence collected for this project, the author finds the best approximation of his birth year to be 1853. Pleasant Hill would have been the closest town to the farm on which he was born. It has been repeatedly written that Traylor was born on the plantation of George Hartwell Traylor; accounts, including John Getson Traylor's estate files, land records, plats, land warrants, and deed books, prove

otherwise. The spelling of Getson is presumed to have come from John's patrimonial line; another spelling, Getzen, was attached to his matrilineal line. Records use John G. or J. G. (as he is often referred to herein) and are not clear on the preferred spelling of his middle name.

2 Traylor may have had children beyond the bounds of his three marriages (two legal, one common law) and the records that pertain to them; any such children are beyond the scope of this study.

3 After fulfilling Traylor's request by writing a letter to Traylor's daughter Easter (often spelled Esther on documents) in Detroit, Michigan, Charles Shannon received a response from her noting that her father had attempted to live with various adult children outside the South on several occasions, but those stays had never lasted. Her letter states that he had spent stretches in Chicago, New York, Philadelphia, Washington, DC, and "other different places." Shannon references Easter's letter in Maresca and Ricco/C. Shannon interview, 1989, 22.

 For all Traylor's accounted-for fifteen children (including one stepchild), documents that explain their whereabouts between 1940 and 1946, when Bill might have traveled to see them, exist for only a few. Easter and Walter were living in Detroit. Lillian was in the Washington area, in either Prince George's County, Maryland, or the District. Clement was in a suburb of Pittsburgh, Pennsylvania, between 1940 and 1942 and perhaps longer; he lived close to his half-sister Nellie and may have relocated to Washington later in the decade. Jimmie, too, was living in Pittsburgh but served in World War II and had various legal troubles, so it is unlikely that Traylor stayed with him. Reuben died in 1939; before his death he lived in Buffalo, NY, with his brother John Henry. All this information is gathered from vital records, city directory listings, and military documents.

4 Traylor may have made art before 1939, and various sources (photographs and eyewitness accounts) attest that he did so beyond this four-year period, yet no work created after 1942 is known to have survived.

5 Estimates for Traylor's production have ranged from one thousand to two thousand works. Charles Shannon, who collected most of Traylor's oeuvre, believed the count to be between fifteen and eighteen hundred. He based his rough figures on the (imprecise) inventories he kept of the works he owned; factoring in the knowledge that others bought Traylor's works in smaller quantities than Shannon did, and that a portion of the art had not been saved, Shannon considered the lower figure to be the better approximation. If we eliminate the

unaccounted-for works—including those Traylor made during World War II and after he moved to his daughter Sarah's house in late 1944, the latter disposed of after Traylor's and Sarah's deaths—the number of known extant works is probably closer to twelve or thirteen hundred.

6 Several factors contributed to problems with civic records. During the nineteenth and early twentieth centuries, systems were new, evolving, and kept by hand. They varied from census to census as the demand for specific information shifted. White enumerators may well have presumed that the black informants were incapable of being consistent with family names, ages, and other facts. While a paucity of literacy may have been a component, it should be borne in mind that black informants likely had different values for assessing the importance of such consistency or fixed family definitions, were eager to have the white questioner move on to the next family, or were reluctant to give information.

7 W. E. B. Du Bois, *The Souls of Black Folk: Essays and Sketches*, 3rd ed. (Chicago: A. C. McClurg, 1903), 3, 4.

8 Traylor was born in Dallas County, Alabama, on the John Getson Traylor Plantation, probably in 1853; these facts have been widely overlooked in favor of inaccurate information asserting that he was born in Lowndes County, Alabama, which was erroneously extrapolated from records showing that he lived in Lowndes for many years. Traylor and his family were transferred to Lowndes County in 1863, to live and work on George H. Traylor's plantation; they remained there until around 1908, when they relocated to rural Montgomery County. Around 1927, Traylor moved by himself to the city of Montgomery, where he spent the rest of his life. Traylor died in 1949.

9 The National Register for Historic Places (NRHP) application filed in 1984 gives the neighborhood two designations: the present-day North Lawrence–Monroe Street Historic District, and the name it would have been called in its heyday, the Monroe Street Black Business District. The NRHP file also notes the term Dark Town. Connecting streets in the neighborhood between Monroe and Dexter were North Court, Perry, Lawrence, and McDonough. Officially designated an avenue, Monroe Street, as locals have long called it, is the widely accepted name, used throughout *Between Worlds*.

10 W. E. B. Du Bois, ed., "Resolutions Adopted by the Conference," *The Negro in Business: Report of a Social Study Made under the Direction of Atlanta University* [. . .] (Atlanta, GA, 1899), 50. Also cited in Alabama Historic Commission's "North Lawrence–Monroe Street Historic District National Register of Historic Places Inventory Nomination Form" (Aug. 2, 1984); copy in the author's curatorial file.

THE LIFE OF BILL TRAYLOR

LifeA · *Nineteenth-Century Alabama and the World of Bill Traylor's Parents (pp. 38–58)*

1 "Old Bill" and "Old Sally" would not have been called by the last names of either Calloway or Traylor; the conflated surname "Calloway-Traylor" is used in *Between Worlds* to distinguish Bill and Sally from other people with similar or overlapping names. "Old" was added to their names on John G. Traylor's estate records when his children inherited them, to differentiate the elders from their children with the same names. "Old" is used herein for the same purpose.

In 1937, when Bill Traylor (the artist) filed for a Social Security number (hereafter SSN; see herein fig. 17), he gave his father's name as Bill Traylor and his mother's name as Sallie Calloway. Until the end of the Civil War (May 9, 1865), when they became legally free people, the enslaved did not have or use European American surnames. In the 1866 Alabama state census, such surnames appear more frequently than they had in previous censuses, although some former slaves were still listed in 1866 by a first name only. By the time of the 1870 census, surnames, usually those of the former owners, were common for African Americans.

When or where Old Bill was purchased by Benjamin Calloway is unknown. Old Bill's estimated birth year is based on information found in John G. Traylor's estate records.

2 Old Sally's birth year and place are found in the 1870 census. *Between Worlds* spells her name as Sally based on J. G.'s estate records; it is spelled Sallie on the 1880 census and (years later) on her son Bill's application for a SSN, filed in 1937. Sally's age in 1870 was listed as fifty years old, making her birth year about 1820. In February 1850 the probate court's inventory of the deceased John G. Traylor's estate cited her age as thirty-three, putting her approximate birth year as 1817, which more closely aligns with the records that George Hartwell Traylor, as executor, kept for his brother's estate (which, in 1863, listed her age as forty-five, or born around 1818); this book uses ca. 1819 as a composite date. In the 1870 census, Sally stated her place of birth as Virginia, which her son Bill also gave as her place of birth for the censuses of 1880, 1910, and 1930. The identity of her original owner and the date that Benjamin Calloway purchased her fell beyond the scope of this study and remain unknown.

3 The unnamed girl was most likely E/liza (variously recorded as Elizabeth, Eliza, and Liza), who would thereafter live functionally as the eldest daughter of Sally and Bill Calloway-Traylor, although she may not have been blood kin to either of them. The two adults, George and Drusilla, were not apparently blood kin to each other. Mechal Sobel supposed that the five individuals J. G. purchased from Benjamin Calloway's estate were Old Bill, George, Drusilla, and two children. Sobel asserted that Sally (Bill Traylor's mother) was already on J. G.'s plantation before he bought five humans from Calloway. But the "Sally" mentioned in J. G.'s personal diary (entry Feb. 5, 1837; see below, n10)—whom Sobel proposes as the artist's mother—was, in fact, a different person, a female enslaved at the Green Rives plantation, where J. G. was overseer at the time. See Sobel, *Painting a Hidden Life*, 9, 138n11.

The 1840 census shows, before the Calloway purchase, that J. G. Traylor owned just one slave, an unidentified girl under ten years of age (b. ca. 1830). John G. Traylor's last will and testament (1849) states that Bill and Sally are married and that Liza is one of their children. (The dual parentage is worth noting, as J. G. lists Drusilla's children but does not state that George is their father.)

After J. G.'s death in January 1850, the probate court took inventory of his estate in February 1850. The inventory lists "Eliza" as thirteen years old, which would put her birth year around 1837, making her around five at the time of the Calloway sale of 1842 and therefore likely the unnamed girl purchased in that sale. George H. Traylor's records of 1863 for J. G.'s estate list an approximate age for E/liza that seems erroneous when reconciled with the ages given for her siblings, which otherwise consistently correspond to the probate court's inventory. On June 7, 1937, Bill Traylor (the artist) would name his mother as Sallie Calloway on his application for a SSN (herein fig. 17), thereby cementing her by surname as one of the five individuals purchased from the Calloway estate in 1842. The compiled records all put Old Sally and young E/liza at the Calloway plantation and, subsequently, the J. G. Traylor plantation (see below, n38). Of note is that on census records over the coming decades (1870, 1880, 1910), E/liza repeatedly cited her birthplace (and that of her parents) as South Carolina; this fact indicates she may not have been Bill and Sally's child by birth but rather, came to the Calloway plantation as an orphaned child or became orphaned there. The forced migration of enslaved laborers often entailed travel by foot; many died of fatigue or illness from the journey.

George and Drusilla are the adults (unrelated to Bill and Sally) who J. G. purchased from Benjamin Calloway. Drusilla's children could not have been part of this sale as they were not yet born. According to George's records of 1863 regarding J. G.'s estate, Drusilla's eldest child, Harrison, was born about 1844. His age also concurs with the probate court's inventory from February 1850, which lists him as six years old.

4 John's parents were John Getson Traylor (1755–1850) and Margaret Getzen Traylor (1777–1849). While the spelling of his middle name is presumed herein to be that of his father, it is unconfirmed on documents, on which he regularly used only the initial G.

5 Booker T. Washington, *Up from Slavery: An Autobiography* (Garden City, NY: Doubleday, 1901), 108.

6 Randy J. Sparks, *Africans in the Old South: Mapping Exceptional Lives Across the Atlantic World* (Cambridge, MA: Harvard University Press, 2016), 80.

7 Some sources note that the schooner *Clotilda* arrived in Mobile in 1859, which is more likely the date she embarked on the return voyage from Africa; *Clotilda* arrived in Mobile in July 1860. See Sylviane A. Diouf, *Dreams of Africa in Alabama: The Slave Ship Clotilda and the Story of the Last Africans Brought to America* (New York: Oxford University Press, 2007).

8 Lyman P. Powell, *Historic Towns of the Southern States* (New York: G. P. Putnam's Sons, 1904), 393.

9 Census data for the white Traylor family before they resided in Alabama is difficult to find. The 1810 census lists a family fitting the description of the white Traylors living in Virginia. Some of George Hartwell Traylor's land warrants are dated 1831. No 1830 census record listing George H. has been located, but the 1830 census from Edgefield, South Carolina, lists a John Traylor. While it remains uncertain if this is J. G., the man of interest here, it seems unlikely, given that a John Traylor was in the same area as head of household between 1810 and 1820, when J. G. would have been too young for that role. It is assumed that the entire (white) Traylor family had moved to Alabama, as the obituary for the matriarch, Margaret Getzen (1849), states that she was from Lowndes County.

10 The whereabouts of J. G.'s original diary ("Diary: 1834–1847") is unknown, but a transcribed typescript survives in ADAH. An undated note states that the original diary was loaned by "Mrs. Albert Hall" of Benton, Alabama, to the archives for copying. We can presume the identity of the lender to be Mrs. Arthur Bell Hall of Benton, née Myttie Traylor Hall (1883–1944), daughter of Thomas G. and Amanda Elizabeth Traylor and granddaughter of John Getson Traylor and Mary Calloway Traylor; Thomas was overseer on his father's plantation before the Civil War.

Myttie and Arthur had no children, and her sister, Mary Howard Traylor Webster (1879–1964),

handled Myttie and Arthur's affairs with the probate court. Mary Webster's daughter, Mary Elizabeth, married Alton Callaway Edwards; they seem to have had no direct heirs. John Getson Traylor's diary (hereafter called J. G. Traylor diary, usually accompanied by an entry date), therefore, may have been entrusted to a niece or nephew. Alton's grandparents were Lou and D. B. Edwards.

A note about the diary appears in the papers of Miriam Rogers Fowler (in Bill Traylor curatorial files, Montgomery Museum of Fine Arts, AL), in context of M. R. Fowler/R. Buster interview, ca. 1993. The note says that around 1992, Jennie Kendall Traylor, a great-granddaughter of George Hartwell Traylor and family historian, gave the diary to one of John Getson Traylor's great-great-great-granddaughters. Although the author followed this lead to the living generation of descendants, efforts to determine definitively who is in possession of the original document were unfruitful.

11 When quoting J. G.'s diary, *Between Worlds* adheres to the spellings—inconsistent blends of correct and phonetic—as given in the typescript of the original diary (see above, n10).

12 In entries for 1834–1845, the J. G. Traylor diary mentions mustering and "alections" each nine times. For mustering, see diary entries on Oct. 29, 1834; Nov. 17, 1838; Sept. 8, 1839; Mar. 7, 1840; Mar. 6, 1841; Mar. 5, 1842; Apr. 16, 1844; Mar. 1, 1845; and Aug. 2, 1845. For "alections," see July 4, 1834; Aug. 3, 1835; Nov. 4, 1836; Aug. 6, 1838; Sept. 14, 1839; Nov. 9, 1840; Aug. 1, 1842; Aug. 7, 1843; and Aug. 4, 1845.

13 From 1825 to 1837, approximately twenty-three thousand Creek Indians were removed from their Alabama and Georgia homeland to the area that is present-day Oklahoma. Christopher Haveman, "Creek Indian Removal," Encyclopedia of Alabama (website), Jan. 28, 2009; last updated, Jan. 13, 2007.

14 J. G. Traylor diary, July 5, 7, and 8, 1834.

15 Ibid., Jan. 23, 1837.

16 Ibid., Mar. 30, 1834.

17 J. G. Traylor had a pay dispute with Green Rives and moved to the Saffold plantation in 1840, according to Rosa Lyon Traylor and June Middleton Albaugh, *Collirene, The Queen Hill* (Montgomery, AL: H. Jones–Paragon Press, 1977), 19. Per J. G. Traylor diary (Jan. 1, 1840), the family moved on January 3, 1840.

18 "Went to trickum in Benton with Mr. Murf and bought one of Davy Croclets almanack"; J. G. Traylor diary, Dec. 6, 1834. According to Wikipedia (website), *Davy Crockett's Almanac* (J. G.'s spellings are Croclet and *Almanack*) was published annually from 1835 to 1856; "Davy Crockett," last modified Jan. 10, 2018.

19 Harvey H. Jackson III, "Philip Henry Gosse: An Englishman in the Alabama Black Belt," *Alabama Heritage*, no. 28 (Spring 1993): 44. In his book *Letters from Alabama (U.S.): Chiefly Relating to Natural History* (1859; repr., London: Forgotten Books, 2015), Gosse does not go into detail about who he is lodging with or working for; that information comes from Jackson's research.

20 Jackson, "Philip Henry Gosse," 37.

21 Philip Henry Gosse, *Letters from Alabama*, 156.

22 Ibid., 153.

23 Ibid., 151.

24 Ibid., 156. Charles Johnson gave a similar account of the slave housing, describing them as "unpainted or whitewashed cabins, surrounded by a disordered array of outhouses, . . . their invariable 'dog run' providing a cooling shade," with patches of garden close to the house and newspaper covering the interior walls. See Charles S. Johnson, *Shadow of the Plantation: A Classic Study of Negro Life* (Chicago: University of Chicago Press, 1934; repr., 1966), 11.

25 Gosse, *Letters from Alabama*, 157–58.

26 Carl Carmer, *Stars Fell on Alabama* (New York: Blue Ribbon Books, 1934), 38.

27 Gosse, *Letters from Alabama*, 128–29, 195.

28 Ibid., 254–55.

29 Ibid., 305–6. The words were likely "Fire Marengo" rather than "fire the ringo." Marengo County, Alabama (bordered on the west by the Tombigbee River, which joins the Alabama River to become the Mobile River flowing into the Gulf of Mexico), was a plantation county settled by Bonapartists exiled from France after Napoleon Bonaparte's fall in 1814. The Bonapartist settlers likely sang songs of triumph about the Battle of Marengo (from which the county in Alabama takes its name), which the French had fought in Italy in June 1800 against Austrian forces; the catchy refrain stuck, while the words about fleeing to Canada were added later.

30 J. G. Traylor diary, Oct. 11, 1839.

31 Ibid., Feb. 25, 1844.

32 Ibid., April 1841; mention of the "big diner" is in entry Nov. 2, 1844.

33 Trina Binkley, Robert Gamble, Ed Hooker, and Michael Sims, "Pleasant Hill Presbyterian Church National Register of Historic Places Registration Form" (Washington, DC: US Department of the Interior, National Park Service, 1999).

34 The identity of the "female under age ten" belonging to J. G. Traylor in 1840 cannot be verified. The research for *Between Worlds* indicates that she is most likely an unrelated girl, Martha, who died in 1844. See above, n3, and below, n38, for more information on E/liza and Martha, respectively.

35 J. G. Traylor diary, entries July 11 and 15, 1841.

36 On September 2, 1841, J. G. Traylor noted in his diary that he went to the fort and heard of the death of "Mr. Caloway." It is difficult to understand why he would not have already known about his father-in-law's death, which occurred in August according to Benjamin Calloway's estate records. No exact date for the death was found.

37 The author sought but did not find a record for the Benjamin Calloway estate sale. Neither an itemized bill of sale nor a record of his purchases of enslaved people was among his estate files or in J. G. Traylor's estate files. Calloway left no will, and his affairs were handled by his widow, Elizabeth. Probate court files for the Benjamin Calloway estate reveal a $40,000 debt, for which the personal effects were sold to defray. According to the 1840 census, Benjamin Calloway owned sixteen slaves, but only three (Moses, Jennings, and Peter) are mentioned in his estate papers; these individuals were sold by federal marshals. The census also cites nine Calloway children, five of whom were still minors at Benjamin's death. The rest of the enslaved people were most likely sold or transferred to heirs, but no records have been found to confirm that outcome. Census records indicate that Calloway's widow had no enslaved people at her property in Macon County, Alabama, in 1850 or 1860.

38 As explained above (n1), the Bill and Sally who are discussed here are the older generation originating (in the scope of years covered herein) at the Calloway plantation; the children who would later share the names Bill and Sally were not yet born. In 1844, J. G. entered in his diary that he buried a "negro child, Martha." Martha, whose age and relationship to the rest of the Calloways and Traylors are unknown, is proposed herein (above, n34) as the first human that J. G. purchased, preceding the Calloway sale.

As explained above (n3), J. G. Traylor purchased Sally, Drusilla, Bill, and George from his wife's father, Mr. Calloway; the fifth individual he purchased from Calloway was most likely "E/liza." Liza (as she is most often called) is listed as Bill and Sally's child in J. G.'s last will and testament; being listed first implies that she is the eldest child, but she may have been adopted or fictive kin.

39 At the end of May 1842, J. G. noted, "I was taken sick with the fever." His next days are off and on with work and being sick again, and in July he wrote: "I quit overseeing [on Saffold's plantation] on the account of my helth not being good. this is the end of my over seeing. I have been at it this is 15 years." Shortly thereafter he added, "I moved home." The diary does not substantiate his fifteen years of overseeing, but he may have worked in that capacity before he started keeping his diary.

40 J. G. Traylor diary, Feb. 25, 1843.

41 Ibid., Jan. 24–Aug. 2, 1844.

42 Today the house is owned by a descendant of D. B. Edwards and Lou Traylor Edwards, according to the geographic information system (GIS) map for Dallas County. See Alabama Department of Revenue (website).

43 J. G. Traylor diary, Feb. 13, 1845. "Drusiter" refers to Drusilla (see above, nn3, 38).

44 Ibid., Mar. 26, 1845.

45 George Hartwell Traylor's record of 1863 for J. G. Traylor's estate lists the enslaved boy Frank as eighteen years old (or born 1845). Since neither a census with Frank's birth month nor any other vital records with his birth information has been found, his precise birth date is unconfirmed.

46 J. G. Traylor diary, Sept. 27, 1846.

47 Ibid., Feb. 15, 1847. J. G.'s use of "instan" refers to "instant," a common term in eighteenth- and nineteenth-century newspapers to denote "in the present month." Thus, in this case, the "15th instan" means Feb. 15, 1847.

48 J. G.'s estate files do not mention Silvy and her children. If she was the enslaved girl he purchased in 1840, she and her children were gone from the plantation by 1850. She was most likely a hired hand, as J. G. wrote several entries in his diary about the hiring of slaves but does not mention Silvy beyond this time frame.

49 J. G. Traylor diary, Feb. 26, 27, and Mar. 12, 1847.

50 Traylor and Albaugh, *Collirene*, 18.

51 "Deed from Thomas M. Kindall to John G. Traylor, Dec. 14, 1848," *Dallas County Deeds and Mortgages*, 1847–49, *Book M*, 511–12 (1847.05–1849.04, Box LGM017, Reel 24), Alabama Probate Court (Dallas County).

52 John Getson Traylor's last will and testament; copy in the author's curatorial files.

53 Traylor and Albaugh, *Collirene*, 18–19.

54 J. G.'s last will and testament.

55 Ibid. Bill Traylor (the artist) would be one of the so-called future increases, a yet-to-be-born member of an enslaved family.

56 From a legal perspective, young Bill Traylor was born as estate property; he was managed by George

Hartwell Traylor until John Getson Traylor's children successively reached legal age to receive their inheritances.

57 This last record was made in 1944, when Traylor was baptized a Catholic five years before he died. The baptismal record from Saint Jude Church, 2048 W. Fairview Avenue, Montgomery, Alabama, notes that Bill Traylor was born April 1, 1855; baptized on January 5, 1944, by Reverend Jacob; and died on October 23, 1949, at Oak Street Hospital. (Oak Street Hospital, which was near the corner of Oak and Jefferson Davis Highway but is no longer extant, has no affiliation with Saint Jude Church, which is still in operation.) A copy of this record is in the papers of Miriam Rogers Fowler (in Bill Traylor curatorial files, Montgomery Museum of Fine Arts, AL). The Saint Jude Death Record for Bill Traylor notes that he died on October 23, 1949, and was "buried from St. Jude Church in Montgomery, Alabama, by Reverend Harold Purcell." Copy in the author's curatorial files.

58 Johnson, *Shadow of the Plantation*, 17.

59 George's records for J. G.'s estate approximate Emit's birth year as 1854; the 1870 census indicates 1855; and the 1880 census, 1856. No further records for Emit exist, which leads us to conclude that he may have died between 1880 and 1900 (no 1890 census exists for this area).

60 Bill and Emit are younger brothers to E/liza (b. ca. 1837), Henry (ca. 1843), Frank (ca. 1844), James (ca. 1846), and Sally Traylor (ca. 1850; m. Motley). See family tree of Bill Traylor's parents (herein p. 378) for approximated ages, which in this study are based on compiled records.

61 According to the estate records for J. G. Traylor that were made and kept by executor George Hartwell Traylor.

62 Elizabeth Louisiana Mealing (1810–1853) was George Hartwell Traylor's first wife.

63 George Hartwell Traylor's records for the J. G. Traylor estate show Thomas Traylor was paid $150 to $200 per year.

64 In 1860, Pleasant Hill and Oldtown were census precincts that touched corners near J. G.'s plantation. In 1870 or 1880 his plantation became part of the census district of Kings, a later addition to the map, which also overlaps this same area of land. Census sections have since shifted and been renamed, and contemporary censuses now show Sardis CCD (census county division) where Kings once was (more or less), Selmont-Tyler CCD where Oldtown was, and the town of Pleasant Hill as located in Carlowville CCD. See Census Bureau (website).

65 Mechal Sobel postulated that these boys were "Little Bill" and Emit; this study (*Between Worlds*) makes the same conclusion. These dates confer Bill's birth year as 1853 and Emit's as 1854. See also Sobel, *Painting a Hidden Life*, 7–10.

66 According to the 1860 census.

67 They lived there until at least 1864, according to the estate records of Littleton Edwards (D. B. Edwards's father). The recorded rental fee of twenty dollars was for an indeterminate amount of time, likely a year. Since the J. G. Traylor house and land would eventually pass down through this side of the family, the fact that they were not living there by 1864 indicates that Lou's uncle George H. Traylor was still managing the property. It is presumed that the young couple moved to J. G.'s land after Fannie had come of age and George relinquished control of his late brother's estate.

68 George Hartwell Traylor's compiled records for the John Getson Traylor estate, including record of inheritance for Louisiana E. Edwards, dated Nov. 14, 1860.

69 George Alexander Traylor was born January 8, 1860, and died October 10, 1862, according to the online database FindaGrave.com. Further, the inscription on his headstone reads, "Son of George Hartwell Traylor and Margaret Jane Averyt." See George Alexander Traylor, Mount Gilead Cemetery, Trickem, Lowndes County, Alabama, memorial number 44726259. Record created by Walk The Earth (website), Nov. 23, 2009.

70 Stephen F. Hale to Beriah MaGoffin, governor of Kentucky, Dec. 27, 1860, archived from the original at Causes of the Civil War (website).

71 Marion Hartwell Traylor (1862–1904) is the son of George Hartwell Traylor (1801–1881).

72 Seventy-five dollars per year was notably less than the going rate of the day, which suggests Carson may have been a tenant farmer or sharecropper, giving over a portion of his crops in addition to monetary rent. The Supreme Court of Alabama records show that the going rate for farmland in those years usually ranged from $1.50 to $4.00 per acre. The Traylor farm in Dallas County was just over four hundred acres, so it could have brought $600 to $1,600 annually. B. E. Carson might have been the same "Mr. Carson" who began overseeing the Green Rives plantation when J. G. left to oversee the Saffold plantation in 1840.

73 Proceeds would be set aside until 1865, when Thomas came home from the war and Fannie came of age.

74 George Hartwell Traylor's record for J. G. Traylor's estate, Jan. 20, 1863. Sally was hired out for the years 1863 and 1864; Jim in 1864; and Old Sally and Emit in 1864.

75 Eleanor Jones Harvey, historian and SAAM curator of nineteenth-century American art, notes that George likely would have retained the most productive of the slaves for his own uses and hired out those he could spare. Harvey concurs that the scenario of retaining and hiring out certain workers makes sense in practical terms and in relation to the political upheaval; conversation with Stacy Mince, Feb. 17, 2017.

76 "Biography: Jefferson Davis," American Battlefield Trust (website). The Civil War ended on May 9, 1865, when a detachment of the Fourth Michigan Cavalry captured Davis and his personal entourage, including his wife, Varina, near Irwinville, Georgia. Davis would be imprisoned at Fortress Monroe on charges of treason—although he was never tried for the offense—until he was released on bail in May 1867.

77 Ebenezer Nelson Gilpin, "Diary of Ebenezer Nelson Gilpin, April 1865," *The Last Campaign: A Cavalryman's Journal* (Leavenworth, KS: Press of Ketcheson Print, 1908), 646–49 (The American Civil War website). According to the Civil War Service Index for Iowa (National Archives and Records Administration, *Carded Records Showing Military Service of Soldiers Who Fought in Confederate Organizations*. Compiled 1903–27), Ebenezer Nelson Gilpin was a private with the Third Iowa Cavalry, Company E.

78 The general was possibly Cornelius Robinson, a military man who served in the Creek War and the local militia and owned property there, not far from George H. Traylor's land. Robinson is also buried in the Mount Gilead Cemetery, as are the white Traylors (see above, n69).

79 US War Department, "No. 11: Report of Capt. Joseph B. Williams, Second Indiana Cavalry, of Operations, April 1–16, 1865," *The War of the Rebellion: A Compilation of the Official Records of the Union and Confederate Armies*, series 1, part 1 (Washington, DC: Government Printing Office, 1897), 49:431.

80 Information on the road name was provided by Kendall Buster, telephone conversation with the author, May 16, 2017. Buster is the daughter of Jennie Kendall Traylor and Ralph DeWitt Buster, granddaughter of Gladys Kendall Steele and George Boyd Traylor, great-granddaughter of Annie "Ella" Boyd and Marion Hartwell Traylor, and great-great-granddaughter of Margaret Jane Averyt and George Hartwell Traylor.

81 Bettye Benjamin, retired teacher and member of the Lowndesboro Historical Society, Montgomery, AL, gave this oral history to Jeffrey Wolf and Marcia Weber at a café in Lowndesboro on July 14, 2016; notes in the collection of Jeffrey Wolf, New York. A historical marker near Lowndesboro (a town midway between Benton and Montgomery) notes a skirmish between Confederate troops and Wilson's Raiders on April 10, 1865; see Lowndesboro Historical Society (website).

82 Bill Traylor would have told the story about the Raiders at the time he was living with his daughter Sarah Traylor Howard. His granddaughter Margaret (in her teens), who lived nearby, and her sister Myrtha Lee Traylor Delks (daughters of Will Traylor) visited with him there.

83 Kogan and Weber/Staffney video interview, 1992. In Maresca and Ricco/C. Shannon interview, 1989 (p. 5), Charles Shannon reported hearing the same story from Bill Traylor.

84 John Bryant Traylor Jr., a great-grandson of George Hartwell Traylor, gave this information to Jeffrey Wolf on March 22, 2017, in Selma, AL; Wolf, email to the author, May 18, 2017. John Bryant Traylor Jr. told Wolf that the bullet hole (left by Wilson's Raiders) went through the ceiling into the attic space above the living room and was never repaired. The house that stood during the Civil War was torn down in the 1970s but replaced by another house, where John Bryant Traylor Jr. lives at the time of this publication.

85 Twenty enslaved people is commonly noted as the threshold over which a plantation was considered "large" or of "plantar status." See John Michael Vlach, *Back of the Big House: The Architecture of Plantation Slavery* (Chapel Hill: University of North Carolina Press, 1993), 7.

86 In the Dallas County census of 1866, several individuals appear with the surname Traylor, but none match information for Bill's family to align with the records that show his family had moved to Lowndes several years earlier.

87 According to the 1870 census.

88 John G. Traylor's land subsequently passed down through his daughter Lou's children.

89 According to the 1870 census. The relationship of this Benjamin Edwards to the rest of the Edwards family was beyond the scope of this project and remains unknown.

90 The 1870 census also reconciles a birth year of 1853. Although "William" occasionally appears in censuses after this point, no findings specify that Bill's birth name was William.

91 Rosa Lyon Traylor (1914–2001) was the mother of John Bryant Traylor Jr. (b. 1940), a great-grandson of George H. Traylor. In a letter to Antoinette Staffney Beeks, dated July 8, 1992 (in the 1992

reunion booklet), Rosa explained that she never knew Bill: "He left the plantation before I married." She also shared her memories with Charles Shannon (Maresca and Ricco/C. Shannon interview, 1989, 5). It is unclear how Rosa knew which cabin may have been Bill's. Remnants of various outbuildings, which may have been slave quarters or other structures, exist on the George H. Traylor property as this book goes to press but are in severe states of decay. The house that Rosa and her husband, John Traylor, owned and lived in was not the original plantation house but rather, a house built on the same site in the 1970s; John Bryant Traylor Jr. resides there today (see above, n84).

92 W. E. B. Du Bois, ed., *The Negro in Business: Report of a Social Study Made under the Direction of Atlanta University* [. . .] (Atlanta, GA, 1899), 5.

93 Johnson, *Shadow of the Plantation*, 34, including quote by the formerly enslaved Ellen Haygood.

94 Hasan Kwame Jeffries, *Bloody Lowndes: Civil Rights and Black Power in Alabama's Black Belt* (New York: New York University Press, 2009), 10. Jeffries cites Poillon from John B. Myers, "Reaction and Adjustment: The Struggle of Alabama Freedmen in Post-Bellum Alabama, 1865–1867," *Alabama Historical Quarterly* 32, nos. 1 and 2 (Spring and Summer 1970): 14.

95 The agriculture schedule in the 1880 census notes that George Traylor collectively paid his workers a total of $1,000 the year before. No names of workers are given. No renters or sharecroppers were reported to be on the property.

96 Jeffries, *Bloody Lowndes*, 10.

97 Ibid., 12.

98 Some of the Masonic orders were the Knights of the Wise Men, the Knights of Pythias, the Odd Fellows, and branches for women such as the Messiah Household of Ruth and the Knights and Daughters of Tabor.

99 Jeffries, *Bloody Lowndes*, 13.

100 William H. Grimshaw, *Official History of Freemasonry* (Freeport, NY: Books for Libraries Press, 1971), 67–83. The first black Freemasons lodge was started in 1775 in Boston by Prince Hall. Granted a charter by the Grand Lodge of England in 1784, they are commonly referred to as the Prince Hall Masons. See also Charles H. Brooks, *The Official History and Manual of the Grand United Order of Odd Fellows in America* (Philadelphia: Odd Fellows' Journal Print, 1902), 12–14.
In 1843 in New York City, Peter Ogden, a black immigrant from Liverpool, England, started the first black Odd Fellows lodge. After a group of black men petitioned the white Independent Order of Odd Fellows to create their own lodge and were denied, Ogden, who was a member of the Odd Fellows in Liverpool, reached out to his lodge to suggest it gain a charter by accepting the new, black lodge. The black men's application was granted, and from then on, the black sect was called the Grand United Order of the Odd Fellows.

101 Ariane Liazos and Marshall Ganz, "Duty to the Race: African American Fraternal Orders and the Legal Defense of the Right to Organize," special issue, *Social Science History* 28, no. 3 (Fall 2004): 493.

102 A. E. Bush and P. L. Dorman, *History of the Mosaic Templars of America: Its Founders and Officials* (1924; repr., Fayetteville: University of Arkansas Press, 2008), 81.

103 Ibid., 138, 154. For a detailed discussion on the importance of black fraternal orders' influence on the civil rights movement, see Theda Skocpol and

Jennifer Lynn Oser, "Organization Despite Adversity: The Origins and Development of African American Fraternal Associations and the History of Civil Society in the United States," special issue, *Social Science History* 28, no. 3 (Fall 2004): 355–66.

104 Monroe Avenue was the official designation. For more information, see Prologue, n9.

LifeB · *Bill Traylor's Adult Life and Family, 1880–1949 (pp. 59–103)*

1 Most of the 1890 censuses for the nation, including the one for Lowndes County, were destroyed in 1921 in a fire at the old Commerce Department building in Washington, DC, which was located at 19th Street and Pennsylvania Avenue NW.

2 The 1880 census suggests an 1854 birth year for Bill Traylor.

3 The amount that George H. Traylor paid to black wageworkers was confirmed in the agricultural schedule of the 1880 census.

4 Kings is part of Oldtown and appeared as such for the first time on the 1880 census. See LifeA.n64.

5 Marriage license of William Traylor and Elsey Dunklin, August 17, 1880, *Marriage Record: White & Black, Lowndes County, AL, Book A,* 475 (herein fig. 7).

6 It's unknown how or if Minta Dunklin and Elsey Dunklin were related. Several Dunklin families lived in Lowndes County, Alabama, and numerous unrelated ex-slaves may have used the surname of their former owners. The marriage certificate of Bill Traylor and Elsey Dunklin posed new questions for the research for *Between Worlds,* since the union has not been recognized in previous studies. The most pointed one is: to whom does the document refer—the future artist Bill Traylor, or another man with the same name? It is difficult to identify people accurately based solely on names, considering that four Traylor families living in Lowndes and Dallas Counties in 1860 owned slaves: in Lowndes, George Hartwell Traylor, and in Dallas, Thomas G. Traylor (John G.'s estate), Joel Traylor, and Lucy A. Traylor (widow of Thomas L. Traylor). The George H. and the John G. estates were the larger slave owners, but only the names of the people John G. enslaved are known. Moreover, records indicate that at least one other William Traylor lived in Montgomery during roughly the same years as Bill Traylor the artist; this William Traylor died in 1923.
The name Elsey Dunklin was brought to the author's attention by filmmakers Jeffrey Wolf and Fred Barron, who commissioned information on Bill Traylor from genealogical researcher Hal Horrocks of Southern California (dated Nov. 19, 2015); Wolf and Barron, email to the author, Aug. 11, 2016. The identity of Elsey Dunklin in relationship to the Bill Traylor of this study (*Between Worlds*) was confirmed by the SSN application filed in 1963 by one of their children, Sarah (birth name Sallie) Traylor Howard, who specifies that Elsey Dunklin (with a varied spelling) was her mother; copy obtained from Social Security Administration by Stacy Mince is in the author's curatorial files. See below, n41.

7 On the 1870 census, a Stephen Duncan (35) has daughters Elsy (13), Hester (8), and son Gerome (6). While the surname is inconsistently spelled, the family information closely matches that in the 1880 census, in which a Stephen Dunklin (45; read in some searches as Druklin) has a daughter Elsey (21) and a son, Gerome (18; name illegible); a likely conclusion is that this is the Elsey who married Bill. The marriage license is the last record found for Elsey Dunklin Traylor. She may have died (likely in childbirth with Sallie/Sarah in 1887) or left the family

between then and 1891, when Bill married Laurine E. Dunklin.
No compelling records for the identity of Laurine have been found; the 1870 census for Lowndes County lists a Laura Dunklin, noted as being age six at the time—daughter of a different Stephen Dunklin (53) and Betsy (40), sister of Anjany (4; name illegible). This Laura would have been eleven years younger than Bill; no evidence confirms that she was the same person as "Laurine" from the marriage certificate.

8 The deduction that Bill and Elsey had three children is based on the close birth years of the first three children traced to Bill Traylor (1884, 1885, 1887) followed by a gap before the next three (1892, 1893, 1896).

9 Nellie appears with the surname Williams on the 1910 census. Her death certificate lists her father's name as Burrell Williams; see also below, nn47, 82, 84.

10 In their film *Bill Traylor: Chasing Ghosts* (2018), filmmakers Jeffrey Wolf and Fred Barron theorize that Nellie may be a daughter of Bill and Laura's predating their marriage. Research for *Between Worlds* has found no evidence to confirm that possibility and honors the oral tradition the family used per her paternal parentage.

11 Marion was most likely the boyhood companion of Bill Traylor's mentioned in the accounts, given by Margaret Elizabeth Traylor Staffney, a granddaughter of Bill Traylor, of the Wilson's Raiders cavalry divisions coming through Benton. See LifeA. nn81, 84.

12 Alpha Champion, Surveyor, Lowndes County, Alabama, "Field Notes and Plat of M. H. Traylor's Land, 1888" (herein fig. 9). Rosa Lyon Traylor's copy of the survey, made from the original, is in Marcia Weber's personal files on Bill Traylor.

13 C. Albert White, *A History of the Rectangular Survey System* (Washington, DC: US Department of the Interior, Bureau of Land Management, 1983; 1991), 529–30.

14 Beyond the shared name of Calloway and the likelihood of some historical relationship between the white Calloways and the former slaves who took that name, no evidence indicates that Theo Calloway was directly related to either of Bill Traylor's parents, Bill and Sally Calloway-Traylor.

15 "Callaway [*sic*] Lynched: A Terrible Murder Expirated [*sic*] by Judge Lynch," *Atlanta Constitution,* Mar. 31, 1888, 1. At the time, the veracity of the white press had been under scrutiny, so the accuracy of the incident between Mitchell Gresham and Theodore Calloway is undetermined. Ida B. Wells, in her anti-lynching editorial "Southern Horrors: Lynch Law in All Its Phases" (*New York Age,* June 25, 1892), critiqued the white press for purposely misconstruing stories to justify lynching. Of all the articles about Calloway's lynching and the riots that followed, the *Atlanta Constitution* was the only newspaper found to give an excuse other than self-defense. A few months later (Oct. 26, 1892), Wells reprinted a slightly revised version of her article as a pamphlet; see Project Gutenberg (website).

16 "An Impudent Letter: An Alabama Sheriff's Response to the Governor," *New York Times,* April 13, 1888, 4.

17 "An Alabama Riot," *Evening Bulletin* (Maysville, Kentucky), May 7, 1888.

18 "A Race Conflict: Alleged Plot to Murder Whites in Alabama," *Los Angeles Times,* May 10, 1888, 1. The lodges mentioned in the article are not named but are said to have "large societies throughout the

United States"; it further reports that Lowndes, Butler, and Crenshaw Counties have the largest clubs in Alabama (which were possibly Masonic lodges). The article names a Neil Mangum as the secretary and treasurer of the lodge, with Bob Robinson as the meeting leader.

19 Ibid.

20 No record was found to indicate that anyone from the Traylor plantation participated in the riots or the planning, but the absence of such documentation does not preclude the possibility.

21 In 1892, Lowndes County was thought to have the highest ratio of blacks to whites in Alabama, which were generalized as being roughly seven to one. In a letter that year from Charlotte R. Thorn and Mabel W. Dillingham to the *Christian Union* (New York, NY), they described the ratio as "one hundred white people and twenty-five hundred black people." Charlotte R. Thorn and Mabel W. Dillingham, letter to the editor, "Light in a Dark Place," *Christian Union* 46, no. 15 (Oct. 8, 1892): 646.

In 1902, Rev. Pitt Dillingham, Mabel's brother, gave the figures as 28,000 to 4,000. Pitt Dillingham, "The Settlement Idea in the Cotton Belt," *Outlook* 70, no. 15 (Apr. 12, 1902): 920.

22 In their letter to the editor of the *Christian Union* above, n21), Charlotte Thorn and Mabel Dillingham requested monetary contributions to support the students, saying "The negroes expected a free school." But the founders also insisted they always intended for students to pay a small tuition, as the school was operating at a loss. Citing an interview with Rev. Pitt Dillingham, the *New York Times* in 1896 reported that about forty students who boarded on school grounds paid their way with house and farmwork and attended night school. "In Aid of Colored Men: Work That Is Carried On in the Calhoun School in Alabama," *New York Times*, Jan. 21, 1896, 9.

23 A letter from a Georgia Washington (likely a teacher) thanking a friend for a donation of Bibles to the school described the pupils as "two hundred and ninety children, ages ranging all the way from five years to twenty-six years." Georgia Washington, "Calhoun Colored School—Alabama," *Friend: A Religious and Literary Journal* 66, no. 33 (Mar. 11, 1893): 262.

24 Rose Herlong Ellis, "The Calhoun School, Miss Charlotte Thorn's 'Lighthouse on the Hill' in Lowndes County, Alabama," *Alabama Review* 37, no. 3 (1984): 193.

25 William L. McDavid, "Calhoun Land Trust: A Study of Rural Resettlement in Lowndes County, Alabama" (master's thesis, Fisk University, Nashville, TN, 1943), 43–58.

26 Ibid. Most contracts were extended past three years, as farmers were unable to pay their rent within the original allotted time. By 1917 black farmers had acquired approximately four thousand acres of land through the program.

27 Quoted in Hasan Kwame Jeffries, *Bloody Lowndes: Civil Rights and Black Power in Alabama's Black Belt* (New York: New York University Press, 2009), 9, 259n4.

28 Ibid., 9. W. E. B. Du Bois's original research was published later as Augustus Granville Dill and W. E. B. Du Bois, eds., *The Negro American Artisan: Report of a Social Study Made by Atlanta University under the Patronage of the Trustees of the John F. Slater Fund* [. . .] (Atlanta, GA: Atlanta University Press, 1912), 136.

29 Linda O. McMurry, *To Keep the Waters Troubled: The Life of Ida B. Wells* (New York: Oxford University Press, 1998), 130–33. The three men

lynched in Memphis were Thomas Moss, the proprietor of the People's Grocery; Calvin McDowell, a clerk; and Will Stewart, a stockholder.

30 Ibid., 178–79, 190–96, 225.

31 Ibid., 255–57. While Booker T. Washington went on to be Theodore Roosevelt's adviser on African American issues, Ida B. Wells's rhetoric left her on the radars of the Federal Bureau of Investigation (FBI) and Military Police Investigations Division (MPID). After race riots in East St. Louis, Illinois, and Houston, Texas, left dozens of black Americans dead, Wells and her husband rallied black citizens to take up arms to protect themselves from police. The white press labeled Wells a subversive, and her authority waned.

At the height of her influence, Wells's editorials were published in national newspapers (both black and white), but NAACP's efforts overshadowed her accomplishments in spearheading the anti-lynching campaign. Wells's association with whites was problematic within her own community, which may explain why Alabama papers such as the *Colored Alabamian* and *The Emancipator* ran articles about Washington's call for industriousness rather than Wells's for racial justice. The relationship between Wells and Washington was friendly in the beginning. She supported his efforts until his response to a lynching in 1899 didn't align with her views. Two decades later, during the Red Scare, the FBI and MPID would consider it "un-American" to speak out against lynching.

32 McMurry, *To Keep the Waters Troubled*, 272–73. Wells's speech, which she gave in 1903 at the Chicago Political Equality League, emphasized that through contact with different races, prejudice would lessen.

33 McMurry, *To Keep the Waters Troubled*, 272–73, 256.

34 Bryan Stevenson, *Lynching in America: Confronting the Legacy of Racial Terror* 3rd ed., 2017, Equal Justice Initiative (website). According to a multiyear research report conducted by the Montgomery-based nonprofit organization Equal Justice Initiative, 4,084 "racial terror lynchings" were documented in twelve states between 1877 and 1950. The Equal Justice Initiative found that: "[Most lynchings] can be best understood as having the features of one or more of the following: (1) lynchings that resulted from a wildly distorted fear of interracial sex; (2) lynchings in response to casual social transgressions; (3) lynchings based on allegations of serious violent crime; (4) public spectacle lynchings; (5) lynchings that escalated into large-scale violence targeting the entire African American community; and (6) lynchings of sharecroppers, ministers, and community leaders who resisted mistreatment, which were most common between 1915 and 1940."

35 *Oxford English Dictionary*, s.v. "lynch law," http://www.oed.com. The *Oxford* definition of "Judge Lynch" is the "imaginary authority from whom the sentences of lynch law are jocularly said to proceed." The etymology of the term "lynch laws" can be traced to Captain William Lynch of Pennsylvania, who in 1780 created his own judicial tribunal while in Virginia.

36 Marriage license of Will Traylor and Laurine E. Dunklin, August 13, 1891, *Colored Marriage Book, Book C, c. 1889–1897*, 202 (herein fig. 10). Miriam Rogers Fowler first discovered this document and published her findings in *Bill Traylor*, exh. brochure (Houston, TX: O'Kane Gallery, 2001). Some researchers have read the handwritten name on the certificate as Laurence Dunklin, although the *e* ending the first name (alternately read as a *c*) is lowercase and the apparent middle initial *E* is

capitalized, which strongly argues for it as a middle initial. This interpretation favors the reading as Laurine E. Dunklin; this woman's nickname is noted as Lorisa or Larisa on the 1900 census, and no other documents use Laurine; she is thereafter recorded as Lorisa (or Larisa). It has not been determined what happened to Laurine/Lorisa/Larisa after her relationship with Bill ended.

37 In 1883, Elsey Dunklin's father, Stephen Dunklin, married Amanda Thomas at Henry Lewis's plantation. Three years earlier, in 1880, Stephen was listed on the census as widowed, and Amanda Thomas as a live-in servant at the Lewis plantation, where Bill Traylor and Elsey may have married three years earlier. The census that year didn't ask if the women had any children, and no child was reported to live in the household with Amanda; if Amanda had a daughter, that child may have been living elsewhere for work. This scenario could explain where the surnames Dunklin, from Bill and Laurine's marriage license, and Thomas, from Lillian Traylor Hart's death certificate and Walter Traylor's SSN application, come from. It could also explain why Clement listed his sister's name as Nellie Thomas on his draft registration form in 1918. Furthermore, if Laurine was Amanda's child but living with other relatives, those relatives could have been named Winston, though no connections have been made with official records.

As stories about family trickled down through the years, it may have been difficult for family members to keep the names straight and the information intact, which might explain why all Laurine's children knew her maiden name differently. That the two children who had the name Thomas on their death certificates were apparently born to separate mothers (Lillian to Laurine/Larissa, and Walter to Laura) suggests that either these women are one and the same or the children did not clearly differentiate between their birth mothers and the mother who raised them.

38 The 1895 register of live births for Lowndes County shows a daughter born to Laura Traylor that year. This date aligns with Alline's birth information as given on the 1900 census. Laurine's child Lillie was born around 1896, which increases the likelihood that Laura Williams was, in fact, Alline's birth mother.

39 Other records from around 1900 show another William Traylor living in Montgomery. The 1902 Montgomery city directory has a "Wm Traylor" married laborer living at 76 Chandler Street. Montgomery has two Chandler Streets (one east of downtown, the other north of downtown), but the 1903 city directory clarifies the Chandler Street location, noting: "Wm Traylor" unmarried laborer in a house in Pleasant Grove (a mile and a half north of the city limits between Court Street and the L&NRR rail line). The William on Chandler Street is almost certainly not Bill Traylor the artist. Not only was the name William or Bill common, but there were at least eight Traylor plantations in Alabama counties: in Lowndes, George H. Traylor; in Dallas, Thomas G. Traylor (John G.'s estate), Joel Traylor, and Lucy A. Traylor (widow of Thomas L. Traylor); in Coosa, Robert Traylor and T. H. Traylor; and in Randolph, W. B. Traylor and Washington Traylor. The directory also shows a Walter Traylor, whose name was variously spelled as Taylor and Trailor throughout the years.

The Montgomery city directories from 1904 to 1906 have no "Wm Traylor" or variant, but "Wm Traylor" appears again in 1907 as a married laborer on Goode Street, below Norwood Street, just south of city limits. The 1909 Montgomery city directory has "Wm Traylor" as an unmarried yardman for Edward McAdam at 462 Clayton Street, between Hanrick and Whitman Streets. "Wm Traylor" appears again in the 1915–16 Montgomery city

directory as a married laborer in a house at 201 James Street (now Patrick Street), which is between Hill Street and the Atlantic Coast Line RR. It's unknown whether the latter name is the Bill Traylor who died in 1923 (see above, n6) or Bill Traylor the artist.

40 For information on Lorisa/Larisa, see above, n36.

41 The 1930 census notes Bill's age at the time of his "first marriage" as thirty-five; this notation is at odds with several others and (if correct) would mean that either he was not the William Traylor who married Elsey Dunklin in 1880 or the age recorded for his first marriage was off by about eight years. The research for *Between Worlds* points to the latter possibility as being correct, as one of Traylor's children (Sallie/Sarah Traylor Howard) later, on her SSN application in 1963 (herein fig. 12), gave her mother's name as Elsey Dunklin, albeit with a slightly varied spelling, "Elsie Duncin."

42 The grandson of Lillian Traylor Hart explained that he understood his grandmother's birth name to be Lillie Lee, which she later changed to Lillian. Frank L. Harrison Jr., email exchange with Stacy Mince, Feb. 1, 2018.

43 The signature line of Sarah's SSN application says "unable to obtain signature, IRS," meaning that an IRS employee filled it out, which increases the likelihood of a misspelled name. Sarah's death certificate does not contain a mother's name. The person who completed the form was most likely an employee of the nursing home and did not know Sarah Traylor Howard's mother's name.

Records for Pauline and George have been sought for this study but not discovered. The SSN applications reviewed in the *Between Worlds* research came from the Social Security Administration and were ordered by Stacy Mince specifically for this project. Mince ordered Sarah's death certificate from the Center of Health Statistics, Alabama Department of Public Health, Montgomery.

44 Charles Shannon made the note on the back of the drawing (*Mother with Child*, pl. 2). He dated the work July 1939.

45 Bill's first wife, Elsey Dunklin, disappears from the family records around 1887; an 1891 marriage certificate notes Bill's second marriage, to Laurine Dunklin. Mechal Sobel asserted that while Traylor was married to his second wife, Laurine (also called Lorisa; spelled Larisa in Sobel's text), he was simultaneously involved with the woman who would later become his third wife, Laura Williams.

Sobel concluded that a drawing Traylor made (many years after he and Laurine married)—a rare work that shows a woman and female child together (pl. 2)—was a reflection on Laurine's exit from the family. Sobel's theory that the drawing pertains to a departing mother and distraught child may be correct; Sobel did not consider Elsey as a first wife (and mother to Pauline and Sarah), but the distressed child in the drawing may nonetheless be Sarah, based on the girl's appearance as a youth rather than a small child. Lillie, Nellie, and Alline are less likely as possibilities; Lillie and Alline for being very young in the late 1900s, and Nellie being bonded to the mother who stayed, Laura. Sobel, *Painting a Hidden Life*, 46.

46 Whether "Nertie" and Nellie were two separate children has been explored in depth for this study. "Nertie," the girl shown as "daughter" to Bill and Laurine/Lorisa/Larisa in 1900, is not named on the 1910 census; instead, a Nellie is recorded as being age nineteen (putting her birth year around 1891). The records after 1900 and the history as relayed by family members (see below, n48) strongly suggest that "Nertie" and Nellie are one and the same, not two girls born in different years. The important (but

unlikely) circumstances are that if "Nertie" was indeed an individual born around the same year and coincidentally in the same month (October) as Nellie, she vanished from the official record and family memory at the very moment Nellie appeared.

47 Her death record says: "Nellie May (Williams) Pitts (m), daughter of Burrell Williams and Laura (maiden name) Traylor; her recorded last name of Williams stays with her for life." This information was conveyed in 1952, after Nellie died, by her husband, J. C. Pitts, who probably never knew his mother-in-law's actual maiden name; he knew Laura by her married surname, Traylor. Nellie May Pitts, Commonwealth of Pennsylvania Department of Health Bureau of Vital Statistics Certificate of Death, Oct. 24, 1952.

48 Nettie Trayler-Alford, "Who Was Nutie?" in the 1992 reunion booklet.

49 The 1900 census suggests Nellie was born in 1887; the death record for Nellie May Traylor Pitts says she was born in 1889; the 1910 census says Nellie was nineteen that year, which would make her birth year 1890 or 1891.

50 If birth years on the 1900 census are correct, Bill had daughters Sallie/Sarah and Nertie/Nellie within three months of each other in the same year (1887). If Nertie and Nellie were two different individuals, then Elsey Traylor must have been pregnant with Sallie/Sarah while Lorisa was pregnant with Nertie. However, if Nertie and Nellie are the same person, as is believed, then Nertie/Nellie must have been Laura's child but for reasons unknown lived with Bill and Lorisa from the time she was very young. If Nertie (b. 1887) is a different individual from Nellie (b. 1891), then it is likely that she had fledged (as did all the older children, Pauline, George, Sallie/Sarah) by or before the point Bill "married" or set up household with Laura Williams. By 1909, Bill's first children (Elsey's and Laurine/Lorisa's) would have been between twenty and twenty-five years old. Alline's and Lillie's birth years are also proximate; see above, nn38, 45, and below, n52.

51 Sobel, *Painting a Hidden Life*, 10; see also above, nn46, 50.

52 Alline's and Lillie's birth years are also extremely close in proximity (ca. 1895 and 1895, respectively), adding likelihood to the possibility that Laura Williams was the mother of Alline, as stated on her birth record, and that Traylor was involved with Laurine and Laura simultaneously, as he possibly had been with Elsey and Laurine.

53 Sharecropping predated the American Civil War and existed globally, but it proliferated in the United States with the freeing of the slaves. Those who couldn't afford their own land would contract with landowners to farm portions of rented land, and they paid with part of their harvests for land use, tools, and shelter. A slim margin of crops provided the sharecropper with his family's food and income. The system was generally geared to leave the sharecroppers indebted to the landowner at the end of the year; landlords set all prices, kept all records, and charged sharecroppers for replacing equipment. Widespread illiteracy put sharecroppers at an extreme disadvantage. If the landowner determined that a debt was owed, the sharecropper, under contract, became bound to the land until he became debt free. For more information about sharecropping, see Louis Ferleger, "Sharecropping Contracts in the Late-Nineteenth-Century South," *Agricultural History* 67, no. 3 (Summer 1993): 31–46.

Peonage, also called "debt slavery," was a punitive measure by which a person could be enslaved in lieu of serving jail time. Such debts might be financial or legal, and no crime or debt was too small. Corrupt lawmen often assisted landowners by falsely

arresting people simply because the landowner needed workers.

While Congress technically outlawed peonage in 1867, the practice continued well into the twentieth century with few lawbreakers prosecuted. It wasn't until President Franklin D. Roosevelt was in office that the laws were upheld. Roosevelt's attorney general, Francis Biddle, in 1941 put out a directive to all US attorneys that defined procedures regarding cases relating to peonage. The directive, known as Circular No. 3591, forced the courts in all states to uphold the laws that had been set in place seventy-four years earlier. For more information about peonage, see N. Gordon Carper, "Slavery Revisited: Peonage in the South," *Phylon* 37, no. 1 (1976): 85–99. For more information about Circular No. 3591, see Francis Biddle, "Circular No. 3591: From the Attorney General to All U.S. Attorneys Concerning Servitude, Slavery, and Peonage," Dec. 12, 1941, Wikisource.

54 Where Bill Traylor and his family appear on the 1910 census he is listed as "farmer" instead of "farm laborer," which suggests that he may have been tenant farming or possibly sharecropping. Finding their situation lacking, the members of the Bill Traylor family still living in Bill's household found work at John "J. A." Sellers's plantation, not as sharecroppers but as paid workers. It is unknown precisely when Bill and his family moved to the Sellerses' farm. The 1920 census notes that Bill and Laura are no longer working and lists the children as "farm laborers."

55 Allen Rankin, "He Lost 10,000 Years" *Collier's*, June 22, 1946, 67.

56 According to descendant Kendall Buster, George Boyd Traylor and his brother John Bryant Traylor Jr. may have jointly inherited and managed the property after Margaret's death. Telephone conversation with the author, Nov. 15. 2017.

57 DePasse/R. Buster interview, 1996. Specifics about the farm management after Margaret Traylor's death remain factually unestablished.

58 Laurine/Larisa/Lorisa may have died by 1910; a death record has not been located.

59 Bill is listed as an employer strictly because his family works the farm and he is the head of the family. According to the 1910 census instructions, "A wife working for her husband or a child working for its parents is returned as an *employee*, even though not receiving wages. The husband or parent in such case should be returned as an *employer*." Department of Commerce and Labor, Bureau of the Census, Washington, *Thirteenth Census of the United States April 15, 1910: Instructions to the Enumerators* (Washington, DC: Government Printing Office, 1910), 37.

60 In 1920, Congress gave the US Census Bureau permission to destroy papers the bureau deemed to have "very little or no probable value." The bureau consequently ordered one hundred tons of paper, including the 1910 censuses and their agriculture schedules, to be "mutilated and sold as waste paper." US Census Bureau, "Preservation of Records," *Annual Report of the Director of the Census to the Secretary of Commerce for the Fiscal Year Ended June 30, 1921* (Washington, DC: Government Printing Office, 1921), 25.

61 Billy J. Singleton, *Montgomery Aviation* (Charleston, SC: Arcadia Publishing, 2007). Wilbur Wright visited Montgomery in February 1910, searching for a good location for his flight school. He met with the Commercial Club—later called the Chamber of Commerce—and settled on the cotton planation of Frank D. Kohn (just west of Montgomery on Washington Ferry Road),

who offered use of the land to the Wright brothers at no charge.

The Commercial Club promptly cleared three miles of cotton fields and installed lighting. By the time Orville Wright arrived in March, two students and a mechanic were already there, a hangar had been erected, and a "flying machine" was assembled and ready for flight. Orville made the first flight there (for five minutes at fifty feet) on March 26, 1910, in the Wright Flyer No. 10. Unfortunately, the school did not last. When Alabama's oppressive summer heat arrived, the Wrights moved the operation to Dayton, Ohio. It would be eight years before the airfield was used again, during World War I.

62 Mary Ann Neeley, introduction to her *Montgomery: Capital City Corners* (Dover, NH: Arcadia Printing, 1997). The Wright brothers' school was the first such school in the United States, and although it existed only for a couple of months, one graduate—Walter Brookins, who made the first recorded night flight on May 25, 1910—would be regarded as a historic Montgomery figure.

63 "1901–1950," *Alabama History Timeline*, ADAH (website).

64 "The Boll Weevil and the Negro Farmer," *Colored Alabamian*, Apr. 12, 1913. Microfilmed at Archives and Special Collections, Auburn University at Montgomery Library, AL, August 1986. The article discusses how large numbers of black farmers thought the boll weevil story was a hoax to get them to buy fertilizer and then were not prepared for the reality of the pest.

65 Roger L. Ransom and Richard Sutch, *One Kind of Freedom: The Economic Consequences of Emancipation* (New York: Cambridge University Press, 1977), 171–72.

66 "The Great Migration," StudyModeResearch (website).

67 Isabel Wilkerson, *The Warmth of Other Suns: The Epic Story of America's Great Migration* (New York: Random House, 2010), 161.

68 Martin T. Ollif, "World War I and Alabama," Encyclopedia of Alabama (website), May 22, 2008; last updated Jan. 28, 2016.

69 Wilkerson, *Warmth of Other Suns*, 161.

70 Brentin Mock, "The 'Great Migration' Was about Racial Terror, Not Jobs," June 24, 2015, CityLab (website).

Bryan Stevenson of the Equal Justice Initiative in Montgomery, Alabama, has been leading an effort to map where the close to four thousand lynchings of African Americans happened in America between 1880 and 1940. "Lynching in America: A Community Remembrance Project" (Equal Justice Initiative website) states: "Between the Civil War and World War II, thousands of African Americans were lynched in the United States. Lynchings were violent and public acts of torture that traumatized black people throughout the country and were largely tolerated by state and federal officials. 'Terror lynchings' peaked between 1880 and 1940 and claimed the lives of African American men, women, and children who were forced to endure the fear, humiliation, and barbarity of this widespread phenomenon unaided. This was terrorism." For more on the Equal Justice Initiative, see Director's Foreword, n1; LifeB.n34; and ArtB.n48.

71 US Department of Agriculture, "The Boll Weevil Monument, Enterprise, Alabama," Special Collections, USDA National Agricultural Library. The inscription on the monument reads: "After the boll weevil destroyed (1910–15) the area's cotton, diversified farming was begun. In gratitude for the resulting prosperity, the city erected a monument to the

boll weevil in 1919." The boll weevil atop the monument was added about thirty years later.

72 See "Race and Multiracial Americans in the U.S. Census," chap. 1, *Multiracial in America,* June 11, 2015, Pew Research Center (website).

73 For information on Elsey Dunklin from the 1870 census, see above, n7.

74 The information on "M2" is according to the 1910 census instructions for the enumerators. Department of Commerce, *Thirteenth Census, April 15, 1910,* 29.

75 Charles S. Johnson, *Shadow of the Plantation: A Classic Study of Rural Negro Life* (Chicago: University of Chicago Press, 1934; repr., 1966), 40–41.

76 "Persuading Parties to Follow Norms: Superstitions, Conjure, and the Broomstick," in *Strange Ways and Sweet Dreams: Afro-American Folklore from the Hampton Institute,* ed. Donald J. Waters (Boston: G. K. Hall, 1983), 74–75.

77 In 1992 descendants of Bill Traylor went to court to determine their rights as heirs. A summary of the settlement they reached with Charles Shannon and New York's Hirschl & Adler gallery (see below, n198) explains their relationship to Bill Traylor, noting the belief that Laura was the woman Bill married in 1891 and that all children after that marriage descended from her. If true, some of the less explicable parts of the narrative would be simplified, but the 1910 census strongly contends that Laura was a subsequent wife to Laurine/Lorisa and that the children came from those two marriages, not one.

78 Such records have been sought for this study but not discovered.

79 If Clement was also Laura's child by birth, then two of her children—he and Alline—resided with Bill and Laurine/Lorisa in 1900. The listing lacks sufficient information from which to draw firm conclusions about bloodlines.

80 Another inconsistent record is the 1895 Lowndes County birth register, which says "Laura" and Bill Traylor had a baby girl on May 24. This information corresponds to the 1900 and 1910 census data for Alline (also spelled Aleen). The questions then are: was the name Laura mistakenly given, or given as an overlapping nickname, when Alline's mother was, in fact, Laurine/Lorisa/Larisa, or is Alline another child of Laura's living in the home of Bill and Laurine/Lorisa/Larisa in 1900?

81 The research for *Between Worlds* did not unearth a Louisa Weston who matches the criteria that would identify her as the children's mother. See more below, n82.

82 The identity of Laura was researched for *Between Worlds*, but no clear results were netted. The records from the descendants offer several names. All the descendants except Sarah called their mother Laura (see above, n80) regardless of who their birth mother may have been. In birth order from oldest to youngest of age: Reuben's birth certificate and SSN application use the name Laura, with the surname unknown; Esther's death certificate lists her mother's maiden name as Laura Winston, but her SSN application says Louisa Weston; Lillian's death certificate names Laura Thomas; Clement's SSN application gives Laura Whinston; Will's death certificate says Laura Williams; Mack's death certificate says Laura Williams; John Henry's death certificate and SSN application say Laura Williams; James's death certificate says Laura Winston; and Walter's death certificate has no mother listed, but his SSN application names Laura Thomas. Sarah Traylor Howard's SSN application lists her mother's maiden name as Elsey Dunklin (misspelled as Elsie Duncin). Information for

the two children older than Sarah (Pauline and George) has not been located, nor has information for Alline or Roland. None of the children lists their birth mother as Laurine, Lorisa, or Larisa. Esther's SSN application, however, appears to have two different sets of handwriting on it, so it is possible that the person filling it out misheard her mother's name as Louisa Weston instead of Lorisa Winston, for example.

No matches for Louisa Weston (or any variants) or Laura Thomas have been found. Close matches for Laura Winston appear on the 1900 census in Lowndes County near Benton and another in Jefferson County. The Laura in Lowndes, however, was married to another man, William Cary, and their relationship can be tracked for decades; she has therefore been ruled out as having been Bill Traylor's wife. The Laura in Jefferson has also been ruled out, because the distance (four counties to the north) makes it unlikely she is the mother to children who were born before the Traylors moved to Montgomery County around 1908. Other than on the death certificate for Clement that names his mother, no other records have been found for the name variation Laura Wilson; the informant for Clement's certificate is listed as "the decedent," which suggests that Clement himself gave the name Laura Wilson before he died. Clement was also the informant on Esther's death certificate, on which he gave the mother's maiden name as Winston; on his SSN application he gave the name Laura Whinston; the name Wilson seems to be simply an error.

The name Williams is seemingly derived from Laura's previous marriage and is not her correct maiden name. Between 1866 and 1900 three Burrell Williams (the father specified on the 1952 death certificate of Laura's daughter Nellie Mae Williams Pitts) are found on state and federal censuses. On the 1866 Colored Population Schedule for Lowndes County, Alabama, the information is scant but shows two males in the Burrell Williams household—one in the age range of ten to twenty years, and the other between forty and fifty. A possible first husband to Laura, or at least the father to her daughter Nellie, was likely the younger of the two, the son (if was named after his father and was also Burrell Williams). Another Burrell Williams was found on the 1880 census for Dallas County and still another on the 1900 census for Lowndes County; both were married. Any of these men could be have been the father of Nellie; these unions may have been brief for any number of reasons; the use of the last name Williams and the identification of the father's name as Burrell Williams are herein honored as "facts" of oral history.

83 Johnson, *Shadow of the Plantation*, 39, 40.

84 It has also been theorized that Nellie was a biological child of Bill's, regardless of the given last name Williams. No evidence supports this theory, however, nor that Bill Traylor knew Nellie William's mother, Laura, until some years after Nellie was born.

85 Sobel, *Painting a Hidden Life*, 137n2. The 1920 census contains many errors, and it is possible that the enumerator did not even consult the individuals named. Sobel noted that the Montgomery County enumerator listed all blacks and their parents as having been born in Alabama, which suggests a formulaic and inaccurate manner of completing the survey.

86 Laura Traylor is listed as living in Montgomery. The address Will gave as his residence is 220 S. 13th Street in Birmingham. The same address appears on Clement's draft card from 1918, which names Nellie Thomas as his closest kin (see above, n37).

87 Will, Clement, and Reuben all adhered to compulsory draft registrations in 1918 but never served.

Only Clement was living by World War II, and he again registered for the compulsory draft. The only children of Bill Traylor's known to have been in the armed forces was Jimmie, who served in World War II, and Walter, in World War II and Korea. The 1919 Montgomery city directory has a James Thomas living at the address Clement provided; he was presumably Nellie's husband but could have been another relation. Whether the Thomas name originated with Nellie is also unclear.

88 Margaret Traylor Staffney, one of Bill Traylor's granddaughters, recalled having an Uncle Roland who died young. She sent a letter of inquiry to the Alabama Department of Public Health, dated August 9, 1999, but received no information in return. Staffney believed Roland had been born in 1910. A careful reading of the pertinent script on that year's census appears as "Plunk," but the barely legible writing allows for the possibility that the name written is actually "Roland." The author's curatorial files.

89 Walter Traylor was better known as Bubba to his family members, as mentioned in the 1991 reunion booklet; M. R. Fowler and Weber/Delks, Greene, and Staffney audio interview, 1992; and Jeffrey Wolf's interview with Margaret Traylor Staffney, Oct. 2017, Detroit, MI.

90 A death certificate for James Traylor, son of William Traylor and Laura Winston, lists his birth date as December 10, 1911. James/Jimmie is not formally registered on any census found before 1940. He is James on official documents (censuses, death certificate, and draft registration) but Jimmie in the 1991 reunion booklet.

91 The 1940 census lists James Traylor living with his wife, Theresa, and her parents in Pittsburgh, Pennsylvania, on the same street noted on his draft registration card from 1940. Three addresses are given on his draft card, one of which is either his sister Nellie's or his brother Clement's residence. The Avonmore address is also found on Nellie's stepson's (Levi Pitts's) application for World War II compensation and on Clement's application for a SSN. James's World War II compensation form, which was submitted in 1950 and processed in 1953, notes that he was in the Pittsburgh area (US Selective Service System. *World War I Selective Service System Draft Registration Cards, 1917–18*. Washington, DC: National Archives and Records Administration).

92 According to the 1991 reunion booklet, Jimmie died while residing with his sister Easter in Detroit. Easter, written as Esther, was the informant on Jimmie's death certificate. Her address is listed as 978 Brady, and his as 917 Brady. One of the numbers may be a typo, or the siblings were living in proximity but not together when Jimmie died.

93 William Sellers's World War I draft card (1918) says he was a farmer and warehouseman.

94 The 1930 census lists Bill Traylor as a seventy-five-year-old widower.

95 Bill's youngest child, Walter, who would have been only twelve or thirteen, likely attached himself to an older sibling, as Bill was no longer a reliable provider. Kiser's name has not turned up on additional records; as already mentioned, "Kiser" may have been a nickname for Walter. Several Walter Traylors are listed on the 1930 and 1940 censuses, as well as in the Montgomery and Birmingham city directories, but a direct match has not been made. Walter more likely followed Will to Birmingham or traveled elsewhere to find one of his sisters. It is possible that he went to live with Easter in Detroit, with whom he lived at the time of his death in a later decade, or Lillian in Philadelphia. Frank L. Harrison Jr., Lillian's grandson, said Walter lived with Lillian for a time but did not specify when. Frank L.

Harrison Jr., email exchange with Stacy Mince, Feb. 1, 2018.

96 This address housed a restaurant that Asa W. Wilson ran from 1905 to 1928; the 1905 city directory notes an additional address as 9 ½ Coosa Street, which was likely a rented room. Bill does not appear in the 1929 city directory, but his exclusion may have been inadvertent, not a reflection of his changed circumstances. Asa Wilson died that February, and Isaac Griggs took over the restaurant.

97 Samuel C. Adams Jr., "The Acculturation of the Delta Negro," in *Mother Wit from the Laughing Barrel: Readings in the Interpretation of Afro-American Folklore*, ed. Alan Dundes (Jackson: University Press of Mississippi, 1990), 521; originally published in *Social Forces* 26, no. 2 (Dec. 1947): 202–5.

98 Neeley, *Capital City Corners*, 30. The fountain was long-rumored to have been sculpted by Frederick MacMonnies (based on the Italian Neoclassical sculptor Antonio Canova's *Hebe*), a student of Augustus Saint-Gaudens's, but in fact it was mass-produced. See also Carol A. Grissom, *Zinc Sculpture in America, 1850–1950* (Newark: University of Delaware Press, 2009).

99 Jay C. Leavell, "When Downtown Was the Heart," in *Jay's Montgomery Remembered*, compiled and published by Jo Leavell Fleming (Montgomery, AL, 1986), 43. The essays in this compilation were originally published in the *Montgomery Independent*, this one in Nov. 3, 1983.

100 On the National Register for Historic Places (NRHP) application filed by the Alabama Historic Commission in 1984 it is called by both its present-day name (The North Lawrence–Monroe Street Historic District) and the name it would have been called in its heyday (the Monroe Street Black Business District). The racially disparaging epithet "Dark Town" is also noted in the NRHP file.

101 Judge John B. Scott, "Monroe Street" (paper presented to "The Thirteen," Montgomery, AL, Mar. 13, 1958), n.p. Copy in the author's curatorial files, courtesy Mary Ann Neeley of the Landmarks Foundation of Montgomery.

102 Photographer and filmmaker Rudy Burckhardt made the film *Montgomery, Alabama* (1941, color, 4 min.) on a weekend pass from his military duties with the US Army Signal Corps, which he served in from 1941 to 1944. Piano by Earl Hines. The DVD insert states: *Montgomery, Alabama*, directed by Rudy Burckhardt (1941; San Francisco, CA: Estate of Rudy Burckhardt, 2012), disc 1. Jeffrey Wolf located this footage in 2017 during research for his film *Bill Traylor: Chasing Ghosts*.

103 *The Emancipator* (Montgomery, AL), Oct. 6, 1917–Aug. 14, 1920. Microfilmed at ADAH, July 1992.

104 At the time of this newspaper feature, R. A. Ross was still in business with T. J. Jenkins, who also appears in the photographs of prominent funeral directors and embalmers. According to the Montgomery city directories, around 1920–22 their business was called Jenkins-Ross Undertaking Company, located at 102–104 North Perry Street. In 1923 it moved and incurred a change of name and ownership. R. A. Ross and W. M. Clayton formed the Ross-Clayton Undertaking Company at 11 Monroe Street (this address was a typo in the directory that should correctly have been 111 Monroe). In 1932 the name was changed to Ross-Clayton Funeral Home, by which the business exists today. Sometime in 1940 or early 1941, the funeral home moved to 518 South Union Street (which around 1950 was renumbered to 524) and in 1958 moved again, to 1412 Adams Avenue, where it is located today. A note on

the company's website saying it moved to the Union Street location in 1939 may be an error.

105 *The Emancipator* (Montgomery, AL) folded after it pleaded to its readers for several months to pay their overdue subscription fees. According to the Montgomery city directories, *The Emancipator* attempted a return in 1928 at 360 ½ South Jackson Street and again in 1942 at 757 S. Ripley Street. No copies of these editions have been located.

106 Gleason Leonard Archer, *History of Radio to 1926* (New York: American Historical Society, 1938), 202–4. The first radio station was KDKA in Pittsburgh, and the first broadcast was on November 2, 1920, giving results of the landslide presidential victory of Warren G. Harding over James M. Cox.

107 *Radio* (Pacific Radio Publishing, 1922). The Apr. 1920 issue (p. 17) of *Radio* lists station WGH under "Fifth District" as owned by Montgomery Light and Power Co. at 111 Dexter Avenue. The November issue (p. 33) lists WKAN as having applied for a license under the ownership of Alabama Radio Mfg. Co. It also states (p. 32), "There are 487 broadcasting stations licensed by the Department of Commerce up to August 26th."

108 The radio station WSFA's inaugural location was the airfield now known as Maxwell Air Force Base on the outskirts of Montgomery. Its call letters stood for "South's Finest Airport." By 1938 the station had moved to the Jefferson Davis Hotel in Montgomery.

109 Within his lifetime, Bill suffered the loss of three adult children. Four years after Will died, Mack died in Montgomery in 1933. At the time, he was married to Leola (Pettaway) Traylor and living in proximity to his sister Sarah. Ruben died in Buffalo, NY, in 1939. According to the Buffalo city directory for that year, his residence was 14 Wells Street, which was the Erie County Home Relief Shelter. Ruben was preceded in death by his wife, Lucy Thomas. He had previously lived with his brother John Henry in Buffalo, but details about their relationship and why Ruben came to be in a shelter are unknown. Death certificates for Pauline, George, Alline, Arthur (who may be Jimmie), and Roland (who may be Plunk) have not been located.

110 Will Traylor and Mimmie Calloway's children are Margaret (b. 1923), Myrtha Lee (b. 1926), and Clement B. (1927–1981). It is unclear whether Will and Mimmie were cohabitating at the time Will was killed. Records for Mimmie have not been found in the 1920s city directories for Montgomery or Birmingham, nor on the 1930 or 1940 census.

111 "Negro Burglar Is Slain at Home in West End," *Birmingham Post*, Aug. 26, 1929, 3.

112 Will's wife and children may have been living apart from him in Montgomery at the time he was killed, according to M. R. Fowler and Weber/Delks, Greene, and Staffney audio interview, 1992.

113 Eugenia Carter Shannon, "Race Relations in Montgomery, Alabama, 1930s–1940s," in *Bill Traylor, 1854–1949: Deep Blues*, ed. Josef Helfenstein and Roman Kurzmeyer, exh. cat. (New Haven: Yale University Press, 1999), 180.

114 Keith S. Herbert, "Ku Klux Klan in Alabama from 1915–1930." Encyclopedia of Alabama (website), Feb. 22, 2012; last updated Nov. 7, 2013. By 1925, membership was tallied at 115,000 across the state.

115 Robert W. Bagnall, "The Present South," *Crisis* 36, no. 9 (Sept. 1929): 303. Bagnall notes that not only were the police "sadistic," but the civilians were, too.

116 For the 1930 census, Bill told the enumerators that he first married at age thirty-five. In fact, marriage certificates show that he married his first wife, Elsey Dunklin, in 1880 and his second wife, Laurine Dunklin, in 1891, when he would have been twenty-six and thirty-eight, respectively.

117 This and subsequent quotes by David Calloway Ross Sr. are from an interview in Betty M. Kuyk, *African Voices in the African American Heritage* (Bloomington: Indiana University Press, 2003), 167, 170, 176, 190. Kuyk interviewed David Ross Sr. and his son, David Calloway Ross Jr., in January 1987. According to the Ross-Clayton Funeral Home website, David Ross Sr. had taken over the family business from his father, Robert Ambers Ross (see ArtB. n82), in 1935, and David Calloway Ross Jr. would later succeed his father.

118 Kuyk, *African Voices,* 167. The Traylor family members who have been located through records, however, lived primarily in Avonmore, Westmoreland County, a suburb of Pittsburgh. Although no official records found have linked any of Bill's children to Philadelphia, Frank L. Harrison Jr. stated that his grandmother Lillian lived there for a time; he was unsure of how long she was there but stated she moved from Philadelphia to Washington, DC, in 1949 (Frank L. Harrison Jr., email exchange with Stacy Mince, Feb. 1, 2018). It is possible that one of Traylor's children whose vital records could not be found also resided in either Pittsburgh or Philadelphia. Ross's memory of relatives visiting Traylor downtown matches that of Margaret Traylor Staffney who, on several occasions, mentioned visiting her grandfather while he was lodging at the funeral home in the late 1930s.

119 Ross, quoted in Kuyk, *African Voices,* 167.

120 Shannon, "The Depression in Montgomery, Alabama," in Helfenstein and Kurzmeyer, *Deep Blues*, 179.

121 See above, n61, for the cooperation of Montgomery leaders in establishing the Wright brothers' flight school in 1910.

122 Maj. Larry Edward Kangas, "Historical Picture of Maxwell AFB" (master's thesis, Air Command and Staff College Air University, Maxwell AFB, 1986), 10. See also Robert T. Finney, "History of the Air Corps Tactical School, 1920–1940," Research Studies Institute, USAF Historical Division, Air University, 1955; repr., Air Force History and Museum Programs, 1998, Defense Technical Information Center website.

123 With the beginning of the Second World War, the Air Corps Tactical School closed, and the airfield's mission shifted to focus on tactical training. Maxwell continued to grow with more land and longer runways to accommodate the new, specialized flight schools, which taught acrobatic maneuvers and formation flying in single-engine airplanes and piloting of new, heavier aircraft such as the four-engine Boeing B-29 Superfortress bomber (Singleton, *Montgomery Aviation*, 88–95).
 While Maxwell Field was expanding and training pilots, another airfield, the so-called Gunter Field (present-day Gunter Annex), opened in 1940, just east of downtown as another flight training school in the area. The new facility took over the municipal airport that had opened in 1929. Gunter Field became the training site for more than twelve hundred American, British, and French airmen (ibid., 33–34). With the close of the war, the missions for the Maxwell and Gunter airfields changed, and the two flight schools were dismantled.

124 John Bryant Traylor Jr. was the son of Marion Hartwell and Annie "Ella" Boyd Traylor and grandson of George Hartwell and Margaret Averyt Traylor.

125 Lynda Roscoe Hartigan, "Going Urban: American Folk Art and the Great Migration," *American Art* 14, no. 2 (Summer 2000): 34.

126 DePasse, "Memories Within" (chap. 1, 36n47), cites Montgomery Department of Human Resources files, dated Feb. 6, 1936. See also Miriam Rogers Fowler, "Bill Traylor," in *Outsider Artists in Alabama*, comp. M. R. Fowler (Montgomery: Alabama State Council on the Arts, 1991), 52, 53. This document was never located during research for *Between Worlds*.

127 The Ross-Clayton Funeral Home at 111 Monroe Street and 111 ½ Monroe Street, where Jesse and Traylor (1937–39) lived, were on the same block as the *Alabama (Montgomery) Tribune,* which opened its office in 1936 and remained there for a decade. Located at 123 ½ Monroe Street, and overseen by E. G. Jackson as publisher and general manager, it operated from 1936 until 1964.
 The earliest available edition of the *Alabama Tribune* (on microfilm) is from 1946, about the time Traylor left the downtown Montgomery area to live with his daughter Sarah. With the tag line "Clean-Constructive–Conservative," the *Alabama Tribune* set itself apart from previous black-owned newspapers by advertising national products (not just local businesses) and replacing opinion editorials that advocated industriousness and education with fact-driven national and international reports pertaining to black American communities. Like its predecessors, it carried articles about anti-lynching campaigns and congressional attempts to abolish Jim Crow legislation. Black celebrities and athletes were gaining in prominence, so the paper included sports pages as well as features on arts and entertainment. Opinion pieces were reserved for the back pages and pertained primarily to health, beauty, and etiquette. The paper rarely covered local news. The author reviewed the *Alabama Tribune,* Sept. 13, 1946–Dec. 30, 1949, microfilmed at ADAH in Feb. 1988.

128 Leavell, "Doing Graffiti on the Grocery Store Windows," in *Jay's Montgomery Remembered*, 15–17; originally published in the *Montgomery Independent*, Aug. 11, 1983.

129 Ibid. The other two (white) sign painters were Darrell Parks and Bill Taylor (not to be confused with Bill Traylor). Leavell would be a senior at Sidney Lanier High School in 1939 and become an art student at the New South. He wrote an article for a New South publication and became an active member.

130 Leavell, "Downtown Prospered in the 1930s," in *Jay's Montgomery Remembered*, 43; originally published in the *Montgomery Independent*, Dec. 8, 1983.

131 The street number changed to 524 around 1950. The business moved again, in 1958, to 1412 Adams Avenue, where it still operates today. See Ross-Clayton Funeral Home (website).

132 The Brenner family opened a shoe factory at 105 South Court Street in 1915. They moved the business next door, to 101 South Court Street, sometime before 1919. After 1960 the Brenners returned to their original business address at 105 South Court; the building at 101 South Court was razed. The factory building still exists; it is currently the Montgomery Book Factory. Marcia Weber proposed that the Brenners' business was the one Bill was affiliated with, based on its proximity on Goldthwaite Street to Bill's address on Bell Street; email exchange with the author, Mar. 2017. Information on the Brenners' business is found in city directories and from a photograph of the Montgomery Shoe Factory dated around 1960 from ADAH.

133 The only reference to Traylor's living at this location came from Charles Shannon in Maresca and

Ricco/C. Shannon interview, 1989, 4. Shannon notes that Traylor moved to a shoe shop when the funeral parlor moved. Marcia Weber suggested that Liberty Shoe Repair on North Lawrence was likely where Traylor relocated (email to the author, Mar. 2017). Further inquiry into Liberty Shoe Repair found it was owned by a white man, Joseph P. Linahan (alternate spelling Linahen). In the 1940 Montgomery city directory, it is mistakenly listed as a "colored business." The designation may have been just a typographical error, but another possibility is that Traylor was residing there, and the researchers for the directory mistook him for Linahan, the shop's owner.

134 DePasse/Staffney interview, 1996, 19 and chronology, 4. On more than one occasion, Staffney noted visiting Traylor in the late 1930s when he was working as a shoe repairman and further, the memory that he had started making drawings around that time (ca. 1937–38). If correct, the drawings that the New South members saw Traylor making were not the very first ones, as Charles Shannon asserted. See also ArtA.n1.

135 Jay Leavell's shop existed for about a year; he used the profits to attend college in 1940. In 1941, Leavell joined the US Army Air Corps (now US Air Force) to fight in World War II. His brother's café folded sometime around 1941 or 1942. After the war and his discharge from the Air Corps in 1945, Jay attended the Parsons School of Design in New York.

136 DePasse/Lapsley interview, 1996.

137 DePasse/Leavell Fleming interview, 1996.

138 John Lapsley claimed that Shannon implored him to let him, Shannon, have the credit for the "discovery" of Traylor (Lapsley/Hedges interview, ca. late 1980s–early 1990s). Lapsley told DePasse that Leavell was the first to notice Traylor and introduce him to other New South members (DePasse/Lapsley interview, 1996).

139 In 1988, Shannon recalled that his first meeting with Bill took place in "early summer" of 1939; Charles Shannon, "Bill Traylor's Triumph: How the Beautiful and Raucous Drawings of a Former Alabama Slave Came to Be Known to the World," *Art & Antiques* (Feb. 1988): 61. In 1991 he stated the meeting was in the spring rather than early summer; Maresca and Ricco/C. Shannon interview, 1989, 3.

140 For a biographical account of Charles Shannon, see Margaret Lynne Ausfeld, "Unlikely Survival: Bill Traylor's Drawings," in *Bill Traylor: Drawings from the Collections of the High Museum of Art and the Montgomery Museum of Fine Arts*, exh. cat. (Atlanta, GA: High Museum of Art and Del Monico Books/Prestel, 2012), 11–21.

141 Miriam Rogers Fowler, "New South School and Gallery," in *New South, New Deal, and Beyond: An Exhibition of New Deal Era Art, 1933–1943* (Montgomery: Alabama State Council on the Arts, 1989), 7; the essay was reprinted, with different illustrations, in *New South Collection of the Siegel Gallery: An Exhibition of New Deal Era Art, 1933–1943*, exh. cat. (Talladega, AL: Jemison-Carnegie Heritage Hall, 1995), 8–11.
 In some records Blanche Balzer is listed as Blanche Peacock, her married name before she married Shannon; Balzer is her maiden name, to which she reverted around the spring of 1939 (later, in remarriage following Shannon, her surname would become Angell). M. R. Fowler noted that another artist, Roy Flint, may have thought up the idea for the New South coalition with Shannon but did not stay involved.

142 Jean Lewis, quoted in A. Fowler interviews, 1988, 1989.

143　Mission statement of founding members of the New South School and Gallery, "Constitution of the New South," Mar. 15, 1939, in M. R. Fowler, "New South School," 7–10. An undated announcement of the movement, titled "New South," and other materials relating to the New South's founding are in the author's curatorial files.

144　Notable members beyond the original seven and the previously discussed John Lapsley, Jay C. Leavell, and Crawford Gillis were Franz Adler, siblings Ben and Kitty Baldwin, James Durden, Robert Gibbons, Joe Miller, John Proctor Mills, Sarah Frances Parket, and J. H. Thompson. Roman Kurzmeyer provides information on Kitty Baldwin in "The Life and Times of Bill Traylor (1854–1949)," in Helfenstein and Kurzmeyer, *Deep Blues*, 174. Kurzmeyer explains that Kitty Baldwin was Charles Shannon's girlfriend when the New South began; she became a New South member, but no records indicate that she was among the charter group. Kurzmeyer notes that he spoke with Kitty on Feb. 28, 1998, but he gives no location for a transcript. Eileen Knott had interviewed Kitty's sister, Betty Baldwin, on Feb. 5, 1995; copy of the unpaginated transcript is in the author's curatorial files. Betty and Kitty gave consistent information.

145　A. Fowler, "New South" and the New South stationery; the street number is incorrect as written in M. R. Fowler, "New South School and Gallery."

146　"Exhibit Opens by New South," *Montgomery Advertiser*, June 4, 1939, 2.

147　M. R. Fowler, "New South School and Gallery," 8.

148　Rented from Pauline Arrington's brother-in-law.

149　A. Fowler, "New South."

150　In M. R. Fowler/Angell interview, 1990, Blanche Balzer (Shannon) Angell would tell Miriam Rogers Fowler that the roof leaked and the walls got soaked, ruining the murals; the building no longer stands.

The Montgomery Museum of Fine Arts has a sketch of Shannon's painting of Traylor (Charles Shannon, *Bill Traylor, Sketch for New South Mural*, 1939, gouache on paper; Gift of Mr. and Mrs. Richard H. Arrington, III in memory of Mrs. Richard H. Arrington Sr., 1990.0002).

151　Mattie Mae Sanderson, quoted in A. Fowler interviews, 1988, 1989.

152　E. C. Shannon, "Race Relations in Montgomery, Alabama, 1930s–1940s," 180.

153　Jean Lewis, quoted in A. Fowler interviews, 1988, 1989.

154　Phil Patton, *Bill Traylor: High Singing Blue*, exh. cat. (New York: Hirschl & Adler Modern, 1997), 31.

155　David L. Lewis, *When Harlem Was in Vogue* (New York: Alfred A. Knopf, 1981), 98.

156　Miriam Rogers Fowler, "A Glimpse at William 'Bill' Traylor," in *Bill Traylor*, exh. brochure (Houston, TX: O'Kane Gallery, 2001), n.p. Fowler cites a letter from Jean Lewis, Mar. 15, 1990.

157　A. Fowler interviews, 1988, 1989.

158　Alain Locke, ed., *The Negro in Art* (Chicago: Afro-American Press, 1940), 206.

159　Ibid., 140.

160　A circular printed by the New South lists the dates of the exhibition as February 1–19, 1940. A copy of the document is on file at the Montgomery Museum of Fine Arts Library, artist's vertical file, "Traylor, Bill."

161　Jo Leavell Fleming gave information about the making of the New South Gallery's exhibition booklet *Bill Traylor: People's Artist* (1940; herein fig. 26) to gallerist Marcia Weber when Weber worked with Jo in 1984 to sell a group of Bill Traylor's drawings that Jay Leavell had owned.

The exhibition booklet was hand-printed in a small quantity. The images are not original works by Traylor nor photographic reproductions of them but rather, copies of Traylor's original works. Jo noted that her late husband, Jay Leavell, had silk-screened them with equipment from his sign shop. They are not signed, but Jo showed Weber the leftover pages and silkscreened covers to corroborate Jay's role in its creation; Jay's test prints and extra copies of the images lent veracity to her account. An original booklet resides in the Special Collections of the Smithsonian American Art and National Portrait Gallery Library, Smithsonian Libraries, Washington DC; donated by the family of Joseph H. Wilkinson.

Jay's sign-painting shop was about two blocks (on South Perry Street) from where Traylor sat and worked by the Pekin Pool Room; Jay closed the shop sometime in 1940 when he went off to college. Jo also believed that Jay brought Traylor many of the candy box tops (from the candy counter where he worked as a stock boy) that Traylor used to paint on, and that he likely also brought Traylor poster paint from his sign-painting shop (Weber/Leavell Fleming conversations, 1984). Leavell Fleming gave a similar account in DePasse/Leavell Fleming interview, 1996 (chap. 1, pp. 22, 24). DePasse noted that the original silkscreens remained in Leavell Fleming's personal collection at the time.

162　*Bill Traylor: People's Artist*, hand-printed (unpublished) exh. booklet, New South Gallery, Montgomery, AL [1940].

163　Shannon in Maresca and Ricco/C. Shannon interview, 1989, 19.

164　"African Art of Bill Traylor Now on Walls of New South," *Montgomery Advertiser*, Feb. 11, 1940, n.p.; "Ex-Slave's Art Put on Display by New South," *Birmingham News*, Feb. 5, 1940, n.p.

165　"The Enigma of Uncle Bill Traylor," *Montgomery Advertiser*, Mar. 31, 1940.

166　"African Art of Bill Traylor Now on Walls of New South."

167　*Bill Traylor: People's Artist*.

168　"The Enigma of Uncle Bill Traylor," 3.

169　Blanche Balzer Shannon (Angell) visited Traylor at Shannon's request, as Shannon was often away during the week. Between 1935 and 1940, he spent workweeks at his Butler County, Alabama, cabin studio; from 1940 to 1942 he took an artist's residency in Georgia; and between 1942 and 1946 he was serving overseas in World War II. Blanche informed Miriam Rogers Fowler that she collected Traylor's work during the times her husband was away (in M. R. Fowler/Angell interview, 1990).

170　Marcia Weber sold some of these works when she worked at the Leon Loard Gallery in Montgomery. Records of these sales are on file at Auburn University. See Archives and Special Collections, Auburn University at Montgomery Library, "Traylor, Bill," Marcia Weber Folk Art Collection, file 120, box no. 2. The Sandersons, who owned a bookstore where local artists and writers gathered, collected still another group, of approximately ten works.

171　Betty Baldwin, Ben Baldwin's sister, told interviewer Eileen Knott (Feb. 5, 1995) that Ben had owned at least five; from his group she subsequently owned one of these. The others owned by Ben

Baldwin were sold through Carl Hammer Gallery, Chicago. (See above, n144, for documentation.)

172　Mrs. Mickey Ingalls of Montgomery acquired ten works from the Sandersons sometime in the 1950s or 1960s. In 1993, when she engaged Marcia Weber to sell some of the works over several years, she recounted to Weber the story of her purchase of the group, which took place at the Sandersons' bookstore. Weber explained that the Sandersons, who opened their bookstore in 1949, were into cutting-edge art and literature and sometimes bought art for their own collection when traveling in Europe. The store had a small display area for art in the back room, and Ingalls recalled that the Traylor works were on view, on a high shelf out reach. Paul Sanderson told her about "the old man they befriended years earlier" who had painted them. Weber relayed Mrs. Ingalls's account to the author in person on March 31, 2016, and via email on June 14, 2017. Daughters Helen B. Ingalls, Zoe Ingalls, Robin Ingalls, and Madeline Ingalls Henderson inherited several works from the Sanderson group but did not retain ownership; the inventory is on file at Marcia Weber Art Objects, Wetumpka, Alabama (formerly Montgomery).

173　Allen Rankin, who wrote about Traylor on several occasions, owned a group of drawings, according to his sister Eugenia Rankin, who worked as a librarian at ADAH in the late 1970s and 1980s, explained to Marcia Weber that these works were destroyed after being stored in an attic with a leaky roof. Although Shannon related that Traylor was no longer making much work, or work of worthwhile quality, the photos taken during Rankin's visit depict works of art: some are from an earlier period, and others appear to have been made later in varied styles. The works in the latter group are not known to have survived.

174　Shirley Osborne Hensley is cited in Kurzmeyer, "The Life and Times of Bill Traylor (1854–1949)," 175. Kurzmeyer does not give the date or file location of this interview. Jack Lindsey, a former curator of American decorative arts at the Philadelphia Museum of Art, verified this account; email to the author, June 5, 2017. Lindsey explained that Shirley Osborne Hensley, his grandmother, and Virginia Asherton Mendenhall, his great-aunt, purchased about a dozen drawings from Traylor and sent some of them as postcards. Lindsey inherited four of the works (two of which he later sold via Fleisher/Ollman Gallery, Philadelphia) and made efforts to track down the others, to no avail.

175　M. R. Fowler, "New South School and Gallery," 25. Fowler notes that for the War Art Program, Shannon recorded the war's progress in drawings and paintings, and he was an illustrator for the army's Information and Education Division. Shannon's résumé (dated May 21, 1987) corroborates that he was an artist correspondent for the War Department, South Pacific Area, and a picture editor and illustrator for the US Army Information and Education Division in New York (1944–46); copy in the author's curatorial files.

176　Maresca and Ricco/C. Shannon interview, 1989, 22. Shannon is reading from a letter from Esther Traylor Graham; he does not mention the date but notes that it was mailed to him sometime after his return from the war, around 1946.

177　Megan Stout Sibbel, "Reaping the 'Colored Harvest': The Catholic Mission in the American South" (PhD diss., Loyola University Chicago, 2013). Sibbel cites a number of sources, including: James Grossman, *Land of Hope: Chicago, Black Southerners, and the Great Migration* (Chicago: University of Chicago Press, 1989); Davarian L. Baldwin, *Chicago's New Negroes: Modernity, the Great Migration, and Black Urban Life* (Chapel Hill:

University of North Carolina Press, 2007); Ira Berlin, *The Making of African America: The Four Great Migrations* (New York: Viking, 2010); Lisa Krissoff Boehm, *Making a Way Out of No Way: African American Women and the Second Great Migration* (Jackson: University Press of Mississippi, 2009); Alferdteen Harrison, *Black Exodus: The Great Migration from the American South* (Jackson: University Press of Mississippi, 1991); Nicholas Lemann, *The Promised Land: The Great Black Migration and How It Changed America* (New York: Vintage Books, 1992).

178 Wolf/Delks interview, 2017 (see also ArtC.n3).

179 Information told to Marcia Weber by Margaret Traylor Staffney. Weber conversed with Staffney on several occasions in the 1990s, especially after Staffney was widowed and needed help with errands that required driving. Weber drove Staffney around Montgomery for her to verify the sites of her grandfather's life as she recalled them. Staffney specified the house that had belonged to Sarah and Albert Howard on Bragg Street (herein fig. 28) and the location of the "one room shanty" that Traylor had lived in on the Bell Street bluff; this structure was seemingly an unnumbered, abandoned office shack from a used-car lot that stood for a time on this spot.

In DePasse/Staffney interview, 1996 (chap. 1, p. 31), Staffney shared similar details, adding that hobos, too, sometimes camped in the vacant Bell Street location. More information on the "hobos, or railroad bums," as Jay Leavell called them (perhaps referring specifically to the men living on the lower level, on the riverbanks), appears in his "Summertime and the River Life Was Easy," in *Jay's Montgomery Remembered*, 13–14.

180 Sibbel, "Reaping the 'Colored Harvest,'" 22–23.

181 Ibid., 3–4.

182 Ibid., 6. Sibbel cites "Our Negro and Indian Missions: Annual Report of the Secretary of the Commission for the Catholic Missions Among the Colored People and the Indians," Commission Publications and Records, Marquette University, Milwaukee, WI, Microfilm Series 7/1, Reel 1, 1922.

183 Sibbel, "Reaping the 'Colored Harvest,'" 107.

184 The Saint Jude Baptismal Register, vol. 1, entry 12, p. 35, notes that Bill Traylor was born April 1, 1855, and baptized on January 5, 1944, by Reverend Jacob (see LifeA.n57). Traylor's grandson Clement was reported to be an altar boy as well; DePasse/Staffney interview, 1996.

185 Maresca and Ricco/C. Shannon interview, 1989, 20–22. Shannon cites a letter from Esther Traylor Graham date February 3, 1947.

186 Margaret Traylor Staffney, a daughter of Will Traylor, lived for a time near the Howards in Montgomery and regularly visited her grandfather, a memory she recounted to Marcia Weber. Staffney gave a similar account in DePasse/Staffney interview, 1996 (chronology, 5).

187 In Maresca and Ricco/C. Shannon interview, 1989, Shannon stated that when he returned from war in 1946, Traylor was still living on the street, "sitting in his old place by the fruit stand" (p. 20). He noted that Traylor's left leg had been amputated. Given Traylor's lack of mobility at that time, and the records that show him already living with the Howards (1945–49) in a different part of town, Shannon's memory is hard to reconcile with facts that place Traylor elsewhere.

The address of the Bragg Street house changed several times as the city reorganized; in 1948, Allen Rankin listed it as 314 Bragg.

188 Myrtha Lee Delks, who was born in 1926, stated that she first met her grandfather just after high school, when she was seventeen; she also noted visiting him at Sarah's a second time, in 1944. Her memories are recorded in an untitled essay in the 1992 reunion booklet. Delks recounted many of the same memories (although some had become hazy) in Wolf/Beeks and Delks, interview, 2017.

189 Allen Rankin, "He'll Paint for You—Big 'Uns 20 Cents, Lil' 'Uns, a Nickel," *Alabama Journal*, Mar. 31, 1948. Here Rankin wrote: "Immediately after [the war] I was in New York. I heard that the Museum of Modern Art was considering buying the art of a remarkable primitive painter. Critics were talking about the sensational case of an incredible Negro who had not begun to paint until 86—then through some capricious blunder of the centuries, had painted like prehistoric cave artists."

190 M. R. Fowler/Angell interview, July 29, 1990.

191 Allen Rankin, "He Lost 10,000 Years," *Collier's*, June 22, 1946; Maresca and Ricco/C. Shannon interview, 1989, 24.

192 It is possible, yet unlikely, that Traylor had returned to visit the old neighborhood, and Shannon saw him there. That circumstance is improbable, however, given that in 1946, Traylor had a full amputation of his left leg, which Shannon stated had taken place by the time Shannon first saw him again (see above, n187). It is also unknown why Traylor did not return to his previous living situation on Lawrence and Monroe, but clearly something had shifted while he was away, and he took to living on Bell Street, for a second time, in an abandoned shanty or office of a used-car lot, among the homeless or hobo encampments near the rail lines (see above, n179).

193 Shannon, quoted in Maresca and Ricco/C. Shannon interview, 1989, 20–22. Shannon stated the note he received from Sarah was dated February 3, 1947 (see below, n200). For Shannon's letter to Easter, and her response, see above, n185.

194 Myrtha Lee Delks, untitled essay, in the 1992 reunion booklet.

195 The five artworks in Perry's photographs for *Collier's* known to be from an earlier period include: *Black and Red Dogfight* (not illustrated, private collection); *Yellow Chicken*, pl. 25 (The Museum of Modern Art, NY); *Red House with Figures*, pl. 32 (Judy A. Saslow, Chicago, IL); *Man in Blue House with Rooster* (not illustrated, Whitney Museum of American Art, NY); and *Mule with Red Border*, pl. 105 (The William Louis-Dreyfus Foundation Inc.).

196 "Writer Breaks Ankle in Fall into Old Well," *Montgomery Advertiser*, Mar. 5, 1946. Rankin was rescued by local firefighters. A similar article in the *Alabama Journal* mentioned the visit, Rankin's fall, and the arranged paintings. "The pictures were arrayed so Horace could photograph them." "Horace's Sexy Thoughts," *Alabama Journal*, Mar. 5, 1946.

197 Maresca and Ricco/C. Shannon interview, 1989, 5. In Helfenstein and Kurzmeyer, *Deep Blues*, the authors note in its timeline (p. 175) that Traylor "told Charles Shannon that he made no drawings during the war years"; this information is at odds with other accounts and seemingly incorrect. Traylor's grandchildren and great-grandchildren disagree with the assertion that Traylor did not make art during his visits to relatives during the war. Family accounts note that Traylor made art at Easter's home in Detroit and possibly at Lillian's in Philadelphia. (Lillian also lived with Easter in 1940, so she may have come to have some of Traylor's art then.) Although it has not been so recalled, Traylor could have made art elsewhere as well.

Bill Traylor's granddaughter Myrtha Lee Delks recounted (in Wolf/Delks interview, 2017) that she saw artworks of Bill Traylor's at Aunt Easter's house when she visited there in the mid-1950s; Easter specifically told her "my daddy did those."

Great-granddaughter Starlene Trayler Williams (in Wolf/Williams interview, 2018) similarly remembered seeing Traylor's drawings at Easter's house, stating that at times she and the other children were allowed to draw on the backs of them. Traylor's great-grandson Frank L. Harrison Jr., who with his sister, Leila Greene, lived with his grandmother Lillian for some time, said that he saw Traylor's artworks in Lillian's home (Mince and Wolf/Harrison interview, 2018).

When Easter died, Sarah Howard collected the artworks that had been in Easter's possession. When Sarah became ill and died, the artworks were seemingly disposed of. The whereabouts of the works once held by Lillian Traylor are unknown. Leila Greene may have taken possession of them together with other belongings, although in 1992, Leila stated at the Traylor family reunion that she had not seen those artworks since her grandmother Lillian moved from Philadelphia to Washington, DC, in 1949. Leila may have purchased a painting by Bill Traylor at a commercial gallery sometime in the 1990s, perhaps suggesting that she never found the artworks once in her grandmother's possession (no record of such a purchase was found during research for this study). Frank L. Harrison Jr. confirmed to Jeffrey Wolf, Mar. 28, 2018, in Montgomery, AL, that he does not know the whereabouts of those artworks.

198 The older images are visible in the photographs and documented in the installation views of the New South exhibition from 1940 as well (see herein "First Exhibition and Related Works," in the section "Early Work, ca. 1939–1940," p. 125). A note about Shannon's loan of works to Allen Rankin for this purpose appears in the press release "Statement by the Parties Announcing Settlement of the Lawsuit Concerning the Art of Bill Traylor," from the office of Hunton & Williams, NY, Oct. 5, 1993. Originals are on file with the Traylor Family Trust and at Newark Museum of Art curatorial files; copies in the author's curatorial files. The document states: "The family obtained copies of photographs taken in the late 1940s; some in 1946 show Bill Traylor sitting at his daughter's house surrounded by his paintings. Several of the paintings had been borrowed by the photographer from Charles Shannon, others had been recently painted. The last photographs were taken in 1949 [*sic*], not too long before his death." The photographs mentioned here were, in fact, taken in 1948 (see ArtA.n20, for extant photographs of Bill Traylor).

199 According to Marcia Weber (via Allen Rankin's sister, Eugenia Rankin), Rankin stored the works in his attic and eventually lost them to moisture damage. See above, n173.

200 Shannon, quoted in Maresca and Ricco/C. Shannon interview, 1989, 22. Shannon states that the letter he is reading from, a note from Sarah, is dated February 3, 1947, and the hospital was the Fraternal Hospital on Dorsey Street. He noted that he visited Traylor right away, after which Sarah notified him, a few days later, that Traylor had died and was already buried, neither of which was true.

201 According to granddaughter Margaret Traylor Staffney, Sarah Howard misled Shannon on this point, perhaps believing her father to be close to death but also wanting to collect the $25 that Shannon had been holding for Traylor after the sale of an artwork. Staffney explained that Sarah, interested in receiving the money, wrote to Shannon claiming that her father had passed away at the Fraternal Hospital. Traylor had, in fact, left the hospital and returned to Sarah's home, where he lived

for almost two more years, until he was eventually checked into Oak Street Hospital, where he died on October 23, 1949. DePasse/Staffney interview, 1996.

202 Rankin, "He'll Paint for You."

203 The church's name is spelled "Mariah" at the church itself and on some maps; online records and maps show it as "Moriah," after the hill in Jerusalem.

The whereabouts of Traylor's resting place was known to family but not to the public until recently. Marcia Weber located the churchyard site in 2016 and confirmed its accuracy with Traylor family members. Traylor's long-unmarked grave is adjacent to those of daughter Sarah Traylor Howard and her husband, Albert Howard.

In 1992 two of the artist's great-granddaughters, Antoinette Beeks and Leila Greene, selected images to be engraved on the stone's front and back, but they fell short of the funds necessary to have the work completed. In 2017, Marcia Weber together with Jeffrey Wolf, formed a committee and raised the resources to complete the headstone. Through their efforts and the generosity of donors, the project was realized.

On March 27, 2018, family, friends, pillars of the community, and assorted advocates of Bill Traylor gathered at Mount Mariah A.M.E. Zion Church at 4740 Old Hayneville Road, Montgomery, for a celebration of Traylor's life and an unveiling of the headstone. Governor Kay Ivey awarded a posthumous commendation for Traylor's contribution to the arts, and Montgomery Mayor Todd Strange declared it "Bill Traylor Day"; original documents for the decrees were provided to family members, special guests, and staff members on behalf of the Smithsonian American Art Museum. In attendance from Traylor's family were Shirley Trayler (Detroit, MI; granddaughter-in-law), Frank L. Harrison Jr. (with wife, Barbara; Fort Washington, MD; great-grandson), Antoinette Staffney Beeks (Atlanta, GA; great-granddaughter), Starlene Trayler Williams (Detroit, MI; great-granddaughter), Nettie Trayler-Alford (Detroit, MI; great-granddaughter), Cynthia Trayler-Bond (Detroit, MI; great-granddaughter), Roxanne Traylor (Buffalo, NY; great-granddaughter), and Cheryl Traylor Brown Jackson (Buffalo, NY; great-granddaughter). Speakers at the unveiling were Pastor Bertha Allen (master of ceremonies); Michael Briddell, Director, Public Information & External Affairs, City of Montgomery; Leslie Umberger, Curator, Smithsonian American Art Museum, and the author of this monograph on Bill Traylor; Mac McLeod, Chief of Staff to the Mayor of Montgomery; and Bishop Seth O. Lartey. The Mount Mariah children's choir sang.

204 Albert Howard's family had plots at the cemetery; Sarah and Albert Howard were subsequently buried there, near Bill Traylor. Leila Greene (who attended Bill Traylor's burial with her brother, Frank L. Harrison Jr.) recorded her memories in DePasse/Greene interview, 1999, and M. R. Fowler and Weber/Delks, Greene, and Staffney audio interview, 1992. Information from Frank L. Harrison Jr. was confirmed with Jeffrey Wolf, Stacy Mince, and the author at the time of the unveiling.

THE ART OF BILL TRAYLOR

ArtA · *Early Work, ca. 1939–1940 (pp. 106–61)*

Epigraph: Lawrence W. Levine, *Black Culture and Black Consciousness: Afro-American Folk Thought from Slavery to Freedom* (New York: Oxford University Press, 1977), xiii. Levine studied thousands of African American folk songs, stories, proverbs, aphorisms, jokes, verbal games, and long narrative oral poems, or "toasts." He recognizes that such vehicles of folk culture are flexible and exceedingly difficult to date; the original authors are unknown, as is the geography of origin; those who collected them often knew little of the culture with which they were engaged; and black singers and storytellers were usually reluctant and self-protective when asked to recall accounts in original form. Levine also explains that many collectors edited the gathered material to omit passages they regarded as indecent or vulgar. He notes that exceptions include songs collected in the Newman Ivey White papers, 1915–48, Duke University Libraries, Durham, North Carolina, and the collected recordings of Alan Lomax in the Library of Congress, Washington, DC, both of which adhered to a standard of unexpurgated texts. Levine describes the song cited here as one sung by multiple generations of African Americans.

1 In DePasse/Staffney interview, 1996, Margaret Traylor Staffney asserted that as a girl, she and her brother (Will/Willie) visited their grandfather on Monroe Street around 1937–38, and he was already making drawings and selling pencils (DePasse, chap. 1, 36n46). Staffney mentions these same visits to Monroe Street (specifying the Ross-Clayton Funeral Home and the Pekin Pool Room as places Traylor frequented, and that David Ross's daughter was one of her schoolteachers), as well as later visits to his one-room residence on Bell Street and, subsequent to that, Sarah and Albert Howard's home on Bragg Street (1992 reunion booklet). Staffney also mentioned these events in M. R. Fowler and Weber/Delks, Greene, and Staffney audio interview, 1992 (p. 23).

Traylor lived on Bell Street at two different times; the first in 1930, the second around 1942. Conversations Staffney had with Marcia Weber in the 1990s suggest that Staffney knew only about the latter of these two (ca. 1942–45). Staffney recalled her grandfather fixing her shoes, an activity that was a recurring line of work for Traylor that spanned various points in time. About his drawing practice from the Bell Street era (which overlooked the Alabama River and the rail lines), Staffney noted that her grandfather sold his art to "white people" for "a dime, fifteen cents, or a quarter." At the latter Bell Street residence, Staffney's recollection was of her grandfather drawing with charcoal rather than pencil.

If Traylor was drawing before Lapsely and Shannon met him—as Leavell and Staffney independently asserted, in keeping with Shannon's text in the New South exhibition booklet from February 1940 (herein fig. 26), which states that Traylor had been drawing for "less than two years"—it is likely that he was not doing so full time in 1938 and that his skills were still in beginning phases.

2 Charles Shannon, in Maresca and Ricco/C. Shannon interview, 1989, 3. For Monroe Street vs. Monroe Avenue, see Prologue, n9.

3 Shannon, quoted in ibid.

4 DePasse, "Memories Within."

5 The most reliable such account was Traylor's own, as he consistently told census takers that he could neither read nor write. Shannon would make the same claim about Traylor, and family members agree on this point.

6 Alan Brown, ed., *Dim Roads and Dark Nights: The Collected Folklore of Ruby Pickens Tartt* (Livingston, AL: Livingston University Press, 1993), 60–61. In the 1930s, writers sponsored by the Works Progress Administration (WPA; later, Works Projects Administration) of President Franklin D. Roosevelt's administration collected and published more than two thousand oral histories on life during slavery. For this effort Ruby Pickens Tartt chronicled the stories of informant Josh Horn and other ex-slaves in Alabama. Those narratives (some of which are included in Brown's *Dim Roads and Dark Nights*) and others collected around the nation were compiled as "Slave Narratives: A Folk History of Slavery in the United States from Interviews with Former Slaves," seventeen volumes of typewritten records prepared by the Federal Writers' Project, 1936–38, assembled by the Library of Congress Project, Work Projects Administration, for the District of Columbia. Sponsored by the Library of Congress. Illustrated with photographs. Washington, 1941. Available in digital form as "Born in Slavery: Slave Narratives from the Federal Writers' Project, 1936–1938." For this study the author used the book version, Federal Writers' Project, *Alabama Narratives*, vol. 1 of *Slave Narratives: A Folk History of Slavery in the United States from Interviews with Former Slaves, 1936–1938*. Washington, DC: Works Progress Administration for the State of Alabama, 1941. See also Slave Narratives (website).

7 Shannon noted that many black men who were out of work would regularly visit the Monroe Street area: "One of these men became a frequent companion and taught Bill how to write his name; you can see Bill's signatures develop on his drawings from illegible ones to quite readable ones" (Maresca and Ricco/C. Shannon interview, 1989, 14). Shannon also mentioned Traylor's friend who taught Traylor to sign his name, in Shannon, "Bill Traylor's Triumph," *Art & Antiques* (Feb. 1988): 64.

8 Margaret Traylor Staffney believed that when her grandfather repaired family members' shoes, he was putting to use a skill that he knew firsthand. Many shoe-repair shops of the day included a pickup and drop-off service, which would have been a lower-level job in the shop, yet Staffney's often-repeated recollection attests to her grandfather's experience as a repairman (her untitled entry in the 1992 reunion booklet; M. R. Fowler and Weber/Delks, Greene, and Staffney audio interview, 1992; Kogan and Weber/Staffney video interview, 1992; DePasse/Staffney interview, 1996, (chap. 1, p. 31).

9 Shannon, quoted in Maresca and Ricco/C. Shannon interview, 1989, 4.

10 Shannon said that Traylor often drew people who were recognizable from the neighborhood, including a legless man, depicted in *Blacksmith Shop* (pl. 10): "He has the rocker stool and the devices that he used in his hands to propel himself along—that was one. His name was Jimmie; and Traylor would probably see him every day. . . . I saw him often. In fact, I had him come and pose for my art class" (Maresca and Ricco/C. Shannon interview, 1989, 14).

11 Ibid.

12 Shannon reported that other people occasionally bought Traylor's works. Traylor once said to Shannon, "Sometimes they buys them when they don't even need them," which independent curator Susan M. Crawley (formerly of the High Museum of Art) has described as an old Southern epigram referring to questionable spending on nonessential goods. Charles Shannon, "Bill Traylor," in *Bill Traylor: 1854–1947*, exh. cat. (New York: Hirschl & Adler Modern, 1985). Susan M. Crawley, email exchange with the author, Apr. 4, 2018.

13 In M. R. Fowler/Angell interview, 1990, Angell told Fowler that she thought Traylor added his signatures later, yet her report seems to be conjecture rather than fact.

According to Marcia Weber (Weber/Leavell Fleming conversations, 1984), Jo Leavell Fleming said that Jay had shown Traylor how to write his name, but no other source corroborates that anecdote. Leavell Fleming reported the same information in DePasse/Leavell Fleming interview, 1996.

14 Shannon, quoted in Maresca and Ricco/C. Shannon interview, 1989, 11.

15 Kitty Baldwin in interview by Roman Kurzmeyer, "The Life and Times of Bill Traylor (1854–1949)," in *Bill Traylor, 1854–1949: Deep Blues,* ed. Josef Helfenstein and Roman Kurzmeyer, exh. cat. (New Haven, CT: Yale University Press, 1999), 174. Kurzmeyer notes that he spoke with Kitty Baldwin on Feb. 28, 1998, but he gives no location for a transcript. When Eileen Knott interviewed Betty Baldwin, sister of Kitty and Ben Baldwin, on Feb. 5, 1995, Betty had recalled that her siblings were members of the New South collective and good friends with Charles Shannon (see LifeB.n144). See also M. R. Fowler/Angell interview, 1990.

16 Angell, quoted in M. R. Fowler/Angell interview, 1990.

17 Shannon, quoted in Maresca and Ricco/C. Shannon interview, 1989, 26.

18 Ibid., and Shannon, "Bill Traylor's Triumph," 64.

19 Susan Tucker, *Telling Memories among Southern Women: Domestic Workers and Their Employers in the Segregated South* (Baton Rouge: Louisiana State University Press, 2002), 90.

20 The notes Shannon wrote on the backs of Traylor's artworks were made either at the time he collected the works or subsequently, according to his memory. The extant dated (or roughly dated) photographs of Traylor, as well as the contemporaneous photographs showing either him and his art or solely his artworks, are, in chronological order: photographs of Traylor sitting on North Lawrence Street (near the corner of Monroe Street) making art, spring/summer 1939, by Charles Shannon; photographs of Traylor sitting on North Lawrence Street (near the corner of Monroe Street) making art, later in 1939, possibly fall or winter, by Jean and George Lewis; photographs of Traylor's paintings and drawings hanging in the New South Gallery, February 1940, by Jean and George Lewis; a photograph of Traylor sitting on North Lawrence Street (near the corner of Monroe Street) with several works of art, possibly taken by Horace Perry for the *Montgomery Advertiser,* published on March 31, 1940; a photograph of Traylor sitting (pipe in hand) on North Lawrence Street (near the corner of Monroe Street) among his works of art, by an unidentified photographer (a newspaper slug-line on the back indicates that it was taken on June 6 and transmitted on July 19, 1940); photographs of Traylor making art in the backyard of the home of his daughter Sarah Traylor Howard on Bragg Street, taken on March 4, 1946, by Horace Perry for a *Collier's* article published on June 22, 1946; and photographs of Traylor holding a single painting while sitting in the backyard of the home of Sarah Traylor Howard on Bragg Street, taken on March 20, 1948, by Albert Kraus. The last known photograph of Traylor may be an undated picture by Horace Perry; in it Traylor looks extremely aged and is wrapped in a light-colored blanket.

21 Shannon, "Bill Traylor's Triumph," 62.

22 Shannon in Maresca and Ricco/C. Shannon interview, 1989, 4.

23 Montgomery city directories indicate this was likely the Liberty Shoe Repair at 25 North Lawrence near the corner of Monroe.

24 Shannon quoting or paraphrasing Bill Traylor, in Maresca and Ricco/C. Shannon interview, 1989, 26.

25 Shannon met Traylor in the spring or early summer and completed his mural by fall, so the photos must have been taken in the summer. In them Traylor wears no additional layers of clothing over his shirt.

26 In Shannon, "Bill Traylor's Triumph," 62, Shannon notes that the back door to the Pekin Pool Room was "nailed-up." This essay does not reproduce all the photographs that Shannon took that day nor all the photos discussed herein.

27 Shannon took several images of Traylor that day. The information here is gleaned from the photographs; they do not all show the same detail.

28 Eugenia Carter Shannon, "The Depression in Montgomery, Alabama," in Helfenstein and Kurzmeyer, *Deep Blues,* 180.

29 Shannon quoting Bill Traylor, "Bill Traylor's Triumph," 64. In this article Shannon makes a general reference to the notes he wrote, which he based on Traylor's remarks about individual works. Shannon did not specify when he made the notes, but saying that he "jotted them down on the backs" insinuated that they were concurrent with the artwork.
 Shannon's full annotation for the drawing he numbered X-151 (and titled *See'd One in a Show Once*) was, "What dat's I don't know—see'd one in a show once" (copy of the record is in the author's curatorial files). The drawing, of a large feline of some sort, perhaps a panther, is illustrated in Phil Patton, *Bill Traylor: High Singing Blue,* exh. cat. (New York: Hirschl & Adler Modern, 1997), 18.

30 Allen Rankin, "He Lost 10,000 Years," *Collier's,* June 22, 1946; Shannon attempts to set the story straight in Maresca and Ricco/C. Shannon interview, 1989, 24.

31 J. G. Traylor diary, July 2, 1839.

32 Traylor's paints have been variously described as "poster paint," "show card color," tempera paint, and so on. Catherine Maynor, SAAM conservator for works on paper who has examined examples of Traylor's paint, clarified that the names are variably accurate or consistent. The paints Traylor used can be generally classified as opaque watercolor or opaque water-based paint. Since he worked with donated paint, largely from sign makers in the neighborhood, specific paint composition would have to be determined on a case-by-case basis for complete accuracy.

33 Weber/Leavell Fleming conversations, 1984, and DePasse/Leavell Fleming interview, 1996. See above, n13.

34 The painting, *Little Blue Basket,* is reproduced in Patton, *High Singing Blue*, 8.

35 Alabama's Black Belt plantations are in a semitropical climate, so many tropical fruits can survive if planted there. Figs and persimmons are the most common; pineapples would have been grown in pots. The pineapple is a symbol for hospitality, welcome, and friendship; some plantations decorated porches or front lawns with potted pineapples. One southwestern Alabama town in Wilcox County is named Pine Apple. The origin of the name is unknown but may have stemmed from its meaningful symbolism or relation to the region's many pine and apple trees. See Grant D. Hiatt, "Pine Apple," Mar. 17, 2011; last modified May 11, 2018. Encyclopedia of Alabama (website).

36 Theophus H. Smith, *Conjuring Culture: Biblical Formations of Black America* (New York: Oxford University Press, 1994), 4.

37 "Persuading Parties to Follow Norms: Superstitions, Conjure, and the Broomstick," in Donald J. Waters, ed., *Strange Ways and Sweet Dreams: Afro-American Folklore from the Hampton Institute* (Boston: G. K. Hall, 1983), 74–75.

38 Smith, *Conjuring Culture,* 183–205.

39 These are presented here as quotes, but they indicate Shannon quoting or paraphrasing Traylor with a degree of precision that will remain unknown. Sometimes these remarks are written on the drawing's verso and seem to be contemporaneous with the artwork; other times these annotations may have been recollections that Shannon added many years later. Shannon referenced these annotations in Maresca and Ricco/C. Shannon interview, 1989; Lyle Rexer/Charles Shannon interview, 1990; and his "Bill Traylor's Triumph," but such commentary appears on many more artworks than those he discussed.

40 Shannon quoting or paraphrasing Traylor, in Maresca and Ricco/C. Shannon interview, 1989, 14.

41 The collected writing of Ruby Pickens Tartt is just one of many sources that specifies that owls, particularly hooting owls, are considered death omens. See Brown, *Dim Roads and Dark Nights.*

42 Newbell Niles Puckett, *Folk Beliefs of the Southern Negro* (Chapel Hill: University of North Carolina Press, 1926; repr., New York, Dover Publications, 1969), 483–84. Puckett goes on to detail variations on owl lore and ways to circumvent his death omen (pp. 483–85).

43 "A Roost on the Rim of the Moon," *The Book of Negro Folklore,* ed. Langston Hughes and Arna Bontemps (New York: Dodd, Mead, 1958), 181–82.

44 Bontemps, introduction to ibid., viii.

45 Brown, *Dim Roads and Dark Nights,* 2.

46 Charles S. Johnson, *Shadow of the Plantation: A Classic Study of Negro Life* (Chicago: University of Chicago Press, 1934; repr., 1966), introduction, x.

47 Quoted in ibid., 27.

48 Samuel C. Adams Jr., "The Acculturation of the Delta Negro," in *Mother Wit from the Laughing Barrel: Readings in the Interpretation of Afro-American Folklore,* ed. Alan Dundes (Jackson: University Press of Mississippi, 1990), 516–17; originally published in *Social Forces* 26, no. 2 (Dec. 1947): 202–5.

49 Albert J. Raboteau, *Slave Religion: The "Invisible Institution" in the Antebellum South* (New York: Oxford University Press, 1978).

50 See Jeffrey E. Anderson, *Conjure in African American Society* (Baton Rouge: Louisiana State University Press, 2005), 57. Anderson notes that *hoodoo* and *wanga* are African terms common to the American Latin zone; *conjurer* was an English term referring to those who used incantations, a concept derived from Jewish Kabbala. Hoodoists abilities to perform similar feats led them to adopt the title. Folklorist Zora Neale Hurston believed the term *hoodoo* derived from the West African term *juju,* for magic or charm. See also Puckett, *Folk Beliefs,* 520–38.

51 F. Roy Johnson, *The Fabled Doctor Jim Jordan: A Story of Conjure* (Murfreesboro, NC: Johnson Publishing, 1963), 20.

52 Raboteau, *Slave Religion,* 277.

53 Anderson, *Conjure,* 25. Although Anderson's discussion of conjure is primarily related to nineteenth-century practices, he also describes evidence of its existence dating back to the colonial era and its connection to the Salem witchcraft accusations. By the time the WPA recorded slave narratives in the 1930s (see above, n6), accounts of conjure were extremely widespread.

54 Anderson notes, "Without doubt, nineteenth-century blacks built conjure upon an African foundation. The structure they raised, however, incorporated elements from cultures far from their

ancestral homeland. European and American Indian elements were as important in the practice of conjure as those originating in Africa. Moreover, conjure served as a cross-section of the African American experience, demonstrating immigrant African origins coupled with an essentially American experience of assimilation and cultural differences." In Anderson, *Conjure,* 51.

55 Willis Easter, interviewed by the Federal Writers' Project, Texas; quoted in Raboteau, *Slave Religion,* 286, and in F. R. Johnson, *Fabled Doctor,* 1.

56 F. R. Johnson, *Fabled Doctor,* 31.

57 Puckett, *Folk Beliefs,* cited in F. R. Johnson, *Fabled Doctor,* 22. Jeffrey E. Anderson notes the case of Mary Livermore, who once met a conjurer-preacher known as Uncle Aaron, who preached God from the pulpit and combated evil spirits outside the church. Anderson, *Conjure,* 79.

58 F. R. Johnson, *Fabled Doctor,* 31.

59 Anderson, *Conjure,* 79, cites Philip A. Bruce, *The Plantation Negro as a Freedman: Observations on His Character, Condition, and Prospects in Virginia* (New York: G. P. Putnam's Sons, 1889).

60 Bontemps, introduction to Hughes and Bontemps, *Book of Negro Folklore,* ix.

61 Bernard Wolf, "Uncle Remus and The Malevolent Rabbit," in Dundes, *Mother Wit,* 524.

62 Anderson, *Conjure,* 89.

63 Silvia Witherspoon, quoted in interview by Susie O'Brien and John Morgan, "Foots Gets Tired from Choppin' Cotton," in Federal Writers' Project, *Alabama Narratives,* 429 (see above, n6).

64 F. R. Johnson, *Fabled Doctor,* 60–61. Many of the mail-order businesses were based in Chicago. The commercial trade became a predominantly Jewish enterprise rather than an African American one, although Blacks were the targeted customer. Anderson also discusses the commodity culture of mail-order companies and hoodoo shops and the displacement of the communal practitioners; Anderson, *Conjure,* 111. Anderson also cites Carolyn Morrow Long, *Spiritual Merchants: Religion, Magic, and Commerce* (Knoxville: University of Tennessee Press, 2001), 99–126.

65 See "Conjure Shops and Manufacturing: Changes in Hoodoo in the Twentieth Century," in Anderson, *Conjure,* 112–33. Anderson notes that to deter fraud and ensure health, the US government in 1906 passed the Pure Food and Drug Act, which required companies to list product ingredients on labels. The law, however, applied only to ingredients listed in the official US Pharmacopoeia or National Formulary. In 1937, when a patent medicine called Elixir Sulfanilamide caused the deaths of more than a hundred people, the act was intensified. In 1938, Congress passed the Federal Food, Drug, and Cosmetic Act, which placed all medicines under government oversight. Many proprietary medicine companies subsequently shuttered. Mail-order hoodoo companies predominantly skirted this law and claimed "alleged" powers or other disclaimers for their products. Anderson, *Conjure,* 125–26.

66 These associations for red derive from Kongo culture; see ibid., 41.

67 Michael A. Gomez, *Exchanging Our Country Marks: The Transformation of African Identities in the Colonial and Antebellum South* (Chapel Hill: University of North Carolina Press, 1998), 210–13.

68 Ibid.

69 Ibid., 208. Gomez gives a number accounts of the "red cloth tales." See also Sterling Stuckey, *Slave Culture: Nationalist Theory and the Foundations of*

Black America (New York: Oxford University Press, 1987), 3–5.

70 Gomez, *Exchanging Our Country Marks,* 199–209. To evidence an example of the extent to which red reached popular consciousness for use in charm packets, red is the color given to the conjure bag the protagonist uses to protect himself from a bad spirit in the middle-school-level fictional tale *Hoodoo* by Ronald L. Smith (New York: Houghton Mifflin Harcourt Publishing, 2015).

71 Gomez, *Exchanging Our Country Marks,* 211, and Stuckey, *Slave Culture,* 3–5. Both authors cite Edward C. L. Adams, *Nigger to Nigger* (New York: C. Scribner's Sons, 1928), 227–29. Stuckey asserts that King Buzzard may have had pertinence in Igbo culture, where native agency was crucial to the procurement of human beings. Traylor's mother Sally may have been Igbo, a possibility given her Virginia roots and the high number of Igbo from southeastern Nigeria who were imported into South Carolina and Virginia. For Sally's background, see LifeA.n2.

72 Anderson, *Conjure,* 40. Anderson cites Linda France Stine, Melanie A. Cabak, and Mark D. Groover, "Blue Beads as African-American Cultural Symbols," *Historical Archaeology* 30 (1996): 49–75.

73 The Southern belief in the protective power of blue is multifaceted and pertained to white as well as black culture, but it is highly likely that it derived from African beliefs systems.

74 The newsletter was *New South: 1940,* part 1, Feb. 1940, by the New South Writers Group, Montgomery, AL; number of editions or volumes unknown. Marcia Weber, personal files shared with the author, 2015–17; copy in the author's curatorial files. The handmade booklet *Bill Traylor: People's Artist,* for the exhibition of the same name, New South Gallery, Montgomery, February 1–19, 1940 (herein fig. 26; see LifeB.nn161, 162). Another possibility is that the Lewises' images do not document every wall of the gallery. Sunlight reflecting on parts of the walls obliterates a clear view of some sections.

75 Various anecdotal accounts about Shannon's need to control the narrative exist. They include: Lapsley/Hedges interview, ca. late 1980s–early 1990s; M. R. Fowler/Angell interview, 1990 (see LifeB.n169); Umberger/Maresca interview, 2017 (p. 4).

76 The labels on the jars of paint are almost legible but not quite. They appear to say Rayco or Mayco. A paint company called Mayco exists, but seemingly only after 1950, so the brand of the paints is inconclusive.

77 The work now called *Turtle Swimming Down* (pl. 24) was oriented in the New South exhibition with the turtle's head at the top of the page. Shannon subsequently reoriented the work for the exhibition *Black Folk Art in America* in 1982 at the Corcoran Gallery of Art, Washington, DC, and titled it *Turtle Swimming Down.* It is unknown if Traylor remarked on the orientation to Shannon when he saw it at the New South gallery. Installation views are in the author's curatorial files; also illustrated in Jane Livingston and John Beardsley, eds., *Black Folk Art in America, 1930–1980,* exh. cat. (Jackson: University Press of Mississippi and Center for the Study of Southern Culture for the Corcoran Gallery of Art, 1982), 21, and listed on the exhibition checklist, p. 177.

78 See Betty M. Kuyk, *African Voices in the African American Heritage* (Bloomington: Indiana University Press, 2003). Kuyk cites Henry John Drewal and Margaret Thompson Drewal, *Gelede: Art and Female Power Among the Yoruba* (Bloomington: Indiana University Press, 1990), and "Notes from Alabama,"

in Waters, *Strange Ways,* 224; originally published in *Southern Workman* 24, no. 5 (May 1895): 78.

79 These two drawings with birds on the heads of men (pls. 26, 27) and another two of solitary birds (pls. 28, 29) may indeed date to the same era, but they were not documented as being included in the New South exhibition and therefore cannot be firmly dated to 1939–40.

80 References to hues corresponding to skin tone are myriad in songs and literature. Blind Willie McTell's "Lord Sing Me an Angel" (1933), for example, mentions "Atlanta yellow" and "Macon brown." In a glossary accompanying her "Story in Harlem Slang," originally published in *American Mercury* (July 1942), Zora Neale Hurston included an array of terms, including "high yaller, high brown, vaseline brown, seal brown, low brown, dark brown." See also Thomas J. Hennessey, *From Jazz to Swing: African-American Jazz Musicians and Their Music, 1890–1935* (Detroit, MI: Wayne State University Press, 1994). Hennessey mentions (p. 100) that the Cotton Club hired "high yellow" chorus girls.

81 The standard that a person with even "one drop" of African ancestry would be considered 'black' was adopted as law in Tennessee in 1910, then in Virginia under the Racial Integrity Act of 1924.

82 In the collected lore of Newbell Niles Puckett, ample evidence describes the reputed protective powers of chickens. Eating chicken was fortuitous and might destroy dark magic. The blood—alternatively, the droppings—of a fat chicken might reveal any tricks played against you; a poultice of pure manure could remedy a toothache; a hen, splayed open and with its flesh applied to the body, could cure typhoid fever or extract venom from a snakebite. "A 'frizzly chicken' is a veritable hoodoo watchdog," reported Puckett. "It will scratch up every trick laid up against its owner." In early twentieth-century black communities, chickens—with their bones used in spiritual work and their meat eaten for Sunday dinner—were sometimes called the "preacher's bird." One song says, "Ef yer want to hear the preacher sing, Jes' cut up er chicken an' gib him er wing. Ef yer want to hear the preacher pray, Jes' cut up er chicken an' gib him er laig." In Puckett, *Folk Beliefs,* 290. Other chicken lore mentioned in this essay is found on pages 63–64, 295–97, 367, 373, 378.

83 Kym S. Rice and Martha B. Katz-Hyman, eds., *World of a Slave: Encyclopedia of the Material Life of Slaves in the United States* (Santa Barbara, CA: Greenwood, 2011), 110–11.

84 Account by Margo Russell of Andalusia, Alabama. Russell wrote down her memories in conjunction with an exhibition of Traylor's work at the Alexander Gallery, San Francisco, called *Paintings-Drawings by Bill Traylor,* May 3–June 30, 1984. Russell was born in 1943 in Montgomery County, Alabama, adjacent to Lowndes County. According to Russell, her native home was approximately thirty-eight miles from Traylor's. Russell shared her account with the author; a copy of her notes is in the author's curatorial files.

85 Shannon quoting Traylor, "Bill Traylor's Triumph," 61.

86 "[Traylor] said he had been thinking for a long time about how to draw a man inside of a house. After he found a way, he used it many times in later drawings." Shannon in Maresca and Ricco/C. Shannon interview, 1989, 29.

87 Although the cabin that Traylor himself may have lived in while at the George Traylor farm no longer existed by the time scholars took an interest in it, other buildings on the property remained. The houses, including the original plantation house that

stood until the 1970s, were built on brick leg risers, which were standard features. Such facts were obtained on the author's visits to the site with Beth Spivey, a lifelong resident of the Benton area and curator at the Old Depot Museum in Selma, Alabama. Images of and information about the original farmhouse was provided by Kendall Buster, who explained that Rosa Lyon Traylor (wife of John Bryant Traylor Jr., George H. Traylor's grandson) had the original plantation house demolished in the 1970s and a brick ranch-style house built on the same site. Email exchanges with the author, Aug. 11, 2016, and May 29, Aug. 30, and June 5, 2017.

88 Kendall Buster, email exchange with the author, June 5, 2017.

89 Robert Farris Thompson, *Face of the Gods: Art and Altars of Africa and the African Americas*, exh. cat. (New York: Prestel and Museum for African Art, 1993), 68. Thompson cites Karl E. Laman, *Dictionnaire Kikingo-Français avec une étude phonétique décrivant les dialectes les plus importants de la langue Dite Kikongo M–Z* (1936; repr., Ridgewood, NJ: Gregg Press, 1964), 963.

90 "The ladder symbolized the path of communication between the worshipper and the worshipped: the prayer of the devotee was sent upward, and the spirit of god descended to meet the devotee." In Kuyk, *African Voices,* 149.

91 Sobel, *Painting a Hidden Life,* 40.

92 Herbert M. Cole, email to Betty Kuyk, Oct. 21, 1999, in Kuyk, *African Voices,* 149.

93 *Three Figures on Red and Blue Houseboat* (seen herein in fig. 49) is in the collection of Judy A. Saslow, Chicago, IL.

94 Judy A. Saslow, the current owner of *Red House with Figures* (pl. 32), provided a photograph of the back of the work showing the inscription; digital copy is in the author's curatorial files.

95 Gaston Bachelard, *The Poetics of Space: The Classic Look at How We Experience Intimate Places*, translated by Maria Jolas (New York: Orion Press, 1964), 4–5; originally published as *La poétique l'espace* (France: Presses Universitaires de France, 1958).

96 Langston Hughes, quoted in *Autobiography: I Wonder As I Wander*, ed. Joseph McLaren. Vol. 14 of *The Collected Works of Langston Hughes*, ed. Arnold Rampersad (Columbia: University of Missouri Press, 2003), 307.

97 In Maya Angelou, *I Know Why the Caged Bird Sings* (New York: Random House, 1969), the first of her seven autobiographies, quoted in Richard Bak, *Joe Louis: The Great Black Hope* (New York: Da Capo Press, 1998), 103–4.

98 The photographer of this image (herein fig. 54) is unknown. An Associated Press label on the back of the photograph states it was taken on June 6, 1940; the date for the caption is July 19, 1940. No published newspaper article has been associated with the image; it is presumed to be unpublished. *Untitled (Pig with Corkscrew Tail)* (pl. 73) also appears in the photograph, above *Boxers in Blue* (pl. 34).

99 The second image of a couple arguing, the one set in the lower right corner of the window, is *Talking Couple,* in the collection of the Milwaukee Art Museum, Wisconsin (The Michael and Julie Hall Collection of American Folk Art, M1989.236).

100 Shannon, quoted in Maresca and Ricco/C. Shannon interview, 1989, 14.

101 Shannon quoting or paraphrasing Traylor, noted in Montgomery Museum of Fine Arts curatorial files for *Fighter* (pl. 38), 1982.4.26.

102 Given his business as a letterer and sign painter, Jay Leavell, proposed as one of the people who helped Traylor with writing, would have had superior writing abilities to those evidenced by the scrawl on the front of *Man with Hat and Cane* (pl. 1). According to the National Center for Education Statistics, in 1940, "More than half of the U.S. population had completed no more than an eighth grade education. Only 6 percent of males and 4 percent of females had completed 4 years of college." In Thomas D. Snyder, ed., *120 Years of American Education: A Statistical Portrait* ([Washington, DC:] National Center for Education Statistics, US Department of Education, 1993), 18, table 4.

103 No other works by Traylor having two handwritings (theoretically teacher and student) have been identified. While this may or may not be the first place Traylor attempted to copy his name as someone wrote it for him, he likely attempted to mirror the work of another and kept it close at hand to look at. Other iterations of Traylor's "signature" seem even more rudimentary than this one but may indicate his effort to write it independently, without the context of an example to follow.

104 How Traylor would have known a correct spelling for the Traylor family name is not known for certain, but he may have possessed documents from his days on George Traylor's plantation or had other records from over the years. Misunderstandings of the name as Taylor sometimes occurred, as did misspellings on various documents. The census for 1850, for example, lists John G. Traylor's estate but misspells the name as "Trailer." Similarly, the 1870 census lists all the Traylors near George Hartwell as "Trailer." Clement Traylor's World War I registration spells the name "Trailor," and the 1946 Montgomery directory spells Bill's last name as "Trayler." As indicated on Bill Traylor's family tree (herein p. 379), some descendants use the spelling Traylor.

105 Kuyk, *African Voices,* 167. For Kuyk's interviews with David Ross Sr. and his son, see LifeB.n117.

106 *Plant/Animal Forms* (pl. 41) is not known to have been in the New South exhibition but bears great similarity to some therein.

107 The booklet *Bill Traylor: People's Artist* (herein fig. 26; see LifeB.n161) shows three images made to approximate a selection of work in the show.

108 Sobel/Staffney interviews, 1993, 1995.

109 Puckett, *Folk Beliefs,* 109–10.

110 Quoted in Samuel Miller Lawton, "The Religious Life of South Carolina Coastal and Sea Island Negroes" (PhD diss., George Peabody College for Teachers, Nashville, TN, 1939), 212–13; cited in Kuyk, *African Voices,* 173.

111 "The Boy and the Ghost," Waters, *Strange Ways,* 298; originally published in *Southern Workman* 27, no. 3 (Mar. 1898): 57.

112 *Legs Construction with Five Figures* (pl. 43) is not known to have been in the New South exhibition, but it is visually linked to the same general period as the works in the exhibition.

113 The story of the possible murder is discussed herein in part 1, in "Bill Traylor in Montgomery, 1927–1939," page 78. For Kuyk's conversation with David Ross Sr. in which nightmares and murder are referenced, see LifeB.n117. Kuyk was the first to argue that Traylor had killed the illicit lover of one of his wives, and she interpreted many of his violent images as being a tangle of jealously, retaliation, and retribution. Kuyk posits that the "murder" might have happened before Traylor's "first marriage," but neither she nor Sobel, who conveyed Kuyk's observations as irrefutable, knew about Traylor's actual first marriage, to Elsey Dunklin in 1880; their

narratives about the wives and children are hindered by missing facts and inaccuracies.

Sobel contends that Traylor's images are consumed by the theme of two men fighting over a woman, who is almost always in the guise of a bird. This potential story line, however, is based on a select few paintings and, even if true, would account for a just small fraction of the violent scenes that Traylor ultimately created; moreover, it does not account for the various ways in which Traylor depicts birds. It is more probable that Traylor drew on a range of experiences in a harsh world for his images of violence.

Kuyk argued that Traylor, in the years preceding his death, sought to regain an inner balance that he had lost earlier in life through one or more mistakes. This part of her theory seems to hold more weight than the others, for it is common for humans, in general, to seek an inner peace or forgiveness before they face death. The individual conclusions that Kuyk and Sobel posit for Traylor's images may entail partial or even whole truths, but no evidence confirms the specific and somewhat narrow story they each adhere to. Kuyk and Sobel dwell on these ideas throughout their respective books *African Voices* (2003) and *Painting a Hidden Life* (2009).

114 The common vernacular for such dogs in the accounts of ex-slaves is "nigger dogs" or "nigger hounds." See Federal Writers' Project, *Alabama Narratives,* 332 (see above, n6).

115 Quoted in C. S. Johnson, *Shadow of the Plantation,* 190, 191.

116 Leonora Herron, "Conjuring and Conjure-Doctors," in Waters, *Strange Ways,* 228.

117 See Puckett, *Folk Beliefs,* 550.

118 Ruth Bass, "The Little Man," in Dundes, *Mother Wit,* 391; originally published in *Scribner's Magazine* 97 (1935): 120–23.

119 Shannon quoting Traylor, in Maresca and Ricco/C. Shannon interview, 1989, 29.

120 Ibid., 84.

121 See Grey Gundaker, "Tradition and Innovation in African-American Yards," *African Arts* 26, no. 2 (Apr. 1993): 61; Cynthia Carter, "Archaeological Analysis of African American Mortuary Behavior," *The Last Miles of the Way: African-American Homegoing Traditions*, ed. Elaine Nichols, exh. cat. (Columbia: South Carolina State Museum, 1989), 51–55; and Robert Farris Thompson, *Flash of the Spirit: African and Afro-American Art and Philosophy* (New York: Random House, 1983), 138–39. See also the photographs of Gaylord Lee Clark, housed at the McCall Archives, University of Southern Alabama (website). The caption on a photo of a rural graveyard reads: "The slave cemetery on the Hunter Place. Cedars were planted as grave markers. This photo was taken in 1896."

On research trips to Montgomery, the author noted overgrown cedar trees on graves in Westcott Cemetery on Terminal Road in West Montgomery, where Traylor's son Will (Willie) may have been buried in 1929 (records give no information other than a location in Montgomery). Will's daughter Margaret Traylor Staffney specified that her father was buried at Westcott; Bill's son Mack was buried there in 1933, according to his death certificate. M. R. Fowler and Weber/Delks, Greene, and Staffney audio interview, 1992.

122 Glenn Sisk, "Funeral Customs in the Alabama Black Belt, 1870–1910," *Southern Folklore Quarterly* 23 (1959): 169–71, 170.

123 References to cats in folklore accounts, specifically in conjure and superstition, are myriad. See, for example, "The Witch Cats," in Waters, *Strange Ways,* 217. Bottles, bags, or balls might contain the

ingredients of a "trick," a recipe divined by a hoo-dooist or conjurer that might either be buried near the home of the person to be tricked or used by the practitioner to uncover a trick perpetrated on his patient. See also, "The Seriousness of Superstition: The Conjure Doctor," in Waters, *Strange Ways*, 84–85.

124 The verso of *Untitled (Construction with Lamps)* (AKA *Lamps on Mantelpiece*) (pl. 54) is a box top, or possibly an advertisement, for Curtiss Candy (herein fig. 56).

125 Quoted in Harry Middleton Hyatt, *Hoodoo, Conjuration, Witchcraft, and Rootwork* (Hannibal, MO: Western Publishing, 1953–78), 1:512. Hyatt collected these accounts in 1935, this one in Ocean City, Maryland.

126 Shannon quoting or paraphrasing Traylor, in Maresca and Ricco/C. Shannon interview, 1989, 26. On the back of the drawing Shannon wrote, "Jan. 40 Ross—The undertaker, when he comes in, he always looks around seein' if dem boxes is empty," and dated the comment January 1940. Recorded on back of drawing D-172 in the notes for the D Collection; *Black Folk Art in America, 1930–1980* registrar files, Corcoran Gallery of Art Archives. Special Collections Research Center, Estelle and Melvin Gelman Library, George Washington University, Washington, DC.

127 Quoted in "Snakes and Conjure Doctors," in Waters, *Strange Ways*, 297; originally published in *Southern Workman* 27, no. 2 (Feb. 1898): 36–37. Kendall Buster recalled snake lore from her own childhood and explained that it extended well beyond the black communities; a specific memory entailed a distant cousin talking about putting snake parts in "conjure bottles" as well as looking around for conjure bottles anytime a sudden pain was felt in the body. Telephone conversation with the author, Jan. 26, 2018.

128 Zora Neale Hurston (1891–1960) was an African American folklorist and novelist. She recorded her anthropological research on hoodoo and voodoo in a book-length essay called "Hoodoo in America" (1931) and her collection of Negro folklore in *Mules and Men* (1935); her accounts of hoodoo and voodoo are the most extensive and detailed of any on record. Hurston is widely admired for not only her significant research but also her works of fiction, such as *Their Eyes Were Watching God: A Novel* (1937). Some scholars have raised questions over the originality of parts of Hurston's work, but they concur that the rituals she underwent and the secret societies and their initiations were, by and large, real. See also, Notes to the Reader, n1.

129 The goblet is not a common object for Traylor, but it is worth noting that he drew the hourglass-shaped table more than once. In a later drawing (William Louis-Dreyfus Family Collection, inv. no. 65), it appears with a goblet on top, with figures filling the interior space.

130 Henry John Drewal, "Crowning Achievements: Coiffures and Personhood," in Sonya Clark, *The Hair Craft Project* (Richmond, VA: VCUarts and the Center for Craft, Creativity, and Design, 2014), 99.

131 Ingrid Banks, *Hair Matters: Beauty, Power, and Black Consciousness* (New York: New York University Press, 2000), 8. Banks summarizes the views of Orlando Patterson, *Slavery and Social Death: A Comparative Study* (Cambridge, MA: Harvard University Press, 1982), and Willie [Lee] Morrow, *400 Years without a Comb* (San Diego: Black Publishers of America, division of Morrow's Unlimited, 1973). She notes that although Patterson argued that hair was the more potent symbol of servitude, art historian Kobena Mercer maintained that skin color was ultimately the stronger indicator, with hair being almost as significant as a "racial

signifier." Mercer, "Black Hair/Style Politics," in *Out There: Marginalization and Contemporary Cultures*, ed. Russell Ferguson et al. (New York: New Museum of Contemporary Art and MIT Press, 1990).

132 Banks, *Hair Matters*, 7.

133 Ibid., 5.

134 Zora Neale Hurston, "Characteristics of Negro Expression," in *Negro Anthology*, comp. and ed. Nancy Cunard (New York: Wishart, 1934; repr., Negro Universities Press, 1969), 44.

135 Stephanie M. H. Camp, "The Pleasures of Resistance: Enslaved Women and Body Politics in the Plantation South, 1830–1861," in *New Studies in the History of American Slavery,* ed. Edward E. Baptist and Stephanie M. H. Camp (Athens: University of Georgia Press, 2006), 87.

136 Wash Wilson, quoted in "Texas Narratives," vol. 16 of the Federal Writers' Project, "Slave Narratives" (see above, n6), 198. Also quoted in Katrina Hazzard-Gordon, *Jookin': The Rise of Social Dance Formations in African American Culture* (Philadelphia: Temple University Press, 1990), 79.

137 Hazzard-Gordon, *Jookin'*, 19.

138 Ibid., 78. Hazzard-Gordon (*Jookin'*, 88) quotes a performer, Coot Grant, who recounted her childhood memories of her father's Birmingham honky-tonk in 1901: "I had already cut a peephole in the wall so I could watch the dancers in the back room. . . . I remember the Slow Drag . . . then they did the Fanny Bump, Buzzard Lope, Fish Tail, Eagle Rock, Itch, Shimmy, Squat, Grind, Moche, Funky Butt and a million others. And I watched and imitated all of them." Citing an interview with Mrs. Leola Wilson (Coot Grant), Whitesboro, New Jersey, 1959–60, from Marshall and Jean Stearns, *Jazz Dance: The Story of American Vernacular Dance* (New York: Macmillan, 1968), 24.

139 Johnny Shines, quoted in Giles Oakley, *The Devil's Music: A History of the Blues* (1976; repr., New York: Da Capo Press, 1997), 214, and in Hazzard-Gordon, *Jookin'*, 79.

140 Randall Morris, conversation with the author, Jan. 19, 2017, New York. Morris suggests the dance was the jitterbug but did not specifically mention "Call of the Jitterbug," which Cab Calloway wrote and composed with Irving Mills and Edwin Swayze in 1933.

141 For the lyrics and additional information, see "The Jitterbug Dance (1940's)," Jan. 3, 2011, Mortal Journey (website).

142 See Camp, "Pleasures of Resistance," 87–124.

143 William Barlow, *"Looking Up at Down": The Emergence of Blues Culture* (Philadelphia: Temple University Press, 1989), 5.

144 Thaddeus Norris, "Negro Superstitions," in *The Negro and His Folklore in Nineteenth-Century Periodicals*, ed. Bruce Jackson (Austin: University of Texas Press for the American Folklore Society, 1967), 134–35. Norris's account was originally published in *Lippincott's Magazine* 6 (Philadelphia, July 1870): 90–95.

145 As noted elsewhere, Traylor's comments, many of which have long-since been hidden by frames, are the closest extant approximations of the artist's commentaries or titles. The verso of *Untitled (Chase Scene)* (pl. 65) was not examined in the context of the research for *Between Worlds,* so the existence of such a comment or lack thereof is not known.

146 "Preacher and Devil" may have been assigned by Shannon; the origin of the "title" is unclear. The current owner of *Untitled (Chase Scene)* (pl. 65), the

Museum of Everything, has opted, for objectivity, to adjust the titles of the Traylor artworks in its collection.

147 Quoted in Puckett, *Folk Beliefs,* 141.

148 Ibid., 51.

149 Norris, "Negro Superstitions," 137.

150 Jack-o-my-Lantern has variations in name. See Puckett, *Folk Beliefs,* 133–35, and Norris, "Negro Superstitions," 147. The Lowndes County story (Boswell, Maggie, "The Haunted Graveyard in Lowndes County," recorded as a WPA Alabama Writers' Project, Oct. 17, 1936) is on file at ADAH.

151 Barlow, *Looking Up at Down,* 50. Barlow is writing specifically about the Mississippi Delta here but extends this notion to much of the Black Belt region.

152 Carl Carmer, *Stars Fell on Alabama* (New York: Blue Ribbon Books, 1934), 49.

153 Puckett, *Folk Beliefs,* 550.

154 Quoted in Hyatt, *Hoodoo, Conjuration,* 1:104.

155 Barlow, *Looking Up at Down,* 41.

156 Thompson, *Face of the Gods,* 174.

157 Robert Johnson, "Me and the Devil Blues," recorded in 1937, cited in Barlow, *Looking Up at Down,* 50.

158 Thomas S. Marvin, "Children of Legba: Musicians at the Crossroads in Ralph Ellison's *Invisible Man,*" *American Literature* 68, no. 3 (Sept. 1996): 587–608.

159 Shannon, quoted in Maresca and Ricco/C. Shannon interview, 1989, 15.

160 Sterling Stuckey, *Slave Culture,* 11–12, quoted in Robert Farris Thompson, "The Circle and the Branch: Renascent Kongo-American Art," in *Another Face of the Diamond: Pathways Through the Black Atlantic South*, exh. cat. (New York: INTAR, Hispanic Arts Center, 1988), 29.

161 Katrina Hazzard-Donald (formerly Katrina Hazzard-Gordon), "Hoodoo Religion and American Dance Traditions: Rethinking the Ring Shout," *Journal of Pan-African Studies* (Sept. 2011): 5.

162 Thompson, *Face of the Gods,* 107.

163 Samuel A. Floyd Jr., "Ring Shout! Literary Studies, Historical Studies, and Black Music Inquiry," Supplement, *Black Music Research Journal* (Center for Black Music Research—Columbia College of Chicago and University of Illinois Press) 22 (2002): 49–70.

164 Another possible connection to the circle is Ezekiel's wheel, a symbol that the African Methodist Episcopal (A.M.E.) church employed as a link between African symbolism such as the Kongo cosmogram and Christian symbolism. The wheel may not have been symbolism that Traylor had encountered, but it provides another example of the fusion and syncretism between African and African American religious practices. See John Noble Wilford, "Ezekiel's Wheel Ties African Spiritual Traditions to Christianity," *New York Times,* Nov. 7, 2016.

165 Kuyk, *African Voices,* 188. Kuyk attaches this theory to her larger premise, based on conjecture, that Traylor committed a murder and was seeking eternal forgiveness. See above, n113.

166 See figure 64 herein for *Opportunity* magazine. Caroline Goeser, "'On the Cross of the South': The Scottsboro Boys as Vernacular Christs in Harlem Renaissance Illustration," *International Review of African American Art* 19, no. 1 (Jan. 2003): 19–27.

167 Countee Cullen, *The Black Christ and Other Poems*, with illus. by Charles Cullen (New York: Harper & Brothers, 1929).

168 *Contempo* 1, no. 13 (Dec. 1, 1931). North Carolina Collection, The Louis Round Wilson Library, University of North Carolina at Chapel Hill.

169 Goeser, "'On the Cross of the South,'" 25.

170 Langston Hughes, *Scottsboro Limited: Four Poems and a Play,* with illus. by Prentiss Taylor (New York: Golden Stair Press, 1932).

171 Margaret Rose Vendryes, "Hanging on Their Walls: An Art Commentary on Lynching, the Forgotten 1935 Art Exhibition," in Judith Jackson Fossett and Jeffrey A. Tucker, *Race Consciousness: African-American Studies for the New Century* (New York: New York University Press, 1997), 159. The exhibition, *An Art Community on Lynching,* was held February 13 to March 2, 1935, at the Arthur U. Newton Galleries in midtown Manhattan. Vendryes includes a rare illustration of Thomas Hart Benton's *A Lynching* in her essay (fig. 3, p. 160), noting that the original work of art was not well cared for and damaged beyond repair; no color reproductions are known to exist (Vendryes, 175n19).

172 In 1936, Abel Meeropol wrote the poem "Bitter Fruit" under the pseudonym Lewis Allen; it was published in 1937 in the *New York Teacher,* a union publication. Meeropol said the poem was inspired by Lawrence Beitler's widely circulated photograph from the lynching in August 1930 of Thomas Shipp and Abram Smith in Marion, Indiana. When Meeropol and his wife later converted the poem to song as "Strange Fruit," Laura Duncan sang it at Madison Square Garden in New York, where Billie Holiday (or people who worked with her) heard it. In Holiday's autobiography, *Lady Sings the Blues* (1956), Holiday's ghostwriter, William Dufty, suggested that Holiday, Meeropol, and Holiday's accompanist, Sonny White, had worked on the musical arrangement together, lengthening it with a piano introduction by White. When Holiday recorded the song in 1939 as "Strange Fruit," it sold more than a million copies; a second version followed in 1944. Holiday's 1939 recording topped Billboard's charts for two weeks in 1939 at number sixteen and sold more than a million copies. See World's Music Charts and Billie Holiday (websites), and Cary O'Dell, "'Strange Fruit'—Billie Holiday (1939)," Library of Congress (website).

173 Mechal Sobel also explored the connection between God's son and Traylor's son in Traylor's *Crucifixion* and *Black Jesus* (pls. 69 and 70); Sobel, *Painting a Hidden Life,* 83. The artworks lead to such conceptual explorations, but it should be noted that Sobel's ruminations are separate and distinct from those proposed in this chapter.

174 Shannon, quoted in Maresca and Ricco/C. Shannon interview, 1989, 19.

ArtB · *Florescence, ca. 1940–1942 (pp. 212–52)*

1 For information on Traylor's art possibly dating to 1937 or 1938, see ArtA.n1, and LifeB.n134. The precise quantity of art that Traylor made is unknown, but the number of extant works is estimated to be twelve to thirteen hundred, with a possibility that the number is only about eleven hundred or as many as fifteen. As Traylor became more confident and accomplished, his productivity increased; most of his extant works date between early 1940 and mid-1942, during which time Traylor made roughly a thousand artworks. For more information on the status of Traylor's existing works, see Prologue, n5.

2 The extant documentary photographs (herein figs. 1, 38–41, 45–47, 48, 49, 52, 59, 60, 63) are detailed in the preceding section, "Early Work, ca. 1939–1940." For a list of the existing photos of Traylor, see ArtA.n20.

3 One drawing not illustrated herein, *Untitled (Elaborate Building)* in the collection of the High Museum of Art—and documented in *Bill Traylor: Drawings from the Collections of the High Museum of Art and the Montgomery Museum of Fine Arts,* exh. cat. (Atlanta, GA: High Museum of Art and DelMonico Books/Prestel, 2012), 76—makes a compelling case for a circa 1942–44 date. Jeffrey Wolf and Fred Barron have connected this drawing to a vantage point from the Bell Street bluff location at which Traylor resided around 1942–44. The drawing shows a built structure with a head appearing to rest atop of it, together with other geometric shapes. From the Bell Street location, Wolf and Barron made photographic compilations that projected the view as it might have been circa 1942–44, when it was less obstructed by buildings. It is compelling to believe that the drawing shows the head of the goddess Hebe from the downtown fountain as well as architectural features from a downtown Montgomery church—abstracted as they might have appeared from a distance—to be emerging from the top of one of the buildings in the foreground. Wolf and Barron believe the depicted church could be the landmark First Baptist Church on Montgomery's North Ripley Street, also known as the "Brick-a-Day" church, historic for being one of the first black churches in the area. While Traylor lived near that same spot on Bell in the early 1930s, other facts of his artistic timeline favor *Untitled (Elaborate Building)* as being from the latter period.

4 Shannon gave contradictory information as to when he met Traylor, saying variously that it was "early summer" of 1939 and "spring 1939" (see LifeB.n139). But in February 1940, in the handmade booklet *Bill Traylor: People's Artist,* he also stated that he believed he saw Traylor making his very first works "less than two years ago." The exact date they met is unclear, but "early in 1939" seems to be the idea Shannon stuck with over the years.

5 Charles Shannon, quoted in Vivien Raynor, "A Gentle Naif from Alabama," *New York Times,* Sept. 26, 1982.

6 The Rosenwald Schools comprised more than five thousand schools, shops, and teachers' homes across America, aimed at enhancing the education of African American children in the South beginning in the early twentieth century. The project was a partnership between the African American cultural leader Booker T. Washington and Julius Rosenwald, a Jewish American clothier who was part owner and president of Sears, Roebuck and Company. Rosenwald also founded the Rosenwald Fund, which dedicated seed money for schools and other philanthropic causes to local communities that could match the funds. See Rebecca Ryckeley, "The Rural School Project of the Rosenwald Fund, 1934–1946" (PhD diss., Georgia State University, 2015).

7 Shannon, quoted in Maresca and Ricco/C. Shannon interview, 1989, 8.

8 To remind, the Traylor siblings, whether related by both parents, one parent, via adoption, or as "fictive kin," are simply referred to as siblings herein.

9 Easter Traylor Graham died in Detroit, Michigan, on January 15, 1966. After her death, her sisters Sallie (Sarah) Traylor Howard and Lillie (Lillian) Traylor Hart traveled to Michigan to collect the art that Traylor had made while staying at Easter's home and boardinghouse. In an interview, Myrtha Lee Delks, a granddaughter of Bill Traylor's, was among the descendants who recalled having seen (in the

mid-1950s) several drawings on Easter's walls; when she asked about them, Easter told her, "My father did those" (Wolf/Delks interview, 2017). It is unclear if Traylor made these artworks during his visit in 1940 or a later visit in 1942.

According to the statement on the settlement of the legal case (1992) that the Hunton & Williams law office, NY, released to the press on Oct. 5, 1993, these artworks, plus several others, were in Sarah Traylor Howard's home when she was moved to a nursing home in Bessemer, Alabama (where she subsequently died in 1974). At the time of Sarah's move to Bessemer, Lillian had been disabled by a stroke, and another descendant, Walter, was also ill and unable to travel to Sarah's home to collect the remaining art. The art was left with the furnishings and other belongings in the home and either cleared out by realtors readying the house for sale or sold with the property; the letter is unclear on this detail. Copies of the court settlement and the legal summary of the case are in the author's curatorial files.

10 Wolf/Delks interview, 2017.

11 Traylor's single drawing of a cart driver (not illustrated herein)—*Runaway Goat Cart* in the Philadelphia Museum of Art (The Jill and Sheldon Bonovitz Collection, BST-52)—seemingly illustrates a specific story in which the driver lost control of a goat-drawn cart. Here, for Traylor, the anecdote took priority over documenting the vehicle. No drawings of cars, buses, trains, or trucks are known to exist in Traylor's oeuvre.

12 "Racial etiquette" refers to social norms or behavior rituals that required blacks to defer to whites at all times. Historian and Professor Emeritus at California State University, Northridge, Ronald L. F. Davis has written: "This racial etiquette governed the actions, manners, attitudes, and words of all black people when in the presence of whites. To violate this racial etiquette placed one's very life, and the lives of one's family, at risk. . . . In general, blacks and whites could meet and talk on the street. Almost always, however, the rules of racial etiquette required blacks to be agreeable and non-challenging, even when the white person was mistaken about something." Ronald L. F. Davis, "Racial Etiquette: The Racial Customs and Rules of Racial Behaviour in Jim Crow America." Education for Liberation Network (website).

13 Sources on Brer Rabbit and African American rabbit lore abound. Some include Newbell Niles Puckett, *Folk Beliefs of the Southern Negro* (Raleigh: University of North Carolina Press, 1926; repr., New York: Dover Publications, 1969); Langston Hughes and Arna Bontemps, eds., *The Book of Negro Folklore* (New York: Dodd, Mead, 1958); Alan Dundes, ed., *Mother Wit from the Laughing Barrel: Readings in the Interpretation of Afro-American Folklore* (Jackson: University Press of Mississippi, 1990); Babacar M'Baye, *The Trickster Comes West: Pan-African Influence in Early Black Diasporan Narratives* (Jackson: University Press of Mississippi, 2009); and "Animal Stories," American Folklore (website).

14 David Doddington, "Slavery and Dogs in the Antebellum South," Feb. 23, 2012, in *Sniffing the Past: Dogs and History,* a blog by Chris Pearson. Doddington cites John W. Blassingame, ed., *Slave Testimony: Two Centuries of Letters, Speeches, Interviews, and Autobiographies* (Baton Rouge: Louisiana State University Press, 1977), 608.

15 The smoking figure is *Man with Blue Cap and Cigarette*, illustrated in Phil Patton, *Bill Traylor: High Singing Blue* (New York: Hirschl & Adler Modern, 1997), 27.

16 Robert Farris Thompson, "The Song That Named the Land: The Visionary Presence of African-American Art," in *Black Art, Ancestral Legacy: The*

African Impulse in African American Art, ed. Robert V. Rozelle, Alvia Wardlaw, and Maureen A. McKenna, exh. cat. (Dallas, TX: Dallas Museum of Art, 1989), 100.

17 Herbert C. Covey, *African American Slave Medicine: Herbal and Non-Herbal Treatments* (Lanham, MD: Lexington Books, 2007).

18 *Aunt Sally's Policy Players' Dream Book* (herein fig. 73); New York: H. J. Wehman, 1889; multiple editions). Sobel, *Painting a Hidden Life*, 32–33.

19 Dream books and policy gaming are mentioned in blues dating from the 1920s to 1950s, such as "I Ain't Got You" by Jimmy Reed, "Policy Blues" by Blind Blake (Arthur Blake), and "Hand Reader" by Washboard Sam (Robert Brown); see Debra Devi, "Language of the Blues: Policy Game," September 10, 2015, American Blues Scene (website).

20 Sobel, *Painting a Hidden Life*, 30–33.

21 A vernacular account is given in "Snakes and Conjure Doctors," in *Strange Ways and Sweet Dreams: Afro-American Folklore from the Hampton Institute*, ed. Donald J. Waters (Boston: G. K. Hall, 1983), 297; originally published in *Southern Workman* 27, no. 2 (Feb. 1898): 36–37.

22 The recto image of *Whipporwill* (July 1939) is illustrated in Patton, *High Singing Blue*, 30. Charles Shannon kept a record of this work, noting that the verso featured a drawing he called *Long Dog*; a photograph of the verso and a copy of Shannon's record are in the author's curatorial files.

23 In at least one other painting—*Man with Raised Arms*, Sammlung Zander, Bönnigheim, Germany, at http://sammlung-zander.de/bill-traylor/—the figure makes an almost identical gesture, with his right hand pointing or showing a single digit, the left hand open with all five fingers held out. This latter figure seems more agitated with his arms raised, as a preacher might, as opposed to the man in plate 88 herein, who seems to be calmly and intentionally displaying six digits in what appears to be more a gesture of warning.

24 Ronald L. Smith, *Hoodoo* (New York: Boston Mifflin Harcourt, 2015), 69.

25 The pointing man at bottom wears a hat that looks like a Civil War kepi, or forage cap, which African Americans' who fought in the Civil War often still wore during the decades that followed, so the certainty that the encounter was between soldiers and a farmer is inconclusive.

26 At least eight extant images show a bear or bear-like animal.

27 Wikipedia (website), s.v., "Tuskegee Airmen," last modified Mar. 31, 2018. Maxwell Field is discussed herein in "Bill Traylor in Montgomery, 1927–1939" (pp. 78–87) and in notes, LifeB.nn122, 123.

28 Miriam Rogers Fowler, "A Glimpse at William 'Bill' Traylor," in *Bill Traylor*, exh. brochure (Houston, TX: O'Kane Gallery, 2001), n.p. Structures are discussed herein in "Nineteenth-Century Alabama and the World of Bill Traylor's Parents," pp. 38–58.

29 Susan M. Crawley, "Seeing Traylor in Context," in *Sacred and Profane: Voice and Vision in Southern Self-Taught Art*, ed. Carol Crown and Charles Russell (Jackson: University Press of Mississippi, 2007), 233.

30 Hogsheads were used to store and transport tobacco from the colonial period through the early twentieth century.

31 Shannon in Maresca and Ricco/C. Shannon interview, 1989, 8.

32 Christopher E. Koy, "The Mule as Metaphor in the Fiction of Charles Waddell Chesnutt," in *Theory*

and Practice in English Studies: Proceedings from the Eighth Conference of British, American and Canadian Studies (Linguistics, Methodology and Translation), ed. Jan Chovanec (Brno, Czech Republic: Marasyk University, 2005).

33 Zora Neale Hurston, *Their Eyes Were Watching God: A Novel* (Philadelphia: J. B. Lippincott, 1937; First Perennial Library Edition, 1990), 14.

34 Traylor made one painting—*Leopard with Two Black Figures*, 1939–42, in the collection of the Lucas Kaempfer Foundation—in which two men are being scared off by a similar large, spotted cat, offering the possibility that he may have seen such a cat in the wild.

35 Shannon's note on the verso of the artwork says, "Circus animal-crow, March 1940," providing what is more than likely an accurate date and subject for the drawing. The work is herein titled *Spotted Dog and Black Bird*; previous publications have called it *Leopard and Black Bird*.

36 Montgomery directories do not record 121 Dexter Street as having been either a theater or other large public venue; if the space had been vacant at any time, however, it could have been rented for any short-term purpose, such as hosting a traveling "freak show."

37 More than ten works illustrating "dog fights" are known; others may exist, and still others may not have survived.

38 A photograph taken in June 1940 (herein fig. 54) shows Bill Traylor holding a pipe, although granddaughter Margaret Traylor Staffney noted that, in her memory, Traylor did not smoke or drink (M. R. Fowler and Weber/Delks, Greene, and Staffney audio interview, 1992). Great-grandson Frank L. Harrison Jr. (grandson of Lillian Traylor Hart) owns a small metal pipe holder in the shape of a duck or shorebird that was passed down to him as a belonging of Bill Traylor's; it is not known whether Traylor made the item or acquired it elsewhere (image is in the author's curatorial files). While a pipe holder might be a curious possession for a man who lived for a time on the street, David Ross Sr. had a clear memory that Traylor always "carried a bag" containing his art supplies and possibly other small items. See Betty M. Kuyk, *African Voices in the African American Heritage* (Bloomington: Indiana University Press, 2003), 167, 190.

39 The "Alabama Narratives" is the first volume of the Federal Writers' Project's "Slave Narratives: A Folk History of Slavery in the United States from Interviews with Former Slaves," described in ArtA. n6.

40 Charlton Yingling and Tyler Parry, "The Canine Terror," *Jacobin*, May 19, 2016.

41 Solomon Northup, *Twelve Years a Slave,* Sue L. Eakin and Joseph Logsdon, eds. (Baton Rouge: Louisiana State University Press, 1968), 103–4.

42 "Slavery in Alabama," *The Age* (London), July 2, 1903, 3.

43 Yingling and Parry, "Canine Terror."

44 Bryan Stevenson, *Just Mercy: A Story of Justice and Redemption* (New York: Spiegel & Grau, 2015), 177.

45 One Mississippi account notes, "De colored folks lak to take deir dogs at night an' go out in de swamps an' tree a possum." In George Rawick, ed., *The American Slave: A Composite Autobiography,* Supplement, series 1, *Mississippi Narratives—Part 2,* vol. 8 (Westport, CT: Greenwood Publishing, 1977), 1,293.

46 Shannon paraphrased in Michael Bonesteel, "Bill Traylor, Creativity and the Natural Artist," in *Bill Traylor Drawings*, exh. cat. (Chicago: Chicago Office of Fine Arts, 1988), 24. Bonesteel quotes Shannon (p. 24): "He was very serene. He rarely erased. He just started out and worked to a conclusion. He didn't fuss with things. He made up doing the rectangles himself and used colors straight out of the jar. Nobody could have told him how to do what he did."

47 Shannon, quoted in ibid.

48 See the Equal Justice Initiative website for "The National Memorial for Peace and Justice," "Slavery in America: The Montgomery Slave Trade," and Bryan Stevenson, *Lynching in America: Confronting the Legacy of Racial Terror,*3rd. ed., 2017. The Equal Justice Initiative did one report on the South in 1915 and one on the North in 2017; together the reports document forty-three hundred lynchings spanning twenty states. See LifeB.n70. See also Jonathan Capehart, "The Lynching Memorial Ends Our National Silence on Racial Terrorism," *Washington Post*, Apr. 26, 2018.

49 Other similarly clad people suggest this narrative extends beyond the works discussed in this book; a white couple with dotted shirts and solid pants/skirt appear in *Man on White, Woman on Red*, illustrated in Maresca and Ricco, *Bill Traylor*, 100. Another man in similar clothes, in this case with a brown face, appears in *Two Men Walking* (1992.47) in the collection of the Metropolitan Museum of Art, New York. Still another (white) man dressed this way appears in *Pointing Man in Hat and Spotted Shirt* (TRAY 23), owned by the William Louis Dreyfus Foundation Inc.

50 William Arnett, quoted in Maude Southwell Wahlman, "Bill Traylor: Mysteries," in *The Tree Gave the Dove a Leaf*, vol. 1 of *Souls Grown Deep: African American Vernacular Art of the South,* ed. Paul Arnett and William Arnett (Atlanta, GA: Tinwood Books, in association with Schomburg Center for Research in Black Culture, 2000), 279.

51 Ibid., 66.

52 *Daily Advertiser*, Aug. 7, 1895, cited in Burgin Matthews, "'Looking for Railroad Bill': On the Trail of an Alabama Badman, *Southern Cultures* 9, no. 3 (Fall 2003): 80.

53 Matthews, "'Looking for Railroad Bill,'" 80.

54 "He said he had been thinking for a long time about how to draw a man inside of a house. After he found a way, he used it many times in later drawings." Shannon, quoted in Maresca and Ricco/C. Shannon interview, 1989, 29.

55 The iconographic character of "Mr. Peanut" was created in 1916 and can be seen, in part, on the box top Traylor used for *Drinking Bout* (pl. 129). Traylor made at least one painting in which he appears to depict the figure of Mr. Peanut, but the artwork was not located in the research for *Between Worlds*; an image of it is in the author's curatorial files.

56 Puckett, *Folk Beliefs,*84, and "Birds of Ill Omen," in Waters, *Strange Ways*, 346–47.

57 Alan Brown, ed., *Dim Roads and Dark Nights: The Collected Folklore of Ruby Pickens Tartt* (Livingston, AL: Livingston University Press, 1993), 57; "The Seriousness of Superstition: The Conjure Doctor," in Waters, *Strange Ways*, 84.

58 Lowery Stokes Sims, "Bill Traylor (1854–1947)," in *Bill Traylor (1854–1947): People, Animals, Events, 1939–1942*, exh. brochure (New York: Vanderwoude Tananbaum Gallery, 1982).

59 Maude Southwell Wahlman, "The Art of Bill Traylor," in *Bill Traylor (1854–1947)* (see above, n12).

60 Independent researcher and author Derrel B. Depasse conjectured that the suited man on the roof of *Untitled (Yellow and Blue House with Figures and Dog)* (pl. 130) was a conjure man, and she similarly noted the superstitions about black birds on the rooftop signaling death (DePasse, "Memories Within," chap. 2, p. 4).

61 Shannon quoting Traylor, in Maresca and Ricco/C. Shannon interview, 1989, 15.

62 Charles Shannon, "Bill Traylor's Triumph: How the Beautiful and Raucous Drawings of a Former Alabama Slave Came to Be Known to the World," *Art & Antiques* (Feb. 1988): 61.

63 In 1915, Alabama the police seized some 386 illegal stills; reported in, "This Week in Alabama History: June 28–July 4," ADAH (website).

64 Jeffrey A. Miron and Jeffrey Zwiebel, "Alcohol Consumption During Prohibition," *American Economic Review* 81, no. 2 (May 1991): 242–47; Jack S. Blocker Jr., "Did Prohibition Really Work? Alcohol Prohibition as a Public Health Innovation," *American Journal of Public Health* 96, no. 2 (Feb. 2006): 233–43. According to Miron and Zwiebel's research: "Consumption [of alcohol fell] immediately after enactment of Prohibition to 20 to 40 percent of its pre-Prohibition level. Alcoholism, drunkenness, and psychosis estimates indicate a sharp rebound in consumption from 1921 to 1927 and a less dramatic increase after 1927. . . . The later years of Prohibition, cirrhosis, drunkenness, and psychosis estimate consumption to be 50 to 70 percent of its pre-Prohibition value, while alcoholism estimates small increases in consumption."

Blocker's article cites a report by Angela K. Dills and Jeffrey A. Miron, "Alcohol Prohibition and Cirrhosis," *American Law and Economics Association* 6, no. 2 (2004): 285–318, for the following statistics: during the early part of the twentieth century, deaths from liver cirrhosis were "15 per 100,000 total population," and from chronic alcoholism "10 per 100,000 total population."

65 Blocker argues that the repeal of the Eighteenth Amendment was politically based, not the result of the decay of morals or the public's desire to drink. As the liquor, beer, and wine industry shriveled during the 1920s, many lost their employment. The economy felt the effects as tax revenue from distilled spirits fell dramatically between 1919 and 1929. In the next election, people voted for candidates who would help boost the economy with a repeal of Prohibition.

66 Claud Shannon is unrelated to Charles Shannon. During research for this project, the author sought but did not find information on the Seven Sisters Club.

67 When Marcia Weber had Jay Leavell's ten paintings by Traylor on view at the Leon Loard Gallery in Montgomery in November 1988, Shannon came to see them. Regarding *Mexican Lady with Green and Red Spotted Dress* (pl. 152), Shannon told Weber that connecting the eyebrows was Traylor's manner of indicating Mexican ethnicity (Marcia Weber, personal communication with the author, Sept. 7, 2017). Although the United States signed the Mexican Farm Labor Agreement with Mexico, better known as the Bracero Program, in August 1942, the influx of the male laborers came in conjunction with the fall harvest—months after Shannon had left (in June) to serve in World War II; by that time, Traylor had probably left town to visit family. If Traylor depicted Mexican men and women as Shannon suggests, the individuals were likely not part of the all-male Bracero Program; for information on the program, see the websites Immigration to the United States, Borders and Borderlands, and Bracero History Archive.

68 Shannon mentions Traylor's style for depicting Mexicans in Maresca and Ricco/C. Shannon interview, 1989, 14; Marcia Weber, personal communication with the author, Sept. 7, 2017.

69 Shannon is known to have "cleaned up" many of the Traylor works he owned by erasing extraneous lines and smudges and making them, in his view, more presentable for viewers. When Shannon visited Marica Weber at the Leon Loard Gallery in November 1988 he advised Weber to "clean them up with an emery board and a kneaded eraser" and "cut off the dirty strings." He noted that he had "spent years cleaning up his Traylors." (Weber, telephone conversation with the author, Aug. 10, 2017).

Mexican Lady with Green and Red Spotted Dress (pl. 152) was among the works that Jay Leavell purchased directly from Bill Traylor. Leavell left his untouched. Weber agreed with his decision, noting, "If Bill's fingerprints are on these pieces, I want to present them just as they are." (Ibid.)

The condition of this work, from Leavell's original group of ten, may serve as an example of their original state as Traylor had them. Shannon did not keep records about which works he had altered.

70 In the 1930s and 1940s, Montgomery had two communities of Ashkenazi Jews and a smaller contingent of Sephardic Jews.

71 Barry Parker, *A Varon in Us All* (Chattanooga, TN: Parker Communications, 2009), 32–33.

72 Micki Beth Stiller's research into the Varon family's relationship with Bill Traylor revealed that Isaac Varon may have been a source of alcohol for Traylor. Stiller cites conversations with three Montgomery natives, Jeanette Edith Ciarletta, Cohen Rousso, and Esther Varon, the latter of whom, with her husband, Morris Varon, shared a duplex on Felder Avenue with Issac and Mathilda Varon. Stiller, conversation with the author, Aug. 15, 2017, Washington, DC.

73 It is unclear what year the Red Bell Café opened, as Montgomery city directories for 1943 and 1944 do not exist. In the 1942 directory the Varons's business address is listed as a grocery store (opened in 1935 at 120 Monroe), but it may have converted to a café sometime between then and 1945, when the directory first listed the Red Bell Café. Charles Shannon noted in Maresca and Ricco/C. Shannon interview, 1989, that Traylor frequented the Red Bell Café, suggesting that it may have been operating in some capacity before 1942; Shannon was otherwise mistaken regarding the café where Traylor ate. A George's Restaurant, owned by George Maroon, was between Varon's grocery store and the Pekin Pool Room from 1933 to about 1942. (When Varon opened the Red Bell Café, he expanded to take over the neighboring restaurant at 122 Monroe.) Traylor moved out of the Monroe Street neighborhood in 1942.

74 Nace Varon, telephone interview by Mechal Sobel, June 29, 2004, Montgomery, AL, cited in Sobel, *Painting a Hidden Life*, 95.

75 Nace Varon noted that the painting of him was not saved. Traylor is not known to have made any specific comment on the identity of the lady in this painting. In a photograph by Charles Shannon (herein fig. 40), a woman (her head shown in the upper right quadrant) sits just beyond Traylor's spot and a group of standing figures. Alison Lebovitz, Suzanna's great-granddaughter, with the aid of her mother, Arlene Kleinberg Goldstein, has identified the woman as her great-aunt, Matilda, Isaac's wife.

76 This drawing is not included in the exhibition but is similar to several that are (pls. 153–55). The work was originally part of the group to which Charles Shannon gave D numbers: D-38, dated Aug. 5, 1939. In 1982, in conjunction with the Corcoran Gallery of Art's exhibition *Black Folk Art in America,* Shannon wrote notes ("D Collection, Notes on Works") on plain paper, typed as a list. It appears that he copied the remarks from annotations he had made on the artworks at the time he acquired them. Margo Russell kept copies of Shannon's typed lists as well as her own handwritten list of works in the D Collection; both are in the papers of Margo Russell. A third, typed spreadsheet, version of the D Collection inventory is in the papers of Joe Wilkinson, dated Feb. 2, 1994, Bill Traylor files shared with the author, 2016–17.

Additionally, the author has located original records from the *Black Folk Art in America* loans, which include the checklist, registration comments on the condition of artworks incoming to the museum, Shannon's notes on the dates and materials of the artworks therein, his lists of lettered "collections," and notes on the D and the S Collections. *Black Folk Art in America, 1930–1980* registrar files, Corcoran Gallery of Art Archives. Special Collections Research Center, Estelle and Melvin Gelman Library, George Washington University, Washington, DC.

77 Ruth Bass, "The Little Man," in *Mother Wit from the Laughing Barrel: Readings in the Interpretation of Afro-American Folklore,* ed. Alan Dundes (Jackson: University Press of Mississippi, 1990), 389; originally published in *Scribner's Magazine* 97 (1935): 120–23.

78 Hughes and Bontemps, *Book of Negro Folklore,* 19.

79 "A Negro Ghost Story," in Waters, *Strange Ways,* 345; originally published in *Southern Workman* 28, no. 11 (Nov. 1899): 449–50.

80 See Samuel Miller Lawton, "The Religious Life of South Carolina Coastal and Sea Island Negroes" (PhD diss., George Peabody College for Teachers, Nashville, TN, 1939), 212–13, cited in Betty M. Kuyk, *African Voices in the African American Heritage* (Bloomington: Indiana University Press, 2003), 173.

81 Alan Brown, ed., *Dim Roads and Dark Nights: The Collected Folklore of Ruby Pickens Tartt* (Livingston, AL: Livingston University Press, 1993), 57. Tartt collected her folklore accounts in Alabama in the 1930s (see ArtA.n6). The notion that Death rides a pale, or white, horse is rooted in the biblical tale of the Four Horsemen of the Apocalypse.

82 For Robert Ambers Ross, ca. 1920, see Brad Harper, "A Jewel in the Black Community: Ross-Clayton Turns 100," *Montgomery Advertiser,* Apr. 25, 2018. Jeffrey Wolf located this image on Apr. 26, 2018, for his film *Bill Traylor: Chasing Ghosts.*

83 Jennifer P. Borum, "Bill Traylor and the Construction of Outsider Subjectivity," in Crown and Russell, *Sacred and Profane,* 238–59.

84 M. B. Sellers, "Legba," *Deep South Magazine,* Jan. 10, 2014.

85 Lewis Hyde compared Frederick Douglass to Legba in his *Trickster Makes This World: Mischief, Myth, and Art* (New York: Farrar, Straus and Giroux, 1998), 247.

86 Borum, "Outsider Subjectivity," 255.

87 Eugenia Shannon noted that when she and Charles first worked on organizing their Traylor collection in 1975 they broke the works into twenty-eight categories. Eugenia Shannon, "Bill Traylor Categories," letter (dated Aug. 2011), on file on the Montgomery Museum of Fine Arts curatorial files. These categories also appear on documents from the Corcoran exhibition; see above, n76.

88 Shannon, quoted in Maresca and Ricco/C. Shannon interview, 1989, 30–31. Here, when Shannon refers to Traylor's last year of working, he means the last year that he, Shannon, collected works of art by Traylor before leaving in 1942 for service in World War II. Traylor kept painting after

1942, although it was less documented and few, if any, works from his final years survived. See above, Prologue, nn4, 5; see also LifeB.n201.

89 Miriam Rogers Fowler had published some of her ideas about Traylor's use of structures in 2001 in her essay "A Glimpse at William 'Bill' Traylor." Based on information from and communication with Marcia Weber and Fowler—including a phone conversation with Weber, Mar. 8, 1999, and an email exchange with Fowler, Aug. 2, 2000—Susan M. Crawley, in 2007, summarized many of their findings in "Words and Music: Seeing Traylor in Context," in Crown and Russell, *Sacred and Profane*, 215–37. Crawley noted their respective research and conversations with Bill Traylor's descendants.

90 Fred Barron and Jeffrey Wolf, "In Plain Sight," in *Bill Traylor: Drawings*, 23–29. Copy of the Alabama Historic Commission's form dated Aug. 2, 1984, nominating North Lawrence–Monroe Street district to historic status is in the author's curatorial files.

91 The Klein and Son clock was moved, with the relocation of the store, in 1986. In 2009 it was donated to the City of Montgomery and reinstalled in its original location.

92 William Barlow, *"Looking Up at Down": The Emergence of Blues Culture* (Philadelphia: Temple University Press, 1989), 22–23.

93 John and Ruby Lomax collected a blues song also called "Boll Weevil," sung by Willie "Gar Mouth" Williams at Cummins State Farm in Gould, Arkansas; noted in Stephanie Hall, "The Life and Times of Boll Weevil," Dec. 11, 2013, on the Library of Congress's Folklife Today (website).

94 See "Summer 1861: Montgomery—'The Cradle of the Confederacy,'" July 25, 2011, Alabama Heritage (website).

95 F. Scott and Zelda Fitzgerald, "Show Mr. and Mrs. F. to Number—," in *The Crack-up*, ed. Edmund Wilson (New York: New Directions Books, 1945), 54. Quoted in Nancy Milford, *Zelda: A Biography* (New York: Harper and Row, 1970), 192.

96 William Barlow, *Looking Up at Down*, 9. Barlow further notes: "The rural blues thus represented both a break with and a return to the past. It was this tension between innovation and tradition that endowed the blues with a capacity to illuminate the emotional life and social consciousness of the African-American people."

97 Adam Gussow, *Seems Like Murder Here: Southern Violence and the Blues Tradition* (Chicago: University of Chicago Press, 2002), 4. Gussow notes that some writers who have traced the connections are Arthur Flowers, Clarence Major, Sterling Plumpp, Alice Walker, and August Wilson.

98 Ibid., 4–5.

99 John Dollard, *Caste and Class in a Southern Town* (New York: Double Day, 1935; repr., 1957), 303–5, cited in Gussow, *Seems Like Murder Here*, 18.

100 Bryan Stevenson, *Lynching in America: Confronting the Legacy of Racial Terror*, 3rd ed., 2017, Equal Justice Initiative (website). For some of Stevenson's findings, see LifeB.n34.

101 For Gosse's discussion of a possum hunt, see Harvey H. Jackson III, "Philip Henry Gosse: An Englishman in the Alabama Black Belt," *Alabama Heritage*, no. 28 (Spring 1993): 41–42. See also ArtB. n45.

102 In Shannon's lists, including the checklist for the *Black Folk Art in America* exhibition, he called some works, including this one, "possum hunts" or "possum chases."

103 Alfred H. Barr Jr. (38412-14) and Holger Cahill (Apr. 27, 1938), quoted in press releases for the exhibition *Masters of Popular Painting: Modern Primitives of Europe and America*, Apr. 27–July 24, 1938, The Museum of Modern Art, New York.

104 Shannon's recollection was that he took Traylor's work to New York in 1941. The exhibition at the Fieldston School occurred in January 1941, which suggests that Shannon's initial visit to New York to seek venues for Traylor may have taken place earlier than Shannon remembered it to be. Shannon in Maresca and Ricco/C. Shannon interview, 1989, 25.

105 See "Exhibitions at the Fieldston Gallery 1941–1942," Bill Traylor Artist Files, Luise Ross Gallery, New York; copy in the author's curatorial files. Victor D'Amico's affiliation and hire at MoMA was announced in "Annual Report to Members for 1938," *Bulletin of the Museum of Modern Art* 5, no. 1 (Jan. 1938): 3–12.

106 Shannon quoting Traylor, in Maresca and Ricco/C. Shannon interview, 1989, 25. Memo to Alfred H. Barr Jr. from E. Van Hook, "Negro Drawings," Jan. 22, 1942, Alfred H. Barr, Jr. Papers, The Museum of Modern Art Archives, New York, accessed at the Archives of American Art (reel no. 2167, file 52, "Inter-Office memoranda," 1942). The MoMA memo reads:

"The Negro drawings are still in Fieldston but will come here to the Museum maybe next Monday. No price has been set on them, but Miss Knowles suggests that the Museum make an offer on those we wish to keep. The Fieldston School sent $10.00 to the owner, Mr. Charles Shannon, for the privilege of exhibiting them, although they did not keep any. No point in sending the Negro money as he has no home and probably can't read etc. . . . Mr. Shannon bought the drawings from the Negro and would not consider giving any to the Museum. In case of purchase, he said he would refund the whole price to the artist."

Barr's enthusiasm for the work of untrained artists continued with a one-man show for "primitive" painter Morris Hirshfield in 1943 and another of an embellished shoeshine stand by Italian immigrant, self-taught artist, and bootblack Joe Milone that same year. MoMA subsequently distanced itself from Barr's views, calling such projects "frivolous"; Barr was demoted from his directorship in 1943 but later became director of collections and left a legacy as being the catalyst for the success of modern art in the second half of the twentieth century.

107 Maresca and Ricco, *Bill Traylor*, 20. Shannon's World War I enlistment record, "Charles E. Shannon, serial number 34331825," is in National Archives and Records Administration, National Archives at College Park, MD.

ArtC · *Art in the Final Years, 1942–1949* (pp. 346–48)

1 Shannon, quoted in Maresca and Ricco/C. Shannon interview, 1989, 4–5.

2 Myrtha Lee Delks visited her Aunt Easter in Detroit, Michigan, in the mid-1950s and saw works of art her grandfather Bill Traylor had made while there; Wolf/Delks interview, 2017 (see LifeB.nn188, 197). Starlene Trayler Williams also recalled seeing her great-grandfather's art on view in Easter's home; Wolf/Williams interview, 2018.
Great-grandson Frank L. Harrison Jr., who with his sister, Leila Greene, was raised by his grandmother Lillian from 1942 to 1949, believes that Traylor had visited his daughter Lillian in Prince George's County, Maryland (before she moved to Philadelphia with Frank and Leila), and made art while in Maryland,

too. Lillian moved to Washington, DC, in 1949. Mince and Wolf/Harrison interview, 2018.

3 Easter's comments are as relayed through Antoinette Staffney Beeks and Myrtha Lee Delks in Wolf/Delks interview, 2017.

4 Margaret Traylor Staffney, a daughter of Will Traylor, who lived for a time near Sarah and Albert Howard in Montgomery and often visited her grandfather there, gave this information about Traylor's second residence on Bell Street in several accounts. See ibid.; LifeB.n186; and below, n5.

5 Margaret Traylor Staffney recounted her memories to Marcia Weber on various occasions and gave a similar account about her grandfather's illness and surgery in DePasse/Staffney interview, 1996 (chronology, 5). See LifeB.n186.

6 Myrtha Lee Delks was born Laura Traylor and renamed Myrtha Lee (informally at the time she was taken in; legally in 1975) Canty by her adoptive family. Staffney was her first married surname, and Delks her second married surname (she and her sister Margaret married brothers, hence they both had the married surname Staffney). Delks recorded her memories in the 1992 reunion booklet, in which she noted visiting her grandfather Bill Traylor (with Margaret Traylor Staffney) in 1943 and 1944 but without distinct memories of what happened at specific moments in time.

7 Margaret Traylor Staffney, memory recorded in the 1992 reunion booklet. Staffney's recollections span the years from around 1933, when she was ten, to 1946 or 1947, when she was twenty-three or twenty-four. Margaret's note (dated Aug. 1992) in the 1992 reunion booklet seems to conflate various time frames in which she visited her grandfather.

8 Shannon quoting Traylor, in Maresca and Ricco/C. Shannon interview, 1989, 20.

9 Shannon discusses the letter he wrote to Easter, and her response, in Maresca and Ricco/C. Shannon interview, 1989, 20–22; see LifeB.nn185, 193, and 200.

10 Shannon, quoted in Maresca and Ricco/C. Shannon interview, 1989, 20.

11 For the works shown in the photographs, see LifeB.n198.

12 For Traylor's final works, and Rankin's ownership of them, see LifeB.nn173, 199.

13 For information regarding the whereabouts of drawings Traylor may have made in his later years, see LifeB.n197 and above, n2.

14 For more on the church, see LifeB.n203.

Afterlife · *Afterlife: The Posthumous Success of Bill Traylor's Art* (pp. 349–65)

1 For additional information on the organization of artworks by the Shannons, see ArtB.nn 76, 87 and below, n.3.

2 Luise Ross, email exchange with the author, Sept. 20, 2017. Ross also wrote, in 2001: "I first encountered Bill Traylor's work in 1977, and without exaggeration it was an epiphany for me." In *Bill Traylor*, exh. brochure (Houston, TX: O'Kane Gallery, 2001), n.p.
Richard Oosterom recalled that Dintenfass liked the work but was not looking for new artists at that time; Oosterom, interview by Jeffrey Wolf, Oct. 4, 2017, Detroit, MI; copy of transcript in the author's curatorial files.

3 Richard Oosterom, email exchange with the author, Apr. 26, 2017. The five original groups

Oosterom mentions refer to letter groups, or collections, A, B, C, D, and E. An additional (sixth) group was called X and a seventh called S. The smaller S Collection may have been formed as a subgroup for loan to the Corcoran exhibition.

Shannon's handwritten lists dated "8-17-81" of twenty-three works from the S Collection are on file in the *Black Folk Art in America, 1930–1980* registrar files, Corcoran Gallery of Art Archives. Special Collections Research Center, Estelle and Melvin Gelman Library, George Washington University, Washington, DC. A partial list of Joseph H. Wilkinson's D Collection is on file in the same location, as are notes on Shannon's categories. A different inventory of the D Collection was provided to the author by Joseph H. Wilkinson; and another full list of the D Collection, together with notes and correspondence regarding loans to the Corcoran from the D Collection, were provided by Margo Russell (formerly Margo Wilkinson). Photocopies are in the author's curatorial files.

4 Richard Oosterom included Traylor in a group exhibition (with three other artists) in September 1979. Soon after, he organized a one-person show on Traylor, *Bill Traylor, 1854–1974: Works on Paper,* which ran from Dec. 13, 1979, to Jan. 12, 1980; the R. H. Oosterom Gallery closed permanently on Dec. 7, 1980. Information provided by Richard Oosterom, email exchange with the author, Nov. 11, 2017.

5 Ibid. The painting donated to the Schomburg Center was purchased from the solo exhibition at the R. H. Oosterom Gallery (see above, n4).

6 Charles Shannon, Lyle Rexer/Charles Shannon interview, 1990 (p. 13).

7 Information provided by Joseph H. Wilkinson, telephone conversation with the author, Sept. 19, 2017.

8 Joseph H. Wilkinson, untitled essay in *Bill Traylor Drawings from the Collection of Joe and Pat Wilkinson,* auction cat. (New York: Sotheby's, Dec. 3, 1997), 14.

9 Ibid., 14, 15.

10 From 1973 through 1981, Angus Whyte operated the Angus Whyte Gallery in Boston and Provincetown, Massachusetts; New York; and Washington, DC.

11 Shannon selected the thirty works for the Montgomery Museum of Fine Arts, Alabama, from the C Collection. The solo exhibition held there was *Bill Traylor,* Nov. 6–Dec. 30, 1982 (exhibition and brochure by Margaret Lynne Ausfeld). Information from Margaret Lynn Ausfeld, email to the author, May 1, 2017.

12 This two-venue exhibition was *Bill Traylor (1854–1947),* Arkansas Arts Center, Little Rock, Oct. 14–Nov. 28, 1982, and Mississippi Museum of Art, Jackson, Mar. 1–Apr. 9, 1983 (catalogue essay by Maude Southwell Wahlman).

13 Hammer and Hammer Gallery would become Carl Hammer Gallery in 1983; Janet Fleisher Gallery would become Fleisher/Ollman in 1996. Luise Ross worked with Vanderwoude Tananbaum Gallery on its exhibition project and curated the show for the Arkansas Arts Center.

14 Richard Oosterom, email exchange with the author, Apr. 26, 2017, and Nov. 14, 2017. Oosterom explained that Lusie Ross purchased the remaining works from the E Collection sometime after the Corcoran show had opened.

15 Jane Livingston, "What It Is," in *Black Folk Art in America, 1930–1980,* ed. Jane Livingston and John Beardsley, exh. cat. (Jackson: University Press of

Mississippi and Center for the Study of Southern Culture for the Corcoran Gallery of Art, 1982), 14.

16 Like Traylor, William Edmondson had a brush with the New York art world in the late 1930s. In 1937, Edmondson was the first African American artist to have a solo exhibition at the Museum of Modern Art (MoMA), *Sculpture by William Edmondson,* Oct. 20–Nov. 4, 1937. MoMA's first director, Alfred H. Barr Jr., organized the show, which was not particularly well received; at least in part, its lack of success may have contributed to Barr's subsequent demotion.

17 The same thoughts are expressed in Leslie Umberger, "In Memory of the Blood," in *Something to Take My Place: The Art of Lonnie Holley,* ed. Mark Sloan, exh. cat. (Charleston, SC: Halsey Institute of Contemporary Art, College of Charleston School of the Arts, 2015), 19.

18 Ibid.

19 Kay Larson, "Briefs: Bill Traylor at Oosterom," *Village Voice,* Jan. 7, 1980, 59.

20 Gylbert Coker, "Bill Traylor at R. H. Oosterom," *Art in America* 68, no. 3 (Mar. 1980): 125.

21 Vivien Raynor, "Show in Brooklyn Mines Black Folk Vein," *New York Times,* July 2, 1982, C22. Raynor was reviewing *Black Folk Art in America* when it was at the Brooklyn Museum.

22 Luise Ross confirmed her acquisition of work via Oosterom and participation in the exhibition at Vanderwoude Tannanbaum, in email exchange with the author, Sept. 20, 2017. Gallerists Frank Maresca confirmed his and Roger Ricco's co-purchase of the forty works, in Umberger/Maresca interview, 2017 (p. 4).

23 Margaret Lynne Ausfeld, *Bill Traylor* (see above, n11).

24 Lowery Stokes Sims, "Bill Traylor (1854–1947)," in *Bill Traylor (1854–1947): People, Animals, Events, 1939–42,* exh. brochure (New York: Vanderwoude Tananbaum Gallery, 1982), n.p. The life dates commonly used for Bill Traylor at that time were incorrect.

25 Maude Southwell Wahlman, "The Art of Bill Traylor," in *Bill Traylor (1854–1947),* exh. brochure (Little Rock: Arkansas Arts Center, 1982), n.p. Wahlman further explored these ideas in "Africanisms in Afro-American Visionary Art," in *Baking in the Sun: Visionary Images from the South,* exh. cat. (Lafayette, LA: University Art Museum, University of Southwestern Louisiana, 1987). *Baking in the Sun* was held June 13–July 31, 1987, and traveled to six subsequent venues through 1989.

26 The exhibition *A Selection of Works from the 20th-Century Permanent Collection,* held at the High Museum of Art, Atlanta, GA, Oct. 25–Dec. 29, 1983, was not accompanied by a catalogue. Information on the exhibition was provided by Katherine Jentleson, the Merrie and Dan Boone Curator of Folk and Self-Taught Art at the High Museum of Art, in email to the author, Nov. 15, 2017.

27 Donald McKinney was the director of Hirschl & Adler Modern at the time.

28 *Black Folk Art in America, 1930–1980* was on view at the Corcoran Gallery of Art in Washington, DC, Jan. 15–Mar. 28, 1982. Subsequent venues were Speed Art Museum, Louisville, KY (Apr. 27–June 13, 1982); Brooklyn Art Museum, NY (July 4–Sept. 12, 1982); Craft and Folk Art Museum, Los Angeles, CA (Dec. 8, 1982–Feb. 6, 1983); Institute of the Arts, Rice University, Houston, TX (Mar. 4–May 15, 1983); Detroit Institute of Arts, MI (July 10–Oct. 2, 1983); Birmingham Museum of Art, AL (Nov. 6–Dec. 26,

1983); and the Field Museum of Natural History, Chicago, IL (Apr. 14–July 15, 1984).

29 M. R. Fowler and Weber/Delks, Greene, and Staffney audio interview, 1992. Leila Greene specifically noted CBS News Sunday Morning with Charles Kuralt was the show they saw, having been told about it in advance by someone who noticed the family name "Traylor" included in the subjects being covered; the edition of Sunday Morning that covered *Black Folk Art in America* aired on January 16, 1983, six months before the exhibition went on view in Detroit.

30 *Black Folk Art in America, 1930–1980* was at the Detroit Institute of Fine Arts from July 10 to October 2, 1983. Traylor's son Walter was living in Detroit at the time. Traylor's daughter Lillian, who lived until 1984, and Walter, until 1985, were likely aware of this exhibition. Press release, "Statement by the Parties Announcing Settlement of the Lawsuit Concerning the Art of Bill Traylor," from the office of Hunton & Williams, NY, Oct. 5, 1993 (see LifeB.n198). The release notes that "a grandchild and a great grandchild" saw the exhibition "as part of a traveling exhibition in a museum in Detroit in the mid-1980s." It may be in error as to which relations saw the exhibition; other family members then living in Detroit included Myrtha Lee Delks (granddaughter), Shirley Trayler (wife of grandson Clement B. Trayler), great-granddaughter Nettie Trayler-Alford, and possibly other great-grandchildren.

31 Charles Shannon, in Lyle Rexer/C. Shannon interview, 1990 (p. 13).

32 Charles Shannon, "Bill Traylor," in *Bill Traylor, 1854–1947,* exh. cat. (New York: Hirschl & Adler Modern, 1985). Shannon's facts about Traylor were not all correct, but his story became the core outline that articles, essays, and reviews would refer to for years to come. His narrative also cut out other New South members, most specifically Jay Leavell, John Lapsley, and Shannon's first wife, Blanche Balzer Shannon (Angell). Shannon drew from his own essay, revising and lengthening it for his later article "Bill Traylor's Triumph," *Art & Antiques* (Feb. 1988): 61–65, 88. He repeated many of the same statements and ideas in Maresca and Ricco/C. Shannon interview, 1989.

33 Jeffrey Wolf, interview with Nettie Trayler-Alford, Oct. 4, 2017, Detroit, MI; copy of transcript is in the author's curatorial files.

34 Nettie Trayler-Alford worked for the Internal Revenue Service at the Detroit Computing Center at the time (ibid.).

35 The 1991 reunion booklet.

36 Umberger/Maresca interview, 2017 (pp. 22–23). See also above, n32.

37 Great-granddaughter Antoinette Staffney Beeks organized a family reunion held in Atlanta, Georgia, in 1992 for which she gathered written memories, a selection of articles and published excerpts on Bill Traylor's art, and biographical data on the artist (abbreviated herein as the 1992 reunion booklet). Two important interviews (M. R. Fowler and Weber/Delks, Greene, and Staffney audio interview, 1992; and Kogan and Weber/Staffney video interview, 1992) took place, respectively, the day of and a few days after the reunion.

38 The lawsuit was filed on November 12, 1992, as: "Antoinette Beeks, individually and as Representative of the Descendants of Bill Traylor against Charles and Eugenia Shannon and Hirschl & Adler Galleries, Inc." Nov. 12, 1992. The Bill Traylor Family Trust registered copyright for Bill Traylor artworks in 1994. Copies of the lawsuit are on file in various locations, including Marcia Weber personal files shared with the author, 2015–17.

39 Headlines included "Lawsuit Claims Man Stole Ex-Slaves Art" (M. P. Wilkerson, *Montgomery Advertiser*, Dec. 1992); "Kin Sue for Artwork" (Salvatore Arena, *Daily News*, Nov. 14, 1992); and "Art Dealer Sued over Prints and the Pauper" (Hal Davis, *New York Post*, Nov. 27, 1992).

40 The settlement entailed a gift by the Shannons to the Traylor Family Trust of twelve original paintings by Bill Traylor. Hirschl & Adler Modern, Inc., would act as dealer to the Family Trust as needed.

41 "Statement by the Parties Announcing Settlement of the Lawsuits" quotes Richard L. Huffman of Baden Kramer Huffman & Brodsky.

42 These included Hirschl & Adler Modern, Carl Hammer, Fleisher/Ollman, Ricco/Maresca, Luise Ross, and others.

43 Jane Kallir, "Art Brut and 'Outsider' Art: A Changing Landscape," in *Accidental Genius: Art from the Anthony Petullo Collection*, ed. Margaret Andera and Lisa Stone, exh. cat. (Munich: Delmonico Books in collaboration with Milwaukee Art Museum, 2012), 23, for the exhibition in Milwaukee, Feb. 10–May 6, 2012.

44 Ibid., 23–24. The term "outsider" was first suggested to Cardinal by the book's editor and subsequently agreed upon.

45 Ibid., 26.

46 See Leslie Umberger, "David Butler: In Good Company," *Sublime Spaces & Visionary Worlds: Built Environments of Vernacular Artists*, exh. cat. (New York: Princeton Architectural Press and John Michael Kohler Arts Center, 2007), 188–201.

47 See also Umberger, "In Memory of the Blood," in *Something to Take My Place*, 11–33, and "Sam Rodia: Upward Spiral," in *Sublime Spaces*, 110–25.

48 Gregg Blasdel, "The Grass Roots Artist," *Art in America* 56 (Sept./Oct. 1968): 24–41; Walker Art Center, *Naïves and Visionaries*, exh. cat. (New York: E. P. Dutton, 1974).

49 Regenia A. Perry, "Black American Folk Art: Origins and Early Manifestations," in Livingston and Beardsley, *Black Folk Art in America*, 31. Perry cites Robert Farris Thompson, "African Influences on the Art of the United States," paper published for symposium, "Black Studies in the University," at Yale University, New Haven, CT, Apr. 1969, p. 128. Perry also drew on *Drums and Shadows: Survival Stories Among the Georgia Coastal Negroes*, Savannah Unit, Georgia Writer's Project of the Works Progress Administration, Athens (Athens: University of Georgia Press and Brown Thrasher Books, 1940).

50 Perry would revisit this subject in later writings, including "African Art and African-American Folk Art: A Stylistic and Spiritual Kinship," in *Black Art, Ancestral Legacy: The African Impulse in African American Art*, ed. Robert V. Rozelle, Alvia Wardlaw, and Maureen A. McKenna, exh. cat. (Dallas, TX: Dallas Museum of Art, 1989), 100.

51 Bruce Kurtz, "Black Folk Art in America, 1930–1980," *Artforum* 21, no. 7 (Mar. 1983): 80–81.

52 Kay Larson, "Varieties of Black Identity," *New York Magazine*, Aug. 1982, 52.

53 Robert Farris Thompson, *Flash of the Spirit: African and Afro-American Art and Philosophy* (New York: Random House, 1983).

54 Wyatt MacGaffey, "The Black Loincloth and the Son of Nzambi Mpungu," in *Forms of Folklore in Africa: Narrative, Poetic, Gnomic, Dramatic*, ed. Bernth Lindfors (Austin: University of Texas Press, 1977), 148.

55 Grey Gundaker, "Tradition and Innovation in African American Yards," *African Arts* 26, no. 2 (Apr. 1993): 59, 60.

56 Randall Morris, unpublished paper presented in the session "At the Crossroads—Intersections & Engagement: Whose Culture?" at "The Road Less Traveled," an NCPTT Divine Disorder Conference, a partnership of National Center for Preservation Technology and Training, Kohler Foundation Inc. and the John Michael Kohler Arts Center. Sept. 28, 2017, webcast live at #roadlesstraveled2017. Morris shared presentation notes with the author by email, Oct. 1, 2017.

57 See Grey Gundaker and Judith McWillie, *No Space Hidden: The Spirit of African American Yard Work* (Knoxville, TN: University of Tennessee Press, 2005), and Dana Rush, *Vodun in Coastal Bénin: Unfinished, Open-Ended, Global* (Nashville, TN: Vanderbilt University Press, 2013).

58 Morris, "At the Crossroads."

59 See Richard J. Powell, *The Blues Aesthetic: Black Culture and Modernism* (Washington, DC: Washington Project for the Arts, 1989).

60 In addition to the Montgomery Museum of Fine Arts and the High Museum of Art, which collected Traylor's work early on, institutions including the Menil Collection in Houston, the Metropolitan Museum of Art, the Museum of Modern Art, the Newark Museum, the Philadelphia Museum of Art, the Smithsonian American Art Museum, and the Whitney Museum of American Art own his art.

61 Kerry James Marshall had discussed Traylor's art in several texts and interviews, including his essay "Sticks and Stones. . . , but Names. . . ," in *Bill Traylor, William Edmondson, and the Modernist Impulse*, ed. Josef Helfenstein and Roxanne Stanulis, exh. cat. (Urbana-Champaign: Krannert Art Museum, University of Illinois, 2004), 119–23, for an exhibition at the Krannert Art Museum, Oct. 22, 2004–Jan. 2, 2005, which traveled to the Birmingham Museum of Art, AL; the Studio Museum in Harlem, NY; and the Menil Collection, Houston. The essay was republished in Helen Molesworth, ed., *Kerry James Marshall: Mastry* (New York: Skira Rizzoli, 2016), 231–35. Glenn Ligon included works by Bill Traylor in an exhibition he curated, *Blue Black*, at the Pulitzer Arts Foundation, St. Louis, Missouri, June 9–Oct. 7, 2017.

62 Holland Cotter, "Kerry James Marshall's Paintings Show What It Means to Be Black in America," *New York Times*, Oct. 20, 2016.

63 Kerry James Marshall, cited in Randy Kennedy, "Kerry James Marshall, Boldly Repainting Art History," *New York Times*, Sept. 9, 2016. Marshall was referring to the work *Snake* (pl. 87).

64 Ausfeld, *Bill Traylor* (see above, n11).

65 Greg Tate, interview by Jeffrey Wolf, Jan. 12, 2018, New York. Transcript in the author's curatorial files.

66 James Baldwin, "The Precarious Vogue of Ingmar Bergman," *Esquire* 53, no. 4 (Apr. 1960): 128–32; republished as "The Northern Protestant," in Baldwin, *Nobody Knows My Name: More Notes of a Native Son* (New York: Dial Press, 1961), 179.

BIBLIOGRAPHY

The bibliography is organized into groups (Archives, Books, etc.) and subgroups. An entry cannot always be perfectly assigned to a group, as it may fit into more than one or not fit into any of them; but each entry appears in only one group. Select sources cited in these references are also included here. The Interviews and Traylor Family Papers (pp. 401–2) that introduce the notes constitute the bibliographical entries for interviews and family papers.

The acronym SAAM is used for Smithsonian American Art Museum, Washington, DC, and ADAH for Alabama Department of Archives and History, Montgomery. *Southern Workman and Hampton School Record* is abbreviated as *Southern Workman.*

Archives · Government Repositories (and US City Directories)

Alabama 1867 Voter Registration Records Database. ADAH. Updated May 27, 2017. http://www.archives.alabama.gov/voterreg/search.cfm.

Alabama Center for Health Statistics. Office of Vital Records. Alabama Department of Public Health, Montgomery.

"Will Traylor Certificate of Death, August 26, 1929." Printed May 20, 2004.

"Mack Traylor Certificate of Death, May 19, 1933." Printed July 25, 2017.

"Sarah Howard Certificate of Death, January 6, 1974." Printed Apr. 13, 2017.

"Failure to Find: Aline Traylor." Notifications Apr. 13, 2017.

"Failure to Find: Arthur Traylor."

"Failure to Find: Laura Williams/Traylor."

"Failure to Find: Laurine Traylor."

"Failure to Find: Pauline Traylor."

"Failure to Find: Roland Traylor."

Alabama County Courthouse (Lowndes County), Hayneville. "Alabama County Marriages, 1809–1950." Database with images, FamilySearch.com.

"Will Traylor and Laurine E. Dunklin, 13 August 1891." *Colored Marriage Book, Book C, 1889–1897.* FHL microfilm 1,293,896. https://www.familysearch.org/ark:/61903/1:1:QKZS-GRXR.

"William Traylor and Elsey Dunklin, 17 August 1880." *Marriage Record: White & Black, Lowndes County, AL, Book A.* FHL microfilm 1,293,893. https://familysearch.org/ark:/61903/1:1:QKZS-G4BF.

Alabama Department of Archives and History, comp. "Died— Traylor, Mrs. Margaret." Public information subject files—Card index of personal and corporate names and of subjects, ca. 1920–1960. ADAH. Ancestry.com. *Alabama, Marriages, Deaths, Wills, Court, and Other Records, 1784–1920* (online database). Provo, UT: Ancestry.com Operations, 2011. Indexed by Ancestry World Archives Project contributors.

Alabama Historic Commission, Montgomery. "The North Lawrence–Monroe Street Historic District National Register of Historic Places Inventory Nomination Form." US Department of the Interior, National Park Service, August 2, 1984.

Alabama Probate Court (Dallas County), Selma. "A List of Property Appraised Belonging to the Estate of John G. Traylor Deceased on the 21st Day of February 1850." *Accounts, Administrators, Guardians, Inventories, Appraisements, v. H.* FamilySearch. *Dallas County, Alabama, 1817–1935 Probate Records; Indexes 1821–1980.* https://www.familysearch.org/.

———. *Dallas County Deeds and Mortgages: Book H, 1840–42; Book J, 1842–43; Book M, 1847–49.* ADAH. Box LGM017, Reels 22, 24.

———. "John Getson Traylor Last Will and Testament: December 3, 1849." *Record of Wills—Dallas County,* v. B: 2-15-1850–4-26-1871. Ancestry.com. *Alabama, Wills and Probate Records, 1753–1999.* https://www.ancestry.com/.

———. "Littleton Edwards Estate Files." *Dallas County, Alabama Estate Case Files, 1820–1915.* FamilySearch. *Loose Estate Case Files, 1820–1915: Edwards, Charles Y.–Ellebe, A. W.* https://www.familysearch.org/.

Alabama Probate Court (Lowndes County), Hayneville. "Female born to Laura Traylor and Will Traylor, May 21, 1895." *Register of Births, 1881–1905.* ADAH. Roll 27. FamilySearch. Genealogical Society of Utah, 1987–88. https://www.familysearch.org/ark:/61903/3:1:3QSQ-G9KV-N91P?i=293&cat=634772.

Alabama Secretary of State, Montgomery. *Alabama State Census, 1820–1866.* Montgomery: ADAH. Ancestry.com. *Alabama State Census, 1850; 1855; 1866.* Online database. Provo, UT: Ancestry.com Operations, 2010.

Biddle, Francis. "Circular No. 3591: From the Attorney General to All U.S. Attorneys Concerning Servitude, Slavery, and Peonage," Dec. 12, 1941. Wikisource. https://en.wikisource.org/w/index.php?title=File:Circular_No._3591.pdf&page=1.

Binkley, Trina, Robert Gamble, Ed Hooker, and Michael Sims. "Pleasant Hill Presbyterian Church National Register of Historic Places Registration Form." Washington, DC: US Department of the Interior, National Park Service, 1999.

Bureau of Land Management. *United States Bureau of Land Management Tract Books, 1800–c. 1955.* Alabama. v. 40 (Greenville). FamilySearch, 22 May 2014. https://www.familysearch.org/.

———. *General Land Office Records. Automated Records Project; Federal Land Patents, State Volumes.* Land Office at Cahaba, Alabama. http://www.glorecords.blm.gov/.

Department of Commerce and Labor, Bureau of the Census, Washington. *Thirteenth Census of the United States April 15, 1910: Instructions to the Enumerators.* Washington, DC: Government Printing Office, 1910.

District of Columbia Department of Human Services. "Lillian Hart Certificate of Death, December 31, 1984." Washington, DC: Vital Records Branch.

Federal Writers' Project. "Slave Narratives: A Folk History of Slavery in the United States from Interviews with Former Slaves." Typewritten records prepared by the Federal Writers' Project, 1936–38, assembled by the Library of Congress Project, Work Projects Administration, for the District of Columbia. Sponsored by the Library of Congress. Illustrated with photographs. Washington, 1941. Also available in digital form as part of the digital collection "Born in Slavery: Slave Narratives from the Federal Writers' Project, 1936–1938." https://www.loc.gov/collections/slave-narratives-from-the-federal-writers-project-1936-to-1938/about-this-collection/.

———. *Alabama Narratives.* Vol. 1 of *Slave Narratives: A Folk History of Slavery in the United States from Interviews with Former Slaves, 1936–1938.* Washington, DC: Works Progress Administration for the State of Alabama, 1941. Original manuscripts housed at Library of Congress.

Georgia Writer's Project of the Works Progress Administration. *Drums and Shadows: Survival Stories Among the Georgia Coastal Negroes,* Savannah Unit, Athens (Athens: University of Georgia Press and Brown Thrasher Books, 1940).

Maryland State Department of Health. "Clement Traylor Certificate of Death, Dec. 21, 1968." Baltimore: Division of Vital Records. Collection of Jeffrey Wolf, New York, from Antoinette Beeks; copy in the author's curatorial files with permission by Antoinette Beeks.

Michigan Department of Health, Detroit. Vital Records Section. Printed Mar. 8, 2017:

 "Esther Graham Certificate of Death, January 15, 1966."

 "James Traylor Certificate of Death, May 1, 1957."

 "Walter Traylor Certificate of Death, June 4, 1985."

Montgomery County, Alabama, Revenue Commissioner. "Land Books: 1909–1912, 1912–1916, 1916–1919, and 1920–1957, Township 16, Range 17." *Archival Records.* http://nsp.mc-ala.org/RevImages/LandBook.aspx.

———. "Lot Book 4: 1971–1980, Peacock Tract." *Archival Records.* http://nsp.mc-ala.org/RevImages/LotBook.aspx.

National Archives and Records Administration. Office of Records Services—Washington, DC. Modern Records Programs. Electronic and Special Media Records Services Division. WWII Enlistment Record, "Charles E. Shannon, serial number 34331825." World War II Electronic Army Serial Number Merged File, ca. 1938–46. National Archives at College Park, MD.

———. *Carded Records Showing Military Service of Soldiers Who Fought in Confederate Organizations.* Compiled 1903–27. Documenting the period 1861–65. Fold3. Ancestry.com. *Civil War Soldiers—Confederate—Alabama—Jefferson Davis Artillery—Traylor, Thomas G.*

———. *Index to Compiled Service Records of Volunteer Union Soldiers Who Served in Organizations from the State of Iowa.* Compiled 1899–1927. Documenting the period 1861–66. Fold3. Ancestry.com. *Civil War Soldiers—Union—Iowa—3rd Cavalry—Gilpin, Ebenezer N.*

Montgomery Weekly Mail. Oct. 3, 1862. ADAH. *Alabama Civil War and Reconstruction Newspapers.* http://digital.archives.alabama.gov/cdm/compoundobject/collection/cwnp/id/1967/rec/60.

New York State Department of Health. Division of Vital Statistics, Buffalo, NY. Printed 2017.

"John Henry Traylor Certificate of Death, February 8, 1954."

"Ruben Traylor Certificate of Death, December 2, 1939."

Pennsylvania Department of Health. "Nellie May Pitts Certificate of Death, 24 October 1952." *Death certificates, 1906–1963.* Series 11.90. Record Group 11. Pennsylvania Historical and Museum Commission, Harrisburg. Ancestry.com. *Pennsylvania, Death Certificates, 1906–1964.* Online database. Provo, UT: Ancestry.com Operations, 2014.

State of Alabama, Jefferson County. "William Traylor and Mimie Calloway, April 3, 1929." *Marriage Records: Alabama Marriages.* FamilySearch. Salt Lake City, UT. Ancestry.com. *Alabama, County Marriages, 1805–1967.* Online database. Lehi, UT: Ancestry.com Operations, 2016.

Traylor, George Hartwell, comp. "Estate of John G. Traylor." 1863. *Dallas County, Alabama Estate Case Files, 1820–1915; Index, 1818–1957.* Ancestry.com. *Alabama, Wills and Probate Records, 1753–1999.* Online database. Provo, UT: Ancestry.com Operations, 2015.

Traylor, John Getson. "Diary: 1834–1847" [J. G. Diary]. Transcribed at ADAH; typescript on file there. Copy of typescript obtained from Miriam Rogers Fowler, files on Bill Traylor, Collection of Jeffrey Wolf, New York, is in the author's curatorial files.

US Census Bureau. "Preservation of Records." *Annual Report of the Director of the Census to the Secretary of Commerce for the Fiscal Year Ended June 30, 1921.* Washington, DC: Government Printing Office, 1921.

——. *First Census of the United States, 1790.* National Archives and Records Administration, Washington, DC. NARA microfilm publication M637. Ancestry.com. *1790 United States Federal Census* (online database). Provo, UT: Ancestry.com Operations, 2010. Images reproduced by FamilySearch:

> *Second Census of the United States, 1800, M32. 1800 United States Federal Census.*
>
> *Third Census of the United States, 1810, M252. 1810 United States Federal Census.*
>
> *Fourth Census of the United States, 1820, M33. 1820 United States Federal Census.*
>
> *Fifth Census of the United States, 1830, M19. 1830 United States Federal Census.*
>
> *Sixth Census of the United States, 1840, M704. 1840 United States Federal Census.*
>
> *Seventh Census of the United States, 1850. M432. 1850 United States Federal Census.*
>
> *Eighth Census of the United States, 1860, M653. 1860 United States Federal Census.*
>
> *Ninth Census of the United States, 1870, M593. 1870 United States Federal Census.*

——. *Tenth Census of the United States, 1880, T9.* Ancestry.com and the Church of Jesus Christ and Latter-Day Saints. *1880 United States Federal Census.* Lehi, UT: Ancestry.com Operations, 2010. *1880 U.S. Census Index* provided by The Church of Jesus Christ of Latter-day Saints.

——. *Twelfth Census of the United States, 1900.* National Archives and Records Administration, Washington, D.C. NARA microfilm publication T623. Ancestry.com. *1900 United States Federal Census* (online database). Provo, UT: Ancestry.com Operations, 2004.

> *Thirteenth Census of the United States, 1910,* T624, 2006.
>
> *Fourteenth Census of the United States, 1920,* T625, 2010.
>
> *Fifteenth Census of the United States, 1930,* T626, 2002.
>
> *Sixteenth Census of the United States, 1940,* 2012.

US City Directories, 1822–1995. Ancestry.com. https://www.ancestry.com/. Online database. Provo, UT: Ancestry.com Operations, 2011:

> *Montgomery City Directory.* Atlanta, GA: Maloney Publishing and Mutual Publishing, 1901.
>
> *The Montgomery City Directory.* Atlanta, GA: Foote and Davis, 1902.
>
> *The Montgomery City Directory.* Columbus, OH: Wiggins Directories Publishing, 1903.
>
> *Montgomery (Alabama) City Directory.* Montgomery, AL: R. L. Polk, 1904–8.
>
> *Montgomery Directory.* Montgomery, AL: R. L. Polk, 1909–16.
>
> *Montgomery City Directory.* Birmingham, AL: R. L. Polk, 1919–90, 1922–23, 1925.
>
> *Montgomery (Alabama) City Directory.* Richmond, VA: R. L. Polk, 1926, 1928.
>
> *Montgomery (Alabama) City Directory.* Birmingham, AL: R. L. Polk, 1929, 1931.
>
> *Montgomery (Montgomery County, Alabama) Directory.* Birmingham, AL: R. L. Polk, 1933, 1935, 1937, 1939–42.
>
> *Polk's Buffalo (Erie County, NY) City Directory.* Buffalo, NY: Polk-Clement, 1939.
>
> *Montgomery (Montgomery County, Alabama) Directory.* Richmond, VA: R. L. Polk, 1945–47, 1949–60.

US Department of Agriculture. "The Boll Weevil Monument, Enterprise, Alabama." Special Collections, USDA National Agricultural Library. https://www.nal.usda.gov/exhibits/speccoll/items/show/1060.

US Geological Survey, National Geographic Society, i-cubed. "Lowndes County, AL Topographical Map." 2013. ArcGIS. *USA Topo Maps.* http://www.arcgis.com/home/webmap/viewer.html?webmap=931d892ac7a843d7ba29d085e0433465.

US Selective Service System. *World War I Selective Service System Draft Registration Cards, 1917–18.* Washington, DC: National Archives and Records Administration. M1509. Imaged from Family History Library microfilm. Ancestry.com. *U.S., World War I Draft Registration Cards, 1917–1918.* Online database. Provo, UT: Ancestry.com Operations 2005.

——. *Selective Service Registration Cards, World War II: Multiple Registrations.* St. Louis: MO: National Archives and Records Administration. Record Group 147, Fold3 by Ancestry.com. *World War II Draft Registration Cards.* Ancestry.com Operations, 2012.

US Social Security Administration. "Application for Account Number":

> "Bill Traylor." Montgomery, AL, June 7, 1937.
>
> "Clement Traylor." Avonmore, PA, May 5, 1941.
>
> "Esther Traylor Graham." Detroit, MI, Nov. 27, 1936.
>
> "John Henry Traylor." Buffalo, NY, Feb. 18, 1937.
>
> "Ruben Traylor." Buffalo, NY, Nov. 1, 1937.
>
> "Sarah T. Howard." Montgomery, AL, May 9, 1963.
>
> "Walter Traylor." Detroit, MI, Dec. 31, 1936.

US Department. "No. 11: Report of Capt. Joseph B. Williams, Second Indiana Cavalry, of operations April 1–16." *The War of the Rebellion: A Compilation of the Official Records of the Union and Confederate Armies*. Series 1, part 1. Vol. 49 (chap. 61), "Operations in Kentucky, Southwestern Virginia, Tennessee, Northern and Central Georgia, Mississippi, Alabama, and West Florida." Jan. 1–June 30, 1865. Washington, DC: Government Printing Office, 1897. Cornell University Library, Ithaca, NY. http://ebooks.library.cornell.edu/m/moawar/waro.html.

White, C. Albert. *A History of the Rectangular Survey System*. Washington, DC: US Department of the Interior, Bureau of Land Management, 1983; 1991. https://www.blm.gov/sites/blm.gov/files/histrect.pdf.

Witherspoon, Silvia. "Foots Gets Tired from Choppin' Cotton: Interview with Silvia Witherspoon." By Susie O'Brien and John Morgan. Federal Writers' Project. "Alabama Narratives."

Works Progress Administration. *Historical Maps of Alabama*. Montgomery: Alabama State Highway Department, 1936.

Dallas County Property Ownership Maps. http://alabamamaps.ua.edu/historicalmaps/counties/dallas/dallas.html.

Lowndes County Property Ownership Maps. http://alabamamaps.ua.edu/historicalmaps/counties/lowndes/lowndes.html.

Montgomery County Property Ownership Maps. http://alabamamaps.ua.edu/historicalmaps/counties/montgomery/montgomery2.html.

World War II Veterans Compensation Applications, ca. 1950s. Records of the Department of Military and Veterans Affairs, Record Group 19, Series 19.92. Pennsylvania Historical and Museum Commission, Harrisburg. Ancestry.com. *Pennsylvania, Veteran Compensation Application Files, WWII, 1950–1966* (online database). Provo, UT: Ancestry.com Operations, 2015.

Archives · Library, Museum, Personal, and University Collections

These entries include archival and personal collections as well as individual items in those collections.

Angell, Blanche Balzer (Shannon), to Miriam Rogers Fowler, July 29, 1990. In Bill Traylor curatorial files. Montgomery Museum of Fine Arts, Alabama.

"Antoinette Beeks, individually and as Representative of the Descendants of Bill Traylor against Charles and Eugenia Shannon, and Hirschl & Adler Galleries, Inc." No. 92 CIV 9119. US District Court, Southern District of New York. Nov. 12, 1992. Copies of the lawsuit are on file in various locations, including Marcia Weber personal files shared with the author, 2015–17.

Black Folk Art in America, 1930–1980 registrar files, Corcoran Gallery of Art Archives. Special Collections Research Center, Estelle and Melvin Gelman Library, George Washington University, Washington, DC.

Champion, Alpha. "Field Notes and Plat of M. H. Traylor's Land." 1888. Copied from the original by Rosa Lyon Traylor. Marcia Weber's personal files shared with the author, 2015–17.

Contempo: A Review of Books and Personalities 1, no. 13 (Dec. 1, 1931). North Carolina Collection, The Louis Round Wilson Library, University of North Carolina at Chapel Hill. Cover image at http://www.flashpointmag.com/hughes_scottsboro_christ.htm.

Fowler, Miriam Rogers. Files on Bill Traylor. In Collection of Jeffrey Wolf, New York.

———. Papers in Bill Traylor curatorial files. Montgomery Museum of Fine Arts, AL.

Hunton & Williams. Press release, "Statement by the Parties Announcing Settlement of the Lawsuits Concerning the Art of Bill Traylor." New York: Edelman Public Relations, 1993. Copies of the statement are on file in various locations, including Marcia Weber personal files shared with the author, 2015–17.

Montgomery Museum of Fine Arts, AL. Bill Traylor curatorial files.

"New South." Materials relating to New South's founding, including an undated announcement of the movement. In the author's curatorial files.

Luise Ross Gallery Bill Traylor Artist Files, including "Exhibitions at the Fieldston Gallery 1941–1942." In the author's curatorial files.

Russell, Margo. Andalusia, AL. Files on Bill Traylor.

Shannon, Eugenia. "Bill Traylor Categories." Letter (dated Aug. 2011). Montgomery Museum of Fine Arts curatorial files.

Sobel, Mechal. Research files for *Painting a Hidden Life*. In the author's curatorial files.

Staffney, Margaret Elizabeth Traylor, to Alabama Department of Public Health, Division of Vital Statistics, Aug. 9, 1999. Marcia Weber/Alabama Folk Artists Collection, 95/3. Archives and Special Collections, Auburn University at Montgomery Library, AL.

Traylor, Myttie Estelle. *Personal Diary*. Benton, Lowndes County, AL. 1899–1901. Collection of Jeffrey Wolf, New York.

Umberger, Leslie. The author's curatorial files for *Between Worlds: the Art of Bill Traylor*, as indicated throughout the notes, comprise a wide range of collected records, photographs, and writings. They also include the Bill Traylor Artist Files from Luise Ross Gallery, New York, and Mechal Sobel's research files for *Painting a Hidden Life*.

Marcia Weber/Alabama Folk Artists Collection, 95/3. Archives and Special Collections, Auburn University at Montgomery Library, AL. http://aumnicat.aum.edu/sites/default/files/docs/weber.pdf.

Weber, Marcia. Personal files on Bill Traylor. Copies of the originals given to Alabama Folk Artists Collection, 95/3. Archives and Special Collections, Auburn University at Montgomery Library, AL. Also shared, in part, with the author.

Wilkinson, Joseph H. Files on Bill Traylor. Shared with the author, 2016–17.

Wolf, Jeffrey. Files on Bill Traylor for *Bill Traylor: Chasing Ghosts*. Collection of Jeffrey Wolf, New York.

Books

Adams, Samuel C., Jr. "The Acculturation of the Delta Negro." In Dundes, *Mother Wit*, 515–21. Originally published in *Social Forces* 26, no. 2 (Dec. 1947): 202–5.

Anderson, Jeffrey E. *Conjure in African American Society*. Baton Rouge: Louisiana State University Press, 2005.

Angelou, Maya. *I Know Why the Caged Bird Sings*. New York: Random House, 1969.

Archer, Gleason Leonard. *History of Radio to 1926*. New York: American Historical Society, 1938.

Aunt Sally's Policy Players' Dream Book and Wheel of Fortune. New York: H. J. Wehman, 1889. http://www.americanvalues.org/search/item.php?id=2705.

Bachelard, Gaston. *The Poetics of Space: The Classic Look at How We Experience Intimate Places*. Translated by Maria Jolas. New York: Orion Press, 1964. Originally published as *La poétique de l'espace*. Paris: Presses Universitaires de France, 1958.

Bak, Richard. *Joe Louis: The Great Black Hope*. New York: Da Capo Press [, 1998.

Banks, Ingrid. *Hair Matters: Beauty, Power, and Black Consciousness*. New York: New York University Press, 2000.

Barlow, William. *"Looking Up at Down": The Emergence of Blues Culture*. Philadelphia: Temple University Press, 1989.

Bass, Ruth. "The Little Man." In Dundes, *Mother Wit*, 388–96. Originally published in *Scribner's Magazine* 97 (Feb. 1935): 120–23.

Blassingame, John W., ed. *Slave Testimony: Two Centuries of Letters, Speeches, Interviews, and Autobiographies*. Baton Rouge: Louisiana State University Press, 1977.

Bontemps, Arna. Introduction to Hughes and Bontemps, *Book of Negro Folklore*, vii–xv.

Borum, Jennifer P. "Bill Traylor and the Construction of Outsider Subjectivity." In Crown and Russell, *Sacred and Profane*, 238–59.

"The Boy and the Ghost." In Waters, *Strange Ways*, 298. Originally published in *Southern Workman* 27, no. 3 (Mar. 1898): 57.

Brooks, Charles H. *The Official History and Manual of the Grand United Order of Odd Fellows in America*. Philadelphia: Odd Fellows' Journal Print, 1902. https://books.google.com/books?id=Sj-jv2g7utcC.

Brown, Alan, ed. *Dim Roads and Dark Nights: The Collected Folklore of Ruby Pickens Tartt*. Livingston, AL: Livingston University Press, 1993.

Bush, A. E., and P. L. Dorman. *History of the Mosaic Templars of America: Its Founders and Officials*. Little Rock, AR: Central Printing, 1924; repr., Fayetteville, AR: University of Arkansas Press, 2008.

Camp, Stephanie M. H. "The Pleasures of Resistance: Enslaved Women and Body Politics in the Plantation South, 1830–1861," 87–124. In *New Studies in the History of American Slavery*. Ed. Edward E. Baptist and Stephanie M. H. Camp. Athens: University of Georgia Press, 2006.

Carmer, Carl. *Stars Fell on Alabama*. New York: Blue Ribbon Books, 1934.

Covey, Herbert C. *African American Slave Medicine: Herbal and Non-Herbal Treatments*. Lanham, MD: Lexington Books, 2007.

Crawley, Susan M. "Words and Music: Seeing Traylor in Context." In Crown and Russell, *Sacred and Profane*, 214–37.

Crown, Carol, and Charles Russell, eds. *Sacred and Profane: Voice and Vision in Southern Self-Taught Art*. Jackson: University Press of Mississippi, 2007.

Cullen, Countee. *The Black Christ and Other Poems*. Illustrations by Charles Cullen. New York: Harper & Brothers, 1929.

Danto, Arthur C. *Beyond the Brillo Box: The Visual Arts in Post-Historical Perspective*. New York: Farrar, Straus and Giroux, 1992.

Dickson, Moses. *Manual of the International Order of Twelve of Knights and Daughters of Tabor, Containing General Laws, Regulations, Ceremonies, Drill, and a Taborian Lexicon*. 1891. https://catalog.hathitrust.org/Record/007322019.

Dill, Augustus Granville, and W. E. B. Du Bois, eds. *The Negro American Artisan: Report of a Social Study Made by Atlanta University under the Patronage of the Trustees of the John F. Slater Fund* [. . .]. Atlanta, GA: Atlanta University Press, 1912.

Diouf, Sylviane A. *Dreams of Africa in Alabama: The Slave Ship Clotilda and the Story of the Last Africans Brought to America*. New York: Oxford, 2007.

Du Bois, W. E. B., ed., *The Negro in Business: Report of a Social Study Made under the Direction of Atlanta University* [. . .]. Atlanta, GA, 1899.

———. *The Souls of Black Folk: Essays and Sketches*. 3rd ed. Chicago: A. C. McClurg, 1903.

Dundes, Alan, ed. *Mother Wit from the Laughing Barrel: Readings in the Interpretation of Afro-American Folklore*. Jackson: University Press of Mississippi, 1990.

Ferris, William, ed. *Afro-American Folk Art and Crafts*. Jackson: University Press of Mississippi, 1983.

Fett, Sharla M. *Working Cures: Healing, Health, and Power on Southern Slave Plantations*. Chapel Hill: University of North Carolina Press, 2002.

Fitzgerald, F. Scott, and Zelda Fitzgerald. "Show Mr. and Mrs. F. to Number—," 41–55. In *The Crack-up*. Ed. Edmund Wilson. New York: New Directions Books, 1945.

Gellert, Lawrence, Elie Siegmeister, and Hugo Gellert. *Negro Songs of Protest*. New York: American Music League, 1936.

Givner, Joan. *Katherine Anne Porter: A Life*. New York: Simon and Schuster, 1982.

Gombrich, E. H. *The Preference for the Primitive: Episodes in the History of Western Taste and Art*. New York: Phaidon, 2002.

Gomez, Michael A. *Exchanging Our Country Marks: The Transformation of African Identities in the Colonial and Antebellum South*. Chapel Hill: University of North Carolina Press, 1998.

Gosse, Philip Henry. *Letters from Alabama (U.S.): Chiefly Relating to Natural History*. 1859; repr., London: Forgotten Books, 2015.

Grimshaw, William H. *Official History of Freemasonry*. Freeport, NY: Books for Libraries Press, 1971.

Grissom, Carol A. *Zinc Sculpture in America, 1850–1950*. Newark: University of Delaware Press, 2009.

Gundaker, Grey, and Judith McWillie. *No Space Hidden: The Spirit of African American Yard Work*. Knoxville: University of Tennessee Press, 2005.

Gussow, Adam. *Seems Like Murder Here: Southern Violence and the Blues Tradition*. Chicago: University of Chicago Press, 2002.

Hazzard-Gordon, Katrina. *Jookin': The Rise of Social Dance Formations in African-American Culture*. Philadelphia: Temple University Press, 1990.

Hennessey, Thomas J. *From Jazz to Swing: African-American Jazz Musicians and Their Music, 1890–1935*. Detroit, MI: Wayne State University Press, 1994.

Herron, Leonora. "Conjuring and Conjure-Doctors." In Waters, *Strange Ways*, 228.

Hughes, Langston. "I, Too, Sing America." In *Poetry of the Negro*, 82.

———. *Scottsboro Limited: Four Poems and a Play*. Illustrations by Prentiss Taylor. New York: Golden Stair Press, 1932.

Hughes, Langston, and Arna Bontemps, eds. *The Book of Negro Folklore*. New York: Dodd, Mead, 1958.

———. *The Poetry of the Negro, 1746–1970*. New York: Doubleday, 1970.

Hurston, Zora Neale. *Barracoon: The Story of the Last "Black Cargo."* New York: Amistad, Imprint of HarperCollins Publishers, 2018.

———. "Characteristics of Negro Expression." In *Negro: An Anthology*. Comp. and ed. Nancy Cunard. New York: Wishart, 1934; repr., Negro Universities Press, 1969.

———. *Mules and Men*. Philadelphia: J. B. Lippincott, 1935.

———. *The Sanctified Church: The Folklore Writings of Zora Neale Hurston*. 2nd ed. Berkeley: Turtle Island Foundation, 1981.

———. *Their Eyes Were Watching God: A Novel*. Philadelphia: J. B. Lippincott, 1937.

Hyatt, Harry Middleton. *Hoodoo, Conjuration, Witchcraft, Rootwork: Beliefs Accepted by Many Negroes and White Persons, These Being Orally Recorded among Blacks and Whites*. 5 vols. Hannibal, MO: Western Publishing, 1953–78.

Hyde, Lewis. *Trickster Makes This World: Mischief, Myth, and Art*. New York: Farrar, Straus and Giroux, 1998.

Jackson, Bruce, ed. *The Negro and His Folklore in Nineteenth-Century Periodicals*. Austin: University of Texas Press for American Folklore Society, 1967.

Jeffries, Hasan Kwame. *Bloody Lowndes: Civil Rights and Black Power in Alabama's Black Belt*. New York: New York University Press, 2009.

Johnson, Charles S. *Shadow of the Plantation: A Classic Study of Negro Life*. Chicago: University of Chicago Press, 1934; repr., 1966. References are to 1966 edition.

Johnson, F. Roy. *The Fabled Doctor Jim Jordan: A Story of Conjure*. Murfreesboro, NC: Johnson Publishing, 1963.

Kemp, Kathy, and Keith Boyer. *Revelations: Alabama's Visionary Folk Artists*. Birmingham, AL: Crane Hill, 1994.

Kuyk, Betty M. *African Voices in the African American Heritage*. Bloomington: Indiana University Press, 2003.

Laman, Karl E. *Dictionnaire Kikongo-Français avec une étude phonétique décrivant les dialectes les plus importants de la langue Dite Kikongo M – Z*. Ridgewood, N.J. Gregg, 1964.

Leavell, Jay C. *Jay's Montgomery Remembered*. Comp. by Jo Leavell Fleming. Montgomery, AL: J. L. Fleming, 1986.

Levine, Lawrence W. *Black Culture and Black Consciousness: Afro-American Folk Thought from Slavery to Freedom*. New York: Oxford University Press, 1977.

Lewis, David L. *When Harlem Was in Vogue*. New York: Alfred A. Knopf, 1981.

Livermore, Mary A. *The Story of My Life, or The Sunshine and Shadow of Seventy Years*. Hartford, CT: A. D. Worthington, 1897.

Locke, Alain, ed. *The Negro in Art*. Chicago: Afro-American Press, 1940.

Lomax, Alan. *The Rainbow Sign, A Southern Documentary*. New York: Duell, Sloan and Pearce, 1959.

Long, Carolyn Morrow. *Spiritual Merchants: Religion, Magic, and Commerce*. Knoxville: University of Tennessee Press, 2001.

M'Baye, Babacar. *The Trickster Comes West: Pan-African Influence in Early Black Diasporan Narratives*. Jackson: University Press of Mississippi, 2009.

MacGaffey, Wyatt. "The Black Loincloth and the Son of Nzambi Mpungu," 144–51. In *Forms of Folklore in Africa: Narrative, Poetic, Gnomic, Dramatic*. Ed. Lindfors Bernth. Austin: University of Texas Press, 1977.

Maresca, Frank, and Roger Ricco. *Bill Traylor: His Art, His Life*. New York: Alfred A. Knopf, 1991.

McLaren, Joseph, ed. *Autobiography: I Wonder As I Wander*. Vol. 14 of *The Collected Works of Langston Hughes*. Edited by Arnold Rampersad. Columbia: University of Missouri Press, 2003.

McMurry, Linda O. *To Keep the Waters Troubled: The Life of Ida B. Wells*. New York: Oxford University Press, 1998.

Mercer, Korbena. "Black Hair/Style Politics," 247–64. In *Out There: Marginalization and Contemporary Cultures*. Ed. Russell Ferguson et al. New York: New Museum of Contemporary Art and MIT Press, 1990.

———. *Welcome to the Jungle: New Positions in Black Cultural Studies*. New York: Routledge, 1994.

Milford, Nancy. *Zelda: A Biography*. New York: Harper and Row, 1970.

Morrow, Willie [Lee]. *400 Years without a Comb*. San Diego: Black Publishers of America, division of Morrow's Unlimited, 1973.

Neeley, Mary Ann. *Montgomery: Capital City Corners*. Dover, NH: Arcadia Printing, 1997.

"A Negro Ghost Story." In Waters, *Strange Ways*, 345. Originally published in *Southern Workman* 28, no. 11 (Nov. 1899): 449–50.

Norris, Thaddeus. "Negro Superstitions," 134–43. In *The Negro and His Folklore in Nineteenth-Century Periodicals*. Ed. Bruce Jackson. Austin: University of Texas Press for the American Folklore Society, 1967. Originally published in *Lippincott's Magazine* 6 (Philadelphia, July 1870): 90–95.

Northup, Solomon. *Twelve Years a Slave*. Ed. Sue L. Eakin and Joseph Logsdon. Baton Rouge: Louisiana State University Press, 1968.

"Notes from Alabama." In Waters, *Strange Ways*, 224. Originally published in *Southern Workman* 24, no. 5 (May 1895): 78.

Oakley, Giles. *The Devil's Music: A History of the Blues*. 1976. Repr., New York: Da Capo Press, 1997.

Odum, Howard Washington, and Guy Benton Johnson. *The Negro and His Songs: A Study of Typical Negro Songs in the South*. Chapel Hill: University of North Carolina Press, 1925.

Parker, Barry. *A Varon in Us All*. Chattanooga, TN: Parker Communications, 2009.

Patterson, Orlando. *Slavery and Social Death: A Comparative Study*. Cambridge, MA: Harvard University Press, 1982.

Plant, Deborah G. Introduction to Hurston, *Barracoon*, xiii–xxv.

Powell, Lyman P. *Historic Towns of the Southern States*. New York: G. P. Putnam's Sons, 1904.

Puckett, Newbell Niles. *Folk Beliefs of the Southern Negro*. Chapel Hill: University of North Carolina Press, 1926; repr., New York: Dover Publications, 1969. References are to 1969 edition.

Raboteau, Albert J. *A Fire in the Bones: Reflections on African-American Religious History*. Boston: Beacon Press, 1995.

———. *Slave Religion: The "Invisible Institution" in the Antebellum South*. New York: Oxford University Press, 1978.

Ransom, Roger L., and Richard Sutch. *One Kind of Freedom: The Economic Consequences of Emancipation*. New York: Cambridge University Press, 1977.

Rawick, George P., ed. *The American Slave: A Composite Autobiography*. Supplement. Series 1. *Mississippi Narratives—Part 2*. Vol. 8. Westport, CT: Greenwood Publishing, 1977.

———. *Texas Narratives—Part 4*. Vol. 16 of *Slave Narratives: A Folk History of Slavery in the United States from Interviews with Former Slaves*. Westport, CT: Greenwood Publishing, 1972.

Rice, Kym S., and Martha B. Katz-Hyman, eds. *World of a Slave: Encyclopedia of the Material Life of Slaves in the United States*. Santa Barbara, CA: Greenwood, 2011.

"A Roost on the Rim of the Moon." In *The Book of Negro Folklore*, 181–82.

Rosengarten, Theodore. *All God's Dangers: The Life of Nate Shaw*. Chicago: University of Chicago Press, 2000.

Rush, Dana. *Vodun in Coastal Bénin: Unfinished, Open-ended, Global*. Nashville, TN: Vanderbilt University Press, 2013.

Russell, Charles. *Groundwaters: A Century of Art by Self-Taught and Outsider Artists*. London: Prestel, 2011.

"The Seriousness of Superstition: The Conjure Doctor." In Waters, *Strange Ways*, 84–85.

Singleton, Billy J. *Montgomery Aviation*. Charleston, SC: Arcadia Publishing, 2007.

Smith, Ronald L. *Hoodoo*. Boston: Houghton Mifflin Harcourt, 2015.

Smith, Theophus H. *Conjuring Culture: Biblical Formations of Black America*. New York: Oxford University Press, 1994.

"Snakes and Conjure Doctors." In Waters, *Strange Ways*, 297. Originally published in *Southern Workman* 27, no. 2 (Feb. 1898): 36–37.

Sobel, Mechal. *Painting a Hidden Life: The Art of Bill Traylor*. Baton Rouge: Louisiana State University Press, 2009.

Sparks, Randy J. *Africans in the Old South: Mapping Exceptional Lives Across the Atlantic World*. Cambridge, MA: Harvard University Press, 2016.

Stearns, Marshall Winslow, and Jean Stearns. *Jazz Dance Jazz Dance: The Story of American Vernacular Dance*. New York, Macmillan, 1968.

Stevenson, Bryan. *Just Mercy: A Story of Justice and Redemption.* New York: Spiegel & Grau,2015.

Stuckey, Sterling. *Slave Culture: Nationalist Theory and the Foundations of Black America.* New York: Oxford University Press, 1987.

Talley, Thomas W. *The Negro Traditions.* Knoxville: University of Tennessee Press, 1930.

Thompson, Robert Farris. *Flash of the Spirit: African and Afro-American Art and Philosophy.* New York: Random House, 1983.

Tillman, Jno P. "Terrell v. Cunningham." *Reports of Cases Argued and Determined in the Supreme Court of Alabama,* 2nd ed. Book 44. Vol. 70. Saint Paul, MN: West Publishing, 1904.

Traylor, Rosa Lyon, and June Middleton Albaugh. *Collirene, The Queen Hill.* Montgomery, AL: H. Jones–Paragon Press, 1977.

Tucker, Susan. *Telling Memories among Southern Women: Domestic Workers and Their Employers in the Segregated South.* Baton Rouge: Louisiana State University Press, 2002.

Vendryes, Margaret Rose. "Hanging on Their Walls: An Art Commentary on Lynching, the Forgotten 1935 Art Exhibition," 153–76. In *Race Consciousness: African-American Studies for the New Century.* Exh. cat. Ed. Judith Jackson Fossett and Jeffrey A. Tucker. New York: New York University Press, 1997.

Vlach, John Michael. *Back of the Big House: The Architecture of Plantation Slavery.* Chapel Hill: University of North Carolina Press, 1993.

Wahlman, Maude Southwell. "Bill Traylor: Mysteries." In *The Tree Gave the Dove a Leaf,* 276–79. Vol. 1 of *Souls Grown Deep: African American Vernacular Art of the South.* Ed. Paul Arnett and William Arnett. Atlanta, GA: Tinwood Books, in association with Schomburg Center for Research in Black Culture, 2000.

Washington, Booker T. *Up from Slavery: An Autobiography.* Garden City, NY: Doubleday, 1901.

Waters, Donald J., ed. *Strange Ways and Sweet Dreams: Afro-American Folklore from the Hampton Institute.* Boston: G. K. Hall, 1983. https://babel.hathitrust.org/cgi/pt?id=mdp.39015010355694;view=1up;seq=98.

Wilkerson, Isabel. *The Warmth of Other Suns: The Epic Story of America's Great Migration.* New York: Random House, 2010.

"The Witch Cats." In Waters, *Strange Ways,* 217.

Wolfe, Bernard. "Uncle Remus and the Malevolent Rabbit." In Dundes, *Mother Wit,* 524–40.

Work Projects Administration Writers' Program. *Alabama: A Guide to the Deep South.* American Guide Series. New York: R. R. Smith, 1941.

Exhibition Catalogues
(in reverse chronological order)

This section includes exhibition catalogues, brochures, and booklets and an auction catalogue; they do not all represent exhibitions of works by Bill Traylor. Publications for exhibitions that included Traylor's work are marked with a dagger (†) and mention exhibition dates. Authors/essays named in the entries are those cited in the notes and do not necessarily reflect the complete authorship of the source.

2016

Helen Molesworth, ed. *Kerry James Marshall: Mastry.* New York: Skira Rizzoli, 2016.

2015

Mark Sloan and Lizz Biswell, eds. *Something to Take My Place: The Art of Lonnie Holley.* Essay by Leslie Umberger ("In Memory of the Blood"). Charleston, SC: Halsey Institute of Contemporary Art, College of Charleston School of the Arts, 2015.

2014

Sonya Clark. *The Hair Craft Project.* Essay by Henry John Drewal ("Crowning Achievements: Coiffures and Personhood"). Richmond, VA: VCUarts and the Center for Craft, Creativity, and Design, 2014.

2012

Margaret Andera and Lisa Stone, eds. *Accidental Genius: Art from the Anthony Petullo Collection.* Essay by Jane Kallir ("Art Brut and 'Outsider' Art: A Changing Landscape"). New York: Prestel, for Milwaukee Art Museum, 2012.

† *Bill Traylor: Drawings from the Collections of the High Museum of Art and the Montgomery Museum of Fine Arts.* Essays by Margaret Lynne Ausfeld ("Unlikely Survival: Bill Traylor's Drawings") and Fred Barron and Jeffrey Wolf ("In Plain Sight"). Atlanta, GA: High Museum of Art and Del-Monico Books/Prestel, 2012. Touring exh., High Museum of Art, Feb. 5–Apr. 15, 2012; two subsequent venues.

2007

Leslie Umberger. *Sublime Spaces & Visionary Worlds: Built Environments of Vernacular Artists.* Essays ("David Butler: In Good Company" and "Sam Rodia: Upward Spiral"). New York: Princeton Architectural Press and the John Michael Kohler Arts Center, 2007. Exh., John Michael Kohler Arts Center, Sheboygan, WI.

2004

† Josef Helfenstein and Roxanne Stanulis, eds. *Bill Traylor, William Edmondson, and the Modernist Impulse.* Essay by Kerry James Marshall ("Sticks and Stones . . . , but Names. . . . "). Urbana-Champaign: Krannert Art Museum, University of Illinois, 2004. Touring exh., Krannert Art Museum and Kinkead Pavilion, Oct. 22, 2004–Jan. 5, 2005; three subsequent venues.

2001

† *Bill Traylor.* Essay by Miriam Rogers Fowler ("A Glimpse at William 'Bill' Traylor") Houston, TX: O'Kane Gallery. Exh., University of Houston, Nov. 1–Dec. 18, 2001.

1999

† Josef Helfenstein and Roman Kurzmeyer, eds., *Bill Traylor, 1854–1949: Deep Blues.* New Haven, CT: Yale University Press. Essays by Josef Helfenstein ("Bill Traylor and Charles Shannon: A Historic Encounter in Montgomery"); Roman Kurzmeyer ("The Life and Times of Bill Traylor [1854–1949]"); and Eugenia Carter Shannon ("The Depression in Montgomery, Alabama" and "Race Relations in Montgomery, Alabama, 1930s–1940s"). Ger. ed. for exh. at Kunstmuseum Bern, Nov. 4, 1998–Jan. 31, 1999, and Museum Ludwig, Cologne, Feb. 26–May 16, 1999; Engl. ed. for exh. at Robert Hull Fleming Museum, University of Vermont, Burlington, June 17–Aug. 22, 1999.

1997

† Joseph H. Wilkinson. Essay in *Bill Traylor Drawings from the Collection of Joe and Pat Wilkinson,* 12–15. Auction cat. New York: Sotheby's, Dec. 3, 1997.

† Phil Patton. *Bill Traylor: High Singing Blue.* New York: Hirschl & Adler Modern, 1997. Exh., Jan. 18–Mar. 8, 1997.

1995

Jemison-Carnegie Heritage Hall. *New South Collection of the Siegel Gallery: An Exhibition of New Deal Era Art, 1933–1943.* Talladega, AL: Brannon's, 1995. The essay was reprinted, with different illustrations, in an exh. cat. of the same name (Talladega, AL: Jemison-Carnegie Heritage Hall, 1995), 8–11.

1993

Robert Farris Thompson. *Face of the Gods: Art and Altars of Africa and the African Americas.* New York: Prestel and Museum for African Art, 1993.

1991

† Miriam Rogers Fowler, comp. *Outsider Artists in Alabama.* Essay by M. R. Fowler ("Bill Traylor"). Montgomery: Alabama State Council on the Arts, 1991. Exh., Nov. 1991.

1989

† *New South, New Deal, and Beyond: An Exhibition of New Deal Era Art, 1933–1943.* Essay by Miriam Rogers Fowler ("New South School and Gallery"). Montgomery: Alabama State Council on the Arts, 1989. Touring exh., Alabama Artists Gallery, Montgomery, Sept. 14–Oct. 27, 1990; one subsequent venue.

Elaine Nichols, ed. *The Last Miles of the Way: African-American Homegoing Traditions.* Essay by Cynthia Carter ("Archaeological Analysis of African American Mortuary Behavior"). Columbia: South Carolina State Museum, 1989.

Richard J. Powell. *The Blues Aesthetic: Black Culture and Modernism.* Washington, DC: Washington Project for the Arts, 1989.

† Robert V. Rozelle, Alvia Wardlaw, and Maureen A. McKenna, eds. *Black Art, Ancestral Legacy: The African Impulse in African American Art.* Essay by Robert Farris Thompson ("The Song That Named the Land: The Visionary Presence of African-American Art"). Dallas, TX: Dallas Museum of Art, 1989. Exh., Jan. 3, 1989–Feb. 25, 1990.

1988

Another Face of the Diamond: Pathways Through the Black Atlantic South. Essay by Robert Farris Thompson ("The Circle and the Branch: Renascent Kongo-American Art"). New York: INTAR, Hispanic Arts Center, 1988.

† *Bill Traylor Drawings, From the Collection of Joseph H. Wilkinson and an Anonymous Chicago Collector.* Essay by Michael Bonesteel ("Bill Traylor, Creativity and the Natural Artist"). Chicago: Chicago Office of Fine Arts, 1988. Touring exh., Randolph Gallery of the Chicago Public Library Cultural Center, Feb. 6–Apr. 16, 1988; two subsequent venues.

1987

Baking in the Sun: Visionary Images from the South: Selections from the Collection of Sylvia and Warren Lowe. Essay by Maude Southwell Wahlman ("Africanisms in Afro-American Visionary Arts"). Lafayette: University Art Museum, University of Southwestern Louisiana, 1987.

1985

† *Bill Traylor: 1854–1947.* Essay by Charles Shannon ("Bill Traylor"). New York: Hirschl & Adler Modern, 1985. Dec. 2, 1985–Jan. 11, 1986.

1982

† *Bill Traylor.* Exh. brochure. Text by Margaret Lynne Ausfeld. Montgomery, AL: Montgomery Museum of Fine Arts, 1982. Exh., Nov. 6–Dec. 30, 1982.

† *Bill Traylor (1854–1947).* Exh. organized by Luise Ross. Essay ("The Art of Bill Traylor") by Maude Southwell Wahlman. Little Rock: Arkansas Arts Center, 1982. Touring exh., Arkansas Arts Center, Oct. 14–Nov. 28, 1982, and Mississippi Museum of Art, Jackson, Mar. 1–Apr. 9, 1983.

† *Bill Traylor (1854–1947): People, Animals, Events, 1939–1942.* Exh. organized in cooperation with Luise Ross. Essay by Lowery Stokes Sims ("Bill Traylor [1854–1947]"). New York: Vanderwoude Tananbaum Gallery, 1982. Exh., Sept. 8–Oct. 9, 1982.

† Jane Livingston and John Beardsley, eds. *Black Folk Art in America, 1930–1980.* Essays by Jane Livingston ("What It Is") and Regenia A. Perry ("Black American Folk Art: Origins and Early Manifestations"). Jackson: University Press of Mississippi and the Center for the Study of Southern Culture for the Corcoran Gallery of Art, 1982. Touring exh., Corcoran Gallery of Art, Washington, DC, Jan. 15–Mar. 28, 1982; seven subsequent venues.

1981

Joseph Cornet and Robert Farris Thompson. *The Four Moments of the Sun: Kongo Art in Two Worlds.* Washington, DC: National Gallery of Art, 1981.

American Folk Art: The Herbert Waide Hemphill Jr. Collection. Essays by Michael D. Hall, Herbert W. Hemphill Jr., Russell Bowman, Donald B. Kuspit. Milwaukee, WI: Milwaukee Art Museum, 1981.

1976

Herbert W. Hemphill Jr., ed. *Folk Sculpture USA.* Brooklyn, NY: Brooklyn Museum of Art, a department of the Brooklyn Institute of Arts and Sciences, 1976.

1974

Naïves and Visionaries. Walker Art Center. New York: E. P. Dutton, 1974.

1940

† *Bill Traylor: People's Artist.* Hand-printed (unpublished) booklet by members of New South Gallery, Montgomery, AL. Images of Traylor's works silk-screened by Jay Leavell and text presumably written by Charles Shannon. Exh., New South Gallery, Feb. 1–19, 1940. Special Collections of the Smithsonian American Art and National Portrait Gallery Library, Smithsonian Libraries, Washington DC; donated by the family of Joseph H. Wilkinson.

Newspapers and Periodicals

"African Art of Bill Traylor Now on Walls of New South." *Montgomery* (AL) *Advertiser,* Feb. 11, 1940.

"In Aid of Colored Men: Work That Is Carried On in the Calhoun School in Alabama." *New York Times,* Jan. 21, 1896. Proquest Historical Newspapers.

"An Alabama Riot." *Evening Bulletin* (Maysville, Kentucky), May 7, 1888. http://chroniclingamerica.loc.gov/lccn/sn87060190/1888-05-07/ed-1/.

Alabama Tribune, Sept. 13, 1946–Dec. 30, 1959. Microfilmed at ADAH, 1988.

Arena, Salvatore. "Kin Sue for Artwork." *Daily News.* Nov. 14, 1992.

Asma, Stephen T. "The Blues Artist as Cultural Rebel." *Humanist* 57, no. 4 (July-Aug. 1997): 8–15.

Bagnall, Robert W. "The Present South." *Crisis* 36, no. 9 (Sept. 1929): 303, 321–22.

Baldwin, James. "The Precarious Vogue of Ingmar Bergman." *Esquire* 53, no. 4 (Apr. 1960): 128–32. Republished as "The Northern Protestant," in James Baldwin, *Nobody Knows My Name: More Notes of a Native Son.* New York: Dial Press, 1961.

Beito, David T. "Black Fraternal Hospitals in the Mississippi Delta, 1942–1967." *Journal of Southern History* 65, no. 1 (Feb. 1999): 109–40.

Blasdel, Gregg. "The Grass Roots Artist." *Art in America* 56 (Sept./Oct. 1968): 24–41.

Blocker, Jack S., Jr. "Did Prohibition Really Work? Alcohol Prohibition as a Public Health Innovation." *American Journal of Public Health* 96, no. 2 (Feb. 2006): 233–43.

Bloome, Deirdre, and Christopher Muller. "Tenancy and African American Marriage in the Postbellum South." *Demography* 52, no. 5 (Oct. 2015): 1409–30.

"The Boll Weevil and the Negro Farmer." *Colored Alabamian,* Apr. 12, 1913. Microfilmed at Archives and Special Collections, Auburn University at Montgomery Library, AL, Aug. 1986.

Brown, David H. "Conjure/Doctors: An Explanation of a Black Discourse in America, Antebellum to 1940." *Folklore Forum* 23, no. 1/2 (1990): 3–46. http://hdl.handle.net/2022/2091.

Browne, Ray B. "Some Notes on the Southern 'Holler.'" *Journal of American Folklore* 67, no. 263 (Jan.-Mar. 1954): 73–77.

"Callaway [*sic*] Lynched: A Terrible Murder Expirated [*sic*] by Judge Lynch." *Atlanta Constitution,* Mar. 31, 1888. ProQuest Historical Newspapers.

Capehart, Jonathan. "The Lynching Memorial Ends Our National Silence on Racial Terrorism." *Washington Post,* Apr. 26, 2018. https://www.washingtonpost.com/blogs/post-partisan/wp/2018/04/26/the-lynching-memorial-ends-our-national-silence-on-racial-terrorism/?utm_term=.6481541757bd.

Carper, N. Gordon. "Slavery Revisited: Peonage in the South." *Phylon* 37, no. 1 (1976): 85–99.

Chatters, Linda M., Robert Joseph Taylor, and Rukmalie Jayakody. "Fictive Kinship Relations in Black Extended Families." *Journal of Comparative Family Studies* 25, no. 3 (Autumn 1994): 297–312.

Coker, Gylbert. "Bill Traylor at R. H. Oosterom." *Art in America* 68, no. 3 (Mar. 1980): 125.

Cone, James H. "Strange Fruit: The Cross and the Lynching Tree." *African American Pulpit* 11, no. 2 (Spring 2008): 18–26.

Conn, Steve. "The Politics of Painting: Horace Pippin the Historian." *American Studies* 38, no. 1 (Spring 1997): 5.

Cotter, Holland. "Kerry James Marshall's Paintings Show What It Means to Be Black in America." *New York Times,* Oct. 20, 2016.

Davis, Hal. "Art Dealer Sued over Prints and the Pauper." *New York Post.* Nov. 27, 1992.

Dillingham, Pitt. "The Settlement Idea in the Cotton Belt." *Outlook* 70, no. 15 (Apr. 12, 1902): 920–22.

Ellis, Rose Herlong. "The Calhoun School, Miss Charlotte Thorn's 'Lighthouse on the Hill' in Lowndes County, Alabama." *Alabama Review* 37, no. 3 (1984): 183–201.

The Emancipator (Montgomery, AL), Oct. 6, 1917–Aug. 14, 1920. Microfilmed at ADAH, July 1992.

"The Enigma of Uncle Bill Traylor." *Montgomery* (AL) *Advertiser*, Mar. 31, 1940.

"Exhibit Opens by New South." *Montgomery* (AL) *Advertiser*, June 4, 1939.

"Ex-Slave's Art Put on Display by New South." *Birmingham News*, Feb. 5, 1940.

Ferleger, Louis. "Sharecropping Contracts in the Late-Nineteenth-Century South." *Agricultural History* 67, no. 3 (Summer 1993): 31–46.

Ferris, William R. "Racial Repertoires among Blues Performers." *Ethnomusicology* 14, no. 3 (Sept. 1970): 439–49.

Fleming, Mary M. "From the Black Belt." *Southern Workman* 28, no. 3 (Mar. 1899): 113.

Floyd, Samuel A., Jr. "Ring Shout! Literary Studies, Historical Studies, and Black Music Inquiry." Supplement, *Black Music Research Journal* 22 (2002): 49–70.

Fowler, Miriam Rogers. "Artists of Alabama, Unite!" *Alabama Magazine*, July 1990, 18–23.

Gellert, Lawrence. "Negro Songs of Protest in America." *Music Vanguard* 1, no. 1 (Mar.-Apr. 1935): 3–14.

Goeser, Caroline. "'On the Cross of the South': The Scottsboro Boys as Vernacular Christs in Harlem Renaissance Illustration." *International Review of African American Art* (Hampton University Museum Publications) 19, no. 1 (Jan. 2003): 19–27.

Gundaker, Grey. "Tradition and Innovation in African American Yards." *African Arts* 26, no. 2 (Apr. 1993): 58–71, 94–96.

Hackett, David G. "The Prince Hall Masons and the African American Church: The Labors of Grand Master and Bishop James Walker Hood, 1831–1918." *Church History* 69, no. 4 (Dec. 2000): 770–802.

"Hags and Their Ways." *Southern Workman* 23, no. 2 (Feb. 1894): 26–27.

Harper, Brad. "A Jewel in the Black Community: Ross-Clayton Turns 100." *Montgomery Advertiser*, Apr. 25, 2018. https://www.montgomeryadvertiser.com/story/money/business/2018/04/25/jewel-black-community-ross-clayton-funeral-home-turns-100/525692002/.

Hartigan, Lynda Roscoe. "Going Urban: American Folk Art and the Great Migration." *American Art* 14, no. 2 (Summer 2000): 26–51.

Hathaway, Rosemary V. "The Unbearable Weight of Authenticity: Zora Neale Hurston's 'Their Eyes Were Watching God' and a Theory of 'Touristic Reading.'" *Journal of American Folklore* 117, no. 464 (Spring 2004): 168–90. http://www.jstor.org/stable/4137820.

Hazzard-Donald, Katrina. "Hoodoo Religion and American Dance Traditions: Rethinking the Ring Shout." *Journal of Pan-African Studies* (Sept. 2011): 5.

"Horace Pippin, 57, Negro Artist, Dies." *New York Times*, July 7, 1946.

"Horace's Sexy Thoughts." *Alabama Journal*, Mar. 5, 1946.

Hughes, Robert. "Finale for the Fantastical: Washington's Corcoran Mounts a Fiery, Marvelous Folk Show." *Time*, Mar. 1, 1982, 70–71.

Hurston, Zora Neale. "Hoodoo in America." *Journal of American Folklore* 44, no. 174 (1931): 318–417.

———. "Story in Harlem Slang." *American Mercury*, July 1942. http://storyoftheweek.loa.org/search?q=%E2%80%9CStory+in+Harlem+Slang%2C%E2%80%9D+Zora+Neale+Hurston.

"An Impudent Letter: An Alabama Sheriff's Response to the Governor." *New York Times*, Apr. 13, 1888.

Jackson, Harvey H., III. "Philip Henry Gosse: An Englishman in the Alabama Black Belt." *Alabama Heritage*, no. 28 (Spring 1993): 37–45.

Kennedy, Randy. "Kerry James Marshall, Boldly Repainting Art History." *New York Times*, Sept. 9, 2016.

Kennicott, Philip. "A Memorial That Refuses to Let Dixieland Look Away." *Washington Post*, Apr. 25, 2018.

Kurtz, Bruce. "Black Folk Art in America, 1930–1980." *Artforum* 21, no. 7 (Mar. 1983): 80–81.

Langa, Helen. "Two Antilynching Art Exhibitions: Politicized Viewpoints, Racial Perspectives, Gendered Constraints." *American Art* 13, no. 1 (Spring 1999): 10–39.

Larson, Kay. "Briefs: Bill Traylor at Oosterom." *Village Voice*, Jan. 7, 1980, 59.

———. "Varieties of Black Identity." *New York Magazine*, Aug. 2, 1982, 52–53.

Leone, Mark P., and Gladys-Marie Fry. "Conjuring in the Big House Kitchen: An Interpretation of African American Belief Systems Based on the Uses of Archaeology and Folklore Sources." *Journal of American Folklore* 112, no. 445 (Summer 1999): 372–403.

Lewis, Ella Jackson, as told to Rudolph Lewis. "Conjuring and Doctoring: A True Store About the Fabled Doctor Jim Jordan." *New Laurel Review* 21 (1999): 82–86.

Liazos, Ariane, and Marshall Ganz. "Duty to the Race: African American Fraternal Orders and the Legal Defense of the Right to Organize." Special issue. *Social Science History* 28, no. 3 (Fall 2004): 485–534.

Locke, Alain. Review of Zora Neale Hurston, *Their Eyes Were Watching God: A Novel* (1937). *Opportunity*, June 1, 1938. http://people.virginia.edu/~sfr/enam854/summer/hurston.html.

MacGaffey, Wyatt. "Complexity, Astonishment and Power: The Visual Vocabulary of Kongo Minkisi." Special issue, *Journal of Southern African Studies* 14, no. 2 (1988): 188–203.

Marvin, Thomas S. "Children of Legba: Musicians at the Crossroads in Ralph Ellison's *Invisible Man*." *American Literature* (Duke University Press) 68, no. 3 (Sept. 1996): 587–608.

Mathews, Burgin. "'Looking for Railroad Bill': On the Trail of an Alabama Badman." *Southern Cultures* 9, no. 3 (Fall 2003): 66–88.

Myers, John B. "Reaction and Adjustment: The Struggle of Alabama Freedmen in Post-Bellum Alabama, 1865–1867." *Alabama Historical Quarterly* 32, nos. 1 and 2 (Spring and Summer 1970).

The Museum of Modern Art (New York). "Annual Report to Members for 1938." *Bulletin of the Museum of Modern Art* 5, no. 1 (Jan. 1938): 3–12. http://www.jstor.org/stable/4057932.

———. Press releases, *Masters of Popular Painting: Modern Primitives of Europe and America*, April 27–July 24, 1938." No. 38412-14 and "April 27, 1938." https://www.moma.org/calendar/exhibitions/2090.

"Negro Burglar Is Slain at Home in West End." *Birmingham Post*, Aug. 26, 1929.

New South Writers Group. *New South: 1940*. Newsletter. Part 1. Montgomery, AL: New South, 1940. Number of editions unknown. Copy provided by Marcia Weber in the author's curatorial files.

Pierpont, Claudia Roth. "A Society of One: Zora Neale Hurston, American Contrarian." *New Yorker*, Feb. 17, 1997. https://www.newyorker.com/magazine/1997/02/17/a-society-of-one.

"A Race Conflict: Alleged Plot to Murder Whites in Alabama." *Los Angeles Times*, May 10, 1888. ProQuest Historical Newspapers.

Radio 4, no. 4 (Apr. 1922); 4, no. 11 (Nov. 1922).

Rankin, Allen. "He Lost 10,000 Years." *Collier's*, June 22, 1946, 67.

———. "He'll Paint for You—Big 'Uns 20 Cents, Lil' 'Uns, a Nickel." *Alabama Journal*, Mar. 31, 1948.

Raynor, Vivien. "A Gentle Naif from Alabama." *New York Times*, Sept. 26, 1982.

———. "Show in Brooklyn Mines Black Folk Vein." *New York Times*, July 2, 1982.

Saint Jude Catholic Church (Montgomery, AL). *Baptismal Record* 1, no. 35, entry 12.

Sellers, M. B. "Legba." *Deep South Magazine*. Jan. 10, 2014. http://deepsouthmag.com/2014/01/10/legba/.

Shannon, Charles. "Bill Traylor's Triumph: How the Beautiful and Raucous Drawings of a Former Alabama Slave Came to Be Known to the World." *Art & Antiques* (Feb. 1988): 61–65, 88.

Sisk, Glenn. "Funeral Customs in the Alabama Black Belt, 1870–1910." *Southern Folklore Quarterly* 23 (1959): 169–71.

Skocpol, Theda, and Jennifer Lynn Oser. "Organization Despite Adversity: The Origins and Development of African American Fraternal Associations and the History of Civil Society in the United States." Special issue, *Social Science History* 28, no. 3 (Fall 2004): 367–437.

"Slavery in Alabama." *The Age* (London), July 2, 1903.

Smith, Roberta. "Rays of Light and Menacing Shadows: Roberta Smith's 2013 Art Highlights, and Some Concerns." *New York Times*, Dec. 12, 2013.

Snyder, Thomas D., ed. *120 Years of American Education: A Statistical Portrait*. [Washington, DC:] National Center for Education Statistics, US Department of Education, 1993. https://nces.ed.gov/pubs93/93442.pdf.

Stine, Linda France, Melanie A. Cabak, and Mark D. Groover. "Blue Beads as African-American Cultural Symbols." *Historical Archaeology* 30 (1996): 49–75.

Stuckey, Sterling. "Through the Prism of Folklore: The Black Ethos in Slavery." *Massachusetts Review* 9, no. 3 (Summer 1968): 417–37.

Thorn, Charlotte R., and Mabel W. Dillingham. Letter to the Editor, "Light in a Dark Place." *Christian Union* 46, no. 15 (Oct. 8, 1892): 646–47.

Washington, Georgia. "Calhoun Colored School—Alabama." *Friend: A Religious and Literary Journal* 66, no. 33 (Mar. 11, 1893): 262.

Wilford, John Noble. "Ezekiel's Wheel Ties African Spiritual Traditions to Christianity." *New York Times*, Nov. 7, 2016.

Wilkerson, M. P. "Lawsuit Claims Man Stole Ex-Slaves Art." *Montgomery Advertiser*. Dec. 1992.

Wingo, Ajume H. "African Art and the Aesthetics of Hiding and Revealing." *British Journal of Aesthetics* 38, no. 3 (July 1998): 251–64.

"Writer Breaks Ankle in Fall into Old Well." *Montgomery* (AL) *Advertiser*, Mar. 5, 1946.

Wright, Richard. "Between Laughter and Tears." Review of *Their Eyes Were Watching God* (1937). *New Masses*, Oct. 5, 1937. http://people.virginia.edu/~sfr/enam358/wrightrev.html.

Yingling, Charlton, and Tyler Parry. "The Canine Terror." *Jacobin*. May 19, 2016. https://www.jacobinmag.com/2016/05/dogs-bloodhounds-slavery-police-brutality-racism/.

Dissertations, Lectures, Papers, Theses, and Unpublished Manuscripts

Bond, Julian. "Bill Traylor," lecture at Decatur House, Washington, DC, Dec. 10, 1997. Organized by Joe Wilkinson and Sotheby's in conjunction with the sale "Bill Traylor Drawings from the Collection of Joe and Pat Wilkinson," Sotheby's, New York, Wednesday, Dec. 3, 1997. Lecture copyrighted to Julian Bond, Nov. 10, 1997; unpublished transcript provided by Joe Wilkinson, Apr. 28, 2017, is in the author's curatorial files.

Fowler, Ann. "The New South." Unpublished graduate research paper, Emory University, Atlanta, Georgia, 1990. Copy in the author's curatorial files with permission from A. Fowler.

Kangas, Maj. Larry Edward. "Historical Picture of Maxwell AFB." Thesis, Air Command and Staff College Air University, Maxwell AFB, Montgomery, AL, 1986. http://www.dtic.mil/get-tr-doc/pdf?AD=ADA168255.

Koy, Christopher E. "The Mule as Metaphor in the Fiction of Charles Waddell Chesnutt." In *Theory and Practice in English Studies: Proceedings from the Eighth Conference of British, American, and*

Canadian Studies (Linguistics, Methodology and Translation), 93–100. Ed. Jan Chovanec. Brno, Czech Republic: Marasyk University, 2005. https://www.researchgate.net/publication/253373992.

McDavid, William L. "Calhoun Land Trust: A Study of Rural Resettlement in Lowndes County, Alabama." Master's thesis, Fisk University, Nashville, TN, 1943.

Miron, Jeffrey A., and Jeffrey Zwiebel. "Alcohol Consumption During Prohibition." *American Economic Review* 81, no. 2. Papers and Proceedings of the Hundred and Third Annual Meeting of the American Economic Association (May 1991): 242–47.

Morris, Randall. "Crossroads and the Spirit: Comments on Bill Traylor and J. B. Murray." Lecture presentation at the Metropolitan Pavilion, New York. Jan. 26, 2013.

———. "Mules, Men, Women, and Spirits: Conjure in Bill Traylor's Time." Lecture presentation at the American Folk Art Museum, New York. Sept. 16, 2014.

———. "The Road Less Traveled." Unpublished paper presented at NCPTT Divine Disorder Symposium, a partnership of National Center for Preservation Technology and Training (NCPTT), National Park Service, US Department of the Interior, Natchitoches, Louisiana; Kohler Foundation, Kohler, Wisconsin; and John Michael Kohler Arts Center, Sheboygan, Wisconsin, Sept. 28, 2017.

Owen, Mary Alicia. "Among the Voodoos." In *The International Folk-lore Congress 1891: Papers and Transactions*. Ed. Joseph Jacobs and Alfred Nutt, 230–48. London: David Nutt, 1892.

Ryckeley, Rebecca. "The Rural School Project of the Rosenwald Fund, 1934–1946." PhD diss., Georgia State University, 2015. http://scholarworks.gsu.edu/eps_diss/133.

Scott, Judge John B. "Monroe Street." Paper presented to "The Thirteen," Montgomery, AL, Mar. 13, 1958. Courtesy Mary Ann Neeley of the Landmarks Foundation of Montgomery.

Sibbel, Megan Stout. "Reaping the 'Colored Harvest': The Catholic Mission in the American South." PhD diss., Loyola University Chicago, 2013. http://ecommons.luc.edu/luc_diss/547.

Thompson, Robert Farris. "African Influences on the Art of the United States." Paper published for symposium, "Black Studies in the University," at Yale University, New Haven, CT, Apr. 1969.

Blogs and Websites

Alabama Department of Archives and History (ADAH), Montgomery. http://www.archives.state.al.us/.

———. "1901–1950." *Alabama History Timeline*. http://www.archives.alabama.gov/timeline/al1901.html.

———. Recorded Oct. 17, 1936. WPA files, Lowndes County Folklore. http://digital.archives.alabama.gov/cdm/singleitem/collection/wpa/id/858/rec/3.

———. "This Week in Alabama History: June 28–July 4." http://archives.state.al.us/historythisweek/week27.html.

Alabama Geographic Information Systems (GIS). "Lowndes County, Alabama Public GIS Parcel Search." Suwanee, Georgia: Flagship GIS. http://www.alabamagis.com/Lowndes/frameset.cfm?cfid=444789&cftoken=76647231.

Alabama Department of Revenue, Montgomery. County Offices/Appraisal & Assessment Records. Dallas County. https://revenue.alabama.gov/property-tax/county-officesappraisal-assessment-records/. Dallas County's Parcel Viewer. https://arcg.is/1mfy1T.

Alabama Heritage of the University of Alabama, University of Alabama at Birmingham, and ADAH. "Summer 1861: Montgomery—'The Cradle of the Confederacy.'" July 25, 2011. http://www.alabamaheritage.com/civil-war-era/summer-1861-montgomerythe-cradle-of-the-confederacy.

American Battlefield Trust. "Biography: Jefferson Davis." https://www.civilwar.org/learn/biographies/jefferson-davis.

American Folklore. "Animal Stories." http://americanfolklore.net/folklore/animal-stories/.

Billie Holiday Official Website. http://www.billieholiday.com/portfolio/strange-fruit/.

Borders and Borderlands. http://mexicanborder.web.unc.edu/the-bracero-program-3/.

Boswell, Maggie. "The Haunted Graveyard in Lowndes County." W. D. Autrey and Mrs. Till, consultants. Oct. 17, 1936. WPA Alabama Writers' Project. *Folklore: Lowndes County, #3*. ADAH. http://digital.archives.alabama.gov/cdm/ref/collection/wpa/id/858.

Bracero History Archive. A project of the Roy Rosenzweig Center for History and New Media, George Mason University, the Smithsonian National Museum of American History, Brown University, and the Institute of Oral History at the University of Texas at El Paso. http://braceroarchive.org/about.

Census Bureau. https://www2.census.gov/geo/maps/pl10map/cou_blk/st01_al/c01047_dallas/PL10BLK_C01047_000.pdf.

Davis, Ronald L. F. "Racial Etiquette: The Racial Customs and Rules of Racial Behaviour in Jim Crow America." 2006. Education for Liberation (website). http://www.edliberation.org/resources/lab/recordsracial-etiquette-the-racial-customs-and-rules-of-behaviour-in-jim-crow-america.

Devi, Debra. "Language of the Blues: Policy Game," Sept. 10, 2015, American Blues Scene. https://www.americanbluesscene.com/2015/09/language-of-the-blues-policy-game/.

Doddington, David. "Slavery and Dogs in the Antebellum South." *Sniffing the Past* (blog). Feb. 23, 2012. https://sniffingthepast.wordpress.com/2012/02/23/slavery-and-dogs-in-the-antebellum-south/.

Equal Justice Initiative. https://eji.org/.

———. "Lynching in America: A Community Remembrance Project." https://eji.org/reports/community-remembrance-project.

———. "The National Memorial for Peace and Justice." https://eji.org/national-lynching-memorial.

———. "Slavery in America: The Montgomery Slave Trade." https://eji.org/reports/slavery-in-america.

Finney, Robert T. "History of the Air Corps Tactical School, 1920–1940." Research Studies Institute, USAF Historical Division, Air University, 1955; repr., Air Force History and Museum Programs, 1998.Defense Technical Information Center. Www.dtic.mil/dtic/tr/fulltext/u2/a432954.pdf.

Gilpin, Ebenezer Nelson. "Diary of Ebenezer Nelson Gilpin, April 1865." In *The Last Campaign: A Cavalryman's Journal*. Leavenworth, KS: Press of Ketcheson Print, 1908. American Civil War: Letters and Diaries database. http://solomon.cwld.alexanderstreet.com/cgi-bin/asp/philo/cwld/getdoc.pl?S1578-D002.

Hale, Stephen F. Stephen, to the Governor of Kentucky, Dec. 27, 1860. Causes of the Civil War. http://civilwarcauses.org/hale.htm.

Hall, Stephanie. "The Life and Times of Boll Weevil." Dec. 11, 2013. Library of Congress, Folklife Today. https://blogs.loc.gov/folklife/2013/12/the-life-and-times-of-boll-weevil/.

Haveman, Christopher. "Creek Indian Removal." Encyclopedia of Alabama. Jan. 28, 2009; last updated Jan. 13, 2017. http://www.encyclopediaofalabama.org/article/h-2013.

Hebert, Keith S. "Ku Klux Klan in Alabama from 1915–1930." Encyclopedia of Alabama. Feb. 22, 2012; last updated Nov. 7, 2013. http://www.encyclopediaofalabama.org/article/h-3221.

Hiatt, Grant D. "Pine Apple." Encyclopedia of Alabama. Mar. 17, 2011; last updated May 11, 2018. http://www.encyclopediaofalabama.org/article/h-3031.

Immigration to the United States. http://www.immigrationtounitedstates.org/389-bracero-program.html.

Lowndesboro Historical Society, Montgomery, AL. Historical marker, Wilson's Raiders, Apr. 10, 1865. http://www.waymarking.com/gallery/default.aspx?f=1&guid=cadede42-f96e-4cd6-8500-e805d89a5849&gid=2.

Mock, Brentin. "The 'Great Migration' Was about Racial Terror, Not Jobs," June 24, 2015, CityLab. https://www.citylab.com/equity/2015/06/the-great-migration-was-about-racial-terror-not-jobs/396722/.

Mortal Journey. "The Jitterbug Dance (1940's)." Jan. 3, 2011. http://www.mortaljourney.com/2011/01/1940-trends/jitterbug-dance.

O'Dell, Cary. "'Strange Fruit'—Billie Holiday (1939)." Library of Congress. https://www.loc.gov/programs/static/national-recording-preservation-board/documents/StrangeFruit.pdf.

Ollif, Martin T. "World War I and Alabama." Encyclopedia of Alabama. May 22, 2008; last updated Jan. 28, 2016. http://www.encyclopediaofalabama.org/article/h-1545.

Pew Research. *Multiracial in America*. Chap. 1, "Race and Multiracial Americans in the U.S. Census." June 11, 2015. http://www.pewsocialtrends.org/2015/06/11/chapter-1-race-and-multiracial-americans-in-the-u-s-census/.

Ross-Clayton Funeral Home. http://www.rossclaytonfh.com/our-history.html.

Slave Narratives. https://www.slave-narratives.com/.

Stevenson, Bryan. *Lynching in America: Confronting the Legacy of Racial Terror*. 3rd ed. 2017. Equal Justice Initiative. https://lynchinginamerica.eji.org/report/.

StudyModeResearch. "The Great Migration." http://www.studymode.com/essays/The-Great-Migration-80871.html.

University of Southern Alabama. Gaylord Lee Clark Photographs. The Doy Leale McCall Rare Book and Manuscript Library. https://www.southalabama.edu/libraries/mccallarchives/clark.html.

Walk The Earth. "George Alexander Traylor at Mount Gilead Cemetery, Trickem, Lowndes County, Alabama, memorial no. 44726259." Find A Grave Inc. Nov. 23, 2009. https://www.findagrave.com/memorial/44726259.

Wells, Ida B. *Southern Horrors: Lynch Law in All Its Phases* (1892). Project Gutenberg. https://www.gutenberg.org/files/14975/14975-h/14975-h.htm.

Wikipedia. "Davy Crockett." Last modified Jan. 10, 2018. https://en.wikipedia.org/wiki/Davy_Crockett#Family_and_early_life.

———. "Tuskegee Airmen." Last modified Mar. 31, 2018. https://en.wikipedia.org/wiki/Tuskegee_Airmen.

World's Music Charts. http://tsort.info/music/ds1930.htm.

Documentary Recordings

Burckhardt, Rudy, dir. *Montgomery, Alabama*. 1941. Disc 1. *Rudy Burckhardt Films*, DVD. San Francisco, CA: Estate of Rudy Burckhardt, 2012. Distributed by Microcinema International.

Wolf, Jeffrey, dir., prod., ed. *Bill Traylor: Chasing Ghosts*. New York: Breakaway Films, 2018.

IMAGE CREDITS

Unless otherwise specified, all photographs were provided by the owners/collections of the artworks noted in the captions and are used with permission. Every effort has been made to obtain permissions for all copyright-protected work used in this book. Additional photograph credits:

All artworks by Bill Traylor © 1994, Bill Traylor Family Trust.

pp. 24, 29 © Kerry James Marshall. Photo: Matthew Fried, © MCA Chicago; **p. 27** © Kerry James Marshall. Courtesy of the artist and Jack Shainman Gallery, New York; **p. 28 (top)** Reproduced from Stacey Epstein, *Alfred Maurer: At the Vanguard of Modernism* (Andover, MA: Addison Gallery of American Art, Phillips Academy, 2015). Photo by Mindy Barrett; **p. 28 (bottom)** Photo © Sheldon Museum of Art; **pp. 372–73** Series 9, box # EL1982.01–.02, COR5.1: Corcoran Gallery of Art registrar's office records, Special Collections Research Center, George Washington University Libraries, Washington DC; **pp. 378–81** Family trees created by Stacy Mince, designed by Eleni Giannakopoulos.

Pls. 2, 12, 32, 34, 43, 53, 68, 161, 203 Photo by James Prinz, Chicago; **pls. 4, 10, 37, 59, 70, 87, 142, 185** Image copyright © The Metropolitan Museum of Art. Image source: Art Resource, NY; **pls. 5, 129, 133** Photograph by Blu Tint Photography owner Lieutenant Norals IV; **pls. 7, 39, 72, 73, 79, 83, 90, 104, 130, 137, 172, 176, 180, 199, 201** Photo by Gene Young; **pls. 8, 114** Photo credit: The Philadelphia Museum of Art/Art Resource, NY; **pls. 9, 25, 85, 100, 140, 178** Digital Image © The Museum of Modern Art/ Licensed by SCALA/Art Resource, NY; **pls. 11, 58, 74, 107, 122, 147, 170, 181, 186, 204** Photo: William Louis-Dreyfus Foundation Inc.; **pls. 13–15, 18, 200** Image courtesy the Betty Cuningham Gallery; **pls. 17, 21, 52** Image courtesy Bethany Mission Gallery, Philadelphia; **pls. 19, 27, 40, 48, 71, 93, 117, 121, 136, 139, 166, 174, 175, 198** Photo by Mike Jensen; **pls. 22, 31, 56, 65, 75, 163, 193** Image courtesy The Museum of Everything; **pls. 29, 66, 86** Photo by James Prinz, Chicago; Courtesy BMS Art; **pl. 30** Photography by Gavin Ashworth; **pls. 33, 78, 124–26, 128, 144, 146, 156, 164, 168, 169, 188** Photo: Matt Flynn © Smithsonian Institution; **pl. 35** Photo courtesy Hill Gallery; **pls. 36, 63** Photo by Mindy Barrett; **pls. 42, 84, 189** Photo: Stephanie Arnett; **pl. 46** Photo by @criscophoto; **pl. 51** Photo by Miguel Benavides; **pl. 54** Photography: Sandy Gellis; **pls. 61, 173, 195, 205** Photo by William H. Bengtson, Chicago; **pls. 76, 80, 91, 92, 97, 102, 106, 109, 110, 118, 134, 148, 152, 165, 197, 202** Photography by Teri Bloom; **pl. 95** Photo by Robert A. Lisak; **pl. 99** Image courtesy Ricco Maresca Gallery; **pl. 103** Photo: James Connolly; **pl. 108** Photo by Ellen McDermott; **pls. 112, 145** Photo by Scott Saraceno; **pls. 120, 123, 141, 182** Photo by Visko Hatfield; **pl. 138** Photo Credit: Newark Museum/Art Resource, NY; **pl. 149** Photo by Annabel Ruddle; **pl. 160** Photo by Randy Batista; **pl. 162** Photo by Bonnie H. Morrison, NYC; **pl. 183** Photo by John Parnell, American Folk Art Museum/Art Resource, NY; **pl. 191** Photography by Peggy Tenison, Courtesy San Antonio Museum of Art; **pl. 192** Photograph © John A. Faier; **pl. 196** Reproduced from catalogue for *Bill Traylor*, exhibition in 1982 at the Arkansas Arts Center. Photo by Mindy Barrett.

Fig. 2 Courtesy Smithsonian Libraries, reproduced from Philip Henry Gosse, *Letters from Alabama, Chiefly Relating to Natural History* (Morgan and Chase, 1859), p. 157; **fig. 3** Image courtesy Selma Dallas County Public Library; **figs. 4, 16, 19 (and detail)** Maps created by Stacy Mince, designed by Eleni Giannakopoulos; **figs. 5, 6** Image courtesy the Alabama Department of Archives and History; **figs. 8, 50** Photo courtesy Kendall Buster; **figs. 9, 20, 22, 28, 71** Marcia Weber research files; **figs. 11, 14, 15** Image retrieved from Ancestry.com; **figs. 12, 17** Courtesy US Social Security Administration; **fig. 13** Image courtesy Special Collections, USDA National Agricultural Library; **fig. 18** John Engelhardt Scott negative collection, LPP116, Alabama Department of Archives and History; **figs. 21, 23** Photograph (copy), Sanderson Collection, from Miriam Rogers Fowler, files on Bill Traylor. Collection of Jeffrey Wolf, New York; **fig. 25** ©Van Vechten Trust/Beinecke Library; **fig. 26** Courtesy Smithsonian Libraries, Washington, DC; **figs. 27, 34, 35, 80, 81** Photo by Leslie Umberger; **fig. 29** Courtesy Alabama State Council on the Arts; **fig. 30** Image located in the papers of Luise Ross, donated to Smithsonian American Art Museum in 2017; **fig. 31** Reproduced from Mechal Sobel, *Painting a Hidden Life: The Art of Bill Traylor* (Baton Rouge: Louisiana State University Press, 2009). Photo by Mindy Barrett; **figs. 32, 82** Albert Kraus/Tommy Giles Photographic Services; **fig. 33** From Miriam Rogers Fowler, files on Bill Traylor, Collection of Jeffrey Wolf, New York; **fig. 42** The Miriam and Ira D. Wallach Division of Art, Prints and Photographs: Photography Collection, The New York Public Library; **fig. 43** Reproduced from Carl Carmer, *Stars Fell on Alabama* (New York: Blue Ribbon Books, 1934). Photo by Mindy Barrett; **fig. 44** Image courtesy Tim Samuelson; **fig. 51** Library of Congress, FSA/OWI Collection LC-USF34-031907-D; **fig. 53** Photo by NY Daily News Archive via Getty Images; **fig. 55** Photo by ullstein bild/ullstein bild via Getty Images; **fig. 56** Photography: Sandy Gellis; **fig. 57** Photo by Picking Pittsburgh; **fig. 58** Photo by Ian Maybury/Alamy Stock Photo; **fig. 61** Photo © CORBIS/Corbis via Getty Images; **fig. 62** Photo by Mildred Baldwin; **fig. 65** Image courtesy UNC-Chapel Hill Library; **fig. 66** Reprinted by permission of Harold Ober Associates Incorporated. Copyright 1994 by the Langston Hughes Estate; **fig. 68** © Estate of Rudy Burckhardt/Artist's Rights Society (ARS), New York; **fig. 69** Image courtesy Debbie George; **fig. 70** Image courtesy sunkentreazures; **fig. 72** Retrieved from Encyclopedia Britannica (online); **fig. 73** Reproduced from *Aunt Sally's Policy Players' Dream Book* (Chicago: Stein Publishing House, 1926). Photo by Mindy Barrett; **fig. 74** Library of Congress, Historic American Engineering Record HAER SC-11; **fig. 75** Image courtesy Documenting the American South, UNC-Chapel Hill Library; **fig. 77** Image courtesy Curtis Licensing; **fig. 78** Photo by James Prinz, Chicago; **fig. 79** Reproduced from Barry Parker, *A Varon in Us All* (Chattanooga, TN: Parker Communications, 2009). Photo by Mindy Barrett; **fig. 83** Reproduced from Josef Helfenstein and Roman Kurzmeyer, eds. *Bill Traylor, 1854–1949: Deep Blues* (New Haven, CT: Yale University Press, 1999), p. 176. Photo by Mindy Barrett.

INDEX

(Names, Titles, and Select Subjects)

Artworks by Bill Traylor are not indexed; see List of Plates (p. 383). Page numbers in *italic* refer to figure illustrations. Endnote locators refer to headers in the Notes section: DF (Director's Foreword), PR (Prologue), NR (Notes to the Reader), LA (LifeA), LB (LifeB), AA (ArtA), AB (ArtB), AC (ArtC), and AF (Afterlife).